(1992)

£12

ART

(twelve)

22/24

The Royal Watercolour Society

THE FIRST FIFTY YEARS
1805-1855

AN
ANTIQUE COLLECTORS' CLUB
RESEARCH PROJECT

Published for the Antique Collectors' Club
by the Antique Collectors' Club Ltd.

British Library CIP Data
Royal Society of Painters in Water-colours
 The Royal watercolour Society: directory of artists,
 exhibits and purchases: an ACC research project.
 Vol.1 The first fifty years, 1805-1855
 I. Title II. Antique Collectors Club
 759.2074

ISBN 1 85149 099 X

Printed in England by
the Antique Collectors' Club Ltd.
Woodbridge, Suffolk

Contents

Antique Collectors' Club

The Antique Collectors' Club was formed in 1966 and now has a five figure membership spread throughout the world. It publishes the only independently run monthly antiques magazine *Antique Collecting* which caters for those collectors who are interested in widening their knowledge of antiques, both by greater awareness of quality and by discussion of the factors which influence the price that is likely to be asked. The Antique Collectors' Club pioneered the provision of information on prices for collectors and the magazine still leads in the provision of detailed articles on a variety of subjects.

It was in response to the enormous demand for information on "what to pay" that the price guide series was introduced in 1968 with the first edition of *The Price Guide to Antique Furniture* (completely revised 1978 and 1989), a book which broke new ground by illustrating the more common types of antique furniture, the sort that collectors could buy in shops and at auctions rather than the rare museum pieces which had previously been used (and still to a large extent are used) to make up the limited amount of illustrations in books published by commercial publishers. Many other price guides have followed, all copiously illustrated, and greatly appreciated by collectors for the valuable information they contain, quite apart from prices. The Antique Collectors' Club also publishes other books on antiques, including horology and art reference works, and a full book list is available.

Club membership, which is open to all collectors, costs £17.50 per annum. Members receive free of charge *Antique Collecting*, the Club's magazine (published ten times a year), which contains well-illustrated articles dealing with the practical aspects of collecting not normally dealt with by magazines. Prices, features of value, investment potential, fakes and forgeries are all given prominence in the magazine.

Among other facilities available to members are private buying and selling facilities, the longest list of "For Sales" of any antiques magazine, an annual ceramics conference and the opportunity to meet other collectors at their local antique collectors' clubs. There are over eighty in Britain and more than a dozen overseas. Members may also buy the Club's publications at special pre-publication prices.

As its motto implies, the Club is an amateur organisation designed to help collectors get the most out of their hobby: it is informal and friendly and gives enormous enjoyment to all concerned.

For Collectors — By Collectors — About Collecting

The Antique Collectors' Club, 5 Church Street, Woodbridge, Suffolk

Publisher's Preface

The information in this volume has been taken from two sources. The name of the artist, date of the exhibition, catalogue number, title of the painting and any quotation describing the painting come from the printed catalogues of the exhibitions of the Society of Painters in Water Colours while the price and details ·of the purchasers, frames, Art Union prizes and occasional other comments come from the hand-written Sales Books of the same Society. The information obtained from the latter is printed in roman type.

In both cases the original spelling and punctuation have been followed, hence the wonderful inconsistency in spelling of not only places names (for example Windermere and Berkeley Square, not to mention numerous places in Wales) but purchasers' names and titles, and even the names of the artists themselves. As J.L. Roget pointed out in his *A History of the 'Old Water-colour' Society* (first published in 1891 and reprinted by the Antique Collectors' Club in 1972) '[George] Barret's name has often been erroneously printed with two t's, even in many of the Society's catalogues to as late a date as 1820. He himself spelt it with one.' Many artists, therefore, have more than one entry, under different spellings (Barret and Barrett, Whichelo and Wichelo, for example) or different initials (Fielding Copley and Fielding CV, Jenkins JJ, Jenkins Jos J and Jenkins Joseph J, etc.).

In a few instances very lengthy titles of paintings have been cut and in rather more instances the descriptive quotations, many of which ran to several verses. All such omissions are indicated by . . . in or at the end of the title or quotation. If . . . appears at the beginning then it was in the original printed catalogue, as also were --- and &c. &c.

The Sales Books are written in a number of hands, some more illegible than others, and many entries proved impossible to decipher. Some pages have faded, ink blots have obliterated key words, and one or two of the scribes seem to have taken a delight in scribbling 'settled in full' or 'paid in full' over prices or purchasers' names. Where pencil has been used it has sometimes faded or been smudged, and it is often not clear whether pencilled prices or purchasers were the actual ones, or merely tentative.

There are, therefore, a large number of question marks. While it may at first glance seem rather unhelpful to list a purchaser as 'Mr. ???' or even as just a string of question marks, this has been done to indicate that the painting was sold but the purchaser's name is illegible.

The old-fashioned writing proved difficult also, with the letters T, J, F, S and I giving the most problems. Similarly, it was not always easy to distinguish between Messrs. and Miss and also between Mr. and Mrs., although Esq. was usually used. On occasion square brackets have been used in an attempt to clarify matters.

Sales books for 1831, 1838, 1840, 1842, 1849, 1851 and 1853 are missing.

Catalogue numbers 333-359 are missing from the Sales Book of 1827, as are 1-12 from 1835 and 1-8 and 25-32 from 1837.

The asterisks beside some catalogue numbers appeared in the original printed catalogues and indicate that two quite separate paintings were given the same catalogue number.

In 1823 a loan exhibition was held after the close of the regular exhibition. These 212 drawings were not limited to works by Members and Associates but included works executed prior to 1822 by any British artist, living or dead. Items from this loan exhibition are identified by L after the date 1823.

Prices appear in both pounds and guineas in the Sales Books, and again the original has been followed. (When a number appears on its own it was not clear whether it was pounds or guineas.) These prices did not include the frame and glass and some Sales Books give a separate price for these and sometimes the handwritten entries indicate whether or not the purchaser bought the frame and glass (by putting 'Yes' or 'No' under that column) or, occasionally, requested a new one.

Abbreviations

AU	Art Union
Do.	Ditto
G	guineas
gns.	guineas
L	1823 Loan Exhibition
PAU	Art Union Prize
Sd.	Sold
T.G.	A frequent purchaser, presumably T. Griffith(s)

A Short History

A Short History from 1804-1855 (taken from *A History of the 'Old Water-Colour' Society* by John Lewis Roget, originally published in 1891 and reprinted by the Antique Collectors' Club in 1972)

Ten watercolour artists met in London at the Stratford Coffeehouse in Oxford Street on 30th November 1804 and formed The Society of Painters in Water-Colours. Membership was limited to twenty-four who must be of 'moral character', 'professional reputation' and 'resident in the United Kingdom'. The ten were W.S. Gilpin (who was elected President), S. Shelley (Treasurer), Robert Hills (Secretary), F. Nicholson, N. Pocock, W.H. Pyne, W.F. Wells (Committee-men), J.C. Nattes, J. Varley and C. Varley.

Their aim was to bring their art to the attention of the general public by holding exhibitions exclusively devoted to watercolours where they were not relegated to second place or overshadowed by oil paintings as was the case in other exhibitions at that time. It was also decided to be less coy about prices and the catalogue of the first exhibition stated that 'A Person attends the Rooms with a book, containing the Prices (independent of the Frames) of such Pictures as are to be disposed of; with whom, to prevent any mistake, the Purchaser is requested to leave a deposit of ten per cent, and his Card of Address.'

This first exhibition was held from 22nd April to 8th June 1805 at No. 20 Lower Brook Street, Bond Street (admittance one shilling, catalogue included). By then a further six artists had joined: George Barret, Joshua Cristall, John Glover, William Havell, James Holworthy and Stephen Francis Rigaud. Of the 275 drawings exhibited, forty-two were by John Varley; Shelley and Pyne contributed twenty-eight each, Hills and Glover twenty-three each, Wells twenty-one, Gilpin twenty, Pocock seventeen, Nicholson fourteen, Havell and Cornelius Varley twelve each, Barret eleven, Cristall eight, Rigaud six and Holworthy and Nattes five each.

Nearly 12,000 people paid for admission in the seven weeks, a total of over £577, and after all expenses the Society had a surplus of nearly £272. In accordance with the rules of the Society, this sum was divided among the members 'in sums proportioned to the drawings sent and retained for exhibition', each member having valued his own works. Roget produced an interesting table of the self-estimation of these first exhibitors by dividing their valuations by the number of paintings contributed to give an average price per exhibit for each artist:

1.	Shelley	£26.10. 6	5.	Hills	£10.18. 0
2.	Glover	£22. 1. 0	6.	Rigaud	£10. 2. 6
3.	Pocock	£13. 0. 0	7.	Gilpin	£ 9.18. 0
4.	Nattes	£12. 2. 6	8.	Holworthy	£ 9. 0. 0

9.	Wells	£7. 0. 0	13.	J. Varley	£4.14. 0
10.	Cristall	£6.13. 0	14.	Barret	£4. 9. 6
11.	Havell	£5.14. 0	15.	Pyne	£4. 8. 0
12.	Nicholson	£5.12. 0	16.	C. Varley	£3.14. 0

The average price of a drawing at this first exhibition was, therefore, about £10.11s.0d. As Roget remarked, 'the foregoing table of precedence does not in all cases agree with the verdict of posterity as to the merits of the artists named therein.'

Encouraged by the success of the first exhibition a larger scale exhibition was planned for the following year and the Society resolved to increase the number of exhibitors by forming a new class called 'Fellow Exhibitors' (later called 'Associate Exhibitors'). These should not exceed sixteen and would be allowed five drawings only at any one time. It was further agreed that two new Members a year be added, from the ranks of the Fellow Exhibitors, till the number twenty-four was reached.

On 30th December 1805 the following nine artists were selected out of sixteen candidates: Anne Frances Byrne, John James Chalon, William Delamotte, Robert Freebairn, Paul Sandby Munn, Richard Ramsay Reinagle, John Smith (who did not exhibit in 1806), Francis Stevens and John Thurston. Gilpin resigned the Presidency in March 1806, on moving from London to the country, and Wells was eventually elected to succeed him, Pocock having refused the position.

The second exhibition, again at Brook Street, was held from 21st April to 14th June 1806. 12,439 people paid to see the 301 paintings, catalogues were this year charged for at 6d. each, and the gross receipts were £766.16s.0d. The surplus of £440.3s.0d. was again divided between the sixteen Members and Miss Byrne who, as the first lady associate to be admitted, was in a special position, being allowed to 'partake of the *profits* in the same proportion as the Members, while they [the ladies] are exempt from the troubles of official duties and from every responsibility whatever on account of any *losses* incurred by the Society.'

The system of apportioning the profits was beginning to be queried and Shelley resigned as Treasurer in the spring of 1807 when the Society passed resolutions that his large number of portraits could not fairly be said to promote the Society's objects and did not entitle him to a share of the profits. He was replaced by Richard Ramsay Reinagle who, with 'Warwick' Smith, had become a Member in December 1806. On 23rd March 1807 Thomas Heaphy and Augustus Pugin were selected as new Associates, out of nineteen candidates.

The arrangement of having someone in the rooms empowered to enter into sale agreements was successful, but for the second exhibition the deposit was increased to twenty per cent for all pictures priced below ten guineas. A further condition stipulated that any deposits left for pictures not claimed within one month of the close of the exhibition would be forfeited and the artist considered at liberty to dispose of his pictures to any other person. Some difficulties were obviously encountered as the catalogue for the fourth exhibition further states

that 'the Person who attends the Rooms is particularly directed to mark no Painting whatever as sold, unless the deposit be paid at the time.' The words 'and Glasses' were also added to 'independent of the Frames' in the conditions of the fourth exhibition.

The third exhibition, 27th April to 13th June 1807, was held at The Old Royal Academy Rooms, Pall Mall. 324 drawings were exhibited, 14,366 people paid for admission, 6d. each was again charged for catalogues and £471.17s.10½d. was the sum divided, with Glover, who was to become President in November on Wells' resignation, receiving the largest amount, £88.6s.3d. Four days after the close of the exhibition Claude Nattes was expelled from the Society, being found guilty of trying to pass off other people's work as his own in order to obtain a larger share of the profits.

Heaphy and Chalon became Members in November and in January 1808 Robert Freeman died (a new rule was made allowing the family of a deceased Member or Associate to exhibit works prepared by him for the gallery) and John Augustus Atkinson and William Turner were elected Associates.

The 1808 exhibition was held at No. 16 Old Bond Street as the Old Academy rooms were surveyed as being in a dangerous condition. 18,999 admissions were recorded and there was a profit of over £445. At the anniversary meeting on 30th November Turner and Atkinson were made full Members and, on Glover's resignation, Reinagle became President. Shelley died on 22nd December.

The 1809 exhibition, the first of twelve to be held at Spring Gardens, was the most successful yet, with 341 drawings, admissions of nearly 23,000 and a profit of £626. Over the next four years twelve more artists joined the Society as Associates: Thomas Uwins, William Payne, Edmund Dorrell and Charles Wild in February 1809; Frederick Nash, Peter De Wint and Anthony Vandyke Copley Fielding in January 1810; William Westall in June 1810; William Scott in November 1810; David Cox, Luke Clennell and C. Barber in June 1812. Stevens and Dorrell became full Members in June 1809, Nash and Uwins in June 1810, De Wint and Westall in June 1811 and Wild and Pugin in June 1812. Paul Sandby died in the autumn of 1809 and Pyne resigned in July 1809, Thomas Heaphy in February 1812.

After the successful 1809 exhibition, however, the Society's fortunes changed, suffering from the general depression of the times and the renewed conflict with France. Both patronage and attendance went down until the surplus dividend after the 1812 exhibition was a mere £121.18s.4d., with only 10,624 paid admissions (see Table A). The rival society 'Associated Artists (or Painters) in Water-Colours', who had held exhibitions from 1808, were also struggling and their 1812 exhibition, despite admitting oil paintings and increasing their number of exhibitors, was a commercial failure and their last (see Table G).

The Society met on 5th November 1812 to discuss future prospects and estimated that only 230 drawings would be forthcoming for the next exhibition. A resolution to invite the co-operation of all watercolour artists was overwhelmingly rejected, but a resolution to accept oil paintings as well as watercolours was carried by a majority of ten to eight. A further meeting was held one week later, the matter again discussed, and this time the admission

of oils was confirmed by the casting vote of Cornelius Varley. Chalon, Stevens and Dorrell resigned immediately and Reinagle, the President, took no further part in the affairs of the Society. Four days later, however, eighteen members rescinded the resolution on the grounds 'that the admission of Pictures in Oil would entirely change the character of the Society'. As they could see no prospect of being able to mount a viable exhibition they proposed the Society be dissolved on 30th November and at a meeting held on that day at the house of the Secretary, Robert Hills, it was resolved 'That the Society, having found it impracticable to form another Exhibition of Water-Colour Paintings only, do consider itself dissolved this night'. This final meeting was attended by Wells, Nicholson, Pocock, Chalon, Pugin, Nash, C. Varley, Rigaud, Smith, De Wint, Havell (who took the chair), Uwins, Barret, Dorrell, Glover, Holworthy, J. Varley, Cristall, Atkinson, Wild and Hills. (Wells and Rigaud appear no more and Reinagle, Chalon and Westall took no part in the proceedings of the new society).

The original Society of Painters in Water-Colours had therefore divided into two opposing factions, and those who favoured admitting oils had met on 26th November in order to form 'a society for the purpose of establishing an exhibition consisting of pictures in oil and watercolours'. At this meeting were Nicholson (in the chair), Barret, Cristall, Havell, Holworthy, John and Cornelius Varley, Smith, Uwins, Fielding and two newcomers, James Holmes and John Linnell. The new body was to consist of twenty Members and it was agreed that a select number of other artists should be specially invited to contribute to the exhibitions. Two days later it was resolved that oils and watercolours should be 'kept separate and distinct', the centre of the room being devoted exclusively to watercolours, and that the paintings should be so arranged that the public came to the oils only after passing through the watercolours.

The 'Society of Painters in Oil and Watercolours', meeting on 3rd December, consisted of Barret, Cristall, Cox, Copley Fielding, Holworthy, Nicholson, Linnell, Glover, Miss Harriet Gouldsmith, Havell, Holmes, Turner, Uwins, Smith and the two Varleys. On 17th Nicholson was elected President, Smith Secretary, Barret Treasurer and Uwins, C. Varley, Glover and Cristall were the committee. Frederick Mackenzie was elected Member on 4th February and Henry Richter on 18th.

Atkinson, Pugin, Nash, Scott, Clennell, Barber, De Wint, Miss Byrne, Dorrell, Stevens and Wild exhibited with the reconstitued Society, but did not join it. As before, non-members were nominally restricted to five works each, later increased to eight. Twenty-nine non-members co-operated with eighteen Members to provide 250 works for the 1813 exhibition which was called 'The Ninth', in spite of the dissolution of the original Society. Unfortunately the catalogue makes no distinction between oils and watercolours, but it is known that in 1813 Glover, Hills, Turner, Havell and J. Varley exhibited oils, and in 1818 about half the total paintings were in oil.

Nicholson resigned in November 1813, exhibited as a Member in 1815 and then appeared no more in the catalogues. Richter resigned in 1813, occasionally exhibited thereafter and eventually rejoined. Two new Members were elected in December 1813, George Fennel Robson and William Sawrey

Gilpin, but the latter exhibited five drawings in 1814, 'no effects' in 1815 and then disappeared from the catalogues.

The inclusion of oil paintings did not bring financial success. The largest surplus was £126.1s.5d. for the 1813 exhibition, and there were deficits for the years of 1816 (when paid admissions numbered only 7,063), 1819 and 1820. The deficit of £32.10s.0d. in 1820 was incurred despite that exhibition containing the largest number of works exhibited in the 1813-20 period (382) and by far the greatest number of artists represented (ninety-six) (*see* Table B).

In 1817 the Committee had decided to fund £100 from the £118.10s.1d. surplus for the use of the Society and that in future all Members should be entitled to an equal share of the profits. John Glover, who had been one of those to have profited most under the old system, resigned in December 1817 and Allport was elected in January 1818. In March 1819 the Members resolved to dine together once a year at the cost of the Society's fund, and in June 1819, in spite of a small loss (£13.6s.0d.) on the exhibition, they instituted three premiums of £30 each to be given to three Members (chosen each year by lot) as an incitement to produce works of greater importance 'for the benefit of the exhibition and the improvement of the Society'. Watercolours for these premiums had to be at least 30ins. long if of figures and 39ins. if landscapes; oils had to be at least 5ft. long. Barret, Cristall and Varley received the first set of premiums but the 1820 catalogue does not indicate which particular paintings were executed under these conditions.

No indications of the sizes of the paintings are given in the catalogues, but scraps of paper in the Sales Books for 1821, 1822 and 1823 gave dimensions for five, eleven and two paintings respectively (some illegible). Perhaps new frames were to be made for these. Although the frame and glass were not included in the price of each watercolour, some Sales Books give a separate price and sometimes it is indicated whether or not the purchaser bought the frame and glass or, on the rare occasion, requested a new one. According to Roget, 'in the very early times a heavy environment of gold round the pale washed drawings which then formed the mere germ of the school would obviously have been fatal to their effect'. However, when watercolours vied with oils, richer drawings were framed more in the manner of oils, and in 1823 watercolours 'were displayed in gorgeous frames, bearing out in effect against a mass of glittering gold, as powerfully as pictures in oil'. In 1824 Pyne wrote 'It is only of late that such cabinet productions in this material could be rendered sufficiently rich and deep in tone, to bear out against those broad and superb frames which seemed alone fitted to the power of oil pictures of the same size...' He was speaking of the small landscapes of Barret, Fielding, Varley and Cox. By the mid-1840s heavy French rococo moulded frames tended to give way to lighter frames with 'a plain surface within the outside border'.

There were fifteen Members at the time of the 1820 exhibition: Allport, Barret, Cox, Cristall, Fielding, Miss Gouldsmith, Holmes, Linnell, Prout, Robson, Smith, Stephanoff, Turner and the two Varleys. As already mentioned, despite the large number of exhibits and exhibitors there was again a deficit and on 5th June at a well-attended meeting of the Society in the exhibition room it was resolved, after a full discussion, 'That the Society should

henceforth be a Society of Painters in Water-Colours only, and that no Oil Paintings should be exhibited with their Works'. The resolution was confirmed on 14th and the name formally changed to 'The Society of Painters in Water-Colours'. (Exhibitors from 1805-1812 and 1813-20 are shown in Table D.)

Linnell and Cornelius Varley promptly retired and the name of the only lady member, Miss Gouldsmith, was also withdrawn. Richter, Pugin and Miss Byrne rejoined in June and July, and on 5th June Scott was again made an Associate together with three new men, William James Bennett, James Duffield Harding and William Walker. By the end of the year there were fifteen Members and four Associates. Numbers increased to seventeen and five by February 1821 with the election of Wild and Mrs. T.H. Fielding as Members and H. Gastineau as Associate.

At general meetings in June and July 1820 it was decided to keep the number of Members limited to twenty and to establish a body of no more than twelve Associate Exhibitors, from whom future Members were to be elected. The status of lady artists was changed. They were to 'be called Members and have the rights of Associate Exhibitors, being subject to no expenses nor trouble of business in the Society', but they were not 'to have any interest in the receipts'. The system of premiums was continued but restricted to Members of at least one year's standing. One only was granted for 1821, to John Varley (No. 72 in the catalogue, *Scene from the Bride of Abydos*).

Joshua Cristall was appointed the first President of the reformed Society, a position he held until 1831 (*see* Tables C and E). Fielding was Secretary for the first six years of Cristall's Presidency, followed by Wild for five. Smith was Treasurer for 1821 and 1822, Wild until 1826 and Hills till 1831.

When the decision was made to include oils the 1813 exhibition catalogue had announced rather disingenuously 'The Society of Painters in Water-Colours stimulated by Public Encouragement, and gaining Confidence from Success, have ventured this year on a considerable extension of their Plan. Pictures in Oil and in Water Colours, Portraits, Models and Miniatures are admitted with the present Exhibition...' It was in a similar fashion that the decision to exclude oils was explained in 1821 as being necessary because of the smaller size of the new exhibition room. The Society also took the opportunity to publish a manifesto on the position of watercolour art in general, urging its claims to extended public recognition and generally extolling its virtues.

In fact the Society found it quite difficult to fill their new smaller room and only 191 works were hung in 1821, more than two thirds of which came from six Members: Fielding (thirty-five), Robson (twenty-six), Barret (twenty), Cristall, Prout and Wild (nineteen each). 8,715 people paid for admission, 3,718 catalogues (still 6d.) were bought, but a modest surplus of £44.4s.0d. was achieved, enabling the Society to give a premium for 1822, which fell to the lot of John Smith (No. 35, *A General View of the City and Bay of Naples...*'. Allport resigned in June and was replaced by Harding; in July Holmes and Richter ceased to be Members, the former at his own request, the latter by default (both had failed to exhibit). In February 1822 Charles Moore and Francis Oliver Finch were elected Associates and in April 1822 Frederick Mackenzie and George Cattermole.

The 1822 exhibition had only 175 drawings, 7,037 paying visitors and resulted in a deficit of over £6. It was felt that more exhibitors were needed and better accommodation, ideally permanent, to house larger exhibitions. The Society had long been looking for its own premises and in 1822 Wild and Robson were deputed to negotiate the use of a new exhibition gallery being erected in Pall Mall East with the result that by Christmas the Society had signed a lease for seven years at an annual rent of £260. The building assumed the name of the *Gallery of the Society of Painters in Water-Colours*. In early 1823 Hills and Stevens rejoined as Members, Miss Barret and Miss M. Scott were elected lady Members and W.A. Nesfield, R.H. Essex, S. Jackson and H. Whichelo Associates. In April 1823 Allport was readmitted as an Associate and Richter was also allowed to exhibit again.

The 1823 exhibitors therefore comprised:

Members

George Barrett	*J.D. Harding	J. Stephanoff
*Miss Barret	Robert Hills	F. Stevens
Miss Byrne	F. Mackenzie	*Miss Scott
David Cox	Samuel Prout	William Turner
Joshua Cristall	Augustus Pugin	John Varley
Copley Fielding	G.F. Robson	Charles Wild
*Mrs T.H. Fielding	John Smith	

Associates

H.C. Allport	*H. Gastineau	H. Richter
*W.T. Bennett	*S. Jackson	W. Scott
R.H. Essex	*C. Moore	W. Walker
*F.O. Finch	*W. Nesfield	*J. Whichelo

(* new since 1821 but most had exhibited as 'outsiders' at Spring Gardens)

11,139 visitors came to the first Pall Mall East Exhibition and attendance numbers rose each year thereafter, reaching 14,234 in 1826. The deficit was turned into an annual surplus which was mainly used to fund premiums — two in 1825, four in 1826, five in 1827, six from 1828-30 and eight in 1831. The minutes of the Society show that sales at the exhibition totalled £2,295.12s.0d. and that in 1829 125 drawings were sold at the exhibition, one hundred before it opened, leaving 176 of the 401 unsold. It was resolved in May 1825 that no drawing should be exhibited for sale at under four guineas.

In 1823 a loan exhibition was held after the regular exhibition, attracting 4,238 visitors. 212 drawings not limited to works by Members and Associates but 'extended to those executed prior to 1822 by British artists, living or dead', were lent by a large number of collectors and patrons including the King, the Duke of Argyll, the Marquises of Hertford and Stafford, Earls Brownlow, Carlisle, Lonsdale and Tankerville, the Earl and Countess of Essex, Sir John Swinburne, Sir Robert Harry Inglis, the Right Hon. Sir Robert Peel, the Rev. Dr. Burney and Messrs. J. Alnutt, T. Griffiths, J. Gwilt, G. Hibbert, W. Leader, E.H. Locker, T. Tomkison, J. Vine, W. Wells and B. Windus. Allnutt was the largest contributor, he and Vine between them lending more than sixty drawings in nearly equal numbers; Leader lent fifteen and Griffiths twelve.

John Masey Wright was made Associate in February 1824 and Member in June of the same year. John Frederick Lewis was elected an Associate in March 1827 and full Member in June 1829. Penry Williams became an Associate in April 1828, Alexander Chisholm and the sisters Eliza and Louisa Sharpe in February 1829. In February 1831 John William Wright and Frederick Tayler became Associates.

Miss Byrne resigned in 1834 and died in 1837. Mrs. T.H. Fielding resigned in 1835. Miss M. Scott (Mrs Brookbank) contributed from 1823 to 1837 and Miss M. Barret from 1823 to 1835, the year before her death.

From 1831 to 1855, under Copley Fielding's Presidency, the Society continued to flourish (see Table F). In July 1834, after the close of the exhibition, the Duchess of Kent and Princess Victoria were received, in 1836 Queen Adelaide and in April 1838 the young Queen Victoria. After the last visit the Society requested permission to call themselves the Royal Society of Painters in Watercolours but this honour was not to be granted until 1881. Another visit by the Queen was apparently made in 1854 when Fielding was out of London.

In the first twelve years of Fielding's Presidency the average number of paying visitors (regular purchasers appear to have been given 'season tickets' and lists of those spending over ten guineas are included in some of the 1830s Sales Books, presumably forming the list of free admissions for the following season) per season was over 19,000, the annual admissions varying from 16,166 in 1834 to 21,569 in 1837. The financial position was sound, enabling an average of more than seven thirty guinea premiums to be given each year and sums to be given to representatives or families of deceased Members as well as donations to the Artists' General Benevolent Institute and the Sick and Wounded Relief Fund for Soldiers in the Crimea.

A note in the 1836 Sales Book states 'In 1836 The Society for the encouragement of Art held at Paul & D. Colnaghi's purchased 2 drawings amounting to £23.2.0. or about 1/100th of the whole sales. In 1837 — Nothing. In 1838 One Art Union prize was purchased, a 25 guinea drawing being about an 1/80th part of the whole sales. 1839 — Nothing. 1840 Six pictures were purchased which were in amount about a 1/13th part of the whole. 1841 19 pictures of a 1/6th part of the whole. 1842 47 pictures or about 1/3 of the whole amount. 1842 about 1/4th.

Fielding died on 13th March 1855 and the Society passed a resolution postponing the election of a successor in accordance with a general feeling of respect for the deceased. John Frederick Lewis was appointed President in November 1855.

Presidents,
Treasurers and Secretaries

	President	Treasurer	Secretary
1805	W.S. Gilpin	S. Shelley	R. Hills
1806	F.W. Wells	S. Shelley	R. Hills
1807	F.W. Wells	R.R. Reinagle	R. Hills
1808	J. Glover	R.R. Reinagle	R. Hills
1809-12	R.R. Reinagle	S.T. Rigaud	R. Hills
1813	F. Nicholson	G. Barret	J. Smith
1814	J. Smith	A.V.C. Fielding	T. Uwins
1815	J. Glover	C. Varley	A.V.C. Fielding
1816	J. Cristall	G. Barret	J. Smith
1817	J. Smith	J. Linnell	T. Uwins
1818	J. Smith	A.V.C. Fielding	T. Uwins
1819	J. Cristall	J. Smith	A.V.C. Fielding
1820	G.F. Robson	J. Cristall	A.V.C. Fielding
1821-22	J. Cristall	J. Smith	A.V.C. Fielding
1823-26	J. Cristall	C. Wild	A.V.C. Fielding
1827-31	J. Cristall	R. Hills	C. Wild
1832-44	A.V.C. Fielding	F. Mackenzie	R. Hills
1844-48	A.V.C. Fielding	F. Mackenzie	J.W. Wright
1848-54	A.V.C. Fielding	F. Mackenzie	G.A. Fripp
1854-55	A.V.C. Fielding	W. Collingwood Smith	J.J. Jenkins
1855	J.F. Lewis	W. Collingwood Smith	J.J. Jenkins

Tables of Exhibitions and Exhibitors

TABLE A
EXHIBITIONS 1805-1813

Year	Members	Asso-ciates	Drawings	Admissions on payment	Members' valuations			Surplus divided		
					£	s.	d.	£	s.	d.
1805	16	–	275	11,542[1]	2,860	0	0	270	19	0
1806	16	8	301	12,439	Return wanting			440	3	0
1807	18	8	324	14,366	4,380	1	0	471	7	10½
1808	19	7	334	18,999	5,787	1	6	445	14	8
1809	20	7	341	22,967	5,222	5	0	626	6	11⅓
1810	22	8	328	20,030	4,807	17	0	480	14	0
1811	24	8	369	19,067	6,610	15	6	523	7	5
1812	25	6	341	10,624	4,498	11	6	121	18	4

[1] Approximately.

TABLE B
EXHIBITIONS 1813-1820

EXHIBITIONS OF THE SOCIETY OF PAINTERS IN *OIL AND WATER COLOURS* AT THE GREAT ROOM, SPRING GARDENS.

Year	Artists repre-sented	Members exhibit-ing	Exhibitors not Members	Works exhibited	Admissions on Payment	Surplus or Deficit		
						£	s.	d.
1813	47	18	29	250	10,039	+ 126	1	5
1814	51	16	35	308	11,746	+ 92	0	4
1815	68	17	51	359	9,389	+ 91	2	7½
1816	71	15	56	325	7,063	− 73	17	3
1817	64	13	51	305	11,018	+ 118	10	1
1818	66	14	52	369	10,007	+ 107	15	7½
1819	74	14	60	350	8,527	− 13	6	0
1820	96	15	81	382	8,598	− 32	10	0

TABLE C
EXHIBITIONS 1821-1831

Year	Full Members	Ladies	Associates	Total	Works Exhibited
1821	15	2	5	22	191
1822	13	2	7	22	174
1823	18	4	12	34	303
1824	17	4	11	32	307
1825	19	4	10	33	345
1826	20	4	9	33	284
1827	22	4	12	38	360
1828	22	4	14	40	366
1829	23	6	15	44	401
1830	23	6	14	43	366
1831	24	6	15	45	427

TABLE D

EXHIBITORS AT THE 'SOCIETY OF PAINTERS IN WATER-COLOURS' (1805–1812) AND THE 'SOCIETY OF PAINTERS IN OIL AND WATER COLOURS' (1813–1820).

Exhibitors whose names are printed in small capitals were at some time or times (either during these periods or afterwards) Members, and those in italics Associates only of the Society. P signifies President; S, Secretary; T, Treasurer; M, Member; A, Associate (between 1805 and 1812); and E, Exhibitor (between 1813 and 1820). The small letter *a* signifies that the artist on a line with whose name it is placed exhibited also with the 'Associated Artists.'

IN CATALOGUE OF EXHIBITION OF

	1805	1806	1807	1808	1809	1810	1811	1812	1813	1814	1815	1816	1817	1818	1819	1820
Agasse, T. L.												E				E
Aglio, A.														E		
ALLPORT, H. C.									E	E	E	E	E	E	M	M
ATKINSON, J. A.			A	M	M	M	M		E	E	E	E	E			
Badger, *Miss*											E					
Baker, *Miss*																E
Barber, C.					a		a	a	E		E	E				
Barber, *Miss* E.												E				
Barber, J. V.									E							
Barker, B.								a	E	E	E	E		E	E	E
Barney, J. (senior)														E		
Barney, J. (junior)											E	E		E	E	
BARRET, G.	M	M	M	M	M	M	M	M	T	M	M	T	M	M	M	M
Barry, J.									E							
Baynes, J.					a	a	a	a								E
Baynes, T. M.																E
Belisario, J.											E	E	E	E		
Bennett, T.												E	E	E	E	
Bennett, W. T.					a	a	a	a	a						E	E
Betham, *Miss*							a	a		E	E					
Bewick, W.																E
Blake, B.																E
Boaden, J.														E	E	
Bradley, J.														E	E	
Buckler, J. C.											E	E	E	E		E
Burgess, J.												E				
BYRNE, *Miss*		A	A	A	M	M	M	M								
Carpenter, *Mrs.*														E		
Cattermole, R.									E	E			E			
Cawse, J.						a						E	E	E	E	
Chalon, H. B.											E					
CHALON, J. J.		A	A	M	M	M	M	M								
Chantrey, F. L.											E					
Childe, E.															E	E
Christmas, T.															E	E
Clennell, L.						a	a	a	E	E	E					
Clint, G.											E					
Collen, H.																E
Collins, *Miss*																E
Coney, J.								a								E
Cooper, A.									E	E	E	E	E			
Cooper, G.								a								E
Corbould, H.											E					
Cotton, *Miss*																E
Coventry, C. C.											E					
Cox, D.					a	a	a	a	M	M	M	M		M	M	M
Cranmer, C.										E						
CRISTALL, J.	M	M	M	M	M	M	M	M	M	M	M	P	M	M	P	T
Curtis, J.															E	
Davis, R. B.															E	
Deane, C.													E	E	E	E
Delamotte, W.		A	A	A												
Derby, W.																E
Devis, A. W.										E						
DE WINT, P.					a	a	A	A	M	E	E		E			
Dinsdale, G.						a	a			E						
DORRELL, E.						A	M	M	E		E	E		E	E	
Essex, W.															E	
Everett, E. (or Everitt)															E	E
FIELDING, A. V. C.						A	A	A	M	T	S	M	M	T	S	
FIELDING, *Mrs.* T. H.																E
Fielding, N.														E		
Fielding, N. T.										E						
Fielding, T.												E	E	E	E	E
FINCH, F. O.																E

Table — caption header spanning the year columns: **IN CATALOGUE OF EXHIBITION OF**

Name	1805	1806	1807	1808	1809	1810	1811	1812	1813	1814	1815	1816	1817	1818	1819	1820
Findlater, W.												E	E	E		E
Fox, E.												E	E		E	E
Fradelle														E		
Freebairn, R.		A	A													
GASTINEAU, H.														E	E	E
GILPIN, W. S.	P	M	M	M	M	M	M	M		M	M					
GLOVER, J.	M	M	M	P	M	M	M	M	M	M	P	M	M			
Glover, W.										E	E	E	E	E	E	
Goodwin, E.				a	a	a		a								
GOULDSMITH, *Miss*									M	M	M	M	M	M	M	M
Graham, T.																E
Grimaldi, W.												E				
Groves, *Mrs.* (J.)												E	E	E	E	
Haines, W.											E					
HARDING, J. D.														E	E	E
Harley, G.												E	E	E	E	E
Harrison, A. P.											E					
Hartley, T.																E
Has(e)ler, H.												E	E			
Hastings											E					
Hastings, E.												E	E	E	E	E
Havell, E.													E	E	E	E
Havell, R.												E	E	E		
HAVELL, W.	M	M	M	M	M	M	M	M	M	E	E	E				E
Hawkins, H.																
Haydon, B. R.										E		E	E			
Hayter, C.																E
Hayter, J.																E
Hayter, *Miss*													E			E
HEAPHY, T.			A	M	M	M										
Henderson												E				
Hewlett, J.				a	a	a	a	a	E	E	E	E	E		E	
HILLS, R.	S	S	S	S	S	S	S	S	E	E	E	E	E		E	
Holmes, J.					a	a	a	a		M	M	M	M	M	M	M
HOLWORTHY, J.	M	M	M	M	M	M	M	M	M							
Hunt, W.										E	E				E	E
Jones, G.																E
Jones, *Miss* (E.)															E	E
Kangeisser, H. F.										E						
Kendrick or Kenrick, *Miss* (E.E.)											E	E	E	E	E	
Kidd, W.													E			
King, J.										E						E
Knight, *Miss*																E
Landseer, E.												E	E			E
Landseer, H.																E
Landseer, *Mis*													E			E
Leslie, C.													E			
Lewis, F. C.										E		E	E	E	E	E
Lewis, J. F.																E
Lewis, G.										E		E	E			
LINNELL, J.									M	M	M	M	T	M	M	M
Linton, W.														E	E	E
Lonsdale, J.													E			
MACKENZIE, F.							a	a	M	M	M	M				E
Maisey, T.															E	E
Mandy, J. C.										E						
Miller, J. H.												E				
Morton, H.										E	E				E	
Mulready, *Mrs.*									E	E	E	E	E			
Munn, P. S.		A	A	A	A	A	A	A			E					
NASH, F.				a	a	A	M	M		E			E		E	E
NATTES, C.	M	M	M													
Neale, J. P.													E	E		
Nicholson, —															E	
NICHOLSON, F.	M	M	M	M	M	M	M	M	P		M					
Nicholson, *Miss*										E						
Parez, L.																E
Pastorini, F. C.										E						
Payne, W.					A	A	A	A								
Pellegrini										E						
Pelletier, A.												E				
Phillips, G. H.																E
Pickering, G.											E	E	E	E		
Plant, W.															E	
POCOCK, N.	M	M	M	M	M	M	M	M	E	E	E	E	E			
Pocock, W. T. or W. J.													E			
Powell, J.				a	a	a	a						E	E		
PROUT, S.							a	a			E	E	E	E	E	M
PUGIN, A.			A	A	A	A	A	A[1]	E	E	E	E	E		E	E

18

	IN CATALOGUE OF EXHIBITION OF															
	1805	1806	1807	1808	1809	1810	1811	1812	1813	1814	1815	1816	1817	1818	1819	1820
Pyne, W. H.	M	M	M	M							E					
Reinagle, R. R.		A	T	T	P	P	P	P						E		
Richardson, M.														E		
Richardson, T. M.														E	E	
Richter, H.					a	a	a	a	M	E		E			E	E
Rigaud, S. T.	M	M	M	M	T	T	T	T								
Roberts, J. A.									E							
Roberts, T. S. or S. T.					a							E				
Robertson, A.												E	E	E	E	E
Robertson, J.													E	E		
Robertson, C. J.						a			E		E		E	E		E
Robson, G. F.						a	a	a	E	M	M	M	M	M	M	P
Roe, Miss																E
Rouw, P.									E	E	E	E	E			
Sauerweid, A.											E					
Schetky, J. or A.						a	a	a				E	E			
Schetky, J. C.				a	a	a	a	a				E	E			
Schoenberger													E			
Scotney, F.										E						
Scott, W.							A	A	E	E	E	E		E	E	E
Severn, J.													E			
Shelley, S.	T	T	M	M												
Shepheard, G.										E	E					
Smith, G.											E					
Smith, G. W.															E	E
Smith, J.			M	M	M	M	M	M	S	P	M	S	P	P	T	M
Smith, W.										E	E	E		E	E	E
Stanley, C. R.								a								
Stark, J.													E	E	E	E
Stein, R.																E
Stephanoff, F. P.					a	a	a		E		E			E	E	E
Stephanoff, J.					a	a	a	a	E	E	E	E	E	E	M	M
Stevens, F.			A	A	A	A	M	M	M				E		E	
Stewart, Miss M.															E	
Stowers, T.									E	E						
Stump, S. J.								a		E	E	E	E	E	E	E
Sumpter, H.													E			E
Thomson, W. J.				a	a										E	E
Thurston, J.		A														
Turner, W.				A	M	M	M	M	M	M	M	M	M	M	M	M
Tytler, G.														E		
Uwins, T.				A	A	M	M	M	S	M	M	S	S			E
Van Worrell, A. B.																E
Varley, C.	M	M	M	M	M	M	M	M	M	M	T	M	M	M	M	M
Varley, J.	M	M	M	M	M	M	M	M	M	M	M	M	M	M	M	M
Villiers, Huet									E							
Vincent, G.													E			E
Walker, W.					a	a	a	a	E	E	E	E	E	E	E	E
Walton, Miss										E	E	E	E	E		
Ward, J.																E
Watson, S.															E	
Watts, W. H.					a						E					E
Webster, M.													E			
Wells, F. W.	M	P	P	M	M	M	M	M								
Westall, W.					a	a	A	M								
White, Mrs. C.									E							
White, W.														E		
Whitehead, J.																
Wild, C.					A	A	A	A²		E	E		E	E	E	E
Wilson, J.															E	E
Woodman, R.																E
Worrell, A. B.															E	
Wyon, W.									E							
Zeigler, H. (B.)													E	E	E	E

[1] Pugin was elected Member on 8 June, 1812, after the exhibition for that year had been held.

[2] Wild was elected Member on 8 June, 1812, after the exhibition for that year had been held.

TABLE E
EXHIBITORS AT THE 'SOCIETY OF PAINTERS IN WATER-COLOURS' DURING THE PRESIDENCY OF CRISTALL (1821-1831)

	IN CATALOGUE OF EXHIBITION OF										
	1821	1822	1823	1824	1825	1826	1827	1828	1829	1830	1831
ALLPORT, H. C.	M		A								
AUSTIN, S.							A	A	A	A	A
BARRET, G.	M	M	M	M	M	M	M	M	M	M	M
Barret, Miss		M	M	M	M	M	M	M	M	M	M
Bennet, W. J.	A	A	A	A	A						
Byrne, Miss	M	M	M	M	M	M	M	M	M	M	M
Byrne, J.							M	M	M	M	M
CATTERMOLE, G.			A								
Chisholm, A.									A	A	A
Cotman, J. S.					A	A		A	A	A	A
COX, D.	M	M	M	M	M	M	M	M	M	M	M
CRISTALL, J.	P	P	P	P	P	P	P	P	P	P	P
DE WINT, P.					M	M	M	M	M	M	M
Essex, R. H.			A	A	A	A	A	A	A	A	A
EVANS, W. (of Eton)								A	A	A	M
FIELDING, A. V. C.	S	S	S	S	S	S	M	M	M	M	M
Fielding, T.									A	A	A
Fielding, Mrs. T. H.	M	M	M	M	M	M	M	M	M	M	M
FINCH, F. O.		A	A	A	A	A	A	M	M	M	M
GASTINEAU, H.	A	A	A	M	M	M	M	M	M	M	M
HARDING, J. D.	A	M	M	M	M	M	M				
HAVELL, W.							M	M			
HILLS, R.			M	M	M	M	T	T	T	T	T
HUNT, W. HENRY				A	A	A	A	M	M	M	M
Jackson, S.			A	A	A	A	A	A	A	A	A
LEWIS, J. F.							A	A	A	M	M
MACKENZIE, F.			A	M	M	M	M	M	M	M	M
Moore, C.			A	A	A	A	A	A			
NASH, F.				M	M	M	M		M	M	M
NESFIELD, W.			A	M	M	M	M	M	M	M	M
PROUT, S.	M	M	M	M	M	M	M	M	M	M	M
PUGIN, A.	M	M	M		M	M	M	M	M	M	M
Pyne, G.							A	A	A	A	
RICHTER, H.			A		A	M	M	A	M		M
ROBSON, G. F.	M	M	M	M	M	M	M	M	M	M	M
Scott, Miss			M	M	M	M	M	M	M	M	M
Scott, W.	A	A	A	A	A	A	A	A			
Sharpe, Eliza									M	M	M
Sharpe, Louisa									M	M	M
SMITH, J.	T	T	M								
STEPHANOFF, J.	M		M	M	M	M	M	M	M	M	M
STEVENS, F.			M								
TAYLER, F.											A
TURNER, W.	M	M	M	M	M	M	M	M	M	M	M
VARLEY, J.	M	M	M	M	M	M	M	M	M	M	M
Walker, W.	A	A	A	A	A	A	A	A	A	A	A
Whichelo, J.			A	A	A	A	A	A	A	A	A
WILD, C.	M	M	T	T	T	T	S	S	S	S	S
Williams, P.								A	A	A	
WRIGHT, J. M.				A	M	M	M	M	M	M	M
WRIGHT, J. W.											A

Names of Associates who attained to full Membership are printed in italics

TABLE F
EXHIBITORS AT THE 'SOCIETY OF PAINTERS IN WATER-COLOURS' DURING THE PRESIDENCY OF FIELDING (1832-1855)

*	Exit	Enter	Elected Member	Last Exhibit
1832	*Pugin*			
1833	*Robson*	*Frank Stone*	1842	1846
—	*Wild*			
	Williams			
1834	*Austin*	*George Chambers*	1835	1840
—	Mrs. Fielding	*Charles Bentley*	1843	1854
—		*Joseph Nash*	1842	1879-80
1835	*Mrs. Barret*	V. Bartholomew	—	1876-7
—	Essex	*James Holland*	1857	1869-70
1837	T. Fielding	*Arthur Glennie*	1858	1889-90
—		Lake Price	—	1852
1838	Mrs. Brookbank	*William Callow*	1848	—
1839	*Chambers*			
	Cotman			
1841		*George A. Fripp*	1845	—
1842	*Barret*	*Octavius Oakley*	1844	1867-8
—	Mrs. Seyffarth			
1843	*J. Varley*	*Samuel Palmer*	1854	1881-2
—	*G. Pyne*	*J. M. Richardson*	1851	—
—		*W. C. Smith*	1849	1887-8
1844	*Hills*	*Alfred D. Fripp*	1846	—
—		Douglas Morison	—	1846
1845		Wm. Evans (of Bristol)	—	1859
—		George Harrison	—	1846
—		Samuel Rayner	—	1850
1846	*Stone*			
—	*Harding*			
—	J. Byrne			
—	W. Walker			
—	Morison			
1847	Chisholm	Maria Harrison	—	—
—	*Cristall*			
1848	*J. W. Wright*	*George F. Rosenberg*	—	1870
—		*George H. Dodgson*	1852	1880-1
—		*Edward Duncan*	1849	1882-3
—		*F. W. Topham*	1848	1877-8
1849	*De Wint*	David Cox (junior)	—	1886
—		*Joseph J. Jenkins*	1850	1883
—		Charles Branwhite	—	1862
—		Mrs. Criddle	—	1880
1850	Scott	John Callow	—	1878-9
—	S. Rayner	Nancy Rayner	—	1855
—	Cattermole	*Carl Haag*	1853	—
—	Nesfield	*Paul J. Naftel*	1859	—
1851	*Prout*	John Burgess	—	1874
1852	Price	John Bostock	—	1854
—		*John Gilbert*	1854	—
—		Henry P. Riviere	—	1888-9
—		Margaret Gillies	—	1887
—		*Walter Goodall*	1861	1884
1853	*Mackenzie*	Samuel P. Jackson	1876	—
1854	*C. Fielding*	Henry Brandling	—	1856
	Bentley			

To the above have to be added the changes which occurred in the short interregnum after Fielding's death, during which the exhibition of 1855 took place. They were as follows :

*	Exit	Enter	Elected Member	Last Exhibit
1855	Nancy Rayner	*Frederick W. Burton*	1855	1869
		William Collingwood	1884	
		Charles Davidson	1858	

Names of Associates who attained to full Membership are printed in italics

* N.B. The dates in the first column are those of last and first appearance as exhibitors in the Gallery, not those of exit from, or entrance into, the Society.

TABLE G

Members and Exhibitors of and with the
Associated Artists (or *Painters*) *in Water-Colours*.

P signifies President ; T, Treasurer ; S, Secretary ; M, Member ; HM, Honorary Member ; AM, Associated Member ; E, Exhibitor ; HE, Honorary Exhibitor.

	In Catalogue of Exhibition of				
	1808	1809	1810	1811	1812
Annis, W.	E				
Barber, C.			E	M	M
Barker, B.					M
Baxter, Thomas	E				
Baynes, James		E	E	M	M
Bennett, William James	M	M	M	T	T
Betham, Miss				E	E
Blake, W.					M
Bone, Henry Pierce	M				
Bourlier, Miss					E
Brighty, G. M.					E
Brooke, W. H.			E		E
Burden, J.					E
Cartwright, C. M.					E
Cawse, J.			E		
Chalon, Alfred	M				
Clennell, Luke			M	M	M
Cockburn, R.					E
Compton, T.					E
Condé, P.				E	E
Coney, J.					E
Cooper, G.					E
Cotman, J. S.			M	M	
Cox, David		E	P	AM	AM
Craig, J.				E	E
Craig, W. M.		E	M	AM	AM
Dagley, R.	E				E
De Barde, Chevalier					E
De Wint, P.	E	M			
Dighton, D.					E
Dinsdale, George	E	E			
Dixon, J.				E	
Dixon, Robert		E			
Douglass, J.					E
Fogg, A.					E
Foster, W.					E
Francia, L.	E		M	S	S
Gartside, Miss	E				
Gauci, M.					E
Goddard, J. (Strand)				E	
Goddard, J. (Upper Grosvenor Street)				E	E
Goodman, T.					E
Goodwin, E.	E	E	E		
Green, James	T	T	T		
Green, Mrs.	M	M	M		
Green, W.			E	E	
Hassell, J.					E
Hayter, G.					M
Hewlett, J.	E	E	E	M	M
Hoffland, T. C.					E
Holmes, J.	E	M	M	AM	AM
Huet-Villiers, J.	M	M	M	AM	AM
Ibbetson, John				HE	E
Jones, Mrs. S.					E
Kennion, Charles James			E		
Laporte, John	M	M	M	AM	E
Leschallas, J.	E	E			
Lévêque, J.					E
Mackenzie, Fred.				E	M
Martin, —					E
Meen, Mrs.			M		
Morton, H.				E	E
Nash, Frederick	E	M			
O'Neill, H.					E
Owen, Samuel	M	M	M		
Papworth, John	M	S		HM	HM
Pearson, William	E	E			
Perkins, L.					E
Powell, Joseph	E	E	E	E	E
Prout, S.			M	M	M
Richter, Henry		E	M	P	P

| | IN CATALOGUE OF EXHIBITION OF | | | | |
	1808	1809	1810	1811	1812
Roberts, T. Santell . .		E			
Robertson, Andrew . .	S	M	M		
Robertson, C. . .		E			
Robertson, C. J. . .			E		
ROBSON, G. F. . .			E	M	M
Sass, Richard . .		E			
Schetky, J. . . .			E	M	M
Schetky, J. C. . .	E	E	E	M	M
Shepperson, M. . .			E	E	
Smith, Miss Emma . .	M				
Smith, J. Clarendon . .	E	M	M		
Smith, S. . . .				E	E
Stanley, C. R. . .					E
Steele, Miss J. . .				E	M
Stephanoff, F. P. . .		E	E	M	
STEPHANOFF, JAMES .		E	E	M	M
Stump, S. J. . . .					E
Thomson, D. . . .	E				
Thomson, William John (or Thompson) . .	M	M			
Tulloch, Mrs. . . .		E	E		
Turner, C. . . .	E				
Upham, — . . .					E
Walker, William (Junior) .	M	M	M	AM	AM
Watts, William Henry . .	M				
WESTALL, WILLIAM .	M	M			
Williams, H. W. . .	M	M			
Wilson, Andrew . .	M	M	S		
Wood, William . . .	P	P	M		

The sources of confusion arising from similarity of names and places appear to be inexhaustible. There was yet to be another body of 'Associated Painters in Water-Colours,' which held three exhibitions at 16 Old Bond Street in 1832-34. It was started by the late Mr. James Fahey, and was the origin of the 'New Society of Painters in Water-Colours,' now the 'Royal Institute.' (See *Athenæum*, 19 Dec. 1885, and *infra*.)

ANON
1823L 46 *A Sketch, Earl of Essex.*
1845 344 *Interior at Rouen, 6gns., Wm. Forsyth Esq., 3 St. Andrews Place, Regents Pk., Frame and glass £1.8.6 new.*

AGASSE J L
1816 189 *Coachmen meeting and comparing Notes.*

AGASSE T L
1820 131 *A Mail Coach.*

AGLIO A
1818 143 *The Eagles' Nest between the Upper and Lower Lake of Killarney in Ireland.*

ALEXANDER W
1823L 207 *Four Sketches in China, E.H. Locker, esq. M.P.*

ALLPORT H
1818 129 *Barr Park, Staffordshire, seat of Sir J. Scott, Bart.*

ALLPORT H C
1814 198 *Cottage, at Aldridge, Staffordshire - Winter.*
1814 257 *Mountain Pass, at Beddkelert.*
1814 269 *Riveaux Abbey, Yorkshire.*
1815 61 *Scene in Patterdale.*
1815 84 *Windermere, from the high ground, above Lowood, Westmoreland, £31.10.0, J.M. Barrett Esq.*
1815 299 *Kirkstall Abbey, Morning, £3.3.0, Mr. Willimott.*
1815 346 *Whitby Abbey, Morning.*
1816 53 *Scene on the Conway, at its Junction with the Machno, North Wales.*
1816 233 *Conway Castle.*
1817 20 *Furness Abbey.*
1817 69 *Ullswater, from Gobarrow Park.*
1817 79 *Fountains Abbey, Yorkshire, £26.5.0, J.H. Quintin Esq.*
1818 213 *Ullswater.*
1818 236 *Ullswater.*
1819 1 *Rippon Cathedral - Morning, £3.3.0, J. Willimott Esq., Streatham.*
1819 23 *Conway Castle - Evening, £3.3.0, Mr. Bradshaw.*
1819 74 *Tivoli, looking across the Campagna - Evening, £52.10.0, W. Haldimand Esq.*
1820 66 *Tivoli - Morning.*
1821 36 *Bolton Abbey, Yorkshire - Evening.*
1821 61 *Nice, from a Sketch by W. Tennant, Esq.*
1821 146 *Barnard Castle, Yorkshire - Morning.*
1821 153 *Penmachno Mill, North Wales.*
1821 176 *Part of the Claudian Aqueduct, Tivoli.*
1823 121 *Tivoli, the Claudian Aqueduct, £4.4.0, T.E. Barker Esq.*
1823 131 *Evening - Italy, £8.8.0, T.E. Barker Esq.*

1823 138 *Morning - Savoy, £8.8.0, T.E. Barker Esq.*
1823 235 *Scene on the Conway, £8.8.0, T.E. Barker Esq.*

ALPORT H C
1813 12 *Scene at Beddgelart, North Wales - Morning.*
1813 117 *Lichfield, as seen from Stow, Morning.*

ALPORT H G
1813 97 *Eccleshall, Staffordshire - Mid-May.*

ATKINS J A
1811 96 *Smugglers surprised.*

ATKINSON J
1818 200 *Skirmish of Cavalry, £5.5.0, Walter Fawkes Esq.*
1823L 112 *Cossacks, J. Vine, esq.*

ATKINSON J A
1808 6 *The Athenian peasant requesting Aristides (whom he did not know) to vote for his own banishment, by inscribing his name in the shell.*
1808 15 *The dying soldier announcing to the Athenians the victory at Marathon.*
1808 155 *Sancho condoling with Don Quixote, after the adventure of the muleteers.*
1808 308 *Cossacks on a march, Mr. Blades.*
1808 325 *Scene on the Paddington Canal, Mr. Emery.*
1809 34 *Troops on a march.*
1809 160 *Russian hay-market.*
1809 171 *French infantry.*
1809 172 *French dragoons.*
1809 187 *French chasseurs.*
1809 188 *French hussars.*
1809 201 *Calmouck Tartars.*
1809 205 *Landscape and figures.*
1809 217 *The British light infantry charging and breaking la premiere legere at the battle of Maida.*
1809 265 *The recruit.*
1809 275 *Fishermen hauling out, ready to put to sea, 25gns., Lord Cawdor.*
1809 281 *Scene on the coast, fishermen.*
1810 3 *Mamelukes.*
1810 42 *Ploughmen.*
1810 46 *Hussars charging.*
1810 258 *Peasantry returning from Labour.*
1810 259 *Girls drawing Water, Mr. Warner.*
1810 289 *Fisherman mending his Net.*
1810 290 *Taming of the Shrew.*
1810 291 *Penelope, when urged by her Father to stay with him, expressing her wish to follow her Husband, by lowering her Veil.*
1810 292 *Don Quixote let down into the Cave of Montesinos.*
1810 293 *Falstaff relating the manner in which his Booty was taken from him.*

1810	294	*Mowers.*
1810	300	*The Field of Battle.*
1811	27	*French Chasseurs of the Imperial Guard.*
1811	72	*Ale-House Door.*
1811	197	*French and English Cavalry skirmishing.*
1811	270	*Meditation.*
1811	303	*Fishermen.*
1811	318	*Harvest.*
1811	327	*Going to Market.*
1811	343	*Milking.*
1811	346	*A Chalk Pit.*
1811	366	*Peasantry.*
1812	153	*Shakspeare's Seven Ages.*
1812	168	*Harvesters.*
1812	177	*Scene on the Paddington Canal.*
1812	327	*Unloading a Coal Barge.*
1812	330	*Hussars, 18th.*
1812	334	*Polish Lancers.*
1812	335	*Smugglers on the Look-out.*
1812	337	*Hussars, 15th, Duke of Cumberland's.*
1813	236	*Gravel Diggers.*
1813	238	*Scene in Harvest.*
1814	25	*French Vidette.*
1814	33	*Russian Vidette.*
1814	189	*Tartar.*
1814	232	*English Picquet.*
1814	305	*Cossack.*
1815	204	*Capture of the French Artillery and Baggage at the Battle of Vittoria.*
1815	215	*Hastings, Fishing Boats going out,* £10.10.0, Mr. Holford.
1815	321	*Officer of Hussars of the Imperial Guard,* £3.3.0, Sir J. Swinburne.
1815	327	*Mameluke.*
1815	337	*A Polish Lancer.*
1816	38	*British Officer of Hussars.*
1816	172	*Picquet of Cossacks.*
1816	208	*A Russian Officer.*
1816	231	*Hussar Pursued.*
1817	117	*The Waggoner.*
1817	132	*Landscape and Figures.*
1818	281	*The Duke of Wellington,* £7.7.0, Walter Fawkes Esq.

AUSTIN S

1827	9	*A Gleaner,* Sold.
1827	208	*Liverpool - Squally Day,* Sold.
1827	237	*Interior of the new Market, Liverpool,* Sold.
1827	246	*Sunrise after a Storm - Boats going out to the assistance of a Wreck,* 30gns.
1827	250	*Skiddaw, from Borrowdale, Autumnal Morning,* 12gns.
1827	274	*Eneas at the Court of Dido, asking refuge for his followers - Carthage,* Sold.
1827	341	*Liverpool.*
1828	11	*Smugglers sinking their Cargo at the approach of a Revenue Cutter,* 30gns.
1828	35	*The New Baths, Liverpool,* 20gns.
1828	76	*Stratford-upon-Avon,* 12gns.
1828	107	*Dolbadern from the Road to Llanberis,* 6gns., T. Griffiths Esq.
1828	118	*Coast Scene - Shrimp Girls,* 6gns., Moon Esq., 6 Pall Mall.
1828	124	*Clearing a Buoy,* 20gns., C.H. Turner Esq., Rooks Nest, Surrey.
1828	240	*Cader Idris,* 12gns.
1828	361	*Welch Girl at a Spring, Washing Vegetables,* 12gns., John Coindez, 92 Dean St., Soho.
1829	50	*Cologne on the Rhine, arrival of Boats with Fruit,* 35 gns., Sold by order of Mrs. Austin.
1829	118	*Scheveling, on the Coast of Holland,* 20gns.
1829	181	*Coast Scene at Ostend,* 15gns., Parrott Esq.
1829	184	*Gleaners,* 20gns., Munro Esq.
1829	268	*Dort - with Market Boats - Morning,* Sold.
1829	313	*A Study,* 5gns., Baring Wall Esq.
1829	371	*Ducks,* 6gns.
1829	389	*View in Ghent,* 8gns., Duchess of Bedford.
1830	72	*Landscape, with a Timber Wagon,* 40gns., Sold.
1830	145	*Dieppe Harbour, at low water,* 12gns., Thompson Esq., Refer to Mr. Griffiths about it.
1830	150	*Morning - preparing for Market,* Sold.
1830	167	*Dutch Vessels - Entrance to the Meuse,* 20gns., Sold.
1830	183	*Fecamp from Yport, Coast of Normandy,* 15gns., Sold.
1830	191	*On the Flemish Coast,* 8gns., Sold.
1830	221	*Llanberris Pass, North Wales,* 25gns., Sold, Marked by Mr. Austin's desire.
1830	348	*The Coast of Dieppe - Low Water,* Sold.
1831	29	*A Scene in the Highlands, "Between twa birks, out o'er a little lin . . ."* Allan Ramsay.
1831	75	*A Scotch Peasant Girl.*
1831	97	*A Cottage Scene on Llannberris Lake - Evening.*
1831	176	*Coblentz, with the Fort of Ehrinbreitstein, from the Banks of the Moselle.*
1831	206	*A Scotch Cattle Fair - the Grampian Hills in the distance.*
1831	215	*Coast Scene, Minehead, Somersetshire.*
1831	251	*A Landscape.*
1831	326	*The Vegetable Market, Ghent.*

1832	4	*Dort - Evening*, 30gns., Sold.
1832	108	*The Penitent Page*, 18gns., Sold.
1832	119	*Highland Lass*, 10gns., Mr. N. Wilkinson, at D. Colnaghi's, Pall Mall East.
1832	123	*Ghent - Morning*, 18gns., Sold.
1832	153	*Gypsies*, 25gns., Sold.
1832	201	*Landscape on the Severn*, 30gns., Sold.
1832	205	*On the Mersey - Squally Day*, 10gns., Sold.
1832	209	*Gresford, Denbighshire*, 16gns., Sold.
1833	18	*Antwerp, from the Remains of an old Fortress on the Banks of the River*, Sold.
1833	39	*Welsh Peasants at a Spring*, Sold.
1833	105	*The Brook, a Scene near Corwen*, 25gns.
1833	179	*Dort, Squally Day*, 15gns.
1833	219	*The Studio*, Sold.
1833	232	*Dieppe*, Sold.
1833	357	*Heath Scene with Sheep*, Sold.
1833	421	*A Peasant Girl*, Sold.
1834	69	*Quay, Regent's Dock, Liverpool*, Sold.
1834	105	*Church of St. Ouen at Rouen*, 25gns.
1834	123	*Tibbie Inglis, "Oh bonnie Tibbie Inglis! . . ." See Mary Howitt's Ballad. – Forget Me Not for this year.* 20gns., Mr. Wilson, 14 Widcomb Crescent, Bath, To be sent to Mr. Leggat, Cornhill who will pay for it.
1834	182	*Coast Scene*, 10gns., Mrs. Munro, 113 Park Street.
1834	213	*View of Rouen, from the Havre Road*, 30gns.
1834	236	*Coast Scene*, 18gns.
1834	346	*Mill near Bangor*, 7gns.

BADGER MISS

1815	359	*Flowers.*

BAKER MISS

1820	155	*A Study of Fruit, from Nature.*
1820	157	*A Study of Flowers, from Nature.*

BARBER B

1813	216	*Scene between West Cowes and Fresh-Water-Gate, Isle of Wight.*

BARBER C

1813	66	*Dolgelly, North Wales.*
1813	140	*Cattle.*
1813	179	*View near Ascott, Staffordshire.*
1813	181	*Powis Castle - Morning Twilight, "Twilight beams with mellow'd lustre play . . ." From a Collection of Poems by J. Findlay.*
1815	48	*Landscape.*
1815	148	*Northfield, Worcestershire.*
1815	171	*View from the Mountains, at the back of Barmouth, looking towards Dolgellie, North Wales.*
1816	161	*Llanbadern near Aberystwith, Cardiganshire.*

BARBER J V

1813	65	*View of the Breddin Hills.*

BARBER MISS E

1816	67	*Flowers and Fruit.*
1816	69	*Flowers and Fruit.*

BARBER –

1823L	180	*Landscape*, Sir J. Swinburne, Bart.

BARKER B

1813	159	*Drawing from Nature.*
1813	193	*Scene from Wotun.*
1813	212	*Scene near Chepstow, South Wales.*
1813	221	*Cottage, at Chippenham, Wilts.*
1814	204	*View from Nature.*
1814	215	*Landscape - Stormy weather.*
1814	216	*View from Nature.*
1814	224	*Scene in North Wales.*
1814	233	*Scene near Oxford.*
1814	235	*Battle Piece.*
1815	174	*Landscape.*
1815	180	*Landscape*, £36.15.0, Lord Dartmouth.
1815	181	*Scene near Bath.*
1815	191	*Landscape*, £36.15.0, Mr. Maud?
1815	244	*Scene in North Wales.*
1815	257	*Scene in North Wales.*
1816	60	*Scene at Hampton Cliffs, near Bath.*
1816	133	*Composition.*
1816	169	*Scene near Crickshowell.*
1816	173	*Battle Piece, Sketch.*
1816	228	*From Nature.*
1818	64	*Landscape. Composition.*
1818	78	*Landscape*, £36.15.0, Mr. Danby.
1818	105	*Landscape. Composition.*
1818	108	*Landscape. Composition.*
1818	111	*Landscape. Composition.*
1818	121	*Landscape.*
1818	165	*Scene in the Vale of Llanrwst, North Wales.*
1819	92	*Scene from Nature.*
1819	95	*Composition.*
1819	100	*Moonlight.*
1820	38	*Composition.*
1820	39	*Scene near Chepstow, Monmouthshire.*
1820	40	*Composition.*
1820	51	*Moonlight.*
1820	220	*Composition.*
1820	230	*Scene in North Wales.*

BARNEY J JUN

1815	276	*Fruit.*
1816	156	*Fruit and Flowers*
1818	154	*Fruit and Flowers*
1819	87	*Fruit and Flowers*

BARNEY J SEN
1818	153	*Flowers.*

BARRET G [*See also* BARRETT]
1805	68	*A lake scene.*
1805	76	*An evening effect.*
1807	9	*Twilight effect.*
1807	33	*View in the canton of Glarus, Switzerland.*
1807	115	*Study from nature.*
1807	130	*Stormy evening.*
1807	143	*Sun-set.*
1807	151	*View at Neasdon, Middlesex.*
1807	242	*Dunster Town and Castle.*
1813	35	*View near Beddgelart, North Wales.*
1813	70	*Moel Heydog, North Wales.*
1813	72	*Hampstead Heath.*
1813	211	*View in Carnarvonshire, North Wales.*
1813	229	*View on Hampstead Heath.*
1813	243	*View of Harrow, from Hampstead Heath.*
1821	15	*Evening,* £21.0.0, Mr. Vine.
1821	25	*Mortlake, Surrey,* £8.8.0, Wm. Knyvett Esq.
1821	28	*Medmenham, on the Thames.*
1821	82	*Walton on Thames,* £31.10.0, T.G.
1821	87	*Wandsworth Common.*
1821	89	*Lake of Wallinstadt, Switzerland.*
1821	96	*Scene in Switzerland.*
1821	101	*Westminster Abbey, from Vauxhall.*
1821	105	*Scene on the Thames, from Vauxhall Bridge,* £10.10.0, W. Knyvett Esq.
1821	111	*Windermere, Westmoreland,* £4.4.0, Viscount Ingestre.
1821	115	*Snowdon, from near Llyn Dinas.*
1821	130	*Figures crossing a Brook.*
1821	133	*Thames Ditton,* £3.3.0, G. Giles Esq.
1821	134	*Scene on Hampstead Heath.*
1821	141	*Moonlight,* £21.0.0, T. Tomkison Esq.
1821	147	*Lambeth.*
1821	168	*Medmenham Ferry.*
1821	172	*Westminster Bridge.*
1821	173	*Scene in Switzerland.*
1821	178	*Scene in Switzerland.*
1822	8	*View from Richmond Hill,* Mr. Est.
1822	24	*Puckester, Isle of Wight - the Cottage of Jas. Vine Esq.,* J. Vine Esq.
1822	27	*Afternoon,* £8.8.0, J. Dimsdale Esq.
1822	28	*Sun-set,* £10.10.0, J. Webster Esq.
1822	56	*Harrow, from Hampstead Heath.*
1822	78	*Carisbrooke Castle,* £6.6.0, Mr. Windus.
1822	98	*Harleford on the Thames, the Seat of Sir W. Clayton, Bart.*
1822	112	*Bisham Abbey, near Marlow, the seat of G. Vansittart, Esq.,* £26.5.0, J.C. Warner.
1822	121	*Dunnose, Isle of Wight,* £3.3.0, T.G.
1822	122	*Castle Point, near Puckester, Isle of Wight,* £3.3.0, C. Stokes Esq.
1822	126	*Steep Hill, Isle of Wight.*
1822	130	*Stormy Evening.*
1822	134	*Scene from the Sitting Room of James Vine, Esq. Puckester, Isle of Wight.*
1822	135	*Chale Church, Isle of Wight.*
1823	14	*Twilight,* £21.0.0, W. Cotton Esq.
1823	18	*Evening.*
1823	35	*Retirement,* £63.0.0, J. Allnutt Esq.
1823	82	*Fresh Water, from Yarmouth, Isle of Wight.*
1823	83	*Distant View of Hurst Castle.*
1823	85	*Shanklin Chine, Isle of Wight.*
1823	97	*Carisbrooke Castle, Isle of Wight.*
1823	102	*Morning,* £5.5.0, Watts(?) Russell Esq.
1823	196	*Pukester, from Cripplepath, Isle of Wight.*
1823	221	*Solitude.*
1823	241	*Twilight.*
1823	242	*Angling.*
1823L	8	*Evening,* J. Allnutt, esq.
1823L	26	*Evening,* J. Vine, esq.
1823L	36	*Westminster,* J. Allnutt, esq.
1823L	41	*Barnes Common,* J. Vine, esq.
1823L	44	*The Harvest Moon,* "Meanwhile the Moon, Full-orb'd, and breaking thro' the scatter'd clouds, Shews her broad visage in the crimson'd east." Thomson. J. Vine, esq.
1823L	51	*Coast Scene,* J. Vine, esq.
1823L	131	*Moonlight - Composition,* T. Tomkison, esq.
1824	17	*Shore Scene.*
1824	20	*Sea Storm - Moonlight.*
1824	22	*Storm in Harvest,* "– the circling mountains eddy in . . ."
1824	37	*Sea Shore.*
1824	54	*Moonlight.*
1824	56	*Evening.*
1824	114	*Retirement.*
1824	120	*Evening.*
1824	130	*Sun-set.*
1824	156	*Evening.*
1824	165	*Morning.*
1824	170	*Afternoon.*
1824	179	*Evening.*
1824	181	*Hastings Fishing Boats.*
1824	183	*Sea Port.*

1824	184	*Evening.*
1824	186	*Landscape.*
1824	217	*Scene from the Odyssey, "Now all the land another prospect bore . . ."*
1824	257	*River Scene.*
1824	258	*Twilight.*
1824	259	*Mountain Shepherd.*
1824	263	*Sun-set.*
1824	265	*Twilight.*
1824	271	*Sea Coast.*
1825	4	*Evening,* 6gns.(?), J. Webster Esq., Whiteheads Grove, Sloane Street.
1825	9	*A Castle,* 3gns.
1825	11	*Bathing.*
1825	29	*An Ancient City.*
1825	33	*Evening, "Evening yields The world to night . . ." Thomson.*
1825	45	*Morning.*
1825	51	*River Scene.*
1825	55	*Morning,* 10gns., Ireland Esq.
1825	62	*The Rookery, "Should I my steps turn to the rural seat . . ." Thomson.* 25gns., Mr. Monteith, Frame and glass £6.3.0.
1825	65	*Lake Scene,* 3gns., Mr. Broderip, 1 Gower Street.
1825	75*	*River Scene,* 3gns.
1825	82*	*Scene on the Thames,* Sold.
1825	95	*Thorley Church, Isle of Wight,* 6gns.
1825	101	*Mid-Day,* 6gns.
1825	111	*The Landing Place,* Sold, E. Durant Esq.
1825	137	*Evening.*
1825	163	*The Embarkation,* Sold.
1825	174	*Sun-set.*
1825	183	*River Scene.*
1825	198	*Morning, "But yonder comes the powerful King of Day . . ." Thomson.* 30gns., T. Griffith Esq.
1825	210	*Scene from Freshwater, Isle of Wight,* Sold.
1825	216	*Cottage Scene,* 3gns.
1825	249	*Evening, "And as they went on their journey, they came in the evening to the river Tigris . . ." Tobias and the Angel.* 40gns., Lord Northwick.
1825	254	*Ancient City - Evening - Moon rising,* 10gns., Marquis Stafford.
1825	266	*Yarmouth, Isle of Wight,* 3gns., Prior Esq.
1825	275	*Evening.*
1825	278	*Evening.*
1825	287	*Sun-set,* Sold [deleted].
1825	292	*The Debarkation,* Sold.
1825	301	*Twilight,* 4gns.
1825	304	*A Sea Port.*
1825	310	*Sun-set,* 6gns.
1825	320	*The Weary Traveller,* 10gns., Rev. I.B. Sumner.
1826	1	*Scene at Hampton Court, Middlesex,* 6gns., Lord Digby, 35 Lower Brook Street, Grosvenor Square.
1826	18	*View from Richmond Hill,* Sold.
1826	35	*Composition,* Sold.
1826	42	*Greenwich,* Sold.
1826	45	*Westminster Bridge, from Millbank,* 6gns.
1826	50	*Morning,* Sold.
1826	51	*Harrow, from the Grounds of General M'Gregor,* Sold.
1826	59	*Composition,* Sold.
1826	117	*Morning,* Sold.
1826	128	*View from Richmond,* Sold.
1826	153	*Evening,* 25gns., Olive Esq., 4 York Terrace, Regents Park.
1826	169	*Composition,* Sold.
1826	190	*Westminster, from Lambeth,* 6gns., Prior Esq.
1826	213	*Evening,* 6gns., Marquis Stafford.
1826	217	*The Seventh Plague of Egypt, "And Moses went out of the city from Pharaoh, and spread abroad his hands unto the Lord; and the thunders and hail ceased." – Exodus, Chap. 9. Verse 33.* 30gns.
1826	221	*Evening,* Sold.
1826	222	*Kingston Bridge,* 5gns.
1826	236	*Evening,* Sold.
1826	244	*Moonlight,* Sold.
1826	266	*Freshwater, Isle of Wight,* Sold.
1826	273	*Boys Bathing, Evening,* 15gns.
1826	283	*Moonlight,* Sold.
1827	16	*Moonlight,* Sold.
1827	61	*Boys Bathing,* Sold.
1827	76	*Shepherd - Evening,* Sold.
1827	102	*River Scene,* 20gns., Speak to Miss Barret.
1827	126	*Evening,* Sold.
1827	129	*Travellers,* 6gns.
1827	131	*"Two with our herald thither we command . . ." Homer's Odyssey.* Sold.
1827	134	*Scene from Gil Blas, with Robbers,* Sold.
1827	154	*"In lowly dale, fast by a river's side . . ."* 50gns., C. Barclay Esq.
1827	163	*View of Richmond Hill, from Ham,* Sold.
1827	168	*Early Morning, with Banditti,* 12gns., Mr. Blake.
1827	207	*Landscape,* Sold.
1827	253	*Morning,* Sold.
1827	254	*Evening,* Sold.

1827	285	*Evening*, Sold.
1827	294	*Scene from Richmond Hill*, Sold.
1827	339	*Evening*.
1828	26	*Evening*, 15gns., Knyvett Esq., 45 Gt. Marlborough St.
1828	43	*Evening*, "*Now all the land another prospect bore . . .*" *Odyssey*. 70gns., Allnutt Esq.
1828	48	*Twilight*, Sold.
1828	56	*London, with Part of the Regent's Park, from Primrose Hill - Morning*, 25gns.
1828	109	*Storm*, Sold.
1828	120	*Westminster, from Vauxhall*, 6gns.
1828	140	*Storm breaking off*, "*As from the face of heaven the shattered clouds . . .*" *Thomson*. 25gns.
1828	242	*Retirement*, 15gns.
1828	244	*Moonlight*, 5gns.
1828	254	*Moonlight*, "*Portia – 'That light we see is burning in my hall.'*" *Merchant of Venice*. 20gns.
1828	272	*Noon Day*, 8gns., General Grey, 13 Hertford Street.
1828	288	*Evening*, 8gns., Braithwaite Esq.
1828	332	*Day-break*, Sold.
1828	345	*Landscape, with Ruins*, Sold.
1828	351	*Wood Scene*, Sold.
1828	357	*Mid-day*, Sold.
1828	363	*Landscape, with Figures*, Sold.
1829	39	*Ulysses, on his return with his old Servant Umaeus*, "*Along the road, conversing side by side, Proceed Ulysses and the faithful swain.*" – *Odyssey*. 50gns.
1829	57	*Evening*, Sold.
1829	86	*Moonlight*, 4gns.
1829	89	*Effect of Moonlight*, 8gns.
1829	112	*Sultry Evening*, 15gns., Shaw Esq., Gower St.
1829	273	*Sun-set*, Sold.
1829	297	*Evening*, Sold.
1829	307	*Evening*, 8gns., Roberts Esq.
1829	319	*Twilight*, 8gns.
1829	329	*Twilight*, 8gns.
1829	376	*Moonlight*, Sold.
1829	393	*Moonlight*, 6gns.
1830	19	*Retirement*, "*When in the crimson cloud of even The lingering light decays . . .*" *Beattie*. 25gns., Sold.
1830	52	*Twilight, with the Moon going down*, 30gns., Sold.
1830	159	*Evening*, "*Upon the old accustomed hill The summer sun is lingering still . . .*" *Poetical Sketches, by Alaric A. Watts, Esq. 5th Edit.* 70gns., Sold, Marked ????? Mrs. Griffiths.
1830	173	"*– amid his subjects safe, Slumbers the monarch swain . . .*" *Thomson*. 20gns., Sold.
1830	247	*Evening*, Sold, C. Wild Esq.
1830	275	*Morning*, Sold.
1830	285	*Evening*, 8gns., Miss Shepley, 28 Devonshire Place.
1830	310	*Twilight*, Sold.
1830	336	*Twilight*, 5gns.
1830	342	*Repairing a Boat*, 5gns., Mr. Baring Wall.
1830	344	*Yarmouth, in the Isle of Wight*, 8gns., Sold.
1830	345	*Sun-set*, 15gns., Stewart Esq.
1830	360	*Twilight*, 8gns., Sold.
1830	365	*Shower clearing off*, 5gns.
1831	9	*English Pastoral*.
1831	64	*Evening*.
1831	87	*Twilight*.
1831	126	*Morning*, "*Now, flaming up the heavens, the potent sun . . .*" *Thomson*.
1831	182	*Morning*.
1831	296	*Sun-set*.
1831	339	*Moonlight*.
1831	350	*Twilight*.
1831	352	*Twilight*.
1831	360	*Sun-set - Hastings Fishing Boats*.
1831	385	*Early Morning*.
1831	393	*Moonlight - Avenue to Portia's House*, "*Portia. – 'That light we see is beaming in my hall.'*" *Merchant of Venice*.
1832	102	*Sun-set*, 15gns., Mr. Moxon.
1832	135	*Twilight*, 5gns.
1832	142	*An Ancient City - Storm clearing off*, 35gns.
1832	146	*Mid-day*, 5gns.
1832	166	*Pastoral*, 20gns., J. Shaw Junr., 1 Chatham Place.
1832	168	*Twilight*, 8gns.
1832	212	*Morning*, 12gns., Mr. J.V. Thompson, 4 Belgrave St., Belgrave Square.
1832	269	"*The west yet glimmers with some streaks of day . . .*" *Macbeth*. 15gns.
1832	286	*The Deserted Garden*, Sold.
1832	294	*Hazy Morning*, 8gns., Mr. J. Lewis Brown, 10 Leicester Place, Leicester Square.
1832	303	*Sun-set*, 8gns., Mrs. W.S. Bond, 24 Devonshire Place.
1832	354	*Sun-set*, 8gns., Mrs. E. Pepys, 15 Upper Harley St.
1832	356	*Pastoral*, Sold.
1832	377	*Retirement*, 8gns.
1832	400	*The Debarkation*, 18gns.
1833	78	*Mid Day*, "*Even to those shores is Ithaca renown'd, Where Troy's majestic ruins strew the ground.*" 40gns.
1833	171	*Harvest Moon*, 10gns.

1833	177	*Solitude*, Sold.
1833	180	*Mountain Shepherds descending with their Flocks*, 12gns.
1833	182	*"Yon amber light that gleams along the sky . . ."* 15gns.
1833	186	*Mid Day*, Sold.
1833	196	*A Storm*, 8gns.
1833	251	*"The herds descending to the well-known pool, Their thirst allay, their heated bodies cool."* 16gns.
1833	257	*Hazy Morning*, Sold.
1833	277	*Morning*, 6gns., Mr. R. Cancellor, 3 Cambridge Place.
1833	317	*Sun Set*, Sold.
1833	368	*Sun Set*, Sold.
1833	372	*Morning*, Sold.
1833	394	*A Scene in the Isle of Wight*, 5gns.
1833	403	*Afternoon*, 6gns., Mr. Hixon, 67 Quadrant.
1833	408	*A Moonlight*, 6gns.
1834	11	*The Church Yard, "Beneath those rugged elms, that yew tree's shade."* 5gns., Mr. Angell, 26 Ely Place (Mr. Foord).
1834	22	*Moonlight, with Wolves*, 8gns.
1834	26	*Cottage in Devonshire*, 6gns.
1834	86	*An extensive Scene*, 8gns., Mr. Joseph Walker, Birmingham.
1834	122	*Early Morning*, 15gns., C.H. Turner, 15 Bruton Street.
1834	131	*A Showery Day*, 6gns., Mr. E.N. Winstanley, 7 Poultry.
1834	148	*Twilight*, 5gns.
1834	156	*Hazy Morning*, 25gns., Mr. Maw by order of Mr. Barret.
1834	167	*Cottages in Hampshire*, 6gns.
1834	169	*Afternoon - Cows in the Water*, 5gns.
1834	178	*Banditti*, 15gns., Joseph Walker Esq., Birmingham.
1834	220	*Coming Storm, "How dark and still the waters of yon lake . . ."* M.S. 40gns.
1834	242	*Felling Timber, "How bow'd the woods beneath their sturdy stroke."* 5gns.
1834	247	*Twilight*, 5gns.
1834	268	*Twilight, "The curfew tolls the knell of parting day."* 6gns., Mr. William Taylor, 5 Canonbury Square, Islington.
1834	270	*Thames Boats - Putney in the Distance*, 7gns.
1834	271	*Landscape and Cattle*, 5gns.
1834	297	*The Fountain*, 14gns.
1834	299	*Hastings - Fishing Boats*, 5gns., Sold.
1834	321	*The Dawn, "The breezy call of incense-breathing morn."* 5gns., Mr. D.J. White, Oxford Street.
1834	345	*Mid-day*, 8gns., Mr. Munro, 113 Park Street.
1834	352	*Mid-day*, 10gns., Mr. Joseph Walker, Birmingham.
1834	372	*Morning*, 8gns., Sold, To go to Eton with Mr. Evans' drawings.
1834	388	*Sun-set*, 8gns., Sold.
1835	21	*Afternoon*, 20gns., Mr. H.J. Wheeler, 11 Montague Place, Bryanston Square.
1835	53	*Sun-set*, 25gns.
1835	63	*Mid-day*, Sold.
1835	97	*Scene near Beddgelert, North Wales*, 5gns., Mr. Ashlin, 22 Edwd. Street, Hampstead Road.
1835	114	*Retirement*, 20gns.
1835	125	*Pastoral*, Sold, To be sent to Mrs. Clifton, Hammersmith.
1835	139	*Sun-set*, Sold, To be sent to Mrs. Clifton, Hammersmith.
1835	147	*Afternoon*, Sold, To be sent to Mrs. Clifton.
1835	149	*Mid-day*, 8gns., J.R. Gowen Esq., York Chambers, St. James Street.
1835	155	*Mid-day*, Sold, To be sent to Mrs. Clifton.
1835	159	*Morning*, 8gns., B.G. Windus, Tottenham Green.
1835	162	*Garden &c. in Ruins, "The aged steward, who was the only person remaining of the family . . ."* 25gns.
1835	238	*Morning*, 6gns.
1835	269	*Twilight*, 10gns., Mr. B. Austen, 33 Guilford Street.
1835	279	*Evening*, Sold, To be sent to Mrs. Clifton.
1835	287	*Morning*, 18gns.
1835	294	*Harvest*, 18gns.
1835	305	*Scene from Richmond - Evening*, Sold.
1836	42	*Twilight*, 6gns., John Hewett Esq., Leamington.
1836	92	*An Autumnal Morning*, 15gns.
1836	107	*Afternoon*, 20gns.
1836	137	*Evening, "How changed the scene the sun late shone upon! . . ."* M. S. 30gns.
1836	220	*Going to Market*, 8gns., Froggat Esq., Union Cottage, Cranmer Road, Kennington, 30 Poultry.
1836	244	*Afternoon - A Road Scene with Sheep*, Sold.
1836	264	*The Ferry*, 7gns.
1836	284	*Sun-set*, 8gns., Domett Esq., Balham Hill.
1836	287	*Twilight*, 4gns.
1836	290	*Twilight*, 10gns.
1836	303	*The Watering Place - Morning*, 18gns., Society of Encourt. of British Art at Colnaghi & Co.
1836	305	*Scene on the Thames, looking towards Richmond*, 10gns., Mr. Ashlin, Edward St., Hampstead Rd.

1836	307	*The Elopement*, 10ns.
1836	315	*Windsor Castle, from the Forest*, 8gns.
1836	321	*A Timber Carriage*, 7gns., H. Ashlin Esq., 22 Edward St., Hampstead Rd..
1836	334	*At Hampton Court - Evening, With a Rising Moon*, 8gns., G. Hibbert Esq.
1836	339	*Evening*, 12gns.
1837	34	*Retirement*, 6gns.
1837	64	*Wood Scene, "The herds oppress'd, the scorching sun evade, Seek the cool grove, and slumber in the shade."* 15gns., Froggatt Esq., Union Cottage, Cranmer Road, Kennington.
1837	107	*Morning after a Stormy Night, "The shore looked wild, without the trace of man . . ."* Don Juan, Canto ii. 40gns.
1837	121	*English Pastoral*, 30gns.
1837	167	*Lane Scene - Evening*, 18gns.
1837	249	*Twilight*, Sold.
1837	317	*Evening - with the Rising Moon*, 18gns.
1837	338	*Moonlight*, 6gns.
1837	345	*Mountain Scene*, 6gns.
1837	348	*Morning*, 20gns.
1837	357	*The Rising Moon*, 6gns., Henry Wilkinson, Clapham Common.
1838	56	*Penning Sheep.*
1838	89	*Harvest Moon.*
1838	128	*Lake of Killarney.*
1838	160	*Twilight.*
1838	177	*Milking.*
1838	178	*Moonlight.*
1838	250	*Boys Bathing.*
1838	270	*Spring - Morning.*
1838	275	*Evening - Travellers Reposing.*
1838	297	*Sunset.*
1838	341	*Wood Scene.*
1838	352	*Scene from Gil Blas.*
1838	354	*Mid Day.*
1839	89	*From Gray's Elegy*, Sold.
1839	107	*Afternoon, "The Sun has lost his rage . . ."* 35gns.
1839	113	*Mid-day*, Sold.
1839	146	*Misty Morning*, 18gns.
1839	148	*Stormy Afternoon*, 15gns.
1839	150	*Grey Morning, with Ploughing Team*, 25gns., Franz Baron von Kreusser, 141 Regent Street.
1839	167	*Carisbrook Castle*, 8gns.
1839	193	*The Setting Sun - Thomson*, 25gns., Henry Ashlin Esq.
1839	239	*Autumnal Morning*, 18gns.
1839	264	*A Brook Scene*, 6gns.
1839	274	*Evening, with the Rising Moon*, 6gns.
1839	285	*Pastoral*, 18gns.
1839	313	*A River Scene*, 10gns.
1839	322	*Twilight*, 12gns.
1839	328	*A Swiss Village*, 6gns.
1839	343	*Embarkation*, 15gns.
1839	345	*A Forest Scene*, 6gns.
1840	36	*English Pastoral.*
1840	99	*Half-way House.*
1840	126	*Storm Clearing off.*
1840	162	*Wood Scene, with Travellers.*
1840	174	*Stormy Evening.*
1840	243	*Cattle- Afternoon.*
1840	269	*Fine Afternoon.*
1840	278	*Afternoon Sun.*
1840	294	*Morning.*
1841	77	*Timon of Athens at his Cave in the Twilight of the Evening*, 20gns., Henry Wilkinson Esq., Clapham.
1841	111	*Afternoon*, Sold.
1841	115	*A River Scene*, Sold.
1841	116	*Harvest Scene*, 10gns.
1841	145	*Retirement*, 30gns., E.N. Winstanley, 7 Poultry, Art Union.
1841	147	*The Watering Place*, Sold.
1841	160	*Mountain Shepherds*, 12gns.
1841	222	*Heath Scene, from Macbeth*, 10gns.
1841	246	*Drovers*, 12gns., N.K. Bayley, 5 Lincolns Inn, New Sqre., Art Union.
1841	287	*Twilight*, Sold.
1841	297	*Afternoon, "The sun has lost his rage, his downward orb . . ."* 25gns.

BARRET G & TAYLER F

1834	10	*Morning*, 40gns., C. Barclay Esq.
1834	40	*Gleaners*, 40gns., Mrs. B. Austen, Guilford Street (Mr. D. Colnaghi).
1834	150	*Evening*, 40gns., Mr. C.H. Turner, 15 Bruton Street.
1835	43	*Morning - Reapers - Plain of Stirling, "The fresh, the fragrant, the light hearted morn . . ."* Craigforth, MS. Poem. Sold.
1835	69	*Tending Sheep - Banks of Loch Fyne*, sold.
1835	105	*Evening- Harvest-home - Plain of Stirling,"And tho' the hour be dear When those soft suns we've watched in their decline . . ."* Craigforth, M.S. Poem. Sold.
1835	135	*Scene on the Moors*, 25gns., Sold.
1835	216	*Highland Pastoral*, 40gns.
1836	73	*Mountain Scene*, Sold.
1836	101	*English Pastoral*, Sold.
1836	238	*Evening - Return from the Moors*, Sold.

| 1836 | 267 | *Morning - Departure for the Moors*, Sold. |
| 1836 | 323 | *Returning from Market*, 15gns. |

BARRET G THE LATE

1842	65	*Cows.*
1842	79	*Sunset.*
1842	113	*"Unhappy he, who from the first of joys Society is cut off, is left alone Amid this world of death: day after day, Sad on the jutting eminence he sits." – Thomson.*
1842	116	*Twilight.*
1842	145	*Stormy Twilight.*
1842	164	*Thoughts in a Church Yard, "Tis dusky eve, and all is hush'd around; The moons sinks slowly . . ." From a Poem by the Artist.*
1842	189	*Carisbrook Castle.*
1842	273	*Setting Sun.*
1842	280	*Richmond Hill.*
1842	287	*Morning.*
1842	290	*View on the Thames.*
1842	307	*Afternoon.*
1842	326	*Warwick Castle.*

BARRET MISS

1823	198	*Still Life.*
1823	225	*Luncheon.*
1823	245	*Cut Apple*, £3.3.0, J. Vine Esq.
1824	137	*Interior of a Cottage.*
1825	34	*Pigeons*, 8gns.
1825	47	*Pigeons in a Larder*, 6gns.
1825	262	*Roach and Dace*, 5gns.
1825	273	*Teal*, 6gns.
1825	337	*A Carp.*
1826	84	*Cottage Scene*, 8gns.
1826	173	*Fish*, 4gns.
1827	233	*Duck*, 4gns.
1827	256	*Shelldrake*, 4gns., Mr. Gwilt.
1827	277	*Teal - Shelldrake*, 5gns., W. Wells Esq.
1827	298	*Drakes*, 5gns., Gwilt Esq.
1827	329	*King Fishers*, 4gns.
1827	347	*Game.*
1828	211	*Partridges*, 5gns.
1828	219	*Fruit*, 5gns.
1828	327	*Pheasants*, Sold.
1829	349	*Group of Small Birds*, 5gns.
1830	335	*Fowls in Basket - a Sketch*, Sold.
1831	80	*Ducks.*
1831	245	*Pigeons.*
1831	348	*Oysters.*
1832	249	*Jay and Plover*, 6gns.
1832	296	*Nuts*, 5gns.

1833	15	*China*, 4gns., Mr. Shaw, 2 Harper Street, Red Lion Square.
1833	253	*Fowls*, 8gns.
1834	125	*Teal*, 6gns.
1834	192	*Currants.*
1835	7	*Grapes.*
1835	203	*The Mischievous Intruder*, 12gns.
1835	204	*Pewit*, 4gns.
1835	237	*Wild Ducks*, 6gns.
1835	239	*Pheasant and Pewit*, 6gns.

BARRETT G [*See also* **BARRET**]

1805	10	*View from nature.*
1805	16	*View from nature.*
1805	53	*A river scene.*
1805	91	*The second bridge on the Paddington canal.*
1805	134	*Horner Wood, Somersetshire.*
1805	148	*View upon the Paddington canal.*
1805	176	*View from nature.*
1805	184	*Twilight effect.*
1805	227	*A mountain scene after rain.*
1806	15	*Chelsea Church, twilight.*
1806	26	*Evening.*
1806	35	*Morning.*
1806	61	*Composition.*
1806	62	*View from Nature.*
1806	101	*A group of Oak Trees.*
1806	119	*A View of Switzerland, an effect of rain.*
1806	146	*Mine Head, Somersetshire.*
1806	158	*Mine Head, Somersetshire.*
1806	199	*Oystermouth Castle, Glamorganshire.*
1806	207	*View in Switzerland.*
1806	249	*A Landscape.*
1806	250	*A Twilight effect.*
1806	251	*Sun-set.*
1806	255	*A Cottage.*
1806	260	*Convent of St. O'Delia, province of Alsace.*
1806	285	*Harlesden Green, on the Harrow Road.*
1806	293	*Wood Scene.*
1808	9	*View at Hastings, with fishermen.*
1808	19	*Dover Castle.*
1808	22	*Boats at Rye, Sussex.*
1808	32	*View upon the Thames, at Richmond.*
1808	45	*Hastings' boats.*
1808	61	*Hill-street, Hastings - twilight*, Mr. Beardmore.
1808	68	*Hastings Castle, Sussex, taken near the White Rock - morning.*
1808	106	*West Cliff, Hastings.*
1808	121	*Beggar's Bush, Hastings.*

1808	152	Chepstow Castle.
1808	154	Rye Harbour, Mr. Beardmore.
1808	192	Cottages at Hastings.
1808	210	View upon the Thames, at Twickenham.
1808	224	Hastings fishing boat - evening.
1808	245	Dover boats.
1808	288	Rye prison.
1808	321	Pevensey Bay, Sussex.
1808	323	View on the Thames, at Twickenham.
1809	19	View near Capel Carig, N. Wales.
1809	23	Snowdon, from near Capel Carig, N. Wales, the bursting of a thunder storm.
1809	44	Rye Harbour, Sussex - moonlight.
1809	60	View at Hastings, with fishing boats.
1809	96	Gloucester Bridge - twilight.
1809	150	View at Beddington, Kent.
1809	166	Fishing boats.
1809	202	View near Beddgelert, N. Wales.
1809	233	Moel Siabod, Caernarvonshire, N. Wales.
1809	304	Rye Harbour, Sussex.
1809	312	Boats at Dover.
1809	319	Rye Harbour, Sussex.
1809	326	Cutters at Hastings, a study from nature.
1809	332	Fishing boats at Hastings.
1810	11	View at Chiswick.
1810	21	View at Putney.
1810	29	View at Hammersmith.
1810	31	View at Hammersmith, Morning.
1810	126	View at Hammersmith - Morning.
1810	186	View near Bedgelert, North Wales.
1810	206	View on the Thames.
1810	207	View at Hastings - Morning.
1810	237	Hastings, Fishing Boats.
1810	240	Rye Harbour, Sussex.
1810	319	A rocky Scene in a mountainous Country.
1811	5	Girl getting Water at a Brook.
1811	30	View in Cumberland.
1811	113	View near Lowdore, Borrowdale.
1811	129	View of London, from Greenwich - Evening.
1811	230	Fishing Boats, at Hastings.
1811	244	Bridge at Beddgelert, North Wales.
1811	263	Fishing Boats - Morning.
1811	269	Shipwright's Yard, Hastings.
1811	278	Alpine Bridge at Capel Carig - Morning.
1811	284	View of the East Cliff, Hastings.
1811	287	View at Beddgelert, North Wales - Evening.
1811	302	Pevensey Bay, Beachy Head in the Distance.
1811	307	View on the Thames, near Barnes.
1811	361	Fishing Boat - Stormy Effect.
1811	362	Distant View of Dover.
1812	34	A Cottage near Capel Carig, North Wales - After Rain.
1812	39	A Scene on the Thames, with Putney in the Distance.
1812	50	Mill, near Beddgelert, North Wales - Storm breaking off.
1812	174	Ashted Church, Surrey.
1812	215	Hastings Fishing Boats.
1812	218	Moel Hedog, near Beddgelert.
1812	221	Battersea, from Cheyne Walk - Twilight.
1812	246	Harrow, from Hampstead.
1812	259	Harlech Castle, North Wales.
1812	294	Morning.
1812	300	Chepstow Castle, Monmouthshire.
1812	308	A Heath near Ogwen, Caernarvonshire.
1812	311	Evening.
1814	88	Scene on the Thames at Hammersmith.
1814	89	View of the New Church in the Regent's Park.
1814	92	Scene on Hampstead Heath.
1814	99	Scene on the Thames, at Mortlake.
1814	100	Market Garden, at Chelsea.
1814	104	Capel Carrig, with Snowdon in the Distance.
1814	119	Scene in Cumberland.
1814	132	Lake of Killarney, Ireland.
1814	150	Mid-day Effect.
1814	151	Cottage near Beddkelert, North Wales.
1814	153	Scene at Thames Ditton.
1814	171	East-Cliff, Hastings.
1814	184	Scene at Rye, Sussex.
1814	212	Scene from the Swan Ferry, Thames Ditton - Morning, £31.10.0, Mr. Windham.
1815	97	View from Notting Hill, on the Uxbridge Road.
1815	102	View in Hyde Park.
1815	109	Kingston Bridge.
1815	117	Distant View of Hampton Court, £2.2.0, Mr. Burn.
1815	121	Llyn Dinas Lake, North Wales, Morning.
1815	127	View of Kingston, from Thames Ditton.
1815	134	Scene at Thames Ditton.
1815	135	Scene at Hampton, £4.4.0, J. Gwilt Esq.(?).
1815	161	Paddington Church-Yard.
1815	165	Hampstead Heath, £1.11.6, Mr. Pou???.
1815	175	Lake of Killarney, Morning.
1815	185	Kingston Market.
1815	245	Distant view of Kingston, Evening.

1815	258	*Scene on the Thames, near Barnes, Elms.*
1815	260	*Hastings, Fishing Boats, Morning.*
1815	284	*Lake of Killarney, Ireland.*
1815	309	*Scene at Hampton Court, Evening.*
1815	334	*Llyn Dinas, Caernarvonshire.*
1815	348	*Scene at Hampton.*
1816	125	*Beddgelart Bridge, North Wales.*
1816	250	*Evening, Moon-light.*
1816	251	*Morning.*
1816	258	*Evening.*
1816	263	*Evening, "The curfew tolls the knell of parting day . . ." Gray's Elegy.*
1816	271	*Summer Evening.*
1816	279	*Hastings Castle, Sussex.*
1816	299	*Angling.*
1816	301	*Scene in Wales.*
1816	307	*Retirement.*
1816	309	*Evening.*
1816	320	*Evening.*
1817	70	*Boy, with Sheep. Scene at Neasdon, near Harrow.*
1817	180	*Scene near Capel Cerrig, North Wales.*
1817	206	*Holland Park from Shepherd's Bush.*
1817	216	*Scene at Hampton.*
1817	222	*Scene at Neasdon.*
1817	225	*View at Shepherd's Bush.*
1817	246	*Scene in Regent's Park.*
1817	250	*Hastings Fishing Boats, £2.2.0, Mr. Burn.*
1817	271	*Kingston Bridge.*
1817	287	*Distant View of Chelsea Hospital.*
1817	303	*Chelsea Church.*
1818	60	*The Happy Valley, "From the mountains on every side, rivulets descended that filled all the valley . . ." Rasselas. £105.0.0, J. Allnutt Esq.*
1818	77	*Scene at Mortlake, Surrey.*
1818	100	*Scene at Petersham, near Richmond, Surrey. Shower of Rain.*
1818	126	*Medmenham Ferry, near Henley.*
1818	130	*Scene at Hampton.*
1818	166	*View from Richmond Hill.*
1819	2	*Scene at Medmenham.*
1819	40	*Ulysses in Search of Eumaeus - Morning, "But he, deep musing o'er the mountains, stray'd . . ." Vide Odyssey, Book XIV.*
1819	75	*Scene at Thames Ditton.*
1819	91	*Scene upon the Thames, near Putney.*
1819	94	*Walton Bridge.*
1819	96	*Scene at Kingston, £10.10.0, J. Vine Esq.*
1819	107	*Scene in a Lane at Thames Ditton.*
1819	133	*Storm breaking off.*
1819	291	*Sand Banks.*
1819	292	*Scene near Hurley, £3.3.0, J. Vine Esq.*
1819	293	*Richmond Bridge.*
1819	319	*Hammersmith, £6.6.0, J. Allnutt Esq.*
1819	345	*Forest Scene.*
1819	348	*West Cliff, Hastings.*
1820	53	*Evening, "The sun has lost his rage: his downward orb. . ." Vide Thomson. 30gns., Premium.*
1820	303	*Hedsor, the Seat of Lord Boston, near Maidenhead.*
1820	314	*Storm breaking off.*
1820	316	*Hastings Fishing Boats.*
1820	324	*East Cliff, Hastings.*
1820	326	*Hastings Cutters.*
1820	345	*The Harvest Moon, "Meanwhile the Moon . . ." Thomson. £21.0.0, Mr. Vine.*
1820	357	*Scene at Hedsor, near Maidenhead.*
1820	359	*Scene upon Hampstead Heath.*
1820	363	*Mortlake, Surrey.*
1820	367	*View of Hastings.*
1820	373	*Timber Carriage.*
1820	377	*Scene near Henley.*
1820	378	*Scene near Maidenhead.*
1822	32	*Evening, £8.8.0, T.G.*
1828	22	*Twilight, "The curfew tolls the knell of parting day . . ." Gray. 25gns., Bishop of Winchester.*
1832	84	*Pastorella discovered by the Shepherd - Evening, "Yet left not quite, but drew a little space Behind the bushes . . ." Faery Queen, Book VI. Canto XII. 60gns.*
1839	78	*Morning, with Cattle, Sold.*

BARRY J

| 1813 | 196 | *The Interior of a Hall, on the first Day of Pheasant Shooting.* |

BARTHOLOMEW V

1835	60	*Rock Melon and Grapes, 20gns., Miss Swinburne, 18 Grosvenor Place.*
1835	96	*Convolvolus, 18gns.*
1835	318	*Flowers, 12gns.*
1836	165	*Windsor, from the Lock, 4gns.*
1836	184	*The Hedge-Sparrow's Nest, 10gns.*
1836	188	*Melon and Grapes, 18gns.*
1836	195	*Group of Fruit and Flowers, 12gns.*
1836	208	*Camellias, Apple Blossom, &c., 18gns., B.M. Lumley Esq., 21 Suffolk Street.*
1836	299	*Windsor, near Datchet Lane, Sold.*
1837	183	*Fruit, 15gns., Frame and glass 3gns.*
1837	215	*Dahlias, 40gns., Frame and glass 10gns.*

1838	1	*Flowers and Birds, Flowers – The céreus grandiflorus or night blowing céreus, impomaea rubro, ceruloea, ipomaea. . .*
1839	316	*Fruit,* 20gns., Miss Sheepshanks, Frame and glass £5.15.6.
1840	198	*Fruit.*
1840	288	*Flowers.*
1841	200	*Poppies,* 15gns., Col. Scott, 40 Hertford, Frame and glass 3gns.
1841	215	*Autumn Fruit, "The Autumn comes, with all her glorious skies . . ." By Mrs. V. Bartholomew, late Mrs. Turnbull.* 30gns., Sold.
1841	232	*Cactus Speciosissimus,* 10gns., Frame and glass £3.
1841	250	*Fruit,* 14gns., Col. Sibthorpe M.P., Delahay Street, May Fair, Frame and glass 3gns.
1842	81	*Dendrobium-nobile, an air plant (native of the East Indies).*
1842	126	**Phalenopsis Amabile, from Manilla; Dendrobium pulchellum* - One of the most rare and beautiful of the class of air plants; painted from the plant in the possession of Sigismund Rucker Esq. There are at present only about three specimens of this truly exquisite flower in Europe, one of which is in the collection of his Grace the Duke of Devonshire, at Chatsworth. "How wonderful is nature! not a spot . . ." Recollections of Nature, by Mrs. V. Bartholomew.*
1842	222	*Camellia Japonicas.*
1842	223	*Convolvulus.*
1843	74	*Fruit,* 35gns., Frame and glass £5.0.0.
1843	121	*Group of Orchidaceae (from the Collection of Sigismund Rucker, Esq., West Hill, Wandsworth), Cattleya Albida, Dendrobium Cambridgianum, Laelia Albida.* 30gns., Frame and glass £4.10.0.
1843	168	*Azaleas, "Azaleas, with your graceful forms . . ." Mrs. Valentine Bartholomew.* 20gns., John Lomax Esq., Clayton Hall, nr. Blackburn, Lancashire, Frame and glass £4.4.0.
1843	285	*China Asters,* 20gns., Frame and glass £5.10.0.
1843	351	*Camellias, Arbutus, &c.,* 18gns., John Haes Esq., 13 Park Road, Stockwell Common, Frame and glass £5.15.0.
1843	354	*Pineapple, Plum &c.,* 20gns., Frame and glass £3.7.0.
1844	279	*Fruit,* 20gns., P. Macdowell Esq., 75 Margaret St., Cavendish Sqre.
1844	282	*Piony and Camellias,* 18gns., Colonel Sibthorp, Frame and glass £5.10.0. Colonel Sibthorp will take the frame.
1844	287	*Flowers,* 20 gns., Lewis Loyd, 6 Green St., Grosvenor Sq., Frame and glass £3.7.0.
1844	298	*Just Gathered (Camellias),* 20gns., Mrs. Packe, 7 Richmond Terrace, Frame and glass £3.6.0.
1845	102	*Dahlias,* 30gns., Frame and glass £4.4.0.
1845	210	*Hollyhocks,* Sold, Sigismund Rucker Esq., West Hill, Wandsworth, Surrey.
1845	222	*Fruit,* 30gns., Frame and glass £2.12.6.
1845	288	*Fruit,* 20gns., Frame and glass £2.12.6.
1845	315	*Camellias,* 20gns., R.H. Robertson Esq., Dulwich Wood, Frame and glass £2.2.0 Yes.
1846	45	*Hollyhocks,* Sold.
1846	220	*Peonies,* 25gns., Miss Bicknell, Herne Hill, Frame and glass £3.13.6.
1846	245	*Coelogyne Cristata - a rare Air Plant, native of the East Indies (Painted for Sigismund Rücker, Esq.), "Flowers, ye are lovely things . . ." Mrs. V. Bartholomew.* 15gns., Sigismund Rucker Esq., Frame and glass £3.0.0.
1846	248	*Rhododendron, &c.,* Sold.
1846	277	*Camellias and Azaleas, &c.,* 20gns., Robert Hall Esq., 8 Deans Yard, Westminster, Frame and glass £3.0.0.
1847	103	*Convolvoli, "Sweet flowers! yet fill our thoughts with dreams . . ." Mrs. V. Bartholomew.* 30gns., Jos. Feilden Esq., Frame and glass £3.15.0.
1847	110	*Fruit,* 30gns., Frame and glass £3.10.0.
1847	198	*Chrysanthemums,* 30gns., Frame and glass £3.10.0.
1847	201	*Poppies,* 50gns., Frame and glass £8.8.0.
1848	50	*Fruit,* 20gns., Frame and glass £2.2.0.
1848	64	*Hollyhocks, "Queen of the autumn flow'rs art thou . . ." Homage to Flowers, by Mrs Valentine Bartholomew.* 35gns., Frame and glass £8.0.0.
1848	123	*Fruit,* 20gns., Frame and glass £2.0.0.
1848	265	*Fruit,* 20gns., Frame and glass £2.10.0.
1849	203	*Hollyhocks.*
1849	217	*Flowers and Fruit.*
1849	302	*Fruit.*
1850	76	*Vase of Flowers,* 20gns., Frame and glass £3.3.0.
1850	179	*Coelogyne Wallichii, a rare species of Air Plant,* Sold.
1850	235	*Rhododendrons, Camillas, &c.,* 30gns., N. Vaughan, Ch??? Hill, C???, Frame and glass £2.12.6.
1850	256	*Roses &c.,* 15gns., Frame and glass £1.16.0.
1850	323	*Camellias &c.,* Sold.
1850	354	*Fruit,* 18gns., Frame and glass £2.2.0.
1851	1	*The Victoria Regia, The new gigantic Water Lily. Painted for his Grace the Duke of Devonshire, from the plant at Chatsworth.*
1851	275	*Currants and Flowers.*
1851	280	*Camellias and Azaleas.*
1851	289	*Flowers.*

1852	63	*Varieties of Convolvulus*, 20G, Mrs. Ramsden Roe, Wootton Wawen, Henley in Arden, Warwickshire, Frame and glass £2.2.0 No.
1852	72	*Roses &c.*, 15G, Mrs. J. Robinson, Berkhampstead, Frame and glass £2.2.0.
1852	211	*Hollyhocks*, 30G, Frame and glass £3.5.0.
1852	226	*Flowers, The large flower in the centre was painted from one of the newly introduced Scented Peonies* . . . 30G, Frame and glass £3.0.0.
1853	208	*Flowers.*
1853	291	*Flowers.*
1854	4	*Fruit and Flowers*, 18gns., Revd. D.R. Rousdell(?), Gledstose, Skipton, Yorkshire, Frame and glass £1.5.0.
1854	189	*Hydrangeas*, £26.5.0, including frame and glass.
1854	240	*Roses*, 20gns., Frame and glass £1.12.0.
1854	262	*Camellias and Arbutus*, 18gns., Miss Poole, Frame and glass £1.5.0.
1854	294	*Dahlias and Fruit*, 25gns., Ebenr. Foster, The Elms, Cambridge, Frame and glass £2.2.0 Yes.
1855	191	*Flowers*, 20gns., Rev. H.P. Roundell.
1855	231	*Flowers*, 20gns., Revd. L.P. Roundell.
1855	263	*Fruit and Flowers*, 25gns., John Peel, 4 Whitehall Gardens, Frame and glass £2.2.0.

BAYNES J

1820	226	*Landscape Composition.*
1820	236	*Part of Goodrich Castle, Herefordshire.*
1820	251	*Landscape - approaching Storm.*
1820	256	*Cori-lin, a fall of the Clyde, near Lanark.*
1820	269	*Part of Valle Crucis Abbey, near Llangollen, North Wales.*
1820	333	*A Cottage, near Maidstone, Kent.*
1820	351	*Landscape - Morning.*

BAYNES J M

| 1820 | 318 | *Windermere, from Troutbeck, Westmoreland*, £3.3.0, Mr. Dyson. |
| 1820 | 356 | *Magdalen College and Bridge at Oxford.* |

BAYNES T M

1820	25	*A Cottage near Oxford.*
1820	29	*Rossthwaite near Eagle Crag in Borrowdale, Cumberland.*
1820	268	*Dungeon Gill in Little Langdale, Westmoreland.*
1820	277	*Scale Force, near Crummock Lake, Cumberland.*
1820	305	*A Water Mill in Ruins, near Dolgellie, North Wales.*

BELISARIO I

| 1815 | 103 | *Road Scene, with Cattle*, £7.7.0, Mr. Willimotte. |

BELISARIO J

| 1817 | 252 | *Landscape with Cattle.* |

BELISARIO J A

| 1816 | 244 | *Landscape and Cattle.* |

BELISARIO J M

| 1818 | 267 | *Road Scene, with Cattle - Afternoon.* |

BENNET

| 1825 | 52 | *A Brisk Gale entering the New Mole Harbour, Gibraltar*, 25gns., Mr. R. Williams, 29A Albemarle Street. |

BENNET T

| 1817 | 133 | *Portrait of a Lapdog.* |

BENNETT T

1816	52	*Portrait of an Officer's Charger.*
1817	128	*Martin Cat and Pheasant.*
1818	132	*Portrait of a small Spaniel, the property of a Lady of Quality.*
1818	141	*Portrait of a Cart Horse.*
1819	115	*Fox and Cubs.*

BENNETT W J

| 1819 | 33 | *View of the Island of Capri, Bay of Naples.* |
| 1821 | 64 | *Vessels in a calm*, £10.10.0, Bishop of Ferns. |

BENNETT W T

1820	97	*Brisk Gale, with a distant View of Castel a'Mare, and the Mountains on the SE. side of the Bay of Naples.*
1820	266	*View of Harmar's Wharf, Erith, Kent.*
1823	44	*View of Ape's Hill on the Coast of Barbary, with a Pirate Felucca from Ceuta.*
1824	230	*Mount Vesuvius.*

BENTLEY C

1834	8	*Scarborough, Yorkshire*, 6gns.
1834	55	*Scarborough, Yorkshire*, 35gns.
1834	113	*Coast Scene*, 5gns.
1834	179	*Wreck on the Coast of Shegness, Lincolnshire*, 10gns.
1834	248	*Church of Santa Salute, Venice*, 40gns., J.H. Maw Esq., Aldermanbury.
1835	72	*On the Thames - Battersea*, 4gns., T. Griffiths Esq.
1835	81	*View from the Promenade, Venice*, 40gns., Sold Mr. Bentley.
1835	143	*Regness, on the Coast of Lincolnshire*, 20gns.
1835	202	*View on the Dort*, 35gns., Sold Mr. Bentley.
1835	248	*Portsmouth*, 7gns., Richard Hodgson Esq., Pall Mall, bought by Mr. Lewis.
1836	76	*Dunluce Castle (Loch of Antrim)*, 35gns., J. Marshall Esq., 41 Upper Gros. Street.
1836	257	*Near Bon Church, Isle of Wight*, 5gns.
1836	260	*Near Litchfield*, 4gns.
1837	185	*On the Coast, Lincolnshire*, 4gns.
1837	349	*Kingsworn, on the Dart, Devon*, 6gns., J. Olive Esq., 4 York Terrace, Regents Park, To be deld. with the frame and glass as per order of Mr. Bentley dated 27th June.

1838	27	*Inesfallen Island, Lower Lake, Killarney.*
1838	95	*Dunluce Castle - County of Antrim.*
1838	107	*Sligo, Ireland.*
1838	196	*From the Red Rover, "The restrained silence which is so apt to succeed a sudden burst of displeasure . . ." Vide the Red Rover.*
1838	198	*From Tom Cringle's Log, "After the slave ship sank she gave a sudden heel, and while five hundred human beings, pent up in her noisome hold, split the heavens with their piercing death yells, down she went with a heavy lurch, head foremost, right in the wake of the setting sun ."*
1838	244	*Lower Lake, Killarney.*
1839	17	*Garden Scene,* 35gns., Frame and glass 8gns.
1839	24	*Ferry Boat,* 15gns., C. Heath Esq., 6 Seymour Place.
1839	149	*Wicklow Bay, Ireland,* 35gns., Geo. Cooke Esq., Carr House, Doncaster.
1839	197	*Tenby, South Wales,* 20gns., Franz Baron von Kreusser, 141 Regent Street.
1839	279	*Tenby Bay, Wales,* 4gns., Thos. Evans Esq., Lyminster, near Arundel, care of Mr. J.W. Wright, 54 Gt. Marlborough Street.
1840	19	*On the Beach near Dover, looking towards Folkestone.*
1840	20	*Entrance to Sligo Harbour, Ireland.*
1840	53	*Santa Salute, from the Piazzetta, Venice.*
1840	105	*Ferry Boat.*
1840	195	*Near Penzance, Coast of Cornwall.*
1840	315	*Needles, Isle of Wight.*
1841	7	*Trebizond, Black Sea, the lower range of the Caucasus - after a Sketch by Coke Smyth, Esq.,* 20gns.
1841	22	*Lock Scene,* 15gns.
1841	44	*Abydos - Dardanelles, from a Sketch by Coke Smyth, Esq.,* 20gns.
1841	73	*Fishing Boats - Wicklow Bay, Ireland,* 25gns., Richd. Ellison Esq., Sudbrooke Holme, Lincoln.
1841	106	*Donegal Bay, Kellybeg Mountains in the Distance - Ireland,* 35gns.
1841	194	*Fishing Boats running into Harbour in a stiff Breeze,* 100gns., Frame and glass 28gns.
1842	10	*Fecamp Coast, Normandy.*
1842	43	*Avranches, Normandy.*
1842	133	*Tréport, Coast of Normandy.*
1842	152	*Pier at Broadstairs, Fishing Boat running in - Early Morning.*
1842	203	*Northfleet, on the Thames.*
1842	227	*Scene near Munthorpe, Lincolnshire.*
1842	275	*Oyster Women on the Coast at Granville.*
1842	298	*Hay Barge off the Nore.*
1843	21	*Brig and Fishing Boats off St. Valery, Coast of Normandy,* 35gns., Lady Mary Lambton, 13 Cleveland Row, St. James, Prize of 25£ in the Art Union of London.
1843	47	*Tréport, Coast of Normandy,* 20gns.
1843	101	*Granville, Coast of Normandy,* 35gns., Lord Charles Townshend.
1843	111	*Scene in the Mountains, near the Tal-y-Bont, N. Wales,* 25gns., Frame and glass £7.7.0.
1843	134	*Vale of Llanrwst, from Roe, North Wales,* 25gns., Frame and glass £7.7.0.
1843	182	*Hay Barges &c. - Mouth of the Medway,* 30gns., T.S. Smith Esq., Asthall W. Sheffield, Bridgenorth, Salop per Thomas Bishop Esq., 41 Mornington Place, Mornington Crescent, Prize of 25£ in the Art Union of London.
1843	214	*Pont Hugon on the River Roe, North Wales,* 40gns., Frame and glass £11.11.0.
1843	266	*Tenby, South Wales,* 15gns., Sir John Guise, 48 Eaton Place, Frame and glass £4.4.0.
1844	19	*Spithead - Seventy-four firing a Salute on leaving Port,* 40gns., C.H. Turner Esq., Rooksnest, Godstone, Frame and glass 8gns.
1844	42	*Dutch Boats off the Coast of Holland,* 40gns., Frame and glass £10.0.0.
1844	53	*On the Thames - an Indiaman being Towed up - Early Morning,* 25gns., Chas. T. Maud, Athenaeum, Frame and glass 6gns.
1844	112	*Town and Castle of Dieppe, from the Sea,* 40gns., Frame and glass £10.10.0.
1844	127	*Mont. St. Michel, Coast of Normandy - Early Morning,* 25gns., Robert Johnston Esq., 87 Lower Gardiner St., Dublin, Frame and glass £6.6.0.
1844	151	*Port Madoc, North Wales - Storm clearing off,* 25gns., W. Gosling, 15 St. James's Square, Frame and glass £6.6.0.
1844	153	*Dieppe Pier - Fishing Boats going out,* 40gns., Frame and glass £10.10.0.
1844	161	*Making Signal for a Pilot off St. Malo,* 40gns., Mrs. R. Cumming, 1 Mannor Cottages, Holloway, Frame and glass £8.8.0, P.AU.
1844	204	*Fishing Boats running into Harbour,* 25gns., B. Smith Esq., 5 Blandford Sq., Frame and glass £6.6.0.
1844	256	*Near Burgh, Fens of Lincolnshire,* 10gns., G. Loftus Esq.
1845	3	*Tremadoc, North Wales,* 15gns., Benj. Leigh Smith Esq., Frame and glass £5.5.0.
1845	19	*Collier on a Sand-bank, off Leigh, on the Thames,* 25gns., Frame and glass £6.6.0.
1845	46	*Wreck on the Rocks of Elizabeth Castle, Jersey,* 40gns., Miss Leigh Smith, Frame and glass £7.7.0.
1845	48	*East Keal, Lincolnshire,* Sold.

1845	74	*Quilleboeuf, on the Seine*, 25gns., Frame and glass £6.6.0.
1845	95	*An Indiaman Lying to - Making Signals for a Pilot*, 15gns., J. Simpson Esq., 10 Henrietta St., Cavendish Sq., Frame and glass £4.4.0, P.AU. 15£.
1845	110	*Fishing Boats off Leigh, on the Thames*, 12gns., Frame and glass £3.3.0.
1845	117	*Ballyshannon, Donegal, North of Ireland*, 15gns., Frame and glass £5.5.0.
1845	123	*Granville - Coast of Normandy*, 25gns., Frame and glass £6.6.0.
1845	125	*Salmon Trap, on the River Lleder, Pass of Dolwyddelan, North Wales*, 15gns., J.H. Brown Esq., 19 College Green, Gloucester, Frame and glass £5.5.0, P.AU. 15£.
1845	133	*Broadstairs - an Indiaman in Distress, Boat going out to her assistance*, 25gns., J. Ryman Esq., Frame and glass £6.6.0.
1845	183	*Cardigan Bay, North Wales*, 40gns., Frame and glass £7.7.0.
1845	186	*Near Festiniog, North Wales*, 5gns., Revd. T.A. Firminger, Sittingbourne, Kent.
1845	199	*Alton, Lincolnshire - Storm clearing off*, 15gns., I.H. Hawkins Esq., 16 Suffolk St., Frame and glass £5.5.0.
1845	326	*Hay-making, Tetford, Lincolnshire*, 15gns., C.S. Fallowdown Esq., 2 Paper Buildings, Temple, Frame and glass £5.5.0 No, P.AU. 15£.
1845	331	*Traeth Mawr - Range of Mountains, Snowdon, &c. from Tremadoc*, 15gns., Lord Bishop of Winchester, St. James Square, Frame and glass £5.5.0.
1846	4	*Lock Scene, near Boston, Lincolnshire*, 15gns., Frame and glass £4.4.0.
1846	25	*Wreck on the Rocks, Dunluce Castle, North Ireland*, 25gns., Fred. Cavendish Esq., Frame and glass £5.5.0.
1846	35	*Fishing Boats off Granville, Coast of Normandy*, 25gns., S. Rucker Jun. (?) Esq., Frame and glass £5.5.0.
1846	77	*Leigh, on the Thames - Sunset*, 10gns., Frame and glass £3.10.0.
1846	135	*In the Downs - Deal in the distance*, 30gns., Chas. Russell, 27 Church St., St. James, Frame and glass £5.5.0.
1846	146	*On the Medway*, 30gns., S.W. Brown Esq., Claremont Villas, Brixton Hill, Frame and glass £5.5.0, AU. 20£.
1846	159	*Pilot Boat - Folkestone in the distance*, 15gns., Miss Oates, Oxton, near Nottingham, New frame to replace Mr. B's £4.4.0.
1846	221	*Near Penmachno, North Wales*, 10gns., Frame and glass £3.10.0.
1846	223	*Granville, Coast of Normandy*, 15gns., Lady Mary Lambton, Frame and glass £4.4.0.
1846	240	*Dusseldorf, on the Rhine*, 15gns., Fred. Cavendish Esq., Frame and glass £4.4.0.
1846	300	*On the Coast, Southend*, 10gns., Miss M. Jones, 32 York Place, City Rd., Frame and glass £3.10.0, AU.
1846	310	*Mountain Scene, from Portmadoc, North Wales*, 15gns., Wm. Murton Esq., 14 Trinity Terrace, Southall, Frame and glass £4.4.0, AU. 20£.
1846	315	*Wreck on the Sands, Cricceath Castle, Cardigan Bay, North Wales*, 10gns., Sir John Guise, Frame and glass £3.10.0.
1847	23	*Scene in the Bay of Cardigan - Cricceath Castle, North Wales*, 30gns., W.F. Beadon Esq., 11 John St., Berkeley Sq., Frame and glass £5.5.0, P.AU. 25.
1847	32	*Fresh Breeze - off Whitby, Coast of Yorkshire*, 30gns., The Hon. Mrs. Bathurst, Grosvenor Sq., Frame and glass £5.5.0.
1847	42	*Fishing Boats off St. Malo*, 25gns., Frame and glass £5.5.0.
1847	60	*Bay, Donegal, Kellybegs Mountains, North of Ireland*, 15gns., Lloyd (Brothers), 22 Ludgate Hill, Frame and glass £4.4.0.
1847	78	*Scene in the Downs - Dover in the distance*, 30gns., Frame and glass £5.5.0.
1847	126	*Corn Field, near the Pass of Llanberis, North Wales*, 15gns., John Gregory Cottingham Esq., Chesterfield, Rec'd. for frame £4.4.0, AU. 10£.
1847	146	*Ferry Boat - Storm Clearing Off*, 40gns., B. Gosling, Frame and glass £8.8.0.
1847	162	*Fishing Boats preparing for Sea*, 10gns., Edward Swinburne Esq., 18 Grosvenor Place, Frame and glass £3.3.0, P.AU. 10£.
1847	189	*Sea Piece - Coast of North Wales*, 15gns., Countess Grey, 30 Belgrave Sq., Frame and glass £4.4.0.
1847	250	*On the Coast - Normandy, near Treport*, 15gns., Marquis of Douglas, 13 Connaught Place, Frame and glass £4.4.0.
1847	272	*Tattershall Castle, Lincolnshire - Evening*, 15gns., J. Mitchel(?) Esq., Frame and glass £4.4.0.
1847	275	*On the Coast, near Tremadoc, North Wales*, 10gns., Miss Leigh Smith, 5 Blandford Sq., Frame and glass £3.3.0 Yes.
1847	278	*Dover Castle*, 10gns., Frame and glass £3.3.0.
1847	280	*Elizabeth Castle, Jersey - Sunset*, 15gns., J.H. Tomkins, 8 Russell Place, Fitzroy Sq., Frame and glass £4.4.0, P.AU. 15.
1847	301	*On the Coast, Southend - Boat Running on Shore*, 10gns., William Griffiths Esq., Newcastle, Staffordshire, Frame and glass £3.3.0, P.AU. 10£.

1848	6	*Haymaking - Tattershall Castle, Lincolnshire, 15gns., Frame and glass £3.3.0.*
1848	12	*Criccieth Castle, Cardigan Bay, North Wales, 15gns., Frame and glass £3.3.0.*
1848	18	*Edinburgh from the Sea, 50gns., Frame and glass £8.8.0.*
1848	31	*Quilleboeuf, looking up the Seine, 15gns., Frame and glass £3.3.0.*
1848	44	*Landguard Fort, Harwich in the distance - Coast of Essex, 30gns., Frame and glass £5.5.0.*
1848	53	*Near Burntsland, Coast of Fifeshire, 15gns., Mrs. Whitcombe, Manor House, Marsh ?. Richmond, Frame and glass £3.3.0, change frame, AU. 15.*
1848	95	*On the Essex Coast, near Harwich, 15gns., Frame and glass £3.3.0.*
1848	98	*Harwich, from the River Stour, 25gns., Frame and glass £5.5.0.*
1848	128	*St. Michael's Mount, Coast of Cornwall, 10gns., Frame and glass £2.10.0.*
1848	165	*Killybeg Mountains, Donegal Bay, North Ireland, 10gns., Frame and glass £2.10.0.*
1848	169	*On the Coast of Normandy, 10gns., Mrs. Phillips, 15 Westbourne Grove, Bayswater, Frame and glass £2.10.0 No, AU. 10.*
1848	194	*Scarborough, from the Sea, 30gns., Frame and glass £5.5.0.*
1848	207	*An Old Breakwater on the Coast, Essex, 15gns., Rev. Hare Townshend, Frame and glass £3.3.0 Yes.*
1848	211	*Fishing Boats Running into Harbour - Storm coming on, 30gns., Frame and glass £5.5.0.*
1848	302	*Near Coningsby, Lincolnshire, 5gns.*
1849	16	*Town and Harbour of Sligo, Ireland.*
1849	18	*On the River Stor - Harwich in the distance.*
1849	29	*Tattershall Castle, Lincolnshire - Sunset after a Storm.*
1849	46	*Lower Lake, Killarney, Ireland - Early Morning.*
1849	55	*Trèport, Coast of Normandy.*
1849	57	*Bantry Bay, Ireland - Storm clearing off.*
1849	67	*Mountain Sene near Sligo, Ireland.*
1849	110	*St. Michael's Mount, Normandy.*
1849	134	*Kirkaldy, coast of Fifeshire.*
1849	140	*Trebizond - Distant Range of the Caucasus, after a Sketch by Coke Smyth, Esq..*
1849	160	*Mountain Scene from Port Maddock, North Wales.*
1849	206	*Off the Dutch Coast.*
1850	8	*Men-of-War in the Medway - Sheerness in the distance, 10gns.*
1850	14	*Mountain Scene, on the River Roe, North Wales, 30gns.*
1850	48	*Mountain Scene, Snowdon - taken from Tremadoc, 30gns., J. Noble Esq., 15 Upper Bedford Place.*
1850	55	*Vessel on the Rocks - Scarborough in the distance, 15gns., Miss Hodder, Isle of Man.*
1850	57	*Wreck on the Coast of North Wales, Criccaeth Castle, 20gns., Thomas Hilton Reith Esq., 6 Highgate Rise, Kentish Town (East India House), AU. 20.*
1850	84	*Burntisland, Coast of Fifeshire, Scotland, 30gns., J. Dowell(?), Buxton.*
1850	112	*Dunluce Castle, North of Ireland, 40gns.*
1850	174	*The Town and Harbour of Sligo, Ireland, 30gns, R.H. Holford, 2 Hanover(?) Sq., Frame and glass £5.7.6, 5inch moulding.*
1850	185	*Mountain Scene near Glengariff, Ireland, 6gns.*
1850	233	*Fishing Boats running into Harbour, 10gns., Mathew Wise Esq.*
1850	291	*On the Yorkshire Coast, near Scarborough, 15gns.*
1850	340	*St. Catherine Rock, near Tenby, South Wales, 10gns., A.D. Cockburn Esq., Piccadilly, AU. 10£.*
1850	341	*Fishing Boats off the Coast of Normandy, 10gns.*
1850	365	*On the Medway, 10gns., Robert Barclay Esq., Lombard St..*
1851	8	*Sunset - on the Thames, near Limehouse.*
1851	19	*Tenby, South Wales.*
1851	22	*Irish Peasants returning from Market - Killybegs Mountains, Coast of Donegal, Ireland.*
1851	26	*Coast of Cardigan, near Port Madoc, North Wales.*
1851	29	*Fishing Boat pushing off - Holy Island, Coast of Northumberland.*
1851	62	*Fishing Boats running into Harbour.*
1851	83	*St. Michael's Mount, Normandy.*
1851	93	*Portobello, looking towards Edinburgh.*
1851	103	*Bruntisland, Coast of Fifeshire.*
1851	131	*Wreck off Bamborough Castle, Coast of Northumberland.*
1851	165	*Wicklow Bay, Ireland.*
1851	175	*Fishing Boats off the Coast of Sheerness.*
1851	229	*Mountain Scene near Bettws-y-Coed, North Wales.*
1851	277	*Fishing Boats off St. Valery en Caux, Coast of Normandy.*
1851	305	*Scarborough Coast, Yorkshire.*
1852	8	*Mountain Scene, near Roe, North Wales - Evening, 15G, Mr. Bacon.*
1852	51	*Scene in the Highlands, 45G, Robert Philips Greg Esq., Chancery Lane, Manchester.*

1852	111	*Caernarvon Castle - Sunset*, 25G.
1852	114	*South Foreland - near Dover*, 20G.
1852	121	*Dover from the Channel*, 40G.
1852	167	*Broadstairs*, 15G, John Labouchere Esq.
1852	180	*Summer Afternoon, on the Thames, near Erith*, 25G.
1852	186	*Granville, Coast of Normandy*, 25G.
1852	259	*Elizabeth Castle, Jersey - Sunset after a Storm*, 10G, Thos. D. Hill, Parsons Green, Fulham.
1852	271*	*Tremadoc, North Wales*, 5G, Henderson Esq., 3 Montague St., Russell Sq.
1852	279	*Fishing Boats*, 5G.
1852	294	*Scarborough - Coast of Yorkshire*, 10G, John Field Esq., Dornden, Tonbridge Wells.
1852	297	*On the Ledder, near Bettws-y-Coed*, 10G.
1853	17	*Sligo, Ireland*.
1853	23	*Fishing Boats off Ramsgate*.
1853	44	*Mountain Scene, between Bettws-y-Coed, North Wales*.
1853	72	*Dunluce Castle, Ireland - Sunset after a Storm*.
1853	98	*On the Coast of Fifeshire, Scotland*.
1853	157	*Coast Scene near Harwich*.
1853	167	*Old Pier at Broadstairs*.
1853	180	*Mountain Scene, Donegal Bay, Ireland*.
1853	191	*Elizabeth Castle, Jersey - Storm clearing off*.
1853	211	*Mountain Scene, near Port Maddoc, North Wales*.
1853	226	*Fishing Boat, near Southend*.
1853	230	*Vale of Dolwyddelan, North Wales*.
1853	237	*Cardigan Bay, North Wales*.
1853	282	*Sea Piece*.
1854	8	*Composition - Evening*, 25gns.
1854	22	*Scarborough*, 40gns., Kay Esq., Hill St. 36.
1854	65	*Looking up the River from Southend*, Sold.
1854	69	*Tattushall Castle, Lincolnshire - Sunset after a Storm*, 15gns.
1854	84	*The Dogana, Venice*, 12gns., Abel Peyton Esq.
1854	87	*South Foreland - Dover in the Distance*, 12gns., John Beadnell, Tottenham.
1854	193	*Tintern Abbey*, 25gns., Ebenr. Foster, The Elms, Cambridge.
1854	202	*Ballyshannon Bay, Ireland*, 6gns.
1854	206	*Wicklow Bay, Ireland*, 6gns.
1854	208	*Sea Piece*, 6gns., R. Ellison Esq.
1854	213	*Hastings, from the Sea*, 50gns., A. Attwood Esq., 19 St George's Terrace, Hyde Park, Art Union Prize.
1854	238	*Street Scene - Verona*, 12gns., Rowney Esq.
1854	277	*Torquay, Devonshire*, 8gns., H.G. Patrick Esq.
1854	309	*Bantry Bay, Ireland*, 8gns., Richard Ellison Esq.

1854	322	*Port Madoc, North Wales*, Sold.
1854	349	*Burntisland, Coast of Fifeshire*, Sold.

BENTLEY S

1837	37	*The Raft*, 100gns.

BETHAM MISS

1814	5	*Frame, containing Six Portraits: Miss Bedingfeld, Captain Betham, Robert Southey, Esq. the two Miss Leums, and the late Mrs. J. Collinson.*
1814	19	*Sketch of Mrs. T. Fancourt.*
1814	20	*Sketch of Mrs Schimmelpenning.*
1815	17	*Portrait of Henry Bedingfield, Esq..*
1815	24	*Portrait of Miss Collinson of Islington.*

BEWICK W

1820	140	*Una resting in the Forest - Painted for Sir John Leicester, Bart., "III. Yet she most faithfull Ladie, all this while . . . IV. One day nigh wearie of the yrksome way . . ." Vide Spenser's Faérie Queene, Book I. Canto III.*

BLAKE B

1820	135	*Sportsman's Breakfast*, £5.5.0, Duke of Northumberland.
1820	137	*Dead Game*, £12.12.0, H.P. Hope Esq.
1820	143	*Dead Hare*, £5.5.0, J. Belisario Esq.

BOADEN J

1819	35	*The Weird Sisters, A drum, a drum, Macbeth doth come. – Macbeth.*
1819	144	*Muschats' Cairn - Jeannie Dean's waiting the interview with Robertson (Vide the Heart of Mid Lothian).*
1820	64	*View of the Thames from Mortlake.*
1820	88	*Fishing Boats off Brighton.* 60G.

BOSTOCK J

1852	67	*Going to Market*, 60G.
1852	206	*The Lonely One, "I wander about like a shadow of pain. . .T.K. Hervey.* 60G.
1853	200	*The Inseparables.*
1854	222	*A Gathering for the Birthday*, 60gns.

BRADLEY J

1819	184	*Portrait of a Lady.*

BRADLEY T

1820	184	*Study of a Head.*

BRANDLING H

1854	20	*Crypt of Glasgow Cathedral*, 30gns.
1854	200	*Interior of the Church of St. Lawrence, Nuremberg*, 100gns.
1854	219	*Durham Cathedral - Installation of Bishop Neville, 1441*, 100gns.
1855	90	*Tower in the Castle, Nuremberg*, 25gns.
1855	144	*Altar in Wood, by Veit - Stoss, Nuremburg*, 25gns.
1855	173	*Entrance to the Castle, Nuremburg*, 10gns.
1855	192	*The Spittler Thor, Nuremburg*, 10gns.

BRANWHITE C

1849	31	*Lock on the Avon.*
1849	96	*Evening.*
1849	183	*On the East Lyn, North Devon.*
1850	26	*Near Bettws-y Coed, North Wales*, 20 Pounds, R. Barclay Esq., 55 Lombard St., Frame and glass £1.0.0.
1850	146	*A Dull Day in January*, 45 Pounds, Frame and glass £7.10.0.
1850	163	*A Frosty Morning*, 20 Pounds, Frame and glass £1.0.0.
1851	18	*On the East Lyn, Lynmouth, North Devon.*
1851	42	*Old Windmill, near Walton, Somersetshire.*
1851	57	*On the Bath Canal - Frosty Evening.*
1851	252	*Sketch from Nature, near Conham.*
1852	75	*An Autumn Evening - near Whitchurch, Somersetshire*, 15G, Frame and glass £1.15.0.
1852	187	*An Old Wind Mill near Almsbury, Gloucestershire*, 15G, J.M.W. Vokins, Frame and glass £1.15.0.
1852	193	*An Old Grist Mill on the River Tuyn, Devonshire*, 25, Frame and glass £2.10.0.
1852	203	*The Frozen Ford*, 50, J. Robinson Esq., Frame and glass £4.0.0 No.
1853	198	*A Winter Morning.*
1854	16	*Scene on the River Conway, above the Falls, North Wales*, £40.0.0, H. Wild Esq., Frame and glass £3.10.0.
1854	38	*Winter - Sunset*, £30.0.0, Gambart Esq., Frame and glass £3.0.0.
1854	199	*A Nook of the Conway, North Wales*, 15gns., Bishop of Winchester, With frame £1.5.0.
1855	26	*A Pool of the Conway, North Wales*, £40.0.0, Her Grace The Duchess of Sutherland, Frame and glass £2.0.0.
1855	114	*The Gorky, Bed of a River, North Devon*, £20.0.0, Rev. C.J. Sale, Frame and glass £2.0.0.
1855	168	*A Winter Morning*, £30.0.0, G. Gwyn Elgar Esq., Frame and glass £2.0.0.
1855	183	*A Scrap-on the Hedder, North Wales*, 6gns., Anderson Rose Esq., Frame and glass £1.1.0.

BROOKBANK MRS

1836	280	*Grapes*, 7gns.
1837	324	*Plums*, 5gns.

BROOKBANK MRS, LATE MISS SCOTT

1834	267	*Apples*, 4gns.

BUCKLER I C

1819	11	*Part of Fountains Abbey, Yorkshire.*

BUCKLER J C

1815	280	*Interior View of York Minster, from the North Transept.*
1815	317	*Nave of York Minster*, £8.8.0, Mr. Holford.
1816	256	*West Front of Landaff Cathedral.*
1816	306	*Headington Cross, near Oxford.*
1817	163	*The Monumental Chapels of Cardinal Beaufort and Bishop Fox, in Winchester Cathedral.*
1817	280	*St. Mary's Church, Beverly, Yorkshire.*
1818	223	*Interior View of the Transept of Fountain's Abbey, Yorkshire.*
1819	211	*South East View of York Minster.*
1819	217	*Interior View of Rievaulx Abbey, Yorkshire.*
1819	247	*South-east View of York Minster.*
1820	342	*Gloucester Cathedral, with the Ruins of St. Catherine's Priory.*
1820	350	*Tewkesbury Abbey Church and Gateway.*

BUCKLER T C

1817	207	*Merton College, Oxford*, £5.5.0, Mrs. Harvey.

BURGESS J

1816	10	*Portrait of Himself.*
1816	11	*Portrait of a Lady.*

BURGESS J JUN

1851	20	*The Cloisters of the Church at Treguier, Brittany.*
1851	27	*Shrine and Chapel of St. Ives, in the Church of Treguier, Brittany.*
1851	158	*Chateau de la Duchesse d'Anne Bretagne, Folgout, Brittany.*
1851	181	*The Old Bridge at Stirling.*
1852	48	*Roodloft under restoration in the Church at Dixmude, Belgium*, 20G.
1852	55	*Rubens' Statue, and Cathedral at Antwerp*, 25G.
1852	83	*Pulpit in the Cathedral at Ypres, Belgium*, 20G.
1852	132	*Canal Scene at Oudenarde, Belgium*, 10G.
1852	141	*Fountain and Church, Market Place, Guingamp, Brittany*, 10G, Abel Peyton Esq.
1852	171	*The Shrine of St. Sibald, Nuremberg*, 25G.
1853	2	*Interior of the Church at Trèves - Moselle.*
1853	55	*Le Gros Horloge, Rouen.*
1853	129	*Street Scene at Caudebech, Seine.*
1853	135	*Tomb of the Duc de Brezé, Rouen Cathedral.*
1853	160	*Statue of Joan of Arc, from Gateway of Hotel Bourgthèroulde, Rouen.*
1853	184	*Interior of Church at Caudebec, Seine.*
1853	193	*Church at Harfleur, Normandy.*
1854	58	*Street Scene and Chateaû, at Amboise, Loire*, 18gns.
1854	104	*Interior of Porch in Cathedral at Chartres*, 15gns.
1854	109	*Cathedral at Chartres*, 20gns.
1854	141	*Cathedral at Chartres, South Transept and Porch*, 20gns.
1854	218	*Street Scene and Clock Tower at Amboise, Loire*, 18gns., Edward Thornton(?) Esq., Temple.

1854	221	*L'Escalier, Chateaû de Chambord, Loire,* 12gns., Turner Esq., Bruton St..
1854	227	*Interior of South Porch, Cathedral at Chartres,* 18gns.
1855	38	*L'Eglise St. Jacques à Caen,* 15gns., Stephen Lane, 102 Piccadilly.
1855	77	*Remains of an Old Church at Orleans,* 15gns.
1855	80	*Statue of Jeanne d'Arc, at Orleans,* 15gns.
1855	138	*Sakramentshauschen in Der Lorenzkirche, Nuremberg,* 18gns.
1855	177	*Maison des Bateliers, at Ghent,* 20gns., E. Thornton(?) Esq., Temple, Frame and glass £3.10.0.
1855	184	*The Ruined Abbey of Clare, Galway, Ireland,* 15gns.
1855	208	*The Town Hall at Audenaude, Belgium,* 25gns.
1855	225	*The Keep at Clare, Galway, Ireland,* 15gns.

BURTON F W

| 1855 | 181 | *Franconian Peasantry (Pilgrims) in the Cathedral of Bamberg,* 200gns. sold before opening [scribbled out in pencil]. |
| 1855 | 239 | *Peasantry of Upper Franconia waiting for Confession,* £85.0.0 Copywright reserved, Messrs. Vokins. |

BYRNE J

1827	23	*Chepstow Castle, Monmouthshire,* Sold.
1827	49	*Tintern Abbey - looking down the South Transept,* 7gns., Mrs. Rothchild, Piccadilly.
1827	115	*Rochester Castle,* 7gns., G. Morant Esq.
1827	145	*Richmond Hill,* Sold.
1827	205	*Scene on the Avon, near Clifton,* 7gns.
1827	209	*Chepstow Castle - showing the Course of the Wye into the Severn,* 10gns., Mrs. Hilton.
1827	214	*Gundulph's Tower, Rochester Castle,* 4gns., Mrs. Hilton.
1827	242	*Group of Scotch Firs,* 4gns., Mr. Utterson, 32 York Terrace, Regents Park.
1827	356	*Twickenham.*
1828	28	*Tivoli, from a Sketch by Mr. G. Morant, jun.,* 7gns.
1828	61	*Part of Chepstow Castle from the Fosse,* 4gns.
1828	79	*Caerphilly Castle, Glamorganshire,* 25gns.
1828	144	*Twickenham,* 7gns., Mrs. Hilton.
1828	232	*Chepstow Castle, from Piercefield,* 8gns., John Shaw, No. 28 Gower St., Bedford Sq.
1828	262	*Firs - Autumnal Morning,* 6gns., Rev. J.P. Maud.
1828	340	*Eton College - Sunset,* 5gns., Mr. Shaw, Gower Street.
1829	60	*Folkstone - Sun-set,* 6gns.
1829	61	*The Old Pump-room (now taken down) at Bristol Hot Wells - Sun-set,* 7gns.
1829	238	*The Old Park at St. Donat's, Glamorganshire, South Wales – on the high ground are the remains of a Watch Tower – in the distance, the Bristol Channel and Coast of Somersetshire,* 40gns.
1829	270	*Interior of Tintern Abbey Church,* 5gns., Prior Esq.
1829	294	*Glastonbury, Somersetshire,* 6gns.
1829	298	*Ramsgate Harbour,* Sold.
1830	21	*The Tor, or Tower Hill, Glastonbury, Somersetshire,* 40gns.
1830	23	*Caldecot Castle, Monmouthshire,* 6gns., Sir W. Herries, 35 Clarges St.
1830	36	*A Day in Greenwich Park,* 10gns.
1830	84	*Clifden on the Thames, near Maidenhead,* 4gns.
1830	190	*Twickenham on the Thames,* 25gns.
1830	300	*The Star and Garter, Richmond Hill,* 5gns., Lady Montague, No. 6 Hamilton Place, Piccadilly.
1830	322	*London, from Greenwich Park,* 12gns., Mrs. Hilton.
1831	25	*Menai Bridge, near Bangor - Twilight.*
1831	74	*Pont y Cyfven, near Capel Cûrig.*
1831	90	*Harlech, North Wales.*
1831	125	*Scene from Llanrwst, looking towards North Wales.*
1831	140	*Harlech Castle, North Wales.*
1831	179	*Eagle Tower, Caernarvon.*
1832	44	*C. Marius, the Roman Consul, amidst the Ruins of Carthage, Plutarch's Life of Caius Marius.* 45gns.
1832	91	*Scene on the Thames, at Twickenham - the site of Pope's Villa, the present mansion the residence of Sir Wathen Waller,* 8gns.
1832	182	*Harrow, from Child's Hill - a Sketch from Nature,* 4gns.
1832	221	*Part of the Faubourg St. Sèver, near the bridge of Boats, Rouen,* Sold.
1832	265	*At Child's Hill near Hampstead - a Sketch from Nature,* 5gns.
1832	308	*Place de la Pucelle, Rouen,* 8gns.
1832	361	*The Mountain Stream,* 7gns.
1832	411	*Sun-set–Scene on the Thames, at Greenhithe, Kent,* 5gns., Mr. C. Brookbank, Brighton.
1833	40	*Lynnmouth, North Devon,* 30gns.
1833	159	*One of the Gates of Conway, North Wales,* 6gns.
1833	205	*Harlech Castle, North Wales,* 20gns.
1833	252	*Nant Mill, North Wales,* 12gns.
1833	263	*The Ruin,* 6gns.
1833	371	*The Cottage,* 6gns.
1834	59	*Leionay Bridge on the Seine,* 4gns.

1834	77	*A Solitary, at his Devotions, 5gns.*
1834	87	*Entrance to the Pont de la Concorde, Paris (Pont Louis Seize). The statues represent Condé and Turenne the military heroes of the age of Louis XIV, 6gns., Mr. D.T. White, Oxford Street.*
1834	97	*Pavillon de Flore, Galerie du Louvre and part of the Pont Royal, Paris, 6gns.*
1834	101	*At Nantes on the Seine - Sun-rise, 12gns.*
1834	250	*Bridge over the Seine at Vernan, 7gns.*
1834	288	*A Roman Army with its Eastern Allies overwhelmed by an Earthquake in passing a defile, 10gns.*
1834	338	*Vernan, on the Seine, 4gns.*
1835	42	*Church of St. Eustache, Paris, 8gns.*
1836	82	*Tivoli, 8gns.*
1837	32	*Atrano, near Amalfi, Kingdom of Naples.*
1837	75	*Pont Neuf, with part of l'Ile du Palais, Paris, 6gns., H. Robinson Esq., 56 Wigmore Street.*
1837	110	*The Italian Goatherd, 10gns.*
1837	165	*Genzano on the Lake of Nemi, 9gns., Geo. Morant Esq.*
1837	226	*Group of Peasants, Inhabitants of Cervera, a Village situated in the Appenines above Subiaco, Italy, 15gns.*
1838	22	*Remains of a Roman Aqueduct, which anciently supplied the City of Nismes - the lower tier of arches forms a bridge over the river Gard, and is hence called Pont du Gard - South of France.*
1838	61	*View in the Harbour of Boulogne.*
1838	204	*View at Sorrento, Kingdom of Naples.*
1838	243	*Entrance to the Town of Marino, near Frascati - Evening Peasants returning from their various Occupations.*
1838	248	*Part of Roma Vecchia, on the Ancient Road to Albano -the Alban Hills in the Distance.*
1838	260	*The Ancient Mole at Savona, a Sea Port on the Coast of Piedmont.*
1839	66	*Netley Abbey, near Southampton, 10gns.*
1839	121	*A Convent at Tivoli, now occupied by English Monks, 10gns.*
1840	49	*Environs of Rome, near the Porta San Lorenza.*
1840	66	*Farm Yard - Evening.*
1840	101	*Farm Yard - Morning.*
1840	191	*Castel Gondolfo, on the Lake of Albano.*
1840	199	*Convent of St. Benedict Subiaco, with a Fall of the Aniena.*
1841	26	*Looking up the Pass of Llanberis, near the Upper Lake, 20gns.*
1841	41	*Conway Castle, 8gns.*
1841	48	*Mill at Treffrier, 15gns.*
1841	62	*Coetmoor Mill on the River Ogwen, 10gns.*
1841	112	*Welsh Farm House, Caernarvon, 8gns.*
1841	161	*Penrhyn Castle, near Bangor, 15gns.*
1842	51	*Villa d'Este looking towards Rome.*
1843	103	*Ruins in the Campagna di Roma, situated a few miles from the Gates of Rome, 10gns.*
1843	227	*Falls at Dolymelynllyn near Dolgelly, North Wales, 10gns.*
1844	55	*A Street in Dartmouth, 8gns.*
1844	70	*La Grande Chartreuse, a Monastery situated in the Alps, near Grenoble, 10gns.*
1844	107	*A Street in Dartmouth, 20gns., Christ. Hughes Esq., Northampton, P.AU.*
1844	120	*Welch Dingle, 20gns.*
1844	128	*Teignmouth, Devonshire, 4gns.*
1844	152	*The Pool, Dartmouth, 6gns.*
1844	156	*Evening, 4gns.*
1844	250	*Scene near the Mouth of the River Dart, 4gns.*
1845	36	*Richmond Castle and Bridge, Yorkshire, 40 Pounds.*
1845	65	*Bolton Abbey, 10 Pounds.*
1845	135	*Papal Palace at Castel Gondolfo, on the Lake of Albano, 15 Pounds.*
1845	173	*View near Knaresborough, 8 Pounds.*
1846	104	*Near Lynmouth, North Devon, 8gns.*

BYRNE MISS

1806	86	*Fruit and Flowers.*
1807	11	*Flowers and fruit, Alex. Davison.*
1807	15	*Flowers and fruit, A. Davison.*
1807	57	*Flowers and fruit.*
1807	104	*Flowers.*
1807	176	*Flowers, A. Davison.*
1808	138	*The pumpkin of Peru, with fruit and flowers.*
1808	139	*Fruit and flowers, 40gns., Mr. Davenport.*
1808	312	*Fruit and flowers.*
1809	181	*Fruit and flowers.*
1810	18	*Fruit and Flowers.*
1810	19	*Flowers.*
1810	23	*Fruit and Flowers.*
1810	26	*Flowers and Bird's-nest.*
1810	27	*Fruit and Flowers.*
1810	134	*Flowers.*
1810	145	*Fruit and Flowers.*
1811	273	*Fruit and Flowers.*
1812	217	*Gooseberries.*
1812	303	*Flowers.*
1812	340	*The Orleans Plum.*
1820	153	*Fruit and Flowers. Painted for Mrs. Sandford Graham.*
1821	49	*Flowers, £21.0.0, G. Giles Esq.*

1821	52	*Flowers*, £36.15.0, G. Giles Esq.
1821	56	*Fruit and Flowers*, £21.0.0, G. Giles Esq.
1821	167	*The Tuscany Plum, Apricots and Cherries*, £4.4.0.
1822	44	*Fruit and Flowers.*
1822	73	*Tulips*, £7.7.0, Mr. Sedgwick.
1822	132	*Fruit and Flowers*, £21.0.0, Mrs. Hilton.
1822	136	*Fruit and Wild Flowers*, £15.15.0, Mr. Marshall.
1822	137	*Flowers*, £21.0.0, Mrs. Hilton.
1823	203	*The Deserted Garden.*
1824	169	*Wild Flowers.*
1823	256	*Strelitza Regina.*
1824	174	*Grapes.*
1824	178	*Fruit and Flowers.*
1825	167	*Grapes*, 30gns., Lord Carlisle.
1825	177	*Fruit and Flowers*, 25gns., Mrs. Hilton.
1825	186	*Fruit and Flowers.*
1826	26	*A Partridge*, 25gns.
1826	38	*Grapes and Roses*, 35gns.
1826	162	*Wild Fruits*, 10gns.
1826	172	*Nest and Wild Flowers*, 10gns.
1826	267	*Canaries*, 10gns.
1827	187	*Flowers*, 30gns.
1827	317	*Fruit and Flowers*, 7gns., Mr. Blake, Portland Place.
1827	346	*Fruit &c.*
1828	298	*Wild Flowers*, 8gns.
1828	321	*Fruit and Flowers*, 40gns.
1829	279	*Fruit*, 8gns., N. Duppa (?), No. 4 Old Square, Lincolns Inn.
1829	399	*Grapes*, Sold.
1830	122	*Flowers*, Sold.
1830	244	*Fruit*, 8gns., Mrs. Hilton.
1830	272	*Horse Chestnuts*, Sold.
1831	255	*Fruit and Flowers.*
1832	127	*Fruit*, 5gns.
1832	193	*Fruit*, 15gns.
1832	391	*Nest, and Wild Flowers*, 8gns., Mr. Allnutt, Clapham.
1833	365	*Goldfinch and Nest*, 10gns., Dowr. Countess of Morton, Barham House, Edgeware.
1833	375	*Bullfinch's Nest*, Sold.

BYRNE S

| 1829 | 167 | *Goodrich Castle, on the Wye*, 5gns., Mr. Morant, Sold at Mr. Byrne's house. |

CALLOW JOHN

1850	23	*Heavy Weather - Brig beating to windward - Ailsa Crag in the distance*, 18gns., George Gregory Esq., Hillesborough, near Ashford, Kent, Frame and glass £3.13.6 No.
1850	49	*Trading Bark making Signals off Dover*, 25gns., T. Schunck Esq., Manchester, Frame and glass £4.14.6 No.
1850	64	*Hastings - Fishing-boat taking Nets on Board*, 15gns., Frame and glass £2.12.6.
1850	77	*Wreck - St. Hilier's Bay, Jersey - Elizabeth Castle in the distance*, 30gns., Frame and glass £4.14.6.
1850	121	*Margate, from the Sands - Sunrise*, 25gns., Frame and glass £5.5.0.
1850	198	*Lowestoft, from the Harbour - breaking up Wrecks*, 12gns., Frame and glass £2.12.6.
1850	207	*Shipping, &c. on the Thames*, 18gns., M.A. Alexander, Frame and glass £3.13.6 No.
1850	218	*Indiaman Laying-to for a Pilot in the Downs*, 20gns., Joseph N. Goff Jun.(?), Hale House, Nr. Salisbury, Frame and glass £3.13.6.
1851	3	*Repairing a Vessel in Folkestone Harbour.*
1851	7	*Men-of-War leaving Portsmouth.*
1851	35	*Sunset at Sea - Frigate Signalling a Convoy, "Blow! swiftly blow, thou keel-compelling gale!" – Childe Harold.*
1851	60	*Elizabeth Castle, Jersey - Fort Regent and St. Heliers in the distance.*
1851	80	*The Victory, Portsmouth Harbour.*
1851	172	*Les Autelets, Island of Sark.*
1851	246	*On the Thames - Towing an Indiaman.*
1851	257	*The Reculvers - Collier Brigs beating up the River.*
1852	5	*Wrecks Ashore, near Whitby, Yorkshire*, 18G, Frame and glass £3.3.0.
1852	24	*Signalling a Pilot in the Downs*, 15G, Frame and glass £2.12.6.
1852	47	*Mont Orgueil Castle, Grouville Bay, Jersey*, 30G, Frame and glass £4.14.0.
1852	89	*Dismantling a Merchantman on the Thames, near Greenwich*, 30G, F.A.L. Kirchner, 18 Bridge Street, Boro'., Frame and glass £5.5.0, AU.
1852	92	*Entrance to Yarmouth Harbour, Norfolk - Towing out a Brig*, 25G, Frame and glass £4.14.6.
1852	150	*Steamer Weathering the Caskets in a Storm*, 22G, The Marquis of Lansdowne, Frame and glass £3.13.6 No.
1852	161	*Ship making for Ramsgate Harbour - Bad Weather coming on*, 25G, Frame and glass £4.14.6.
1852	199	*Bringing Fish Ashore - Lowestoffe, Suffolk*, 20G, Frame and glass £3.13.6.
1853	3	*Dymchurch, Romney Marsh.*
1853	37	*The Outward Bound at Gravesend.*
1853	45	*Emigrant Ship embarking Passengers in Plymouth Sound - Early Morning.*

1853	81	*Assisting a Disabled Ship into Yarmouth Harbour.*
1853	120	*Town and Castle of Hastings, from the Rocks.*
1853	147	*Stormy Weather at Sea.*
1853	152	*Brig making for Brixham, Torbay.*
1853	187	*Margate, from the Sands.*
1854	51	*Fleet at Spithead, July 28, 1853,* 28gns., Frame and glass £4.14.6.
1854	90	*St. Michael's Mount, Cornwall,* £ 40, ? Nevile(?), Llanelly, Carmarthenshire, Frame and glass £6.6.0.
1854	115	*Yarmouth, Isle of Wight,* 20gns., Frame and glass £3.3.0.
1854	117	*Pendennis Castle - Falmouth in the Distance,* 35gns., Mr. R. Barrett, Frame and glass £5.5.0.
1854	119	*Shipping on the Humber, at Hull,* 23gns., Frame and glass £3.13.6.
1854	171	*Teignmouth, South Devon,* 30gns., Frame and glass £4.14.6.
1854	186	*Long Ship Light-House, Land's End, from the Sea,* 30gns., Frame and glass £4.14.6.
1854	210	*Brig off Hastings,* 16gns., Frame and glass £2.2.0.
1855	55	*Ship Disabled at Anchor in the Medway,* 30gns., Frame and glass £4.14.6.
1855	84	*Distant View of Edinburgh from the Frith of Forth - Storm Clearing Off,* 80gns., Frame and glass £12.12.6.
1855	109	*Mounts Bay, Cornwall,* 18gns., Richard Till, Frame and glass £2.12.6.
1855	121	*Merchantman passing Dover - Fresh Breeze,* 30gns., Frame and glass £4.14.6.
1855	130	*Town and Harbour of Whitby, Yorkshire,* 35gns., Frame and glass £5.5.0.
1855	176	*Wreck on Shore - Sunset,* 25gns., Mrs. Craig, Dalkeith, Frame and glass £3.3.0, AUP.
1855	185	*Sidmouth, South Devon,* 30gns., A.F. Mackay, Liverpool, for P.M. Miller, Frame and glass £5.5.0.
1855	196	*Dartmouth, from the Castle,* 20gns., Richard Till, Frame and glass £3.3.0.

CALLOW W

1838	142	*Entrance to the Port of Marseilles.*
1838	184	*Castle and Village of Montrejean, near Bagneras de Bigorre, Pyrenees.*
1838	207	*Town of Vienne, on the Rhone.*
1838	208	*The Town of Avignon, on the Rhone.*
1838	236	*Montpelier, from the Aqueduct, South of France.*
1838	317	*Fort St. Jean, and Part of the Bay, Marseilles.*
1838	339	*The Old Bridge at Avignon, on the Rhone.*
1838	357	*View of the Vignemale, from the Lac du Gaube, Upper Pyrenees.*

1839	29	*The Town of Schaffhausen, Switzerland,* 15gns., Frame and glass 5gns.
1839	44	*Distant View of Heidelberg, with Icome River,* 15gns., Franz Baron v. Kreusser, 141 Regent Street.
1839	56	*Mayence, on the Rhine,* 15gns., Frame and glass 5gns.
1839	90	*Town of Lucerne, on the Lake of Quatre Cantons,* 50gns., Frame and glass 11gns.
1839	143	*Lake of Geneva, from the Church of St. Martin - Verry,* 50gns., Frame and glass 11gns.
1839	229	*Chrenbrustler and Coblentz, from the Nutha of Pfaffenany,* 25gns., Geo. Cooke Esq., Carr House, Doncaster.
1839	249	*On the Rhine at Rheuse - Castle of Marksburg in the Distance,* 15gns., Frame and glass 5gns.
1839	258	*Rheinfels and St. Goar, from the Castle of Katz, on the Rhine,* 25gns., Frame and glass 7gns.
1840	2	*Interior of the Port of Havre.*
1840	35	*View of Lyons, from near the Junction of the Rhone and Soane.*
1840	62	*Lowestoffe - Fishing Boats.*
1840	72	*Tain and Tournan on the Rhone.*
1840	77	*Castle and Town of Heidelberg, from the Terrace.*
1840	131	*Rheinfels and St. Goar, from St. Goarshausen, Rhine.*
1840	147	*The Allée Blanche, from Col de la Seigne, Savoy.*
1840	175	*Lowestoffe - Fishing Boats preparing to Launch.*
1841	14	*Oberwesel on the Rhine,* 25gns., Miss Walker, 23 Gt. George St.
1841	27	*Pizzo Falcone, from the Villa Reale, Naples,* 15gns., Mr. Rd. Sykes, West Ella, nr. Hull, Frame and glass 3gns.
1841	90	*Naples, from the Porta del Carmine,* 40gns., Frame and glass 9gns.
1841	94	*Gravedona, on the Lake of Como,* 25gns., E.M. Freer Esq., Leicester, Frame and glass 7gns. Art Union.
1841	101	*The Rialto at Venice,* 15gns., Hopkins Esq., Alsford, Hants., Frame and glass 3gns.
1841	109	*Mecaenas' Villa and Cascatella of Tivoli,* 15gns., Frame and glass 3gns.
1841	149	*Neapolitan Fishing Boat - Sunrise,* 8gns., H.R.H. Prince Albert, Frame and glass 2gns.
1841	156	*Venice, from the Riva degli Schiavoni,* 50gns., Frame and glass 9gns.
1842	1	*View of Como.*
1842	9	*Naples, from the Sea - Sun-rise.*
1842	47	*View from the Church Yard at Thun, Switzerland.*

1842	84	*On the Grand Canal, Venice.*
1842	132	*Chateau of Dieppe, Coast of Normandy.*
1842	165	*In the Bay of Naples.*
1842	230	*Granville, Coast of Normandy.*
1842	238	*Lake of Wallenstall, from Weser, Switzerland.*
1843	52	*Fishing Boat off Dieppe,* 25gns., John Martin Esq., 14 Berkeley Sq., Frame and glass £6.6.0.
1843	65	*Citadel at Plymouth - Mount Batten and Catwater in the Distance,* 30gns., Frame and glass £7.7.0.
1843	93	*Verona, from the Old Bridge,* 25gns., Lord C. Townshend, Frame and glass £6.6.0.
1843	177	*Hospital of the Grimsel, and Lake of Kleinsee, Switzerland,* 30gns., R. Ellison Esq., Warrens Hotel, Frame and glass £7.7.0.
1843	204	*Distant View of Exeter,* 40gns., Frame and glass £10.0.0.
1843	220	*Street in Bologna looking towards the Piazza,* 30gns., Lord C. Townshend, 9 South Audley Street, Frame and glass £7.7.0.
1843	239	*Torquay, looking over Torbay,* 25gns., Mrs. C? Wood, Rectory House, Sible Hedingham, per Mr. D. Colnaghi, Frame and glass £6.6.0, Prize of 30£ in the Art Union of London.
1843	259	*On the Grand Canal, Venice, from the Dogana,* 40gns., J. Wild Esq., Clapham Lodge, Clapham Common.
1844	1	*Durham,* 40gns., Frame and glass 8 gns.
1844	4	*Santa Salute and Dogana, Venice,* 30gns., Frame and glass 7 gns.
1844	38	*Jedburgh Abbey, Scotland,* 25gns., Frame and glass 5gns.
1844	65	*Entrance to the Port of Tréport, Coast of Normandy,* 25gns., T. Whittaker Esq., per Committee, Frame and glass £5.5.0, P.AU.
1844	125	*Wetterhorn and Upper Glacier, Grindelwald, Switzerland,* 30gns., Frame and glass £7.7.0.
1844	157	*Street in Bologna,* 30gns., Colonel Pennant, Frame and glass £7.7.0.
1844	159	*Ehrenbreitstein, on the Rhine,* 25gns., J. Staunton, Tidmington, Shipston on Stour, Frame and glass £5.5.0.
1844	173	*Edinburgh, from Salisbury Craggs,* 60gns., Frame and glass £13.13.0.
1845	16	*Cochem, on the Moselle,* 25gns., Frame and glass £3.3.0.
1845	24	*Lake of Geneva, from Vevay - Morning,* 30gns., Marquis of Lansdown, Frame and glass £6.6.0.
1845	49	*Old Houses at Trarbach, on the Moselle,* 30gns., Frame and glass £6.6.0.
1845	85	*House of the Francs Bateliers and Church of St. Nicholas, on the Canal of Ghent,* 60gns., William Betts Esq., Bevis Mount, Southampton, Frame and glass £10.10.0.
1845	90	*Vico - Bay of Naples,* 25gns., The Hon. Mrs. Stewart MacKenzie, Richmond, Frame and glass £3.3.0, P.AU. 25£.
1845	96	*Street in Calais,* 30gns., Col. Pennant, Frame and glass £6.6.0.
1845	114	*The Piazza Falcone, &c. from the Quai St. Lucia, at Naples,* 30gns., Frame and glass £6.6.0.
1845	193	*Entrance to the Port of Havre,* 40gns., Frame and glass £7.7.0.
1846	13	*Street in Rotterdam, with the Church of St. Lawrence,* 30gns., R. Abethell Esq., H.M. Dockyard, Pembroke, Frame and glass £7.7.0, AU.
1846	15	*Castle and Town of Trarbach, on the Moselle,* 30gns., Mathew Wise Esq., Leamington Spa, Warwickshire, Frame and glass £6.6.0.
1846	16	*Dutch Fishing Boat at Dort,* 25gns., Frame and glass £5.5.0.
1846	26	*Nieder Heimbach, on the Rhine - Bacharach in the distance,* 25gns., Frame and glass £5.5.0.
1846	33	*Cathedral of Antwerp, from the Rue du Port,* 30gns., Frame and glass £7.7.0.
1846	42	*Rotterdam,* 40gns., Frame and glass £8.8.0.
1846	92	*The Rialto, Venice,* 40gns., Frame and glass £8.8.0.
1846	133	*Old Bridge, at Avignon, on the Rhine,* 30gns., H.R.H. the Duchess of Cambridge for H.R.H. The Grand Duchess of Mecklenburg Strelitz, Frame and glass £7.7.0, AU. 25£.
1847	13	*Amsterdam - Dutch Boats running in - Stiff Breeze,* 30gns., B. Gosling, Frame and glass £6.6.0.
1847	63	*Piazza del Duomo, Trent, in the Tyrol,* 40gns., Frame and glass £7.7.0.
1847	115	*Casa Grimani, on the Grand Canal, Venice,* 30gns., Frame and glass £6.6.0.
1847	127	*Bridge of Sighs, Venice, looking towards the Grand Canal,* 30gns., Frame and glass £6.6.0.
1847	140	*Richmond Castle, Yorkshire,* 30gns., Frame and glass £6.6.0.
1847	147	*Melrose Abbey, from the Banks of the Tweed,* 25gns., Rev. W. Bryans, Bowness, Kendall, Frame and glass £5.5.0, AU. 25.
1847	167	*Scarborough - Sunrise,* 25gns., Frame and glass £5.5.0.
1847	192	*The Pfalz, with Caub and the Castle of Gutenfels, on the Rhine,* 40gns., Frame and glass £7.7.0.
1848	20	*Ilfracombe, from Capstone Hill, looking towards Hillsborough,* 15gns.
1848	23	*Distant View of Cologne, on the Rhine,* 30gns., Frame and glass £5.5.0.
1848	37	*Watermill on the West Lynn, Lynmouth, North Devon,* 25gns., Frame and glass £5.5.0.

1848	52	*The Neu-Münster, &c. Würzburg, Bavaria (during the Fair)*, 50gns., Frame and glass £8.8.0.
1848	108	*Lynmouth, from the Sea, North Devon*, 15gns.
1848	130	*The Rath-haus, on the Platz, at Lucerne*, 30gns., Frame and glass £6.6.0.
1848	178	*Cochem, on the Moselle*, 30gns., Frame and glass £6.6.0.
1848	210	*Glacier du Rhone and the Garlingstock - Pass of the Furca, Switzerland*, 30gns., Frame and glass £5.5.0.
1849	2	*Distant View of Monmouth.*
1849	52	*Distant View of Melrose Abbey.*
1849	64	*The Gronsel Merkt, Ghent.*
1849	92	*View of Ross, from the Wye.*
1849	98	*Llanthony Abbey, Monmouthshire.*
1849	109	*An Old Street in Frankfort.*
1849	132	*Goodrich Court - Distant View of the Castle.*
1849	137	*Lugano, on the Lake of Lugano.*
1849	157	*Abergavenny, from the Monmouth Road (with the Procession of the Cwmrygiddion).*
1849	166	*Paris - View of the Tuilleries, Pont Royale, &c..*
1849	185	*Old House, High-street, Tewkesbury.*
1849	197	*Maison des Francs Bâteliers, at Ghent.*
1849	199	*The Neustadt, Innsprück.*
1849	215	*Part of the Ruins of Ragland Castle.*
1849	223	*West Entrance to Tintern Abbey.*
1849	224	*Village of Cauterets, Hautes Pyrenees.*
1849	230	*Riva dei Schiavoni, Venice.*

CALLOW WILLIAM

1850	4	*Inverary Castle, the Seat of his Grace the Duke of Argyll*, 30gns., Frame and glass £5.5.0.
1850	12	*Lucerne, Lake of the Quatre Cantons*, 12gns.
1850	29	*Bay of Arran, from the Lamlash Road, looking towards Brodick and Goat-fell*, 20gns., Frame and glass £2.2.0.
1850	47	*Venice - On the Grand Canal - Palazzo Contarini, delle belle, Arti, &c., "There is a glorious city in the sea ..." Vide Rogers's Italy.* 50gns., Frame and glass £8.8.0.
1850	103	*The Tolbooth, Glasgow, from the Salt-Market*, 10gns., Frame and glass £2.2.0.
1850	106	*The Trongate, Glasgow, the Tron Church, &c.*, 25gns., Rev. Robert Morgan, Smeeth Paddock, Ashford, Kent, £26.16.0 with frame.
1850	126	*On the Chiaja, Naples*, 12gns.
1850	140	*Trent, Valley of the Adige*, 30gns., William Hobson Esq., 43 Harley St., Frame and glass £5.5.0 No.
1850	172	*The Piazzetta, Venice*, 8gns., Rob. Lang Esq., Frame and glass £1.12.0 Not fit.
1850	193	*Old House in the Neustadt, Innsprück*, 6gns., Frame and glass £1.1.0.
1850	202	*Weymouth, Dorsetshire - Bill of Portland in the distance*, 15gns., Frame and glass £2.2.0.
1850	209	*Tours - on the Loire*, 15gns., Frame and glass £2.2.0.
1850	220	*View of Inverary, on Loch Fyne*, 20gns., Frame and glass £2.2.0.
1850	221	*All Saints' Church, Hereford*, 25gns.
1850	227	*Street in Calais, looking toward the Grand Place*, 35gns., J. Noble Esq., 15 Upper Bedford Place, Frame and glass £6.6.0.
1850	245	*Old Gateway, Great Malvern, Worcestershire*, 15gns., Frame and glass £2.2.0.
1850	271	*The Butter Cross, Winchester*, 10gns., Henry Newdigate, Dartmouth House, Blackheath, Frame and glass £2.2.0 Yes.
1850	273	*Interior of the Bishop's Court, Liege*, 6gns., Edward Hurt Esq., 34 Dorset Sq., Frame and glass £1.1.0 Yes.
1850	301	*Dutch Fishing Boats, Amsterdam*, 6gns., Frame and glass £1.1.0.
1850	342	*Water Mill at Lee, North Devon*, 6gns., S. Cowley Esq., 1 Park Crescent, Portland Place, Frame and glass £1.1.0 No.
1851	16	*Worcester Cathedral - from the Quay.*
1851	32	*The Town and Fortress of Bellinzona, on the Ticino.*
1851	37	*Tower on the Vrydag's Markt, at Ghent.*
1851	50	*Cauterêts, Pyrenees.*
1851	75	*Durham Cathedral, from the River.*
1851	101	*Castle and Village of Angera, from Arona, Lago Maggiore.*
1851	105	*On the Rokin Canal, Amsterdam.*
1851	134	*The Weighing House at Amsterdam.*
1851	147	*Rue St. Honoré, Paris, looking towards the Palais Royal.*
1851	177	*Distant View of Lancaster from the Meadows.*
1851	206	*The Rialto, Venice - from the Fish Market.*
1851	211	*The Piazzetta, Venice, looking towards San Giorgio.*
1851	216	*The Market House, Ross, on the Wye.*
1851	245	*Remains of St. Mary's Priory, Monmouth.*
1851	262	*The Blackfriars, Hereford.*
1851	286	*The Trongate, Glasgow, from the corner of the High Street.*
1851	306	*Il Ponte della Paglia Riva dei Schiavoni, Venice.*
1851	309	*The Pantiles, Tunbridge Wells - Morning.*
1851	314	*Blois, on the Loire - Evening.*
1851	317	*Old Houses at Berncastle on the Moselle.*
1852	7	*Palazzo Barbarigo (the Residence of Titian), Venice*, 15G, Abel Peyton Esq., Edgbaston, nr. Birmingham.

1852	22	*Looking into the Grand Place at Lille - from the Place du Théatre*, 50G, Augustus Mordan Esq., 17 New Finchley Rd., Hampstead, Frame and glass £5.5.0.
1852	52	*Distant View of Ross, on the Wye*, 20G, Frame and glass £3.3.0.
1852	69	*Grand Entrance to Hurstmonceaux Castle, Sussex*, 25G, Mrs. Hardwick, 21 Cavendish Sq., Frame and glass £4.4.0 Yes.
1852	79	*Abergavenny, Monmouthshire - The Holy Mountain in the distance*, 20G, Frame and glass £3.3.0.
1852	113	*Distant View of Naples - Early Morning*, 35G, Her Majesty the Queen, Frame and glass £5.5.0.
1852	131	*Château d'Amboise, on the Loire*, 15G, Rev. C. Upham Barry, Charlemont, Ryde, I. of W., Frame and glass £2.12.6.
1852	159	*The Belfry at Ghent, from the Marché au Grain*, 18G, A. Morison Esq., Frame and glass £2.12.6.
1852	162	*The Stone Bow, High Street, Lincoln*, 30G, Colonel Sibthorp, Frame and glass £4.4.0 Yes.
1852	177	*Part of the Cathedral of Abbeville*, 10G, The Hon. Captain Howard, R.N., M.P., 86 Eaton Place, Frame and glass £1.11.6 No.
1852	185	*Castle and Village of Mont-Richard on the Cher, Department Loire-et-Cher*, 35G, Lt. John Middleton R.N., 93 Gt. Portland Street, Portland Place, Frame and glass £5.5.0 Yes.
1852	209	*Les Halles, Grande Place, Bruges*, 7G, J. & W. Vokins, Frame and glass £1.1.0.
1852	210	*Place d'Armes, Calais*, Sold.
1852	217	*Riva dei Schiavoni, Venice*, 8G, J. Anderson Rose(?) Esq.
1852	219	*Church of the Santa Salute, Venice - from the Belle Arti*, 15G, Mrs. Austen, 6 Montague Place.
1852	233	*Maison des Francs Bâteliers, Ghent*, Sold.
1852	241	*Remains of Nether Hall, Essex*, 6G, N.C. Smith(?), Frame and glass £1.11.6.
1852	246	*Interior of the Port of Havre*, 15G, R. Phillips Grey Esq., Chancery Lane, Manchester, Frame and glass £2.12.6.
1852	262	*The Guildhall, High Street, Exeter*, 6G, C. Clifford Esq., 30 Piccadilly, Frame and glass £1.11.6.
1852	269	*Water Mill at Lee, near Ilfracombe*, 15G, Robert Philips Grey Esq., Chancery Lane, Manchester, Frame and glass £2.12.6.
1852	271	*Chapel of St. Jean at Orleans*, 6G, De Gex(?), 4 Stour(?) Bd., Lincolns Inn, Frame and glass £1.11.6.
1852	291	*Chapel of the Holy Blood, Bruges*, 12, T. Toller, Frame and glass £2.2.0.
1853	10	*The Burg Strasse, Hanover.*
1853	28	*The Rialto, Venice.*
1853	74	*Church of San Giovanni and San Paolo, with the Monument of Colleone.*
1853	83	*Cathedral of Abbeville, from the Grand Place.*
1853	88	*Mont Blanc, from Chamouni.*
1853	97	*The Niewe Kerk, on the Damrak, Amsterdam.*
1853	103	*The High Street, Lincoln.*
1853	126	*Interior of the Court of the Wartburg. The place of Luther's captivity in 1521.*
1853	182	*The Market Place, Eisenach.*
1853	205	*The Hotel de Ville, Bruges.*
1853	206	*At Malines, near the Fish Market.*
1853	221	*The Market Place, Padua.*
1853	227	*Entrance to the Court of the Ducal Palace, Venice.*
1853	232	*The Pantiles, Tunbridge Wells.*
1853	241	*The Hotel de Ville, Ghent.*
1853	261	*Interior of the Port of Marseilles.*
1853	277	*St. Mary's Hall, Coventry.*
1853	278	*Castle of Hammerstein, from Andernach.*
1853	286	*Frankfort-on-the-Maine.*
1853	288	*Riva dei Schiavoni, Venice.*
1853	298	*On the Grand Canal, Venice.*
1854	3	*Gateway of Battle Abbey, Sussex*, 18gns., Honble. Lady Webster, Court Lodge, Robertsbridge, With frame £2.12.6.
1854	9	*Basle, Switzerland, from the Bridge*, 35gns., Richard Fothergill, Abernant House, Aberdare, near Cardiff, With frame £5.5.0.
1854	13	*On the Grand Canal, Venice, looking towards the Foscari Palace*, Sold.
1854	43	*Eastgate Street, Chester - Autumnal Evening*, 35gns., The Rev. C.J. Sale, Frame and glass £5.5.0.
1854	45	*Oberwesel, on the Rhine, with the Castle of Schomberg*, 25gns., George J. Barker, Wolverhampton, Frame and glass £3.13.6.
1854	75	*Venice*, Sold.
1854	77	*La Place d'Armes, Lille*, 25gns., George J. Barker, Wolverhampton, Frame and glass £4.4.0.
1854	96	*Dresden, from the Gardens of the Japanese Palace*, 12gns., Frame and glass £1.11.6.
1854	120	*The Rath-Haus on the Market-Place, Leipzig*, 40gns., William Kay, 36 Hill St., Berkeley Sq., Frame and glass £5.5.0.
1854	122	*Orleans*, 15gns., Frame and glass £2.2.0.
1854	152	*The Ca, d'Oro de Venise, from the foot of the Rialto*, Sold.
1854	167	*The Castle of Katz, from St. Goar, on the Rhine*, 20gns., Frame and glass £2.2.0.

1854	211	*Heidelberg, from above the Bridge*, 18gns., Frame and glass £2.2.0.
1854	214	*Old Houses in Northgate-street, Chester*, 20gns., Tomlatin Esq., No. 8 Adam St., Frame and glass £3.13.6.
1854	215	*Tain and Tournon, on the Rhone*, 17gns., Frame and glass £2.2.0.
1854	255	*From the Ponte della Pieta, Venice*, 15gns., A.M. Campbell, 4 Trafalgar Square, Frame and glass £2.12.6.
1854	267	*Church of San Pietro, Como*, Sold.
1854	275	*The Breitwig, at Magdeburg*, 12gns., Whitmore Esq., 2 Wilton Crescent, Frame and glass £1.11.6.
1854	278	*From the Foscari Palace, Venice*, 8gns., Herbert Esq., Frame and glass £1.1.0.
1854	285	*Neapolitan Fishing Boat*, 8gns., Revd. John Goring, Wiston Park, Steyning, Frame and glass £1.1.0.
1854	327	*The Fish Market, Ghent*, Sold.
1854	352	*The Dom-Platz, Frankfort*, Sold.
1855	6	*On the Grande Canal, from the Leone Bianco, Venice*, Sold.
1855	36	*Church of St. Pierre, Caen*, Sold.
1855	43	*Mayenz, on the Rhine*, 20gns., Frame and glass £2.12.6.
1855	44	*The Dom-Kirche at Wurzburg from the Bridge, during the Fair*, 100gns., Frame and glass £9.9.0.
1855	56	*The Old Feudal Town of Oberwesel, on the Rhine*, Sold.
1855	103	*Castel Nuovo, from the Mola, Naples*, 12gns., Richard Till, Clapham, Frame and glass £2.2.0.
1855	105	*Lutheran Church at Bacarach, on the Rhine*, 18gns., Decimus Burton Esq.
1855	132	*On the Place du Theatre, Lille*, Sold.
1855	157	*San Giorgio, Venice*, 16gns., Rev. Benjn. Winthrop, Clifton Park, nr. Bristol.
1855	162	*Castle of St. Angelo, Rome*, 12gns., H. Miles(?), Dawnfield, Frame £2.2.0 included.
1855	170	*Canal at Ghent, with the Church of St. Nicholas*, 25gns., Hanson Esq., Epsom, Frame and glass £3.3.0.
1855	179	*Crossing the Rialto, Venice*, 15gns., J.J. Ekman, Sweden, care of Mr. S. A. Broad at Messrs. Fred Huth & Co., Moorgate, Frame and glass £2.12.6.
1855	187	*Pallazzo Foscari, from the Belle Arti, Venice*, Sold.
1855	205	*The Piazza at Padua*, 30gns., Jones Loyd, 77 Eaton Sqre., Frame and glass £3.13.6.
1855	215	*A Street in Verona*, 50gns., Frame and glass £5.5.0.
1855	224	*The Belfry at Evreux*, 25gns., James B. Tomalin Esq., Adam St., Adelphi, Frame and glass £3.3.0.
1855	228	*Corso Francese, Milan*, Sold.

1855	258	*Evening at Sutton Valance*, 10gns., Frame and glass £1.11.6.
1855	259	*Doune Castle*, 9gns., R. Ellison Esq., Frame and glass £1.11.6.
1855	265	*Eton College - Sunset*, 10gns., R. Ellison Esq., Frame and glass £1.11.6.
1855	269	*Old House in Ghent*, Sold.
1855	273	*The Market Cross at Salisbury*, 8gns., H. Barnard, 69 Portland Place, Frame and glass £1.1.0.
1855	276	*Distant View of Nice*, 8gns., John Moxon, 8 Hanover Terrace, Regents Park, Frame and glass £1.11.6.
1855	291	*Distant View of Tewksbury*, 10gns.
1855	306	*Tell's Chapel, Lake of the Four Cantons*, 8gns., Charles Du Cane, Esq., Braxted Park, Witham, Essex or 64 Lowndes Square, Frame and glass £1.11.6.
1855	313	*Foregate Street, outside the Walls, Chester*, Sold.

CARPENTER MRS W

1819	156	*Sketch of a Neapolitan Woman.*

CATTERMOLE G

1822	15	*View of the West Front of Wells Cathedral.*
1829	196	*Saul - a Sketch.*
1829	206	*Morning.*
1829	373	*Interior - Composition*, Sold.
1829	398	*Composition*, Sold.
1830	4	*"– comrades free Carousing after victory."* Sold.
1830	41	*A Sketch*, Sold.
1830	56	*A Study*, Sold.
1830	99	*Merchant of Venice, "Portia. – 'Come, merchant have you any thing to say?' . . ." Act IV. Sc. 1.* Sold.
1830	118	*The Rural Guests*, Sold.
1830	155	*Composition*, Sold.
1830	164	*Interior of Fielding's House, at West Stour, Dorset*, Sold.
1830	323	*The Captain's Story*, Sold.
1831	4	*Composition.*
1831	49	*The Captives.*
1831	221	*The Castle Surprised.*
1831	308	*The Impenitent.*
1831	407	*View in Haddon Hall, Derbyshire.*
1831	413	*"For his bride a soldier sought her, And a winning tongue had he."*
1831	415	*The Guard Room.*
1832	29	*View in Miller's Dale, Derbyshire*, Sold.
1832	247	*Interior - Composition, "There will he pause till all is done, And hear the prayer, but utter none." Byron.* 40gns., Chas. Matthews Junr. Esq., To be delivered by J.E. at No. 7 Furnivals Inn.

1832	285	*Scene from King John*, 10gns., Rev. E. Coleridge.
1832	290	*Room in the Warren House, Chingford*, Sold.
1832	309	*Interior at Haddon Hall, Derbyshire*, Sold.
1833	211	*A Sketch*, Sold.
1834	151	*After the Sortie*, Sold, E.M. Fitzgerald Esq., Parliament Place.
1835	52	*Study of Armour*, 25gns., Mr. D. Colnaghi.
1835	152	*The Abbot*, 70gns., N. Wilkinson.
1835	163	*Gallery in Naworth Castle*, 30gns., Mr. D. Colnaghi.
1835	260	*The Bridal Toilet*, Sold.
1836	125	*Murder of the Bishop of Liege*, "The butcher rose, seized his weapon and stealing round behind De la Marck's chair, stood with it uplifted in his bare and sinewy arms." Scene from Quentin Durward. Sold.
1836	254	*New Hall, Warwickshire*, Sold.
1837	120	*The Horn of Egremont Castle*, "And while thus in open day Once he sate, as old books say . . ." Wordsworth. Sold.
1837	162	*Pilgrims at a Church Door*, Sold.
1838	132	*The Minstrel*.
1838	165	*Scene from the Life of Salvator Rosa*.
1838	272	*The Armourer relating the Story of the Sword*.
1838	288	*Macbeth*.
1838	300	*Hawking - a Sketch*.
1838	338	*The Castle Defended*.
1838	340	*Scene from Chap. I. of Woodstock*.
1838	356	*Belted Wills Oratory - Naworth Castle*.
1839	70	*Sir Walter Raleigh witnessing the Execution of the Earl of Essex in the Tower*, Sold.
1839	317	*Wanderers Entertained*, 100gns., S.G. Moon.
1839	334	*The Taking of Wardour Castle*, Sold, J. Hewitt Esq.
1839	340	*The Portrait*, Sold, J. Hewett Esq.
1840	272	*The Refectory*.
1842	130	*The Castle Chapel*.
1842	175	*Hospitality to the Poor*.
1843	123	*Scene from Peveril of the Peak*, "The King, on his visit to the armory at the Tower, recognises his old friend, Major Coleby." Sold.
1843	138	*Hamilton of Bothwellhaugh*, Sold, Revd. C. Hare-Townshend, 9 Gt. Cumberland St., Portman Square.
1843	143	*The Chapter House*, Sold, H. Burton Esq., 150 Aldersgate Street.
1843	148	*Father Thomas takes in a suspicious Note*, Sold.
1843	162	*The Syren's Turret*, Sold, H. Burton Esq., 150 Aldersgate Street.
1843	172	*The Faithful Minstrel*, Sold.
1843	333	*After the Second Battle of Newbury*, "So the king lay that night at Donnington Castle, and all the army about him." – Clarendon. Sold.
1843	345	*Watermill at Rowsley, Derbyshire*, Sold, H. Burton Esq., 150 Aldersgate Street.
1844	81	*The Contest for the Bridge*, "And now no day passed without action, and very sharp skirmishes." Clarendon, Hist. Civil Wars. 200gns., J. Flamank, Tavistock, Devon, P.AU.
1844	135	*The Refectory - Grace*, Sold.
1844	150	*Old Porch*, Sold.
1844	303	*Rook-shooting*, Sold.
1845	263	*On the Yarrow*, Sold.
1845	282	*Scene from The Monastery*, Sold.
1845	294	*Ride!*, Sold.
1845	300	*Benvenuto Cellini Defending the Castle of St. Angelo*, Sold.
1845	330	*The Visit to the Monastery*, Sold.
1846	66	*The Unwelcomed Return*, 180gns. Sold.
1846	114	*Staircase at Naworth*, 25gns., Mr. Rayner(?).
1846	267	*Amy Robsart*, Sold.
1846	291	*Conspirators*, Sold.
1846	301	*The Hall*, 40gns., T.G. Sambrooke Esq.
1848	143	*Landscape*, Sold.
1848	151	*The Minstrel in Danger*, Sold.
1848	259	*Refectory - Grace*, Sold.
1848	272	*The Youthful Champion departing to the Combat*, Sold.
1848	317	*The Silent Warning*, Sold, Miss Hanbury, 60 Lombard St., Frame and glass 15 7/8 x 11 6/8.
1848	331	*Scene from the story of Sintram*, – "Biorn was sitting at a huge table, with many flagons and glasses before him, and suits of armour ranged on either side of him . . ." Sold.
1848	344	*Watermill in Kinross-shire*, Sold, Foord?
1849	117	*Landscape and Castle*.
1849	136	*The Cartland Crags, Lanarkshire*.
1849	189	*Interior - Preparing the Banquet*.
1849	242	*The Chapel*.
1849	253	*The Call at the Monastery*.
1849	264	*On the Esk, near Roslyn*.
1849	283	*The Exhortation*.
1849	327	*Mill near Glamis*.
1849	328	*The Goldsmith*.
1849	337	*Mill Pool, Rowsley, Derbyshire*.
1850	285	*I. The Offence. 2. The Challenge. 3. The Sword.*, Sold.
1850	294	*Three Scenes from Macbeth, 1. Act I. Scene III. "Mac. 'Speak, I charge you.'" 2. Murder of Duncan. 3. Act IV. Scene I. "Mac.'Ay, now I see 'tis true . . .'"* Sold.

1850	299	*1. The Departure. 2. The Combat. 3. The Issue,* Sold.
1850	318	*Scene with Macbeth and the Murderers of Banquo, "Mac. – 'So is he mine; and in such bloody distance, That every minute of his being thrusts Against my near'st of life.'"* Sold.
1850	330	*Scene from Woodstock – Sir Henry Lee and his Daughter joining in the Church Service at the Keeper's Lodge,* Sold.
1850	344	*Sketch,* Sold, R. Ellison.
1850	377	*Interior, with Monks Reading,* Sold.

CATTERMOLE R

1814	121	*View in Westminster Abbey, looking towards Henry the Seventh's Chapel from the Chapel of Erasmus.*
1814	276	*View in the North Aisle, Westminster Abbey.*
1815	251	*Vespers,* £8.8.0, J. Allnutt Esq.
1815	255	*Chapel in a Cathedral, preparing to perform Mass,* £8.8.0, J. Gwilt Esq.
1818	32	*Queen Mary's State Bedchamber, Hampton Court.*
1818	39	*Cupola Room, Kensington Palace.*
1823L	140	*Preparing for Mass,* J. Gwilt, esq.

CAWSE J

1816	61	*The Old Man and his Sons. Vide AEsop's Fables,* £21.0.0, Mr. Bush, Bristol.
1816	71	*The Chemist.*
1816	113	*The old Horse.*
1816	145	*The Astrologer, "That deals in destinies, dark councils ..." Hudibras, Part II, Cant. iii.*
1817	111	*The Goose and Golden Eggs. See Esop's Fables.*
1817	131	*A Scene in the Play of the Alchymist, by Ben Jonson, Act IV. Scene I. "Subtle in his study - Enter Sir Epicure Mammon and Face ..."*
1818	134	*Sir John Falstaff examining his Recruits, "Falstaff. 'What trade art thou?' ..." Second Part of King Henry the Fourth.* £52.10.0, W. Haldimand Esq.
1818	144	*The Discovery of the concealed Letter of King Charles the First by Oliver Cromwell and General Ireton. (Memoirs of the Protectorate House of Cromwell, by the Rev. Mark Noble, F. A S.).*
1818	145	*Sidrophel, "He deals in destiny's dark counsels ..." Hudibras, Canto III.*
1819	37	*The Quarrel between Pistol, Dol Tearsheet and Falstaff, "Falstaff. 'Give me my rapier, boy.' ..." Vide Henry IV. Part 2d, Act 2d, Scene 4th.*
1819	47	*Pistol announcing the Death of King Henry IV to Falstaff in the Garden of Justice Shallow, "Pistol. 'Sir John, thy tender lambkin now is king. – Harry the Fifth's the man.'" Vide Henry IV. Part 2d, Act 5th, Scene 3d.*

1819	51	*The Pedlar.*
1819	82	*Falstaff acting the King. "Falstaff. 'Shall I? Content. This chair shall be my state, this dagger my sceptre, and this cushion my crown.'" Vide Henry IV Part 1st, Act 2d, Scene 4th.*
1819	105	*Jack Cade and his Rabble condemning the Clerk of Chatham, "Cade. 'Dost thou use to write thy name? or hast thou a mark ...'" Vide Henry VI. Part 2d, Act 4th, Scene 2d.*
1819	139	*Gadshill and the Carriers, "Gadshill. 'I pray thee, lend me thy lanthorn to see my gelding in the stable ...'" Vide Henry IV. Part 1st. Act 2d, Scene 1st.*

CHALON H B

1815	60	*A group of Game, with Sporting Dogs.*

CHALON J J

1806	22	*A Sluice, a scene in a hilly country.*
1806	24	*Hardway, near Gosport, Hants.*
1806	54	*Soldiers on a March.*
1806	78	*Study from Nature.*
1806	217	*Carisbrook Castle and Church, seen from Newport Isle of Wight.*
1807	8	*A scene near Great Marlow.*
1807	81	*Entrance to a farm at Bisham, Berks.*
1807	94	*Swiss peasants surprised by a bear.*
1807	210	*The road at Maidenham, Bucks.*
1807	304	*Windsor.*
1808	24	*The Coldwell rocks, on the banks of the Rye.*
1808	57	*Chepstow Castle on the Wye, seen from Piersfield.*
1808	62	*Scene on the Wye, near Goodrich.*
1808	70	*A barn at Great Marlow, Bucks.*
1808	268	*Morning,* Mr. Roby.
1808	281	*A street in Ross, Herefordshire.*
1808	298	*Thread my needle.*
1808	318	*Eaton College.*
1808	320	*Cottage in the village of Landago, on the banks of the Wye.*
1809	62	*Tintern Abbey - evening.*
1809	123	*Scene on the Thames,* 10gns., Geo. Hibbert Esq.
1809	140	*Fire at Drury-lane theatre, seen from Westminster bridge.*
1809	162	*A forge at Tintern.*
1809	163	*A study.*
1809	165	*A study.*
1809	236	*Marlow Bridge.*
1809	242	*Buildings in the neighbourhood of Tintern Abbey.*
1809	258	*Scene on the Thames, near Bisham Abbey.*

1809	278	*Boys angling*, 20gns., Lord Essex.
1809	285	*Lace-makers, scene near Marlow*, Mr. Roby.
1809	291	*Evening effect on the Thames, near Marlow, Bucks.*
1810	10	*Birds-nesting.*
1810	24	*See-saw*, 15gns., F. Freeling Esq.
1810	37	*Evening, "As when some shepherd, on the mountain's brow . . ." Vide Thompson's Liberty.*
1810	39	*A River Scene.*
1810	47	*A Corn Rick.*
1810	49	*Cottages at Great Marlow, Bucks.*
1810	129	*The Bathing Place.*
1810	146	*Scene on the River Wye.*
1810	157	*A Bridge, near Great Marlow.*
1810	203	*Cottages near Great Marlow.*
1810	208	*A Study.*
1811	101	*An Evening Walk.*
1811	116	*New Lock Ferry on the River Thames.*
1811	219	*Rural Employment.*
1811	227	*Angling - A Scene on the Thames.*
1811	254	*A Road through a Wood.*
1811	277	*Preparing Willows for Basket Making.*
1811	301	*Banks of a River.*
1811	324	*Idle Fellows.*
1812	21	*Retirement.*
1812	97	*An Italian Sea Port.*
1812	144	*Evening.*
1812	150	*Morning.*
1812	167	*A River Scene.*

CHAMBERS G

1834	14	*At Lingfield, Sussex*, 12gns., Mr. D. T. White, Oxford St., corner of Regent St..
1834	31	*A Collier in Stays, Tynemouth Castle*, 14gns., Griffith Esq., Norwood.
1834	41	*A Kentish Apple Boat - Passing Shower - River Thames*, 25gns.
1834	115	*South Pier, Sunderland*, 20gns.
1834	194	*The Tower - Boats leaving Billingsgate*, 25gns., Mr. Domett, Balham Hill.
1834	209	*Peter Boats, Sea Reach*, Sold.
1834	245	*Starths, Yorkshire*, Sold.
1834	381	*Paying off the Maidstone Frigate, Portsmouth Harbour, sketched in 1832*, 10gns.
1835	57	*Purl Boat and Barges on the Thames - Morning*, 12gns.
1835	67	*Greenwich, from Blackwall Reach*, 15gns.
1835	194	*Taking a Pilot on Board off the Port of Whitby*, 30gns.
1835	220	*Ship Breaking, Rotherhithe*, 15gns.
1835	291	*A Ferry Boat going into Portsmouth, passing Blockhouse Fort*, 20gns., Michael Hodgson Esq., Pall Mall.
1835	293	*Fishing Smack running foul of a Peter Boat*, 18gns.
1836	3	*Running into Harbour*, 18gns., Frame and glass £4.4.0.
1836	22	*Colliers getting under Way*, 10gns., Frame and glass £2.10.0.
1836	36	*Pleasure Boats, Southend*, 20gns., Frame and glass £4.12.0.
1836	59	*Peter Boats, Sheerness*, 20gns., Frame and glass £4.4.0.
1836	204	*Swansea Harbour*, 10gns., Frame and glass £3.12.0.
1837	29	*Rotterdam.*
1837	119	*Ship Breaking, Devonport*, 12gns., Frame and glass £4.0.0.
1837	143	*Saw-Mill, on the Canal near Rotterdam*, 15gns., Frame and glass £5.0.0.
1837	164	*Sketch from Nature*, 5gns., Henry Ashlin Esq., Edward Street, Hampstead Road.
1837	204	*Dutch Schuits going out of Port*, 15gns., Frame and glass £6.0.0.
1837	230	*The Victory breaking the Line, Battle of Trafalgar*, 30gns., Chs. Spencer Ricketts Esq., 2 Hyde Park Terrace, Cumberland Gate.
1838	75	*West Indiaman and Collier Stranded - Sailors clearing away the Wreck.*
1838	114	*The Situation of H.M. Ship Victory, at the time when Lord Nelson was Killed, Battle of Trafalgar.*
1838	254	*Fishing Smacks getting their Anchors.*
1838	261	*Whitby Rocks - Study from Nature.*
1839	2	*Clifton, from Rownam Ferry*, 20gns., Frame and glass £5.0.0.
1839	109	*Marines going off to an Indiaman - Northfleet*, 18gns., Frame and glass £5.0.0.
1839	195	*Swansea Castle - Sketch from Nature*, 7gns., Frame and glass £2.10.0.
1839	225	*Grace Darling and her Father going out to the Wreck*, 10gns., Frame and glass £3.0.0.
1839	300	*Delft Haven, Holland*, 15gns., Price Edwards Esq., Weston, Nr. Bath, Frame and glass £3.10.0.
1839	324	*Dutch Passage Boat crossing the Maas, Holland*, 10gns., Frame and glass £3.3.0.
1839	337	*Broad Stairs - Anchor-Boat going off*, 25gns., W. Strachan Esq., 34 Hill Street.
1840	44	*Greenlandman bearing up to leave the Ice – full Ship.*
1840	79	*Indiaman laying-to for Passengers, Dover Roads.*
1840	90	*German Reapers leaving Amsterdam for the different Towns in Waterland - Evening.*

1840	179	*Dutch River Scene, near Dort.*
1840	258	*Dover Pilot-Lugger returning to the Harbour.*

CHANTREY F L

1815	75*	*Model of a Monument to the Memory of Mary Anne Johnes, who died in the bloom of youth after a few days illness. She was the only child of Thomas and Jane Johnes, who are re-presented attending her in her dying moments. The marble group from this model, which may be seen at Mr. Chantrey's will be placed in the Church of Hafod, in Cardiganshire.*

CHILDE E

1819	52	*The Alehouse Door - Horses Baiting,* £21.0.0, G. Giles Esq., Enfield.
1819	80	*The Farrier's Shop.*
1820	43	*Hastings, from the West Cliff.*
1820	89	*View on Barnes Common.*
1820	110	*Fore-Street, Lambeth.*

CHISHOLM A

1829	221	*An Old Woman,* 10gns.
1829	230	*Reaper's Children,* 10gns., Mr. Smart.
1829	241	*An Illicit Still- Proving the Whiskey,* 17gns., Frame and glass £3.3.0.
1829	302	*Maternal Affection,* Sold.
1830	265	*China Mender,* 25gns., Captain Wm. Cripps(?), 24 Bury Street, St. James.
1831	44	*The Butterfly.*
1831	280	*Dragging for Sand Eels.*
1832	14	*What's your Will?, "The girl sat down her water pitcher, hardly understanding what was said to her . . ." Vide Old Mortality.* Sold.
1832	32	*Selling Crockery,* 13gns.
1832	252	*Chair Mender,* 8gns.
1832	359	*King James I, and his Jeweller, George Heriot, "His sense of dignity giving way to the full feeling of triumph, he threw himself into his easy chair, and laughed with unconstrained violence till he lost his breath, and the tears ran plentifully down his cheeks as he strove to recover it . . ." Vide Fortunes of Nigel.* 30gns.
1833	86	*A Fisherman looking for the Return,* 10gns.
1833	231	*Mary Queen of Scots Surrendering herself to the Confederated Lords at Carberry Hill, "Mary surrendered herself upon promise of respect and kind treatment . . ."* Sold.
1833	234	*Scotch Milk Boy,* 10gns.
1833	261	*Hotspur before Henry IV, "My Liege I did deny no prisoners." Act I. Scene 3.* Sold.
1834	206	*Conversation at a Well,* Sold.
1834	241	*A Covenanter,* Sold.
1835	195	*The Widow's Mite,* 20gns.

1836	48	*Scene from Burns, "Luath – the Twa Dogs. 'That Merry day the year begins' . . ."* 35gns., B.B. King, Monument Yard.
1836	206	*Scene from the Antiquary, "'No, wretched beldame,' exclaimed Oldbuck, who could keep silence no longer, 'they drank the poison that you and your wicked mistress prepared for them.' . . ." Vol. 6.* 20gns.
1836	291	*Peasant Girl of Shetland,* 5gns., Lady Rolle.
1837	216	*Lady Jane Grey going to Execution, "Lord Dudley was the first that suffered and while the Lady Jane was conducting to the place of execution, the officers of the Tower met her, bearing along the headless body of her husband . . ." Vide Goldsmith's History of England.* 40gns.
1837	238	*Interior of a Shetland Cottage, "Lo! at the couch where infant beauty sleeps; Her silent watch the mournful mother keeps." Vide Campbell's Pleasures of Hope.* 15gns., W.J. Prentice Esq., Newgate Market.
1838	91	*Leonar*
1839	108	*The Fair Maid of Perth listening to the Instructions of the Carthusian Monk, at the foot of the Hill of Cannoul,* 20gns.
1840	6	*Girl and Child.*
1840	29	*Interior of a Cottage in the neighbourhood of Lerwick, Shetland.*
1840	190	*The Prisoner.*
1840	251	*David Deans, "The sun sent its rays through a small window at the old man's back (shining motley through the 'reek' to use the expression of a bard of that time and country), illuminated the grey hairs of the old man, and the sacred page which he studied." – Vide Heart of Midlothian, p.296.*
1841	132	*Selling Crockery,* 10gns.
1842	234	*New Year's Eve - Scene from Burn's Twa Dogs, "The cantie auld folks crakin crouse, The young ones ranting through the house . . ."*
1843	248	*Charles the First on his way to Carisbrook Castle, "As he passed through the town of Newport, a gentlewoman of that place presented him with a damask rose and her blessing, which pleased the king very much." Vide Herbert's Memoir of Charles the First.* 15 Pounds.
1844	79	*Queen Elizabeth Knighting Admiral Drake – Her Majesty dined on board his ship at Deptford, and as she was about to retire, conferred on him the honour of knighthood,* 50gns.
1846	205	*Gold Fish,* 15 Pounds.
1847	14	*The Minister of Kinneff and his Wife concealing the Scottish Regalia, "I, Mr. James Grainger, Minister of Kinneff, grant me to have in my custody the Honours of the Kingdom, namely, the crown, sceptre, and sword . . ." (The Minister's Letter.) March 13, 1652.* 20 Pounds.

| 1847 | 202 | *Prince Henry acknowledging the authority of Judge Gascoigne, 50 Pounds.* |

CHISHOLM H

| 1840 | 163 | *Galileo pointing out to Milton his Discovery of the Solar System.* |

CHISHOLME A

1830	5	*The Tetotum, 20gns.*
1831	417	*Morning Ablution.*
1832	329	*Shakspeare before Justice Shallow - To be engraven for the work entitled "The Gallery of the Society of Painters in Water Colours," 40gns., The Duchess of St. Albans.*

CHRISTMAS J

| 1820 | 62 | *Dogs.* |
| 1820 | 125 | *The Wounded Leopard.* |

CHRISTMAS T

1819	54	*Study of a Dog, £4.0.0, Mr. Bailey.*
1820	42	*Morning.*
1820	48	*The Careful Mother, £8.8.0, C. G. Wakefield Esq.*

CLENNEL L

1813	109	*A Smuggling Scene, near Bonner, on the Coast of Northumberland, 25gns.*
1813	161	*A North Country Fair, £26.5.0, J.G. Lambton Esq., M.P.*
1813	169	*Highland Whisky Smugglers, with a distant View of Ben Lomond.*
1813	190	*Going to the Fair.*

CLENNELL L

1813	7	*Going to Church.*
1814	40	*View on the Clyde, with Dumbarton in the Distance.*
1814	72	*View on the Tyne, North Shields.*
1814	82	*Waiting for Fish Boats, £15.15.0, C. Birch Esq.*
1814	84	*Returning from the Wars.*
1814	260	*Sportsman caught in a Storm.*
1814	262	*Scotch Herd.*
1814	297	*Queen's Ferry, £18.18.0, Mr. Leader.*
1815	239	*Frost Fair, a Sketch.*
1815	242	*Black Gang Chine, Isle of Wight.*
1815	278	*A View of North Shields Lighthouse with Tynemouth Castle in the Distance.*
1815	288	*A distant View of Holy Island, Fish Boats.*
1815	307	*Fish Boats, £6.6.0, Walter Fawkes Esq.*
1815	324	*An Old Shepherd driving his Flock, Morning.*
1823L	11	*A North Country Fair, J.G. Lambton, esq. M.P.*
1823L	33	*Crossing the Ford, J. Allnutt, esq.*
1823L	45	*Dunbarton Castle, W. Leader, esq. M.P.*
1823L	53	*Scene on the Coast of Northumberland, W. Leader, esq., M.P.*
1823L	65	*The Inn, J. Vine, esq.*

1823L	86	*Bridge at Killin, Perthshire, J. Allnutt, esq.*
1823L	116	*Marine Subject, W. Leader, esq.*
1823L	134	*The Inn Door, J. Vine, esq.*
1823L	142	*View at North Shields, J. Vine, esq.*
1823L	193	*The Cobler, J. Allnutt, esq.*

CLINT G

| 1815 | 16 | *Portrait of the Rev. Thomas Jones, Curate of Creaton.* |
| 1815 | 173 | *Christ visited by Nicodemus, a Sketch.* |

COLLEN H

| 1820 | 178 | *My Mother.* |

COLLINGWOOD W

1855	17	*The Library, Levens, Westmoreland, 70gns.*
1855	82	*The Hall, Levens, Westmoreland, 70gns., Frame and glass £4.0.0.*
1855	164	*A Village Forge in Devonshire, 12gns., W. Reed Esq., Hanworth, Nr. Hownslow.*
1855	204	*Mills at Montreux, Lake of Geneva, 16gns., Frame and glass £2.10.0.*
1855	219	*The Absent, 70gns., Tomalin Esq. 50gns., Frame and glass £5.0.0.*

COLLINS MISS

| 1820 | 124 | *Landscape Composition - Morning.* |

CONEY J

1820	1	*Great West Entrance, Rochester Cathedral, Kent.*
1820	239	*Interior of the Great West Aisle, Tewkesbury Abbey Church, Gloucestershire.*
1820	241	*Winchester Cathedral - shewing the Chantries of Bishop Waynflete, Cardinal Beaufort, Langton &c.*
1820	247	*Interior of Waltham Church, Essex.*
1820	312	*Wells Cathedral - Interior of the South Aisle, shewing the Entrance into the Choir, Monument of Bishop Beckington and St. Mary's Chapel.*
1820	346	*Edward the Confessor's Chapel, Westminster Abbey, shewing the Monument of Edward the Confessor, and the Coronation Chair in the centre - to the left Henry Third's Monument, Henry Fifth's Shrine and Chantrey - Queen Philippa's, Edward Third's and Richard Second's Monuments.*

COOPER A

1813	198	*The Hovel, "Keen blows the blast, or ceaseless rain descends . . ." Vide Bloomfield's Farmer's Boy. £21.0.0, Lord Cawdor.*
1814	57	*Study of a Scotch Terrier's Head.*
1814	59	*Study of a Head between a Pug and Terrier.*
1814	60	*Study of Asses.*
1815	50	*The unwelcome Guest.*
1815	57	*A Terrier, from Nature.*
1815	85	*A Poney, Dog and Syracusian Goat.*

1815	172	*The Banditti, a Sketch, "He will go on, until his crimes provoke." Juvenal.*
1816	75	*First of October, "With the game in my net, I return home at night, For my dogs and my gun is my constant delight." Mr. Gosden.*
1816	76	*First of September, "O! the deuce take the first of September". Mr. Gosden.*
1817	98	*Still Life,* £7.7.0, J. Allnutt Esq.
1817	109	*The Old Grey Pony.*
1817	112	*Head of a Fox.*

COOPER G

1820	246	*View on the Arno, near Florence.*
1820	301	*The Piazza Navona, Rome.*
1820	313	*The Temple of Jupiter Clitumnus, near Foligno.*
1820	323	*Campo Vaccino, with the Ruins of the Temple of Concord, at Rome.*

CORBOULD H

1815	29	*From the Corsair, by Lord Byron, "Impatience bore At last, her footsteps to the midnight shore . . ."*
1815	35	*From Childe Harold's Pilgrimage, by Lord Byron, "Where are those bloody banners which of yore . . ." Vide Stanza xxxv.*
1815	36	*From Rokeby, by Walter Scott, "She saw too true, stride after stride . . ." Canto V. Stanza xxviii.*
1815	37	*From the Giaour, by Lord Byron, "But shape or shade, whate'er thou art, In mercy, ne'er again depart." Vide Line 1245.*
1815	44	*From the Giaour, by Lord Byron, "His breast with wounds unnumbered riven, His back to earth, his face to heaven, Fall'n Hassan lies —"*
1815	47	*The parting of Hector and Andromache, "Thus having spoke, the illustrious chief of Troy . . ." Vide Pope's Homer's Iliad, Book vi.*
1815	150	*From the First part of Shakespeare's King Henry IV, "I saw young Harry, with his beaver on . . ." Act iv. Scene i.*

COTMAN J

| 1828 | 260 | *A Street Scene, at Andely, Normandy,* 15gns. |

COTMAN J S

1823L	134*	*Barges,* Rev. Dr. Burney.
1823L	175	*Trees,* Rev. Dr. Burney.
1825	104	*Dieppe, from the Heights to the east of the Port, looking down upon the Harbour, Churches of St. Jacques and St. Remi, and along the coast towards St. Vallery,* 10gns., J. Webster Esq.
1825	105	*Abbatial House, of St. Ouen, at Rouen, taken down in 1817,* 22gns., J. Webster Esq.
1825	109	*Mount St. Michael, on the side of Pontorson, Normandy, shewing the Phenomenon of the Mirage,* 10gns., J. Webster Esq.
1826	91	*Landscape - Composition,* 5gns.
1826	93	*View on the Scheldt,* 6gns.
1826	132	*Landscape - Composition,* 10gns.
1826	185	*Landscape, near Pont Audemer,* 8gns.
1826	192	*Porch of the Church of Louviers,* 12gns.
1826	199	*Town of Alençon,* 8gns.
1826	215	*Abbey Church of St. Stephen at Caen,* 15gns.
1826	242	*Boats on the Beach, at Cromer,* 18gns.
1828	203	*Cliffs on the North-east side of Point Lorenzo, Madeira,* Sold.
1829	35	*Fishing Boat off Cromer,* 10gns.
1829	162	*Danish Merchant Ship off Yarmouth, unlading timber,* 15gns., Roberts Esq.
1829	248	*Fountains in the Fish Market at Basle, from a Sketch by W. H.Harriott, Esq,* 25gns.
1830	3	*Fishing Smack in a Gale,* Sold.
1830	224	*A Chapel in the Abbey at Fecamp,* 18gns., Roberts Esq., 7 Percy St..
1830	237	*Abbey Gate of St. Martin, at Aumale,* 18gns., Roberts Esq., 6 Percy Street.
1830	354	*City Scene - Composition,* 20gns., W.H. Harriott Esq., 30 Manchester St..
1831	47	*Crosby Hall.*
1831	102	*Hôtel de Ville, Ulm.*
1831	105	*Abbatial House of the Abbey of St. Ouën, Rouen.*
1831	194	*Danish Merchant - Brig unlading off Yarmouth.*
1831	380	*Fishing Boats off Yarmouth.*
1832	58	*Sir Simon Spruggins, Knt. the tall fellow of the family of that ilk, Vide Lady Morley's Spruggins' Family.* 15gns.
1832	106	*Dutch Galliot in a Breeze,* Sold, E. Winstanley Senr. Esq.
1832	150	*Entrance to Gunton Park, Norfolk,* Sold.
1833	21	*Barge on the Medway,* 10gns., J.H. Davis, University Club, St. James, All but this drawing to be packed and sent to Mr. Cotman, Norwich.
1833	36	*Landscape - Composition,* 15gns., Mrs. Harriott.
1833	45	*Landscape - Composition with the Story of Bathsheba,* 15gns., Mrs. William Harriott.
1833	83	*Interior of Spruggins' Hall, Manor of Dulfuddle, Bedfordshire, leading to the Picture Gallery, Arms of Spruggins, Gull, Whittingham, Bagnigge, Kiltwaddle, and Sucklethumkin, over the Doorway. , Vide Spruggins's Gallery.* 15gns., E. Winstanley, Poultry.
1833	96	*Sea View,* 10gns., Mr. Hixon.
1833	222	*King John and Prince Henry at Swineshead Abbey, attended by the Earls of Salisbury, Oxford, Pembroke, Essex, and Warrenne, after their Defeat and Loss at Crossing the Lynn Wash,* 20gns.
1833	249	*A Painter's Study,* 18gns.
1833	304	*Italian Peasant at a Fountain in the Valley of Coriati,* 12gns., W.H. Harriott, Esq..

1834	237	*A Study of Armour*, Sold.
1835	144	*A Landscape*, 8gns., Sold.
1836	49	*The Drawing Lesson*, 18gns.
1836	127	*Sea View*, 15gns., N.? Glyn Esq., 37 Upper Brook Street.
1836	151	*Figures on the Sands at Blakeney*, Sold.
1836	187	*Italian Boys with a Lady of Loretto*, Sold.
1836	194	*Velasquez designing his celebrated Picture of the Crucifixion*, 20gns.
1836	247	*A Dutch Canal*, Sold.
1836	255	*A Sketch*, Sold.
1838	223	*Lee Shore, with the Wreck of the Houghton, Pictures, Books &c. sold to the Empress Catherine of Russia, including the celebrated and gorgeous Landscape of the Waggoner, by Rubens.*
1839	152	*A Lady of Alençon*, 7gns.
1839	162	*Corridor in the Castle of Falaise*, 7gns.
1839	250	*Interior of the Abbey, Jumieges*, 7gns.
1839	310	*Vessels off Yarmouth*, 15gns.

COTMAN S

1830	81	*Man of War - Tender off Yarmouth*, 15gns., J.F. Lewis Esq.

COTTON MISS

1820	152	*Fruit and Flowers.*
1820	158	*A Group of Flowers.*

COUSINS T

1823L	144	*Langdale Pikes*, Rev. Dr. Burney.

COUSINS –

1823L	60	*Scene in Switzerland*, Mrs. Deverell.
1823L	205	*Salerno*, W. Leader, esq. M.P.

COVENTRY C C

1815	45	*The Ale-House Door.*
1815	75	*The Intombment of Christ.*
1815	199	*The Toilet*, £10.10.0, G. Reid Esq.

COX D

1813	9	*Gravesend Fishing Boat.*
1813	10	*Hay-Stack, Sketch from Nature.*
1813	64	*Eton College.*
1813	101	*View on the Banks of the Thames, near Chertsey.*
1813	107	*Lane near Dulwich.*
1813	118	*Hasting fishing boats, returning, on the approach of a Storm.*
1813	121	*Westminster Abbey, from Battersea Fields.*
1813	122	*Llanberris Lake.*
1813	123	*A Heath Scene.*
1813	144	*Corn Field, near Dulwich.*
1813	166	*Edinburgh Castle.*
1813	167	*A Barley Field.*

1813	168	*Stacking Hay.*
1813	170	*A Lee Shore, Coast of Sussex.*
1813	174	*Cottage near Windsor, Sketch from Nature.*
1813	182	*The Wrekin, Shropshire.*
1813	191	*Westminster Bridge, from Lambeth.*
1814	26	*Cottage near Windsor.*
1814	30	*Oak Trees.*
1814	136	*Sketch from Nature.*
1814	137	*Twilight.*
1814	138	*Westminster Abbey, from Lambeth.*
1814	142	*Windsor Castle, from St. Leonards Hill.*
1814	145	*Mid-day.*
1814	146	*Llanberis Lake, North Wales.*
1814	174	*View on the Thames below Gravesend.*
1814	193	*Millbank, Thames side.*
1814	194	*Morning.*
1814	241	*Snowden, North Wales.*
1814	261	*Dulwich Mill, Surrey.*
1814	264	*Beddkelert, North Wales.*
1816	97	*Sketch on the Banks of the Thames.*
1816	149	*Wind-Mill, in Staffordshire.*
1816	194	*Hastings, Boats.*
1816	265	*Cottages from Hereford.*
1816	275	*Chepstow Castle, River Wye.*
1816	303	*The Sands at low-water, Hastings.*
1816	312	*Fish Market, Hastings.*
1818	2	*View on Sydenham Common*, £3.3.0, Mr. Barnard.
1818	20	*View in the Vale of Festiniog, North Wales.*
1818	37	*View on the Thames, near Gravesend.*
1818	210	*View on the River Lugg, near Hereford.*
1818	266	*Gloucester, from the Ross Road.*
1818	268	*Heath Scene.*
1818	278	*Early Morning.*
1818	280	*Scene on the Beach at Hastings.*
1818	295	*A Stack Yard.*
1818	302	*Three Figures - Cottage Child - Hastings Fisherman - Beggar.*
1818	312	*Ploughing. A Sketch.*
1818	316	*Cottage in Kent.*
1818	345	*Landscape. Morning.*
1819	157	*Landscape - A Sketch.*
1819	219	*Dindor Hill and Rotheros Woods - River Wye, near Hereford.*
1819	233	*Windmill, a Sketch.*
1819	248	*View, looking down the Valley from Dolgelly to Barmouth, North Wales.*
1819	249	*Fish Market on the Beach at Hastings*, £4.4.0, Sir J. Swinburne.

1819	252	*Hay Field, £3.3.0, Sir J. Swinburne.*
1819	271	*Part of Hereford - a Sketch made on the spot.*
1819	284	*Cader Idris, from the Machynlleth Road, looking towards Tal-y-llyn, North Wales.*
1819	307	*Distant View of Goodrich Castle, on the river Wye, £3.3.0, Captn. Festing.*
1819	310	*Stacking Hay - a Sketch.*
1820	4	*Coast Scene - Evening.*
1820	7	*View in North Wales.*
1820	9	*Coast Scene.*
1820	10	*Hay-Makers, £2.2.0, E. Swinburne Esq.*
1820	21	*Coast Scene near Hastings.*
1820	27	*Ploughing Scene in Herefordshire with Stoke Park and the Malvern Hills in the Distance.*
1820	221	*Cottage in Herefordshire.*
1820	222	*View in the Pass of Llanberis, North Wales.*
1820	228	*View of the City of Bath from Beacon Hill.*
1820	232	*Sketch from Nature.*
1820	257	*Scene on the Sands of Hastings.*
1820	264	*Hay Field.*
1820	275	*Sketch from Nature - Lugg Meadows, near Hereford.*
1820	279	*View on the Coast near Barmouth, N. Wales.*
1820	288	*Ross Market House, Herefordshire - A sketch.*
1820	292	*Boy Angling - View on the River Lugg, Herefordshire.*
1820	296	*Llanberis Lake, and Snowdon Mountains.*
1820	362	*Cader Idris, North Wales.*
1821	33	*Water Mill at Festiniog, North Wales.*
1821	113	*Caesar's Tower, and part of Leicester Buildings, Kenilworth Castle.*
1821	120	*Comb Martin, North Devon.*
1821	131	*View on the Beach, near the Old Pier, Hastings, £21.0.0, T.G.*
1822	11	*View near the Village of Pipe, Herefordshire, £2.2.0, Mr. Powell.*
1822	64	*Repairing a Vessel on the Thames, off Rotherhithe.*
1822	87	*Morning Scene on the Thames, near Gravesend, £2.2.0, T.G.*
1822	89	*Evening Scene on the Thames, £2.2.0, T.G.*
1822	96	*Scene on the Thames, near Northfleet, £2.2.0, T.G.*
1822	128	*Scene on the Thames, near Gravesend.*
1822	149	*Domestic Ducks.*
1822	163	*Town and Castle of Hay, on the River Wye, Brecknockshire.*
1822	168	*View in the Pass of Llanberis, North Wales.*
1822	169	*Hay Field, Gloucestershire, £3.3.0, Mrs. B. Cochrane.*
1822	170	*Distant View of Harlech Castle, North Wales - Morning, £4.4.0, J. Webster Esq.*
1822	173	*Scene on the Beach at Hastings, Sussex, £3.3.0.*
1823	15	*Boats on the Thames - Morning, £2.2.0, J. Webster Esq.*
1823	16	*Peter Boat on the Thames, above Westminster Bridge.*
1823	51*	*A Heath Scene.*
1823	52	*Rocky Scene, with Figures.*
1823	110	*Hastings - Fishing-boats, £2.2.0, General Grey.*
1823	117	*North Shore, Liverpool.*
1823	126	*Hawkers crossing the Sands near Barmouth, North Wales, £2.2.0, Wm. Knyvett Esq.*
1823	135	*Dock-yard - building a Sloop, £2.2.0, Wm. Knyvett Esq.*
1823	141	*Gravel Pit.*
1823	172	*Scene on the Thames below Greenwich, £2.2.0, W. Knyvett Esq.*
1823	177	*Scene on the Thames, near Rotherhithe, £2.2.0, W. Knyvett Esq.*
1823	184	*On the Medway, £2.2.0, W. Knyvett Esq.*
1823	195	*The Pool of London.*
1823	202	*View near Norwood, £2.2.0, Sir J. Swinburne.*
1823	206	*Vessels on the Thames, £2.2.0, Sir J. Swinburne.*
1823	234	*Embarkation of His Majesty George IV from Greenwich, Aug. 10th, 1823, £42.0.0, J. Webster Esq.*
1823	261	*Boats on the Thames - Gravesend in the distance, £2.2.0, Watts Russell Esq.*
1823	265	*Boats on the Thames - Evening - Greenwich in the distance, £2.2.0, E. Tattersall Esq.*
1823	269	*Village of Bullingham, Herefordshire, £2.2.0, J. Webster Esq.*
1823	271	*Lane Scene, near Hereford.*
1823	272	*Fishing-boat on the Thames.*
1823L	23	*Cottage on a Heath, Earl of Essex.*
1823L	37	*Scene in Herefordshire, J. Allnutt, esq.*
1823L	43	*View near Dolgelly, J. Allnutt, esq.*
1823L	96	*Angling, Sir J. Swinburne, Bart.*
1823L	129	*Afternoon, J. Allnutt, esq.*
1824	2	*A Hay Cart.*
1824	9	*Early Morning on the Thames, near Battersea.*
1824	15	*Cader Idris, from the Barmouth Road.*
1824	19	*Fishing Boat, on the Thames.*
1824	39	*Boys and Sheep - Scene below Gravesend.*
1824	48	*Vessels coming up the Thames.*
1824	65	*Shepherds collecting their Flocks - Evening, from Scenery in Herefordshire.*
1824	112	*Interior of Tintern Abbey.*

1824	119	*Gravesend Fishing Boats.*
1824	121	*Passengers Landing at the Stairs - Gravesend.*
1824	129	*Vessels on the Thames, by the Custom-House.*
1824	131	*Boats on the Thames, near Gravesend.*
1824	140	*Westminster Abbey, from Lambeth Palace.*
1824	146	*Rocks on the River Wye.*
1824	153*	*Part of Goodrich Castle, Herefordshire.*
1824	160	*Windmill on a Heath.*
1824	167	*Great Malvern Church, a Sketch.*
1824	182	*Sands at low-water - Hastings.*
1824	195	*Distant View of Harlech Castle - Morning.*
1824	240	*Greenwich, from Sydenham Hill.*
1824	248	*Vessels at Rotherhithe.*
1824	250	*Lymouth Pier, North Devon.*
1824	294	*Lambeth Palace, from Mill Bank - A sketch.*
1824	296	*Cows - Evening.*
1824	298	*Hay Field - View near Hereford.*
1825	3	*Boats on the Thames near Battersea,* 4gns., Mr. Vale, 29 New Norfolk Street, Park Lane.
1825	73	*Distant View of Greenwich,* Sold.
1825	75	*Llanilted Vale, North Wales - Morning,* 4gns.
1825	76	*Vessels coming up the Thames, Gravesend in the Distance,* 6gns., Mr. Knyvett, 21 Edgware Road.
1825	80	*View on the Wye,* Sold.
1825	107	*Carthage - Aeneas and Achates, "They climb the next ascent, and looking down . . ." Eneid, Book I.* 50gns.
1825	126	*Aberystwith Castle - Evening,* 2gns.
1825	134	*Coast Scene, near Barmouth,* Sold.
1825	140	*Evening,* 2gns., Mr. J. Page, Cirencester Place.
1825	160	*Goodrich Castle, Herefordshire,* 5gns.
1825	171	*Cader Idris, from Kymmer Abbey, North Wales,* 5gns., Lord Northwick.
1825	180	*Corn Field, Herefordshire,* Sold.
1825	189	*A Sketch,* 1gn., Sir John Swinburne.
1825	206	*A Heath Scene,* 10gns.
1825	213	*Near Rome,* 2gns.
1825	214	*On the Medway, Kent,* Sold.
1825	222	*Lane near Hereford,* 3gns.
1825	224	*Hay Field,* 4gns.
1825	234	*Hay, on the River Wye,* Sold.
1825	242	*Evening,* 2gns.
1825	263	*Billingsgate from the Custom-House Stairs, low water,* 20gns.
1825	274	*View on the Wye,* 2gns.
1825	279	*A Sketch,* 3gns., Mr. S. Tamworth, Greenwich.
1825	283	*Chester,* 2gns.
1825	284	*Boats on the Thames near Battersea,* 2gns., Mr. John Birch.
1825	285	*Hay Field, from Nature,* 3gns., Mr. J. Braithwaite.
1825	288	*Battersea Bridge,* 3gns., Mr. Broderip.
1825	291	*Clifton, near Bristol,* 3gns., Sir John Swinburne.
1825	295	*Gravesend Boats,* 3gns., Mr. J. Braithwaite.
1825	297	*On the Thames,* 2gns.
1825	302	*Morning,* 2gns., J. Braithwaite.
1825	305	*Landscape, with Sheep,* 3gns.
1825	308	*Warwick Castle,* 3gns.
1825	332	*Hereford - a Sketch from Nature,* 3gns.
1826	2	*View on the Thames,* 4gns.
1826	7	*A Sketch,* 4gns.
1826	33	*Valle Crucis Abbey, Denbighshire,* 4gns.
1826	64	*Hay Field,* 5gns., Mr. Birch, 15 Sussex Place, Regents Park.
1826	73	*Coast Scene, with Fishermen,* 5gns., Prior Esq.
1826	83	*Pirates' Isle, "A Sail! a Sail! a promised prize to hope . . ." Lord Byron's Corsair.* 40gns., Lord Northwick.
1826	94	*Moelwyn, near Tan-y-bwlch, Merionethshire,* Sold.
1826	95	*Evening,* 4gns.
1826	111	*Distant View of Cardigan Bay, from near Harlech,* 5gns., Lord Digby, 35 Lower Brook Street, Grosvenor Square.
1826	113	*Boats on the Thames - Greenwich in the Distance,* 4gns.
1826	120	*Snowdon, from near Beddgelert,* 5gns.
1826	122	*Westminster Bridge,* 5gns., Mr. C. Stokes, 4 Verulam Buildings.
1826	131	*Kenilworth Castle - Evening,* Sold.
1826	133	*The Inn at Talyllyn, North Wales,* 4gns.
1826	175	*View between Hay and Builth, Brecknockshire,* 15gns.
1826	189	*London, from Herne Hill,* 4gns., Sir J. Swinburne, 10 Grosvenor Place.
1826	191	*A Sketch,* 4gns.
1826	193	*Lymouth Pier, North Devon,* 4gns.
1826	204	*Snowden,* 4gns., Sir J. Swinburne.
1826	231	*Lane Scene,* 4gns.
1826	239	*Westminster from Lambeth - Twilight,* 4gns.
1826	240	*Cottage Scene,* Sold.
1826	278	*Hay Field, Harlech in the distance,* 6gns., Lord Northwick.
1827	8	*Dover, from the Sea,* 5gns.
1827	17	*Debarkation - Composition,* 4gns., I. Wyatville (?) Esq.
1827	22	*Hay Field,* 7gns., Sold.
1827	63	*Fishermen - Hastings,* 6gns.

1827	65	*Part of Kenilworth Castle*, 4gns.
1827	72	*Canal, Birmingham*, 4gns.
1827	99	*Festiniog - North Wales*, 5gns.
1827	125	*On the Coast, near Towyn, North Wales*, 4gns., Mrs. J. Braithwaite.
1827	133	*Great Malvern, from the Worcester Road*, 4gns.
1827	136	*East Cliffs, Hastings*, 5gns., Sir John Swinburne, 10 Grosvenor Place.
1827	184	*London, from Nun-Head Hill*, 7gns.
1827	264	*View near Dolgelly, North Wales*, 10gns.
1827	293	*Shrimp Catchers going out*, 4gns., W. Wells Esq.
1827	309	*Fishermen on the Coast, Hastings*, 7gns., Prior Esq.
1827	315	*Corn-Field*, 6gns., Birch Esq.
1827	324	*Scotch Drovers*, 7gns., Wm. Taylor, 10 Birchin Lane.
1827	334	*Shrimp Catchers*.
1828	4	*Hayfield*, 30gns.
1828	62	*View from Kymmer Abbey, North Wales*, 6gns., A. Pugin Esq.
1828	64	*Marine Palace - Composition*, 8gns., Mr. Samuel Angell, 26 Ely Place.
1828	121	*London, from Greenwich Park*, 4gns., Mr. Roberts, Hanway St.
1828	131	*The Grave*, 5gns.
1828	136	*Cader Idris - Evening - Storm clearing off*, 50gns.
1828	155	*Ulleswater - Morning*, 5gns.
1828	167	*Welch Drovers*, 6gns.
1828	172	*A Windmill*, 4gns., Rev. J. Brown.
1828	209	*Lymouth Pier, North Devon*, 5gns.
1828	212	*The Dying Brigand - Evening*, Sold.
1828	274	*A Heath Scene*, 4gns., Birch Esq., Heathfield Lodge, Norwood.
1828	275	*On the Beach, at Hastings*, 5gns., Lord Wharncliffe(?), No. 15 Curzon Street.
1828	277	*Dolgelly, North Wales*, 5gns.
1828	283	*The Arun Mountain, from the Beddgelert Road*, 4gns.
1828	289	*Chelsea Reach*, 5gns., Mr. Bentley, 13 Batemans Building, Soho Square.
1828	294	*Bolton Abbey, Yorkshire*, 4gns.
1828	297	*Hastings - Boats returning, on the approach of a Storm*, 6gns.
1828	310	*The Moelwyn, North Wales - Misty Morning*, 4gns.
1828	317	*On the Coast, near Towyn, North Wales*, 4gns., W. Prior Esq., Calverts Brewhouse.
1828	325	*Scotch Drovers*, 4gns., Sir John Swinburne.
1828	331	*Cader Idris, from the Barmouth Road*, 4gns.
1828	335	*Snowdon - Twilight*, 4gns.
1828	342	*Boats on a River - Twilight*, 4gns., J. Moxon Esq., Lincolns Inn Fields.
1828	352	*On the Banks of the Thames - Battersea*, 7gns.
1828	355	*South Side of Cader Idris, North Wales*, 10gns., Sold.
1828	358	*The Arun Mountain, North Wales*, Sold.
1829	14	*On the Thames below Gravesend*, 4gns.
1829	122	*Fruit and Flower Market at Brussels*, 8gns., Parrott Esq.
1829	123	*Road Scene, with Figures*, 7gns., A. Stewart Esq.
1829	137	*From Little Malvern Hill, Worcester in the distance*, 6gns., Broderip Esq.
1829	138	*Pastoral Landscape*, 6gns., T. Griffiths Esq.
1829	166	*Entrance to Calais Harbour*, 6gns.
1829	169	*Landscape*, 7gns., Baring Wall Esq.
1829	180	*Shepherds*, 7gns., Evans Esq.
1829	186	*Rocks, near Beddgelert*, 4gns., Revd. Edward Craven Hawtrey, Gordon's Hotel, Albemarle St.
1829	199	*Vessels off Gravesend*, 4gns., Angel Esq., Ely Place, Holborn.
1829	201	*Dutch Hay Boats*, 4gns., Roberts Esq.
1829	208	*Heath Scene - Afternoon*, 4gns., Rev. Buller.
1829	210	*Gravel Pit*, 4gns., W. Prior.
1829	212	*Calais Pier*, 25gns., M. Shipley Esq.
1829	220	*Returning from Market*, 6gns., Stewart Esq.
1829	239	*Interior of Maentreoog Church, North Wales*, 4gns.
1829	287	*Sand Carriers, Calais*, 5gns., A. Stewart Esq.
1829	288	*On the Coast, Boulogne*, 5gns., D. Colnaghi.
1829	289	*Dutch Boats on the Scheldt*, 4gns., Vine Esq.
1829	291	*Tintern Abbey*, 4gns.
1829	296	*Fish Market, Boulogne*, 5gns., W. Prior Esq.
1829	299	*Millbank, Thames-side*, 4gns.
1829	301	*On the Sands at Hastings*, 4gns., Duchess of Bedford.
1829	308	*Hay Field*, 6gns., W. Prior Esq.
1829	309	*Vessels on the Thames, below Greenwich*, 4gns., Miss Wynne, 38 Conduit St.
1829	320	*Wandsworth Common*, 5gns., C.B. Plestow Esq., To be delivered to Mr. Stanley, 25 Gt. Maddox St.
1829	321	*Boats on the Thames, off Greenwich*, 4gns., D. Colnaghi Esq.
1829	323	*Westminster from Vauxhall*, 4gns., Sir J. Swinburne, 18 Grosvenor Place.
1829	327	*Gipsies*, 4gns.
1829	328	*Convict Ship, Sheerness*, 4gns.
1829	336	*Beach at Hastings*, 5gns.
1829	337	*Coast Scene*, 4gns., A. Stewart Esq.

1829	344	*Gleaners - Afternoon*, 8gns., G. Morant Esq.
1829	372	*Coast Scene*, 4gns.
1829	397	*Dover*, 4gns., Cobridge Esq., Eton.
1830	17	*Cottages on a Common*, 6gns.
1830	24	*Bolton Abbey*, 6gns., Sold.
1830	61	*Cader Idris - Morning*, 7gns., Sold.
1830	107	*The Severn and the Wye, from Wyndcliff*, 50gns., Mrs. Roberts.
1830	114	*Village of Mansel, near Hereford*, 6gns., Sold.
1830	115	*Boats on the Thames*, 4gns.
1830	116	*Chelsea Hospital*, 4gns.
1830	117	*Shrimpers, Calais*, 4gns., Moon, Boys & Graves.
1830	125	*Shepherds*, 4gns., G. Pitman Esq., 34 Bernard St., Russel Square.
1830	126	*Sand Banks, Calais*, 5gns., Sold.
1830	128	*East Cliff, Hastings*, 5gns., William Fox, May Field St., Dalston, Drawing to be delivd. 36 Old Jewry.
1830	154	*London Bridge, in 1825*, 5gns.
1830	163	*On the Coast - Boulogne*, 5gns., Sold.
1830	178	*In the Garden of the Tuilleries*, 7gns., Sold.
1830	187	*Shakspeare Cliff*, 5gns.
1830	205	*Part of the Tuilleries, at Paris*, Sold, Who has bought it for Mr. Baring Wall.
1830	206	*Pedmore Church, Worcestershire*, 4gns.
1830	260	*Gleaners*, 6gns., Sold.
1830	261	*On the Coast of Picardy*, 7gns., Sold . . . by desire of Mr. Cox.
1830	264	*Coast Scene*, 4gns., G. Morant Junr.
1830	269	*Cader Idris, from the Barmouth Road*, 10gns., Sold.
1830	287	*Evening*, 5gns., Sold.
1830	293	*On the Thames*, 4gns., C.B. Plestow Esq.
1830	294	*Drovers*, 4gns., C.B. Plestow Esq.
1830	297	*Gleaners Returning - Afternoon*, 10gns., Sold.
1830	301	*Goodrich Castle*, 8gns., J. Shaw Esq., Gower St., Bedford Square.
1830	303	*Vauxhall Bridge*, 5gns., J.H. Shaw Esq.
1830	313	*Ferry-house*, 5gns., Sold.
1830	319	*Coast, Hastings*, 6gns., W. Hughes Esq., 26 Euston Place, New Road.
1830	349	*On the Lake - Tallylyn, North Wales*, 6gns., Shaw Esq., Gower Street.
1830	357	*Corn Field*, 6gns., Sold.
1831	6	*View on the Wye, near Chepstow*.
1831	85	*Pont Neuf from the Quai de l'Ecole, Paris*.
1831	104	*Brigands, "Tell o' er the tales of many a night of toil . . ." Byron*.
1831	114	*Harlech Castle - Evening*.
1831	115	*Pont Louis Seize, Paris*.
1831	122	*Lyn Dinas, North Wales*.
1831	132	*A Sketch in Yorkshire*.
1831	173	*Tal-y-llyn Lake, North Wales*.
1831	183	*Interior of Hales Owen Church, Salop*.
1831	197	*Winchester Tower, Windsor Castle*.
1831	202	*A Saw-Pit*.
1831	216	*Boats, Hastings*.
1831	234	*Landscape with Banditti*.
1831	240	*Boats on the Scheld*.
1831	243	*Ploughing*.
1831	246	*Rue Vivienne, Paris*.
1831	289	*Part of Greenwich Hospital*.
1831	290	*Door of the Church of St. Roch, Paris*.
1831	294	*Chelsea Reach*.
1831	298	*Lane Scene, near Hereford*.
1831	305	*Fort Rouge, Calais*.
1831	313	*Dieppe Pier*.
1831	316	*A Heath Scene*.
1831	325	*Harlech Castle - Twilight*.
1831	334	*The Arrival*.
1831	335	*Whitehall*.
1831	337	*Calais Pier*.
1831	338	*Bridge in Warwickshire*.
1831	347	*Cottage near Hereford*.
1831	363	*Scene in Yorkshire*.
1831	364	*Chamber of Deputies, Paris*.
1831	365	*Wynd Cliff, on the Wye*.
1831	374	*Goodrich Castle, on the Wye*.
1831	377	*Sketch from Nature - Battersea Fields*.
1831	404	*Cader Idris, North Wales*.
1831	419	*On the River Ure, Yorkshire*.
1831	427	*On the Wharf, near Bolton Abbey, Yorkshire*.
1832	40	*Bolton Castle, Wensleydale, Yorkshire*, 10gns., Mrs. W. Hughes, 32 Albany St., Regents Park.
1832	47	*Antwerp - Morning*, 4gns., Sold.
1832	49	*Entrance to the Inner Court, Dudley Castle*, 4gns.
1832	53	*A Hay-field*, 12gns., Sold.
1832	64	*An Interior*, 4gns.
1832	82	*Peat Moor, North Wales*, 4gns., Mr. N.W. Coit?, Mr. Howard March, 39 Margaret St., Cavendish Sq.
1832	100	*The Great Hall, Haddon*, This belongs to a set of 25 sketches of Haddon Hall to be sold altogether.
1832	138	*Heath Scene*, 5gns.
1832	155	*Corn-field*, 5gns., Mrs. Jolly, 29 Upper Belgrave Place.

1832	160	*A Rocky Glen*, 6gns.
1832	163	*Part of Windsor Castle*, 4gns., J. Shaw Junr. Esq., 1 Chatham Place.
1832	169	*Stacking Hay*, Sold.
1832	185	*June*, 7gns., Mr. Green, Lichfield, By order of Mr. Cox.
1832	197	*Lane in Herefordshire*, 6gns., Martin Esq., 112 Mount St.
1832	213	*Westminster from Vauxhall Bridge*, 6gns., Mr. D. Colnaghi.
1832	231	*Harlech Castle*, 4gns.
1832	241	*Entrance to Haddon Hall*, 20gns.
1832	245	*Ploughing*, 5gns.
1832	251	*Windermere during the Regatta*, "But never yet, by night or day . . ." Lalla Rookh. Sold, Mr. Broderip, Not sold in the Gallery.
1832	271	*Langdale Pikes, Westmorland*, 6gns.
1832	275	*Westminster Abbey from Lambeth*, 4gns.
1832	277	*A rocky Coast, after a Storm*, Sold.
1832	281	*Near Dolgelly, North Wales*, Sold.
1832	283	*Bed Room at Haddon*, Sold.
1832	302	*Pier at Dieppe*, 4gns.
1832	304	*Shrimpers on the Coast, Calais*, 5gns., E.N. Winstanley Esq.
1832	323	*Bolton Abbey*, 6gns., Mr. Munro, 113 Park St.
1832	325	*Calais Boats off Fort Rouge*, Sold, Rev. Mr. Coleridge.
1832	327	*Coast, Boulogne*, 5gns., Mrs. H. Davis, University Club, St. James's Square.
1832	350	*Recess in the Drawing Room, Haddon*, 8gns., Sold.
1832	362	*Rowsley Bridge, Derbyshire*, 5gns.
1832	372	*Near Harlech - Morning*, 5gns.
1832	397	*Snowdon, North Wales*, 6gns., Sold.
1832	403	*The Garden, Haddon*, This belongs to a set of 25 sketches of Haddon Hall to be sold altogether.
1832	415	*On the Coast near Barmouth*, 4gns., The Honble. Richard Cavendish, 1 Belgrave Square.
1833	5	*Landscape - Showery Day*, 11gns., Sold.
1833	16	*Calais Pier*, 5gns., Mr. Ryman, Oxford, To Mr. Graves, Pall Mall.
1833	20	*The Causeway, Boulogne*, 4gns.
1833	46	*A Brig entering Dieppe Harbour*, 20gns.
1833	68	*The Music Lesson*, 6gns.
1833	70	*Landscape*, 5gns., Sold.
1833	87	*On the French Coast*, 5gns., Sold.
1833	98	*The Proposal*, 7gns.
1833	100	*On the Sands, Calais*, 6gns., Sold.
1833	112	*Coast near Boulogne*, 5gns., Sold.
1833	139	*Harlech Castle*, 5gns.
1833	161	*Rocky Landscape*, 4gns.
1833	165	*Dieppe Pier*, 6gns., J.L. Brown.
1833	221	*An Old House at Amiens*, 6gns., J.L. Brown.
1833	271	*Garden Scene*, 5gns., Mr. R. Cancellor, Cambridge Place, Regents Park.
1833	281	*Ploughing*, 10gns., Sold.
1833	288	*Bridge near Maentwrog, North Wales*, 4gns.
1833	298	*From Richmond Hill*, 10gns., Mr. Evans.
1833	300	*Boat on the Thames*, 4gns., Sold.
1833	318	*Hay Field*, 14gns., Sold.
1833	324	*Dieppe - Morning*, 6gns., Sold.
1833	327	*Pont-y-Cysylty, Vale of Llangollen*, 10gns., Mr. R.Cancellor, Cambridge Place.
1833	329	*A Landscape*, 5gns., Sold.
1833	330	*Returning from Ploughing*, 10gns., Sold.
1833	335	*Funeral of a Nun*, 5gns., Rev. Craven Hawtrey.
1833	342	*Fort Rouge, Calais - Morning*, 5gns., Mr. J.C. Powell, 32 Upper Harley Street.
1833	350	*Staircase at Haddon Hall*, 6gns.
1833	359	*Boats on the Scheldt*, 5gns., The Rev. Mr. Cooksley, Eaton (Mr. Evans).
1833	361	*On the Sands, Boulogne*, 6gns., Sold.
1833	366	*Melham Cove, Yorkshire*, 6gns., Sold.
1833	376	*Bolton Abbey, Yorkshire*, 5gns., Mrs. Constable, Arundel, Sussex.
1833	379	*Boats on the Thames*, 5gns., The Rev. Mr. Cooksley, Eaton (Mr. Evans).
1833	389	*A Road Scene*, 5gns., Sold.
1833	399	*Shakspeare's Cliff*, 5gns., Mr. Ryman, Oxford, To Mr. Groves, Pall Mall.
1833	401	*Lane Scene, Herefordshire*, 7gns., Sold.
1833	411	*Entrance to Calais Harbour*, 5gns., J.L. Brown.
1834	21	*Bridge over the Derwent near Chatsworth Park, Derbyshire*, 7gns.
1834	64	*On the French Coast*, 4gns.
1834	71	*Lane Scene, Staffordshire*, 6gns., Sold.
1834	120	*Rocky Landscape, with Figures*, 7gns.
1834	140	*Bolton Abbey*, 5gns., W. White.
1834	142	*Distant View of Bolsover, Derbyshire*, 35gns.
1834	154	*On the Castle Walls, Harlech, N. Wales*, 5gns.
1834	162	*Snowdon*, 5gns., Sold.
1834	181	*Landscape, Showery Day*, 5gns., N. Wilkinson Esq., Tooting Common, Streatham.
1834	214	*Part of Kymmer Abbey, N. Wales*, 5gns.
1834	279	*A Villa*, 5gns., Sold.
1834	281	*Barge on the Thames*, 5gns., Sold.
1834	292	*On the Coast, near Boulogne*, 5gns.
1834	302	*Near Cernioge, N. Wales*, 5gns., Mr. W. Taylor, Canonbury Square, Islington.
1834	304	*Lane Scene, Herefordshire*, 6gns.

1834	315	*Penmaenmawr*, 4gns.

1834 315 *Penmaenmawr*, 4gns.
1834 317 *Heath Scene*, 6gns., Sold.
1834 326 *View near Ambleside*, 7gns., Sold.
1834 328 *Road Scene, with Figures*, 6gns., Sold.
1834 339 *Heath Scene*, 6gns., Sold.
1834 349 *The Lady of the Manor*, 7gns., Mr. Baring Wall, Berkeley Square.
1834 351 *Lac de Gaure, Hautes Pyrenees, where, in the Autumn of 1832, W. H. Pattison Esq. and his Lady were unfortunately drowned together, within one month of their Marriage, – from a sketch made on the spot by Mr. J.H. Bland*, Sold.
1834 378 *Woody Landscape*, Sold.
1834 386 *A Terrace, with Figures*, 6gns., Sold.
1835 6 *Ulverstone Sands*.
1835 145 *South Downs, Sussex*, 5gns., J. H. Maw Esq.
1835 154 *Waterfall of Pont-y-pair, North Wales*, 10gns., J.H. Maw Esq.
1835 157 *Waiting for the Ferry Boat*, 5gns., Sir John Swinburne, 18 Grosvenor Place.
1835 167 *Showery Day - Bolton, Yorkshire*, 5gns., J.H. Maw Esq.
1835 168 *Hope Green, Cheshire - A Sketch from Nature*, 5gns.
1835 191 *Returning from Ploughing*, 5gns., Mr. Angel, Southampton St., Holborn.
1835 199 *Heath Scene with Figures*, 5gns.
1835 244 *Lane Scene*, 5gns., Mr. Joseph Walker, Birmingham, To be sent 49 Fleet Street.
1835 252 *Lane Scene, Herefordshire*, 5gns.
1835 253 *Lancaster - Morning*, 12gns., N. Shepley Esq.
1835 265 *Richmond Hill*, 12gns., J.H. Maw Esq.
1835 270 *On the Thames, near Gravesend*, 5gns.
1835 274 *A Fresh Breeze*, 5gns., S. Ellis Esq.
1835 281 *Norwood, Surrey*, 5gns., T. Griffiths Esq., Norwood.
1835 286 *On the River Llugwy, North Wales*, 10gns.
1835 304 *Old London Bridge*, 6gns., Rainbow Esq.
1835 312 *Market People crossing the Ulverstone Sands*, 5gns., T. Griffiths Esq.
1835 314 *Holyhead Road, Nant Frangon*, 12gns.
1835 325 *Bolsover Castle*, 5gns., Mr. Rainbow, 2 Winterslow Place, Kennington.
1836 33 *Pass of Killicrankie*, 25gns., D. Colnaghi Esq.
1836 100 *Stirling Castle - Evening*, Sold, ?Froggatt, 30 Poultry.
1836 117 *Ellerside Peat Moss, Lancashire*, Sold.
1836 119 *Lancaster Sands - Market People returning from Ulverstone*, 35gns.
1836 122 *Haddon Hall*, Sold.

1836 135 *Bridge near Capel Cûrig, North Wales*, 5gns.
1836 138 *Lane Scene*, Sold.
1836 147 *Windmill, near Kenilworth, Warwickshire*, Sold.
1836 225 *Harlech Castle, North Wales*, 5gns., D. Colnaghi Esq., Pall Mall East.
1836 227 *Cottages near Lancaster*, 4gns.
1836 230 *Landscape with Fern Cutters*, 6gns., Mr. Ashlin, Edward St., Hampstead Road.
1836 233 *Market People crossing the Lancaster Sands*, 6gns., Lady Louisa Cornwallis.
1836 237 *Chatsworth Park, Derbyshire*, Sold.
1836 239 *Bolton Castle, Yorkshire - Twilight*, 12gns.
1836 241 *Harlech Castle from Tan-y-Bwlch*, 5gns., Austin Esq., 33 Guilford Street.
1836 243 *Heath Scene*, 6gns., D. Colnaghi Esq., Pall Mall East.
1836 261 *Boats on the Scheldt*, 4gns., S. Fuller Esq., Rathbone Place.
1836 263 *Bridge near Coniston Lake, Westmorland*, 5gns.
1836 271 *Windmill - Morning*, 5gns., D.T. White Esq., 15 Princes St., Hannover Sqre.
1836 275 *Waterfall on the Luggy, North Wales*, 4gns., Sir Thos. Baring, 21 Devonshire Place.
1836 281 *Landscape*, Sold.
1836 292 *Near Loch Awe, North Britain*, 5gns., M. Wilkinson Esq.
1836 293 *On the French Coast - Evening*, 4gns., Mr. Boys, 11 Golden Square.
1836 296 *Lancaster Sands - Morning*, 8gns., Mr. Vaughan, 28 Cumberland Terrace, Regents Park.
1836 306 *Road Scene with Figures*, Sold.
1836 309 *On the Road from Tremaddoc to Beddgelert, North Wales*, 5gns.
1836 319 *Cottages near Bettwas-y-Coyed, North Wales*, Sold.
1836 324 *Cricaeth Castle, North Wales*, 4gns.
1836 326 *Evening*, Sold, Revd. R. Cattermole.
1836 327 *Showery Day*, 5gns., Mr. Fuller, Rathbone Place.
1836 333 *Aston Hall, Warwickshire*, Sold.
1836 335 *Barden Castle, from Bolton Park, Yorkshire*, 5gns.
1836 337 *Snowdon, and Moel Siabod Mountains, from Pentre Voelas, North Wales*, 7gns.
1836 342 *On the Road from Sheffield to Baslow, Derbyshire*, Sold.
1837 3 *Cottage on Gills Heath, Warwickshire*.
1837 30 *A Mountain Road - Infantry on their March*, J.H. Maw Esq., Aldersgate Street.
1837 138 *Landscape - Showery Day*, 6gns.

1837	139	*Road Scene*, Sold.
1837	142	*Near Harlich, North Wales*, 8gns.
1837	151	*Heath Scene*, Sold.
1837	152	*Goodrich Castle, Herefordshire*, Sold.
1837	161	*Windsor Castle - Morning*, Sold.
1837	168	*Portrait Gallery*, Sold.
1837	188	*Market People crossing Lancaster Sands*, 4gns., S. Pye Esq.
1837	193	*Water-Mill, near Dolbenmaen*, 5gns., J. Ruskin Esq., Herne Hill.
1837	201	*Lane Scene*, 6gns.
1837	243	*Landscape, Cattle and Drivers*, Sold.
1837	250	*Pont y Cefn, near Capel Cûrig, North Wales*, **Sold.**
1837	263	*Cottage in Surrey*, Sold.
1837	273	*Vallis Crucis Abbey, near Llangollen*, Sold.
1837	274	*Calais Pier*, Sold.
1837	302	*Lancaster Sands - Evening*, 6gns., Rainbow Esq., Hazel(?) Road, N. Brixton.
1837	306	*Windsor Castle*, Sold.
1837	308	*Entrance to Calais Harbour*, 6gns., Harcourt Esq., Crawleys Hotel, Albemarle St..
1837	310	*Cyssylte Aqueduct*, Sold.
1837	319	*Haddon Hall, Derbyshire*, Sold.
1837	325	*Showery Day*, Sold.
1837	327	*Windermere Lake*, Sold.
1837	329	*Public House, side of Ulverstone Sands*, Sold.
1837	334	*Road near Ulverstone*, 5gns., G. Cattermole Esq., 36 Gerrard Street.
1837	335	*Kenilworth Castle*, 5gns., Thos. Wood Esq., 39 Craven Street, Stroud.
1837	351	*Ploughing*, Sold.
1837	362	*Cornfield - Mid-day*, Sold.
1837	363	*Evening - Gleaners returning*, Sold.
1838	18	*Returning from Hawking - Haddon Hall*.
1838	73	*Ulverston Sands*.
1838	78	*The Louvre and Tuilleries, from Pont Neuf*.
1838	86	*Bolton Abbey, Yorkshire*.
1838	87	*Windmill, near Kenilworth*.
1838	103	*Kenilworth Castle*.
1838	115	*Boat on the Thames*.
1838	124	*On the Coast near Aberdovey*.
1838	125	*Rocky Scene - Infantry on the March*.
1838	139	*Road Scene, with Gypsies*.
1838	145	*On the Thames, near Gravesend*.
1838	148	*River Scene, North Wales*.
1838	154	*The Pier at Ulverstone*.
1838	155	*Terrace in the Garden at Powis Castle*.
1838	166	*Near Bolton Park, Yorkshire*.
1838	167	*Gypsies*.
1838	170	*Garden Scene - Powis Castle*.
1838	173	*Dover Pier*.
1838	179	*Ploughing*.
1838	193	*Landscape, near Woodstock*.
1838	220	*Lancaster Sands - Morning*.
1838	227	*Harlech Castle*.
1838	265	*Castleton, Derbyshire*.
1838	296	*Powis Castle, the Seat of the Right Honourable Lord Clive*.
1838	302	*Noon - Boys Angling*.
1838	309	*Going to Market*.
1838	316	*Penmaenmawr, North Wales*.
1838	323	*Going out Hawking*.
1838	326	*Barden Tower, on the Wharfe, Yorkshire*.
1838	331	*Drovers*.
1838	336	*A Mountain Road*.
1838	345	*Stirling Castle - Cavalry on the March*.
1839	10	*Market People crossing Lancaster Sands*, 40gns., C. Birch Esq., Tipton, Nr. Birmingham.
1839	20	*A Farm in Staffordshire*, Sold.
1839	22	*Boys Angling*, Sold.
1839	34	*Barden, from Bolton Park*, 8gns.
1839	60	*The Town Walls, Conway*, 5gns.
1839	71	*Going to Market*, 15gns.
1839	83	*Bolsover Castle, Derbyshire*, 5gns., C. Hughes, 17 Gate St., Lincolns Inn Fields.
1839	94	*Cavalry on the March*, 5gns.
1839	96	*Going to Hay Field*, 15gns.
1839	100	*View near Windsor*, 6gns.
1839	104	*Rocky Scene, with Brigands*, 15gns.
1839	112	*Cadir Idris, North Wales*, Sold, H. Gastineau Esq., to be sent with his drawings.
1839	119	*A Lane Scene*, 6gns.
1839	125	*A Hay Field*, Sold.
1839	156	*Evening*, 6gns., I.M. Herbert Esq., 9 Old Square, Lincoln's Inn.
1839	157	*A Saw Pit*, 15gns.
1839	164	*A Summer Day*, 6gns.
1839	166	*On the Thames - Morning*, Sold.
1839	169	*On the Holyhead Road, near Penmaenmawr, North Wales*, 40gns.
1839	190	*Bala Lake, North Wales*, 6gns., J.S. Froude(?) Esq., 43 Lincoln's Inn Fields.
1839	224	*A Hay Cart*, Sold.
1839	236*	*Inverary Castle*, 5gns., J. Angell Esq., Southampton St., Bloomsbury.
1839	280	*Battersea Fields*, 6gns., The Marquis of Conyngham, Dudley House, Her Majesty.
1839	287	*A Mountain Road*, 5gns.

1839	288	*A Marine Village - Morning*, 5gns., C. Baring Wall Esq. M.P., 44 Berkeley Square.
1839	297	*A Castle in the Olden Time*, 8gns., Marquis of Conyngham, Her Majesty.
1840	3	*From the Tremadoc Road, looking towards the Pass of Pont Aberglaslyn, North Wales*.
1840	15	*A Brook*.
1840	23	*A Forest*.
1840	75*	*Boats on the Thames*.
1840	82	*A Bay Window in the Portrait Gallery, Hardwick*.
1840	89	*The Portrait Gallery, Hardwick Hall, Derbyshire*.
1840	94	*Throne in the Portrait Gallery, Hardwick Hall*.
1840	108	*A Farm Yard*.
1840	123	*Mill on the Trent*.
1840	132	*Water Mill in Staffordshire*.
1840	145	*Mountain Road*.
1840	154	*Rocky Coast*.
1840	172	*Harlech Castle, North Wales*.
1840	218	*Coast Scene*.
1840	244	*Pier at Liverpool*.
1840	284	*A Wood Scene*.
1840	290	*Bolsover Castle, Derbyshire*.
1840	297	*Hardwick Park, Bolsover Castle in the Distance*.
1841	38	*Noon*, 5gns., Gubbins Esq., Whitechapel, To go to Tooth.
1841	43	*Market People Crossing the Lancaster Sands*, 20gns., Henry Johnson, 20 St. Petersburgh Place, Bayswater, Art Union.
1841	53	*Road through a Wood - Tan-y-bwlch, North Wales*, 20gns., Henry Brown, Welfield House, Streatham, Art Union.
1841	125	*On the River Llygwy, North Wales*, 8gns.
1841	210	*Landscape - Composition - Brigands Reposing*, 18gns.
1841	213	*Lancaster Sands, from Hest Bank*, 10gns.
1841	275	*A Heath Scene*, 10gns., W. Evans Esq., Eton.
1841	315	*Vale Crucis Abbey, North Wales*, 10gns., Mr. Geo. Constable, Arundel, Sussex.
1841	317	*A Brook Scene*, 8gns.
1841	324	*Windsor Castle, from Sandpit Gate*, 15gns., Richd. Ellison Esq., Sudbrooke Holme, Lincolnre.
1842	5	*Brook Scene*.
1842	33	*Lancaster*.
1842	82	*The old Holyhead Road, near Penmachuo*.
1842	129	*Twilight*.
1842	148	*Distant View of Kenilworth Castle*.
1842	150	*Corn Field - Kenilworth Castle*.
1842	158	*Bolsover Castle*.
1842	171	*Powis Castle*.
1842	208	*Farm Yard, at Beckenham, Kent*.
1842	237	*Lane at Harbourne, Staffordshire*.
1842	248	*Bolton Abbey*.
1842	257	*Gypsies*.
1842	263	*Going to Plough*.
1842	271	*Heath Scene*.
1842	294	*Powis Park*.
1842	300	*Gate Tower, Kenilworth Castle*.
1842	303	*Fern Gatherers*.
1842	338	*Breiddyn Hills, from Powis Park*.
1843	54	*Sands at Rhyl, North Wales*, 12gns.
1843	57	*Penmaen Mawr, North Wales*, 30gns., Jos. Fielden Esq., Whitton House, Blackburn, Lancashire.
1843	130	*Cader Idris, North Wales*, 10gns., M. Bufzard Esq., Lutterworth, Prize of 10£ in the Art Union of London.
1843	133	*Bolsover Castle, Derbyshire*, 50gns.
1843	156	*Stubble Field with Gleaners*, 25gns.
1843	183	*River Wrion, North Wales*, 50gns.
1843	189	*On the Wharf, near Bolton Abbey*, 8gns.
1843	199	*Sherwood Forest*, 8gns.
1843	237	*Wharton Hall, Yorkshire*, 8gns.
1843	257	*Chatsworth*, 8gns., John C. Bourne Esq., 19 Lambs Conduit Street.
1843	270	*Lancaster Sands - Morning*, 15gns.
1843	281	*Harlech Castle, North Wales*, 10gns., Charles Brown, Coomb House, Croydon.
1843	289	*Kenilworth Castle*, 10gns., Charles Brown Esq., Coombe House, Croydon for the Art Union, Prize of 20£.
1843	303	*A River Scene*, 10gns.
1843	337	*Vale of Conway from near Llanbedr*, 35gns., Walker Esq., Birmingham.
1844	16	*Summons to the Noonday Meal - North Wales*, Sold.
1844	39	*Scene in Bolton Park, Yorkshire*, 45gns., Frame and glass £7.0.0.
1844	62	*A Mill near Bromsgrove*, 8gns., Frame and glass £3.10.0.
1844	103	*Bala Lake, North Wales*, 40gns., Frame and glass £7.0.0.
1844	114	*Lower End of Llyn Dinas, N. Wales*, 30gns., Richard Dalton Esq., University Club, Frame and glass £6.6.0, P.AU.
1844	141	*Merivale - Seat of W.S. Dugdale, Esq. M.P.*, Sold.
1844	165	*A Moor Scene, Yorkshire*, 40 gns., Frame and glass £7.0.0.

| 1844 | 228 | *A Mill on the Trent*, 8gns., Stewart Esq. |

1844 228 *A Mill on the Trent*, 8gns., Stewart Esq.

1844 275 *Mountain Road, near Harlech*, 10gns., Frame and glass £3.10.0.

1844 280 *River Scene, Derbyshire*, 8gns., Stewart Esq.

1844 288 *Powis Park*, 8gns., R.H. Robertson, 9 Watling St., Frame and glass £3.10.0.

1844 309 *On the River Llugwy, near Capel Cûrig, N. Wales*, 8gns., Revd. T.A. Firminger, Sittinbourne, Kent, Frame and glass £3.10.0.

1845 32 *Distant View of Kenilworth Castle*, 20gns., J. Stewart Esq., 3 Gloucester Crescent, Regents Park.

1845 59 *Gipsies - Early Morning*, Sold.

1845 60 *Market People crossing the Lancaster Sands*, 15gns., Col. Pennant, Frame and glass £2.12.6.

1845 69 *Distant View of Brough Castle*, 25gns.

1845 101 *Knaresborough Castle*, 25gns., W.Curling Esq., Club Chambers, 15 Regent St., P.AU. 15£.

1845 112 *Cloudy Day*, 18gns., N. Wilkinson Esq., 15 Regent Street.

1845 132 *Garden Terrace, Haddon*, 30gns.

1845 146 *River Wye, near Chepstow*, 10gns.

1845 209 *Mill, near Conway, North Wales*, 8gns., F.S. Lace Esq., Ingthorpe Grange.

1845 248 *Hampton Court*, 10gns., I. Beadwell Esq, West Green Road, Tottenham.

1845 250 *Dryslwyn Castle, Vale of Towy, South Wales*, 10gns., R.H. Solly Esq., 48 Gt. Ormond St.

1845 262 *Morning*, 5gns., Prior Esq., 7 Middleton Square.

1845 318 *Evening*, 5gns., Hon. Col. Pennant, Frame and glass no.

1845 335 *Cottages in Cheshire*, Sold.

1845 338 *Mid-day*, 5gns.

1845 340 *Going to Plough*, 10gns., J.J. Ruskin Esq.

1846 9 *Hardwick Hall, Derbyshire*, 35gns.

1846 55 *Outskirts of a Forest*, 35gns., D. Cox Esq., Greenfield House, Harbourne, nr. Birmingham.

1846 75 *Vale of Dolwyddelan, North Wales*, 35gns.

1846 87 *Mill at Bettws y Coed, North Wales*, 15gns.

1846 96 *The Watering Trough*, 25gns.

1846 138 *Ford over the River Wharfe, above Otley, Yorkshire*, 12gns., S.H. Hawkins Esq., 105 Pall Mall.

1846 149 *A Brook Scene*, 12gns., Hogarth Esq., Haymarket.

1846 164 *A Mountain Spring*, 30gns.

1846 194 *Knaresborough Castle, Yorkshire*, 10gns.

1846 216 *Cottages at Bettws y Coed, North Wales*, 10gns., George Constable Esq., Arundel.

1846 218 *Near Atherstone, Warwickshire*, 10gns.

1846 226 *Harlech Castle, North Wales*, 12gns., John Martin Esq., 14 Berkeley Sq.

1846 275 *Corn Field, near Rhyl, North Wales*, 10gns., Richard Ellison Esq., Frame and glass £1.10.0.

1846 278 *A Weedy Bank*, 12gns., G. Harrison Esq.

1846 289 *Cottages at Rowley, Staffordshire*, 10gns.

1847 45 *River Llygwy, from Pont-y-Kyfyn, near Capel Cûrig*, 35gns.

1847 76 *Windsor Park*, 50gns.

1847 83 *George's Dock, Liverpool*, 5gns.

1847 104 *Mill near Llangadoc, S. Wales*, 8gns.

1847 116 *Bolton Abbey*, 50gns., Miss Wilkinson, 32 Park St., Grosvenor Sq.

1847 117 *East Cliffs, Hastings*, 5gns., N. Wilkinson Esq.

1847 122 *Caer-Cennen Castle, S. Wales*, 7gns., T. Taylor, 3 Fig Tree Ct.(?), Temple.

1847 165 *Vale of Dolwyddelan, North Wales*, 30gns., Mrs. Wilkinson, 32 Park St.

1847 186 *Cottages at Bettws-y-Coed*, Sold.

1847 210 *Mill in Staffordshire*, 6gns., H. Burton(?) Esq.

1847 227 *Near Atherstone, Warwickshire*, 10gns., Mrs. Wilson, ???.

1847 242 *Moorland near Kirby Stephen*, 8gns.

1847 281 *Welsh Scenery*, 10gns., J.M. Rainbow(?), Guilford Lodge, Upper Tulse Hill.

1847 310 *Vale of Clwyd*, 10gns., W.B. Morgan Esq., Grove, Highgate and 14 Angel Court, Throgmorton Street.

1848 13 *Lower end of the Vale of Clwyd, North Wales*, 40gns., Joseph Parrinton Esq., 20 Crooms Hill, Greenwich.

1848 32 *Going to the Hayfield*, 50gns.

1848 45 *A Green Lane, Staffordshire*, 50gns.

1848 97 *The Skylark*, 45gns., C.F. Cheffin Esq.

1848 114 *Windy Day*, 10gns., Capt. Wigram, 68 Portland Place.

1848 129 *River Trent*, 18gns.

1848 154 *Peace and War*, 50gns.

1848 206 *Sherwood Forest*, 40gns.

1848 213 *Haymaking - Festiniog, North Wales*, 8gns., I.H. Hawkins Esq., 105 Pall Mall.

1848 254 *Showery Day*, 12gns., J. Stewart Esq.

1848 264 *A Gravel Pit*, 8gns., S. Angell Esq.

1848 307 *Mountain Stream, Trefrew, North Wales*, 8gns., Tom Tayler, 3 Fig Tree Court(?), Temple.

1848 322 *Village of Rowsley, Derbyshire*, 8gns., H. Burton.

1848 341 *Holyhead Road, near Pentre Voelas, North Wales*, 15gns., I.H. Hawkins Esq., 105 Pall Mall.

1849 27 *Barden Tower, Yorkshire*.

1849 33 *The Night Train*.

1849	86	*Counting the Flock.*
1849	106	*The Missing Flock.*
1849	138	*Cross Roads.*
1849	158	*Beeston Castle, Cheshire.*
1849	179	*Shepherds Collecting their Flocks.*
1849	233	*Lane in Surrey.*
1849	256	*Going to the Corn Field.*
1849	268	*Cottages at Rowley, Staffordshire.*
1849	278	*Near Altringham, Cheshire.*
1849	305	*River Leder - from Pont-y-Pant.*
1849	309	*The River Machno, N. Wales.*
1849	320	*Mill of Bettws-y-Coed, N. Wales.*
1849	340	*Rainy Day.*
1849	348	*From the Mountain above Bettws-y-Coed.*
1850	24	*Summer,* 50gns., J. Parrinton Esq.
1850	28	*A Rocky Glen,* 8gns., J.W. Brown Esq., Claremont Villas, Brixton Hill.
1850	35	*Changing the Pasture,* 40gns., John W. Brown Esq., Claremont Villas, Brixton Hill.
1850	81	*Vale of the Conway - Evening,* 10gns., Mrs. Francis Fuller, Frame and glass £2.7.6 New 4 inch swept.
1850	133	*Beaver Grove, Bettws-y-Coed,* 8gns., S.W. Whymper Esq., 20 Canterbury Place, Lambeth.
1850	141	*Blackberry Gatherers,* 35gns., Capt. Geo. Hotham.
1850	143	*Cottages near Bettws-y-Coed,* 8gns., Jo Vokins.
1850	152	*The Water Tower, Kenilworth Castle,* 30gns.
1850	171	*The Vale of Conway,* 8gns., Mrs. Parrinton, Croydon.
1850	212	*A Welsh Funeral, Bettws-y-Coed, North Wales,* 80gns., W.T. Masten Esq., Sleaford, Frame and glass £6.0.0, AU. 80.
1850	295	*River Machno, near Pandy Mill, North Wales,* 10gns., Wm. Ray Snell(?), Bank of England.
1850	296	*Rocks near Bettws-y-Coed,* 8gns., W. Vokins.
1850	297	*Flint Castle,* 8gns., Miss Leigh Smith.
1850	355	*A Farm at Bettws-y-Coed, North Wales,* 10gns., Miss Barrinton.
1850	366	*Near Pandy Mill, North Wales,* 10gns., I.G. Cattley.
1851	70	*Rocky Scene, near Capel Cûrig, North Wales.*
1851	102	*Going to the Hay-field.*
1851	111	*A Gipsy Encampment.*
1851	124	*Morning.*
1851	126	*Shearing Sheep - Vale of Dolwyddelan.*
1851	132	*Corn-field, Bettws-y-Coed, North Wales.*
1851	135	*Cutting Green Rye.*
1851	138	*Laugharne Castle, South Wales.*
1851	248	*Beaver Grove, Bettws-y-Coed.*
1851	265	*Moel Siabod, near Capel Cûrig, North Wales.*
1851	269	*Sketch near Llanrwst, North Wales.*
1852	10	*Cottages at Harbourne, Staffordshire,* 6G, George Sharp, 10 Wentworth Place, Dublin for John Crampton, Washington, U.S..
1852	58	*Part of Conway Castle,* 6G.
1852	62	*On the River Conway, near Bettws-y-Coed,* 6G, Mrs. Mollett.
1852	129	*Bettws-y-Coed Church, North Wales,* 50G.
1852	147	*Besom Makers gathering Heath on Carrington Moss, Cheshire,* 50G, J. Noble Esq.
1852	158	*On the Llugwy, near Bettws-y-Coed,* 8G.
1852	198	*Peanmean Bach, on the Coast between Conway and Bangor,* 50G.
1852	232	*A Peat Bog above Bettws-y-Coed,* Sold.
1852	252	*Lane near Llanrwst, North Wales,* 10G, Capt. Wigram, 68 Portland Place.
1852	264	*Gipsies Crossing a Heath,* 8G, F.W. Topham Esq.
1852	284	*Mountain Path above Bettws-y-Coed,* 8G, George Sharp, 10 Wentworth Place, Dublin for John Crampton, Washington, U.S.
1852	286	*Lane near Sale, Cheshire,* 8G, John Bostock Esq.
1852	301	*On the Coast near Rhyl, North Wales,* 8G, G. Constable.
1853	20	*Rainbow.*
1853	58	*Barden Castle.*
1853	78	*Near Bettws-y-Coed, North Wales.*
1853	79	*Mountain Rill.*
1853	91	*Mountain Pastoral.*
1853	119	*The Summit of a Mountain.*
1853	175	*The Challenge.*
1853	222	*The Old Road from Capel Cûrig to Bangor.*
1853	238	*North-East Point of Great Orms Head.*
1853	242	*Windy Day.*
1853	272	*Coast of Rhyl, North Wales.*
1853	292	*Lane near Bettws-y-Coed, North Wales.*
1853	294	*Bathers.*
1854	107	*Near Capel Cûrig,* 7gns., Henderson Esq.
1854	164	*Keep the Left Road,* 80gns., Sharp Esq., Frame and glass £10.10.0.
1854	254	*Snowdon, from near Capel Cûrig,* Sold, Wm. Collingwood Smith Esq.
1854	304	*Peat Gatherers,* Sold.
1854	320	*Cutting his Stick,* Sold.
1854	329	*Ludford Bridge,* Sold.
1854	335	*Crossing the Downs,* Sold.
1855	31	*Skirt of a Wood,* Sold.

1855	32	*Flint Castle*, Sold.
1855	57	*Snowden, from Capel Cûrig*, 25gns., Sold.
1855	100	*Hay Field*, 25gns., Frame and glass £12.0.0.
1855	106	*The Coming Gale*, Sold.
1855	107	*Besom Makers carrying Heather*, 20gns., George Constable Esq., Sefton House, Arundel.
1855	108	*Crossing the Heath - Moonrise*, Sold.
1855	236	*Gipsy Encampment*, Sold.
1855	243	*Going to Market*, Sold.
1855	248	*Heath Scene*, Sold.
1855	250	*The Old London Stage*, Sold.
1855	257	*Asking the Way*, 25gns.
1855	286	*Church at Bettwys-y-Coed*, Sold.
1855	294	*Near Ludlow*, Sold.

COX D JUN

1850	56	*Guildford, from the Banks of the Wey*, 20gns., Mrs. Solomon(?) Maw.
1850	88	*Distant View of Hardwick Hall, Derbyshire*, 20gns., Mrs. George Hotham, 74 Oxford Terrace.
1850	119	*Folkestone, Kent*, 6gns.
1850	122	*Goring Church, Oxfordshire*, 8gns., Rev. S. Ramsden Roe, The Limes, Gt. Stanmore, Middlesex.
1850	201	*Hever Castle, Kent*, 12gns., Benj. Leigh Smith, 5 Blandford Sq.
1850	225	*Garden Scene*, 8gns.
1851	30	*On the River Arun, near Arundel*.
1851	43	*Waterfall and Mill on the River Machno, North Wales*.
1851	58	*On the River Llugwy, North Wales*.
1851	73	*Lane near Kenilworth*.
1851	94	*Junction of the Rivers Conway and Lledr*.
1851	108	*Penmachno Mill*.
1851	256	*On the River Conway*.
1852	21	*On the River Ogwen, below Nant Frangon*, 5G, M.E. Ellis Esq., 1 Birchin Lane.
1852	29	*Sussex Oaks*, 5G.
1852	49	*Near Capel Cûrig*, 5G, A. Morison Esq.
1852	87	*Distant View of Conway*, 15G, John Bawtree Junr., Colchester, AU. 15£.
1852	122	*Conway Towers*, 10G, Robert Hazeon Esq., 10 Gt. College Street, Camden Town, Frame and glass £2.2.0, AU.
1852	140	*On the River Machno, North Wales*, 20G.
1852	165	*Near Aber, North Wales*, 6G.
1852	205	*Summer Idleness*, 15G.
1853	7	*Stokesay Castle - Moonlight*.
1853	15	*Valence*.
1853	95	*Jullins, on the Isere*.

1853	113	*Village of Sassenage, and Mountains, near Grenoble*.
1853	164	*Bringwood Chase, Salop*.
1853	174	*Vienne, on the Rhone*.
1853	183	*Grenoble, from Grande Tronche*.
1853	196	*Ludlow Castle, Salop*.
1854	21	*Stokesay, Salop*, 15gns.
1854	44	*Beaver Pool on the Conway, North Wales*, 18gns., T.M. Poole.
1854	126	*Near Capel Cûrig*, 8gns., Mrs. Davison.
1854	166	*Uffington, Sussex*, 8gns., His Grace The Archbishop of Canterbury.
1854	178	*Valley of Grésivaudan, Isere, from near Voreppe*, 30gns.
1854	205	*A Welsh River*, 18gns., Wm. Nollins, Pleaxley Vale, Mansfield, Notts.
1854	209	*Oak Trees near Worthing*, 8gns.
1854	212	*Sketch on the Llugwy*, 10gns.
1855	33	*Bringwood Chase, from Downton Woods, Hertfordshire*, 30gns.
1855	45	*On the Llugwy, North Wales*, 20gns.
1855	49	*Denbigh Castle*, 25gns., Thos. Lambert, 39 Russell Square, Frame and glass Foorde £4.15.0.
1855	140	*In Richmond Park*, 6gns., George Coles, Clapham Park.
1855	156	*River Scene*, 6gns., Miss E. Clarke, 17 Royal Parade, Cheltenham.
1855	175	*Vale of the Conway*, 25gns.
1855	180	*Conway Castle*.
1855	188	*Ludlow Castle - Evening*, 10gns.

COX DAVID JUN

1849	3	*Malling Abbey, Kent*.
1849	36	*Roslin Castle*.
1849	61	*Gateway of Leyburn Castle, Kent*.
1849	116	*Mill near Rhw, North Wales*.
1849	209	*Chilham, Kent - from the Gardens*.
1849	261	*Trottescliffe Church, Kent*.
1849	322	*Bridge over the Ledder*.
1849	343	*Chilham - Afternoon*.
1850	36	*View from Wrotham Hill, Kent*, 18gns., W. Vokins.
1850	187	*Near Llan Iltyd, North Wales*, 8gns., Mrs. Joseph Robinson, Berkhampstead, Herts, Frame and glass £2.3.6 New with margin.
1851	207	*View of the Caernarvonshire Mountains from near Bettws-y-Coed, North Wales*.

CRANMER C

1813	220	*A Cottage*.
1813	230	*A Cottage*.

CRIDDLE MRS H

1849	73	*"With him she pray'd, to him his Bible read . . ." Vide Crabbe's Borough - The Church*.

1849	187	*Nature and Art.*
1849	226	*Lavinia and her Mother, "Together thus they shunn'd the cruel scorn . . ." Vide Thomson's Seasons.*
1849	358	*Phoebe Dawson, "In haste to see, and happy to be seen." Vide Crabbe's Poems - The Parish Register.*
1850	74	*Resignation*, 10gns., Frame and glass £2.10.0.
1850	238	*The Little Culprit*, 40gns., James Walker Esq., 23 Great George Street.
1851	164	*Wild Flowers.*
1851	203	*Edith Granger on the eve of her Marriage - Vide Dombey and Son.*
1851	213	*Molly's Appeal (see old Song).*
1852	204	*The Irksome Task*, 40G, Frame and glass £3.13.6.
1853	116	*A Little Quiet Enjoyment.*
1853	156	*The Soldier's Legacy.*
1853	195	*"Ye little loves that round her wait, To bring me tidings of my fate, As Celia on her pillow lies, Ah! gently whisper – Strephon dies."*
1853	244	*The First Sorrow – "Thy will be done."*
1854	15	*The Sisters. Crabbe's Tales of the Hall, Book VIII., "She then, for Lucy mild forbearance tries . . ."* £50.0.0, Frame and glass £3.3.0.
1855	246	*The Thoughts Elsewhere*, 10gns.

CRISTALL J

1805	15	*A scene near Windsor.*
1805	32	*Snowdon, from Capel Carig: Morning.*
1805	93	*The judgment of Paris, "Then to the son of Priam came, & c." Vide Potter's Euripides.*
1805	99	*The rival goddesses, "Soon as they reach'd the shady grove, Undress'd . . ." Vide Potter's Euripides - Andromache.*
1805	126	*The pool of three grains, Tallyllyn in the distance.*
1805	129	*Harlech, Merionethshire, North Wales.*
1805	165	*Ambrosio and Matilda, from the Monk: a sketch.*
1805	171	*Lycidas, "Thus sang the unlettered swain to the oaks and rills . . ." Milton.*
1806	20	*"Cheer'd by the milder beam, the sprightly youth speeds to the well-known pool." Thompson's Summer*
1806	83	*A Well near Ambleside.*
1806	91	*A Well, near Ambleside.*
1806	117	*Shepherds, "Sweet are the whispers of yon vocal pine . . ." Theocritus.*
1806	135	*A study from Nature.*
1806	150	*The Rape of Proserpine - Ovid's Metamorphosis, Book V.*
1806	152	*A Sketch.*
1806	169	*Study from Nature.*
1806	195	*A Study from Nature.*
1807	34	*Phaeton.*
1807	77	*A boy fishing*, Lord Essex.
1807	84	*A woodcutter*, Lord Essex.
1807	89	*Bacchus and Ariadne, a sketch.*
1807	157	*Diana and Endymion.*
1807	205	*A landscape.*
1807	262	*Hylas and the nymphs*, Thos. Welsh Esq.
1807	305	*Hop-picking*, Mr. Beardmore.
1808	37	*The fish-market, Hastings.*
1808	58	*Coast of Sussex, pushing off a boat to a vessel in distress*, 100gns., Duke of Argyle.
1808	82	*Fishermen bringing lobsters ashore.*
1808	89	*Bird-catcher.*
1808	188	*The cottage door*, 5gns., Mr. G. Barrett.
1808	200	*A lobster boy*, Mr. B. Oakley.
1808	239	*A sketch.*
1808	249	*A fisherman making nets*, 6gns., Lord Whitworth.
1808	250	*Fishermen mending nets.*
1808	289	*Margate.*
1808	302	*Hastings, fishing boats coming in.*
1809	131	*The deluge, a sketch.*
1809	183	*Embarking on board the packets, Margate.*
1809	211	*Fairlop Fair, a sketch*, Mr. Vine.
1809	270	*A girl with sticks*, Miss Fanshawe.
1809	286	*A study from nature.*
1809	318	*A cottage girl.*
1810	7	*Girl with a Basket of Sticks.*
1810	53	*Children at a Cottage Gate.*
1810	80	*A Girl at a Well.*
1810	85	*A Cutter, at Hastings, Sussex.*
1810	219	*Fishing Boats at Hastings, Sussex.*
1810	220	*A Shepherd on the Cliff, Hastings.*
1810	241	*A Gleaner.*
1811	29	*View near Buttermere, Cumberland.*
1811	49	*Girl Shelling Peas.*
1811	63	*Girl at a Well.*
1811	111	*Arcadian Shepherds, vide 7th Pastoral of Virgil*, Mr. Wheeler.
1811	123	*Lake Nemi.*
1811	128	*A Poor Boy.*
1811	262	*Girl with Fish.*
1811	283	*A Girl and Pitcher.*
1811	285	*A Gleaner.*
1811	289	*Dover Pier.*
1811	298*	*A View near the Wye.*

1811	305	*View in Windsor Forest.*
1811	334	*View near Beddgelert.*
1811	356	*Girl on a Heath.*
1811	365	*In Hatchet-Lane, near Windsor.*
1812	22	*Fishermen, at Hastings.*
1812	36	*Boys angling, Mrs. Hodson.*
1812	46	*Travellers reposing, a Scene near Hastings.*
1812	64	*Solitude.*
1812	100	*Cottages, at Capel Carig, North Wales.*
1812	111	*Gleaners.*
1812	158	*A Garden Scene.*
1812	165	*Cottage Children at Needlework.*
1812	172	*A Wood-Cutter.*
1812	224	*A Shepherd, near Hastings.*
1812	228	*Girl at a Spring.*
1812	237	*Cottage Children at a Gate.*
1812	245	*A Gleaner returning Home.*
1812	254	*Girl at a Well.*
1812	276	*Scene near Harrow.*
1812	302	*Fishermen going on Board, at Hastings.*
1812	329	*A Child returning from Gleaning.*
1813	46	*Greek Shepherds, £26.5.0, Lady de Grey.*
1813	47	*View near Beddgelart, North Wales.*
1813	60	*View of Penmaunmawr, North Wales.*
1813	81	*A Cottage at Birchett's Green, near Maidenhead, Berks.*
1813	85	*A Cottage at Bon Church, Isle of Wight.*
1813	90	*Puckester Cove, near Niton, Isle of Wight.*
1813	92	*A Girl with Sticks.*
1813	95	*A Cottage Sempstress, £21.0.0, General Ramsey.*
1813	108	*A Child at a Well.*
1813	111	*A Fisherman, at Puckester, Isle of Wight.*
1813	134	*View near Rosstwaithe, Cumberland.*
1813	139	*Rocks near Niton, Isle of Wight.*
1813	180	*Under-Cliff, Niton, Isle of Wight.*
1814	73	*Vessel on the Rocks near Dover - Sketch.*
1814	79	*Fisherman's Boy.*
1814	80	*Harlech Castle, Merionethshire.*
1814	86	*Fisherman's Boy, - Hastings Sussex.*
1814	87	*Scene near Beddkelert, North Wales.*
1814	91	*Landscape, with Figures.*
1814	95	*Bridge near Beddkelert, North Wales.*
1814	97	*A Gleaner.*
1814	98	*Children Reading - A Sketch.*
1814	113	*Cottage on the Road to Hastings, Sussex.*
1814	115	*Shepherds - Evening, £15.15.0, Mr. Dimsdale.*
1814	117	*View on the Coast of Hastings, Sussex.*
1814	120	*Rossthwaite, Cumberland.*
1814	128	*Girl with Elder Flowers.*
1814	143	*Fleet sailing up Channel, off Hastings, Sussex, Mr. Leader.*
1814	156	*Cottage at St. Lawrence, in the Isle of Wight.*
1814	161	*Boy in a Wood.*
1814	162	*Cutters, near Hastings, Sussex.*
1814	163	*Girl with Boughs.*
1814	172	*Margate Pier.*
1814	179	*Scene at Hastings, Sussex.*
1814	188	*Wastdale Head, Cumberland.*
1814	191	*Boy, with a Sleeping Child.*
1814	225	*Cottage, Berks.*
1814	254	*Puckester, Isle of Wight - Morning.*
1814	263	*Boy with a Dog.*
1814	271	*Boats - Hastings, Sussex.*
1814	285	*Fishermen - Puckester, Isle of Wight, £10.10.0, Mr. Kinnaird.*
1814	294	*Rocks near Niton, Isle of Wight.*
1815	38	*View of the Coldwell Rocks on the Wye, Monmouthshire.*
1815	43	*Girl at a Cottage Door, Steep-hill, Isle of Wight.*
1815	46	*Landscape and Figures.*
1815	67	*View of Crowcombe, Somersetshire.*
1815	107	*A Gleaner.*
1815	115	*A Mower, J. Allnutt Esq.*
1815	147	*Landscape, and Figures, £26.5.0, Mr. Barber, Birmingham.*
1815	209	*Shepherd and his Dog, £3.3.0, G. Dimsdale Esq.*
1815	217	*View of Goodrich Castle on the Wye, Monmouthshire, £3.3.0, Mr. Tomkison.*
1815	218	*Fisher Boy, Puckester, Isle of Wight.*
1815	246	*Girl going to Market, Binsted, Isle of Wight.*
1815	259	*Fisherman, Puckester, Isle of Wight.*
1815	291	*View of Chepstow Castle, Monmouthshire.*
1815	295	*Shepherds reposing on the side of a Mountain, £26.5.0, J. Bramwell Esq.*
1815	304	*Shepherds conversing.*
1815	332	*View on the New Weir on the Wye, Monmouthshire, £3.3.0, J. Allnutt Esq.*
1815	345	*View of Tintern Abbey, on the Wye, Monmouthshire, £3.3.0, Do. [Mr. Willmott.]*
1816	85	*In Ashy Wood Lane, Birchett's Green, Berkshire.*
1816	118	*Fishermen going out, Ventnor, near Steep-hill, Isle of Wight.*
1816	202	*Shepherd's Boy, South Down, near Brighton.*
1816	266	*Boy with Sticks, Windsor Forest.*

1816	273	*Iö metamorphosed into a Heifer, makes herself known to her Father, the river Inachus, and her former Companions, who are lamenting her loss,* Mr. Dimsdale.
1816	276	*Near Berchett's Green, Berkshire.*
1816	281	*Apollo and the Muses.*
1816	294	*Deal Boatmen.*
1816	295	*Mountain Shepherds, Morning.*
1816	300	*Landscape with Figures.*
1816	304	*Portrait of a Lady.*
1816	308	*Landscape with Shepherds.*
1816	313	*Boy with Gleanings.*
1816	321	*Near Beddgelart, North Wales.*
1817	74	*Latona and the Lycian Peasants, "She fled the furious Juno's power . . ." Vide Ovid's Metamorphoses, Book VI.*
1817	97	*Ross, Herefordshire.*
1817	239	*Landscape and Figures.*
1817	249	*Landscape with Figures.*
1817	259	*Puckester, Isle of Wight,* £10.10.0, J. Allnutt Esq.
1817	273	*A Gleaner.*
1818	4	*Mountain Shepherds.*
1818	15	*Scene at Medmenham, Bucks..*
1818	42	*Shepherds.*
1818	69	*Fishermen at Hastings, Sussex.*
1818	92	*Village of Medmenham, Bucks,* £52.10.0, C. Wood Esq.
1818	202	*Cottage Children.*
1818	211	*Boats coming in - Hastings, Sussex.*
1818	224	*A Peasant Boy.*
1818	225	*View of Harrow, from Hampstead Heath.*
1818	229	*Fisherman - Hastings, Sussex.*
1818	233	*Fisher Boy.*
1818	269	*Ashey Hill, Harley, Bucks.*
1818	276	*Scene at Medmenham, Bucks.*
1818	288	*Shanklin Chine, Isle of Wight.*
1818	298	*Water Fall, and Figures.*
1818	308	*View at Bonchurch, Isle of Wight.*
1818	309	*Gipsy Girl, Hampstead Heath.*
1818	310	*Chepstow Castle, Monmouthshire.*
1818	315	*View from Hampstead Heath.*
1818	317	*A Gleaner.*
1818	318	*Landscape and Figures.*
1818	319	*Goodrich Castle.*
1818	322	*Boy Angling, Windsor Forest.*
1818	324	*Storm. Woods set on Fire by Lightning, "As in the mountains a destroying fire . . ." Homer's Iliad. Book ii. v.456.*
1818	325	*Goatherds.*
1818	329	*The Transformation of Daphne into a Laurel. (Ovid's Metamorphoses.),* £31.10.0, T.G.
1818	332	*A Storm coming on.*
1818	333	*A Storm.*
1818	344	*Barking Timber in Witchwood Forest, Oxfordshire,* £15.15.0, J. Allnutt Esq.
1818	348	*Girl at a Well.*
1818	352	*Landscape and Figures.*
1818	366	*Mercury and Argus.*
1819	141	*Gipsies.*
1819	225	*Deal Boatmen.*
1819	274	*Portrait of a Lady.*
1819	301	*Landscape and Figures - Boys Bathing.*
1819	308	*Narcissus - (Vide Ovid's Metamorphoses).*
1819	312	*Highland Girl - Scene near Loch Lomond.*
1819	315	*Landscape and Figures.*
1819	323	*A Highland Shepherd Boy.*
1819	335	*Group of Scotch Peasants,* £6.6.0, G. Hibbert Esq.
1820	95	*Jupiter nursed in the Isle of Crete by the Nymphs and Corybantes,* £126.0.0, T.G.
1820	325	*Peasant Boy, Windsor Forest.*
1820	340	*Portrait of Master Harrison.*
1820	341	*Portrait of a Lady.*
1820	348	*Portrait of a Gentleman.*
1820	349	*Portrait of a Lady.*
1820	358	*Fisher Boy - Isle of Wight.*
1820	376	*Luss, on Loch Lomond, Dumbartonshire,* 8gns., Duke of Argyle.
1821	7	*Instruction - A Composition,* £21.0.0, Mr. Vine.
1821	12	*Glen Lochay, near Loch Tay, Breadalbane - Evening,* £8.8.0, J. Allnutt Esq.
1821	57	*Dolgelly Bridge, Merionethshire, North Wales.*
1821	60	*Girl at a Well-scene in Cumberland,* £4.4.0, Mrs. Charlton, Hexham.
1821	69	*Scotch Travellers resting near Ben More, Breadalbane,* £15.15.0, J.C. Warner Esq.
1821	77	*Mill at Dolgelly, Merionethshire, North Wales - Sketch from Nature,* £5.5.0, C. Wood Esq.
1821	79	*Unloading Peat at Luss, Loch Lomond.*
1821	81	*Loch Ketterine, near Lettree, Perthshire,* £8.8.0, T. Tomkison Esq.
1821	84	*Ben Venue, Perthshire.*
1821	88	*Counting Herrings, Hastings, Sussex.*
1821	102	*Landscape - Composition,* £12.12.0, Major Cockburn.
1821	112	*Girl making Lace,* £6.6.0, J. Allnutt Esq.
1821	119	*Phoebe Dawson, "Two summers since, I saw at Lammas fair . . ." Vide Crabbe's Parish Register.* £10.10.0, Mr. Towers.

1821	128	*"Lo!, One who an infant in her arms sustains . . ." Vide Crabbe's Parish Register.* £10.10.0, Mr. Towers.
1821	135	*Welsh Peasant, near Dolgelly, Merionethshire.*
1821	164	*Fishing Boats, Hastings, Sussex.*
1821	179	*Derwent River, near Keswick, Cumberland.*
1821	184	*Moonlight - Composition,* £5.5.0, Major Cockburn.
1821	188	*Abergavenny, Monmouthshire,* £4.4.0, Mr. Powell.
1822	38	*A Fountain - Composition,* £21.0.0, Major Cockburne.
1822	45	*Scene at Tal-y-Llyn, Merionethshire,* £4.4.0, C. Woodd(?) Esq.
1822	69	*Near Hurley, Berks,* £4.4.0, C. Stokes Esq.
1822	79	*Cottage near Capel Curig, Caernarvonshire,* £4.4.0, Lady Halford.
1822	91	*A Waterfall.*
1822	102	*Alpine Bridge, Beddgelart, Merionethshire,* £5.5.0, T.G.
1822	116	*Scotch Peasants - Luss, Dumbartonshire,* £21.0.0, C. Woodd Esq.
1822	123	*Welch Peasant, Tal-y-llyn, Merionethshire,* £7.7.0, T.G.
1823	9	*Cotton Spinning, Luss, Loch Lomond, North Britain,* £12.12.0, Duke of Argyll.
1823	19	*A Bridge at Achray near Loch Ketterine, North Britain.*
1823	21	*At Marcle, near Ledbury, Herefordshire,* £8.8.0, Countess de Grey.
1823	41	*Loch Katerine, North Britain,* £8.8.0, Rev. I.B. Sumner.
1823	107	*Girl at a Well,* £10.10.0, Marquis of Stafford.
1823	115	*Scene at a Fountain, Inverary, North Britain,* £52.10.0, R. Windus Esq.
1823	128	*Unloading Peat Boat at Luss, Loch Lomond, N. Britain.*
1823	155	*Welsh Peasant Girl, near Dolgelly, Merionethshire, North Wales.*
1823	161	*Welsh Girl, near Dolgelly, Merionethshire, North Wales.*
1823	201	*Mountain Peasant, near Dolgelly, Merionethshire, North Wales.*
1823	205	*Returning from Potatoe Digging, near Dolgelly, North Wales.*
1823	279	*Moel Hebog, Beth Gellart, Caernarvonshire.*
1823	283	*Snowdon, from Nant Gwynant, Caernarvonshire.*
1823	287	*At Nant Gwynant, Caernarvonshire.*
1823	294	*Beth Gellart Church, Caernarvonshire.*
1823L	6	*Puckester, Isle of Wight,* J. Vine, esq.
1823L	12	*New Wier on the Wye,* J. Allnutt, esq.
1823L	14	*Puckester, Isle of Wight,* J. Vine, esq.
1823L	17	*Girl at a Spring,* W. Leader, esq. M.P.
1823L	20	*Boy and Child at a Cottage Door,* J. Allnutt, esq.
1823L	22	*Shepherd - Evening,* J. Elliott, esq.
1823L	35	*Coast of Sussex - pushing off a boat to a vessel in distress,* Duke of Argyll.
1823L	39	*Puckester Cove, Isle of Wight,* J. Vine, esq.
1823L	52	*Fishermen,* J. Allnutt, esq.
1823L	58	*Daphne and Apollo, Vide Ovid's Metamorphoses.* T. Griffith, esq.
1823L	69	*Fishermen at Deal,* J.Allnutt, esq.
1823L	72	*Landscape - Boys Bathing,* J. Allnutt, esq.
1823L	76	*Gleaners,* J. Vine, esq.
1823L	77	*Shepherd - Evening,* J. Vine, esq.
1823L	78	*Hop-pickers,* J. Barrett, esq.
1823L	85	*Waterfall,* J. Allnutt, esq.
1823L	93	*Evening,* J. Allnutt, esq.
1823L	104	*Counting Herrings, Hastings,* J. Vine, esq.
1823L	105	*A Cottage Girl,* J. Gwilt, esq.
1823L	109	*Cottage Scene,* J. Vine, esq.
1823L	111	*A Child returning from Gleaning,* J. Gwilt, esq.
1823L	118	*Instruction - A Composition,* J. Vine, esq.
1823L	135	*Lace-Maker,* J. Allnutt, esq.
1823L	136	*A Study from Nature,* J. Vine, esq.
1823L	139	*Gleaner,* J. Vine, esq.
1823L	141	*A Girl at a Well,* J. Vine, esq.
1823L	157	*Composition,* G. Hibbert, esq.
1823L	158	*Fishermen,* J. Vine, esq.
1823L	165	*Gypsies,* J. Vine, esq.
1823L	169	*Boys Angling,* G. Hobson, esq.
1823L	184	*The Deluge,* C. Wood, esq.
1823L	191	*Sketch of the Deluge,* J. Vine, esq.
1823L	192	*Fisherman,* J. Vine, esq.
1823L	201	*A Lobster Boy,* J. Vine, esq.
1824	232	*Bess and her Spinning Wheel, "I'll sit me down and sing and spin . . ." Vide Burns.*
1825	5	*Welsh Peasant Girl on Cader Idris, Merionethshire,* 20gns., Mr. Delafield, Campden Hill, Kensington, Frame and glass Mr. Cristall, 32 Berwick Street, Oxford Street.
1825	15	*Cottage on Coppet-hill, near Goodrich, Herefordshire,* 15gns.(?), Sold.
1825	48	*Cottage near Goodrich, Herefordshire,* 15gns.
1825	69	*Landscape and Figures,* 15gns., George Hibberts Esq.
1825	85	*The Good Samaritan,* 8gns., J. Page Esq.(?).
1825	176	*Welsh Peasant Girls, with Cader Idris in the Distance,* Sold 100gns.
1825	197	*Scene on the Thames, near Henley,* 6gns.

1825	219	*Welsh Peasant Boy*, 10gns., Lord Northwick.
1825	272	*Welch Peasant Girl - Scene near Bethgellert*, 20gns., Mr. Delafield, Campden Hill, Kensington.
1825	296	*A Composition*, 4gns.
1825	303	*Scene near Beddgelert, Caernarvonshire*, 2gns., Mr. J. Pye.
1826	10	*Hercules dragging Cerberus from the infernal regions - A Sketch*, Sold.
1826	116	*Welch Peasant Girls*, 30gns., H. Harrison Esq., 41 Bedford St., Covent Garden.
1826	125	*Scene at Hastings, Sussex*, 10gns., Sold.
1826	129	*Scene at Callander, North Britain*, Sold.
1826	137	*Theseus, with the assistance of Ariadne, destroys the Minotaur - a Sketch*, Sold.
1826	139	*Daedalus and Icarus - a Sketch*, Sold.
1826	149	*A Welsh Peasant Girl crossing a Stream*, 10gns.
1826	197	*Cadmus slays a Dragon at the Fount of Dirce - a Sketch*, 6gns., Sold.
1826	212	*A Welsh Peasant Boy - Scene in Caernarvonshire*, 15gns., Sold.
1826	223	*A Sketch*, Sold.
1826	225	*Crossing the Stream - Scene at Dolgelly, Merionethshire*, 15gns., Sold.
1826	226	*Landscape and Figures*, 10gns., Sold.
1826	235	*A Water-fall with Figures*, 8gns., Morant Esq.
1826	261	*Scene near Bethgellert, North Wales*, Sold.
1826	262	*Fishing on Loch Lomond*, Sold.
1826	265	*A Cottage at Bisham, Berkshire*, 8gns., Mr. C. Stokes, 4 Verulam Buildings.
1826	269	*The Steam Boat on Loch Lomond, North Britain*, Sold.
1826	270	*A Fountain - Scene at Inverary, Argyleshire*, 25gns., Sold.
1826	281	*Minding Children*, 6gns., G. Holford Esq., Hampstead.
1827	70	*A Fishing Party on the Thames - Portraits*, 50gns., Sold.
1827	130	*Scotch Peasants*, 40gns., Sold.
1827	179	*Fountain, at Inverary, North Britain*, 45gns., Sold.
1827	183	*Welch Peasant Girl*, 10gns., Countess De Grey.
1827	193	*Girl at a Well*, 8gns., S. Smith Esq.
1827	219	*Scotch Girl at Work*, 6gns., S. Smith Esq.
1827	289	*Lane Scene, Hurley, Berks*, 6gns., Prior Esq.
1828	34	*Midsummer Night's Dream - Act. II. Scene III., "Scene - a Wood, near Athens. Titania and her Train . . ."* 150gns., Frame and glass 20gns.
1828	318	*A Welch Peasant Girl*, 8gns., Duke of Norfolk.
1828	348	*Midsummer Night's Dream - Act IV. Scene I, "Scene—the Wood. Oberon. – 'Now, my Titania; Wake you, my sweet queen.'"* 12gns.
1828	360	*Winter's Tale, Act III. Scene III. "Scene a Desert Country near the Sea, Shepherd. – 'Look thee here, boy . . .'"* 12gns.
1829	51	*Lane Scene, Goodrich, Herefordshire*, 15gns.
1829	62	*Fern Burner, Goodrich, Herefordshire*, 4gns.
1829	66	*A Pastoral Scene*, 25gns., Sold.
1829	163	*A Pastoral Scene*, 15gns.
1829	173	*Scotch Peasants, Loch Lomond, North Britain*, 100gns., Lord Northwick.
1829	190	*View on the Wye, near Goodrich, Herefordshire*, 6gns.
1829	219	*Fern Burners, Goodrich, Herefordshire*, 15gns.
1829	253	*Moonlight - Shepherds conversing*, 10gns.
1829	262	*Glen Crow, North Britain*, 8gns., Sold.
1829	263	*Scotch Peasants, Loch Achray*, 20gns., Sold.
1829	303	*Scotch Peasant - Loch Lomond, North Britain*, 20gns., Sold.
1829	312	*Pastoral Scene, with Shepherds*, 10gns.
1829	325	*Fern Burners, Goodrich, Herefordshire*, 20gns., Sold.
1829	368	*Scotch Spinner, Luss, North Britain*, 10gns., Sold.
1830	174	*Unloading Peat at Luss, Loch Lomond, Dumbartonshire*, Sold.
1831	65	*Pass of Tall-y-llyn, Merionethshire*.
1831	121	*Gleaners*.
1831	276	*Fern Burner, Coppet Hill, Goodrich, Herefordshire*.
1831	346	*A Pastoral Subject, with Shepherds conversing*.
1831	372	*A Pastoral Subject, with a Shepherd Piping*.
1833	19	*A Welsh Peasant Girl offering Crystals for Sale*, 15gns., Sir Thos. Ackland.
1833	133	*A Girl at a Fountain, Barmouth, North Wales*, 10gns., M. Wells, Redleaf (Mrs. F. Lee, 16 Norton Street).
1833	181	*Jupiter Nursed by Amalthea the Nymph, and Corybantes*, Sold.
1833	422	*A Girl Knitting - at Harlech, North Wales*, 12gns.
1834	24	*Girl Knitting - Barmouth, N. Wales*, 18gns., C. Barclay Esq.
1834	27	*Girl at a Fountain, Barmouth, N. Wales*, 20gns.
1834	52	*Girl Knitting - Barmouth, N. Wales*, 20gns.
1834	104	*Apollo tending the Flocks of Admetus, "While pure Amphrysus winds along the mead . . ." Lucan's Pharsalia, Sixth Book.* 80gns.
1834	144	*A Girl Knitting, Barmouth, N. Wales*, 6gns., Rev. J. Eden.
1834	259	*Fern Burner Resting - Goodrich, Herefordshire*, 6gns.
1834	280	*Girl Working, Barmouth*, 10gns., J.H. Maw, Aldermanbury.

1834	305	*Girl Knitting at a Cottage Door*, 10gns., Elliott Esq.
1835	66	*The Loiterer*, Sold.
1835	78	*A Girl Knitting - Barmouth, Merionethshire*, 10gns., Sold.
1835	85	*A Shrimper - Barmouth, Merionethshire*, 10gns.
1835	213	*Girl Knitting, near Beddgelert, North Wales*, 16gns., Earl Jermyn, 6 St. James' Square.
1835	256	*Girl at a Cottage Door, North Wales*, 18gns.
1835	282	*Returning from Milking, North Wales*, Sold.
1835	306	*Glen Ogle, North Britain*, 5gns.
1835	316	*Aberllan near Beddgelert, North Wales*, 10gns.
1836	26	*Scene on the Wye, near Goodrich, Herefordshire*, 25gns.
1836	104	*Scotch Peasant Girls, Luss, near Loch Lomond*, Sold.
1836	120	*A Girl Spinning - Luss, near Loch Lomond*, Sold.
1837	56	*Market-day*, 10gns., Benj. Godrey Windus Esq., Tottenham Green.
1837	112	*Girls ascending the side of Snowden, on the Upper Farm of Aberthlan, near Beddgelert, N. Wales*, Sold, J. Elliott Esq.
1837	232	*Girl crossing a Brook over Stepping Stones*, 8gns.
1838	12	*Market Girl*.
1838	14	*Scene near Killin, North Britain*.
1838	29	*On the Wye - Cottages under the Coldwell Rocks*.
1838	158	*Rocks on the Caernarvon Road, near Beddgelest*.
1838	191	*Pastoral Scene - Shepherd Piping*.
1839	46	*Cynthia, with her attendant Dews and Zephyrs*, 40gns.
1839	237	*A Fern Burner*, 6gns., Lady Rolle.
1840	10	*Girl Knitting - Barmouth, North Wales*.
1840	184	*A Consultation*.
1840	234	*Embroidering*.
1840	262	*Bleaching Linen, Highlands of Scotland*.
1841	10	*The Youthful Florist*, 20gns., W.R. Hall Esq., Springfield, Nr. Ross, Somerset.
1841	15	*A Young Lady Embroidering*, 20gns., Edwd. Pritchard Esq., Ross, Hereford.
1841	33	*Highlanders Consulting - Scene near Inverary, North Britain*, 30gns., James Elliott Esq., 32 Berwick Street, Soho.
1841	119	*The Traveller, "As when some simple swain his cot forsakes . . ." Pope's Homer, Book VII. verse 572*. 8gns.
1841	216	*Contemplation*, 20gns., Ross Esq., Rocklands, Goodrich.
1841	229	*A Lady Drawing*, 20gns., Sir Edmund Head Bart., 41 Cambridge Terrace.
1841	277	*Studying in the Garden at Springfield - Ross in the Background*, 20gns., W.R. Hall Esq., Springfield, nr. Ross, Hereford.
1841	307	*Shepherd, with other Figures, among Rocks and Trees*, 10gns., Mrs. Chellingworth, Grendon, Nr. Ross, Herefordre.
1841	310	*Landscape - Shepherd Piping*, 10gns., James Elliott Esq., 32 Berwick Street, Soho.
1841	333	*A Lady Drawing*, Sold, Wm. Clifford Esq., Perristone, nr. Ross, Herefordre.
1842	153	*Narcissus and Echo, "Pleased with the form and coolness of the place . . ." Vide Ovid's Metamorphoses, Book III.*
1843	245	*Bleaching Linen - Loch Tay, North Britain*, 10gns., J. Elliott Esq., 32 Berwick Street, Soho.
1843	318	*A Welch Peasant Girl at a Fountain, Barmouth, North Wales*, 20gns., J. Elliott Esq., 32 Berwick Street, Soho.
1844	148	*Reverie - a Peasant Girl at a Fountain - Barmouth, Merionethshire, North Wales*, 30gns., James Elliott Esq., 32 Berwick St., Oxford St.
1844	200	*A Fern Burner at Goodrich, Herefordshire*, 8gns.
1844	269	*A Peasant Girl at a Fountain*, 5gns.
1844	296	*A Welch Peasant Girl Knitting - North Wales*, 10gns., James Elliott Esq., 32 Berwick St., Oxford St.
1845	257	*A Girl Spinning - Luss near Loch Lomond, Dumbartonshire*, Sold, James Elliott Esq.
1845	277	*Market-day*, Sold, James Elliott Esq.
1846	40	*A Pastoral*, 60gns.
1847	72	*Jupiter Nursed by Amalthaea, the Nymphs, and Corybantes, in the Island of Crete*, Sold.
1847	77	*A Gleaner of Herefordshire*, Sold.
1847	222	*A Scotch Peasant Girl embroidering muslin at Luss, Loch Lomond*, Sold.
1847	309	*A Welch Girl at a Fountain - Barmouth, Merionethshire*, Sold.

CRISTALL J AND BARRET G

| 1830 | 137 | *"Come unto these yellow sands."* |
| 1831 | 414 | *Titania and the Indian Boy*. |

CUMBERLAND G

| 1818 | 74 | *Woods, from the Windmill, Clifton, near Bristol*. |

CURTIS J

| 1819 | 28 | *Kirby Church, Norfolk*. |

DAVIDSON C

1855	13	*At Gatton Park, Surrey*, £40.0.0, W. Herbert Esq., Frame and glass £3.0.0.
1855	15	*An Autumn Afternoon*, 40gns., Frame and glass £3.0.0.
1855	21	*Sandy Lane, Red Hill, Surrey*, £30.0.0, Sold, Frame and glass £1.0.0.

1855	34	*Pevensey Castle, Sussex, 65gns., G. Bailey Esq., 13 Lincolns Inn Fields, Frame included.*
1855	41	*Evening, 18gns., Frame and glass £1.2.0.*
1855	51	*Haymaking, £35.0.0, Frame and glass £3.0.0.*

DAVIS R B

1819	106	*Horses.*
1819	111	*Horses.*
1819	129	*Horses in a Storm.*

DEANE C

1817	92	*Goodrich Castle.*
1817	93	*Brathay Bridge and the Village of Clappersgate, near Ambleside, Westmoreland.*
1817	103	*View on the Wye.*
1818	59	*An Overshot Mill, £21.0.0, J. Quintin Esq.*
1818	62	*View on the Thames, from Lord Dysart's Ground, £8.8.0, F. Bury Esq., Barnstaple.*
1818	70	*View on the River Wye, £16.16.0, W. Brooke Esq.*
1818	116	*Glen-Coin, on the Banks of Ullswater.*
1818	152	*Petersham Wood, Surrey.*
1819	38	*Scene on the Banks of Winandermere, £21.0.0, J. Bullock Esq.*
1819	39	*Kirkstall Abbey - Moonlight.*
1819	44	*Chepstow Castle, £16.16.0, Mr. Bush, Bristol.*
1819	90	*Richmond Hill, from Twickenham Ferry.*
1819	116	*Grassmere Water, Westmoreland.*
1819	175	*Scene on the river Wharfe, near Bolton Abbey, Yorkshire.*
1820	34	*View on the Thames - Moonlight.*
1820	45	*Wood Scene.*
1820	98	*Knaresborough Castle - Morning.*
1820	112	*View on the River Nid at Knaresborough.*
1820	148	*Derwent Water, looking into Borrowdale, Cumberland.*
1820	156	*Windsor, from Eton College Play-Ground.*

DELAMOTTE W

1806	104	*View between Llanrwst and Capel Cerig, N. Wales.*
1806	128	*A scene in Dovedale, Derbyshire.*
1807	10	*A scene on the River Thames, Oxon.*
1807	73	*A view near Marlow.*
1807	85	*A village in Oxfordshire.*
1807	186	*A Ford.*
1807	213	*Pont-neuf, Paris, with Pont au change seen through the arch.*
1808	47	*The palace of the Thuilleries, and Pont de la Reunion, ci-devant Pont Royal, taken from Pont de la Concorde. The sketch made in 1802.*
1808	72	*Study of walnut-trees, near Bisham, Berks.*
1808	95	*A lane near Marlow, Bucks.*

1808	230	*La Sainte Chapelle, with part of the palace, in the island of Notre Dame. The sketch made in 1802.*

DERBY W

1820	150	*Dahlias - Study from Nature.*

DEVIS A W

1815	18	*Belvidera, "A Chamber in the House of Aquilina, a Greek Courtezan. Enter Belvidera. 'I'm sacrificed! I'm sold . . .'" Venice Preserved, Act iii, Scene i.*

DEWINT P

1810	69	*A Hay Field.*
1810	239	*A Corn Field, 25gns., Lord Ussulston.*
1810	261	*A Landscape.*
1810	280	*East Gate, Lincoln.*
1810	321	*A Landscape.*
1811	19	*A Landscape.*
1811	46	*Lincoln Cathedral.*
1811	122	*Stacking Hay.*
1811	176	*A Landscape.*
1811	222	*A Hay-Field.*
1812	5	*Conisborough Castle, Yorkshire.*
1812	11	*A Corn Field.*
1812	40	*An Old Bridge in Lincoln.*
1812	49	*A Turnip Field.*
1812	71	*Mid-Day.*
1812	75	*A Ferry, near Doncaster.*
1812	79	*Twilight.*
1812	95	*A Hay Field.*
1812	98	*Landscape.*
1812	184	*A Harvest Scene.*
1812	213	*A Landscape.*
1813	43	*A Landscape.*
1813	52	*Stacking Hay.*
1813	110	*Ploughing.*
1813	119	*A Scene in Yorkshire.*
1813	147	*A Scene in Buckinghamshire.*
1814	24	*A Village Church.*
1814	160	*Moor-Game Shooting.*
1814	190	*View in Bolton Wood, Yorkshire, £15.15.0, J. Allnutt Esq.*
1814	192	*View of Cookham, Berks..*
1814	284	*View of Taplow from Maidenhead Bridge.*
1814	289	*Harewood Castle, Yorkshire.*
1815	130	*A Bridge, in Derbyshire.*
1815	208	*A Distant View of Lincoln.*
1815	212	*A Windmill, near Lincoln, £31.10.0, J. Bramwell Esq.*
1815	266	*A Cricket Match.*
1815	293	*Entrance to a Village in Nottinghamshire.*

1815	302	*A Landscape.*
1815	310	*Cottages in Somersetshire*, £8.8.0, Mr. Maundrell.
1815	325	*A Windmill.*
1818	221	*Landscape, with Cattle.*
1818	265	*A Landscape.*
1818	279	*View of Jerveaux Abbey, Yorkshire.*
1818	349	*Greenwich - (for Cooke's Work of Thames Scenery).*
1823L	31	*Near Lincoln,* – Call, esq.
1823L	114	*Landscape.* –
1823L	132	*Stacking Hay,* Hon. Mrs. Cochrane.
1823L	138	*A distant View of Lowther Castle,* Earl Lonsdale.
1823L	170	*Corn Field,* J. Harman, esq.
1823L	185	*A Rainbow,* The Artist.
1825	14	*Distant View of Ulles Water, Cumberland,* 60gns., Marquis Ailesbury.
1825	58	*Patterdale, Westmoreland,* 15gns.(?), Sir Abraham Hume(?).
1825	97	*View from the Church-Yard at Newnham, Gloucestershire,* 40gns., Mr. Wilson, Pall Mall.
1825	106	*Neath Abbey, with the Copper Works, Glamorganshire,* 30gns.
1825	117	*Pennarth Castle - Glamorganshire,* Sold, Honble. W. Liddle(?).
1825	153	*Distant View of Derwent Water,* 30gns., Mr. Nightingale, 57 Brook Street.
1825	211	*Stacking Barley,* 50gns., Mr. Blake.
1825	228	*Hastings, from the East Cliff,* Sold 20gns.
1825	271	*Briton Ferry, Glamorganshire,* Sold 30gns.
1826	238	*View of Lancaster,* 60gns., Sir Thos. Baring.
1827	6	*View in Silverdale, Lancashire,* 35gns., Sold.
1827	12	*Hay Field - June,* 10gns., Sold.
1827	43	*Lincoln,* 35gns., J.H. Langston(?).
1827	106	*View in the Isle of Wight,* 8gns.
1827	140	*Windmills, near Lincoln,* 15gns., Lord Brownlow.
1827	144	*Cornfield, Westmoreland,* 50gns.
1827	161	*Dacre Castle, Cumberland,* 50gns.
1827	164	*The Keep of Cardiff Castle,* 5gns.
1827	194	*Landscape,* 8gns., N.H. West(?).
1827	241	*Kenilworth Castle,* 35gns.
1827	257	*Hay Field,* 5gns., Lady Torrens, 30 Portland Place.
1827	259	*View on the River Yore,* 40gns.
1827	323	*Scarborough Castle,* 6gns.
1827	340	*Windmill, with a distant Corn-Field.*
1828	14	*Distant View of Goodrich Castle,* 12gns., Mr. Roberts, Hanway Street.
1828	20	*Distant View of Lynn, from Castle Rising Common,* 35gns., Earl Brownlow.
1828	52	*Hayfield,* 12gns., Knyvett Esq., 45 Gt. Marlborough St.
1828	73	*View on the Wye,* 8gns., W. Prior Esq.
1828	87	*A Rainbow - View in Norfolk,* 15gns.
1828	110	*View on the Coast of Glamorganshire,* 6gns., Smith Wright Esq., 81 Harley St.
1828	132	*A Corn-field,* 10gns., Thos. Hudson Esq., King Street, Norwich.
1828	137	*View of Lancaster,* 20gns.
1828	174	*View on the Brathy, near Ambleside,* 60gns., Sold.
1828	182	*Evening,* 12gns., Sold.
1828	183	*Dunstanborough Castle,* 8gns.
1828	245	*Stacking Barley, Castle Rising,* 15gns., C. Holford Esq., Hampstead.
1828	258	*View in Lancashire, near Levens,* 50gns., C. Barclay Esq.
1829	12	*Over Bridge, near Gloucester,* 15gns., Braithwaite Esq.
1829	29	*Ploughing, Westmorland,* 40gns.
1829	95*	*A Barley Field, Norfolk,* 30gns.
1829	135	*Matlock High Tor,* 12gns., J. Braithwaite Esq.
1829	147	*Elijah, "So he departed thence, and found Elisha the son of Shaphat, who was plowing . . ." 19th chap. 1st book of Kings, 19th and 20th verses.* 80gns., Lady D. Cawdor, 16 Berkeley Sq.
1829	154	*A Corn Field, Lincolnshire,* 15gns., Sold.
1829	172	*Rouen,* 50gns.
1829	191	*View on the Essex Coast,* 12gns.
1829	211	*Caerphilly Castle,* 50gns.
1829	223	*Caën,* 20gns., Lady Anne Beckett.
1829	356	*A Landscape, with Cattle,* 12gns., Thos. Churchyard, solicitor, Woodbridge, Suffolk.
1829	359	*Lime Kilns, Westmoreland,* 12gns.
1829	363	*Tending Cows, Normandy,* 12gns., J. Shaw Esq., Gower Street.

DE WINT P

1830	12	*Dieppe Castle,* 35gns., W. Cavendish Esq., Devonshire House.
1830	22	*View of Lincoln from the Brayford,* 60gns., Haldimand Esq., Seymour Place.
1830	39	*Mowing,* 12gns., Roberts Esq.
1830	50	*A Corn Field in Silver Dale, Westmorland,* 15gns.
1830	65	*Lincoln, from the Banks,* 30gns., Griffiths Esq.
1830	86	*A November Morning,* 20gns., E. Pepys Esq.
1830	90	*A Corn Field - with a distant view of Lincoln,* 15gns., Rev. E. Colridge.

1830	108	*Fecamp, Normandy*, 14gns.
1830	110	*View in Covendale, Yorkshire*, 12gns.
1830	129	*Twilight*, 12gns., Sold.
1830	149	*Travelling Gypsies, with a distant View of Bolsover Castle*, 40gns., Stewart Esq.
1830	220	*View in the Grounds at Belton, the Seat of Earl Brownlow*, 50gns., Earl Brownlow.
1830	255	*Village Smithy*, 12gns., General Grey, 13 Hartford Street.
1830	257	*Landscape, with Cattle*, 12gns., Roberts Esq.
1830	290	*View of Morcambe Bay, with Arnside, from Witherstack, Westmorland*, 14gns., Austin Esq.
1830	306	*Penrith Castle, Cumberland*, 12gns., L. Sullivan Esq.
1830	311	*View in Glen-Coe, in Westmorland*, 20gns., E. Pepys Esq.
1830	361	*Castle Rising, from Babingly, Norfolk*, 14gns., Col. Greville Howard.
1831	8	*View near Ludlow.*
1831	21	*Ludlow Castle.*
1831	30	*Grange Bridge, Cumberland.*
1831	41	*Nant y Bellan, Wynnstay, Denbighshire.*
1831	50	*Cottages in Caernarvonshire.*
1831	58	*Lincoln.*
1831	93	*A Rainbow.*
1831	108	*A Watermill.*
1831	152	*Summer.*
1831	188	*View on the Thames.*
1831	212	*Conway.*
1831	222	*A Barley Field.*
1831	256	*Distant View of the Forest Hall Mountains, Westmorland - To be engraven for the work entitled "The Gallery of the Society of Painters in Water Colours".*
1831	319	*A Windmill.*
1831	411	*Ripon.*
1831	421	*A Fishing House, with Cattle.*
1832	19	*Middleham Castle, Yorkshire*, 15gns.
1832	57	*A Corn-field, Lincoln in the Distance*, 30gns., Miss H. Langston.
1832	63	*A Gypsey Camp*, 70gns.
1832	92	*Fountain's Abbey*, 15gns.
1832	103	*Penrhyn Castle, with Puffin Island in the Distance*, 20gns.
1832	121	*Loading Hay*, 12gns., Lawrence Sullivan Esq.
1832	125	*A Watermill near Bangor*, 26gns., E. Pepys Esq.
1832	152	*Castle Rising*, 50gns., The Honble. Mrs. Howard.
1832	174	*Wynnstay*, 50gns., Sir W.W. Wynn.
1832	203	*Norwich*, 50gns.
1832	216	*Cambridge*, 35gns., Sold.
1832	218	*View on the Thames*, 15gns., Miss Langston.
1832	262	*View in Norfolk*, 20gns.
1832	395	*View in Cumberland*, 12gns., Mr. Henry M. Musgrave, 15 Alfred Place, Bedford Square.
1832	404	*View in Montgomeryshire*, 15gns., Alfred Shaw Esq., 1 Chatham Place.
1833	22	*View in Westmorland*, 15gns., Richard Cavendish Esq., 1 Belgrave Square.
1833	38	*A Corn Field, Huntingdonshire*, 30gns., John Heathcote Esq., 41 Charles Street, Berkley Square.
1833	49	*A Common*, 15gns., Lawrence Sulivan Esq., War Office.
1833	54	*View in the Grounds of Wentworth Castle, Yorkshire*, 50gns., Frederick Vernon Wentworth Esq., 11 Connaught Place.
1833	89	*Distant View of Crowland Abbey*, 30gns., Mr. Leggatt, Cornhill.
1833	103	*A Village In Lincolnshire*, 14gns., John Lewis Brown Jr. Esq., 10 Leicester Place, Leicester Square.
1833	153	*View above Wilton Park, Yorkshire*, 50gns., Sir John Lowther Bart., 32 Grosvenor Square.
1833	163	*View near Beddgelert*, 16gns., John Lewis Brown Jr. Esq., 10 Leicester Place, Leicester Square.
1833	178	*A Landscape with Cattle*, 15gns., Miss Langston, 32 Upper Brook St..
1833	184	*A Pastoral Scene*, 15gns., Mr. Leggatt, Cornhill.
1833	187	*Dale Park, Sussex*, 20gns., Mrs. John Smith, 22 Grosvenor Square.
1833	206	*Scarborough*, 50gns.
1833	224	*Whitby*, 35gns.
1833	225	*A Glen in Westmorland*, 12gns., John Lewis Brown Jr. Esq., 10 Leicester Place, Leicester Square.
1833	308	*A Waterfall*, 15gns., Mr. Leggatt, Cornhill.
1834	9	*Bolton near the Sands, Lancashire*, 15gns., Miss Langston, 32 Upper Brook St.
1834	29	*Whitehaven*, 50gns., Earl of Lonsdale, 12 Charter Street, Berkley Square.
1834	35	*Castle Rising*, 10gns.
1834	56	*Scene at Wilderness Park, in 1832, upon the occasion of the Review of the West Kent regiment of Yeomanry Cavalry by the Duke of Wellington and also of this Regiment and others, being entertained at a Banquet by the Marquess Camden on the same day*, 70gns., Marquis of Camden, 22 Arlington Street.
1834	61	*Wilsford, Lincolnshire*, 18gns., R.H. Cheney Esq., 43 Upper Seymour St., Portman Square.

1834	68	*Lowther Church*, 15gns., Lady Frederick Bentinck, 12 Charter Street, Berkley Square.
1834	94	*A Windmill*, 14gns.
1834	109	*View on the River Mite, Cumberland*, 15gns., R.H. Cheney Esq., 43 Upper Seymour Street, Portman Square.
1834	126	*Mask Mill, Yorkshire*, 12gns., The Honble. Mrs. Butler Johnstone, 24 Park St., Grosvenor Sq.
1834	132	*The Village of Skirwith, Cumberland*, 40gns., R.H. Cheney, Esq.
1834	146	*Boats at Lincoln*, 12gns., Rev. J. Eden.
1834	165	*The Holkar Sands, Lancashire*, 30gns., Lord Cavendish, 10 Belgrave Square.
1834	175	*A Castle in South Wales*, 12gns., R.H. Cheney Esq.
1834	188	*Askham Bridge and Mill, Westmorland*, 25gns., Richard Cavendish Esq., 1 Belgrave Square.
1834	200	*Lancaster*, 80gns.
1834	227	*View in Normandy*, 12gns.
1834	258	*Distant View of Black Combe*, 35gns., J.H. Maw Esq., Aldermanbury.
1835	20	*Crowland Abbey, Lincolnshire*, 45gns., Earl Brownlow.
1835	31	*Torksey Castle, Lincolnshire*, 30gns.
1835	33	*A River Scene - Lincoln*, 20gns.
1835	44	*View of Scaw Fell, looking towards Wast Water*, 70gns., Mr. Richard Cavendish.
1835	68	*Water Mill at Bampton, Westmorland*, 45gns., Richard Ellison Esq.
1835	80	*A Village*, 10gns., Mr. Hippisley, 12 Chesterfield St., Mayfair, To be forwarded to Dowr. Lady Mordaunt, Avonhurst, Stratford on Avon by Tantivy Coach and Baylis Carrier.
1835	87	*A Village in Norfolk*, 12gns.
1835	106	*Lincoln*, 50gns., Henry Cheney Esq., 43 Upper Seymour Street, Portman Square.
1835	124	*View of Askham, on the River Lowther*, 20gns., Miss Thompson.
1835	134	*Lowther Church*, 20gns., Lady Frederic Bentinck.
1835	142	*View of Nether Levens, on the River Kent, Westmorland*, 35gns., E. Pepys Esq., 17 Upper Harley Street.
1835	178	*Carisbrooke*, 25gns., Mr. Froggatt.
1835	224	*View in the Vale of Newlands, near Keswick*, 12gns., Mrs. E. Pepys, 17 Harley Street.
1835	231	*Twilight*, 35gns., Miss Henriette Langston, 32 Upper Brook Street.
1835	255	*Egremont Castle, Cumberland*, 14gns., Edwd. Swinburne Esq.
1835	259	*View on the Holmes, near Lincoln*, 20gns., F. Chaplin Esq.
1835	267	*A Lane at Kilburn, with Hampstead in the distance*, 14gns., L. Sulivan Esq., War Office.
1836	2	*Retirement, "Dew-dropping coolness to the shade retires . . ." Thomson's Summer*. 30gns.
1836	9	*Water Mill on the Conway, North Wales*, 40gns.
1836	11	*Dolbaddern and the Lake of Llanberis, looking towards Caernarvon*, 15gns., Sir Thos. Baring, 21 Devonshire Place.
1836	25	*Ferry at Caernarvon*, 25gns.
1836	28	*Corn Field at Church Hyckham, Lincolnshire*, 10gns., Miss Bentinck, 13 Carlton House Terrace.
1836	34	*A Village in Lincolnshire*, 10gns.
1836	39	*Dolwyddelan Castle, North Wales*, 15gns.
1836	53	*A Corn Field*, 40gns.
1836	62	*Water Mill at Beddgelert*, 35gns.
1836	71	*Stacking Hay*, 20gns., Lady Harriet ????, 53 Grosvenor St.
1836	90	*Lincoln*, 60gns., Richard Ellison Esq., Sudbrooke Holme, Lincolnshire.
1836	103	*Distant View of Lowther Castle*, 15gns., Miss Thompson, 12 Charles Street, Berkeley Square.
1836	124	*View on the River Lochy, North Britain*, 10gns.
1836	129	*View on the Foss Dyke, near Lincoln*, 30gns., The Rev. Dr. Procter, Brighton.
1836	160	*Ashtead Forest with Gipsies - Leith Hill in the distance*, 60gns.
1836	179	*The Eagle Tower of Caernarvon Castle*, 40gns., The Honble. Richard Cavendish, No. 1 Belgrave Square.
1836	248	*View on the Thames, near Henley*, 10gns., The Rev. Dr. Procter, Brighton.
1836	266	*View near Keswick*, 12gns., Austen Esq., 33 Guilford Street.
1837	7	*A River Scene*, M. Ellis Esq., Cleave Place, Larkhall Lane, Clapham Road.
1837	21	*Crummock Water, with a Corn-field in the Foreground*, 35gns., Sold.
1837	26	*A Hay-field*, The Revd. Dr. Proctor, Brighton, Order of Mr. De Wint.
1837	41	*View of Lincoln, from Washingborough*, 60gns., Revd. H.W. Sibthorp, Washingborough, Order of Mr. De Wint.
1837	48	*A Hoar Frost at Castle Rising, Norfolk*, 40gns., Lady Eleanor Balfour, 3 Grosvenor Square, Order of Mr. De Wint.
1837	60	*Washingborough, Lincolnshire*, 40gns., Revd. H.W. Sibthorp, Washinborough, Order of Mr. De Wint.
1837	77	*View in Wales, between Tan-y-Bwlch and Beddgelert*, 25gns.
1837	82	*View on the Thames, near Twickenham*, 15gns., Lawrence Sullivan Esq.
1837	97	*A View on the Thames, near Kingston*, 35gns., L. Houghton Esq., 30 Poultry.

1837	108	*A Snow Storm at Castle Rising, 29 Oct. 1836,* 25gns., Lady Harriet Clive, 53 Grosvenor Street, order of Mr. De Wint.
1837	177	*Richmond,* 20gns., T.G. Parry Esq., 9a Langham Place.
1837	200	*A Cottage Scene,* 10gns., Revd. Dr. Proctor, Brighton, order of Mr. De Wint.
1837	256	*Summer View on the Thames,* 20gns., R.H. Cheney Esq., 43 Upper Seymour Street, order of Mr. De Wint.
1837	276	*Distant View of Bromfield Church, from Oakley Park, Shropshire,* 10gns., T.G. Parry Esq., 9a Langham Place.
1837	304	*Distant View of Kirby Lonsdale,* 12gns., N. Prior Esq., Middleton Square.
1837	313	*Twilight - Felpham, Sussex,* 10gns.
1837	346	*Autumn - Scene in Norfolk,* 15gns., Lady Milton, Halkin St., Grosvenor Place.
1838	6	*Gledstone House, Yorkshire.*
1838	13	*Early Morning, with Haymaking.*
1838	23	*Clifton, near Penrith, with the Crossfell Mountains.*
1838	30	*View of Ingthorpe, Yorkshire.*
1838	38	*A Cottage Scene.*
1838	44	*Gordale.*
1838	58	*Lincoln.*
1838	69	*Newark Castle.*
1838	90	*View on the Lowther, with Cattle in the Water.*
1838	98	*View on the River Lowther.*
1838	111	*Beverley.*
1838	151	*Distant View of Redcar.*
1838	269	*View on the Beach at Redcar, looking towards Huncliff.*
1838	276	*A Corn-field.*
1838	303	*A Lane Scene.*
1838	307	*Harvest Figures.*
1838	342	*View of the Haweswater Mountains, from the Western Terrace, Lowther Castle.*
1838	346	*View on the Thames, near Putney.*
1839	9	*View of the Ennerdale Mountains, near Whitehaven,* 40gns., Richd. Ellison Esq., Sudbrooke Holme.
1839	27	*Glenridding, near Ulswater,* 30gns., F.I. Lace, 41 Queen's Square.
1839	31	*A Rural Scene, with Cattle in Water,* 15gns.
1839	35	*December,* 15gns.
1839	41	*A Timber Waggon crossing a Ford,* 15gns., J.B. Philips Esq., 10 Park Crescent.
1839	47	*Bolton Abbey,* 35gns., Marquis of Northampton, Piccadilly Terrace.
1839	72	*View on the Ribble,* 18gns.
1839	80	*View in Wales, between Penthill and Bangor,* 45gns.
1839	88	*A Hay Field, in Montgomeryshire,* 20gns., E. Pepys Esq., 17 Upper Harley St.
1839	110	*Lowther,* 60gns.
1839	136	*Scalby Mill, near Scarborough,* 30gns., Lady Harriet Clive, 53 Lower Grosvenor St.
1839	175	*Richmond Hill, from Twickenham Ferry,* 25gns., Miss Blair, Welbeck Street, Cavendish Sqre.
1839	182	*A Fen Mill, Peterborough in the Distance,* 25gns.
1839	283	*View on the River Eden, near Kirk Oswald,* 20gns., Richd. Ellison Esq., Sudbrooke Holme.
1839	291	*Loading Corn,* 10gns., Mr. Hippisley, 12 Chesterfield St., Mayfair.
1839	306	*Eton College, Twilight,* 12gns., Revd. Dr. Proctor, Brighton.
1839	329	*On the Thames, near Wooburn,* 12gns., Captain E. Fletcher, 43 York Terrace, Regents Park.
1839	335	*Stacking Barley,* 10gns.
1840	78	*Autumn - View in the High Park at Lowther.*
1840	118	*Knaresborough Castle.*
1840	122	*Harrowing - View near the Cross Fells, Cumberland.*
1840	161	*Distant View of Dover Castle.*
1840	185	*The Green Hills Farm, Matlock.*
1840	226	*Matlock High Tor.*
1840	231	*Connington Castle, the Seat of J. M. Heathcote, Esq.*
1840	257	*Water Mill in Wensley Dale.*
1840	317	*Stormy Effect on the Cross Fells, Cumberland.*
1841	1	*"As he lay along Under an oak ..." As You Like It. (The Trees and Studies of Oaks, at Oakley Park, near Ludlow.)* 40gns.
1841	3	*Ferry on the Severn, near Tewkesbury,* 25gns., Sold.
1841	46	*Powis Castle,* 60gns., Sold.
1841	76	*Winter,* 20gns., Sold.
1841	93	*Ingthorpe Grange, near Skipton,* 35gns., Sold.
1841	95	*Knaresborough, from the Castle Hill,* 20gns.
1841	110	*An Effect on the Cross Fells, Cumberland,* 25gns.
1841	135	*A Barley Field,* 10gns., George Hotham Esq., York.
1841	165	*Study of an Oak Tree at Oakley Park - the Seat of the Hon. Robert Henry Clive M. P.,* 30gns., Sold.
1841	175	*View of the West Front of Lincoln Cathedral, from the Castle Hill,* 100gns., Sold.
1841	212	*A Gypsy Tent,* 10gns.
1841	238	*View from Knipe Scar, Westmorland,* 12gns., Sold.

1841	244	*Knaresborough, from the Harrowgate Road,* 12gns., Sold.
1841	254	*View from Conishead Priory, near Ulverstone,* 15gns., Sold.
1841	280	*View on the River, Kent, in the Park at Levens,* 15gns., Miss Maude, 16 Savile Row, Art Union.
1842	11	*Falls of the West Lynn, at Lynmouth, North Devon.*
1842	15	*"From the bellowing East, In this dire season, oft the whirlwind's wing Sweeps up the burden of whole wintry plains At one wide waft." –* Thomson's Winter.
1842	39	*Minehead, Somersetshire.*
1842	49	*View on the River Lowther.*
1842	57	*Goodrich Castle, "Low walks the sun, and broadens by degrees Just o'er the verge of day."*
1842	109	*A Windmill in the Fens.*
1842	134	*View near Pangbourne, Berkshire, "To where the silver Thames first rural grows."*
1842	156	*View in Leven's Park, Westmorland.*
1842	161	*View from the Warren at Minehead, Somersetshire.*
1842	169	*"– the cherish'd fields Put on their winter robes of purest white."*
1842	170	*Gloucester, from St. Catherine's Meadow, " – sober evening takes Her wonted station in the middle air!"*
1842	177	*Scene at Badger, Shropshire, "The loosen'd ice Let down the flood, and half dissolv'd by day . . ." Thomson's Winter.*
1842	181	*Water Mill at Allerford, Somersetshire.*
1842	239	*A Corn Field - Windsor in the Distance.*
1842	286	*Scene in Westmorland, "Where down yon dale the wildly winding brook Falls hoarse."*
1842	293	*A Cottage Scene, Worcestershire.*
1842	302	*Market Place at Dunster, Somersetshire.*
1842	314	*Mill at Maple Durham, Berkshire.*
1843	12	*A Village in Westmorland,* 35gns., Sir William Eden.
1843	37	*Distant View of Barden Tower, Yorkshire, "Straight mine eye hath caught new pleasures . . ." L'Allegro.* 25gns., F. I. (?) Lace, 48 Baker Street, Portman Sqre.
1843	58	*A Lane Scene,* 30gns., Richd. Ellison Esq.
1843	86	*View on the Severn, Shropshire,* 30gns., G. Constable Esq., Arundel, Sussex.
1843	89	*A Ferry,* 10gns.
1843	102	*Whitby, "Oft did the cliff and swelling main Recall the thoughts of Whitby's fane." – Vide Marmion.* 40gns.
1843	113	*An Oat Field, Lincolnshire,* 30gns., E. Pepys Esq., 7 Upper Harley St.
1843	122	*View on the Derwent, Derbyshire - Cattle Fording the River,* 22gns., Roberts Esq., 100 Mount St., Grosvenor Sq., Frame and glass £4.4.0, Prize in Art Union of 30£.
1843	139	*Smugglers - Early Morning,* 20gns.
1843	144	*A Windmill,* 10gns., Charles Montgomery Esq., Ibbotson's Hotel.
1843	150	*Rocks at Youlgrave, Derbyshire,* 12gns.
1843	165	*The Port of Gloucester,* 25gns., Henry Cheney Esq., 3 Audley Sqre.
1843	194	*Brougham Mill, Westmorland,* 50gns., Rev. H. Sibthorpe, Prize of 10£ in the Art Union of London.
1843	203	*"Now air is hush'd, save where the weak-eyed bat . . ." Collins.* 15gns., Royal Dublin Society per Charles Montgomery Esq., Ibbotson Hotel.
1843	205	*Tewksbury, "King Edward. – 'We are advertised by our loving friends, That they do hold their course towards Tewskbury.'" King Henry VI.* 50gns., The Earl of Lonsdale, 12 Charles St., Berkeley Sqr.
1843	210	*View in Long Sled-Dale, Westmorland, "– he led towards the hills . . ." Wordsworth's Excursion.* 15gns., J.H. Lowther Esq., 32 Grosvenor Square.
1843	219	*Beverstone Castle, Gloucestershire,* 22gns.
1843	225	*Ventnor Cove, Isle of Wight,* 15gns.
1843	255	*Newark Castle, "Right, against the eastern gate, Where the great Sun begins his state." – L'Allegro.* 30gns., Henry Chenery Esq., 3 Audley Square.
1843	261	*Vallis Crucis Abbey, North Wales,* 21gns.
1843	264	*Harlech, North Wales,* 50gns., George F. Constable Esq. (Junior), Arundel, Sussex, Prize of Art Union of London.
1843	352	*The Pier at Minehead at Low Water, looking towards Conygar Hill,* 35gns.
1844	3	*A Salmon Leap at Lynmouth, North Devon,* 35gns.
1844	21	*View near Salt Hill, Berkshire,* 25gns.
1844	48	*The Abbey Mill at Christchurch, Hampshire,* 40gns.
1844	56	*A Landscape,* 10gns.
1844	59	*A Winter Scene at Badger, Shropshire,* 30gns.
1844	68	*A Brook,* 10gns., R.H. Robertson Esq., 9 Watling St..
1844	77	*View in the Dingle at Badger, Shropshire,* 35gns.
1844	83	*A Corn Field, Derbyshire,* 20gns.
1844	88	*A Waterfall in the Dingle, at Badger, Shropshire,* 55gns.
1844	91	*Kenilworth Castle,* 15gns., C.H. Cornwall Esq., 20 St. Swithins Lane, P.AU.
1844	104	*Dunster, Somersetshire,* 55gns.

1844	117	*Shap Abbey, Westmorland*, 20gns., Lord Brownlow.
1844	132	*Morning View in Cumberland*, 20gns., Lieut. Col. Eden, 14 William St., Lowndes Square.
1844	145	*A Windmill*, 30gns.
1844	174	*Evening, "The shifting clouds Assembled gay . . ."* 100 gns., Includes frame and glass.
1844	212	*Distant View of the Clee Hills, Shropshire*, 50gns.
1844	221	*Kirkstall Abbey, Yorkshire*, 12gns., John Palmer Stocker Esq., 2 New Boswell Court, P.AU.
1844	238	*A Dog Kennel at Connington*, 12gns.
1844	245	*A Village near Cheltenham*, 12gns., Stewart Esq.
1845	2	*Evening*, 12gns.
1845	4	*Stacking Hay*, 40gns., Edward Percival Esq., 22 Portland Terrace, Regents Park.
1845	29	*A Village in Norfolk*, 20gns., ? Conniston Castle, Stilton?.
1845	50	*Distant View of Christchurch, Hampshire*, 45gns., Richd. Ellison Esq.
1845	82	*Ancaster, Lincolnshire*, 20gns.
1845	88	*A Village in Cumberland*, 20gns.
1845	100	*A Village Scene, during Harvest*, 35gns.
1845	111	*View in Nottinghamshire*, 25gns.
1845	124	*Bolton Abbey, Yorkshire*, 60gns.
1845	160	*Bolton Abbey, from the Terrace*, 40gns.
1845	213	*Folding Sheep*, 12gns.
1845	221	*A Corn-field*, 30gns.
1845	242	*A Fair*, 20gns.
1845	307	*Distant View of Kenilworth Castle*, 10gns.
1846	37	*Canterbury*, 50 Pounds, J. Stewart Esq.
1846	53	*View in Ireland*, 18gns., R. Brooke Esq., 19 Duke St. James.
1846	67	*Matlock, High Tor*, Sold.
1846	84	*Bolton Abbey*, 80 Pounds, Algernon Attwood Esq., 3 South Square Grays Inn.
1846	107	*Dover, from the road to Canterbury*, Sold.
1846	130	*A Watermill*, Sold.
1846	143	*Harrow*, 35 Pounds.
1846	162	*Bolton Abbey and Rectory*, Sold, F.J. Lace Esq.
1846	168	*A Rural Scene, with Horses*, 10gns., Bishop of Chester, College, Durham.
1846	190	*Honey Lane Green, Essex*, 15gns.
1846	207	*View on Hampstead Heath*, 25gns.
1846	224	*A Village in Lincolnshire*, 10gns., Richard Ellison Esq.
1846	243	*View in Powis Park*, 15gns., C.H. Hawkins Esq., 27 Bury St., St. James's.
1846	256	*Stacking Hay*, 20gns.
1846	307	*An Oat Field, near Thorp-on-the-Hill, Lincolnshire*, 12gns., Earl Brownlow.
1846	317	*A Corn Field in Lancashire*, Sold.
1847	12	*A Watermill near Corwen, North Wales*, 50gns., N. Hobson Esq., Frame and glass £10.0.0.
1847	16	*Ulleswater, from Glencoin, Westmorland*, Sold.
1847	41	*View in Epping Forest, near High Beech, Essex*, 40gns., Geo. Constable Senr. Esq., Arundel, Sussex.
1847	46	*Richmond, Yorkshire*, 35gns., Col. Pennant, Frame and glass £6.0.0.
1847	64	*A Corn Field near Whitbarrow Scar, Westmoreland*, 25gns., R. Ellison Esq.
1847	106	*Matlock Village, Derbyshire*, 40gns., Frame and glass £8.0.0.
1847	119	*A Watermill*, Sold, Captain Hotham.
1847	125	*View on the Witham, near Lincoln*, 30gns., Lewis Pocock Esq., Frame and glass £3.10.0.
1847	270	*Kenilworth Castle*, 15gns., Frame and glass £2.0.0.
1847	299	*A Corn Field, near Iffley, Oxfordshire*, 12gns., Sir H.H. Campbell, Frame and glass £1.10.0.
1847	300	*Distant View of the Clee Hills, from Oakley Park, Shropshire*, 15gns., Frame and glass £1.10.0.
1847	307	*Stacking Hay*, 12gns., Mr. Hogarth(?), Frame and glass £1.10.0.
1848	3	*A Landscape with Cattle*, Sold.
1848	11	*A Hayfield near Waltham Abbey, Essex*, 20gns.
1848	24	*Saltwood Castle, Kent*, 35gns., Alfred Lewis Esq., 63 ½ King William St., City, AU. 30£.
1848	28	*Nottingham*, Sold.
1848	47	*Lympne Castle, Kent*, Sold.
1848	89	*Berkhampstead*, Sold.
1848	118	*Kenilworth Castle - Evening*, Sold.
1848	119	*View at Walton-upon-Thames*, Sold, Ellison.
1848	135	*The Vale of Dolwyddellan, Wales*, 50gns.
1848	142	*View near Egremont, Cumberland*, 10gns., J.C. Grundy, Exchange St., Manchester.
1848	147	*Lincoln*, Sold.
1848	153	*A Corn Field, Lincolnshire*, 25gns.
1848	248	*View in Epping Forest*, 12gns.
1848	258	*Llandaff*, 15gns., Gen. Vaughan, 28 Cumberland Terr.
1848	279	*A Watermill*, 12gns., John Martin Esq., 14 Berkeley Sq.
1848	290	*A Hay Field*, Sold, Henderson Esq.
1848	309	*A Barley Field near Dunster, Somersetshire*, Sold, Ellison.
1848	335	*Stainton Beck, Lincolnshire*, 10gns., Rev. H. Sibthorp, Frame and glass £1.12.0 Yes.

1849	24	*Matlock High Tor.*
1849	34	*Windsor.*
1849	38	*View on the River Dart, Devonshire.*
1849	124	*Aldbury, Hertfordshire.*
1849	139	*View of Lincoln, from below the Lock, "Now fades the glimmering landscape on the sight, And all the air a solemn stillness holds."*
1849	178	*Bray, on the Thames.*
1849	236	*Stacking Barley.*
1849	260	*A Hay Field on the River Witham.*
1849	276	*Exeter.*
1849	294	*Wilsford, Lincolnshire.*
1849	326	*Kirstall Abbey.*

DINSDALE G

1814	1	*Junction of the Ouse, Trent, and Humber, Sunsetting.*
1814	118	*View in the Western Highlands of Scotland.*
1814	125	*Cascade in Whilfel Gill, Wensleydale, Yorkshire.*
1814	134	*St. Alban's. Autumnal Morning.*
1814	141	*Burleigh Castle, on the Banks of Loch-Leven.*
1814	147	*Grinton Swaledale, Yorkshire.*
1814	158	*Whiskey Distillery, upon Loch Lomond, near Glen-fallach.*
1814	167	*Cascade at the Ferry of Inversnaid, upon Loch Lomond.*

DODGSON G

1848	116	*The Music Party,* Sold.
1848	144	*Crossing the Brook,* 20gns.
1848	152	*Interior - Evening,* 20gns., The Revd. Hare-Townshend.
1848	236	*Ferry Boat - Morning,* Sold.
1848	249	*Village Gossip,* 8gns., R. Lloyd Esq., Ludgate Hill.
1848	253	*The Sortie,* 20gns., Humphrey St.John Mildmay Esq., 46 Berkeley Sq., Frame and glass £2.2.0 Yes.
1848	277	*Christmas Morning,* Sold.
1849	4	*The Ford.*
1849	112	*Noontide Retreat.*
1849	131	*A Sunshine Holiday.*
1849	252	*The Terrace.*
1849	280	*Highland Drovers - Storm passing off.*
1850	149	*The Mill Stream,* 25gns.
1850	253	*Spring,* 20gns.
1850	314	*Evening,* 15gns.
1851	46	*The Escort.*
1851	130	*Waiting for the Ferry Boat.*
1851	160	*The Village Smithy.*
1851	166	*A London Fog.*

1851	167	*The Return from a Christmas Party – Good night.*
1851	267	*Interior - Evening.*
1851	285	*The Stepping Stones.*
1851	302	*Winter.*
1852	181	*A Village Fair,* 70G, Frame and glass £5.5.0.
1852	310	*Pastoral,* 7G, Frame and glass £1.11.6.
1853	30	*Rydal Water.*
1853	114	*The Vesper Bell, "Ave Maria, blessed be the hour . . ."*
1853	218	*Winter Sport.*
1853	249	*A Rainy Day.*
1854	55	*"What is the greatest bliss That the tongue o' man can name? It is to woo a bonnie lassie When the rye comes hame; Twixt the gloaming and the mirk, When the rye comes hame."* 20gns.
1854	176	*Sunny Hours,* 40gns., Kay Esq., Hill St., Berkeley Square, Frame and glass £3.3.0.
1854	264	*The Assault,* 8gns., S. Noble Esq., Frame and glass £1.12.0.
1854	330	*Winter,* 20gns.
1855	137	*The Beacon, "A sheet of flame from the turret high . . ."* 25gns., Willm. Smith Esq., Kilburn House, Kilburn, 27 Glocester Sqre., Frame and glass £2.0.0.
1855	158	*A Forest Road,* 18gns., Frame and glass £2.0.0.
1855	178	*"Many a youth, and many a maid, Dancing in the chequered shade."* 40gns., Frame and glass £2.10.0.
1855	261	*Terrace, Haddon,* Sold.
1855	274	*Summer Time,* 10gns., Messrs.Rowney, Frame and glass £1.10.0.
1855	304	*Village Gossips,* 10gns., Thackeray Esq., 36 Onslow Sqre., Frame and glass £1.10.0.

DORRELL E

1809	95	*Scene in Windsor Forest.*
1809	130	*Village of Watenlath, Cumberland - stormy evening.*
1809	208	*Cottage door, near Winkfield, Berkshire.*
1809	212	*Cottage door, near Winkfield Plain, Berks.*
1809	273	*Scene near Windsor Forest, horses watering.*
1810	1	*Ranelagh Gardens, Chelsea.*
1810	8	*Scene near Twickenham.*
1810	17	*Cottage at Southend, near Bromley, Kent.*
1810	20	*Goodrich Ferry, on the Wye.*
1810	25	*Cottage on the Banks of the Thames, Battersea Fields.*
1810	38	*Scene near Twickenham, Boys Angling.*
1810	41	*Scene on the Thames, Twickenham, Richmond Hill in the distance.*
1810	45	*Cottage and Figures.*

1810	73	Scene on the Thames, near Richmond.
1810	93	Study from Nature, in Hyde Park.
1810	120	Road Scene, near the Village of Goodrich, Monmouthshire.
1810	193	Study from Nature.
1810	214	Goodrich Castle, Monmouthshire.
1810	217	Scene near Richmond Bridge - Evening.
1811	6	Girl with Sticks.
1811	55	Richmond Bridge.
1811	173	Landscape and Figures.
1811	249	Road Scene near Winkfield Plain, Windsor Forest.
1811	295	Landscape.
1811	298	Scene in Windsor Forest.
1811	306	Road Scene, near Banstead, Surrey.
1811	311	Scene on Banstead Downs, Surrey - Morning.
1811	329	Scene near Bromley, Kent; Boys angling.
1811	338	Cottage near Winkfield Plain, Windsor Forest.
1811	348	Girl and Sticks.
1811	358	Mona Bridge, Monmouth.
1812	23	Landscape - Stormy Day.
1812	55	Scene in Windsor Forest.
1812	63	Scene near Windsor Forest.
1812	67	Sketch from Nature.
1812	115	A Cottage Scene.
1812	166	Landscape and Figures.
1812	243	Scene near Richmond.
1812	266	Evening.
1812	270	Scene near Woodmanstone, Surrey.
1812	319	Moonlight.
1812	341	Cottage Children.
1813	1	Scene taken in the Grounds of the Rev. William Pearson, East Sheen.
1813	125	Scene on the Thames, near Battersea Bridge, taken from a Garden belonging to Bellevue House.
1815	41	Paper Mill, Foots Cray, Kent.
1815	65	New Inn, Isle of Wight.
1815	164	Landscape.
1815	213	Temple Grove, residence of the Rev. William Pearson, East Sheen.
1815	214	Temple Grove.
1815	313	Cottage Figure, £2.2.0, J. Dimsdale Esq.
1816	237	Scene near Bromley, Kent.
1819	4	View of Swansea - Glamorganshire.
1819	136	Oyster-mouth Castle, Glamorganshire.
1819	190	Scene at Derwent Water, Cumberland, £2.0.0, Sir George Madden.
1819	234	Cottage Scene, Hatchet Lane, Windsor Forest.
1819	261	Cottage Girl.
1819	265	Cottage Boy.
1819	287	Scene between Derwentwater and Watenlath, Cumberland.
1819	329	Cottage Scene - Hatchet Lane, Windsor Forest.

DUNCAN E

1848	101	Fishing Smack and Vessels off the Nore Light - Squall coming on, 25gns., Frame and glass £2.2.0.
1848	139	Pont-y-Pair Bettws-y-Coed, North Wales, 25gns., Webley Parry Esq., Noyadd Trefawr, Newcastle Emlyn, S. Wales, Frame and glass £2.2.0 Sold, AU. 20.
1848	205	Gillingham, on the Medway, Sold.
1848	234	Hay Field - Sunset, Sold.
1848	281	"Thus, Night, oft see me in thy pale career . . ." Vide Il Penseroso. 5gns., Lewis Pocock, Frame and glass £-.15.- No.
1848	300	Dartford Creek, Thames - Barge Running Up, Sold.
1848	330	Douglas Bay, Isle of Man - Gathering Sea-weed after a Gale, Sold.
1849	167	Lowestoff Roads - Vessels in a Gale, making for the Harbour.
1849	212	Mussel gatherers - Rhossik Bay, South Wales.
1850	111	Gleaners, 20gns., Mrs. T. Astley, Frame and glass £2.2.0.
1850	137	Hoop-shaving, Bridborough, Kent, 30gns., Frame and glass £3.13.6.
1850	214	Fleetwood Ferry, Lancashire, 20gns., Mrs. G.D. Fripp, Frame and glass £2.2.0 Yes.
1850	292	Sheep Feeding on the Downs - a Frosty Morning, 35gns., E.E. Tustin, Frame and glass £3.13.6 (wishes to have frame on trial).
1850	324	The Hay Field, 30gns., Frame and glass £3.13.6.
1850	375	"While around, the wave subjected soil, Impels the natives to repeated toil . . ." Vide Goldsmith's Traveller. 5gns., C.J. Baker Esq., Frame and glass £-.5.-.
1851	90	Boats preparing for the Herring Fishery off Lowestoft.
1851	150	Berry Pomeroy Castle, Devonshire.
1851	186	Pozzuolo, Gulf of Naples.
1851	193	Vessels leaving the Harbour of Great Yarmouth.
1851	199	Lowestoft Beach - Launching a Fishing Boat.
1851	296	On Dartford Creek, Kent.
1851	315	Yarmouth Shrimp Boats.
1852	33	Sunset - Copse Hill, Wimbledon, the Seat of the late Lord Chancellor Cottenham, Sold.
1852	35	Summer Moonlight, Sold.
1852	42	Spring - The Rookery at Penshurst, 25G, Frame and glass £2.2.0.

1852	104	*Cockle Gatherers on the Llanrhidian Sands - Coast of Gower, South Wales*, 80G, Frame and glass £8.0.0.
1852	119	*View of the Philanthropic Society's Farm School at Red Hill, near Reigate, Surrey. Presented by several of its friends and supporters to William Gladstone, Esq., Treasurer*, Sold.
1852	241*	*Vessels leaving the Harbour of Swansea*, 5G, Lewis Pocock.
1852	303	*Sheep Fair, Lewes, Sussex*, Sold.
1853	100	*Fishing Vessels leaving Yarmouth Harbour.*
1853	112	*Crossing the Bar.*
1853	128	*Stormy Sunset - Douglas Head Lighthouse, Isle of Man.*
1853	276	*Colliers unloading on the Beach at Hastings.*
1853	287	*Moonrise.*
1854	32	*A Winter's Morning*, Sold.
1854	40	*The Vraicking Harvest, Guernsey*, Sold.
1854	49	*Carting Seaweed, Coast of Guernsey - Tide coming in*, Sold.
1854	204	*"The moon is up, by heaven, a lovely eve; Long streams of light o'er dancing waves expand." – Childe Harold.* 5gns., Taunton Esq., 38 Craven Hill, ???, Frame and glass £-.10.-.
1854	242	*The Corbière Rocks, Jersey*, 10gns., Whitmore Esq., Frame and glass £1.1.0.
1854	253	*Hay Barge off Purfleet*, 12gns., C.E. Clifford Esq., Piccadilly, Frame and glass £1.5.0.
1854	313	*Rocquaire Bay, Guernsey - Sea Weed Gatherers going out*, Sold.
1854	317	*Boulogne Fishing Boat*, 6gns., Miss Poole, Frame and glass 10/.
1854	356	*A Calm - Vessels off Northfleet Creek*, Sold.
1855	50	*The Harvest Moon*, Sold.
1855	174	*H. M. S. Neptune Bending Sails - Portsmouth Harbour*, 6gns., Col. Sibthorp, Frame and glass £-.15.0.
1855	197	*Sea Weed Gatherers, Guernsey*, Sold.
1855	252	*Wreckers on the Coast of Jersey*, 8gns., R. Weles(?) Esq., Frame and glass £1.0.0.
1855	297	*Sunset - on the Guernsey Sands*, 25gns., Messrs. Vokins, Frame and glass £2.2.6.
1855	315	*Early Morning - Boulogne Fishing Boats making for the Harbour*, 15gns., I. Henderson Esq., Frame and glass £1.0.0.

EDRIDGE H

| 1823L | 146 | *West Porch of the Cathedral at Rouen*, Earl of Essex. |
| 1823L | 176 | *Place de Pucelle, Rouen - with the Statue of Joan of Arc*, E.H. Locker, esq. F.R.S. |

ESSEX R H

| 1823 | 76 | *A Design for a Statue Gallery.* |

1823	178	*View of Gloucester.*
1823	185	*Interior of Easthamstead Church, near Bracknell, Berks.*
1823	192	*Interior of the Church of Sainte Madeleine, Rouen*, £12.12.0, Marquis of Stafford.
1823	193	*A Sketch in the Quadrangle of Magdalen College, Oxford.*
1823	252	*Interior of the Beauchamp Chapel, Warwick.*
1823	259	*Willie Hall, Shropshire, the Seat of Lord Forrester.*
1824	99	*Choir of Ely Cathedral.*
1824	116	*North-West View of Mildenhall Church - Suffolk.*
1824	185	*View in the N.E. aisle of Westminster, with the Monument of Admiral Holmes, W. Pulteney Earl of Bath, &c.&c.*
1824	215	*View of Ely, from the Huntney Hill.*
1824	219	*Interior of Mildenhall Church, Suffolk.*
1824	249	*View in the North Transept of St. Paul's Cathedral, with the Monuments of Sir John Moore, and Sir Ralph Abercrombie.*
1825	23	*Bishop West's Chapel, Ely Cathedral*, £5.0.0.
1825	25	*Entrance to Ely from the Newmarket Road*, £5.0.0.
1825	54	*West Front of Ely Cathedral from Palace Green*, 5gns.
1825	93	*Henry VIIth's Chapel, Westminster, with the Houses of Lords and Commons*, £5.0.0.
1825	220	*View of the East End of Ely Cathedral with the Trinity Chapel*, £15.0.0.
1825	247	*Chapel of Edward the Confessor, Westminster Abbey, with the two Coronation Chairs, and the State Sword and Shield of Edward III*, £15.0.0.
1825	252	*View in the North Aisle of Westminster Abbey, with the Monuments of General Wolf, Earl Ligonier, &c.*, £30.0.0.
1825	324	*Godfrey, and the other Heroes of the First Crusades, paying their Devotions before the Shrine of the Holy Sepulchre at Jerusalem, "Cosi vince Goffredo; ed a lui tanto . . ." Vide la Gerusalemme liberata di Tasso. Conclusion of the last Canto.* £20.0.0.
1826	62	*Part of the Interior of St. Alban's Abbey, Herts.*, £8.0.0., G. Haldimand Esq., 4 Seymour Place, Curzon Street.
1826	71	*View in the Statue Gallery of the Louvre*, 5gns.
1826	110	*View in the North Transept of Westminster Abbey*, 10gns., Lord Brownlow.
1826	184	*View of the Park Gates, at Brussels*, £5.0.0.
1827	18	*Choir of Wells Cathedral*, 30gns.
1827	74	*Monument of Bishop Fox, Winchester Cathedral*, Sold.
1827	142	*Monument of Bishop Waynflete, Winchester Cathedral*, Sold.

1827	148	*Part of the Cathedral of Christ Church, Oxford, with the Statue by F. Chantry, lately erected to the memory of Dr. Cyril Jackson,* 12gns.
1827	150	*View in the South Aisle of Gloucester Cathedral,* 10gns.
1827	270	*St. Mary's Church, Oxford,* 10gns.
1827	275	*Views of the Ruins at Glastonbury, comprising the Tor Hill, part of the Ruins of the Abbey Church, and of the Abbot's Kitchen,* 8gns. the three or 4gns. each.
1827	335	*Interior of the Choir of the Cathedral of Wells.*
1828	122	*Part of St. John's College, Oxford,* £5.0.0, Dowr. Lady Suffield, 20 Upper Brook St.
1828	208	*Lady Chapel, Wells Cathedral,* 5gns.
1828	214	*Church of St. Mary, Redcliffe, Bristol,* £10.0.0.
1828	247	*Organ Screen of New College Chapel, Oxford,* 10gns.
1828	308	*Choir of the Cathedral of Christ Church, Oxford,* 5gns.
1828	343	*Monument of Edward the Second - Gloucester Cathedral,* Sold.
1829	4	*North-West Porch of Salisbury Cathedral,* 5gns.
1829	31	*Interior of St. Paul's Cathedral,* 5gns., Mr. Ph. Hope.
1829	84	*Ross Church, Herefordshire,* 5gns.
1829	164	*Goodrich Castle, Herefordshire,* 5gns.
1829	235	*Karisbrook Castle, Isle of Wight,* 5gns., Dr. Merriman, 34 Brook St., Grosvenor Sq.
1830	226	*Part of the Interior of the Cathedral of St. Gudule, Brussels - shewing the Chapel of the Virgin, and the South Aisle of the Choir,* 6gns.
1830	227	*Part of the Interior of Antwerp Cathedral,* 10gns.
1830	239	*Antwerp,* 10gns.
1830	317	*Pulpit in the Cathedral of St. Bavon, Ghent,* Sold.
1830	326	*Pulpit in the Cathedral of St. Gudule at Brussels,* Sold.
1831	66	*Interior of the Church of St. Sauveur, Bruges.*
1831	76	*Interior of the Church at Waterloo.*
1831	123	*West Front of the Cathedral of St. Gudule, Brussels.*
1831	225	*Interior of the Church of St. Aubin, Namur, during the Karmesse.*
1831	236	*View in the North Aisle of Westminster Abbey.*
1831	362	*The Tour des Cloches, Bruges.*
1832	73	*Part of Clarence Terrace & Sussex Place, Regent's Park,* 4gns.
1832	147	*Part of the Interior of Westminster Abbey,* 8gns.
1832	176	*Cloisters, Westminster Abbey,* 5gns., Dowr. Lady Suffield, 11 Berkeley Square.
1832	189	*West Front of St. Paul's from Ludgate Street,* 10gns.
1832	254	*View of St. Paul's from Cheapside,* 10gns.
1833	12	*Choir of the Church of St. Jaques, Liege - from a Sketch by C. Wild,* 20gns., N.T. Blackston(?) Esq., M.P., Castle Priory, Wallingford.
1833	136	*Church of St. Nicholas and Corn Market, Ghent,* 5gns.
1833	353	*Choir of Ely Cathedral,* 10gns., Mr. Davison, Grove End Place, St. Johns Wood.
1833	382	*Interior of St. Saviour's Church, Southwark,* 10gns., Mr. Thos. Saunders, 81 Great Surrey Street, opposite Nelson Square.
1834	4	*Eglise de St. Madeleine, Rouen,* 35gns.
1834	44	*Interior of Hornsey Church,* 5gns.
1834	106	*Interior of the Shrine of William of Wykeham, Winchester Cathedral,* 5gns.
1834	149	*Interior of Westminster Abbey, from the West End of The Nave,* 8gns., Dowr. Lady Suffield, 11 Berkeley Square, To go home Unmounted.
1834	191	*Eglise de St. Jean, dans l'Isle Liege,* 4gns.
1834	212	*Design, illustrative of English Ecclesiastical Architecture of the Thirteenth Century,* 10gns.
1835	218	*Interior of the Cathedral of St. Aubin, Namur, during Karnesse, in July 1829,* 35gns.

ESSEX W

| 1819 | 165 | *Head of a Terrier, in Enamel, after a Picture by Abraham Cooper, A.R.A.* |
| 1819 | 166 | *Tom, in Enamel, after a Picture by Abm. Cooper, A.R.A.* |

EVANS W

1828	1	*Windsor,* Sold.
1828	10	*Llanberris,* Sold.
1828	102	*Eton,* Sold.
1828	129	*Thames Fishermen - Windsor,* Sold.
1828	184	*Barmouth,* Sold.
1828	197	*Wyatville Tower, from the Playing Fields,* Sold.
1829	15	*The Stollzenfels and Marksburg near Coblentz - Peasants making signal for the Ferry,* 30gns.
1829	76	*Eton, (from the Fishery at Black Pots) the Property of His Majesty,* Sold.
1829	100	*An old Keeper of Mr. Wyndham's at Corhampton (the Property of His Majesty),* 25gns., Sold.
1829	126	*Eton - Canal Boats, working up to the Wharf,* Sold.
1829	152	*The Brunswick and Winchester Towers from the Locks, Windsor,* 30gns.
1829	185	*Liege (the Property of His Majesty),* Sold.
1829	224	*Backarach - Evening,* Sold.
1829	245	*Furstenburg, and the Village of Rheindiebach, near Bacharach,* 20gns.
1830	109	*Mending Eel Pots,* Sold.

1830	133	*A Study*, Sold.
1830	141	*Windsor - Pheasant Shooting*, 15gns., T. Griffiths Esq.
1830	185	*The Housekeeper*, 25gns., Mrs. Griffith, Norwood.
1830	204	*Interior of a Fishing Shed on the Thames*, 25gns.
1830	243	*Club Day - Procession of a Benefit Society In Hampshire*, 45gns.
1830	334	*Cottage Children*, Sold.
1830	346	*A Hampshire Cottage*, 25gns.
1831	12	*Taplow Woods, Cliefden in the distance.*
1831	16	*Meyeringen, Canton of Berne.*
1831	36	*In Windsor Great Park.*
1831	67	*Procession of the Wine Peasants, Bingen.*
1831	82	*An Otter.*
1831	109	*An Italian Fruit Girl.*
1831	119	*In Windsor Great Park.*
1831	159	*Fishing Hut, at Wyrardisbury.*
1831	175	*Otter Hunting on the Erme.*
1831	184	*Thames Barges.*
1831	186	*Bonn.*
1831	209	*A Library.*
1832	13	*Robin Hood's Bay, near Scarborough*, 40gns., Parratt Esq.
1832	77	*Mill Bay, Ventnor, Isle of Wight*, 20gns., Mr. B.G. Windus.
1832	120	*Castle of Voghtsberg, Bingen, the Residence of Prince Frederick of Prussia*, 16gns.
1832	131	*Blacksmith's Shop*, 6gns., Baring Wall Esq.
1832	133	*Fishing Hut at Ventnor, Isle of Wight*, 15gns., Mr. T. Griffith, Norwood.
1832	143	*Cottage Scene in the Grove, Droxford, Hants*, 20gns.
1832	148	*On the Thames, near Windsor*, Sold.
1832	206	*Ventnor - Under Cliff, Isle of Wight*, 12gns., T. Griffith Esq., Norwood.
1832	258	*Distant View of the Isle of Wight, from Droxford, looking over the Forest of Bere*, 18gns.
1832	264	*Mill at Droxford, Hants*, 12gns., Mr. F. Venna, Eaton.
1832	407	*Scene in the Isle of Wight*, 6gns., Mrs. Griffith, Norwood.
1833	7	*The Playing Fields, Eton, during the Montem, 1832, Companion to No. 282 (on the other side of the door)*, Sold.
1833	31	*Cottage near Dunstaffnage*, 15gns., H. Leggat Esq., 85 Yorkhill(?).
1833	99	*On the Coast of Arran, N.B.*, 15gns., H. Leggat Esq., 85 Cornhill.
1833	106	*Dunstaffnage Castle, N.B.*, 15gns., Mr. Leggat, Cornhill.
1833	146	*Newhaven, near Edinburgh*, 50gns.
1833	154	*Mountain Stream, Isle of Arran*, 15gns.
1833	173	*Ben Venue and The Trosacks*, 20gns.
1833	190	*On the Coast of Arran, N.B. between Brodick and Corrie*, Sold, To be sent to Mr. Lees, Norton Street, packed up with 133 and 290.
1833	229	*Fish Wife, Newhaven*, Sold.
1833	282	*School Yard, Eton College, during the Montem of 1832, Companion to No 7 (on the other side of the door)*, Sold.
1833	360	*Newhaven - a Study from Nature*, 8gns., Mr. W.B. Roberts.
1833	380	*Newhaven*, 6gns.
1834	46	*Clovelly*, 12gns.
1834	75	*Clovelly - Evening*, 18gns.
1834	80	*Taplow Weir*, 7gns.
1834	128	*Sun-rise*, 6gns., Miss Shepley, 28 Devonshire Place.
1834	145	*Clovelly*, 20gns., Mrs. Burton Philips, 24 Park Crescent.
1834	157	*Clovelly Pier - Morning*, 12gns.
1834	193	*Chepstow Castle*, 12gns.
1834	204	*Old Houses, Clovelly*, 15gns., M. Shepley Esq., 28 Devonshire Place.
1834	231	*Sun-rise, after a Storm - a Study from Nature*, Sold.
1834	287	*On the Coast of Arran, N. Britain*, Sold, Earl of Lincoln.
1834	311	*Castle Ransa, Isle of Arran*, 10gns., Lord Lincoln.
1834	335	*Barking Hut, near Callander, on the Teith*, 18gns., Mr. B. Austen, 33 Guilford Street.
1834	340	*Windsor*, 7gns.
1834	353	*A Scotch Cart, Isle of Arran*, 18gns.
1834	362	*Fishing Hut at Old Windsor*, 7gns.
1834	374	*Cliefden from Taplow Weir - a Study from Nature*, Sold.
1834	385	*On the Beach, Newhaven, N.B.*, 7gns.
1835	1	*The Pilot's Cottage.*
1835	19	*Christchurch, Hants*, 18gns.
1835	35	*Lymmouth, North Devon*, 20gns., B. Austen, Guilford Street.
1835	73	*Near Broderick, Isle of Arran*, Sold.
1835	76	*Near Brodich, Isle of Arran - a Study from Nature*, 12gns., H. Groves, 6 Pall Mall.
1835	148	*Poole, from Bourne Mouth*, 12gns., Mr. Robert Steele, Norwood.
1835	158	*Poole, from the Grange, near Wareham*, 12gns., Mr. N. Wilkinson.

1835	169	*Poet's Walk, Eton College*, 18gns.
1835	171	*Christchurch, from Mudeford*, 12gns., N. Wilkinson.
1835	180	*Christchurch, from Stanpit*, 12gns.
1835	183	*Old Windsor*, 15gns., Miss Cooke, 6 Pall Mall.
1835	245	*A Study*, 20gns., Miss Munro, Mr. Griffiths, Norwood.
1836	52	*Delphi on the Killeries - a Cunnemara Cabin*, 30gns., J.? Rossiter, Kennington Place.
1836	57	*Scene in the Irish Highlands*, 80gns., Rev. Edwd. Coleridge.
1836	66	*An Irish Peasant Girl*, 35gns., Bishop of Winchester.
1836	84	*The Claddagh, "This is an industrious people . . ." Inglis's Ireland, Vol. II. p.27.* 30gns.
1836	152	*Buttermilk Lane, Galway, "The population of Galway and its neighbourhood has a picturesque appearance . . ." Inglis's Ireland, Vol. II. p. 84.* 35gns., G. Hibbert Esq.
1837	25	*Scene in the Joyce Country, County Galway.*
1837	73	*Between Achill and Newport, County Mayo*, Sold.
1837	93	*Cunnemara Peasants*, Sold.
1837	133	*Inn on the Road to Westport, County Mayo*, 25gns., T.G. Parry Esq., 9a Langham Place.
1837	140	*Near Ma'am, Cunnemara*, Sold.
1837	153	*On the River near Ma'am, Joyce County*, 10gns., T.J. Thompson Esq., 68 Cadogan Place.
1837	246	*Cabin near Renvile, Cunnemara*, Sold.
1837	279	*A Cunnemara Cabin*, 20gns., Balfour Esq., 3 Grosvenor Square.
1837	341	*Muilrea, and the Entrance to the Killery Bay*, Sold.
1837	343	*Windsor Bridge, from Hester's Yard*, 12gns., Honble. Mrs. Craven, Brambridge House, Winchester, by G. Smith Esq., 73 Gt. Portland St.
1837	353	*Corfe Castle, Dorsetshire*, 12gns.
1838	71	*Haddon.*
1838	76	*Castle Campbell.*
1838	81	*Naworth Castle.*
1838	186	*Windsor.*
1838	205	*Eton.*
1838	274	*Ulverston.*
1838	283	*Cliefden, on the Thames.*
1838	294	*Corra Linn.*
1838	348	*Haddon, from the Meadows.*
1839	32	*Mulgrave Castle*, Sold.
1839	52	*Near Ulverston*, Sold.
1839	93	*Haddon, from the River*, Sold.
1839	97	*Mulgrave Castle*, Sold.
1839	210	*Ulverston Sands*, Sold.
1839	267	*Whitby*, Sold.
1839	272	*Stirling Castle*, Sold.
1839	311	*Windsor from Eton Wick*, Sold.
1839	323	*Mulgrave Castle, from the Moors*, 10gns., Sir John Hippisley, 7 Stratton St.
1839	339	*Temple Lock, near Marlow*, 18gns., Wm. Strachan Esq., 34 Hill St., Frame and glass £3.3.0.
1840	52	*Cockermouth Castle.*
1840	63	*The Eagle's Nest, Killarney.*
1840	150	*Killarney, from Mucross.*
1840	156	*Shepherds - Killen, Perthshire.*
1840	247	*Eton.*
1840	286	*Lismore Castle, County of Waterford. (Painted for Her Majesty.)*
1840	293	*Mulgrave Castle. (Painted for Her Majesty.)*
1840	295	*Cottages at Ventnor, Isle of Wight.*
1840	312	*Mill at Portsdown.*
1841	82	*Windsor*, Sold.
1841	102	*Caversham on the Thames*, 80gns.
1841	294	*A Study*, Sold.
1842	26	*Windsor, from Bishop's Gate.*
1842	34	*Windsor.*
1842	42	*Torc Lake, Killarney.*
1842	54	*Windsor, from Dorney Common.*
1842	102	*Ferry on the Thames.*
1842	184	*Durham.*
1843	75	*The Gap of Dunloe*, 40gns.
1843	155	*On the Thames*, 30gns.
1843	195	*Lismore, from the Fishery*, 60gns.
1844	113	*The School Yard, Eton College - The Morning of the Montem of 1841*, Sold.
1844	154	*The Playing Fields, Eton College - the Evening of the Montem of 1841*, Sold.
1846	22	*Rock Holes on the Conway*, 15gns.
1846	50	*Dinas Rock, Denbighshire*, Sold.
1846	102	*Old Post-road, Caernarvonshire - November Morning*, 20gns., Bishop of Winchester, 19 St. James Square, Frame and glass £2.2.0.
1846	178	*Harlech*, 30gns.
1847	191	*Ravine near the Summit of Carnedd Llewelyn, Caernarvonshire*, 30gns.
1847	213	*Mill at Bettws-y-Coed, North Wales*, 10gns.
1848	298	*Interior of a Welch Cottage*, 18gns., Frame and glass £2.2.0.
1849	41	*Interior of a Cottage, North Wales.*
1849	50	*The Sea Gull's Nest.*
1849	58	*Snowdon.*

1849	119	*At Rhw, near Conway.*
1849	207	*Moel Siabod.*
1849	213	*Moel Cnicht - from Port Madoc, N. W.*
1849	246	*Pentre Felin, Caernarvonshire.*
1849	270	*Traeth Mawr, N. Wales.*
1850	2	*Mountain Stream, near Conway,* 15gns.
1850	22	*Greenwich,* 15gns.
1850	33	*Study of Chesnut Trees in Greenwich Park,* 15gns.
1850	63	*Harlech, and the distant Mountains in Caernarvonshire,* 50gns.
1850	353	*The Little Hypocrite,* 8gns.
1851	86	*Ash Church, Kent.*
1852	4	*Part of the Ducal Palace, Genoa,* 15G.
1852	157	*Genoa,* 20G.
1853	4	*View in Wales.*
1853	252	*Landscape.*
1854	194	*Sorrento,* £25.0.0.
1855	19	*Villa D'Esta, Tivoli,* Sold.

EVANS W OF ETON

1845	8	*Folkstone,* Sold.
1845	37	*Tralee Bay, County of Kerry,* 50gns., Chas. Halstead Esq., East St., Chichester, Sussex, P.AU. 50£.
1845	116	*Shakespeare Cliff, Dover,* 40gns., Lady Caroline Clinton, 17 Portman Sq., Frame and glass £8.16.6.
1845	299	*Eton - Evening,* 25gns., Viscount Chelsea M.P., 41 Wilton Crescent, Frame and glass £3.10.0.
1846	47	*Snowdon, from Nant y Gwryd,* 70gns., Frame and glass £11.11.0.
1846	169	*Sandgate,* 20gns., Wm. Watson Esq., 10 Gordon Street, Curzon Sq., AU.
1846	179	*Mill at the Foot of Snowdon,* 70gns., Hobson Esq., 43 Harley St., Frame and glass £11.11.0.
1846	268	*Oxford,* 10gns.
1846	292	*Cliefden,* Sold.
1847	27	*A Day in the Forest of Atholl,* Sold.
1847	39	*Eton,* 35gns., Revd. C. Balston, Eton.
1847	67	*A Day in the Forest of Atholl,* Sold.
1847	90	*Return to the Castle, Blair Atholl,* 45gns., J. Hogarth.
1848	27	*Highland Shearing, Glen Tilt,* 100gns., Mrs. Alexander Ogilby, 3 Gt. Cumberland St., Hyde Park, Frame and glass £9.9.0 Yes (Geo.Foord).
1848	79	*Crossing the Tilt,* 60gns., The Hon. Mrs. Seymour Bathurst, 8 Grosvenor Sq., AU. 20.
1848	90	*Cottage near Killecrankie,* 20gns., John Henderson Esq., Winlaton, Durham, Frame and glass £3.0.0, AU. 15£.

1848	202	*What does he weigh, Sandy?,* 60gns., Chas. Eversfield Esq., Denne Park, nr. Horsham, Sussex, Received of Mr. Stepney for frame £9.5.0 W. Dickinson for S.M. Foord.
1850	45	*Windsor, from the Playing Fields,* 25gns., A. Morison Esq., Mount Blaery(?) Ho.
1850	83	*Loch Vach - Death of the Otter,* 60gns., Frame and glass £8.0.0.
1850	100	*Return from the Hill - Glen Tilt, from Ben-y-Gloe,* 60gns., John Wild Esq., Clapham Lodge, Frame and glass £7.10.0 No.
1851	25	*Glen Tilt, from the Grey Stone - a Drive.*
1851	119	*The Tilt.*
1851	142	*Schihallion, from the Bruar -* 12th August.
1851	271	*Mulgrave Castle, from the Moor.*
1851	291	*Dover.*
1853	50	*The Water Meadows, Droxford, Hants, "Trust me, I have caught many a trout in this particular meadow." Isaac Walton.*
1853	139	*The Water Meadows, Soberton, Hants.*
1854	70	*Grey Stone - Glen Tilt,* Sold.
1854	158	*A Highland Farm - Loch Tammel,* Sold.
1855	126	*Hay Making - Glen Tilt,* 70gns.

EVANS WILLIAM

1845	105	*Salmon Pool, on the Conway,* 20gns., Frame and glass £3.3.0.
1845	150	*Moel Siabod, North Wales,* 25gns., John Hellicar Esq., Newport, Monmouth, Frame and glass £5.5.0, P.AU. 25£.
1845	276	*St. Paul's, from Aldersgate Street,* 20gns., Frame and glass £2.12.6.
1845	317	*Traeth Mawr, North Wales,* 10gns., Frame and glass £2.2.0.

EVERETT E

1819	5	*Fall of the River Rhydol, near the Devil's Bridge, South Wales.*
1819	194	*View near Shrewsbury.*
1819	243	*View near Chepstow, Monmouthshire.*
1820	263	*Vale of Conway, North Wales - Evening.*

EVERITT E

1819	143	*Haughmond Abbey, Shropshire.*

FERGUSON T

1820	82	*Scene near Tynemouth, Northumberland.*

FIELDING C V

1810	162	*Bow Fell, high end of Borrowdale.*
1810	197	*Schofell, from the Pass between Hardknot and Wrynose, Cumberland.*
1810	202	*Peterborough, Northamptonshire,* Col. Maitland.
1810	315	*Helvellyn, from the Druid's Circle, near Keswick, Cumberland.*
1810	328	*View near Ormskirk, Lancashire.*
1811	54	*Watch-Tower, or Mountain Pass, "Forth from their Mists great Mountains scowl ..."*

1811	154	*On the Canal at Bootle, near Liverpool.*
1811	184	*Melrose Abbey, on the Tweed, Scotland; Interior of the Part lately used for Service.The Sketch taken in October, 1810, the Month in which it was altogether deserted.*
1811	186	*Newark Castle, on the River Yarrow, Scotland, "The Way was long, the Wind was cold . . ." Introduction to the Lay of the Last Minstrel.*
1811	198	*Morning - a Composition.*
1812	1	*Llanberris, from the Pass over to Capel Carig, Caernarvonshire.*
1812	10	*The Head of Traeth Bach, Merionethshire.*
1812	38	*Dolbaddern Castle, Caernarvonshire.*
1812	42	*Naworth Castle, Cumberland, a Seat of the Right Hon. the Earl of Carlisle.*
1812	83	*View over Traeth Mawr, towards Tan-y-Bwlch, the Sands now recovering from the Sea by the Tre Madoc Embankment, North Wales.*
1813	14	*Pegwell Bay, Kent.*
1813	25	*Part of Ruthvin Castle, Denbighshire.*
1813	33	*Beddgelart Bridge, Caernarvonshire.*
1813	50	*View in Wales, a Sketch.*
1813	71	*Harlech Castle, Merionethshire.*
1813	87	*Peel of Goldiland, near Branksome Castle, Tiviotdale.*
1813	98	*The Pass of Snowdon, between Caple Careig and Llanberris, a Sketch.*
1813	133	*Morning.*
1813	142	*Carnarvon Castle, North Wales, Afternoon.*
1813	153	*Evening.*
1813	162	*View down the Valley of Llanberris, Carnarvonshire, North Wales.*
1813	163	*Llanberris Lake.*
1813	164	*Snowdon, from Capel Carig.*
1813	165	*Soho Fell, from the Pass-over-Wry-Nose Cumberland.*
1813	173	*View on a Common.*
1813	206	*Morning - Composition.*
1813	210	*Carnarvon Castle, a Sketch.*
1813	226	*Moonlight - View in Roxburghshire - Melrose Abbey in the Distance.*
1814	9	*Six Views to illustrate the Poem of Rokeby.*
1814	48	*Moor Scene.*
1814	67	*Landscape - Sunset.*
1814	68	*Conway Castle, North Wales.*
1814	69	*Caernarvon Castle, North Wales.*
1814	70	*Vale of Lorton, Cumberland - Morning.*
1814	71	*Eagle Tower, Caernarvon Castle.*
1814	114	*The Rydal Mountains and Vale of Ambleside.*
1814	173	*Ullswater, Cumberland - Afternoon.*
1814	177	*Banditti.*
1814	200	*Whitton Hall, the Seat of Newby Lowton, Esq. Durham.*
1814	201	*Distant View of Caernarvon Castle, North Wales.*
1814	202	*A Sketch.*
1814	213	*Cader Idris, seen over the Avonvawr River, from between Barmouth and Dolgelly.*
1814	217	*Pennman-Vechan, Coast of Caernarvonshire, from near Conway - A Sketch.*
1814	223	*Landscape.*
1814	246	*Snowden, from Capel Carig, North Wales.*
1814	247	*View in Borrowdale, Cumberland.*
1814	248	*View down the Valley of Llanberis, North Wales.*
1814	249	*High and low Pikes, from near Ambleside, Westmoreland.*
1814	266	*Vale of Tempe - Inachus discovering his Daughter Io., Ovid's Metamorphoses*
1814	301	*Palace and Town of Bishop's Auckland, Durham.*
1814	306	*Landscape Composition, from the Story of Europa.*
1815	34	*In the vale of Llanrwst, Caernarvonshire,* £2.2.0, Mr. Taylor.
1815	162	*Kenilworth Castle,* £2.12.6, Mr. Renwick.
1815	178	*Ruthyn, and the Vale of Clwyd, Denbighshire.*
1815	183	*Rhydland Castle, and the Vale of Clywd, Denbighshire,* £26.5.0, Mr. Willimott.
1815	187	*View of Langdale, the Pass over Wrynose Head in the Distance, from near Ambleside, Westmoreland.*
1815	201	*Valley of Llanberris, Caernarvonshire.*
1815	221	*Cader Idris, and Dolgellie Bridge, Merionethshire,* £4.4.0, Rev. Sumner, Eton.
1815	227	*View in Borrowdale.*
1815	228	*Durham.*
1815	232	*In the Vale of Keswick, Cumberland.*
1815	233	*Moel Shabod, from near Capel Cerrig.*
1815	254	*Patterdale, from Kirkstone, Westmoreland.*
1815	261	*View up the River Bratha, near Clappersgate, Westmoreland,* £3.3.0, Sir J. Swinburne.
1815	262	*Harlech Castle from the North, Merionethshire.*
1815	263	*Beddgelert Bridge, Caernarvonshire.*
1815	264	*Mill at Beddgelert.*
1815	268	*Chiswick on the Thames.*
1815	273	*Morning, Composition.*
1815	277	*Twilight, on the Lower Lake of Wyburn, Cumberland,* £3.3.0, Mr. Renwick.
1815	287	*View on the River Eden, near Kirk Oswald, Cumberland.*

1815	296	*Conway Castle, Caernarvonshire.*
1815	316	*Raby Castle, Durham, the Seat of the Right Honourable the Earl of Darlington.*
1815	330	*Warwick Castle.*
1815	331	*General View of Conway Castle.*
1815	333	*Harlech Castle, Snowdon in the Distance.*
1815	335	*Ulleswater, from near Pooley Bridge, Cumberland, £8.8.0, Mr. Willimott.*
1815	340	*View on the Wye, near Ross, £4.4.0, J. Leader Esq.*
1815	341	*The Vale of Ewes, near Langholm, Dumfriesshire.*
1815	343	*Part of Ambleside, seen from near the Church, Westmoreland.*
1815	344	*Morning, £3.13.6, Mr. Willimott.*
1815	352	*Morning.*
1815	353	*Afternoon.*
1815	354	*North View of Durham.*
1815	355	*North Bridge, Durham, £1.11.6, Sir J. Swinburne.*
1815	356	*Durham.*
1815	357	*Keep of Kenilworth Castle.*
1816	42	*View near Caerwys, Flintshire, Lord Suffolk.*
1816	74	*View under Moel Shabod, near Bettws, Carnarvonshire.*
1816	77	*Landscape.*
1816	87	*Morning, a River Scene.*
1816	106	*Beddgelart, Carnarvonshire.*
1816	107	*Naworth Castle, Cumberland.*
1816	109	*Eneas on his approach to the Entrance of the Infernal Regions, Vide Lib. vi. Enead.*
1816	138	*Schaw Fell, at the head of Esdale, Cumberland.*
1816	141	*River Scene, a Sketch.*
1816	153	*A Frame, containing four Views in Carnarvonshire. Lake of Dinas Moel Heydog. Chapel and Hamlet of Capel Careig. Lake of Gywnaut.*
1816	170	*Snowdon, from Nant Gwynaut, looking up Cwm-y-Llan, Carnarvonshire.*
1816	174	*Carlisle, Cumberland, Lord Suffolk.*
1816	191	*A Frame containing Four Drawings. The Peak of Snowdon, looking up the River Llwgy. The Vale and Lake Gwynaut. Chiswick on the Thames. Bridge and Mounains at the Head of the Vale of Festiniog.*
1816	225	*Rydall Water and Hall, from the Park, near Ambleside.*
1816	226	*View from the Foot of Cross Fell, near Melmerby, Cumberland.*
1816	227	*Lake and Vale of Llanberries, Carnarvonshire.*
1816	230	*The Vale of Irthing, with a distant View of Lanercost Priory, Cumberland, £12.12.0, G. Hibbert Esq.*
1816	235	*Water Tower, at Chester. Moel Heydog, near Beddgelart, Carnarvonshire.*
1816	270	*Scene in Nant Gwynaut, Carnarvonshire.*
1816	274	*Mill, at the Foot of Snowdon, near Beddgelart, Carnarvonshire.*
1816	277	*Ben Nevis, seen over Loch Eil.*
1816	282	*View from the Upper Road, between Tan-y-Bwlch, and Pont Aberglasslyn, towards the Sands of Traeth Maar, Merionethshire.*
1816	288	*Longleat, Wiltshire, the Seat of the Marquis of Bath. - The Offices, Green House, &c. designed and executed by Jeffery Wyatt, Esq. Architect. Engraved for Havell's Views of Mansions, Villas, &c. &c.*
1816	289	*Kings-Weston near Bristol, the Seat of Lord de Clifford, Engraved for Havell's Views of Mansions, Villas. &c.*
1816	292	*Dieppe, in Normandy, from a Sketch by R. Hills Esq.*
1816	297	*Ullswater, Cumberland.*
1816	298	*Wass-water, Cumberland.*
1816	302	*Brougham Castle, near Penrith, Cumberland.*
1816	317	*A Sketch.*
1816	318	*Vale of Elwy, Flintshire.*
1817	2	*Brancepeth Castle, Durham, £8.8.0, Lady de Grey.*
1817	5	*Corsham House, Wilts, the seat of P. C. Methuen, Esq. Drawn for Havell's Views of Gentlemen's Seats.*
1817	6	*Afternoon - Naworth Castle, Cumberland.*
1817	10	*Naworth Castle, Cumberland.*
1817	11	*West Tower, and part of the great Hall in Goodrich Castle, Herefordshire.*
1817	14	*Kingston upon Thames.*
1817	62	*View in Merionethshire, from the upper or Mountain Road between Beddgelert and Tan-y-Bwlch, about two miles from Pont Aberglaslyn.*
1817	89	*Snowdon and Capel Cerrig, Caernarvonshire.*
1817	95	*Scene from Ariosto - Orlando Furioso, book i, stanzas 35, 36., "Trovossi al fine in un boschetto adorno . . ."*
1817	162	*Dolbadern Tower, a Sketch.*
1817	170	*Mountain Scene near Pont Aberglaslyn, Caernarvonshire.*
1817	171	*Afternoon, a sketch.*
1817	176	*A Frame containing two Drawings, a Mountain Scene on the Road between Tan-y-Bwlch and Pont Aberglaslyn; and Scene near Ullswater, Cumberland.*
1817	203	*East End of Caernarvon Castle.*
1817	205	*A Sketch.*
1817	215	*The Lakes of Llanberis and Dolbadern Castle, Clouds passing off after rain.*

1817	219	*Dolbadern Tower, Caernarvonshire.*
1817	228	*Goodrich Castle, and the River Wye, from the Hill above the Ferry, £12.12.0, Lady de Grey.*
1817	235	*Castle of Caernarvon, looking over the Town from the Llanberis Road.*
1817	245	*View on the Thames at Twickenham, Pope's Villa in the Distance.*
1817	254	*Sketch of a Beech Tree.*
1817	260	*Cnight, a Mountain near Festiniog.*
1817	261	*Mountains at the head of Traethmawr, Merionethshire, Storm passing off.*
1817	267	*Gateway to Denbigh Castle, North Wales.*
1817	268	*Gateway to Lanercost Priory, Cumberland.*
1817	269	*Carlisle Castle, Cumberland.*
1817	270	*King's Tower, Denbigh Castle.*
1817	272	*View of Goodrich Castle, looking down the Wye, Herefordshire.*
1817	275	*View looking down the Vale of Llanberris, Caernarvonshire.*
1817	282	*A Frame containing four Drawings - View of Carlisle - Snowdon from Nant Gwinant - View of Moel Hebog, looking down the River towards Beddgelert (Evening) and Ivy Cottage at Rydal near Ambleside, Westmorland.*
1817	285	*Morning - Scene in the Vale of Clwyd, Denbighshire.*
1817	293	*View in the Pyrenees.*
1818	3	*View of Ambleside. Coniston Fell in the Distance. Westmoreland.*
1818	7	*Brougham Castle, Westmoreland.*
1818	31	*Cottage Scene.*
1818	47	*Holywell, Flintshire.*
1818	48	*The Vale of Irthing, with a distant View of Lanercost Priory, Cumberland.*
1818	73	*Moel Hebog, Caernarvonshire.*
1818	87	*Scene on the Road near Capel Curig.*
1818	106	*Caernarvon Castle.*
1818	146	*Scene on the Coast of Merionethshire. Storm passing off. Coasting Vessels landing Cattle on the Sands.*
1818	204	*Ullswater, Cumberland.*
1818	207	*Llyn Ogwen, near Capel Curig, Caernarvonshire.*
1818	220	*View of Snowdon, over the Peat Bogs at the Head of Traeth Mawr, near Pont Aberglaslyn, Merionethshire.*
1818	228	*Raby Castle, Durham, £15.15.0, Walter Fawkes Esq.*
1818	231	*Two Distant Views of Carlisle, Cumberland.*
1818	239	*View of the Valley and Falls of the River Llugwy, two miles from Capel Curig, Caernarvonshire, £12.12.0, G. Hibbert Esq., Clapham.*
1818	240	*Two Drawings - Priory, at Brecon; and Windermere, from the Station.*
1818	255	*River Scene - Evening.*
1818	282	*Distant View of Harlech Castle, Merionethshire, £2.12.6, Lady Mary Bennett.*
1818	283	*Two Drawings - Cascade, at Bolton - Goodrich Castle, on the Wye, £1.1.0, T.G.*
1818	284	*Four Drawings - The Bridge, at Beddgelert - the Vale of Clwyd, from near Denbigh - Mountain Scene, looking down to Llyn Gwynant, Caernarvonshire - Bala Lake, Merionethshire.*
1818	285	*View of Windermere, from near Bowness.*
1818	286	*Two Drawings - The Tower of Goldilands, Roxburghshire - View of Snowden, from the Road to Capel Cûrig, Caernarvonshire.*
1818	291	*View of the Wrynose Mountains, Westmoreland (Evening).*
1818	292	*Four Drawings - Vale of Llanberris, with distant View of Dolbadern Castle - Llyn Gwynant, Caernarvonshire - View near Bolton, Yorkshire - Bridge at Brecon.*
1818	293	*Rydal Lake, from the Park near Ambleside, Westmoreland.*
1818	306	*Landscape.*
1818	323	*View of Scho Fell, taken from the Ravenglass Road between Hardknot and Wrynose, Cumberland.*
1818	326	*Conway Castle.*
1818	331	*Cnight, a singular Mountain of Merionethshire, as seen from the Road between Tan-y-bwlch and Beddgelert.*
1818	334	*Dolwydelan Castle near Capel Curig, Caernarvonshire.*
1818	339	*View of Snowdon, from the Mountain Road to Ffestiniog from Beddgelert.*
1818	341	*Bridge in the Vale of Ffestiniog, two miles above Maentwrog, Merionethshire, £8.8.0, Do. [Lord Suffolk].*
1818	356	*Sion in the Valais, from a Sketch by Newby Lowson, Esq.*
1818	361	*View in St. John's Vale, Cumberland, Saddleback in the Distance.*

FIELDING COPLEY

1819	6	*The Lake of Nemi, with a distant View of the Pontine Marshes and Mediterranean. Part of the Town of Gensano is seen on the right, and the Promontory of Circe in the extreme Distance - from a Sketch by Major Cockburn, £21.0.0, J. Wells Esq., Redleaf, Kent.*
1819	9	*Shakespeare Cliff - Twilight.*
1819	10	*Sun-set near Sandgate, Kent, £8.8.0, Mr. Robertson.*
1819	12	*Derwent Water and Skiddaw, from near Lowlore Water Fall, Cumberland.*

1819	17	*Dover Castle.*
1819	18	*Sun-rise, near Sandgate, Kent, £5.5.0, Mr. Bradshaw.*
1819	22	*Snowdon, from Nant Gwynant, Caernarvonshire.*
1819	24	*Two Views of Derwent Water, Cumberland.*
1819	25	*Scene near Ulleswater, and distant View of Harlech Castle.*
1819	26	*View from Rydal Woods, near Ambleside.*
1819	196	*View of the Rydal Mountains and Ambleside, with Waterhead seen over Winandermere.*
1819	197	*Four Drawings - Cnight, Merionethshire - Snowdon - View on the River Emont, Cumberland - and distant View of Carlisle.*
1819	205	*View in a Field near Carlisle - Rydal Water, Westmoreland - On the Thames, near Chiswick - View at Sandgate, Kent.*
1819	207	*View on the Thames, near Battersea.*
1819	213	*Ulles Water - Naworth Castle, Cumberland - View in Nant Gwynant, Caernarvonshire - Cottage Scene near Ulleswater.*
1819	216	*View near Putney on the Thames, £3.3.0, J. Augusthe Esq.*
1819	222	*Four Drawings - Ulles Water and Crummock Water, Cumberland - and Two Views of Llyn Gwynant, Caernarvonshire, £10.10.0, G. Hibbert Esq.*
1819	224	*Stonehenge, £21.0.0, W. Fawkes Esq.*
1819	226	*View on the River Brathy at Clappersgate, near Ambleside.*
1819	229	*Bridge in the Vale of Ffestiniog, Merionethshire.*
1819	230	*Boats, and Martello Tower, Sandgate, Kent - from Nature, £7.7.0, Sir T. Acland.*
1819	232	*Brecon, South Wales.*
1819	236	*View on the Thames near Vauxhall.*
1819	239	*Lanercost Priory, Cumberland.*
1819	245	*Beddgelert, Caernarvonshire - Wyburn Water, Cumberland - Cottage near Morden, and Morden Church, Surrey.*
1819	251	*Two Subjects on the St. Gothard Route, Switzerland, £3.3.0, Sir T. Acland.*
1819	253	*The Fall of the Hepstey, Glamorganshire, and View of Carlisle, Cumberland.*
1819	254	*Three Drawings of Marine Subjects - from Nature.*
1819	263	*View near Servos, in Savoy.*
1819	275	*Two Drawings of Sandgate Fishing Boats - from Nature.*
1819	280	*Chepstow Castle, Monmouthshire, £47.5.0, T.G.*
1819	281	*View on the Italian side of the Route of the Simplon.*
1819	285	*The Cliffs, near Sandgate, Kent - From Nature.*
1819	286	*Three Drawings from Nature; Scenes near Sandgate, Kent.*
1819	288	*Fishing Boats, at Sandgate, Kent - From Nature.*
1819	297	*Stone Boats, at Folkestone Pier Head, Kent.*
1819	298	*Cottage Scene, in Eskdale, Dumfrieshire.*
1819	300	*Cliffs near Folkstone - Drawn from Nature.*
1819	304	*Sun-set, at Folkestone, before a stormy night, £21.0.0, J. Allnutt Esq.*
1819	314	*Cattle Scene.*
1819	322	*View of the Vale of Clwyd, from near Denbigh.*
1819	326	*View on the Thames, near Fulham.*
1819	340	*Carlisle Castle, Cumberland.*
1819	341	*Southampton, from Netley Fort, £3.3.0, J. Wells Esq.*
1819	342	*View on the Thames, near Putney.*
1819	344	*Two Views of Lymne Castle and Church, near Hythe, looking over Romney Marsh, Kent.*
1820	6	*View of Naples and the Bay from the Road to Camaldoli - Vesuvius in the Distance - The Castle of St. Elmo on the right. From an original sketch, £21.0.0, Mr. Webster, Chelsea.*
1820	8	*View looking across Ulles Water, Cumberland.*
1820	14	*Skiddaw and Derwent Water, from Borrowdale, Cumberland.*
1820	19	*View near Lenham, Kent.*
1820	31	*Brothers Water in Patterdale, Cumberland.*
1820	32	*Beccles in Suffolk, looking over Gillingham Marsh.*
1820	35	*View of the Flintshire Coast across the Estuary of the Dee, from Park Gate, Cheshire - Stormy Effect, £8.8.0, J. Belisario Esq.*
1820	159	*Moel-Hebog, from near Beddgelert, Caernarvonshire.*
1820	219	*Three Drawings - Goodrich Castle - Scene near Beccles, Suffolk - View in Wastdale, near Keswick.*
1820	224	*Two Drawings - Caernarvon Castle - and Twilight Scene in Hyde Park.*
1820	225	*Four Drawings - Elter Water, near Ambleside - The Head of Borrowdale, near Keswick - Honister Crags, seen over Buttermere and Crummock Water - View on Ulles Water, Cumberland.*
1820	231	*Snowdon, from the Head of Lliniau Mymber, near Capel Cûrig, Caernarvonshire.*
1820	234	*Two Views of Ulles Water, Cumberland - Moelwyn, from Pont Aberglaslyn, and View on the River Conway, about five miles above Aberconway, Caernarvonshire.*
1820	237	*Sandgate Fishermen and Boats, Kent.*
1820	240	*Rydal Water, near Ambleside, and Wyburn Water, near Keswick.*

1820	243	*Garianonum, or Burgh Castle, the Roman Camp near Yarmouth, Norfolk - Sun-set.*
1820	244	*River Scene, and View on Keswick Lake, Cumberland.*
1820	248	*Warwick Castle, and Ulles Water.*
1820	249	*Snowdon and Capel Cûrig, Caernarvonshire.*
1820	253	*Turf Cutters on the Peat Bog, between Pont Aberglaslyn and Tany-y-Bwlch - Snowdon and the Caernarvonshire Mountains in the Distance.*
1820	254	*View from the Top of Shakspeare Cliff, near Dover - Folkestone in the Distance, the Sussex Hills beyond.*
1820	259	*View from Shornecliff over Hythe & Romney Marsh, Kent.*
1820	265	*The Vale of the Wye and Goodrich Castle, looking up the River from Bishop's Wood.*
1820	267	*Fishing Boats at Sandgate, Kent.*
1820	270	*Fishing Boats on the Sands at Folkestone.*
1820	276	*Lymne Castle, near Hythe, Kent - Sun-rise, £10.10.0, Mr. Windus.*
1820	281	*Sea View, looking over the Straits of Dover to the Coast of France - A Windy Day.*
1820	283	*Scene on the Sands at Folkestone - A Calm.*
1820	295	*Sun-set before a Stormy Night - Scene at the Mouth of Folkestone Harbour, £10.10.0, Mr. Windus.*
1820	302	*Distant View of Harlech Castle, North Wales, £3.3.0, Genl. Grey.*
1820	304	*Four Drawings - Views of Wast Water, a Scene near Keswick, Cumberland - Pont-y-Pair, near Llanrwst, and Beddgelert, Caernarvonshire.*
1820	321	*View of Folkestone, Kent - Evening.*
1820	322	*Coniston Water, Lancashire.*
1820	328	*Near Ambleside, Westmoreland.*
1820	336	*Rydal Woods and Lake, with a distant View of the Langdale Mountains, Westmoreland, £7.7.0, Major Pym.*
1820	343	*Scene in the Appenines.*
1820	344	*Caistor Castle, near Yarmouth, Norfolk.*
1820	354	*Sun-set, at Shoreham, Sussex.*
1820	364	*Encampment of Gipsies.*
1820	368	*Sun-rise, View of Folkestone and Shakspeare Cliff.*
1820	369	*Four Drawings - Causeway Pike, over Derwent Water - Waterfall in Merionethshire - Wood Scene near Penrith - and Wilton Castle, on the Wye.*
1820	370	*The Bay of Naples and Vesuvius.*
1820	371	*Distant View of the Downs and North Foreland, from Ramsgate, Kent.*
1820	375	*The Lower Lake of Wyburn, near Keswick, Cumberland.*

1821	13	*Vessels in a strong gale, the South Foreland in the distance, £16.16.0, Mr. Garle.*
1821	17	*Waterfall near Ambleside, Westmoreland, £6.6.0, J. Taylor Esq.*
1821	20	*View on the Shore at Hastings.*
1821	22	*Scene on the St. Gothard Route - Switzerland, £6.6.0, Sir J. Swinburne.*
1821	38	*Vessels at the Entrance of Folkstone Harbour in a Stormy Day, £16.16.0, Bishop of Ferns.*
1821	58	*View of Derwent Water, Cumberland, £3.3.0, J. Taylor Esq.*
1821	59	*Two Scenes in Cumberland, £4.4.0.*
1821	68	*The Pierhead at Folkstone.*
1821	71	*View of Snowdon and Capel Cûrig.*
1821	75	*Dolbadern Tower, Caernarvonshire.*
1821	78	*Scene in Teesdale, Durham.*
1821	83	*Scene in Greenwich Park.*
1821	86	*Vessels in a Gale of Wind, a Ground-swell in the Sea.*
1821	106	*View of Ulleswater, Cumberland, £3.3.0, J. Taylor Esq.*
1821	107	*Distant View of Crummockwater, Cumberland, £3.3.0, C. Cotton Esq.*
1821	109	*London, from Greenwich Park, £47.5.0, Mr. Webster.*
1821	138	*Scene in the Wilds of Denbighshire near Guytherin, the burial-place of St. Winifred.*
1821	139	*Caernarvon Castle and Harbour - Afternoon.*
1821	140	*Folkstone, Kent - A Storm clearing off, £16.16.0, Bishop of Ferns.*
1821	142	*The Mountains of Skiddaw and Saddleback in Cumberland, as seen from the Moors near Matterdale.*
1821	143	*Harlech Castle, Merionethshire, £8.0.0, Bishop of Ferns.*
1821	150	*Caistor Castle, Norfolk, by Moonlight.*
1821	154	*Scene at the Mouth of the Mersey, Liverpool, £7.7.0, Bishop Ferns.*
1821	156	*Barnard Castle on the Tees, Durham.*
1821	158	*Twilight, "The west yet glimmers with some streaks of day . . ." Shakspeare.*
1821	160	*The Head of Cardigan Bay, looking from Criccieth Castle, over to Harlech in the distance, £8.8.0, C. Stokes Esq.*
1821	163	*Distant View of Helvellyn, over Ulleswater, Cumberland.*
1821	170	*Fishermen going out in the Morning, Scene in Eastwere Bay, near Folkstone, Shakespeare Cliff in the distance, £9.9.0, Sir J. Swinburne.*
1821	171	*Three Views of Ulleswater, Cumberland, and a River Scene in Devonshire.*
1821	174	*Derwent Water, from near Portinscale, £4.4.0, Mrs. Charlton.*

1821	180	*Bradwardine, Herefordshire.*
1821	187	*Chepstow Castle, £7.7.0, Mr. Powell.*
1821	189	*View of Lymouth, from Linton, on the Coast of North Devon.*
1821	190	*Scene in St. John's Vale, Cumberland.*
1821	191	*St. Donat's Castle and Church, Glamorganshire.*
1822	2	*Sun-rise - distant View of Shakspeare Cliff, over Folkstone Harbour.*
1822	6	*Hythe, Kent.*
1822	12	*Bulverhithe, near Hastings; and View of Dover Castle, £4.4.0, Mr. August and Mr. Taylor.*
1822	22	*Scene in North Wales.*
1822	26	*Cottages in Folkstone, Kent.*
1822	31	*Chepstow Castle.*
1822	37	*Dinas Emrys at the foot of Snowdon, near Beddgelart.*
1822	40	*Romney Marsh, Kent, £31.10.0, T.G.*
1822	47	*Scene on the Beach at the entrance of Dover Harbour.*
1822	48	*View in Patterdale.*
1822	49	*Coast Scene near Sandgate, Kent, £3.3.0, C. Birch Esq.*
1822	63	*Distant View of Rye, Winchelsea, and the Hastings Hills, over Romney Marsh, £12.12.0, T.G.*
1822	66	*Fall of the Oltschibach, near Meyringen, Switzerland, from a Sketch by W. Nesfield, Esq., £16.16.0, Earl Grey.*
1822	67	*Castle of Stolzenberg, on the Rhine, near Coblentz, from a Sketch by W. Nesfield, Esq..*
1822	72	*Sketch of Trees.*
1822	81	*Harlech Castle, Merionethshire.*
1822	82	*View near Romney, Kent.*
1822	83	*Winchelsea Castle, Sussex, £6.6.0, Mrs. Basil Cochrane.*
1822	88	*The River Llygwy near Capel Cûrig, Caernarvonshire, £6.6.0, Sir J. Swinburne.*
1822	93	*View on Elter Water, near Ambleside, £3.3.0, Mr. Baillie.*
1822	94	*Lymne Castle, near Hythe, Kent, £2.12.6, G. Hibbert Esq.*
1822	95	*Ragland Castle, Monmouthshire, £3.3.0, Sir Chas. De Veaux(?).*
1822	100	*Goodrich Castle.*
1822	110	*View of Shakespeare Cliff, from Dover.*
1822	111	*Vessels on the Sands, near Folkestone.*
1822	115	*The Sands at low-water near Park-Gate, Cheshire, looking over the Dee, into Flintshire.*
1822	119	*Chepstow.*
1822	129	*View on the Thames near Chiswick, £3.3.0, Mr. Powell.*
1822	131	*Retirement.*
1822	133	*View in Wastdale, Cumberland, £12.12.0, Mr. Smith.*
1822	141	*Windermere, Westmoreland, £7.7.0, J. Newman Esq.*
1822	142	*Sun-set at Hastings, £7.7.0, Rev. W. Long.*
1822	143	*Sun-rise, Eastwere Bay, near Folkstone, Shakespeare Cliff in the distance.*
1822	145	*Caistor Castle, Norfolk; and Cottage Scene.*
1822	151	*Four views of the Lakes in Cumberland, £8.8.0, G. Hibbert Esq.*
1822	157	*Twilight, £2.2.0, Mrs. Oglanden, Oxford.*
1822	159	*Kenilworth Castle, £2.2.0, G. Hibbert Esq.*
1822	161	*Crummock and Buttermere Waters, Cumberland.*
1822	167	*Criccaeth Castle, Caernarvonshire.*
1823	7	*Scene between Brighton and Shoreham, Sussex.*
1823	10	*View on the River Llygwy near Capel Curig, Caernarvonshire; the Peaks of Snowdon in the distance - Morning, £8.8.0, Mr. Whitmarsh.*
1823	12	*View in Merionethshire.*
1823	20	*Vale of Llanrhwst, Caernarvonshire.*
1823	40	*View of the South Downs and Bramber Castle, Sussex.*
1823	43	*Scene on the Banks of Derwentwater; the Mountain of Saddleback in the distance, £7.7.0, Honble. Col. Stanhope.*
1823	46	*View near the Vale of Ffestiniog, North Wales, £4.4.0, Mr. Hullmandel.*
1823	51	*Distant View of Venice, £4.4.0, E. Tattersall Esq.*
1823	56	*Conway Castle, Caernarvonshire.*
1823	70	*A Scene in Switzerland.*
1823	86	*Sun-set - Scene on the Thames, near Deptford.*
1823	96	*Scene on Romney Marsh.*
1823	101	*Harlech Castle - Sunset, "The shifting clouds . . ." £6.6.0, Marquis of Stafford.*
1823	103	*Dunnose, Isle of Wight, £7.7.0, Honble. Col. Stanhope.*
1823	109	*Denbigh, in the Vale of Clwyd, North Wales.*
1823	111	*Harlech Castle, Merionethshire.*
1823	119	*Scene on the Beach near Folkstone, Kent, £3.3.0, Sir Abraham Hume.*
1823	120	*Ragland Castle, Monmouthshire.*
1823	123	*Passengers going off to a Packet.*
1823	124	*Rydal Water, Westmoreland, £4.4.0, F. Powell Esq.*
1823	125	*View on Ulleswater, Cumberland, £4.4.0, Do.*
1823	129	*Sandown Bay, Isle of Wight - Morning, £8.8.0, Wm. Knyvett Esq.*
1823	130	*Scene near Ulleswater.*

1823	144	*London, from London-bridge - Evening*, £7.7.0, Mrs. Basil Cochrane.
1823	148	*Sea Shore - Morning*, £3.3.0, G. Haldimand Esq.
1823	151	*Brook Scene*, £2.2.0, Mr. Hullmandel.
1823	163	*Near Watenlath, above the Fall of Lowdore, Cumberland.*
1823	182	*Scene on the Sea Beach - a Vessel stranded - with a distant View of Brighton*, £7.7.0, G. Constable Esq., Arundel.
1823	190	*Skiddaw and Derwentwater, Cumberland.*
1823	213	*Windsor, "Here waving groves a chequer'd scene display . . ." Pope's Windsor Forest.*
1823	218	*Llyn Gwynant, Caernarvonshire.*
1823	219	*View near Edenhall, Cumberland.*
1823	228	*View near Goodrich Castle, Herefordshire.*
1823	229	*Derwent Water, near Keswick*, £4.4.0, F. Powell Esq.
1823	238	*View of Snowdon, from near Bangor.*
1823	260	*Combe Martin, North Devon*, £7.7.0, General Grey.
1823	264	*Fishing Boats at Sea*, £7.7.0, J. Webster Esq.
1823	270	*Shoreham Harbour, Sussex.*
1823	274	*Studies - Dolwyddelan Castle, North Wales - Sunset near Hastings - near Rhydland in the Vale of Clwyd.*
1823	285	*Four Views near Ulleswater, Cumberland.*
1823	292	*Dolbadern Castle, Caernarvonshire.*
1823	298	*View in the Vale of Clwyd.*
1823	300	*Four Marine Views.*
1823L	15	*Distant View of Goodrich Castle*, The Artist.
1823L	79	*Hastings*, The Artist.
1823L	81	*Solitude*, The Artist.
1823L	94	*Chepstow*, T. Griffith, esq.
1823L	95	*Brougham Castle, Westmoreland*, T. Griffith, esq.
1823L	107	*Sun-set*, J. Allnutt, esq.
1823L	119	*Sun-rise*, B. Windus, esq.
1823L	126	*Sun-set*, B. Windus, esq.
1823L	173	*View near Rydal, Westmoreland*, The Artist.
1823L	183	*Wood Scene*, J. Allnutt, esq.
1824	5	*Beddgelert, Caernarvonshire.*
1824	12	*St. John's Vale, Cumberland.*
1824	18	*Evening - Scene in the Highlands.*
1824	21	*View of Ben Vorlich and Mountains, at the Head of Loch Lomond, from near the Point of Farkin - An Effect after Rain.*
1824	23	*Scene on Romney Marsh.*
1824	29	*Brougham Hall, Westmoreland.*
1824	31	*Ulles Water, Cumberland.*
1824	33	*Near Penrith, Cumberland.*
1824	36	*Scene on the Sands at Parkgate, Cheshire.*
1824	57	*Loch Lomond.*
1824	59	*Loch Leven, in the North West Highlands - Morning.*
1824	67	*Goodrich Castle, Herefordshire.*
1824	68	*Vessels at Sea.*
1824	86	*Part of Ulles Water, Cumberland.*
1824	87	*Winandermere, near Ambleside.*
1824	91	*Roslin Castle, near Edinburgh.*
1824	92	*Scene in Glen Falloch, Argyleshire.*
1824	94	*View over Ulles Water, from Gowbarrow Park.*
1824	100	*Morning - Scene from L'Allegro', "Some time walking, not unseen . . ." Vide Milton.*
1824	109	*View of Ben Lomond - from Glen Falloch.*
1824	111	*Scene at the head of Glen Coe - Highlands - Storm passing off.*
1824	124	*Shore at Hastings - Sussex.*
1824	135	*Richmond, in Yorkshire.*
1824	155	*Loch Leven, and Mountains of Glen Coe, from near Ballahulish, Argyleshire - Effect of Rain.*
1824	161	*Loch Awe, and Ben Cruachan, Argyleshire.*
1824	162	*View on Crummock Water, Cumberland.*
1824	168	*Sunset - Fishing Boats at Sea - Worthing in the distance.*
1824	176	*Scene in Glen Lochy, near Killin, Perthshire.*
1824	177	*Folkstone, Kent - Sunset.*
1824	180	*View on Derwent Water, Cumberland.*
1824	191	*Edinburgh, from Salisbury Crags.*
1824	193	*Langdale Pikes, seen over Blea Tarn, Westmoreland.*
1824	197	*Scene from the fourth book of the AEneid, "Meantime the gathering clouds obscure the skies . . ."*
1824	204	*Dunolly Castle, Coast of Argyleshire.*
1824	209	*Vessel on Shore.*
1824	212	*The Trosacks and Ben Venue, seen over Loch Achray.*
1824	213	*View in the West Highlands.*
1824	218	*Goodrich Castle, on the Wye.*
1824	231	*View on Romney Marsh, Kent.*
1824	233	*Loch Leven, West Highlands - View in the Vale of Gwynant, at the foot of Snowdon - View near Killin, Perthshire, and View in Cumberland.*
1824	237	*Loch Achray - Perthshire.*
1824	238	*Ulles Water, Cumberland.*
1824	239	*View, looking down Ulles Water, Cumberland.*
1824	272	*Ilfracombe - North Devon - Sun-rise.*
1824	283	*Llyn Gwinant, Caernarvonshire - Distant view of Winandermere - View in Borrowdale, and Crummock Water, Cumberland.*

1824	284	*Evening - Part of Ulles Water.*
1824	285	*Scene in Caernarvonshire, near Beddgelert.*
1824	289	*Helvellyn, and the Mountains at the head of Ulles Water.*
1824	297	*Distant View of the Isle of Wight, from Portsmouth.*
1824	300	*Cottage Scene.*
1824	301	*Scene on the Thames.*
1824	303	*Views of Skiddaw, from Borrowdale - Llyn Mymber, from Capel Curig - and Two Views of Ulles Water, Cumberland.*
1824	304	*Near Dover, Kent.*
1824	305	*Folkstone, Kent.*
1825	8	*Brook Scene, Evening,* 12gns.
1825	12	*Ben Lawers, Head of Loch Tay, Perthshire,* 7gns., Welby Esq., Frame and glass £3.3.0.
1825	13	*Loch Katrine and Ben Venue from the Entrance to the Trosachs,* 22gns., Mr. Botcherby, Darlington, Frame and glass £4.4.0.
1825	19	*View near Yarmouth, Norfolk,* 3gns., Welby Esq., Frame and glass £1.5.0.
1825	22	*Scene in Shoreham Harbour, Sussex,* 70gns.
1825	32	*Dundarra Castle on Loch Fyne, near Inverary - Effect of Rain clearing off,* 30gns., C.H. Turner Esq., Frame and glass £8.8.0.
1825	36	*Castle of Stolzenberg on the Rhine,* 3¹/₂ gns., Frame and glass £1.5.0.
1825	38	*Doune Castle, Perthshire,* 38¹/₂ gns., Frame and glass £1.5.0.
1825	46	*Distant View of Loch Lomond,* 8gns.(?), Mr. J. Smith Wright(?).
1825	53	*Inverary, Argyleshire - Morning,* 45gns., Mr. Monteith, Altogether picture frame and glass 50gns.
1825	56	*Castle on the Island in Loch Dochart, near Killin, Perthshire,* 10gns.
1825	64	*Chepstow Castle, Monmouthshire,* 3gns., J. Webster Esq., Frame and glass £0.10.0.
1825	68	*Scene in Cumberland,* 2gns., Mrs. Nightingale(?), 57 Lower Brook Street or 36 Upper Seymore Street, Frame and glass £0.14.0.
1825	71	*View under the South Downs, near Bramber, Sussex,* 32gns., Frame and glass £11.11.0.
1825	78	*Folkstone, Kent - Sun-rise,* 14gns., Frame and glass £4.14.6.
1825	79	*Loch Tay, Perthshire,* 5gns., Mr. Lock, 10 Upper Bedford Place, Russell Square, Frame and glass £1.10.6.
1825	83	*View on the Thames near Kingston,* 3¹/₂ gns.
1825	88	*Conway Castle,* 4gns., Mrs. F. Squibb(?), No. 1 Suffolk Place.
1825	94	*Ragland Castle, Monmouthshire,* 5gns., Frame and glass £1.5.0.
1825	114	*Loch Lomond - Ben Vorlich &c. from the Point of Farkin,* 8gns., Rev. H. Duncombe, 24 Arlington Street, Frame and glass £3.3.0.
1825	115	*Derwent Water, looking to Borrowdale - Cumberland,* 4¹/₂ gns., General Grey, No. 13 Hertford Street, Frame and glass £1.1.0.
1825	119	*Snowdon, from Nant Gwynant - Caernarvonshire,* 7gns., Mr. Knights, 24 Duke Street, Grosvenor Square, Frame and glass £3.3.0.
1825	124	*Caernarvon Castle,* 3¹/₂ gns., Mr. Hullmandel, Frame and glass £0.15.0.
1825	125	*Dunolly Castle, Argyleshire,* 4gns., Frame and glass £1.1.0.
1825	145	*Distant View of Brighton,* 30gns., Mr. Roby, Rochdale, Lancashire, Frame and glass £6.6.0.
1825	159	*View on the Clyde looking to Dumbarton Castle,* Sold.
1825	161	*Scene in the Highlands,* 2¹/₂ gns., Frame and glass £0.10.6.
1825	196	*Fisherman's Hut near the Oyster Beds, Shoreham Harbour,* 8gns., Mr. Roby, Rochdale, Lancashire, Frame and glass £3.3.0.
1825	199	*Scene on Romney Marsh, Kent,* 7gns., N. Hebbert Esq., Frame and glass £3.3.0.
1825	203	*River Lochay at Killin, Perthshire,* 4¹/₂ gns., Sir Matthew Ridley, Frame and glass £1.1.0.
1825	204	*Glen Coe - West Highlands,* 40gns.
1825	226	*York, from the Walls,* 6gns., Mr. Bell, 14 York Place, Portman St., Frame and glass £2.12.6.
1825	236	*Scene in Climberland,* 5gns., George Hibbert Esq., Frame and glass £2.12.6.
1825	237	*Evening,* 6gns., Ireland Esq., Verulem Buildings, Grays Inn Lane, Frame and glass £2.2.0.
1825	238	*Distant View of the South Downs, seen over Shoreham Marsh,* 24gns., Mr. Roby, Frame and glass £6.6.0.
1825	253	*Marine view off Folkstone, Kent,* 30gns., Lord Brownlow, Frame and glass £5.5.0.
1825	260	*Scene on the Moor of Rannoch, Argyleshire,* 16gns.
1825	265	*Rydal Water, Westmoreland,* 14gns., Frame and glass £4.4.0.
1825	280	*View near King's House, Argyllshire,* 4¹/₂ gns., Mr. Roby.
1825	289	*Scene near Shoreham, Sussex,* 12gns., Frame and glass £3.13.6.
1825	306	*Harlech Castle, Merionethshire,* 4gns., Frame and glass £1.5.0.
1825	311	*Carlisle Castle,* 2¹/₂ gns.
1825	312	*A Sketch,* 2¹/₂ gns., Mr. Staveley, 9 Brompton Square.

1825 313 *Fishermen - Eastwere Bay, near Folkstone, Kent*, 9gns., Frame and glass £2.12.6.

1825 314 *Windsor*, 4¹/₂ gns., S. J. Ireland Esq.

1825 315 *Shoreham - Sun-set*, Sold, Frame and glass £3.3.0.

1825 316 *Distant View of Harlech Castle, Merionethshire*, 8gns., E. Durant Esq., Frame and glass £2.2.0.

1825 325 *Four Views in Cumberland*, 10gns., Lady De Grey, 4 in the frame, 4 drawings, 2¹/₂ gns. each.

1825 327 *Four Views - Scene on the Thames - Windsor - Loch Katrine, and Glen Dochart*, 12gns., Right hand top and left bottom Mr. Willimott, right bottom C. Birch Esq., Lee Road, Black Heath, 4 drawings, 3gns. each.

1825 331 *Thurlas Castle, and Three Views in Westmoreland*, 8gns., 4 drawings, 2gns. each.

1825 338 *Lymne Castle, near Hythe, Kent*, 3¹/₂ gns., Frame and glass £1.1.0.

1825 339 *Loch Lomond - View in Cumberland - and Harlech*, 6gns., Top sold C. Birch Esq., Lee Road, Black Heath, 3 drawings, 2gns. each.

1825 342 *Scene near Brighton, Sussex*, 10gns., Frame and glass £2.2.0.

1826 8 *View of Brading Harbour, Isle of Wight*, 30gns., Sold.

1826 13 *The Bay of Naples*, 50gns., Frame and glass £10.10.0.

1826 14 *Scene on the Sands, at Ryde, Isle of Wight*, 15gns., Lord Northwick, Frame and glass £3.3.0.

1826 19 *Sea View*, 5gns., Birch Esq., 15 Sussex Place, Regents Park.

1826 22 *Bridge at Totness, Devonshire*, 15gns., Frame and glass £4.4.0.

1826 23 *View in Glen-Lochy, Perthshire*, 5gns., Frame and glass £1.1.0.

1826 25 *Binstead Pier, &c. near Ryde, Isle of Wight*, 15gns., N.E. Nightingale, M????s Hotel, Frame and glass £4.4.0.

1826 29 *Ulles Water, Cumberland*, 5gns., Prior Esq., Frame and glass £2.2.0.

1826 31 *Scene in the Isle of Wight*, 5gns., Lord C. Townshend, 5 Park Crescent, Frame and glass £2.2.0.

1826 34 *Evening - View near Totness, Devonshire*, 12gns., Mr. Staveley, 9 Brompton Square.

1826 37 *Lymouth, North Devon*, 11gns., Mr. G.G. Giles, Enfield.

1826 39 *View, near Dartmoor, Devonshire*, 4gns., Lady Mordaunt.

1826 44 *Scene on the Thames, near Fulham*, 4gns., H. Harrison Esq., 41 Bedford St., Covent Garden, Frame and glass £0.15.0.

1826 47 *Ben Lawers, from Glen Dochart, Perthshire*, 10gns.

1826 48 *View, looking to the entrance of Plymouth Sound, from Mount Edgcumbe*, 18gns., Mr. Wall, 44 Berkeley Square.

1826 61 *Dunbarton Castle, and Ben Lomond in the Distance*, £4.14.6, Blake Esq., Portland Place, Frame and glass £2.2.0.

1826 66 *View in Borrowdale, Cumberland*, 7gns.

1826 75 *Scene at Ryde, Isle of Wight, August 1825*, 8gns., Frame and glass £2.12.6.

1826 76 *Loch Tay, Perthshire*, 7gns.

1826 79 *Distant View of Plymouth Citadel, Mount Batten, and Drake's Island, Plymouth Sound*, 4gns., Dr. Le Mann, 16 Montague Street, Portman Square.

1826 82 *View at Killin, West Highlands*, 20gns., Frame and glass £3.13.6.

1826 85 *View in the Vale of Ambleside, Westmoreland*, 4gns., Lady Chetwynd, 7 Gt. George St., Westminster, To the care of Alfred Nicholson Esq., 31 Conduit Street.

1826 89 *Corri-Lin on the Clyde*, 35gns., A plate glass will be got, £11.11.0.

1826 101 *View at Dartmouth, looking to the Entrance of the Harbour*, 46gns., Duke of Norfolk, Frame and glass also £10.10.0.

1826 103 *Scene in Dunster, Somersetshire*, 8gns., Mr. Wall, 44 Berkeley Square.

1826 107 *Brougham Castle, Westmoreland*, 5gns., Frame and glass £0.15.0.

1826 112 *On the Coast of Kent, near Dover*, 5gns., Prior Esq.

1826 121 *Hastings, Sussex*, 5gns., Mr. Hullmandel.

1826 127 *Edinburgh, from the South*, 30gns., Frame and glass £5.5.0.

1826 130 *A Gale of Wind - Distant View of Portsmouth, from Spithead*, 8gns., Lord C. Townshend, Frame and glass £3.3.0.

1826 138 *View of Eastwere Bay, on the Coast of Kent, near Folkestone*, 7gns., Mr. Prior, Frame and glass £3.3.0.

1826 140 *View across the Marsh to Minehead, Somersetshire*, 22gns., Mr. Moxon, 23 Lincoln's Inn Fields, Frame and glass £5.5.0.

1826 141 *View, looking across Plymouth Sound from under Mount Edgcumbe*, Sold.

1826 142 *View of Ben An in the Trosachs, Perthshire*, 8gns., Frame and glass £3.3.0.

1826 144 *Loch Venachoir, West Highlands*, 4gns., Mr. Tamworth Junr., Greenwich.

1826 150 *Loch Katrine, West Highlands*, 7gns., Smith Esq., Frame and glass £2.12.6.

1826 156 *View in the Highlands, North Britain*, 4gns., Frame and glass £1.1.0.

1826	157	*View at Twickenham*, Sold.

1826 195 *Plymouth Sound - Mount Batten on the right, the Citadel on the left, Mount Edgcumbe in the distance*, 70gns., Lockwood Esq., Lansdown Place, Frame and glass £15.15.0.

1826 202 *Fishing Boats, Coast of Sussex*, 5gns., Mr. Hullmandel, Frame and glass £2.2.0.

1826 205 *Loch Leven, Argyleshire*, 6gns., Mr. B. Smith, 26 Regent St., Frame and glass £1.10.0.

1826 214 *On the Rhine, near St. Goar*, 4gns., Sir M. Ridley, Frame and glass £1.5.0.

1826 227 *Peel of Goldilands, Tiviotdale*, 4gns., Mr. Staveley, 9 Brompton Square, Frame and glass £1.1.0.

1826 253 *View on Romney Marsh, Kent*, 4gns., Marchioness of Stafford, Frame and glass £1.1.0.

1826 254 *View in the Weald, Sussex*, £5.15.6, Frame and glass £2.2.0.

1826 258 *View in Cumberland*, 4gns., Frame and glass £0.15.0.

1826 260 *Distant View of Dunster Castle, Minehead &c. Somersetsh.*, 35gns.

1826 271 *Twilight, at Binstead, Isle of Wight*, 10gns., Frame and glass £3.3.0.

1827 4 *Scene on the Beach at Hastings, Sussex*, 9gns., Mrs. Smith, No. 6 Portland Place.

1827 10 *View in Tilgate Forest, Sussex*, 8gns.

1827 13 *Vessels at Spithead*, 70gns., Sold.

1827 14 *Scene on the Waveney, near Beccles, Suffolk*, Sold.

1827 21 *The River Ouse, at York*, 15gns., Mrs. Baring, Piccadilly.

1827 38 *Stirling Castle*, 42gns.

1827 45 *Entrance of Dartmouth Harbour, Devon*, 8gns., Mrs. J. Braithwaite.

1827 52 *Loch Lomond, from near the Point of Farkin - Ben Vorlich in the distance*, 20gns., Sir John Swinburne, 10 Grosvenor Place.

1827 54 *Shoreham Harbour, Sussex*, 7gns., W. Wells.

1827 84 *Fishing Boats in Sandown Bay, Isle of Wight*, Sold, Mr. Cope.

1827 92 *Castle-Head Crag, and the Mountain of Saddleback, from Derwent Water, Cumberland*, 7gns., R.P. Glyn Esq., 21 Bolton Street, Piccadilly.

1827 93 *Distant View of Portsmouth*, 44gns.

1827 94 *Scene on the Moors above Glen Dochart, Breadalbane*, 15gns.

1827 95 *Vessels on the Coast near Folkestone*, 4^1/$_2$ gns.

1827 96 *View in Shoreham, Sussex*, 4gns.

1827 98 *View on the Coast at Dover - Sunrise*, 5gns., Mrs. N. Brandling, Low Gosforth, Newcastle Tyne.

1827 100 *Fishing Boats on the Shore, at Folkestone, Kent*, 5gns., Birch Esq.

1827 103 *View on the Coast of Sussex*, 5gns., G. Hibbert Esq.

1827 104 *Loch Tay, Perthshire*, 4gns., Lord F. Leveson Gower, 12 Albemarle Street.

1827 108 *Redcar, North Coast of Yorkshire*, 8gns., W. Stuart Esq., No. 10 Hill Street.

1827 109 *Pilot Boat going off to a Vessel in a hard Gale, near the Eddystone*, Sold.

1827 128 *View of Loch Leven, from near Balahulish, Argyleshire*, 6gns., Miss Shepley, 28 Devonshire Place.

1827 138 *View of the Black Mountain, near the head of Loch Lydoch, Argyleshire*, 24gns.

1827 146 *Ben Lomond, from near the head of Loch Lomond*, 6^1/$_2$ gns., Mr. Staveley, 9 Brompton Square.

1827 151 *View on Romney Marsh, Kent, looking towards Rye*, 7gns., Rev. J. Clowes, University Club House.

1827 157 *Lymouth, North Devon*, 8gns., G. Hibbert Esq.

1827 160 *Ben More, as seen over the Woods at the head of Loch Tay, Breadalbane*, 24gns.

1827 162 *Fishing Vessels, at Sea*, 4^1/$_2$ gns., Prior Esq.

1827 175 *View, near Oakhampton, Devonshire*, 6gns., Mr. Erskine Perry.

1827 176 *View on Loch Lomond, looking up to Tarbet*, 5gns., Mr. Erskine Perry, Limmers Hotel, Conduit Street.

1827 186 *Arreton Down, &c. over the Woods, near Binstead, Isle of Wight*, 22gns., F. Birch Esq.

1827 195 *Fishing-house, near the Hambleton Hills, Yorkshire*, 6gns.

1827 197 *Plymouth Sound*, 10gns., Mrs. Ellison, 79 Pall Mall.

1827 198 *View of Snowdon, from the Mountain Road between Pont Aberglaslyn and Vale of Ffestiniog*, 45gns.

1827 202 *Scene in Cumberland - Sunset*, 5^1/$_2$ gns., G. Hibbert Esq.

1827 206 *Scene on the Downs, near Lewes*, 12gns.

1827 210 *Netley Abbey, Hants*, 10gns., Mr. Richard Till(?), Clapham Rise.

1827 212 *Morning - Scene at Killin, Perthshire*, 50gns., Sold.

1827 213 *View, near Bramber, Sussex*, 12gns.

1827 222 *Distant View of Cowes, Isle of Wight*, Sold.

1827 232 *Scene in Romney Marsh, Kent*, 4^1/$_2$ gns., Mr. R.H. Solly, 48 Great Ormond Street.

1827 243 *Loch Venachoir and Ben Venue, West Highlands*, 8gns., Mr. H. West.

1827 278 *Scene near Romney, Kent*, 4gns., B. Smith Esq., 12 Jermyn Street.

1827	287	*Loch Achray, Perthshire,* 4gns.
1827	291	*Folkstone - Sunset,* 10gns., Mr. Haldimand, Paid J. English £16.0.0.
1827	302	*Elter Water, Westmoreland,* 5gns.
1827	305	*Scene on the Shore at Hastings, Sussex,* 5¹/₂ gns., Ms. P. Carew, No. 7 New Cavendish Street.
1827	326	*Evening - Loch Goyle, West Highlands,* 5gns.
1827	354	*Marine Subject.*
1828	15	*Harlech Castle - Merionethshire,* 40gns.
1828	31	*The Rydal Mountains over the Vale of Ambleside - Westmoreland,* 7gns.
1828	39	*At Inverary, Argyleshire,* 13gns.
1828	42	*Scene on the Sands at Brighton, at Low Water,* Sold.
1828	44	*Plymouth Sound, taken under Mount Edgecombe,* 12gns., G. Hibbert Esq.
1828	51	*Ben Lomond, from the Upper Part of Loch Lomond,* 45gns., G. Barclay Esq.
1828	55	*Rydal Water, Westmoreland,* 6gns., Rev. J. Pellands(?), Sunbury, Middlesex.
1828	57	*Distant View of Portsmouth from Spithead,* Sold.
1828	59	*View of Ben Venue and the Trosachs over Loch Achray, West Highlands,* 6gns.
1828	68	*Vessel on the Sands at the Entrance of Dover Harbour,* 12gns.
1828	78	*View near Shoreham, Sussex,* 12gns.
1828	80	*Scene in the Glade of the New Forest, where William Rufus was killed,* 50gns.
1828	90	*The Sands, near Ryde, Isle of Wight - Ebbing-tide,* 20gns.
1828	105	*Cottage Scene, near Guildford, Surrey,* 4gns.
1828	114	*Windermere, Westmoreland,* 4gns., Rev. John Browne, University Club, Pall Mall.
1828	115	*View in Glen Lochy, at the Head of Loch Tay, Breadalbane,* 5gns.
1828	126	*Fishing Boats at Sea, off Hastings,* 14gns.
1828	134	*View, looking up Glen Dochart, near Killin, Perthshire,* 5gns.
1828	143	*View, near Bramber, Sussex,* 5gns., R.H. Solly, Great Ormond Street.
1828	145	*Evening - Distant View of Harlech Castle, Merionethshire,* 12gns.
1828	149	*Four Views - on the Greeta with Saddleback, Cumberland; in Romney Marsh; at Binstead, Isle of Wight, and Dover Pier,* 5gns. each, The Road, right top, E. Swinburne Esq.
1828	150	*Dartmouth Harbour, Devonshire,* 5gns.
1828	151	*Distant View of Winchester,* 8gns., W.B. Kitchner Esq., Albany.
1828	163	*Clovelly, North Devon,* 8gns.
1828	171	*Four Marine Subjects - Hastings; Dover; Eastwere Bay, near Folkestone; and Sandowne Bay, Isle of Wight,* 5¹/₂ gns. each, The Honble. Miss Curl, the top on the right.
1828	181	*Southampton - Sunset,* 70gns., W.B. Kitchner Esq., Albany.
1828	192	*View on Crummock Water - Cumberland,* 7gns.
1828	198	*Marine View at Spithead,* 6gns.
1828	215	*Cottage Scene near Beccles, Suffolk,* 5gns.
1828	229	*Windermere, near Bowness, Westmoreland,* 4gns.
1828	235	*Loch Lomond - Rain coming on,* 7gns., Sir W.W. Wynne.
1828	246	*Scene in the Isle of Wight, near Brading,* 20gns.
1828	251	*The Moor of Rannoch, near King's House, Argyllshire,* 22gns.
1828	265	*View of Loch Lomond, from the Point of Farkin,* 9gns., W. Delafield Esq., 59 Pall Mall.
1828	270	*Marine Subject, a Gale coming on,* 4gns., Henry Streatfield Esq., 15 Buckingham St., Adelphi.
1828	273	*Part of Ambleside, Westmorland,* 5gns., Broderip Esq.
1828	276	*Sunset, at Hastings, Sussex,* 8gns., E.G. Giles Esq., 13 Throgmorton St.
1828	282	*Loch Fyne, near Inverary, Argyllshire,* 4gns., W. Delafield Esq., Pall Mall.
1828	296	*Distant View of Denbigh, in the Vale of Clwyd, North Wales,* 10gns., Earl of Tankerville, 26 Grosvenor Square.
1828	301	*View on the Black Mountain, near Inverary, Argyllshire,* 8gns., Lord F. L. Gower, 12 Albemarle St.
1828	303	*View in the Trosacks, West Highlands,* Sold.
1828	305	*Dover Castle, from the Beach,* 9gns., W.B. Kitchner Esq., Albany, Introduced by J. Kendrick Esq.
1828	306	*Ulleswater, Cumberland,* 6gns., Creswell Baker Esq., at J. Shaw, 28 Gower St., Bedford Square.
1828	313	*Mount Edgcumbe and Plymouth Sound,* 8gns., Olive Esq., North Terrace, Regents Park.
1828	315	*View of Ben More, up Glen Dochart, Perthshire - Sunset,* 6gns., Cresswell Baker Esq., J. Shaw Esq., 28 Gower St., Bedford Square.
1828	323	*Folkstone, Kent,* 5gns.
1828	338	*Landscape - Composition,* 10gns.
1829	5	*View looking across Plymouth Sound - the Citadel and Mount Edgcumbe in the distance,* 20gns., Frame and glass £5.5.0.
1829	11	*Vessels in Yarmouth Roads,* 50gns., J. Demay(?), 10 Duke Street, St. James's, Frame and glass £13.13.0.
1829	17	*View in the New Forest, near Stonycross, Hants,* 20gns., Frame and glass £4.4.0.

| 1829 | 19 | *View on the Lake of Como*, 5gns., Frame and glass £0.10.0. |

1829 19 *View on the Lake of Como*, 5gns., Frame and glass £0.10.0.

1829 24 *Ben Lomond, seen from between Luss and Torbet, West Highlands*, 12gns., Frame and glass £2.12.6.

1829 25 *Citadel at Plymouth*, 8gns., R. Bernard Esq., M.P., Frame and glass £2.2.0.

1829 26 *Ben Vorlich and Loch Lomond from the point of Farkin, West Highlands*, 9gns., K. Denison Esq. (?), 27 Lower Grosvenor St., Frame and glass £2.12.6.

1829 28 *Distant View of Ben Cruachan, Loch Awe, Argyllshire*, 30gns., Frame and glass £4.4.0.

1829 32 *Scene in Glen Falloch, Argyllshire*, 6gns., Frame and glass £1.11.6.

1829 38 *Porchester Castle, Hants*, 40gns., Frame and glass £9.9.0.

1829 47 *Vessels on the Shore, at the entrance of Dover Harbour*, 8gns., Stewart Esq., Frame and glass £1.11.6.

1829 53 *Loch Katrine and Ben Venue, Perthshire*, 7gns., Frame and glass £2.2.0.

1829 69 *View of Helvellyn, looking up to the Head of Ulleswater, Cumberland*, 5gns., Frame and glass £0.15.0.

1829 73 *View of Derwentwater, looking up to Borrowdale, Cumberland*, 6gns., Duchess of Bedford, Frame and glass £1.11.6.

1829 82 *View between Ton-y-bwlch and Harlech, Merionethshire, Harlech Castle in the distance*, 8gns., Lady Chetwynd, Frame and glass £1.11.6. To go to Mr. Prout.

1829 90 *The Langdale Mountains - seen over Rydal Water, Westmoreland*, 7gns., Frame and glass £1.11.6.

1829 95 *Ben-More, from the head of Lock Tay, Perthshire*, 24gns., Frame and glass £6.6.0.

1829 103 *A Scene from the Opening of the third Book of the Odyssey - Telemachus going in search of Ulysses, "The sacred sun, above the waters raised . . ."* 70gns., Mr. Rothschild, 107 Piccadilly, Frame and glass £18.18.0.

1829 105 *Glen Lochy, near Killin, Perthshire*, 14gns., Frame and glass £3.13.6.

1829 108 *View of Loch Awe, Argyllshire*, Sold.

1829 113 *Naworth Castle, Cumberland*, 12gns., Frame and glass £3.3.0.

1829 115 *Skiddaw and Derwent Water, Cumberland*, 6gns., Birch Wolfe Esq., Frame and glass £1.1.0.

1829 117 *Distant View of the Weald over the Earl of Chichester's Park, from the Downs near Brighton*, Sold.

1829 121 *Scene on the Coast of Folkstone, Kent*, 6gns., Sir J. Swinburne, 18 Grosvenor Place, Frame and glass £1.11.6.

1829 124 *View in the Isle of Ceylon, for Captain Grindlay's Scenery, Costumes, &c. of Western India*, Sold.

1829 125 *View at Yarmouth, Norfolk*, 5gns., Frame and glass £1.11.6.

1829 143 *Scene on the Moor of Rannoch, near the head of Glencoe, West Highlands*, 45gns., Frame and glass £10.10.0.

1829 144 *Scene near Steyning, Sussex*, 12gns., Frame and glass £4.4.0.

1829 156 *Vessels at Cowes, Isle of Wight*, 9gns., Rev. Augustus Hare, 73 South Audley Street, Frame and glass £2.12.6.

1829 158 *Loch Leven, from near Balahulish, Argyllshire*, 7gns., E. Applewhaite, Hyde Park Hotel, Frame and glass £2.12.6.

1829 165 *Ulleswater, Cumberland*, 6gns., E. Applewhaite, 6 Upper George St., Bryanston Sq., Frame and glass £2.2.0.

1829 170 *Fishing Boats on the Sands at Ryde, Isle of Wight*, 14gns., J.G. Philips Esq., Frame and glass £2.12.6.

1829 175 *Cottage Scene in Hertfordshire*, 5gns., Frame and glass £0.15.0.

1829 193 *Shoreham Harbour, Sussex*, 37gns., Duke of Bedford, Frame and glass £9.9.0.

1829 200 *Scene off the Coast of Folkstone, Kent*, 9gns., Frame and glass £2.12.6.

1829 209 *On the Shore, near Shanklin, Isle of Wight*, 9gns., Frame and glass £2.12.6.

1829 250 *Distant View of Southampton, from the Shore below Netley*, 16gns., Marquis of Lansdown, Frame and glass £5.5.0.

1829 295 *Ben and Loch Lomond, from near Tarbet, West Highlands*, 6gns., Sir Alex Dickson, Royal Artillery, Frame and glass £1.1.0.

1829 326 *View of Derwentwater, Cumberland*, 5gns., Sir J. Swinburne, 18 Grosvenor Place, Frame and glass £1.11.6.

1829 330 *Brougham Castle, Westmoreland*, 6gns., Morant Esq., Frame and glass £1.11.6.

1829 352 *Distant View of Harlech Castle from the Sands, Merionethshire*, 10gns., Frame and glass £2.12.6.

1829 364 *Fishing Boat on the Shore at Worthing*, 12gns., J. Burton Philips, 25 Cavendish Sq.

1829 367 *Brading Harbour, Isle of Wight*, 9gns., Frame and glass £2.12.6.

1829 382 *Scene on the Shore, with a distant View of Hastings and Beachy Head*, 8gns., Mrs. Rothschild, 107 Piccadilly, Frame and glass £1.12.6.

1829 390 *Folkstone as seen from the Sea*, 8gns., Duchess of Bedford, Frame and glass £2.12.6.

1829 392 *View of Ulles Water, Cumberland*, 7gns., Lady Chetwynd, Frame and glass £2.2.0.

1830	11	*Arundel Castle, Sussex*, Sold.
1830	18	*At Newhaven, Sussex*, 6gns., W.A. Wyett(?), Painswick House, Gloucestershire.
1830	26	*View of the Entrance of Dartmouth Harbour*, 8gns., Mr. Angerstein, 23 St. James Square.
1830	30	*Shoreham Harbour*, 9gns., Sanders Esq., 5 Upper Montague St., Russell Square, Note this drawing ought to have been 7gns.
1830	38	*Composition from the Odyssey - Nausicaa and her Attendants, "They seek the cisterns where Phoeacian dames Wash their fair garments in the limpid streams . . ." Vide Book VI.* Sold.
1830	45	*View near Inveroran, Argyllshire*, 7gns., Revd. Fras. Clerke, 15 Half Moon Street.
1830	46	*The Head of Glen-Coe, Argyllshire*, 8gns., G. Hibbert Esq. Junr., Albany.
1830	53	*Bala Lake, North Wales*, 6gns., Mr. Glyn, 21 Bolton St., Bolton Row.
1830	55	*View from the Sands at Yarmouth, Norfolk*, 6gns., G. Hibbert Esq. Junr., Albany.
1830	62	*View of Dartmouth - looking from the Castle at the entrance of the Harbour*, Sold, C. Wild Esq.
1830	64	*A Gale coming on at Sea*, 50gns., Morant Esq.
1830	75	*Fishing Boats, on the Coast near Shoreham*, 5gns.
1830	85	*Pier at Newhaven, Sussex*, 9gns., J.S. Brown Jr., Prince of Wales's Market, Leicester Place.
1830	94	*A Fresh Breeze*, 25gns.
1830	96	*Fishing Boats at Folkstone, Kent*, 5gns.
1830	102	*Plymouth Sound, from Mount Edgecumbe*, 18gns.
1830	113	*Evening*, 13gns., H. Davidson Esq., 24 Bruton St.
1830	121	*View, looking down Glen-Coe from near King's House, Argyllshire*, 40gns.
1830	124	*View of Ben Venue and The Trosachs over Loch Achray, Perthshire*, 5gns.
1830	132	*Vessels on the Sands, at Ryde*, Sold.
1830	139	*Vessels at Sea*, 10gns., Revd. W.H.E. Bentinck.
1830	140	*Fishing Boats on the Shore at Ryde, Isle of Wight*, 18gns.
1830	151	*Folkstone, Kent*, 11gns., W.H. Harriett Esq.
1830	158	*Loch Lomond, from the point of Farkin, West Highlands - a Rainy Day*, 40gns.
1830	172	*Scene on the Shore at Netley, with a distant View of Southampton*, 20gns., Miss Wisse(?).
1830	188	*Criccaeth Castle, Caernarvonshire*, 6gns., Jolly Esq., 29 Upper Belgrave Place, Pimlico.
1830	192	*Binstead Pier, Isle of Wight*, 10gns., H. Davidson Esq., 24 Bruton St.
1830	198	*Morning*, 10gns., J.V. Thompson, 4 Belgrave Street, Belgrave Square.
1830	214	*Scene in Sussex, near Crawley*, 25gns., Lord Carlisle.
1830	233	*Scene in Folkstone Harbour*, 6gns.
1830	249	*Scene on the Moor of Rannoch*, 10gns., Birch Esq.
1830	267	*Scene in the Isle of the Wight*, 6gns., J. Bigge Esq., 21 Norfolk St., Park Lane.
1830	270	*Distant View of the Downs, Sussex*, 8gns., General Grey, 13 Hertford Street.
1830	276	*Sandown Bay, Isle of Wight*, 6gns., Mrs. Cavendish, Devonshire House.
1830	277	*Scene in Breadalbane, near Inveroran, North Britain*, 6gns., William Hughes.
1830	279	*Distant View of Windsor Castle from the Park*, 6gns., J.H. Shaw Esq.
1830	291	*View on the Thames - Evening*, 8gns., Morant Esq., Wimpole Street.
1830	298	*A Cutter coming on Shore on the Sands at Dover*, 6gns., Mrs. Broadhurst, 25 Montague Sqr.
1830	299	*Aqueduct in Cwm Afon, Glamorganshire*, 6gns., John Coindel, 14 Newman St.
1830	308	*Scene in Cumberland*, 5gns., Mr. Fay, See No. 47. [To be sent to Mr. E. Bernoulle, 3 Mildred's Court, Poultry].
1830	312	*Shoreham Harbour, Sussex*, 7gns., Mrs. Staveley, 9 Brompton Square.
1830	328	*At Ramsgate, Kent*, 6gns., H. Graves Esq., 6 Pall Mall.
1830	331	*Fishing Boat - Scene near Southampton*, 6gns., Mr. Wyett(?) to the care of Mr. Basevi, 17 Savile Row.
1830	351	*Ben More and Loch Tay, Perthshire*, 7gns.
1831	13	*Landscape - Composition.*
1831	18	*Netley Abbey, Hampshire.*
1831	24	*Loch Achray and Ben Venue, Perthshire.*
1831	35	*Vessels at Spithead.*
1831	79	*Southampton - To be engraven for the work entitled "The Gallery of the Society of Painters in Water Colours".*
1831	88	*Loch Lomond and Ben Vorlich, from the Point of Farkin.*
1831	95	*Scene on the Coast of Sussex, near Brighton.*
1831	118	*View near Inveroran, on the Moor of Rannoch, West Highlands.*
1831	135	*Moel Hebog, near Beddgelert, Caernarvonshire.*
1831	137	*Dolbadern Castle and Llanberis Lake, Caernarvonshire.*
1831	138	*View from Cannobie, Eskdale, looking down the Valley to Netherby - Skiddaw and Cumberland Mountains in the distance.*
1831	143	*On the Sands at Ryde, Isle of Wight.*
1831	145	*View near King's House, Argyllshire.*
1831	158	*Shipwreck - Scene on the Coast of Yorkshire.*

1831	161	*Scene at the Entrance of Newhaven Harbour, Sussex.*
1831	168	*Rydal Water, Westmorland.*
1831	180	*Arundel Castle, from the upper part of the Park.*
1831	187	*Plymouth Sound.*
1831	205	*Scene at Newhaven, Sussex.*
1831	207	*View of Ben Lomond, from the Upper Part of Loch Lomond.*
1831	218	*Castlehead Crag, and Saddleback.*
1831	248	*View in Shoreham Harbour, Sussex.*
1831	250	*Scene at the Entrance of Brading Harbour, Isle of Wight.*
1831	274	*Distant View from the East of the Ulles Water Mountains Helvellyn, Cumberland.*
1831	283	*Sun-rise - View, looking over the Moor of Rannoch, from near King's House, Argyllshire.*
1831	292	*View in Perthshire, near Inveroran.*
1831	297	*View at the Foot of the Black Mountain, Argyllshire.*
1831	301	*Cottage near Crawley, Sussex.*
1831	310	*View, looking up Loch Leven, near Balahulish, Argyllshire.*
1831	320	*Snowdon, seen from the Road between Tan-y-bwlch and Pont Aberglaslyn.*
1831	323	*Scene at Ryde, Isle of Wight.*
1831	332	*Vessels at Sea.*
1831	379	*Scene on Loch Fyne, Argyllshire.*
1831	387	*Alverstoke Bay, near Portsmouth.*
1831	396	*Distant View of Chepstow Castle, Monmouthshire.*
1831	399	*Dartmouth, Devonshire.*
1831	409	*Inverary, Argyllshire.*
1832	6	*View of Loch Lomond above Tarbet*, 6gns., Mr. Jolly, 29 Upper Belgrave Place.
1832	72	*View of Ben Lomond, looking down Loch Lomond*, 6gns., B. Baker Esq., 1 Ryder Street, St. James, Frame and glass £1.10.0.
1832	75	*Scene on the Shore at Brighton*, 12gns., Frame and glass £3.3.0.
1832	83	*Scene between Inveroran and King's House, Argyllshire*, 45gns., Mrs. Ruskin, Herne Hill, Dulwich, Frame and glass £12.0.0.
1832	86	*View in Dartmouth Harbour, Devon*, 8gns., Mrs. Copley, 29 Albemarle St., Frame and glass £2.2.0.
1832	90	*Glen Dochart, Perthshire*, 6gns., Mrs. Rothschild, 107 Piccadilly, Frame and glass £1.10.0.
1832	97	*View on the Downs above Arundel Park, Sussex*, 24gns., Wm. Cayley Esq., Wallington, Carshalton, Surrey, Frame and glass £5.5.0.
1832	112	*Vessels in a stiff breeze off Calshot Castle, Hampshire*, 50gns., Lord Grantham, St. James Square, Frame and glass £11.11.0.
1832	122	*Vessels at Spithead*, 10gns., Mr. D. Colnaghi, Frame and glass £3.3.0.
1832	130	*Plymouth Sound*, 7gns., Mrs. Goring, To be sent to Mr. Colnaghi, Pall Mall East.
1832	137	*Distant View of Chepstow Castle*, 6gns., Mr. Jos. Walker, Crescent, Birmingham, Frame and glass £1.10.0.
1832	149	*Pier at Newhaven, Sussex*, 6gns., Mrs. H. Graves, To be sent to Moon Boys & Graves. Frame and glass £1.10.0.
1832	151	*Oakley Park, Suffolk, the Seat of General Sir Edward Kerrison, Bart. M.P.*, Sold.
1832	164	*View in Cowes Harbour, Isle of Wight*, 80gns., Frame and glass £15.0.0.
1832	173	*Composition - Scene in an Ancient Port*, 26gns., Frame and glass £7.7.0.
1832	186	*View on the Moors near Loch Awe, on the Road to Inverary*, 8gns., J. Lewis Brown, 10 Leicester Place, Leicester Square, Frame and glass £1.16.0.
1832	188	*View of Loch Earne, Perthshire*, 5gns., Frame and glass £0.15.0.
1832	190	*Helvellyn, looking up Ulles Water*, 5gns., Frame and glass £0.15.0.
1832	195	*Ben Vorlich, looking up Loch Lomond, from the Point of Farkin*, 8gns., Mr. Glyn, 21 Bolton Street, Frame and glass £1.16.0.
1832	198	*Scene on the Sands at Ryde, Isle of Wight*, 11gns., Mrs. J.V. Thompson, 4 Belgrave St., Belgrave Square, Frame and glass £3.3.0.
1832	207	*Castel del Ovo at Naples*, 5gns., Frame and glass £1.10.0.
1832	210	*Near Ambleside, Westmorland*, 5gns., Mr. R. Cancellor, 3 Cambridge Place, Regents Park, Frame and glass £1.5.0.
1832	222	*Scene on the Shore, Sandown Bay, Isle of Wight*, 8gns., Frame and glass £1.15.0.
1832	238	*Ulles Water, Cumberland*, 5gns., Mr. C. Brookbank, Brighton, Frame and glass £1.10.0.
1832	253	*Derwent Water, Cumberland*, 5gns., Lady Mordaunt, 33 Hertford St., To be sent to the Honble. Miss Walgrave, 4 Park Square, Regents Park. Frame and glass £0.15.0.
1832	273	*Vessel going out of Dover Harbour in a Gale*, 10gns., Mr. E. Pepys, 15 Upper Harley Street, Frame and glass £3.3.0.
1832	284	*Distant View of Carisbrook Castle, looking up the Medina, from near Whippingham, Isle of Wight*, 5gns., Mr. Jos. Walker, Crescent, Birmingham, Frame and glass £1.10.0.
1832	300	*Shore Scene near Sandgate, Kent*, 8gns., Frame and glass £1.15.0.

1832	313	*Caernarvon Castle - Sun-set*, 40gns., Frame and glass £9.9.0.
1832	324	*Scene on the Shore at Folkestone, Kent*, 7gns., Mr. Webb, Cambridge Terrace, Edgeware Road, Frame and glass £1.10.0.
1832	357	*View near Folkestone, Kent*, 6gns., Mr. N.W. Co??, Mr. Howard March, 39 Margarets Street, Cavendish Square, Frame and glass £1.10.0.
1832	363	*View of West Cowes, Isle of Wight*, 6gns., Frame and glass £1.10.0.
1832	378	*Scene at Mount Edgecumbe, Plymouth Sound*, 5gns., Frame and glass £1.5.0.
1832	386	*Scene in Badenoch, North Highlands*, 12gns., Mr. Moxon, Frame and glass £3.8.0.
1832	388	*Loch Earne, Perthshire*, 5gns., Mr. Wentworth Fitzwilliam, Viscount Milton's Grosvenor Place, Frame and glass £1.10.0.
1832	392	*Scene on the Sands at Luccombe, Isle of Wight*, 6gns., B. Baker Esq., 1 Ryder Street, St. James.
1832	394	*Ben More and Loch Tay, Perthshire*, 9gns., J.W. Walker Esq., Crescent, Birmingham, Frame and glass £3.3.0.
1832	398	*A Fountain near the Walls of an ancient City*, 20gns.
1832	414	*Arundel Castle, Sussex*, 13gns., Frame and glass £2.12.6.
1833	3	*View on Loch Lomond, West Highlands*, 5gns., Mrs. Malony, 12 Gloucester Place.
1833	24	*Scene in Plymouth Sound*, Sold, Mr. J.L. Brown.
1833	29	*Vessels in a Gale of Wind off Portsmouth*, Sold.
1833	30	*New and Old Shoreham, and the South Downs, seen from near Lancing, Sussex*, 12gns.
1833	37	*Pevensey Castle, seen over the Marsh, Sussex*, 25gns.
1833	53	*Scene on the Shore, near Shanklin, Isle of Wight*, 8gns., Mr. J. Parkinson Junr., 21 Skinner Street.
1833	56	*View of Snowdon, from near Llanfrothen, Caernarvonshire*, 18gns.
1833	66	*Scene at the Entrance of Folkstone Harbour, Kent*, 36gns., Miss Smith, 6 Portland Place.
1833	67	*Loch Tay, taken from above Killin, Perthshire*, 6gns.
1833	85	*Vessels in a Calm*, 6gns., Mrs. J.C. Powell, 32 Upper Harley Street.
1833	91	*The Vale of Elwy, near St. Asaph, North Wales*, 5gns.
1833	107	*Folkstone, Kent*, 6gns., Miss Fowler instead of 266.
1833	117	*Mountains of Snowdon, Moel Hebog, &c. seen from the South*, 42gns.
1833	121	*Mount St. Michael's, Cornwall*, 6gns.
1833	124	*Vessels in a Gale*, 8gns., Mr. Feilden, 36 Montague Square.
1833	126	*Langdale Pikes &c. over Windermere, Westmorland*, 8gns., Major G.M. Eden, 33 Charles St., Berkeley Square.
1833	129	*Landscape - Composition*, 50gns.
1833	134	*Scene in Sandown Bay, Isle of Wight*, 8gns.
1833	137	*Cottages near Hand Cross, Sussex*, 5gns., Captn. Harcourt, Crawley's Hotel, Albemarle Street.
1833	150	*View on the South Downs near Brighton*, 9gns., Mrs. Moon to Mr. Graves, Pall Mall, Note: This drawing is for Mr. Ryman.
1833	152	*View of the Cumberland Mountains, from near Kirk Oswald*, 34gns.
1833	167	*Distant View of the Castle and Town of Arundel, from the Road to Little Hampton, Sussex*, 10gns., Mr. Musgrave, 6 Woburn Square, Russell Square.
1833	169	*Distant View of the Weald beyond Lewes, from Hollingbury Hill, near Brighton*, 12gns., Mr. Bernall.
1833	176	*Vessels in a Breeze on Southampton Water*, 11gns., Mrs. E. Tustin, Fludyer Street, Whitehall.
1833	185	*Vessels at Spithead*, 11gns., Miss Moon, Threadneedle St..
1833	198	*View from Fairlight Down near Hastings, the Cliffs of Dover seen over Romney Marsh in the Distance*, 70gns.
1833	254	*Sun-Set - Vessels Unloading on the Shore at Ryde, Isle of Wight*, 24gns., Mr. Walker, Stevens Hotel, Bond Street.
1833	256	*Near Carlisle, Cumberland*, 5gns., Mr. G. Constable, Arundel, Sussex.
1833	266	*Scene in Glen Lochy, near Killin, Perthshire*, 5gns., Mr. Fielding.
1833	269	*View on the Downs between Arundel and Bognor, Sussex*, 24gns.
1833	272	*Distant View of Ragland Castle, Monmouthshire*, 5gns.
1833	273	*Picton Castle on Milford Haven, Pembrokeshire*, 5gns.
1833	278	*View of Glen Ogle, near Loch Earne, Perthshire*, 6gns.
1833	279	*Scene on the Moor of Rannoch, North Highlands*, 5gns.
1833	284	*Moel Siabod near Capel Carig, Caernarvonshire*, 7gns., R. Cancellor Esq., 3 Cambridge Place, Regents Park.
1833	293	*The Vale of Clwyd near Denbigh, North Wales*, 8gns.
1833	305	*Morning*, 16gns., Mr. Bernall, Put into Mr. Bernall's name 20 April by order from Mr. Evans.
1833	311	*View at Hastings*, 6gns.

1833 321 *Vessels on the Shore at Southampton*, Sold, J.L. Brown.

1833 325 *Naworth Castle, Cumberland*, 6gns.

1833 336 *Scene on the Shore near Sandgate, Kent*, 8gns., Mrs. Robert Wharton, 35 Upper Guildford St., Russell Square.

1833 337 *Scene on the Shore near Luccombe, Isle of Wight*, 6gns.

1833 377 *Vessels on the Sands at Ryde, Isle of Wight*, 6gns.

1833 385 *View of Derwentwater, looking towards Borrowdale*, 6gns.

1833 397 *Scene near King's House, Argyllshire*, 6gns.

1833 413 *View near Inverness*, 6gns., Lord de Dunstanville, South Place, Knightsbridge, Wishes for frame and glass.

1833 420 *Fishing Vessels at Sea*, 6gns., Mr. G. Constable, Arundel, Sussex.

1834 6 *Ben Cruachan, near Loch Awe, Argyllshire*, 6gns., Mr. Gordon, 13 Hans Place, Sloane Street.

1834 7 *Distant View of the Cumberland Mountains, from Eskdale, Dumfrieshire*, 5gns., Lady Mordaunt, 35 Grosvenor Place.

1834 15 *Ben Venue and the Trossachs, seen over Loch Achray, Perthshire*, 20gns.

1834 18 *View of the Black Mountain, near Inveroran, Argyllshire*, 40gns.

1834 34 *View of Cader Idris, between Dolgellie and Barmouth, Merionethshire*, 10gns.

1834 37 *Sandgate, Kent*, 6gns., E. Newton Esq., Surry Street, Norwich, To be delivered to Mr. Clipperton, 17 Bedford Row.

1834 39 *Scene from the Romance of La Morte d'Arthur, "Alas, sayd the kyng, helpe me hens, for I drede me I have taryed over longe. Than Syr Bedwere toke the kyng upon his backe . . ." Vide La Morte d'Arthur. Book XXI. cap. 5.* 60gns.

1834 45 *View on the shore near Criccaeth, Caernarvonshire*, 6gns., E. Newton Esq., Surrey Street, Norwich, Mr. Clipperton, 17 Bedford Row will pay the balance.

1834 48 *View on the South Downs between Lewes and Brighton, looking over the Weald of Sussex*, 40gns.

1834 53 *Dindarra Castle, near the Head of Loch Fyne, Argyllshire*, 11gns.

1834 54 *A Cutter in a Breeze*, 11gns., J.C. Powell, 32 Upper Harley Street.

1834 57 *View near Beddgelert, Caernarvonshire*, 16gns.

1834 66 *Scene under the Walls of Southampton - Sunset*, 10gns., Sold.

1834 73 *Scene at the Entrance of Dover Harbour*, 8gns., Captn. Harcourt, Crawleys Hotel, Albermarle St.

1834 81 *View of Mount Edgcumbe and Drake's Island - Plymouth Sound*, 8gns., Mr. W.J. Norman.

1834 84 *Dover Pier, with a Vessel about to enter the Harbour*, 25gns., Mr. Beaumont Swete, Oxton, Exeter, Russell's Waggon.

1834 88 *Ulleswater, Cumberland*, 9gns., G.H. Cavendish Esq., Belgrave Square.

1834 93 *View of Snowdon from the Sands of Traeth Mawr, taken at the Ford between Pont Aberglaslyn and Tremadoc*, 46gns., Viscount Mitton, Grosvenor Square.

1834 95 *View from Mount Caburn near Lewes, Sussex*, 10gns., Lord Morpeth, 12 Grosvenor Place.

1834 99 *Landscape - Morning*, 16gns., Tustin Esq., Fludyer St., Whitehall.

1834 103 *View of Ben More up Glen Dochart, Perthshire - Morning*, 45gns.

1834 111 *Ben Venue and Loch Katrine, Perthshire*, 11gns., Capt. Sheddens, Bittern Manor House, Southampton.

1834 133 *A Shipwreck*, 50gns., Mrs. N. Delafield, 4 Stanhope Place, Hyde Park.

1834 134 *Landscape - Evening*, 14gns.

1834 152 *Distant View of Croydon from near Sanderstead, Surrey*, 18gns., Beaumont Swete, Oxton, Exeter, Russell's Waggon.

1834 158 *Ben Lomond, seen from near the Head of Loch Lomond*, Sold.

1834 164 *Scene in the Highlands, near Inveroran, Argyllshire*, 36gns.

1834 180 *Criccaeth Castle, Caernarvonshire*, 8gns., Miss Julia Wilson, Charlton House, Blackheath.

1834 183 *Distant View of Arundel Castle from the Park*, Sold.

1834 208 *Distant View of Minehead and Dunster, Somersetshire*, 12gns.

1834 215 *Scene in Sandown Bay, Isle of Wight*, 8gns., Mr. Ashlin, 22 Edward Street, Hampstead Road.

1834 217 *Scene near Tyndrum*, 10gns., Mr. Ellis, next Jacksons chapel, Hockwell Green.

1834 218 *Glen Lochy, near Killin, Perthshire*, 6gns.

1834 225 *View at Lymouth, Devonshire, from the Shore*, 8gns., Lord Alford, 12 Belgrave Square.

1834 228 *On the Shore at Newhaven, Sussex*, 6gns., Mr. Ashlin, 22 Edward Street, Hampstead Road.

1834 261 *Dartmoor, Devonshire*, 5gns., Mr. H.G. Barnard, 29 Baker Street, Portman Square.

1834 264 *Landscape - Composition*, 30gns., Mr. Marshall, 41 Upper Grosvenor Street.

1834 266 *View near Rhayader, Radnorshire*, 6gns., Mr. D.J. White, Oxford Street.

1834 289 *Seaford, from Newhaven, Sussex*, 8gns., Miss Langston.

1834	294	*Distant View of the South Downs Over the Weald, from near Bolney, Sussex*, 10gns.
1834	306	*Ship on Shore in a Storm*, Sold.
1834	309	*Loch Leven, Balahulish, Argyllshire*, 9gns., Duke of Norfolk.
1834	319	*View of Derwentwater, Cumberland*, 5gns.
1834	324	*View of the South Downs, Sussex*, 5gns., Rev. James Bulwer, 7 Old Burlington Street.
1834	333	*View down the Pass of Llanberris, Caernarvonshire*, 6gns., Mr. Barnard, 29 Baker Street.
1834	336	*View of Ryde, Isle of Wight*, 8gns., The Dowr. Lady Cawdor, 16 Berkeley Square.
1834	354	*Scene at the Entrance of Folkstone Harbour*, 9gns., Rev. John Eden, 36 Craven Street.
1834	355	*Dolbaddern Castle, Caernarvonshire*, 6gns.
1834	360	*Scene on the Moor of Ramach, Perthshire*, 6gns.
1835	3	*The Cliffs at Seaford, new Newhaven, Sussex*.
1835	14	*View of the Weald of Sussex, looking over Buxted and Uckfield, from Crowborough Heath, the South Downs in the Distance*, 60gns., Mr. Ashlin, Hampstead Rd., Sold by Mr. Fielding.
1835	26	*Subject from the 137th Psalm, "By the waters of Babylon we sat down and wept when we remembered thee, O Sion."* 50gns.
1835	39	*Skiddaw, seen over Derwentwater, Cumberland*, 10gns., Mr. Ashlin, Edwd. Street, Hampstead Road.
1835	45	*Inverary, looking towards the Head of Loch Fyne, Argyllshire*, 24gns.
1835	49	*Arundel Castle, Sussex*, 11gns., Sold.
1835	64	*A Fresh Breeze*, 40gns., Lord Clanwilliam?.
1835	74	*Shipwreck under Beachy Head*, 28gns., Sold.
1835	94	*Snowdon, from Traeth Mawr, Caernarvonshire*, 46gns.
1835	103	*View of the Mountains near Festiniog from the Sands of Traeth Mawr, Caernarvonshire*, 10gns., J.J. Ruskin, Herne Hill.
1835	132	*Folkstone, Kent*, 24gns., Mr. Ashlin, 22 Edward St., Hampstead Road.
1835	141	*Glen Lochy, at the Head of Loch Tay, Perthshire*, 25gns., G. Cooke, Carr House, Doncaster.
1835	151	*Bow Hill, Sussex - At Stoke, near Chichester, is a deep hollow in the Downs, immediately under Bow Hill, in the centre of which stands an ancient grove of venerable yews . . . Kingly Bottom, by which this little valley is known*, 36gns., Mr. Hawtrey, Eton.
1835	161	*On the Sands at Park Gate, Cheshire - Flint Castle and the Welsh Coast seen in the distance*, 25gns.
1835	185	*View of Loch Kattrine and Ben Venue, Perthshire*, 25gns.
1835	193	*Scene in Argyllshire, near Loch Rannoch, N. Britain*, 40gns.
1835	242	*View near Inveroran, Argyllshire*, 6gns., Sir Willoughby Gordon.
1835	249	*View on the River Brathay, near Ambleside, Westmorland*, 10gns., Mr. Ashlin, Edward St., Hampstead Rd..
1835	251	*Portsmouth, from Spithead*, 11gns., Mr. Ashlin, Edward Street, Hampstead Road.
1835	257	*A Breeze at Sea*, 8gns., F. Ellis, 4 Cleave Place, Lark Hall Lane, Clapham Road.
1835	263	*Entrance to Folkestone Harbour, Kent*, 8gns., Miss Shepley, 28 Devonshire Place.
1835	273	*View of Windermere, looking across to Langdale, Westmorland*, 8gns., Thomson Hankey Junr.(?), 72 South Audley Street.
1835	277	*View in St. John's Vale, Cumberland*, 6gns., Mr. Ashlin, 22 Edward Street, Hampstead Road.
1835	284	*At the Entrance of Dover Harbour*, 13gns., Mr. Holland, 35 Montague Square.
1835	298	*Harlech Castle, Merionethshire*, 11gns., Sold by Mr. C. Fielding.
1835	299	*The Isle of Wight, seen from the Shore of Alverstoke, Hants*, 10gns., Mr. Ashlin, Hampstead Road.
1835	301	*A Gale at Sea*, 13gns., Sold.
1835	310	*View on the Downs above Stanmer Park, near Brighton*, 6gns., Mrs. Nightingale, 21 Duke Street, Westminster.
1835	317	*Shore Scene near Nettlestone, Isle of Wight*, 6gns.
1836	10	*Stoke Park, near Chichester - with the Isle of Wight in the distance*, Sold, ???? Dickens Esq.
1836	15	*Scene on the Sands at Dover*, 6gns., Heny. Ashlin Esq., 22 Edward St., Hampstead Road.
1836	30	*Raby Castle, Durham, the Seat of the Duke of Cleveland*, 46gns.
1836	69	*Vessels at the Entrance of Dover Harbour*, Sold, N. Baily Esq., Hampton Court.
1836	91	*The Summit of Snowdon, seen over Cwm Dyli, near Capel Cûrig*, 50gns.
1836	96	*View of Ben Lomond, from the upper part of Loch Lomond*, 8gns., G. Hibbert Esq.
1836	105	*View in Glen Lochy, near Killin, Perthshire*, 10gns., Jos. Walker Esq., Colderstone, near Liverpool.
1836	108	*View looking up Loch Leven from near Balahulish, Argyllshire - Sun-rise*, 12gns., Geo Morant Esq.
1836	110	*Raby Castle, Durham*, 10gns., Morison Esq., Royal Hotel, St. James's Street or 95 Regent Street.

1836 111 *Scene in Tilgate Forest, looking over the Weald of Sussex - the South Downs and Bramber Castle in the extreme distance - Twilight,* 12gns., Morison Esq., Royal Hotel, St. James's Street or 95 Regent Street.

1836 116 *View of Snowdon, taken from the upper road between Pont Aberglasslyn and Tan-y-Bwlch, Merionethshire,* 25gns., Chs. Birch Esq., Tipton, nr. Birmingham.

1836 118 *Arundel, Sussex,* Sold, H. Ashlin Esq., Edward Street.

1836 121 *Vessels in a Breeze after a Gale,* Sold, James Wadmore Esq., 40 Chapel Street, Lisson Grove.

1836 123 *Scene from Tasso - Ubaldo and Carlo in the enchanted Boat, on their way to the Gardens of Armida, in search of Rinaldo, "Come la nobil coppia in lui raccolta . . ." Vide Gerusalemme Liberata, Canto XV.* 18gns., Capt. Wilkinson, Walsham Le Willows, Bury Suffolk.

1836 130 *View on the Downs, above Telscombe, near Lewes, Sussex - Seaford Cliff in the distance,* Sold, Dr. Procter, Kent Town, Brighton.

1836 131 *Mill near Hoddesdon, Herts,* Sold, Mr. Ashlin.

1836 144 *View on the Southampton Water, near Itchin Ferry,* 22gns., The Earl of Liverpool, Fife House, Whitehall.

1836 148 *Ben Venue and the Trossachs, seen over Loch Achray - Sun-set,* 12gns., H.R.H. Duchess of Kent.

1836 153 *Scene in the Trossachs, looking up to Ben Venue,* 9gns., Sir Richd. Hunter, 48 Charles St., Berkley Sqre.

1836 219 *Cottage near Minehead, Somersetshire,* 6gns., G. Hibbert Esq.

1836 221 *Folkestone Pier,* 6gns., Lady Rolle.

1836 235 *Vessels in a Breeze,* 10gns., Sir Chas. Greville, 1 Hill St., Berkeley Square.

1836 249 *View from Crowboro' Common, of the South Downs - looking over the Weald of Sussex,* Sold, Thos. Griffith Esq.

1836 250 *View near Hoddesdon, Herts,* Sold, H. AshlinEsq.

1836 252 *Vessels at Spithead,* Sold, Ashlin Esq.

1836 258 *View of Loch Lomond from the East,* 10gns., Her Majesty.

1836 259 *Shore Scene, near Worthing - Sun-rise,* 9gns., Her Majesty.

1836 262 *Plymouth Sound - Drake's Island, and Mount Edgecomb,* 6gns., Countess of Mansfield.

1836 270 *View down Glen Coe, from near King's House, Perthshire - Storm clearing off,* 6gns., Lord Northampton, 7 Park Crescent.

1836 297 *Views of the Mountains at the Head of Traethmawr, Caernarvonshire,* Sold, Mr. Ashlin.

1836 301 *Windermere and the Coniston Mountains, Westmorland,* 8gns., Bothamley Esq., Champion Hill, Camberwell.

1836 310 *View at Southampton,* 6gns., Miss Bentinck, 13 Carlton House Terrace.

1836 325 *Distant View of Portsmouth,* 7gns., L. Houghton, 30 Poultry.

1836 332 *View from Mount Caburn, near Lewes, looking over the Weald of Sussex,* 6gns., Thos. Dyson Esq., 10 York Place, Camberl. New Road, To be sent to Mr. Grittens, 4 Duncannon St., Charing Cross.

1837 17 *Arundel, from Little Hampton, Sussex,* Sold.

1837 23 *View of the Mountains between Inveroran and King's House, Argyllshire,* 11gns.

1837 40 *Rievaulx Abbey, near Helmsly, Yorkshire,* Sold.

1837 44 *Scarborough - Early Morning - Clearing off of a Storm,* Sold.

1837 61 *View from Bow Hill, near Chichester, looking over Kingly Bottom - Goodwood in the distance,* Sold.

1837 65 *Lock Achray, near Loch Katrine, Perthshire,* 6gns., Robinson Esq., 56 Wigmore Street.

1837 78 *The Fairy Lake - Scene from La Morte d'Arthur. – Book I .Chap. 23., "So they rode till they came to a lake, which was a fair water and broad and in the midst of the lake king Arthur was ware of an arm, clothed in white samyte . . ."* 30gns., Bassevi Esq., 17 Saville Row.

1837 94 *View looking over Buxted Woods to the Weald of Sussex and the South Downs in the distance - Showery Weather,* Sold.

1837 96 *The Old Pier at Burlington, York, during a Gale,* Sold.

1837 101 *View looking up Loch Leven, from near Balahulish, Argyllshire,* 6gns., William Duckworth Esq., to be sent to 35 Woburn Place.

1837 113 *Burlington Quay, Yorkshire,* Sold.

1837 114 *Byland Abbey, near Coxwold, Yorkshire,* Sold.

1837 122 *Dolwyddelan Castle, near Capel Cûrig, Caernarvonshire,* 32gns.

1837 124 *Distant View of Craik Castle near Easingwold, Yorkshire - York Minster seen in the Horizon,* Sold.

1837 127 *View of the Head of Tiviotdale a few Miles above Branksome Castle,* 12gns., Lady Milton, Halkin St., Grosvenor Place.

1837 137 *View of the Head of Loch Tay, in Bredalbane,* 6gns., S.W. Beaumont Esq., 144 Piccadilly.

1837 141 *View of Snowdon from near Capel Cûrig, Caernarvonshire,* 8gns., Lord Alford, 12 Belgrave Square.

1837 144 *Distant View of Southampton,* 10gns.

1837 150 *Mountains at the Head of Loch Etive, seen from Inveroran, Argyllshire,* 6gns., T.J. Thompson Esq., 68 Cadogan Place.

1837	166	*View of Ben Venue from the lower Part of Loch Katrine*, 16gns., S. Taylor Esq., 18 St. George's Square, Portsea.
1837	175	*Ben Venue and the Trossachs, seen over Loch Achray, Perthshire*, Sold.
1837	196	*Plymouth Sound*, 6gns., Robinson Esq., 56 Wigmore Street, Colnaghi's Pall Mall East.
1837	234	*Whitby, Yorkshire*, 9gns., T.W. Beaumont Esq. M.P., 144 Piccadilly.
1837	241	*Scene on Dartmoor, Devon*, 5gns., Ryman Esq., at Greaves's, Pall Mall.
1837	258	*Marine View of Seaford Cliffs, Sussex*, 9ns., Lady Rolle, 18 Upper Grosvenor Street.
1837	260	*View of Loch Achray, looking to Ben Venue, Perthshire*, 9gns., Col. Scott, 40 Hertford Street, May Fair.
1837	266	*Hastings*, 12gns., H. Cary Esq., 20 Jermyn Street.
1837	267	*Sandsend, near Whitby, Yorkshire*, 6gns.
1837	268	*Folkstone, Kent*, 6gns., Colnaghi Esq., Pall Mall East.
1837	280	*Vessels in a Breeze*, 8gns., Lord Teignmouth, 19 Portland Place.
1837	288	*Arundel Castle, from the upper part of the Park*, Sold.
1837	307	*Scene near Uckfield, Sussex*, 5gns., The Revd. Alfred Harford, Locking, near Bristol, deliver to Mr. Hogarth, 60 Great Portland St.
1837	315	*Ben Lomond, over Macfarlane's Island, looking down Loch Lomond*, 8gns., R.H. Solly Esq., 48 Great Ormond Street.
1837	326	*Vessel in a Gale*, 14gns., Sir John Rae Reid, 10 Pall Mall.
1837	344	*Vessels in a Calm*, 11gns., J.M. Wequelis(?) Esq., 7 Austin Terrace.
1837	365	*Skiddaw, seen over Derwent Water*, 6gns., Lord Milton, Halkin St., Grosvenor Place.
1838	11	*Vessels in a Gale*.
1838	45	*Snowdon, from Traeth Mawr, Caernarvonshire*.
1838	54	*The Downs near Brighton, looking towards Worthing*.
1838	59	*View from Bow Hill, near Chichester - Early Morning*.
1838	62	*Glen Lochy, at the Head of Loch Tay, Perthshire*.
1838	64	*Scene in the Wilds of Argyllshire, near Inverraron*.
1838	66	*Vessels in a Breeze off Scarborough*.
1838	72	*Vessel off Burlington Pier, Yorkshire*.
1838	85	*Robin Hood Bay, near Whitby, Yorkshire*.
1838	104	*View from Crowborough Hill over the Weald of Sussex - the South Downs in the Distance*.
1838	119	*Arundel Castle, from the Upper Part of the Park*.
1838	127	*The Moor of Rannock, Argyllshire - Early Morning*.
1838	136	*Loch Leven, from near Balahulish, Argyllshire*.
1838	146	*At Worthing, Sussex - Morning*.
1838	149	*View of the Weald and South Downs over Buxted, Sussex*.
1838	153	*View, near Inveroran, Argyllshire*.
1838	157	*Beachy Head, Sussex*.
1838	159	*Folkstone, Kent - Sun-set*.
1838	169	*The Lake of Geneva, from near Lausanne*.
1838	171	*Snowdon, from Capel Cûrig, Caernarvonshire*.
1838	172	*On the Shore, near Shanklin, Isle of Wight*.
1838	180	*Loch Lomond and Ben Lomond, near Ross*.
1838	183	*Scene on the Shore, near Southampton*.
1838	185	*Arundel Castle, Sussex*.
1838	189	*Ben Cruachan, seen over Loch Awe, Kilchurn Castle in the Middle Distance*.
1838	212	*View of the Upper Part of Loch Lomond, looking towards Ben Lomond*.
1838	214	*Scene at the Foot of Hambleton Hills, under Whitestone Cliff and Sutton, near Thirsk, Yorkshire*.
1838	259	*View from Minehead, over the Bay and Marsh - Dunster in the Distance*.
1838	287	*Distant View of Byland Abbey, Coxwold, and the Vale of York*.
1838	298	*View of Ben Venue, over Loch Katerine, Perthshire*.
1838	299	*Scarborough, Yorkshire*.
1838	305	*View over the Vale of York - Sheriff Hatton and York Minster in the Distance*.
1838	312	*Glen Lochy, near Killin, Bredalbane*.
1838	319	*View in Cleveland, near Gisborough, Yorkshire*.
1838	328	*Scene near Broadstairs, Kent*.
1838	350	*The Lakes of Llanberis, Caernarvonshire*.
1839	3	*View on the Coast, at Filey, Yorkshire*, 8gns.
1839	7	*Scene in the Harbour of Whitby, Yorkshire - Sun-set*, 9gns.
1839	18	*Loch Achray and Ben Venue - Summer Evening*, Sold.
1839	37	*Salisbury Plain, with a View of Stonehenge*, 45gns., Lord Northampton, Piccadilly Terrace.
1839	42	*Caerphilly Castle, Glamorganshire*, 20gns., H.C. Marshall, Weetwood Hall, Leeds.
1839	53	*Langdale Pikes, Westmorland*, Sold.
1839	59	*Loch Lomond, with a View of Ben Lomond over Macfarlane's Island*, Sold.
1839	68	*View of Ben Loy, from near Loch Awe, Argyllshire*, Sold.
1839	75	*Rievaulx Abbey, Yorkshire*, Sold.

1839	76	*Burlington Pier, Yorkshire,* Sold.
1839	85	*Conway Castle, Caernarvonshire,* 6gns.
1839	106	*Scene in the Waste of Cumberland, near Bewcastle,* Sold.
1839	114	*Scene on the Moor of Ramock, Argyllshire,* 5gns., ???? Hart A.R.A. for Wm. Henry Hawker Esq. of Plymouth, Frame and glass £1.5.0.
1839	118	*Frascati, near Rome,* 50gns., Hy. Wilkinson Esq., Clapham Common.
1839	120	*Newhaven, Sussex,* 6gns., The Marquis of Conyngham, Her Majesty.
1839	123	*Scene on the Shore, at Folkestone, Kent,* 25gns., Wm. Strachan Esq., 34 Hill Street.
1839	126	*Distant View of the Cumberland Mountains, from Eskdale, Dumfriesshire,* 12gns., ??? Bowdless, 6 St. John's Wood Road.
1839	128	*Scene in the Highlands, near Tyndrum, Argyllshire,* 10gns.
1839	130	*View of Loch Lomond, near Tarbex,* 6gns., Miss E. Clarke, at Mr. Miller's, Black Heath Park.
1839	142	*Scene in the Vale of Llanrhwst, Carmarthenshire,* 10gns., Revd. R.W. Kendall Wood, Little Bowden, Market Harborough.
1839	145	*Distant View of Whitby, from the Sands,* Sold.
1839	171	*Distant View of the Downs, near Lewes, Sussex,* 10gns.
1839	174	*Distant View of Arundel Castle, Sussex,* Sold.
1839	191	*Arundel Castle, from the Mill Pond,* Sold.
1839	219	*Distant View of Dunster and Minehead, Somersetshire,* 8gns.
1839	233	*The South Downs near Lewes, Firle Hill in the Distance,* 6gns.
1839	235	*The Mountains at the Head of Traeth Mawr, Caernarvonshire,* 11gns.
1839	235*	*Arundel Castle, looking down the River,* 6gns., Thos. Evans, care of J.W. Wright Esq.
1839	237*	*View near Dolgellie, Merionethshire,* 6gns., Wm. Moore Hall Esq., Broad Street, Portsmouth.
1839	254	*Distant View of the South Downs and the Weald of Sussex, over Buxted - Showery Weather,* Sold.
1839	255	*View looking over the Weald of Sussex, from Tilgate Forest,* 11gns.
1839	265	*A Fresh Breeze - Folkestone, Kent,* Sold.
1839	293	*The Pass of Killiecrankie, Perthshire,* 20gns., Jr. T. H. Wilkinson, Walsham le Willows, Suffolk, to know price of frame, £2.10.0.
1839	294	*View on the Downs near Worthing, Cissbury Hill seen through a Shower,* 25gns., Thos. Bodley Esq., 13 Brunswick Terrace, Brighton, and 14 Buckingham St., Frame and glass £5.5.0.
1839	299	*Scene on the Shore at Burlington, Yorkshire,* 10gns., Hon. Rev. H. Legge, Blackheath, Frame and glass to be sent.
1839	301	*Loch Leven, near Balaheulich, Argyllshire,* 14gns., Col. Scott, 40 Hertford Street, Mayfair.
1839	330	*Distant View of Portsmouth from Spithead,* Sold.
1839	341	*Scarborough, Yorkshire,* 11gns.
1840	4	*Scarborough from the Sea.*
1840	8	*Cader Idris, from near Dolgellie, North Wales.*
1840	12	*View of Ben Muich Dhuie, looking up Glen Beg, over a part of the old Forest of Dalmore, Aberdeenshire.*
1840	13	*View of the Island of Staffa.*
1840	26	*View of the Isle of Wight and Hayling Island, from the top of Bow Hill, near Chichester.*
1840	56	*Snowdon, from the Sands of Traeth Mawr, Caernarvonshire.*
1840	64	*Distant View of the Town and Castle of Helmsley, with part of Duncombe Park, the Seat of Lord Feversham.*
1840	67	*Llyn Gwynant, Caernarvonshire.*
1840	69	*View near Buxted, Sussex - the South Downs in the Distance.*
1840	74	*Scene on the Shore near Shanklin, Isle of Wight.*
1840	83	*View on the Downs near Lewes, Sussex, the Village of Falmer and Stanmer Park in the Distance.*
1840	88	*View of Ben Cruachan from the West, taken from the Moors above Taynuil, Argyllshire.*
1840	91	*Distant View of Minehead and Dunster, Somersetshire.*
1840	98	*Ben Lomond, seen over Macfarlane's Island from near the Head of Loch Lomond.*
1840	112	*Scene in Teviotdale, a few miles above Branksome.*
1840	121	*Folkestone, Kent.*
1840	125	*Scene in the Isle of Mull, near Torloisk, Ben More in the Distance.*
1840	130	*Scene at Newhaven, Sussex.*
1840	134	*Helvellyn, and the Mountains at the Head of Ulleswater, looking from the lower end of the lake.*
1840	143	*The Mountains of Loch Etive, seen over Inverawe, Argyllshire.*
1840	144	*View of Ben Cruachan, looking up Loch Etive, Argyllshire.*
1840	153	*Benvorlich, looking up Loch Lomond from the Point of Farkin.*
1840	157	*View of Bolton Abbey, looking up Wharfedale, Yorkshire.*
1840	181	*Dunstaffnage Castle, near Oban, Argyllshire, the Mountains of Mull in the Distance.*

1840	197	*Dindarra Castle, near the Head of Loch Fyne, Argyllshire.*
1840	207	*View on the Downs, Rottingdean, Sussex.*
1840	216	*Scene in Strathfillan, near Tyndrum, West Highlands.*
1840	219	*View of Snowdon, from Capel Cûrig, Caernarvonshire.*
1840	220	*Shoreham, Sussex.*
1840	225	*The Old Pier at Burlington.*
1840	228	*Rydal, Westmorland.*
1840	229*	*Vessels on the Shore in Scarborough Bay, Yorkshire.*
1840	230	*The Pier at Newhaven.*
1840	241	*Folkestone, Kent.*
1840	242	*Brougham Castle, Westmoreland.*
1840	273	*Clamshell Cave in Staffa.*
1840	291	*Distant View of Ripon, Yorkshire.*
1840	314	*Landscape - Composition.*
1840	318	*Scene in the Vale of Festiniog, Merionethshire.*
1841	2	*View of Ben Cruachan, looking up Loch Etive, Argyllshire, 36gns.*
1841	19	*Naworth Castle, Cumberland, 10gns., His Royal Highness Prince Albert.*
1841	30	*View of the South-west Point of the Isle of Staffa, Sold.*
1841	37	*Vessel in a Storm off Beachy Head, Sussex, Sold.*
1841	42	*Ben Venue, and the Trossachs, seen over Loch Achray, Perthshire - Early Morning, 20gns., John Reid Esq., 12 Billiton Square, London, late Old London St., Art Union £15.0.0.*
1841	65	*View on the Downs, near Lewes, Sussex, Sold.*
1841	118	*Vessel off Burlington Pier, in a Gale - Yorkshire, 26gns., D. Colnaghi Esq., Pall Mall East.*
1841	130	*Raby Castle, Durham, 36gns., Geo. Brown, No. 1 Upper Thames Street for John Clow, 54 Mount Pleasant, Liverpool, Art Union £30.*
1841	131	*Scarborough, Yorkshire - Morning, Sold.*
1841	133	*Folkestone Pier, Kent, 6gns., The Earl of Uxbridge.*
1841	152	*Sea Coast, with Fishing Boats, 7gns.*
1841	155	*Fishing Boat coming on Shore - Shanklin, Isle of Wight, 6gns., The Earl of Uxbridge.*
1841	158	*Distant View of Bramber Castle, with the South Downs, Sussex, 11gns.*
1841	163	*View from Bolton Park, looking down Wharfedale to Bolton Abbey in the Distance, Yorkshire, 60gns., Sir Edwd. Sugden, 22 Pall Mall.*
1841	184	*View of Loch Etive - Ben Cruachan in the Distance, Argyllshire, 8gns., John Grayling(?), Sittingbourne, Kent, Art Union.*

1841	214	*View of Ben Slarive and the Mountains at the Head of Loch Etive, Argyllshire, 46gns.*
1841	220	*Ben More, from the Head of Loch Tay, Perthshire, 6gns., Mr. Ryman, Oxford.*
1841	225	*Newhaven, Sussex, 6gns.*
1841	226	*View in Borrowdale, Cumberland, 6gns., Revd. W. Gibson, Fawley, Southampton.*
1841	239	*Scene in Shropshire, near Oswestry, 10gns., J. Beaumont Swete Esq., Oxton, Exeter.*
1841	241	*View on the Downs, near Rottingdean, Sussex, 10gns.*
1841	247	*The Town and Castle of Arundel, Sussex, 12gns., Mrs. Howley, Lambeth Palace, Art Union.*
1841	255	*View of Ben Lomond, over the Islands at the lower part of Loch Lomond, 18gns., Mr. J. Bothams, 87 Hatton Garden, Art Union.*
1841	257	*View on the Downs above Ditching, Sussex, 8gns., Richd. Ellison Esq., Sudbrooke Holme, Lincoln.*
1841	269	*The Langdale Mountains seen over Windermere, from near Ambleside, 6gns., Sir Edward Sugden, 22 Pall Mall.*
1841	270	*Ben Venue, looking down Loch Katrine, 6gns., H.R.H. Prince Albert.*
1841	272	*Scene on Romney Marsh, Kent, 14gns., Revd. Richd. Okes, Eton College, nr. Windsor.*
1841	278	*View on Loch Lomond, looking up the Lake to Ben Vorlich, 9gns., Heny. Holland Esq., 44 Montague Square.*
1841	291	*Scene on the Waste of Cumberland, near Bew Castle, Sold, T. Bodley Esq., Brighton.*
1841	298	*Scene on the Shore at Burlington, Yorkshire, Sold.*
1841	305	*Dunolly Castle, near Oban, Argyllshire - Sunset, 12gns., J. Beaumont Swete Esq., Oxton, Exeter.*
1841	314	*Distant View of Whitby from the Sands, Yorkshire, 11gns., Chas. Burrow, 12 Grove Terrace, Kentish Town.*
1841	320	*Bolton Abbey, Yorkshire, Sold.*
1841	321	*Scene near Bishop's Castle, Shropshire, 6gns., Thos. Abbott Green, Pavenham, Beds.*
1841	323	*View from near Taynuilt, of the Mountains at the Head of Loch Etive, Argyllshire, 11gns., W.L. Leitch, 25 Mornington Place, Hampstead Road.*
1841	326	*Loch Katrine, looking over the Island to Ben Venue, Perthshire, 9gns., J. Rivington, St. Paul's Chyd.*
1842	6	*Ben Venue, seen over Loch Achray, West Highlands.*
1842	13	*Dunstaffnage Castle, near Oban, Argyllshire.*
1842	16	*Rivaulx Abbey, near Helmsley, Yorkshire.*

1842	21	*View of Ben Vorlich, at the Head of Loch Lomond, from the Point of Farkin, West Highlands.*
1842	22	*View of Snowdon, over the Sands of Traeth Mawr, Caernarvonshire.*
1842	45	*Scene near Reigate, Surrey.*
1842	60	*Brougham Castle, Westmorland.*
1842	66	*Scene on the Sea Shore, near Portsmouth.*
1842	76	*View on Loch Leven, near Balahulish, Argyllshire.*
1842	80	*Snowdon, from near Capel Cûrig, Caernarvonshire.*
1842	90	*Burlington Pier, Yorkshire.*
1842	99	*Dover Pier.*
1842	100	*Dunstaffnage Castle, looking down Loch Etive, Argyllshire - Sunset.*
1842	101	*View on the South Downs, with Cisbury Hill, near Worthing.*
1842	112	*Fingal's Cave, Isle of Staffa.*
1842	114	*Ben Slarive, seen over the Woods of Inveraw, on the road from Loch Awe to Oban, Argyllshire.*
1842	117	*Newark Castle, on the Yarrow, Selkirkshire.*
1842	125	*Distant View of Bolton Abbey, looking up the River Wharfe, Yorkshire.*
1842	139	*The Langdale Mountains, seen over Rydal Water, Westmorland.*
1842	141	*The Isle of Staffa, North Britain.*
1842	176	*View from Sutton Brow, on the Descent from the Hambleton Hills, looking over an expanse of the North Riding of Yorkshire, towards Thirsk, Northallerton &c..*
1842	179	*Vessels in a Breeze.*
1842	183	*Scene on the Coast, near Filey Bay, Yorkshire.*
1842	213	*Sea Piece, with a distant View of Whitby Abbey.*
1842	228	*Snowdon, and the Mountains at the Head of Traeth Mawr, from the Tan-y-bwlch Road, Caernarvonshire.*
1842	241	*Vessels off Burlington Pier, Yorkshire.*
1842	250	*Skiddaw and Derwentwater, Cumberland.*
1842	251	*Byland Abbey - Coxwold and the Vale of York in the Distance.*
1842	253	*The Bay of Scarborough, Yorkshire.*
1842	262	*View down the Vale of the Wharfe, from Bolton Park, Yorkshire - Bolton Abbey in the Distance.*
1842	266	*View from Bow Hill, near Chichester - the Isle of Wight in the Distance.*
1842	276	*View of Ben Cruachan, up Loch Etive, Argyllshire - Sunrise.*
1842	282	*The Head of Loch Etive, Argyllshire.*
1842	313	*View over Loch Tay, up Glen Doehort, to Ben More, Perthshire.*
1842	319	*View down the Vale of Clwyd, Denbighshire - Ruthin in the Distance.*
1842	324	*Lancing Marsh, Sussex - Old Shoreham in the Distance.*
1842	329	*View of Snowdon, from the Mountain Road to Ffesliniog, North Wales.*
1842	331	*Loch Achray and Ben Venue, Perthshire.*
1842	332	*View of Loch Tay, looking into Glen Lochy, Perthshire.*
1842	337	*Scene in the Trossacks, looking up Ben Venue, Perthshire.*
1843	6	*View near the Head of the Lake of Geneva,* 10gns., Miss Hill, Helstone, Cornwall, per W. Sandys Esq., Frame and glass £1.10.0, Prize of 10£ with Art Union of London.
1843	16	*View over the Weald of Sussex, near Buxted - the South Downs in the distance,* 12gns., Frame and glass £2.8.0.
1843	22	*South View of Bolton Abbey, Yorkshire,* 18gns., W.R. North Esq., Chelsea Hospital, Frame and glass £3.3.0, Prize of 15£ in Art Union of London.
1843	46	*View of Ben More, over Loch Tay, Breadalbane,* 7gns., Joshua Walker Esq., Calderstone, Liverpool, Frame and glass £1.1.0.
1843	49	*Snowdon, from near Capel Cûrig, Caernarvonshire,* 48gns., J. Staunton Esq., Bedford Hotel, Southampton Row, Russell Sq., Frame and glass £9.0.0.
1843	66	*Storm on the Coast near Scarborough, Yorkshire,* 42 gns., Frame and glass £7.0.0.
1843	69	*Near Lymouth, North Devon,* 6gns., E. Taylor Esq., 1 Canonbury Square, Islington, Frame and glass £1.0.0.
1843	71	*Vessels on the Shore, at Ryde, Isle of Wight,* 6gns., Frame and glass £1.4.0.
1843	79	*View of Mount Caburn and Firle Hill, from the Downs near Lewes, Sussex,* 6gns., Revd. W. Ayling, Tillington, Petworth, Sussex, Frame and glass £1.6.0.
1843	81	*The Langdale Mountains, seen over Windermere,* 6gns., E. Taylor Esq., 1 Cannonbury Square, Frame and glass £1.6.0.
1843	88	*View near Uckfield - the South Downs seen over the Weald of Sussex,* Sold, The Honble. Lady Maynard Hesilrige, 23 Upper Brook St.
1843	109	*The Folkestone Cliffs, looking towards Dover - Sun-rise,* 60gns., Frame and glass £12.0.0.
1843	116	*Distant View of Scarborough, Yorkshire,* 6gns., E. Taylor Esq., 1 Cannonbury Square, Frame and glass £1.6.0.
1843	119	*On the Coast, near Sandgate, Kent,* 6gns., Hon. & Rev. H. Legge, Blackheath, Frame and glass £1.1.0.
1843	126	*The South Downs, near Hurst, Sussex,* 6gns., Frame and glass £1.6.0.

1843 127 *Cowes Harbour, Isle of Wight,* 6gns., Charles Chatfield Esq., Croydon, Frame and glass £1.6.0.

1843 135 *Brougham Castle, Westmorland,* 8gns., Frame and glass £1.12.0.

1843 152 *View from Tilgate Forest, over the Weald of Sussex,* Sold, R. Alexander Esq., 9 Carlton House Terrace.

1843 153 *Ben Venue - the Trossacks, and Ben An, over Loch Achray, West Highlands,* 40gns., Miss Roberts, Mannor House, Marsh Gate, Richmond, Frame and glass paid £6.6.0, Prize of 50£ in Art Union of London.

1843 160 *Scene near Tyndrum, West Highlands,* Sold, The Honble. Lady Maynard Hesilrige, 23 Upper Brook Street.

1843 164 *Distant View of Arundel Castle from the Park, looking towards the Coast by Little Hampton,* 26gns., R. Cumming Esq., 1 Mannor Cottages, Holloway, Frame and glass £4.14.6.

1843 174 *View of Ben Lomond, over Loch Lomond, from the Point of Farkin,* 25gns., T.J. Gosling Esq., Richmond, Frame and glass £4.14.6, Prize of 25 Pounds in the Art Union of London.

1843 178 *The Lake of Nemi, the Town of Gensano. (From a Sketch by an Italian Artist.)* Sold.

1843 184 *Scene on the Shore near Brighton,* 11gns., Frame and glass £2.0.0.

1843 187 *Rocks at Filey - Scarborough in the Distance,* 12gns., Mr. Frederick Cavendish, Burlington Gardens. Frame and glass £2.0.0.

1843 188 *View of the Black Mountain near Inveroran, Argyllshire,* 13gns., Frame and glass £3.0.0.

1843 198 *Burlington Pier, Yorkshire,* 13gns., Rev. H. Sibthorpe, Frame and glass £2.0.0.

1843 208 *Ben Cruachan, over Loch Awe, West Highlands,* 6gns., G.S. Morant, 91 Bond St., Hendon, Middlesex, Frame and glass £1.1.0.

1843 232 *Scene off Burlington Pier, Yorkshire,* 6gns., Frame and glass £1.4.0.

1843 233 *Ulleswater, from near Gowbarrow, Cumberland,* 8gns., S.J. Lowther, 32 Grosvenor Sqre., Frame and glass £1.6.0.

1843 244 *Scene in the North Bay, with Scarborough Castle, Yorkshire,* 6gns., Mr. Thos. H. Barker, Albion Street, Will keep the frame and glass £1.6.0, £0.2.0 packing case.

1843 253 *On the Coast of Lancashire, near Walney,* 8gns., Capt. Hotham, Frame and glass £1.12.0.

1843 254 *Scene in the Pass of Glencoe, Argyllshire,* 12gns., Frame and glass £2.2.0.

1843 290 *Ragland Castle, Monmouthshire,* 8gns., Capt. Hotham, Frame and glass £1.12.0.

1843 305 *A Scene in Shoreham Harbour,* 10 Pounds, Frame and glass £1.15.0.

1843 313 *Chepstow Castle, Monmouthshire,* 10 Pounds, Frame and glass £2.0.0.

1843 319 *On the Shore near Ryde, Isle of Wight, looking towards Portsmouth,* 11gns., Frame and glass £2.10.0.

1843 323 *The Entrance to Dartmouth Harbour, Devonshire,* 11gns., Maj. General Osborne, Pengelly House, Chesunt, Herts., Frame and glass £2.5.0, being for a 10£ Prize in the Art Union.

1843 334 *Goodrich Castle, looking down the River Wye, Herefordshire,* 24gns., Alfred Lund Hughes Esq., 115 Piccadilly, To keep the frame and glass £3.10.0, Prize of 25£ in the Art Union of London.

1843 350 *Folkestone, Kent,* 22gns., R. Ellison Esq., Sudbrooke Holme and Warrens Hotel, Frame and glass £3.0.0.

1843 355 *Part of Ulleswater, Cumberland,* 6gns., Frame and glass £1.1.0.

1843 359 *Stonehenge,* 20gns., E. Dickinson Esq., per W. Dickinson Esq., 7 Abbey Hill, Bexley, Frame and glass £4.4.0, Prize of 25£ in the Art Union of London.

1844 22 *Scene on the Shore near Luccombe, Isle of Wight,* 8gns., Mrs. R. Philips (sent to Miss Hibbert, Clapham Common), Frame and glass £1.12.0.

1844 30 *Distant View of Dunster Castle and Minehead, Somersetshire - Sunset,* 60 gns., Brankston Esq., 39 Old Change, Frame and glass £10.0.0, P.AU.

1844 47 *Sea Piece - Vessel off Burlington, Yorkshire,* 50gns., Colonel Pennant, Frame and glass 9 Pounds.

1844 57 *Mountains at the Head of Loch Lomond, West Highlands,* 6gns., Miss Paton, Hampstead Heath, Frame and glass £1.1.0.

1844 78 *Harlech Castle, North Wales,* Sold, Benj. Austen Esq., 6 Montague Place, Russell Sq.

1844 85 *Byland Abbey, Yorkshire - Sun-set,* 22gns., Rev. T. Worsley, Downing Lodge, Cambridge, Frame and glass £3.16.0.

1844 94 *Ben Lomond, seen down Loch Lomond, from above Tarbet,* 6gns., E.S. Kennedy, Loraine Place, Holloway, Frame and glass £1.4.0.

1844 98 *Coast Scene near Ryde, Isle of Wight,* 6gns., Miss Bella Smith, 5 Blandford Square, Frame and glass £1.6.0.

1844 110 *View of Snowdon, from the Sands of Traeth Mawr,* 18gns., Hamilton Cooke Esq., Carr House, Nr. Doncaster, Frame and glass £3.0.0.

1844 118 *Distant View of the South Downs, over the Weald of Sussex, from near Crowborough,* 12gns., Lewis Pocock Esq., Frame and glass £2.0.0.

1844 123 *Lymne Castle, near Hythe, Kent,* 5gns., James Hall Esq., 40 Brewer St., Golden Sq., Frame and glass £1.0.0.

1844 126 *View looking over the Vale of York, from near Hovingham, York Minster seen in the horizon, and Craik Castle in the Middle Distance on the Hill to the Right,* 36gns., Rev. W.C. Mathison, Trinity College, Cambridge, Frame and glass £6.10.0.

1844 136 *Plymouth Sound from Mount Edgcumbe, looking East to Drake's Island - the Citadel and Mount Batten,* 22gns., R.H. Robertson, 9 Watling St., Dulwich Road.

1844 137 *Cottage, near Minehead, Somersetshire,* 6gns., Rev. H.F. Lay(?), Braughiny(?), Ware, Herts., Frame and glass £1.1.0.

1844 144 *View of the South Downs, near Patcham, Sussex,* 34gns., R.H. Robertson Esq., 9 Watling St., City, Frame and glass £6.0.0.

1844 160 *Loch Katrine - Ben Venue seen over Ellen's Island, Perthshire,* 45gns., W. Hobson Esq., Frame and glass £8.10.0.

1844 167 *View of Ben-y-Glo, looking down Glen Tilt, Perthshire,* 34gns., Rev. Joseph Clark, 17 Brunswick Square, Brighton, P.AU.

1844 197 *View in Langdale, near Ambleside, Westmorland,* 6gns., Hugh Perkins Esq., 67 Mark Lane, Frame and glass £1.1.0.

1844 201 *View of the Town and Castle of Arundel, from near Little Hampton, Sussex,* 16gns., Chas. Eversfield, 2 St. James Sq., Deane(?) Park, Horsham, Surrey, Frame and glass £3.0.0.

1844 216 *Leintwardine, Herefordshire,* 6gns., Saml. Angell Esq., 18 Gower Street, Frame and glass £1.8.0.

1844 218 *Scene at the Entrance of Glen Coe, from King's House, Argyllshire,* 9gns., Price Edwards Esq., 2 Southwest Buildings, Weston Rd.(?), near Bath, Frame and glass £1.15.0.

1844 219 *View of Loch Leven, with the Mountains of Glen Coe, from near Balahulish, Argyllshire,* 11gns., Sir John Hobhouse, Frame and glass £1.0.0.

1844 222 *Scene in the Vale of Towy, Caermarthenshire,* 9gns., J.C. Phillips Esq., 11 Canterbury Villas, Maida Vale, Frame and glass £1.10.0.

1844 224 *View of Portsmouth, from Spithead,* 14gns., Chas. Eversfield Esq., Frame and glass £2.10.0.

1844 226 *La Cava, near Sorrento, from a Sketch by an Amateur,* 6gns., Robt. B. Kay Esq., Friars Hill, near Hastings, Frame and glass £1.0.0.

1844 233 *Scene on the Coast of Yorkshire - Scarborough in the Distance,* 14gns., Miss Ritchie, 45 York Terrace, Frame and glass £2.10.0.

1844 235 *Scene on the Moor of Rannoch, Perthshire,* 5gns., Miss Bella Smith, 5 Blandford Square, Frame and glass £1.1.0.

1844 240 *View over the Weald of Sussex, from Sheffield Park, looking to the South Downs, near East Bourne,* 6gns., Chas. Eversfield Esq., Frame and glass £1.8.0.

1844 242 *Stonehenge, Wilts - Sunset,* 9gns., Frame and glass £1.15.0.

1844 244 *Dindarra Castle, near Inverary, looking to the Head of Loch Fyne, Argyllshire,* 6gns., E.S. Kennedy Esq., Frame and glass £1.8.0.

1844 247 *View of Ben Vorlich, from the Point of Farkin, looking up Loch Lomond,* 11gns., Sir John Hobhouse, Frame and glass £2.0.0.

1844 251 *Scene near Inveroran, Argyllshire,* 7gns., Colonel Pennant, Frame and glass £1.0.0.

1844 268 *The Coniston and Langdale Mountains, seen over Windermere, Westmorland,* 6gns., Wm. H. Hawker Esq., Plymouth, Frame and glass £1.8.0.

1844 270 *The Old Pier at Burlington, Yorkshire,* 8gns., B. Smith Esq., 5 Blandford Square, Frame and glass £1.8.0.

1844 274 *View of Ben Venue over Loch Katrine, from the Braes of Strathgartney, Perthshire,* 9gns., Sir John Hobhouse, Frame and glass £1.15.0.

1844 295 *View of the Mountains of Borrowdale, looking up Derwent Water, Cumberland,* 9gns., Colonel Sibthorp, Frame and glass £1.11.0.

1844 299 *Scene in Glen Lochy, Breadalbane,* 12gns., Revd. T.A. Firminger, Sittingbourne, Kent, Frame and glass £2.0.0.

1844 302 *Entrance to Dartmouth Harbour, Devonshire,* 11gns., Miss Osborne, 11 Hereford St., Park Lane, Frame and glass £2.0.0.

1844 304 *Vessels in a Light Breeze,* 8gns., Robert Benson Esq., 6 Sussex Sqre., Frame and glass £1.15.0.

1844 308 *View down the Vale of Irthing, Cumberland with distant view of Lanercost Priory,* 22gns., Jos. Feilden Esq., Witton House, nr. Blackburn, Frame and glass £3.10.0.

1845 11 *View of the Isle of Staffa from the South,* 20gns., Benj. Smith Esq., 5 Blandford Square, Frame and glass £3.0.0.

1845 25 *The Forest of Loch Tulla, in Argyllshire, looking to the Mountains of Glasgour,* 48gns., Lord Bradalbane, 21 Park Lane, Frame and glass £7.10.0.

1845 33 *Rievaulx Abbey, near Helmsley, Yorkshire,* 20gns., Joseph Quick Esq., Sumner Street, Southwark, Frame and glass £3.10.0, P.AU. 15£.

1845 58 *Glen Lochy from near the Head of Loch Tay, Perthshire,* 9gns., Miss Bella Leigh Smith, Frame and glass £1.10.0.

1845 62 *View near Sanderstead, looking over Croydon, Surrey,* 4gns., George Clive Esq., Sanderstead, Croydon, Frame and glass £0.16.0 (new frame and plate glass £1.5.0).

1845 63 *View in Teviotdale, near Branksome Castle,* 9gns., H.C. Bowen Esq., 22 Castle Street, Edinborough, Frame and glass £1.10.0.

1845 70 *Part of Windermere, Westmorland,* 6gns., Marquiss of Lansdown, Frame and glass £1.4.0.

1845 77 *View of Ben and Loch Lomond from Glen Falloch, West Highlands,* 15gns., Dominic Colnaghi, Frame and glass £2.10.0.

1845 83 *Porlock, Devonshire,* 6gns., John Scott, Pall Mall East, Frame and glass £1.4.0.

1845 89 *View near Croydon, Surrey,* 6gns., Mrs. Clive, Sanderstead, Croydon, Frame and glass £1.4.0.

1845 92 *Scene in the South Downs, looking over Goldstone Bottom to the Dyke - the Hamlet of Blatchington on the left - near Brighton,* 36gns., Frame and glass £5.10.0.

1845 106 *Greenwich, from Blackwall,* Sold.

1845 121 *View of the Summit of Snowdon, taken from the side of Moel Hebog, looking over Beddgellert, Caernarvonshire,* 36gns., John Wild Esq., Clapham Lodge, Frame and glass £6.0.0.

1845 137 *Bolton Abbey, Yorkshire,* 12gns., Mrs. Malins, 35 Bedford Place, Frame and glass £2.0.0.

1845 143 *View of Lancaster, from the Coast,* 40gns., Mrs. S??? Wade, Redbourn, Herts., Frame and glass £5.15.6, P.AU. 40£.

1845 151 *View of the South Downs near Lewes, over the Weald of Sussex, from Cuckfield,* 36gns., Mrs. Chas. Mills, Camelford House, Oxford St., Frame and glass £5.10.0, P.AU. 30£.

1845 157 *View of Snowdon from the Head of the Valley, above Capel Cûrig, Caernarvonshire,* 12gns., John Martin Esq., 14 Berkely, Frame and glass £2.0.0.

1845 161 *Vessels in a Gale, off Filey Bridge, running for Shelter into Filey Bay, Yorkshire,* 50gns., Col. Pennant, Frame and glass £7.10.0.

1845 164 *A Scene off Newhaven, Sussex,* 8gns., Henry C. Robarts Esq., 15 Lombard St., Frame and glass £1.8.0, P.AU. 10£.

1845 166 *Distant View of Bolney, Sussex,* Sold, Frame and glass £4.0.0.

1845 174 *View of Ben More up Glen Dochart, Perthshire,* 6gns., E. Tayler Esq., 1 Connersby(?) Sq., Frame and glass £1.4.0.

1845 228 *View near Cuckfield, Sussex,* Sold.

1845 235 *East View of Netley Abbey, Hants.,* 7gns., R.H. Robertson Esq., Dulwich Wood, Frame and glass £1.4.0.

1845 236 *Scene on the Shore at Brighton,* 10gns., Rev. H.A. Soames, Greenwich, Frame and glass £1.15.0.

1845 238 *Distant View of Hurstpierpoint, Sussex,* 11gns., C.J. Cruttwell, New Boswell Court, Frame and glass £2.0.0, P.AU. 10£.

1845 245 *View from Bow Hill, near Chichester, Sussex - the Isle of Wight in the distance,* Sold.

1845 247 *Hastings - Sunset,* 16gns., E.U. Eddis(?) Esq., 78 Newman St., Frame and glass £2.10.0, P.AU. 20£.

1845 259 *Ben Venue over Loch Achray, West Highlands,* 11gns., Master William Smith, Frame and glass £1.15.0.

1845 260 *Loch Venachoir, looking up to Ben Venue, Perthshire,* 8gns., Miss Spooner, Frame and glass £1.10.0.

1845 264 *Burlington Pier,* 4gns., Miss Burton, Frame and glass £1.1.0.

1845 269 *View, looking down the Clyde - Port Glasgow and Greenock in the distance on the left,* 14gns., Sir John C. Hobhouse, Frame and glass £2.0.0.

1845 271 *View of Ben Venue and Ellen's Island, over Loch Katrine,* 6gns., Miss Spooner, Frame and glass £1.4.0.

1845 275 *Mount Edgcumbe, Devonshire - Early Morning,* Sold, Frame and glass £4.0.0.

1845 280 *Scene on the Coast, near Scarborough, Yorkshire,* 6gns., Miss Spooner, Frame and glass £1.4.0.

1845 285 *Distant View of Dunster, Somersetshire,* 9gns., Frame and glass £1.10.0.

1845 291 *Langdale Pikes over Windermere, Westmorland,* 6gns., Master William Smith, Frame and glass £1.4.0.

1845 292 *Near Uckfield, Sussex, the South Downs in the distance,* 6gns., S.H. Hawkins Esq., 16 Suffolk Street, Frame and glass £1.4.0.

1845 297 *Brougham Castle, on the River Emont, Westmorland,* 10 Pounds, William Garfit Esq., Boston, Lincolnshire, Frame and glass £1.10.0.

1845 314 *View from St. John's Common, near Cuckfield, in the Weald of Sussex,* 12gns., G.E. Paget Esq., Caius College, Cambridge, Frame and glass £2.0.0 Pd., P.AU. 10£.

1845 316 *Dindarra Castle on Loch Fyne - Moonlight,* Sold.

1845 323 *Scarborough, from the North Bay, Yorkshire,* 8gns., Richd. Ellison Esq., Frame and glass £1.12.0.

1845 334 *View of Loch Lomond above Tarbet, with Ben Lomond seen over Macfarlane's Island, West Highlands,* 9gns., Countess of Mansfield, Frame and glass £1.10.0.

1845 341 *The Coniston Mountains seen over Windermere, Westmoreland,* 6gns., Miss Anne Smith, Frame and glass £1.4.0.

1845 343 *View near Lindfield, Sussex,* 6gns., Lady Harriet Paget, Royal Hospital, Chelsea, Frame and glass £1.4.0.

1846 7 *Filey Bridge, Yorkshire - during a Storm,* 36gns., Richard Ellison Esq., Frame and glass £5.0.0.

1846	10	*Dunster, with Minehead Point, Somersetshire,* 26gns.
1846	18	*Rievaulx Abbey, Yorkshire,* Sold.
1846	29	*Bolton Abbey, Yorkshire,* Sold.
1846	36	*The Pass of Killiecrankie, Perthshire,* Sold.
1846	48	*The Old Pier at Burlington, Yorkshire,* 12gns., Miss Paton, Hampstead, Frame and glass £2.2.0.
1846	70	*Ben Cruachan, seen from the Moors above Taynuilt, Argyllshire,* Sold.
1846	80	*View of the Rydal Mountains, near the Head of Windermere,* 8gns., Rev. Hare Townshend, 9 Gt. Cumberland St., Frame and glass £1.10.0.
1846	88	*Scene near Cuckfield, Sussex - Lindfield Church in the Distance,* 6gns., Frame and glass £1.4.0.
1846	90	*South View of the Island of Staffa - Early Morning,* Sold.
1846	98	*Ashdown Forest, looking over the Weald of Sussex - the South Downs in the distance,* Sold.
1846	127	*The South Downs, near Lancing, Sussex - the Newhaven Cliffs in the extreme distance,* 30gns., Wm. Gott(?) Esq., Leeds, Frame and glass £4.4.0 Not.
1846	134	*View of Folkestone, Kent - Sunset, after a Gale,* 38gns., Frame and glass £5.12.0.
1846	136	*View up Loch Fyne, of Inverary, seen below the Hill of Dunaquoich, Argyllshire - a Fresh Breeze,* 13gns., H. Cole Bowen Esq., Union Club, Frame and glass £2.2.0.
1846	139	*Caistor Castle, near Yarmouth, Norfolk,* 11gns., Henry Wilkinson Esq., Clapham Common, Frame and glass £1.18.0.
1846	148	*View of Loch Etive, looking up to Ben Cruachan, Argyllshirè,* 9gns., Wm. Grey Esq., York, Frame and glass £1.10.0.
1846	150	*Plymouth Sound, Devonshire,* 6gns., Dr. Whewell, Trinity College, Cambridge, Frame and glass £1.4.0.
1846	155	*The Old Watch House formerly standing at the sea entrance to the Steyne, Brighton,* 16gns., H. Burton Esq., Frame and glass £2.10.0.
1846	161	*Scarborough, Yorkshire - During a Gale,* 22gns., Miss Grenfell, 14 Hyde Park Square, Frame and glass £3.0.0.
1846	176	*View near Bromley, Kent,* 5gns., Frame and glass £-.15.-.
1846	182	*View of Loch Achray and Ben Venue, West Highlands,* 11gns., Edward Betts Esq., 29 Tavistock Square, Frame and glass £2.0.0 Not.
1846	188	*Ben More, seen up Glen Dochart, Breadalbane,* 6gns., R. Philips Esq., 6 Portland Place, Frame and glass £1.4.0.
1846	193	*The Forest of Loch Tulla, looking up to Ben Doran, near Inveroran, Argyllshire,* 12gns., Thos. Hellyer Esq., Architect, Ryde, Isle of Wight, Frame and glass £2.2.0.
1846	208	*View of Ben Vorlich and the Mountains up the Head of Lomore, from near the Point of Farkin,* Sold.
1846	210	*The Langdale Mountains, seen over Rydal Water, Westmoreland,* 6gns., Mrs. Bicknell, Herne Hill, Frame and glass £1.4.0.
1846	213	*View, looking up Loch Linuke, Argyllshire,* 12gns., J.S. Marling Esq., Ebley, W. Stroud, Frame and glass £2.0.0 sold, AU.
1846	228	*Naworth Castle, Cumberland - Evening,* 14gns., J.C. Grundy, Manchester, Frame and glass £2.2.0.
1846	231	*Newhaven, Sussex,* 6gns., Capt. Brown, Manchester Barracks (Army and Navy Club, St. James Sq., Frame and glass £1.4.0 sold.
1846	232	*Distant View of Knowle-house, near Sevenoaks, Kent,* 9gns., Frame and glass £1.10.0.
1846	257	*Scene on the Moor of Rannoch, Breadalbane,* 5gns., Sir H.H. Campbell M.P., 72 Portland Place, Frame and glass £-.15.-.
1846	261	*Shoreham Harbour, Sussex,* 6gns., Jeddere Fisher Esq., Oxford & Cambridge Club, Frame and glass £1.4.0.
1846	264	*View near Cuckfield, Sussex,* Sold.
1846	266	*View from Crowborough Common, looking over the Weald of Sussex to the South Downs,* 15gns., John Dillon Esq., 5 Kensington Terrace.
1846	280	*Loch Etive, from near Connel Ferry, looking up to Ben Cruachan, Argyllshire - Mist clearing off,* 26gns., Mrs. John Field, West Brixton, Frame and glass £3.14.0.
1846	290	*The Shakspeare Cliff, Dover,* 16gns., Rev. Richard Okes, Eton College, Frame and glass £2.10.0.
1846	293	*Scene on the Shore, at Sandgate, Kent,* 5gns., Decimus Burton Esq., 6 Spring Garden, Frame and glass £-.15.-.
1846	295	*Derwent Water, looking into Borrowdale, Cumberland,* 7gns., Mrs. E. Bicknell, Herne Hill, Frame and glass £1.4.0.
1846	296	*Dartmouth, South Down,* 9gns., Frame and glass £1.14.0.
1846	298	*View of Ben Venue, over Loch Achray, West Highlands,* 6gns., Colonel Sibthorp, Stepney, Frame and glass £1.4.0 Yes.
1846	299	*Loch Leven, with the Mountains of Glencoe, Argyllshire,* 6gns., Colonel Sibthorp, Stepney, Frame and glass £1.4.0 Yes.
1846	303	*View of Ben Venue, over the Island, in Loch Katrine, Perthshire,* 6gns., J.C. Birkenshaw Esq., 12 Fludyer St., Westminster, Frame and glass £1.4.0 Paid.
1846	305	*Dartmouth, South Devon,* 10gns., Lord Monteagh, Brook St., Frame and glass £1.12.0.
1846	313	*View up Glen Lochy, from near the head of Loch Tay, Perthshire,* 10gns., R. Micklam Esq., London Hotel, Albemarle St., Frame and glass £1.12.0 sold.

1846 320 *Fishing Boat - the Coast of Sussex*, 6gns., Frame and glass £1.4.0.

1847 5 *A Brisk Wind at Sea*, 6gns., Miss Sterry(?), Upminster, Essex, Frame and glass £-.14.-.

1847 17 *Scene on the Shore at Lymouth, North Devon*, 10gns., John Hall Esq., St. Germans Place, Blackheath, Frame and glass £1.12.0 No.

1847 20 *View of Capel Cûrig, looking up to Snowdon, Caernarvonshire*, 6gns., A.H. Burford Esq., 49 Charing Cross, Frame and glass £1.4.0 sold.

1847 22 *View of Snowdon, from the Mountain Road between Pont Aberglaslyn and Tan-y-bwlch*, 50gns., William Butt Esq. Jun., Trinity College, Cambridge, Frame and glass £8.5.0, P.AU. 50£.

1847 31 *The Isle of Staffa- a View of Clam-shell Cave - Iona seen in the horizon*, 60gns., Sir H.H. Campbell, Frame and glass £8.5.0.

1847 36 *Fishing Boats at Binstead, Isle of Wight*, 6gns., Frame and glass £1.10.0.

1847 43 *Ben Lomond, from the upper part of Loch Lomond*, 25gns., Geo. Braine Esq., 11 Gt. Cumberland Place, Hyde Park.

1847 62 *Ben Vorlich, at the Head of Loch Lomond, seen from near the Point of Farkin*, 36gns., Thos. Toller Esq., Frame and glass £5.5.0.

1847 80 *Italian Landscape, with Sea Port - Composition*, Sold, Frame and glass £8.16.6.

1847 82 *Lake of Como, from a Sketch by an Italian Traveller*, 6gns., Frame and glass £1.4.0.

1847 84 *Snowdon seen over the Upper Lake of Capel Cûrig - Caernarvonshire*, 6gns., John Wilson, Fulham Rd., Brompton, Rose Cottage, Hollis Place, Frame and glass £1.1.0 No.

1847 85 *View in the Isle of Mull, with Ben More in the distance*, 110gns., J. Hogarth, Frame and glass £1.6.0.

1847 87 *Bala Lake, Merionethshire*, 6gns., Sir. Col. Sugden, Boyle Farm, Thames Ditton, Frame and glass £1.4.0.

1847 93 *The Entrance of the Trosachs, from Loch Katrine, looking up to Ben Venue*, 8gns., R. Phillips Esq., Frame and glass £1.2.0 No.

1847 94 *View near King's House, at the Head of Glen Coe, Argyllshire*, 10gns., J. Beadwell(?) Jun., Frame and glass £1.10.0.

1847 95 *Loch Rannoch, Perthshire*, 6gns., G. Leach Esq., 10 Melina Place, St. John Wood, Frame and glass £1.5.0.

1847 111 *View from Bow Hill - Goodwood in the distance - Sussex*, 14gns., The Hon. Alfred Bagot, 23 St. James Square, Rec'd. for frame and glass £2.2.0, P.AU. 15£.

1847 113 *View of Ben Venue, over the Island in Loch Katrine, West Highlands*, 12gns., J. Beadnell(?) Jun., Tottenham, Frame and glass £1.15.0.

1847 128 *Lago Maggiore - from a Sketch by an Italian Traveller*, 6gns., Henry Holland Esq., 46 Montague Sq., Frame and glass £1.4.0.

1847 134 *Ben Nevis, looking up Loch Eil, Inverness-shire - Evening*, 30gns., S.J. Rowton Esq., 29 Austin Friars, Frame and glass £4.4.0 Sold.

1847 136 *Seaford Cliffs, from Newhaven, Sussex*, 26gns., Francis T. Rufford Esq., Prescot House, nr. Stourbridge, Frame and glass £3.10.0.

1847 141 *View from the Sands of Traeth Mawr, of Snowdon and surrounding Mountains, Caernarvonshire*, 46gns., Lord Chas. Townshend, Frame and glass £6.0.0 Sold.

1847 150 *Arundel Castle, from the upper part of the Park, Sussex*, 38gns., B. Cocleigh(?) Winthrop Esq., 8 Marine Parade, Dover, Frame and glass £5.5.0 Sold.

1847 163 *View of York, taken from the old Walls, looking nearly North*, 48gns., Frame and glass £7.0.0.

1847 173 *Farm Cottages, near Lindfield, Sussex*, 7gns., Mr. Vokins, Frame and glass £1.4.0.

1847 175 *Folkestone, Kent*, 6gns., Chas. B. Fripp Esq., Bristol, Frame and glass £1.4.0.

1847 178 *Scene in the Trosachs, looking up to Ben An, West Highlands*, 6gns., Col. Sibthorp, Frame and glass £1.1.0.

1847 185 *The Langdale Mountains, seen over Windermere, Cumberland*, 6gns., Matthew Wise Esq., Frame and glass £-.14.-.

1847 187 *Dartmoor, Devon*, 6gns., Hon. & Rev. H. Legget, Blackheath, Frame and glass £1.4.0.

1847 215 *Loch Venachoir, with Ben Venue in the distance, West Highlands*, 1gns., Thos. Toller Esq., 6 Grays Inn Sq., Frame and glass £2.4.0 No.

1847 226 *Distant View of the Isle of Staffa, from the South*, 14gns., Gambin Parry, Frame and glass £2.2.0.

1847 248 *View in Glen Finglass, looking up to Ben Lawers, West Highlands*, 9gns., Prince Edwd. of Saxe Weimar, Marlbro House, Pall Mall, Frame and glass £1.11.0.

1847 255 *Mount Edgecumbe, seen over Drake's Island, Plymouth Sound*, 24gns., Frame and glass £3.0.0.

1847 257 *Scene off Filey, Yorkshire - Scarborough in the distance*, 8gns., Broadhurst Esq., Holly Lodge, Campden Hill, Kensington, Frame and glass £1.12.0 No.

1847 258 *North View of Arundel Castle, Sussex*, 9gns., Miss C. Brereton, 54 Montpellier Road, Brighton(?), Frame and glass £1.10.0.

1847 265 *Scene off Dover Pier, Kent*, 8gns., Frame and glass £1.12.0.

1847 269 *Distant View of the South Downs and the Weald, from near Cuckfield, Sussex*, 15gns., F. Lushington Esq., Park House, Maidstone, Frame and glass £2.10.0 No.

1847 279 *View of the Upper Part of Loch Etive, with Ben Slarive and the Mountains above Glen Coe, Argyllshire*, 16gns., Mrs. Wild, Clapham Lodge, Frame and glass £2.10.0.

1847 282 *Whitby, Yorkshire*, 6gns., Rev. Thos. Prater(?), Bicester, Oxfordshire, Frame and glass £1.4.0.

1847 294 *Mountain Scene between Inveroran and Glen Coe, Argyllshire*, 11gns., Sir H.H. Campbell, Frame and glass £1.15.0.

1847 297 *View of Bolton Abbey from the North, Yorkshire*, 9gns., Honble. Mrs. Rushout, Wanstead Grove, Essex, Frame and glass £1.11.0 No, P.AU. 10£.

1847 302 *Culver Cliff, from Bembridge, Isle of Wight*, 28gns., S. Lowrey Esq., Barmoor, Berwick on Tweed, Frame and glass £3.10.0 No, P.AU. 30£.

1847 316 *Scene in Glen Falloch, Argyllshire*, 6gns., Bishop of Chester, Frame and glass £1.4.0 No.

1848 21 *View of Ben More, in the Isle of Mull, from near Torloisk*, 35gns., Mrs. Whewell, Cliff Cottage, Lowestoff, Frame and glass £5.15.0.

1848 29 *View in Tilgate Forest, looking over the Weald of Sussex*, 11gns., E.M. Dewing Esq., 2 Harcourt Bds., Temple, Frame and glass £1.9.0 No.

1848 35 *View down the River Wye, with Chepstow Castle, Monmouthshire*, 20gns., B.A. Leach Esq., India House, Frame and glass £3.0.0 No, change, AU. 20£.

1848 38 *A Valley in the Sussex Downs, between Chanctonbury and Cisbury Hills, near Worthing*, 50gns., Frame and glass £8.10.0.

1848 48 *View of the Summit of Snowdon, looking up Cwm-y-Ilan from Nant Gwinant, Caernarvonshire*, 26gns., Frame and glass £3.14.0.

1848 59 *View of Cader Idris, Merionethshire*, 10gns., John Gott Esq., Wythen, nr. Leeds, Yorks., Frame and glass £1.10.0.

1848 66 *Ben Venue, seen over Loch Katrine, Perthshire*, 5gns., Frame and glass £-.15.-.

1848 67 *Dunstaffnage Castle, West Highlands*, 10gns., Ed. Sartoris Esq., 99 Eaton Place, Frame and glass £1.8.0 No.

1848 68 *Windsor, from the Great Park*, 8gns., Rd. Ellison Esq., Frame and glass £1.4.0 Yes.

1848 71 *View of Snowdon, from Traeth Mawr, Caernarvonshire*, Sold, Miss Arkwright, Frame and glass £3.14.0 similar to 291 [S. Rayner].

1848 80 *Sunset - Landscape Composition*, 40gns., Frame and glass £6.0.0.

1848 105 *View near Buxted, looking over the Weald of Sussex*, 6gns., Rev. Hare-Townshend, Frame and glass £1.4.0.

1848 113 *Scene in Glen Dochart, Ben Lawers in the distance, Perthshire*, 6gns.

1848 120 *Storm on the Coast of Mull, with a View of Ben More in the distance, taken from near the Isle of Staffa*, 60gns., Robert Hall, 8 Dean Yd., Westminster, Frame and glass £8.5.0 Sold.

1848 126 *Evening - Goodrich Castle, Herefordshire*, 26gns., Frame and glass not fit.

1848 132 *Scene near Inverawe, Argyllshire*, Sold, 12.12.0?, Hon. R. Cavendish, Compton Place, EastBourne, Frame and glass £1.18.0.

1848 133 *View from near Steyning, looking to the South Downs and over the Weald of Sussex - Wolstonbury Hill in the distance*, 25gns., Frame and glass £3.10.0.

1848 140 *View of Snowdon, from near Tre-Madoc, Caernarvonshire*, 6gns., Victor Garreau cancelled, 149 instead, Frame and glass £1.4.0.

1848 141 *Derwent Water, looking into Borrowdale, Cumberland*, 10gns., E.M. Dewing Esq., Frame and glass £1.8.0 No.

1848 148 *Ben Venue, seen over Loch Venachoir, Perthshire*, 6gns., Miss D. Saltmarshe, Sussex Sq., Brighton, Frame and glass £1.4.0.

1848 149 *Niton, Isle of Wight*, 8gns., Victor Garreau Esq., Frame and glass £1.5.0 Paid.

1848 161 *Ben Venue and the Trosacks, seen over Loch Achray, Perthshire - Early Morning*, 13gns., Colonel Wood, 91 Bond Street, Frame and glass £2.7.0 Yes.

1848 162 *View of Mont Blanc, from Sallenche, after a Sketch by G. S. Nicholson Esq.*, 80gns., Mr. Charles Buxton, Truman's Brewery, Spitalfields, Frame and glass £12.0.0 Yes.

1848 174 *View of Dumbarton Castle, looking down the River Clyde*, 15gns., Frame and glass £2.10.0.

1848 198 *View of Dindarra Castle, looking to the Head of Loch Fyne, Argyllshire*, 40gns., The Hon. R. Cavendish, 1 Belgrave Sq., Frame and glass £6.0.0.

1848 219 *Scene on the Shore, at Worthing, Sussex*, 6gns., F.T.Rufford Esq., Frame and glass £1.4.0.

1848 231 *View of Ben Cruachan, looking up Loch Etive, West Highlands*, 7gns., Col. Sibthorp, Frame and glass £1.3.0 Yes.

1848 240 *Scene on the River Brathay, near Ambleside, Westmoreland*, 12gns., Capn. Hotham, 74 Oxford ?, Frame and glass £1.12.0.

1848 241 *On the Shore near Sandgate, Kent*, 7gns., Col. Sibthorp, Frame and glass £1.3.0 Yes.

1848 244 *Snowdon, from the Moors above Tan-y-bwlch, Merionethshire*, 6gns., Frame and glass £1.4.0.

1848 256 *Distant View of the Isle of Wight, with Calshot Castle, looking down the Southampton Water*, 5gns., Victor Garreau Esq., Frame and glass £0.15.0 No, match 262.

1848 257 *Rydal Water, Westmoreland*, 6gns., G.M. Hicks Esq., 33 Regent Sq., Frame and glass £1.4.0.

1848 262 *View of Ben More, looking up Glen Dochart, Perthshire,* 8gns., John Poynder Esq., M??? St., Lambeth, Frame and glass £1.4.0 Paid.

1848 269 *Distant View of Naworth Castle, Cumberland,* 5gns., Frame and glass £1.0.0.

1848 270 *Coniston Fell, seen over Windermere, Westmoreland,* 5gns., [Sold and Victor Garreau deleted, 256 pencilled in], Frame and glass £-.15.-.

1848 271 *Distant View of Knole House, from the Park, Kent,* 20gns., Frame and glass £3.0.0.

1848 273 *View of Ben Vorlich, looking up Loch Lomond, West Highlands,* 7gns., Rev. H. Sibthorp, Washingbury, nr. Lincoln, Frame and glass £1.3.0 Yes.

1848 287 *View of Arundel Castle, from the Park, Sussex,* 5gns., Frame and glass £-.15.0.

1848 292 *Scene above Taynuilt, near Loch Etive, Argyllshire,* 8gns., Frame and glass £1.5.0.

1848 314 *View in Strath-Fillan, near Tyndrum, Breadalbane,* 5gns., Frame and glass £-.15.0.

1848 318 *Grange Bridge, Borrowdale, Cumberland,* 6gns., Victor Garreau Esq., Frame and glass £1.4.0 No.

1848 319 *View of the South Downs, near Falmer, Sussex,* 6gns., Victor Garreau, 12 Grays Inn Square, Frame and glass £1.4.0 Yes.

1848 334 *Arundel Castle, looking down the River Arun, Sussex,* 8gns., Frame and glass £1.6.0.

1848 346 *View in the Ouse Valley, with the Viaduct near Cuckfield, Sussex,* 9gns., Rev. Hare-Townshend, Frame and glass £1.6.0 No.

1849 7 *View on the River Bratha, near Ambleside.*

1849 11 *Scene in Glen Lochy, Perthshire.*

1849 14 *View from the Moors above Taynuilt, looking to Ben Slarive and the Mountains at the head of Loch Etive, Argyllshire.*

1849 23 *View near the head of Loch Tay, looking up to Ben More, in Glen Dochart - Breadalbane - an effect after rain.*

1849 30 *Ben Venue, from the Trosachs, West Highlands.*

1849 35 *Cottage Scene near Buxted, Sussex.*

1849 59 *View on St. John's Common, near Cuckfield, Sussex.*

1849 65 *View over Loch Tay, looking up Glen Lochy, Perthshire.*

1849 75 *Ben Vorlich, looking up Loch Lomond.*

1849 77 *Mountain Scene near Inveroran, Argyllshire.*

1849 79 *Scene on the Downs, near Lewes, Sussex.*

1849 108 *View looking up the River Wye, with Goodrich Castle on the left - the Brecknockshire Hills in the distance.*

1849 123 *The South Downs, between Steyning and Broadwater, Sussex.*

1849 126 *View of Snowdon, Caernarvonshire, from near Llanfrothen.*

1849 130 *Scarborough, Yorkshire.*

1849 143 *View of Seaford and the Cliffs, from near Newhaven, Sussex.*

1849 153 *The Head of Loch Fyne, with Dindarra Castle, Argyllshire.*

1849 163 *Scene in the Forest of Dalmore, looking up to Ben Mac Dhui, Aberdeenshire.*

1849 169 *Eshton Hall, Yorkshire, the Seat of Miss Currer - from a Sketch by Miss Harrietta Crompton.*

1849 170 *View across the Vale of Clwyd, from near Henllan, Denbighshire - St. Asaph in the distance.*

1849 172 *Ben Lomond, seen over Loch Lomond, from near Luss.*

1849 188 *View of Derwent Water, looking into Borrowdale, Cumberland.*

1849 239 *Folkstone, Kent.*

1849 240 *Bolton Abbey, Yorkshire.*

1849 245 *View looking over Loch Rannoch to Ben Shiehallion, North Highlands.*

1849 250 *Scene in Shropshire, with the Wrekin Hill in the extreme distance on the right.*

1849 251 *The River Greta, near Keswick, Cumberland.*

1849 267 *View of Snowdon over Pont-y-Gwryd, above Capel Cûrig, Caernarvonshire.*

1849 271 *Scene in the New Forest, near Stoney Cross, Hants.*

1849 286 *Distant View of Arundel Castle, from the North, Sussex.*

1849 291 *Scene near Inverawe, with the Mountains at the upper end of Loch Etive, Argyllshire.*

1849 295 *View of Cisbury Hill and the Downs, over Broadwater, Sussex.*

1849 298 *Distant View of Rhyddlan Castle - from Diserth-Flints, the Ormes Head in the extreme distance.*

1849 303 *Cottages near Cuckfield, Sussex.*

1849 308 *Rio Janeiro from the Sea - after a Sketch by an Amateur.*

1849 317 *Sandown Bay, with Culver Cliff, from near Bembridge, Isle of Wight.*

1849 321 *The Moor of Rannoch, from near the Entrance to Glencoe, North Highlands.*

1849 330 *Byland Abbey, Yorkshire.*

1849 353 *The Summit of Blencathera, as seen from Derwentwater, Cumberland.*

1849 356 *View of Ben Lomond and Ben Vorlich, at the Head of Loch Lomond.*

1849 359 *View on the Road to Tan-y-Bwlch - from Pont Aberglasslyn, looking up to Snowdon.*

1849 361 *Scene on the Sea Shore in the Isle of Mull, North Britain.*

1849	362	*View near Inveroran, Argyllshire.*
1850	27	*View from the upper part of Loch Lomond, looking to Ben Lomond,* 6gns., Col. Sibthorp, Frame and glass £1.4.0.
1850	38	*View of Brougham Castle, Westmoreland,* 7gns., Frame and glass £1.4.0.
1850	66	*View of Ben Cruachan, looking over Loch Awe, Argyllshire,* 80gns., Chas. Brown, Lower Tooting, Frame and glass £12.0.0, AU. 80£.
1850	71	*Distant View of the Castle and Town of Arundel, from the South,* 10gns., Robert Lee Esq., Regent Square, Frame and glass £1.10.0, AU. 10£.
1850	72	*Distant View of Lanercost Priory, near Brampton, Cumberland,* 8gns., Mrs. Bacon, 18 South St., Frame and glass £1.2.0.
1850	93	*Byland Abbey, Yorkshire,* 22gns., Frame and glass £3.0.0.
1850	105	*View in the Vale of Irthing, Cumberland - Naworth Castle is seen on the left and Lanercost Priory on the right of the Picture,* Sold, R. Ellison, Frame and glass £6.0.0.
1850	110	*View looking to the Head of Loch Etive, with Blen Slarive on the right, and the Mountains near Glencoe in the distance,* 28gns., Robert N. Philips Esq., The Park, near Manchester, Frame and glass £4.4.0.
1850	113	*Seaford Cliffs, from Newhaven, Sussex,* Sold.
1850	151	*Scene looking down Glencoe, Argyllshire - the effect of Rain in a Storm,* 36gns., Frame and glass £6.0.0.
1850	164	*The Peaks of Snowdon, as seen from the head of the valley above Capel Cûrig, Caernarvonshire,* 34gns., Frame and glass £5.5.0.
1850	176	*The Eddystone Lighthouse - Stormy Weather,* 50gns., A. Alexander Esq., Frame and glass £7.0.0.
1850	183	*Distant View of Staffa, from the North,* 9gns., T. Dowell(?) Buxton(?), Frame and glass £1.11.0 No.
1850	184	*Ben Cruachan as seen from the Moors above Taynuilt, Argyllshire,* 10gns., Frame and glass £1.10.0.
1850	191	*View looking up Loch Etive, from near Connel Ferry, Argyllshire,* 7gns., Col. Sibthorp, Frame and glass £1.3.0 Yes.
1850	219	*View of Ben Vorlich, looking up Loch Lomond,* 15gns., Robt. Hanbury Esq., Frame and glass £2.5.0 Yes.
1850	226	*Ben Lomond, looking down Loch Lomond, over Macfarlane's Island,* 26gns., Robert Hanbury Esq., Frame and glass £4.0.0 Yes.
1850	229	*Scene in the South Downs - a View of Patcham, Sussex,* 20gns., Thos. Bartlett Esq., Whetstone, Middlesex, Frame and glass £3.0.0 No.
1850	247	*View of Moelwyn, Merionethshire - taken from near the Head of Taith Mawr,* 12gns., Dr. George Downing Fripp, 9 Albert Road, Regents Park, Frame and glass £2.0.0 Yes.
1850	250	*Cottages near Lindfield, Sussex,* 7gns., Frame and glass £1.3.0.
1850	254	*Ben More, seen over Loch Tay, Breadalbane,* 6gns., C. Randell Esq., Ewell, Frame and glass £1.4.0.
1850	255	*Scene off the Coast of Argyllshire, looking down the sound between Scarba and Jura,* 8gns., Frame and glass £1.12.0.
1850	257	*Scarborough from the Sands, Yorkshire,* 14gns., Alderman(?) Moore(?), Frame and glass £2.6.0.
1850	261	*Dartmouth, Devonshire,* 5gns., ??? Fuller Esq., 29 Abington Street, Frame and glass £1.3.0 Yes.
1850	266	*The South Downs - seen over Bramber Castle, Sussex,* 9gns., Frame and glass £1.11.0.
1850	267	*View above Beddgelert, looking to Moel Hebog - Caernarvonshire,* 6gns., Rev. C.H. Townshend, Frame and glass £1.4.0.
1850	269	*View over Lancing Marsh, looking to Old Shoreham and the range of the South Downs, Sussex,* 14gns., John Broadhurst Esq., Holly Lodge, Camden Hill, Kensington, Frame and glass £2.6.0.
1850	274	*View of Snowdon from the Upper Road to Tan-y-Bwlch, from Pont Aberglasslyn,* 12gns., Frame and glass £2.8.0.
1850	283	*View of Snowdon over Traeth Mawr, Caernarvonshire,* 15gns., Scott Smith Esq., Frame and glass £2.15.0 Yes.
1850	287	*Distant View of Bolton Abbey, Yorkshire,* 8gns., Frame and glass £1.12.0.
1850	289	*View of Skiddaw, over Derwent Water, Cumberland,* 12gns., Frame and glass £2.2.0.
1850	293	*Morning,* 18gns., Frame and glass included.
1850	309	*Folkestone, Kent,* 7gns., Frame and glass £1.3.0.
1850	315	*Dunstaffnage Castle, Argyllshire,* 14gns., Fr. Astley Esq., Frame and glass £2.6.0.
1850	322	*The Langdale Mountains, seen over Windermere,* 7gns., Robd. Hanbury Esq., Frame and glass £1.3.0 No.
1850	332	*Scene at the Head of Loch Tay, looking up Glen Dochart to Ben More, Perthshire,* 6gns., T. Dowell(?) Buxton, Frame and glass £1.4.0.
1850	337	*Distant View of Chepstow Castle, looking down the River Wye, Monmouthshire,* 7gns., W. Collingwood Smith Esq., Frame and glass £1.3.0 No.
1850	348	*Near Nettlestone, Isle of Wight,* 6gns., Robt. Hanbury.

| 1850 | 359 | *View of Ben More, Perthshire, from the head of the Glen above Dalmally, looking over Loch Arinabea*, 13gns., Lord Breadalbane, 21 Park Lane, Frame and glass £2.7.0 New. |

| 1850 | 369 | *Scene on the Moors near Loch Tulla, Argyllshire*, 6gns., Frame and glass £1.4.0. |

| 1850 | 370 | *Summer Moonlight - View of Gilnockie Castle and Bridge, Eskdale*, 7gns., Frame and glass £1.3.0. |

| 1850 | 371 | *View over Bolney, of the Weald and South Downs, Sussex*, 10gns., R. Davidson, Forres, Frame and glass £1.10.0 Send, AU: Com. |

| 1851 | 33 | *Evening.* |

| 1851 | 39 | *View of Ben Venue, looking up Loch Venachoir, Perthshire.* |

| 1851 | 40 | *Snowdon, over the Peat Moss, near the Head of Traeth Mawr, North Wales.* |

| 1851 | 51 | *View of Ben Lomond, over Loch Ard, Perthshire.* |

| 1851 | 53 | *View of the South Downs, over Lancing Marsh - looking to Old Shoreham, Sussex.* |

| 1851 | 56 | *Loch Achray, with Ben Venue and the Trosachs, Perthshire.* |

| 1851 | 92 | *View in Borrowdale, Cumberland.* |

| 1851 | 95 | *View over Derwentwater - looking to Borrowdale, Cumberland.* |

| 1851 | 107 | *The Cliffs of Dover.* |

| 1851 | 109 | *View of the Black Mountain, near Inveroran, Breadalbane.* |

| 1851 | 145 | *Ben Vorlich and Mountains, at the Head of Loch Lomond.* |

| 1851 | 146 | *View of Ben Slarive and Mountains of Loch Etive, from the Moors above Tainuilt, Argyllshire.* |

| 1851 | 155 | *Stonehenge, Wiltshire - the effect of the Sunset, taken from Nature.* |

| 1851 | 156 | *Ben Venue, with Ellen's Island - seen over Loch Katrine, Perthshire - effect seen just before Sunset.* |

| 1851 | 161 | *Ben Lomond, seen over Loch Lomond, with Macfarlane's Island.* |

| 1851 | 163 | *Scene near King's House, Argyllshire.* |

| 1851 | 187 | *Distant View of Dunstaffnage Castle, Argyllshire.* |

| 1851 | 198 | *View of Cader Idris, from near Barmouth, Merionethshire.* |

| 1851 | 204 | *View of Derwentwater, looking to Skiddaw, Cumberland.* |

| 1851 | 210 | *The Old Pier at Dover.* |

| 1851 | 220 | *Lochnagar, Aberdeenshire.* |

| 1851 | 224 | *Loch Lomond, with the Islands near the lower end of the Loch.* |

| 1851 | 232 | *Entrance to Dartmouth Harbour, Devonshire.* |

| 1851 | 247 | *Bolton Abbey, Yorkshire.* |

| 1851 | 253 | *Snowdon, with the surrounding Mountains, seen from the Sands of Traeth Mawr.* |

| 1851 | 258 | *Brougham Castle, Westmoreland.* |

| 1851 | 276 | *Tintern Abbey, Monmouthshire.* |

| 1851 | 279 | *Ben More, in the Isle of Mull - looking up Loch Tuadh.* |

| 1851 | 287 | *View of Langdale Pikes and Bow Fell, over Windermere, Westmoreland.* |

| 1851 | 294 | *View of Ben Lomond, from the upper end of Loch Lomond.* |

| 1851 | 297 | *View of Gormire, a little Lake under the Hambleton Hills, near Thirsk, Yorkshire.* |

| 1851 | 320 | *Scene in Langdale, Westmoreland.* |

| 1851 | 323 | *Waterfall in Glen Falloch, Argyllshire.* |

| 1851 | 324 | *Vessel at Spithead.* |

| 1851 | 325 | *Snowdon, from Capel Cûrig, Caernarvonshire.* |

| 1852 | 11 | *View in Langdale, Westmoreland*, 8G, Frame and glass £1.8.0. |

| 1852 | 12 | *Schehallion, seen over Loch Rannoch, Perthshire*, 6G, Mrs. E. Gamback(?), Frame and glass £1.1.0. |

| 1852 | 14 | *A Summer Afternoon*, Sold. |

| 1852 | 28 | *Snowdon, from near Capel Cûrig, Caernarvonshire*, 50G, Hugh Mair Esq., North Ingram Court, Glasgow, Frame and glass £6.6.0, AU. £40. |

| 1852 | 31 | *View of Beddgelert, Caernarvonshire*, 14G, Rev. C. Upham Barry, Charlemont, Ryde, I. of Wight, Frame and glass £2.10.0. |

| 1852 | 81 | *Bamborough Castle, Northumberland - Stormy Weather*, 60G, George Sharp Esq., 10 Wentworth Place, Dublin for John Crampton, Washington, U.S., Frame and glass £7.0.0. |

| 1852 | 98 | *Lancaster*, 14G, Dr. Whewell, Frame and glass £2.10.0. |

| 1852 | 103 | *Loch Awe, Argyllshire*, 6G, Captain Peel, 4 Whitehall Gardens, Frame and glass £1.1.0 No. |

| 1852 | 127 | *The Old Groyne at Brighton*, Sold, Chas. Harebury. |

| 1852 | 128 | *Early Morning - A View of Ben Lomond, looking across Loch Lomond, from the Point of Farkin*, 40G, Arthur Vardon Esq., Hanger Lane, Stamford Hill, Frame and glass £4.4.0. |

| 1852 | 136 | *View of Cader Idris over Llaniltyd Bridge, near Dolgellie, Merionethshire*, 14G, C. Gambart Esq., Frame and glass £2.10.0. |

| 1852 | 138 | *Windsor Castle, from the Forest*, 24G, Henry Birkbeck Esq., Stoke Holy Cross, nr. Norwich, Frame and glass £3.16.0 Yes. |

| 1852 | 145 | *The South Downs, seen over Portslade, Sussex*, Sold, Robt. Hanbury Esq. |

| 1852 | 156 | *View between Pont Aberglasslyn and Tan-y-bwlch, Merionethshire - looking down to Traeth Mawr*, 80G, The Rev. Edw. Rhodes, Hampton Villa, Bath, Frame and glass £10.10.0 Yes. |

1852	173	*Scarborough, Yorkshire*, 15G, Frame and glass £2.10.0.
1852	175	*View of Lambeth, from the Thames*, Sold.
1852	218	*Landscape*, 6G, Robert Hollond Esq., 63 Portland Place, Frame and glass £1.1.0 paid.
1852	242	*View of Ben Cruachan, from the Moor above Taynuilt, Argyllshire*, 6G, G. Constable Esq., Frame and glass £-.14.0.
1852	244	*The Cumberland Mountains, seen from Eskdale, Dumfriesshire*, 6G, Mrs. Fuller, R.P., Frame and glass £1.1.0.
1852	247	*View of Ben Cruachan, looking up Loch Etive, from near Connel Ferry, Argyllshire*, 14G, E. Gambart Esq., Frame and glass £2.10.0.
1852	258	*Landscape - Composition*, 15G., George Sharp, 10 Wentworth Place, Dublin, Frame and glass £2.10.0 Yes.
1852	260	*Folkestone, Kent - Sunset*, 6G, Ray.(?) Smee Esq., Frame and glass £1.1.0.
1852	270	*View from the Lower Part of Loch Lomond, of Ben Lomond, and the Mountains at the Head of the lake*, 14G, Miss Wakefield, Longdon, Lichfield, Frame and glass £2.10.0.
1852	272	*Byland Abbey, near Thirsk, Yorkshire*, 7G, E. Gambart, Frame and glass £1.1.0.
1852	273	*The Head of Loch Fyne, with Dindarra Castle, Argyllshire*, 10G, S. & J.Fuller, 34 ??? Place, Frame and glass £1.10.0.
1852	277	*Fishing Boat in a Gale*, 14G, Mrs. J. Mollett, Frame and glass £2.2.0.
1852	280	*View on the Coast of Genoa - from the Sketch of an Amateur*, 9G, Çaptain Howard, 86 Eaton Place, Frame and glass £1.11.0.
1852	290	*Lochnagar, Aberdeenshire*, 6, John Henderson Esq., Frame and glass £1.1.0.
1852	296	*Scene on the Shore at Worthing, Sussex*, 16, John Broadhurst Esq., Frame and glass £2.10.0.
1852	298	*Culver Cliff, seen over Sandown Bay, Isle of Wight*, 6, Charlotte Hardy, 3 Portland Place, Frame and glass £1.1.0.
1852	302*	*Scene in North Wales*, 5G.
1852	307	*View of Shakespeare Cliff and the South Foreland, from near Folkestone, Kent*, 26, Mrs. Bacon, Frame and glass £3.3.0.
1852	311	*View of Skiddaw, looking down Derwent Water, Cumberland*, 6, E. Gambart Esq., Frame and glass £1.1.0.
1852	318	*The Mountains of Mull, seen over Dunstaffnage Castle, from Loch Etive, Argyllshire*, 28G, J.L. Grundy Esq., Frame and glass £3.12.0.
1852	321	*View of Cisbury Hill and the South Downs, seen over Tarring, Sussex*, 12G, Geo. Constable Esq., Frame and glass £1.15.0.
1853	12	*Sea Piece*.
1853	14	*Shore Scene near Bembridge, with Culver Cliff, Isle of Wight*.
1853	27	*View of Windsor Castle, from the Great Park*.
1853	51	*View of the Langdale Mountains, over Windermere, Westmoreland*.
1853	52	*A Distant View of Southampton, from near Netley*.
1853	57	*Scene in Borrowdale, Cumberland*.
1853	60	*Grassmere, Westmoreland*.
1853	69	*View of Ben Slarive, looking up Loch Etive, from near Inverawe, Argyllshire*.
1853	90	*View in the Waste of Cumberland, near Bew Castle*.
1853	99	*South-East Point of the Isle of Staffa, with Clamshell Cave - Iona in the distance*.
1853	101	*Fishing Boats on the Shore, Isle of Wight*.
1853	102	*Brougham Castle, Westmoreland*.
1853	125	*Scene on the Moors, near Taynuilt, Argyllshire*.
1853	132	*View in the Weald of Sussex, near Cuckfield - Bolney Church in the middle distance*.
1853	148	*Mountain Scene, from near Bunawe, looking to the Head of Loch Etive, Argyllshire*.
1853	159	*The Peaks of Snowdon, seen from the side of Moel Hebog, above Beddgelert, Caernarvonshire*.
1853	207	*Sunset - Folkestone, Kent*.
1853	212	*View near Penrith, looking towards Appleby, Westmoreland*.
1853	247	*Flamborough Head, with Filey and Scarborough in the distance - Yorkshire*.
1853	258	*South Downs, from near Poynings, Sussex*.
1853	264	*Burlington Old Pier, Yorkshire*.
1853	267	*Scene at Dover, looking to the South Foreland*.
1853	269	*Distant View of the Cumberland Mountains, Skiddaw, &c. from near Carlisle*.
1853	273	*View of Ben Cruachan, over Loch Awe, Argyllshire*.
1853	285	*View near Hurst, of the South Downs, Sussex*.
1853	302	*A Lane Scene, with Gipsies, near Hurst, Sussex*.
1853	303	*Skiddaw, and Derwent Water, Cumberland*.
1853	305	*Loch Lomond, looking up to Ben Vorlich, &c. West Highlands*.
1854	10	*Langdale Pikes, near Ambleside, Westmoreland*, 28gns., Frame and glass £3.12.0.
1854	19	*The Cliffs of Folkestone, looking to Shakespeare's Cliff*, 27gns., R.H. Grundy, Liverpool, Frame and glass £3.3.0.
1854	30	*View looking over Menteith to the Highlands, near Stirling - Ben Ledi and Ben Venue are seen above the lower range of Hills*, 60gns., Mrs. Cole Smith, Lion Spring House, Clifton, John Walpole Esq., Fulham, Frame and glass £7.0.0, To pay seven pounds for frame on the closing of Art Union.

1854	39	*View over the Clyde from near Greenock - looking to the Mountains of Argyllshire*, 40gns., Agnew, Manchester, Frame and glass £4.15.0.
1854	60	*View in the South Downs, near Lancing, Sussex*, 13gns., Mrs. FitzPatrick, 20 South St., Park Lane to be sent to Mrs. E. Wigram, 2 Connaught Place, Frame to be sent for approval £1.17.0.
1854	63	*Distant View of the South Downs, looking over the Weald of Sussex*, 6gns., The Honble. R. Cavendish.
1854	67	*Ben Nevis, seen over Loch Eil, Inverness-shire*, 6gns., L.H. Winchworth, 11 Blackheath Terrace, Blackheath, Frame and glass £1.4.0.
1854	80	*Glen Lochy, at the Head of Loch Tay, Perthshire*, 50gns., Mr. E.A. Fildes(?), 102 Gloucester Terrace, Hyde Park, Frame and glass £6.10.0.
1854	98	*The Moor of Rannoch, Perthshire - Schihallien seen in the extreme distance*, 40gns., T.J. Parsons Esq., 6 Raymond Buildings, Grays Inn, Will take frame £4.15.0.
1854	101	*View of Snowdon, looking up Traeth Mawr, as it appeared before the embankment was made at Tre Madoc, Caernarvonshire*, 28gns., W. Agnew Esq., Frame and glass £3.2.0.
1854	127	*Helvellyn, and the Mountains round the Head of Ulleswater, Cumberland*, 16gns., Frame and glass £2.4.0.
1854	128	*View in the South Downs, at Patcham, near Brighton*, 15gns., Frame and glass £2.5.0.
1854	130	*Scarborough, Yorkshire*, 60gns., Leopold Redpath, 27 Chester Terrace, Regents Park, Frame and glass £7.0.0.
1854	138	*Snowdon, from Capel Cûrig, Caermarthenshire*, 9gns., E.L. Magoon. In case I am not here at the closing send Baring Brothers, 8 Bishopgate Within, Frame and glass £1.11.0.
1854	139	*View of Ben Venue from the Trosachs, West Highlands*, 7gns., Henry Hessill(?), Diss, Norfolk, Frame full large.
1854	140	*Scene near Inveroran, West Highlands*, 13gns., Revd. John Goring, Wiston Park, Steyning, Sussex, Frame and glass £1.7.0.
1854	143	*Goodrich Castle, Herefordshire*, 8gns., Frame and glass £1.6.0.
1854	150	*The Mountains at the Head of Loch Etive, Argyllshire*, 12gns., Harrison, 70 Herbert St., Gt. North Rd., Frame and glass £1.15.0, Art Union Prize.
1854	163	*Ben Venue and the Trosachs, seen over Loch Achray, Perthshire*, 15gns., ? Tailby(?) Esq., Mirants Hotel, Carlton Hall, Leicester, Frame and glass £2.5.0.
1854	181	*Scene in Borrowdale, Cumberland*, 5gns., Frame and glass £-.10.0.
1854	187	*Ben More, in the Isle of Mull - as seen from near Staffa*, 25gns., Richard Till, Clapham Terrace, This frame does not fit. A new one can be made for £3.10.0.
1854	239	*Vessel in a Breeze*, 5gns., R.H. Grundy Esq., Liverpool, Frame and glass 15/.
1854	266	*Ben Cruachan, from the Moors, near Inverawe, Argyllshire*, 5gns., Miss Heaton, 31 Park Square (send to T. Richmond Esq.), Frame and glass £1.0.0.
1854	283	*View of the Upper End of Loch Fyne, with Dindarra Castle in the distance*, 6gns., Agnew Esq., Manchester, Frame and glass £1.4.0.
1854	286	*View of the Mountains round the Head of Loch Lomond, West Highlands*, 12gns., Agnew Esq., Manchester, Frame and glass £1.12.0.
1854	289	*Distant View of Brougham Castle, Westmoreland*, 7gns., Taunton Esq., Frame and glass £1.3.0.
1854	310	*Scene at the Head of Loch Lomond, West Highlands*, 7gns., Bullock Esq., Frame and glass £1.3.0.
1854	316	*Squally Weather, Dover Old Pier*, 7gns., Agnew Esq., Frame and glass £1.3.0.
1854	325	*Burlington, Yorkshire*, 20gns., E. Bullock Esq., Frame and glass £2.10.0.
1854	331	*View of Ben Lomond, from the Lower end of Loch Lomond*, 7gns., Mrs. Eyre, 5 Porchester Place, Oxford Square, Frame and glass £1.3.0.
1854	333	*Culver Cliff, from near Shanklin, Isle of Wight*, 11gns., Agnew Esq., Manchester, Frame and glass £1.9.0.
1854	337	*Loch Etive, Argyllshire*, 7gns., H.F. Powell, Ashbourne, Derbyshire, Frame and glass £1.3.0 Yes.
1854	346	*Ben Vorlich, looking up Loch Lomond*, 7gns., E. Clowes, 18 Endsleigh St., Tavistock Sq., Frame and glass £1.3.0.
1854	354	*The Isle of Staffa*, 11gns., Richard Ellison Esq., Frame and glass £1.9.0.

FIELDING MRS

1820	105	*Iris Pavonia, Cistus, Acacia, and other Flowers.*
1820	146	*A Glass Salver, with Fruit and Flowers.*

FIELDING MRS T H

1821	90	*Flowers.*
1821	93	*Flowers - Cistus, Tiger-Lily, Acacia, &c.&c..*
1821	97	*Apple-bloom, Dog-tooth, Violet &c. in an antique Jug.*
1822	71	*Snowdrops.*
1822	75	*Wild Heath, and Wood-Lady - Butterflies*, £5.5.0, Mr. Wansey(?).
1822	76	*Fern, with the Admirable, and Gatekeeper Butterflies*, £5.5.0, Mr. Wansey(?).
1823	244	*Chinese Roses, &c.*

1823	249	*Tiger Moth.*
1823	250	*Wild Flowers, "know a bank whereon the wild thyme blows . . ." Midsummer Night's Dream.*
1823	251	*Partridges.*
1823	253	*Clematis.*
1823	254	*The Peacock, and Painted Lady Butterflies and Dragon Fly.*
1825	317	*Hawthorn, Wild Hyacinth, and Mountain Geranium, with Insects, £5.0.0., Frame and glass £1.10.0.*
1826	70	*A Group of Flowers, 10gns.*
1826	218	*Balsams, 5gns.*
1826	220	*French Roses and Persian Iris, 5gns.*
1827	318	*Wood Anemonies and Butterflies, 6gns., G. Hibbert Esq.*
1828	9	*The Robin's Nest, £10.0.0.*
1828	266	*Teal, 5gns., Earl Brownlow.*
1829	56	*Thrush Nest and Crab Blossom, 10gns., Frame and glass £4.4.0.*
1829	340	*Spring Flowers, 5gns., Frame and glass £2.2.0.*
1829	374	*Roses and Geranium, 5gns., Frame and glass £2.2.0.*
1830	216	*King Fishers, 8gns.*
1831	367	*A Group of Flowers.*
1831	398	*A Group of Flowers.*
1832	43	*A Group of Flowers - the Balsam, Blarkia, Salvia &c., 7gns., Frame and glass £1.10.0.*
1833	332	*A Group of Flowers, 4gns.*
1833	424	*A Branch of Roses, 4gns.*
1834	249	*The Strelitzia Regina, White Iris, and Lilac Passion Flowers, 6gns., Frame and glass £1.10.0.*

FIELDING N

1818	122	*Landscape. Composition. Morning.*

FIELDING N T

1815	176	*A View in Cumberland, looking eastward over Thurlspool, the Moon rising from the foot of Helvellin.*
1815	186	*A View, looking over the Ohio, near the Mouth of the Cumberland River.*

FIELDING T

1816	27	*A Windmill.*
1816	84	*View between Pont Aberglasslyn and Tan-y-bwlch, Merionethshire.*
1816	86	*Landscape and Cows.*
1817	38	*Landscape, with Cows, £10.10.0, Rev. A.C. Hawtrey, Eton.*
1817	59	*Scene from the Seventh Pastoral of Virgil.*
1817	82	*Mercury and Argus. - Ovid's Metam.*
1818	55	*Landscape, with Cattle and Figures.*
1818	81	*Scene from the Fifth Pastoral of Virgil.*

1818	89	*Pastoral Scene.*
1818	90	*Dispute at Cribbage.*
1818	104	*The Watering Place, £7.7.0, R. Frankland Esq.*
1818	142	*Cattle. Morning.*
1818	147	*The Spring in the Grounds at Clifton, Bucks, £6.6.0, Mr. Walmsley.*
1818	368	*Landscape and Cattle.*
1819	41	*Landscape, with Cows.*
1819	43	*Landscape.*
1819	45	*Spring at Cliefden, Bucks, £7.7.0, Wm. Paget Esq., Loughboro.*
1819	48	*Scene from Nature.*
1819	97	*Landscape, with Cattle.*
1819	118	*View near Maidenhead, Berks.*
1819	120	*Scene on the road to Highgate.*
1820	59	*Landscape, with Cows.*
1820	60	*Ambleside Waterfall, Westmoreland.*
1820	87	*Landscape, with Cattle.*
1820	106	*Cottage Scene.*
1829	23	*Cedric shewing to Richard and Ivanhoe the bier of Athelstane, Vide Ivanhoe, vol. iii. page 234. 13gns.*
1829	36	*Landscape, with Cattle, 15gns., Frame and glass £5.18.0.*
1829	104	*Job appealeth from men to God - Cap. 17, 30gns., Frame and glass £9.2.0.*
1829	110	*View of the Needles from near Yarmouth, Isle of Wight, 15gns., Mr. T.H. Wilkinson, 9 York Terrace, Regents Park, Country residence Walsham le Willows, near Bury St. Edmunds.*
1829	161	*Fishermen - with a distant View of Beachey Head, 16gns., Mr. Nightingale, 16 Duke St., Westminster.*
1829	183	*Cows going to Water, 16gns., Frame and glass £6.8.0.*
1829	375	*A Duck - Study from Nature, 8gns.*
1830	51	*Distant View of Rye, with Cattle going to Water, 35gns.*
1830	106	*View of Hastings Castle, with Beechey Head in the distance, 15gns.*
1830	123	*Quintin Durward at Breakfast with Louis XI., Parques Dieu! Is she, or does she think herself too good to serve me? 16gns.*
1830	135	*View near Winchelsea, with Cattle, 15gns.*
1830	136	*View of Camber Castle, with Cows, 15gns.*
1830	148	*Scene under the East Cliffs, Hastings - Foggy Morning, 25gns.*
1830	168	*View of the Stone Pier at Dover - Fishermen landing at low water, 25gns.*
1830	182	*Hastings - Fishermen, 25gns.*
1831	91	*Cattle Piece.*

1831	112	*Scene on the Beach at Teignmouth.*
1831	116	*Landscape, with Cows Milking.*
1831	220	*Gipsies Playing Cards - Scene on Blackheath.*
1831	273	*Distant View of Greenwich Hospital.*
1831	408	*Evening, Looking up Blackwall Reach - with Cattle.*
1831	418	*View of the Old and New Breakwater at Weymouth.*
1832	35	*Scene under the Cliffs at Dover, with a Distant View of Folkestone,* 8gns., Mr. T. Griffiths, Norwood, Frame and glass £2.12.6.
1832	111	*Arethusa, pursued by Alpheus, is transformed by Diana into a Fountain, "Yet does he not depart, for he saw not the prints of my feet to reach any further . . ." Ovid's Metamorphoses, Book V.* 20gns., Frame and glass £8.0.0.
1832	202	*Sun-set, with Cattle,* 13gns., Frame and glass £4.10.0.
1832	223	*View from the Chesil Bank, looking over the Bay at Weymouth, with Portlanders returning from Market,* 30gns., Frame and glass £12.0.0.
1832	239	*Corfe Castle - Sun-set,* 7gns., Frame and glass £2.12.6.
1832	267	*Macbeth and the Witches as they vanish into air,* 20gns., Frame and glass £10.0.0.
1832	289	*Coast Scene, with Fishermen,* 5gns., Mr. W. Wells, Blenheim Hotel, Bond Street, To be sent to Mr. Lee, 16 Norton St. Frame and glass £1.15.0.
1832	367	*Boys Fishing for Crabs,* 5gns., Mr. Wilkinson, Walsham, Suffolk, Frame and glass £1.5.0.
1833	35	*Scene on the Beach at Margate - from Nature,* 7gns.
1833	77	*Gypsies Reposing,* 20gns.
1833	120	*Children with Blackberries - from Nature,* 8gns.
1833	157	*Gypsies Playing Cards,* 8gns.
1833	218	*Gypsey Boy and Dog from Nature,* 8gns.
1833	245	*Scene on the Beach at Hastings, from Nature,* 7gns.
1833	299	*Arethusa from the depths of the Peneus discovers Aristaeus on the Banks of the River complaining to his Mother Cyrene, "Sad Aristaues, from fair Tempe fled . . ." Dryden's Virgil, Georgics, Book IV.* 20gns.
1833	358	*The Syrens in pursuit of Proserpine when carried off by Pluto,* 7gns.

FIELDING THALES

1834	67	*Landscape with Cattle - Composition,* 18gns.
1834	112	*Evening View of Corfe Castle and Town,* 8gns.
1834	118	*Scene on the Beach at Hastings,* 5gns., The Earl of Cawdor, 74 South Audley Street.
1834	121	*Portland Ferry-house - Portlanders going to Weymouth,* 7gns.

1834	130	*Dover Pier, with Fishermen,* 7gns.
1834	221	*Morning View of Caerphilly Castle, S. Wales,* 8gns., Miss Eliza Smith, 6 Portland Place.
1834	366	*Scene on the Beach at Teignmouth,* 7gns.
1834	379	*Greenwich Hospital, with Cattle - Sun-set,* 5gns.
1835	23	*Scene on the Beach at Lowestoffe, during the Herring Fishery,* 25gns.
1835	29	*Cattle - with a distant View of Dorchester Church,* 18gns., Mr. Allnutt, Clapham.
1835	37	*Silenus found asleep by the two Swains and the Nymph Aegle – Vide Virgil, Eclogue VI.,* 7gns.
1835	65	*Cattle in the Salt Marshes at Lodmoor, with distant View of the Weymouth Cliffs,* 8gns., Mr. Ashlin, Edward Street, Hampstead Road.
1835	179	*Distant View of Wyke, from Chesiltown, Portland,* 7gns.
1835	225	*Distant View of Pakefield, from the Entrance to the Harbour at Lowestoffe,* 7gns.
1835	296	*Boys Fishing - Sun-set,* 8gns., Geo. H. Wilkinson, Harperly Park, Bishop Auckland.
1836	16	*Sun-rise with Cattle - Scene looking over the Bay at Weymouth,* 18gns., Edmd. M. Scott Esq., Berners St..
1836	113	*Distant View of Rye, taken from near Winchelsea,* 14gns., Frame and glass £3.3.0.
1836	141	*Cattle - Corfe Castle in the distance, taken from the Wareham Road,* 8gns., Frame and glass £1.11.6.
1836	166	*Morning - Boys catching Crabs under the East Cliff, Hastings,* 8gns., Frame and glass £1.1.6.
1836	343	*Cattle Drinking,* 5gns., Frame and glass £1.11.6.
1837	49	*View of Caerphilly Castle,* 9gns.
1837	116	*Cattle, with a distant view of Greenwich Hospital from the Marshes,* 18gns.
1837	132	*Cattle, with a distant View of Plumstead Church, Kent,* 18gns.
1837	181	*Cattle, with a distant View of Snowdon from the Lights above Tan-y-Bwlch,* 25gns.
1837	233	*Cattle,* 5gns.
1837	350	*Shrimping, under the Old Breakwater, Weymouth,* 5gns.

FINCH F O

1820	169	*Garmallon's Tomb, "My son! lead me to Garmallon's tomb; it rises beside that rustling tree . . ." Vide Ossian.*
1822	23	*View of Loch Lomond.*
1822	99	*View in Buckinghamshire,* 1gn.(?), Mr. Allnutt(?).
1822	113	*Castle of Gloom, Scotland.*
1823	2	*Mountain Pass.*
1823	84	*Walnut Gatherers.*

Year	No.	Title
1823	293	*View on Frith Hill, Bucks.*
1824	172	*Landscape - Composition.*
1825	149	*Landscape - Composition,* 4gns., Sir John Swinburne.
1825	168	*Landscape,* 10gns., Smith Esq.
1826	58	*Landscape - Composition,* 20gns.
1826	104	*View in Northwick Park,* Sold.
1826	134	*Distant View of Northwick Park,* Sold.
1826	135	*View in Northwick Park,* Sold.
1826	151	*View of a Fountain in Northwick Park,* Sold.
1826	186	*View, near Edinburgh,* 8gns., Lord Northwick.
1827	34	*Landscape - Composition,* 15gns.
1827	192	*Hawthornden - A Sketch,* 4gns., W. Prior Esq.
1827	229	*Twilight - Landscape Composition,* 15gns.
1827	252	*View on the River Tay,* 15gns., Sold.
1827	336	*Landscape - Composition.*
1828	5	*Twilight,* 15gns.
1828	176	*Distant View of Northwick Park,* Sold.
1828	185	*View of Northwick Park,* Sold.
1828	187	*View of Northwick Park,* Sold.
1828	227	*Morning,* 15gns.
1828	230	*Northwick Park,* Sold.
1828	259	*Castle Campbell, Scotland,* Sold.
1828	320	*Distant View of Northwick Park,* Sold.
1829	33	*View of Edinburgh,* 5gns. [deleted].
1829	41	*View of Windsor Castle.*
1829	257	*View near Jedburg,* Sold.
1829	269	*Landscape - Composition, "Deep in the dreary den, conceal'd from day . . ." Ovid's Metamorphoses, Book Third.* 20gns.
1829	277	*Landscape,* 5gns., Rev. J. Brown Esq.
1830	10	*Study from Nature,* 4gns.
1830	66	*Scene from Cymbeline,* 5gns.
1830	71	*Rocks near the Town of Dolour, Fife,* 10gns.
1830	120	*Rocks near Lanark,* 10gns.
1830	228	*Landscape - Composition,* 4gns.
1830	236	*Evening - Sketch for a Picture,* 5gns.
1830	282	*Ferdinand after his Shipwreck - from the Tempest,* Sold.
1831	1	*Death of Pyrochles, Vide Spenser's Faery Queen, Book II. Canto 8.*
1831	147	*Landscape - Morning.*
1832	69	*Landscape - Composition,* 6gns.
1832	118	*The Flight into Egypt,* 8gns., Mr. Moxon.
1832	240	*View of the College of Aberdeen,* 8gns.
1832	340	*Evening,* 4gns.
1832	352	*Wood Scene,* 4gns.
1832	389	*Rocks near Lanark,* 5gns., Mr. Moxon, 23 Lincoln's Inn Fields.
1833	59	*Sacred Grove,* 15gns.
1833	114	*Landscape - Composition,* 12gns.
1833	175	*Ruins of an Ancient Castle,* 7gns.
1833	289	*Landscape - Composition,* 4gns.
1833	339	*Landscape - Morning,* 6gns.
1834	90	*View on the Coast of Devonshire,* 6gns.
1834	102	*View on the River Jed,* 8gns.
1834	187	*Ruins of an Ancient City,* 20gns., Sold - marked by Mr. Finch's order.
1834	273	*Landscape - Evening,* 5gns., Mr. Prior.
1834	327	*Alpine Scene,* 5gns., Mr. D.J. White, 332 Oxford Street.
1834	369	*Landscape - Morning,* 5gns.
1835	109	*Landscape - Afternoon,* 4gns.
1835	126	*Hermitage,* 15gns.
1835	136	*Landscape - Composition,* 10gns.
1835	175	*Scene from Milton's Comus,* 15gns.
1835	327	*Landscape - Morning,* 4gns.
1836	19	*Landscape - Evening,* 15gns.
1836	80	*Ruins - Temple,* 4gns., D.T. White Esq., 15 Princes St., Hannover Sqre.
1836	216	*Landscape - Composition,* 6gns.
1836	300	*Travellers Reposing,* 6gns., D.T. White Esq., 15 Princes St., Hannover Square.
1837	111	*Landscape - Evening,* 10gns., White Esq., 15 Princes Street, Hannover Square.
1837	130	*View on the River Tay, N. B.,* 4gns., White Esq., 15 Princes Street, Hannover Square.
1837	178	*An Ancient Tomb,* 15gns., Chs. Birch Esq., Tipton, nr. Birmingham.
1837	330	*Landscape - Composition,* 4gns.
1838	5	*Landscape - Composition.*
1838	195	*Landscape - Composition.*
1838	203	*Ruined Tower.*
1838	225	*Alpine Scene - Evening.*
1838	271	*Landscape - Composition.*
1838	320	*Landscape - Evening.*
1839	15	*Ancient Baronial Castle,* 10gns.
1839	117	*Landscape - Evening,* 5gns., R.J. Solly Esq., 18 Great Ormond Street.
1839	161	*Landscape - Composition,* 20gns.
1839	218	*Retirement,* 12gns., T. Evans Esq., Lyminster, nr. Arundel, care of Mr. J.W. Wright, 54 Gt. Marlborough St..
1839	251	*Landscape - Composition,* 15gns.
1840	17	*Landscape - Evening.*
1840	38	*A Watch Tower.*
1840	135	*Landscape - Composition.*
1840	254	*Landscape - Composition.*
1840	256	*Morning.*

1841	5	*Twilight*, 6gns.
1841	167	*Landscape - Morning*, 15gns.
1841	256	*Landscape - Composition*, 5gns.
1841	293	*Evening*, 10gns.
1841	299	*A Grove*, 10gns.
1842	73	*Landscape - Evening.*
1842	211	*Twilight.*
1842	278	*Landscape - Composition.*
1842	315	*Landscape - Afternoon.*
1843	18	*Landscape - Evening*, 15gns.
1843	27	*Landscape - Noon*, 15gns., James Paull Esq., Cambourne, Cornwall.
1843	137	*Landscape - Composition*, 5gns., H.H. White Esq., Old Sq., Lincolns Inn.
1843	147	*Landscape - Meditation*, 5gns.
1843	215	*Castle of Indolence, For as they chanc'd to breathe on neighbouring hill . . . Vide Thomson's Castle of Indolence.* 50gns.
1844	13	*Garden Terrace*, 6gns., C.H. Turner Esq., Rooksnest.
1844	82	*Scene from Comus – The attendant Spirit disguised as a Shepherd listening to the rout of Comus and his crew, "This evening late, by then the chewing flocks . . ."* 50gns.
1844	199	*Pleasure Party returning*, 15gns., Frame and glass £1.10.0.
1844	208	*Landscape - Composition*, 15gns., Frame and glass £1.5.0.
1844	260	*Moon-rise - Summer Twilight*, 6gns.
1845	108	*Sunset - an Effect from Nature*, 20 Pounds.
1845	113	*The Thames, near Cookham, Berkshire*, 25 Pounds.
1845	179	*Receiving House, Hyde Park*, 10 Pounds.
1845	229	*Twilight*, 15 Pounds, J.B. Huntington, 4 Trafalgar Square, P.AU. 15£.
1845	283	*Landscape - Composition*, 10 Pounds.
1845	304	*Environs of an Ancient City*, 10 Pounds, S. Maughan Esq., Barnt Green, Worcestershire, Frame and glass £-.12.-, P.AU. 10£.
1846	61	*Landscape - Evening*, 20 Pounds, I.T. Simes Esq., Highbury Park.
1846	132	*A Look Out*, 10gns.
1846	191	*Landscape - Composition*, 15gns.
1846	200	*Evenings - Travellers*, 15gns.
1846	263	*Sea-shore - Sunset*, 10gns., D.T. White Esq., Madox St.
1847	73	*Garden Terrace*, 40gns.
1847	102	*Coast Scene*, 8gns.
1847	231	*A Fugitive*, 8gns., S.T. Simes.
1847	247	*River Scene - Summer Twilight*, 10gns., D.T. White, 28 Maddox St.
1847	268	*Moonrise - Shepherds Reposing*, 10gns.
1848	36	*The Warder*, 15gns., John Finch Esq., 47 Cambridge Terrace, Hyde Pk., Frame and glass £2.2.0 Probable.
1848	75	*Skirts of a Mountain Forest*, 20gns.
1848	85	*Sea Beach - Sunset*, 15gns.
1848	221	*Late Twilight*, 10gns.
1848	230	*Moonlight*, 10gns.
1849	161	*Landscape, with Ruins.*
1849	243	*Tranquility - Summer Twilight.*
1849	254	*A Cemetery.*
1849	288	*Landscape Composition.*
1849	314	*Moonlight.*
1850	144	*A Garden*, 20gns., Frame and glass £1.10.0.
1850	153	*Landscape, with Cattle*, 15gns., Miss Griffith, Frame and glass £1.10.0.
1850	311	*Landscape - Twilight*, 8gns., Frame and glass £1.1.0.
1850	360	*A Land Storm*, 10gns., Frame and glass £1.10.0.
1850	372	*Moonlight - a Sea-Port*, 8gns., C.J. Baker Esq., Frame and glass £1.1.0.
1851	41	*Landscape, with Cattle.*
1851	237	*Landscape - Evening.*
1852	59	*Ideal Landscape from Keat's Ode to the Nightingale, "The voice I hear * * * oft times hath Charmed magic casements opening on the foam Of perilous seas, in faery lands forlorn."* 15G, Frame and glass £2.5.0.
1852	109	*Moonlight - A Smuggler's Signal*, 8G, R.B. Preston Esq., 9 Bedford Street South, Liverpool, Frame and glass £1.1.0 No.
1852	116	*A Still Evening*, 15G, Frame and glass £1.10.0.
1852	134	*Landscape - Composition*, 15G, Frame and glass £2.5.0.
1852	215	*Alpine Bridge*, 10G, Frame and glass £1.10.0.
1852	299	*Ruined Temple - Evening*, 10, Frame and glass £1.10.0.
1853	123	*Afternoon - Landscape, with Cattle.*
1853	243	*Alpine Fortress.*
1853	301	*Moonlight.*
1854	136	*Coast Scene - Moonlight*, 20gns., Frame and glass £1.10.0.
1854	153	*Landscape - Afternoon*, 20gns., Frame and glass £1.10.0.
1854	243	*Ruined Temple*, 10gns., E.L. Magoon (see No. 138 [Copley Fielding]), Frame and glass £1.1.0.
1854	344	*Landscape - Composition*, 10gns., Frame and glass £1.1.0.
1855	74	*Rocky Glen - Evening*, 20gns.
1855	104	*Moonlight*, 10gns.

1855	235	*Heights o'erlooking the Sea*, £10.0.0, Hy. Mackenzie, 9 Holloway Place, Holloway, Selected for J. Prince Esq., Manchester.
1855	242	*Ruins*, £10.0.0.

FINDLATER W

1820	37	*Shipping on the Thames, off the Tower.*

FOX E

1816	31	*View in Sussex, a Study from Nature.*
1817	61	*Study painted on the Spot.*
1817	106	*Mill near Kilburn.*
1818	49	*Cattle.*
1818	86	*View on the Thames.*
1819	55	*Landscape.*
1819	121	*Road Scene.*
1819	126	*Cottage.*
1820	92	*Cottage Scene.*
1820	138	*Cottage in Sussex.*
1820	145	*A Cottage.*

FRADELLE

1818	83	*Henry the Fourth of France about to put himself at the head of his Army, taking leave of Gabrielle d'Etrées, and pointing to the Romance which he composed on the occasion, as containing the true expression of his sentiments, "Charmante Gabriele! . . ."*
1818	91	*A Nun reading in an Oratory.*
1818	97	*Interior of a Convent in Milan.*
1818	128	*The Porch of St. Ambrose, at Milan.*

FREEBAIRN R

1806	81	*Ponte dell Aquoria, an Ancient Bridge near Tivoli, with Mecaenas' Villa, and the Cascatelli, in the distance.*
1806	94	*Subterraneous Ruins of Maecenas' Villa, at Tivoli.*
1806	205	*Ponte Salaro, an Ancient Bridge upon the Anio (now called Il Tiveroli), which joins the Tiber, near Rome.*
1806	213	*Palace of the Vatican, (the Residence of the Popes) and Part of St. Peter's Church, at Rome.*
1807	169	*The remains of the temple of Venus, at Baia, in the bay of Naples, Mount Vesuvius in the distance.*
1807	227	*Study from nature in the Campagnia at Rome.*
1807	228	*Sketch from nature.*
1807	248	*The fall of the Arr, in the canton of Uric, Switzerland.*
1807	291	*A scene near Tivoli, with the remains of Horace's fountain, Maecena's villa in the distance.*

FRIPP ALFRED

1845	27	*The Fisherman's Cabin*, 33 Pounds, Frame and glass £3.0.0.
1845	34	*The Rosary*, 23 Pounds, J. Ryman Esq., Oxford, Frame and glass £3.0.0.
1845	40	*The Holy Well*, 50gns., Henry Newbould Esq., Sharron Bank, nr. Sheffield, Frame and glass £3.10.0, P.AU. 30£.
1845	72	*The Cabin Door*, 15gns., Col. Sibthorp, 27 Chester St., Grosvenor Place, Frame and glass £2.2.0.
1845	152	*Irish Mendicants*, 45gns., T.M. Gresham Esq., Raheny Park, Co(?) Dublin (per Dr. Atkinson), Frame and glass £2.15.0, P.AU. 40£.
1845	224	*Cabin Fare*, 15gns., John Martin Esq., 14 Barkley Sq., Frame and glass £2.2.0.
1846	58	*Irish Courtship, "But no, alas! we've never seen One glimpse of pleasure's ray . . ." Moore's Irish Melodies.* 50gns., Henry Hope Esq., Duchess St.(?), Pauls Place, Frame and glass £6.6.0.
1846	62	*Interior of a Galway Cabin*, 15gns., Wm. Sams Esq., 1 St. James St.
1846	79	*The Sick Child*, 16gns., John Lees Esq., Plymouth Grove, Manchester.
1846	86	*A Village School Girl*, 15gns.
1846	172	*The Silent Welcome*, 20gns., John Mitchell Esq., 33 Old Bond Street, AU.
1846	180	*Irish Reapers meeting their Friends after harvesting in England*, 150gns.
1846	304	*The Irish Mother*, 20gns., Lord Chas. Townshend, Frame and glass £2.0.0.
1846	312	*Rustic Piper*, 15gns., John Lees Esq., Plymouth Grove, Manchester.
1847	59	*Claddagh Fisherman's Cabin*, 25gns., J.H. Vokin, Frame and glass £2.0.0.
1847	86	*Interior of Conway Castle - a Study*, 15gns., H.G. Mollett Esq., 29 Cornhill, Frame and glass £1.15.0 Pd. Yes, AU. 15£.
1847	107	*The Visionary, "Thus shall memory often, in dreams sublime . . ." Moore's Irish Melodies.* 50gns.
1847	118	*Irish Rusticity*, 25gns., Frame and glass £1.15.0.
1847	129	*The Bog Cabin*, 20gns., B. Gosling, Frame and glass £1.5.0 No.
1847	172	*The Hallowed Relic*, 100gns., Frame and glass £12.0.0.
1847	208	*Connaught Peasants*, Sold, James Robinson Esq., Aighburth, Liverpool, to be packed in case.
1847	239	*On the Welsh Hills*, 20gns., B. Gosling Esq.
1847	266	*Absent Thoughts*, 25gns., Chas. B. Tripp Esq., Bristol, Frame and glass £1.15.0.
1847	283	*A Munster Girl*, 15gns., H.W. White Esq., High St., Merthyr, Frame and glass £2.0.0 sold, P.AU. 15£.

1848	16	*A Study of Willows*, 15gns., Rev. Hare Townshend, Frame and glass £2.0.0.
1848	19	*A Corner of Ireland*, 25gns., Frame and glass £2.15.0.
1848	193	*A Pilgrim at Clonmacnoise, approaching the Altar-site*, 60gns., Frame and glass £4.15.0.
1848	208	*A Child of the Mist*, 40gns., Frame and glass £4.4.0.
1848	220	*Highland Interior*, 15gns., Rich. Ellison Esq., Frame and glass £1.5.0 Yes.
1848	239	*Scotch Interior*, 15gns., Frame and glass £1.15.0.
1848	250	*Poverty*, 25gns., J.F. Bateman Esq., Polygon, Ardwick, Manchester, Frame and glass £2.2.0 No.
1848	261	*The Old Scotch Wife*, Sold, E. Enfield Esq.
1848	283	*A Pond at Highgate*, 5gns., Baring Wall Esq., 44 Berkeley Sq., Frame and glass £-.18.- No.
1848	284	*Conemara Girl*, 20gns., Frame and glass £1.10.0.
1848	311	*Prayer for the Absent*, 30gns., W. Winthrop Esq., 5 Argyll St., Frame and glass £1.15.0 Yes.
1848	343	*The Watcher's Bothy*, 20gns., Frame and glass £1.15.0.
1849	72	*The Arran Fisherman's Return*.
1849	85	*The Well*.
1849	89	*A Contrast*.
1849	105	*English Peasant Boy*.
1849	135	*The Arran Fisherman's Departure*.
1849	184	*The Young Brood*.
1849	210	*Study of an Old Hulk*.
1849	273	*Sketch*.
1849	275	*Connemara Child*.
1849	313	*A Background Study*.
1849	350	*Shepherd Boy and Dog*.
1850	7	*Boy with Dead Sparrow-hawk*, 20gns.
1850	53	*Wood Gatherers*, 50gns.
1850	67	*The Captive Bird*, 12gns.
1850	90	*The Irish Piper*, Sold.
1850	162	*Cottage Interior*, 25gns.
1850	182	*Furze Cutter*, 15gns., Lord C. Townshend.
1850	286	*The Bird Scarer at Home*, 10gns., Rob. Lang Esq., Bristol, Frame and glass £1.5.0 Yes.
1850	350	*Gleaners*, 30gns.
1850	373	*The Village Post Office*, 20gns.
1851	4	*A Galway Girl*.
1851	97	*Welsh Girl Knitting*.
1851	104	*Cross at Clonmacnoise - Twilight*.
1851	140	*Seven Churches - Clonmacnoise*.
1851	153	*Archway at Clonmacnoise*.
1851	168	*Pat and his Child*.
1851	215	*Children in a Storm*.
1851	240	*Irish Cabins*.
1851	266	*A Reverie*.
1851	292	*The Islet Home*.
1851	295	*A Connemara Girl*.
1851	299	*A Neapolitan Musician*.
1851	311	*Peasant Girls of Arricia*.
1852	216	*Un Giorno di Festa*, 35G.
1852	253	*Roman Peasant Girl*, 30G.
1852	265	*Neapolitan Marinaro*, 30G, Lt. Gen. The Hon. C. Lygon, 12 Upper Brook Street, Frame and glass £2.5.0 Yes.
1852	276	*At Tivoli*, 18G, J. Noble Esq.
1852	281	*Italian Girl at a Fountain*, 16.
1852	300	*Annarella*, 30G.
1852	319	*Shepherd Boy of the Campagna*, 15G, Lt. Gen. C. Lygon.
1852	322	*Rites of Love*, 35gns.
1853	124	*"–Il dolce far' niente –."*
1853	142	*Capuchin Convent, Amalfi, now the Luna Hotel*.
1853	165	*Pompeii, The City of the Dead*.
1853	204	*Head of a Neapolitan Boy*.
1853	235	*Chapel Porch, Amalfi. The Good Priest*.
1853	239	*Pilgrims from the Abruzzi*.
1853	263	*Temple of Vesta*.
1853	271	*The Marina, Capri, Naples - Arrival of the Market Boat*.
1853	274	*Cloisters - Visit of the Superior*.
1854	46	*Capri, looking towards the Campanelli*, 10gns.
1854	72	*View in Capri*, 10gns.
1854	95	*Vesuvius, from the Island of Capri*, 10gns.
1854	100	*On the Grand Canal, Venice*, 20gns., Honble. Frd.(?) Byron, 43 Park Street, Grosvenor Square.
1854	103	*Traghetto, on the Grand Canal, Venice*, 18gns.
1854	111	*Palazzo Doro, Grand Canal, Venice*, 16gns.
1854	274	*Girl of Sorrento*, 25gns., E. Sidebotham Esq., 19 Lansdown Place, Cheltenham.
1854	353	*Interior of St. Mark's, Venice*, 22gns.
1855	27	*Vegetable Seller, Rome*, 30gns.
1855	110	*Going Home - Woman from the Mountains of Subiaco*, 60gns., G. Gwyn Elgar Esq.
1855	120	*Last Days of Harvest - the Roman Campagna*, 200gns. sold before opening [scribbled out in pencil].
1855	133	*The Vintage - a Sketch*, 25gns., Henry Bradley Esq., Park Hall, Nr. Kidderminster.
1855	165	*Peasants of Olevano returning from Labour*, 150gns. sold before opening [scribbled out in pencil].

FRIPP ALFRED

| 1855 | 232 | *A Hermitage*, 20gns., Anderson Rose Esq. |
| 1855 | 316 | *Woman of Palombara*, Sold. |

FRIPP ALFRED D

1844	14	*Welch Girl crossing the Stile*, 25 Pounds, Frame and glass £3.3.0.
1844	24	*The Woodman - A Study from Nature*, 10gns.
1844	45	*Girls of Moel Siabod, N. Wales*, 25gns., Mr. Ryman, Oxford.
1844	168	*The Forgotten Word*, 20gns., Capt. Le Hardy Ret., Bury Cross, Gosport, Frame and glass £2.10.0, P.AU.
1844	179	*The Poacher's Hut*, 40gns., E.J. Seville Esq. (per Committee), Frame and glass £5.0.0, P.AU.
1844	181	*The Bather*, 30gns.
1844	198	*The Minstrel, listening to the Echo of his Pipe, "And bubbling runnels joined the sound."* 35gns., Frame and glass £4.0.0.

FRIPP G

| 1846 | 230 | *A View on Hampstead Heath*, 15gns., Mrs. Augustus Clifford, Stoke Newington. |
| 1849 | 142 | *On the Road between Aosta and Villeneuve.* |

FRIPP G A

1841	55	*St. Vincent's Rocks, Clifton - Moonlight*, 10gns., Thomas Gillespy, 12 Billiton Street, Art Union.
1841	72	*Stapleton Mill, near Bristol*, 12gns., George Hotham Esq., York.
1841	113	*Tivoli*, 12gns.
1841	139	*View on the Avon, at Clifton*, 10gns., C.H. Turner Esq., Rooks Nest, Godstone and 15 Bryanston St..
1841	209	*Scene in the Via Mala Pass of the Splugen, Switzerland*, 15gns., Jno. Procter, 18 Cheapside, Art Union.
1841	218	*Scene on the Avon, near Bath*, 10gns., Robt. Prance, Hampstead, Art Union.
1841	292	*Heidelberg*, Sold.
1842	29	*On Hampstead Heath - Spring.*
1842	52	*On the Lake at Tortworth Park, Gloucestershire.*
1842	86	*Falls of the Rhine at Schaffhausen, Switzerland.*
1842	87	*On the Frome, at Stapleton, near Bristol.*
1842	91	*Tenby Castle, South Welsh Coast.*
1842	111	*Caerphilly Castle, South Wales.*
1843	8	*Durham - from Newton Hall*, 30gns.
1843	35	*Durham*, 30gns.
1843	63	*Eel Baskets*, 30gns., Lord. Chas. Townshend.
1843	77	*At Wargrave, on the Thames*, 15gns.
1843	100	*Ferry at Medenham on the Thames*, 25gns., L. Loyd Junr. Esq., 6 Green St., Grosvenor Sq.
1843	132	*Remains of Finchale Priory, on the Wear, N. Durham*, 25gns.
1843	151	*On the Thames at Wargrave*, 30gns.
1843	329	*On the Avon at Clifton*, 15gns.
1844	11	*Richmond Castle, Yorkshire*, 60gns., Frame and glass £10.0.0.
1844	20	*South View of Bolton Abbey, Yorkshire*, 40gns., Frame and glass £5.10.0.
1844	46	*Mecaena's Villa, Tivoli - Twilight*, 30gns., Miss Story, St. Albans, Frame and glass £5.5.0, P.AU.
1844	72	*Scene on the River Wharfe, near Bolton Abbey, Yorkshire*, 20gns., Sir W. Middleton, 13 Whitehall Place.
1844	102	*On the Thames at Wargrave*, 30gns., Mrs. Eyre, 10 Marine Parade, Dover, Frame and glass £7.10.0, P.AU.
1844	115	*The Strid, near Bolton Abbey, Yorkshire*, 20gns., Frame and glass £5.0.0.
1844	134	*On the Thames, near Maidenhead*, 30gns., Frame and glass £5.5.0.
1844	143	*On Hampstead Heath*, 35gns., Frame and glass £5.10.0.

FRIPP GEORGE

1845	21	*Bray Church, on the Thames*, 15gns., I.H. Hawkins Esq., 16 Suffolk St.
1845	28	*On the Thames, near Maidenhead*, 20gns.
1845	115	*Durham, from Nevil's Cross*, 25gns.
1845	156	*South Window of Tintern Abbey*, 20gns.
1845	168	*Mill at Taplow, on the Thames*, 25gns.
1845	188	*View from Bolton Abbey, looking towards the Old Park*, 40gns.
1845	219	*Malham Cove, Yorkshire*, 30gns., F. Fisher Esq., 4 New Sq., Lincolns Inn, P.AU. 30£.
1845	273	*On the Thames, near Cookham*, 20gns., Richd. Ellison Esq., Frame and glass £2.8.0.
1846	3	*Scene on the Coast of Dorsetshire, near Lulworth*, 30gns., George Clive Esq., Sanderstead, Croydon, Frame and glass 3ft. x 28 1/8.
1846	17	*Scene at Clapham, Yorkshire*, 45gns.
1846	20	*Durham*, 20gns., Earl Brownlow.
1846	23	*Near Ingleton, Yorkshire*, 15gns.
1846	30	*On the Thames, Temple, near Marlow*, 15gns., W. Jones Loyd Esq., 14 Bruton St.
1846	68	*A Somersetshire Cottage*, 25 Pounds.
1846	94	*Church at Saltwood, Kent*, 20gns.
1846	103	*Scene in a Glen near Bolton Abbey, Yorkshire*, 15gns.
1846	109	*Saltwood Castle, Kent*, 20gns., Mrs. Augustus Clifford, Stoke Newington, Middlesex.
1846	115	*On the Thames, near Cookham*, 15gns., Thos. Evans Esq., Lyminster, near Arundel.
1846	124	*View from Taplow, Bucks*, 15gns., S.C. Grundy Esq., Manchester.

1846	158	*On the Thames, near Cookham*, 15gns., Harford Battersby Esq., 20 Half Moon St.
1846	215	*Distant View of Saltwood Castle, Kent*, 20gns., Rev. Augustus Clifford, Stoke Newington.
1846	246	*Mill, at Hythe, Kent*, 20gns.
1847	7	*The Lake of Geneva, from Clarens, looking towards the Valley of the Rhone*, 40gns., Edward Ackroyd Esq., Bank Field, Hallifax, Yorks., Frame and glass £5.0.0.
1847	35	*Gordale Scar, Yorkshire*, 15gns., The Hon. Col. D. Pennant.
1847	49	*On the Wharfe, near Kilsey Crag, Yorkshire*, 20gns., W. Franklin Esq., New Brentford, P.AU. 20£.
1847	54	*Near Hythe, Kent*, 20gns.
1847	81	*The Railway Bridge at Maidenhead, on the Thames*, 25gns.
1847	161	*Bolton Abbey, Yorkshire*, 15gns., R. Ellison Esq., Frame and glass £2.16.0.
1847	193	*The Town and Citadel of Huy, on the Meuse*, 30gns.
1847	221	*Scene in the Valley approaching Gordale Scar, Yorkshire*, 20gns.
1847	223	*On the River Colne, near Watford*, 15gns., Edward Higram(?) Esq., 2 Connaught Place West, Hyde Park, P.AU. 15£.
1847	243	*Saltwood Church, Kent*, 20gns.
1847	244	*Kilsey Crag, Wharfedale*, 20gns., W. Franklin Esq., New Brentford [deleted], Exchanged for No. 49.
1847	254	*Easeby Abbey*, 20gns.
1847	271	*Distant View of Easeby Abbey, Yorkshire - Sunset*, 20gns., S.B. Langhorne Esq., Richmond, Yorks.
1847	308	*Mill in Wensley Dale, Yorkshire*, 15gns.
1848	17	*On Hampstead Heath*, 10gns., F. T. Rufford Esq., Prescot House, Stourbridge, Frame and glass £2.2.0 Yes.
1848	34	*Cookham Church, on the Thames*, 15gns., R. Cummings, 6 Compton Terr., Islington, Frame and glass £2.10.0.
1848	46	*Church of Montreux, Lake of Geneva*, 20gns., Frame and glass £3.3.0.
1848	72	*On the Avon, near Clifton*, 25gns., Frame and glass £3.10.0.
1848	84	*On the Wharf, near the Strid, Yorkshire*, 18gns., Frame and glass £3.0.0.
1848	94	*Breane Down, from the Sands, Weston-Super-Mare - Twilight*, 15gns., Frame and glass £3.3.0.
1848	138	*View from Uphill Church, Somersetshire, looking towards Bridgewater Bay*, 20gns., Frame and glass £3.3.0.
1848	155	*The Valley of Desolation, Old Park, Bolton Abbey*, 18gns., George Field Esq., Sister(?) House, Clapham Comm., Frame and glass £2.10.0 Yes.
1848	158	*Under the Cliffs, Dover*, 15gns., Revd. Hare-Townshend, Frame and glass £2.2.0.
1848	163	*Eel Bucks on the Thames, near Cookham*, 18gns., C.F. Cheffin, 9 ? Bds., Frame and glass £3.0.0.
1848	167	*On the Wharfe near Bolton Abbey*, 15gns., R. Lloyd Esq., Ludgate Hill, Frame and glass £3.0.0.
1848	170	*From the Downs at Uphill, Somersetshire, looking across the Bristol Channel*, 20gns., Frame and glass £3.3.0.
1848	266	*The Avon, near Clifton*, 20gns., Frame and glass £3.10.0.
1848	320	*Kewstoke Church, near Weston, Somersetshire*, 8gns., Frame and glass £2.10.0.
1849	8	*Whitchurch Pound Lock, on the Thames*.
1849	19	*Old Mill at Mapledurham*.
1849	26	*Durham*.
1849	40	*Ferry near Cookham on the Thames*.
1849	44	*At Pangbourne*.
1849	47	*Near Chatillon - Val d'Aoste*.
1849	54	*The Valley of the Thames from Hardwicke - Reading in the distance*.
1849	91	*Mill at Sutton, Oxfordshire*.
1849	97	*At Wargrave, on the Thames*.
1849	111	*The Allée Blanche, Mount Blanc - from the bed of the Dora*.
1849	121	*The Weir at Pangbourne*.
1849	128	*In the Pass of the Splugen, Switzerland*.
1849	145	*Angera, from the heights above Arona, Lago Maggiore*.
1849	168	*Mill at Shiplake, on the Thames*.
1849	173	*At Hampstead*.
1849	180	*Old Watermill at Montreux, Lake of Geneva*.
1849	241	*At Mapledurham on the Thames*.
1849	307	*Mapledurham*.
1850	41	*The Strid - on the Wharf, near Bolton Abbey*, 12gns., Thos. Weedon(?) Esq., 22 Paternoster Row, AU. 10.
1850	62	*On the Brent, near Hanwell*, 12gns., Rev. C.H. Townshend.
1850	86	*Mapledurham Mill, on the Thames, near Reading*, 15gns., I.G. Cattley Esq., 121 Regent St.
1850	114	*Bolton Abbey, from the South*, Sold.
1850	117	*View from Bolton Abbey, looking towards the Old Park*, 12gns., Dr. G.L. Fripp.
1850	118	*Study of Oaks in an old Deer Park*, 18gns., Captain Gall, 34 Cambridge St., Hyde Park Sq.

1850	120	*A Study on the Thames, near Medmenham,* 25gns.
1850	124	*Mill, at Shiplake, on the Thames,* 20gns., Rev. George Heathcote, Connington Rectory, Hilton, Huntingdonshire, Frame and glass £2.2.0 Yes.
1850	129	*Ravine in the Dent du Midi, Valley of the Rhone,* 25gns., N.C. Cattley Esq., Windham Club.
1850	161	*Tilly Whim, on the Coast near Swanage,* 15gns.
1850	180	*Old Water Mill at Ullwell, Dorset,* 15gns., Rev. L. Porter, 50 Bullock St., Bolton, Lancashire, AU 15£.
1850	234	*At Ullwell, near Swanage,* 18gns., T. Schunck, Manchester.
1850	252	*The Coast at Lulworth, Dorsetshire,* 25gns.
1850	264	*On the Coast of Dorsetshire - View looking across Studland Bay,* 25gns.
1850	305	*Shiplake Mill - Evening,* 18gns., Captain Gall.
1850	313	*A Dorsetshire Cottage - View looking over Poole Harbour,* 20gns., Lady Cath.(?) Cavendish, Burlington(?) Hse., Frame and glass £3.2.0 Mr. Simpson, 29 Saville Row.
1850	339	*Entrance to the Village of Wookey, near Wells, Somersetshire - Evening,* 25gns., Hon. Richd. Cavendish.
1850	357	*Dancing Ledge - a Study on the coast of Dorsetshire,* 25gns.
1850	368	*On the Coast, near Lulworth,* 25gns.
1850	376	*Wargrave, on the Thames,* 7gns.
1851	6	*A Study on the Moors, under Ben Lawers.*
1851	11	*Near Southall - a Study from Nature.*
1851	28	*Part of Bolton Castle, Yorkshire.*
1851	36	*Shiplake Mill, on the Thames - Evening.*
1851	48	*Falls of the Dochart, at Killin, Perthshire.*
1851	66	*Fall on the Moors, above Killin, Perthshire.*
1851	84	*Scene near Morenish, on Loch Tay, Perthshire - an October Evening.*
1851	87	*View from Ballard Down, looking over Poole Harbour.*
1851	113	*Near Hanwell.*
1851	116	*Old Monastery, outside the Walls of Novara, Piedmont.*
1851	183	*Wetton Bridge, Staffordshire.*
1851	185	*Thors House Tor, on the Banks of the Manyfold, Staffordshire.*
1851	233	*Mapledurham, on the Thames.*
1851	250	*Fountains Abbey, Yorkshire.*
1851	260	*Scene in Glen Lockey, above the Falls.*
1851	288	*On the Thames, at Taplow.*
1851	300	*A Study on the Coast of Dorsetshire, near Lulworth.*
1851	307	*A Mill in the Fens, Huntingdonshire.*
1851	316	*Old Water Mill at Ringwood, Hampshire.*
1852	23	*Eel-traps - on the Thames, near Sonning,* 20G.
1852	30	*Distant View of Poole Harbour, from the Heaths above Studland, Dorsetshire,* 20G, T. Fuller Esq.
1852	39	*Kirkstall Abbey, Yorkshire,* 50G.
1852	57	*Fountains Abbey, Yorkshire,* 17G.
1852	77	*A Peep at Hampstead - from the Fields near Camden Town,* 30G.
1852	90	*Kilchurn Castle, Loch Awe, Argyllshire - View looking towards Glen Strae,* 60G, Her Majesty the Queen, Frame and glass £5.5.0.
1852	125	*On the Edge of a Forest, near Hachenburgh, Duchy of Nassau,* 20G, Dr. Hawtrey, Eton College.
1852	130	*Gordale Scar, Yorkshire,* 17G, R.N. Philips Esq., The Park, Manchester.
1852	133	*Loch Alarich, on the road between Killin and Glen Lyon,* 17G.
1852	143	*Mountain Gorge at the Bae of Ben Cruachan, Argyllshire - the River Awe at this point emerges from the Loch,* 18G, John Labouchere Esq., 16 Portland Place, 20 Birchin Lane.
1852	148	*At Morenish, on the North Side of Loch Tay, Perthshire,* 15G, Rev. George Heathcote, Connington Rectory, Stilton.
1852	155	*At Leigh, on the Coast of Essex - Harvest,* Sold.
1852	166	*The Quiet Pool - A Study,* Sold.
1852	176	*At Yaxley, Huntingdonshire - Whittlesea Mere in the distance,* Sold.
1852	190	*On the Moors above Dalmally - Ben Lawi in the distance - Argyllshire,* 18G, Lady Mary Fox, Addison Road, Kensington.
1852	278	*Under the East Cliff, Dover,* 15G.
1852	288	*Scene on the North Side of Ben Cruachan, near the Summit,* 20G, D.T. White Esq.
1852	313	*Weir at Sonning, on the Thames,* 20G, T. Fuller Esq.
1852	317	*On the Thames, at Shiplake,* Sold.
1853	9	*View on the Cliffs, at Southend, Essex.*
1853	19	*Streatley, on the Thames.*
1853	32	*Sunrise in the Highlands - Scene near Dalmally, Argyllshire.*
1853	33	*Distant View of Barden Tower and the Valley of the Wharfe, near Bolton Abbey.*
1853	39	*On a Village Green in Herts.*
1853	63	*On Loch Awe.*
1853	73	*Old Mill, at Ringwood, Hants.*
1853	84	*A Showery Day.*
1853	96	*A Shed.*
1853	109	*Ben Cruachan, from the Moors, above Dalmally, Argyllshire.*

1853	118	*Mill at Morenish, on Loch Tay, Perthshire.*
1853	130	*Lancaster - Evening.*
1853	133	*Kirby Lonsdale.*
1853	138	*Leigh, on the Coast of Essex.*
1853	150	*Kilchurn Castle, Loch Awe.*
1853	151	*Near Southall.*
1853	163	*Swanage, Dorset.*
1853	177	*A Roadsite Bit.*
1853	188	*Barges loading at Southend.*
1853	219	*Evening - near Swanage, Dorset.*
1853	265	*Fountains Abbey.*
1854	7	*At Caversham, near Reading*, 18gns., J. Anderson Rose, Frame and glass £2.2.0.
1854	12	*Remains of an Old Manor House, near Bristol*, 15gns., Frame and glass £2.2.0.
1854	35	*Near Southend, Essex*, 18gns., Robert Rawlinson, 17 Ovington Sq., Brompton, Frame and glass £2.2.0.
1854	53	*Cleve Mill, on the Thames*, 18gns., The Rev. C. Sale, Frame and glass £2.2.0.
1854	71	*Distant View of Hadley Castle, looking towards the Nore*, 35gns., T.H. Gurney Esq., Norwich, Frame and glass £3.3.0.
1854	91	*Bridge of St. Maurice - Valley of the Rhone, Switzerland*, 60gns., H.W. Jewsbury(?), 2 Mincing Lane, Including frame £4.4.0.
1854	112	*Kirkstall Abbey, near Leeds, Yorkshire*, 16gns., Frame and glass £2.2.0.
1854	123	*Study of Fir Trees, near Streatley*, 23gns., Frame and glass £2.2.0.
1854	125	*Corfe Castle, Dorsetshire*, 38gns., Gurney, Norwich, Frame and glass £3.10.0.
1854	155	*On the Thames, at Goring*, 18gns., His Grace the Archbishop of Canterbury, Frame and glass £2.2.0.
1854	161	*On the Shore, near Southend, Essex*, 35gns., Jonathan Peel Esq., Knowlmere Manor, Clitheroe, Frame and glass £3.15.0.
1854	162	*At Berne, Switzerland*, 15gns., Frame and glass £2.2.0.
1854	172	*Mill at Streatley, on the Thames*, 40gns., Thos. Thomas Jnr., 1 Kingsdown Parade, Bristol, Frame and glass £3.3.0.
1854	197	*Perivale Church, Middlesex*, 12gns., Frame and glass £2.2.0.
1854	247	*At Pangbourne, Berks*, 18gns., Mr. Hay(?), 60 Russell Square, Frame and glass included [£2.10.0 deleted].
1854	249	*On the Thames, at Streatley*, 20gns., Heathcote Esq., Connington Castle, Stilton, Frame and glass £2.2.0.
1854	280	*A Study on the Shore at Southend, Essex - Low Water*, 20gns., Frame and glass £2.2.0.
1854	292	*On the Moors, above Killin*, 16gns., T.G.(?) Cobb Esq., Twickenham, Frame and glass £2.2.0.
1854	340	*Near Dalmally, Argyllshire*, 12gns., John Du Pasquier, 8 Regent St.
1855	4	*Near St. Alban's, Herts*, Sold.
1855	16	*Mountains on the edge of Rannoch Moor, at King's House, Argyllshire*, 50gns., Hanbury Esq., Poles, Frame and glass £4.12.0.
1855	58	*Hadley Castle, Coast of Essex*, 40gns., Wm. Balston, Springfield, Maidstone.
1855	69	*Loch Tulla, Argyllshire - Ben Douran in the distance*, 60gns., Hanbury Esq., Poles, Frame and glass £5.18.6.
1855	91	*The Ploughed Field - Evening, at Hadley, Coast of Essex*, 18gns., Miss Daniels, 12 Wilton Crescent, Mrs. Hammelyn, 9 Lowndes, Belgrave Sq. [in deposit column].
1855	102	*Glen under Ben Cruachan, Argyllshire*, 18gns.
1855	111	*Corner of the Fisherman's Island, Lago Maggiore*, 17gns., Austen Esq., Montague Place.
1855	115	*On the Edge of Durdham Down, near Bristol*, 30gns., Schunck(?) Esq.
1855	116	*On the Coast of Dorsetshire, near Swanage - Sunset*, 20gns.
1855	139	*Near Swanage, Dorsetshire*, Sold.
1855	153	*At Hachenburgh, Duchy of Nassau*, 18gns.
1855	166	*Streatley Mill, Berkshire*, 25gns., Rev. W. Rooper, Wick Hill, Brighton.
1855	267	*Ben Dowran, from the Roadside, near Tyndrum, Argyllshire*, 17gns., Mr. White of Maddox St.
1855	275	*Ferry on the Thames, near Mapledurham*, 17gns., I.A. Johnson, Manchester, A.U.P. £20.
1855	278	*On the Towey at Swansea*, 10gns.
1855	308	*In the Fens, Huntingdonshire*, 14gns., Tomalin Esq., Adam St., Adelphi.
1855	312	*On the Shore at Southend, Essex*, 18gns., Thomas Toller Esq., Grays Inn.

GANDY J

| 1823L | 87 | *Composition*, J. Allnutt, esq. |

GASTINEAU H

1818	27	*Door in the Cloisters, Canterbury Cathedral.*
1818	136	*Coast near Eastbourne*, £10.10.0, Mr. Pleydell.
1818	250	*Sturry Church, Kent*, £4.4.0, J. Holden Esq.
1818	342	*Cottages at Avrington.*
1819	14	*Charlton Church, Kent.*
1819	15	*Beckenham Church, Kent.*
1819	42	*The Crypt, Wells Cathedral.*
1819	57	*Saxon Arch at Old Shoreham Church, Sussex*, £8.8.0, Rev. Dr. Mant.

1819	68	*A Bridge at Broxbourne, Herts - Moon Rising.*
1819	69	*York Gate - Broadstairs - Isle of Thanet.*
1819	128	*Sketch near Wades Mill Herts. - the Commencement of a Thaw.*
1820	260	*Upnor Castle, from the Medway.*
1820	293	*Remains of Cowling Castle, Kent.*
1820	332	*Paulholme, Yorkshire.*
1820	366	*Skirlaugh Chapel, Yorkshire.*
1820	379	*Part of St. Mary's Abbey, York.*
1821	3	*Dover Backwater - Morning, £7.7.0, Bishop of Ferns(?).*
1821	4	*Puckester Cove, Isle of Wight, £7.7.0, Marchioness of Exeter.*
1821	21	*Arrival of the Steam Packet at Southampton, from the Isle of Wight - Moonlight.*
1821	29	*Waverley Abbey, Surrey.*
1821	30	*Reculver Church, Kent, as it appeared in 1812, £8.8.0, Bishop of Ferns.*
1821	31	*Wells Cathedral, Somersetshire, £8.8.0, Mr. Suthaby.*
1821	35	*Shanklin Chine, Isle of Wight.*
1821	162	*Netley Abbey, Hants, £12.12.0, Bishop of Killaloe.*
1822	13	*Seat excavated in a Rock, near Stirling Castle - on the inner part of the Seat is the following Inscription:– "To accommodate the Aged and Infirm, who had long resorted to this Spot, on account of which of its warmth and shelter from every wind, this seat", £7.7.0, Mrs. Hilton.*
1822	61	*View on the Ouse, near York, £3.3.0, J.G. Lambton Esq., M.P..*
1822	86	*Entrance to the Chapter House, Netley Abbey.*
1822	104	*Edinburgh, from the North Bridge, £21.0.0, Lord Glenlyon.*
1822	114	*St. Andrews, Fife, from the South East.*
1822	120	*Remains of the Keep of Guildford Castle, Surrey, £3.3.0, E. Tattersall Esq.*
1822	138	*Loch Lomond, from a field above Tarbet.*
1822	144	*Glencroe, Highlands.*
1823	32	*Trees near Windsor, Berks., £7.7.0, G. Hibbert Esq.*
1823	37	*The Inner Court of Castle Campbell, Scotland, £7.7.0, Mr. Dundee.*
1823	50	*Castle Campbell, Scotland, £7.7.0, T.G.*
1823	91	*Ferry from Eton to Windsor, during the rebuilding of the Bridge which was taken down in 1822, £21.0.0, B. King Esq.*
1823	100	*Loch Long, Scotland - Sun-rise.*
1823	143	*View near Dolor, Scotland - Castle Campbell in the distance.*
1823	176	*View at Burstwick, Yorkshire.*
1823	215	*Roslin Castle, Scotland.*
1824	14	*St. Mary's Abbey, York.*
1824	41	*View on the Tees.*
1824	47	*Coast near Shanklin, Isle of Wight.*
1824	74	*St. Cuthbert's Church, Wells, Somersetshire.*
1824	102	*Lane near Carisbrook, Isle of Wight.*
1824	104	*St. Bernard's Well, Water of Leith - Edinburgh.*
1824	117	*Cross of St. Boniface -Isle of Wight.*
1824	139	*View in Swale Dale - Yorkshire.*
1824	166	*Loch Long, Scotland.*
1824	175	*Lincoln Cathedral.*
1824	187	*Sterling Castle.*
1824	194	*The Ferry at Kirkstall, Yorkshire.*
1824	200	*Barnard Castle - Evening.*
1824	210	*Barnard Castle, Durham, "The Moon is in her summer glow . . ." Rokeby, Canto First.*
1824	214	*Southampton, Hants.*
1824	220	*The remains of the Black Friars Monastery, St. Andrews, Fifeshire.*
1824	221	*St. Andrew's Castle, Fifeshire.*
1824	224	*Edinburgh, from Fifeshire.*
1824	225	*Abbey Gate, Burlington, Yorkshire.*
1824	226	*View in Castle Howard Park, Yorkshire.*
1825	1	*View near Dolgelly, North Wales, 7gns.*
1825	27	*Valle Crucis Abbey, North Wales, 6gns.*
1825	30	*View near Headon, Yorkshire, 3gns., Warren Esq., 24 Charlotte Street, Bedford Square.*
1825	43	*View near Teignmouth, Devon, 3gns., Mrs. J. Braithwaite, Bath Place, Fitzroy Square.*
1825	84	*View near Niton, Isle of Wight, 3gns., Sir Willoughby Gordon.*
1825	87	*Wetherby Bridge, Yorkshire, 3gns.*
1825	128	*Llangollen - North Wales, 15gns., Mr. C. Cope, 22 George Street, Portman Square.*
1825	144	*Part of the Ruins of Jervois Abbey, Yorkshire, 6gns.*
1825	150	*Fall above Pont-y-Pair - N. Wales, 20gns.*
1825	152	*Hornsey Mere, Yorkshire, 7gns.*
1825	169	*Part of the Ruins of Eastby Abbey, 7gns.*
1825	178	*Hawthornden, near Edinburgh, 7gns.*
1825	195	*Loch Katrine, Scotland, 3gns., George Hibbert Esq.*
1825	231	*Waterfall near Capel Cûrig, North Wales, 7gns.*
1825	245	*Newark Castle, Notts, £3.3.0.*
1825	250	*Scene in Glen Croe - Highlands, 3gns.*
1825	269	*View near Ware, Hertfordshire, 3gns.*
1825	282	*Westham Church, and Pevensey Castle, Sussex, 3gns., Mr. Dennis, Richmond Cottage, Richmond Green.*
1825	299	*St. Cuthbert's Church, Wells, Somersetshire, 3gns., Mr. Lock.*

1825	318	*View on the Clyde - Evening*, 2gns., Capt. Robt. Innes, Gullivers(?) Hotel, Albemarle Street.
1825	319	*View near Bettws, North Wales*, 2gns., Capt. Robt. Innes, Gullivers(?) Hotel, Albemarle Street.
1826	11	*Remains of Jervois Abbey, Yorkshire*, 4gns., Mr. Bridges, 35 Great Marlborough St..
1826	28	*Edinburgh, from the Old Bank of Scotland*, 30gns.
1826	40	*View, near Beddgelert, North Wales*, 7gns., C.R. Cotton Esq., Clapham.
1826	46	*Arrochar Kirk, West Highlands*, 7gns., C.R. Cotton Esq., Clapham.
1826	57	*Stirling Church*, 7gns.
1826	77	*Pont y Pair, North Wales*, 7gns., Mrs. Olive, 4 York Terrace, Regents Park.
1826	80	*Fall at Bracklin, Scotland*, 4gns., J. Walker Esq., 46 St. Johns Square, Clerkenwell.
1826	118	*Bridge of Capel Cûrig, North Wales*, 4gns., Willimott Esq., Streatham Common, Collector Custom House.
1826	148	*View in the Isle of Wight*, 4gns., Genl. Grey.
1826	155	*Trees, from Nature*, Sold.
1826	168	*Llyn Gwynant, North Wales*, 4gns.
1826	177	*Ruins at Kirkstall Abbey, Yorkshire*, 4gns., G.F. Robson Esq.
1826	216	*Shanklin Bay, Isle of Wight*, 7gns., Rev. I.B. Sumner, Mr. Frewer's, Reading.
1826	229	*The Castle of Gloom, Clackmannanshire*, 30gns., Mr. Charles Holford, Hampstead.
1826	241	*A View near Teignmouth, from a Sketch by Miss Shepley*, 15gns.
1826	276	*Distant View of Eton*, 6gns., G. Morant Esq.
1827	15	*Coast, near Scarborough, Yorkshire*, 4gns.
1827	28	*View, near Beddgelert, North Wales*, 7gns.
1827	35	*Remains of Peel Castle, Isle of Man, "... perplex'd With rugged rocks, on which the raving tide, By sudden bursts of angry tempests vex'd, Oft dash'd —"* 50gns.
1827	36	*Snowdon, from Capel Cûrig, North Wales*, 7gns., Mrs. Rothchild, 107 Piccadilly.
1827	41	*A Brook Scene*, 7gns., W.H. West, Mr. Willimott's, 9 Ryder Street, St. James's.
1827	51	*Part of Eastby Abbey, Yorkshire*, 4gns.
1827	53	*Barnard Castle, Durham*, 15gns.
1827	56	*Burford Bridge, Surrey*, 4gns.
1827	60	*Trees near Athelstane Abbey, Yorkshire*, 5gns., G. Hibbert Esq., 38 Portland Place.
1827	68	*Landscape - Evening*, 4gns., I. Walker Esq., Harpers Hill House, Birmingham.
1827	69	*Port Erin, Isle of Man - Moonlight*, 4gns., Sold.
1827	71	*Remains of Peel Castle, Isle of Man*, 7gns., Peter Hesketh Esq., Athenaeum Club, 12 Waterloo Place.
1827	88	*Luccumb Chine, Isle of Wight*, 4gns.
1827	132	*Port Erin, Isle of Man*, 4gns.
1827	147	*Bowes Church, Yorkshire - The native place and real scene of the hapless loves of Edwin and Emma, by Mallet*, 5gns.
1827	156	*View in Glen Moijj, Isle of Man*, 7gns., J. Beaumont Swete Esq., Jordan's Hotel, St. James' Street.
1827	174	*Distant View of St. Andrew's, Fife - Morning*, 4gns., Sold.
1827	177	*Bridge above the Pools, Capel Cûrig, North Wales*, 4gns.
1827	188	*Cave at Port Soderick, Isle of Man*, 7gns.
1827	190	*Ancient Tower, Clackmannonshire, Scotland*, 4gns.
1827	201	*Remains of Coverham Abbey, Yorkshire*, 5gns., Miss Shepley, Devonshire Place.
1827	203	*West Port, St. Andrew's, Fifeshire*, 4gns., Sold.
1827	217	*An Aspin Tree, formerly standing at the bottom of Denmark Hill, Camberwell, sketched on the day it was cut down, "Old favorite tree! art thou too fled the scene? . . ." Clare.* 7gns.
1827	245	*Remains of the Cathedral of St. Andrew's, Fife*, 4gns.
1827	281	*Remains of the Interior of Bothwell Castle, Scotland*, 4gns.
1827	282	*Peel Harbour, Isle of Man*, 5gns., Sold.
1827	283	*Kirkstall Abbey, Yorkshire*, 7gns.
1827	295	*Windsor Castle, from Datchet Lane*, 7gns., J. Wyatville Esq.
1827	311	*Moonlight*, 5gns.
1827	313	*Castletown, Isle of Man*, 4gns., Mr. Moxon, No. 23 Lincoln's Inn Fields.
1827	332	*View, near Capel Cûrig, North Wales*, 4gns.
1827	355	*View on the Ouse, York.*
1828	16	*Wootton Church, near Warwick*, 5gns., Le Vicomte D'Anchald, attaché à l'Ambassade de la Majeste ??? Chreticnne, 25 Hill St., Berkeley Square.
1828	29	*St. Bernard's Well, Edinburgh*, 5gns., Sold.
1828	36	*Waterfall - North Wales*, 5gns., Sold.
1828	41	*View near Woolwich*, 5gns., Sir M.W. Ridley.
1828	45	*Fishing Boats, near Castle Town, Isle of Man*, 5gns., Sir M.W. Ridley.
1828	63	*Douglas Harbour, Isle of Man*, 6gns., Braithwaite Esq.
1828	70	*Derwent Water, Cumberland*, 5gns.
1828	72	*View near Keswick, Cumberland*, 6gns., Braithwaite Esq.
1828	81	*Herriot's Hospital, Edinburgh, from the Grey-Friar's Churchyard*, 7gns., Sold.
1828	113	*Moonlight*, 7gns.

1828	128	*View, near Langollen, North Wales*, 4gns.
1828	141	*Douglas, Isle of Man*, 35gns.
1828	173	*Melrose Abbey, "If thou would'st view fair Melrose aright, Go visit it by the pale moon light . . ." Scott.* 30gns.
1828	177	*Trees in Windsor Park*, 7gns.
1828	210	*Kirkstall Abbey, Yorkshire*, 4gns.
1828	216	*Craig Miller Castle, Edinburghshire*, 4gns.
1828	226	*Richmond, Yorkshire*, 50gns.
1828	264	*Langollen, North Wales*, 7gns.
1828	290	*View, near Capel Cûrig, North Wales*, 4gns., Captn. Dundee, No. 1 Argyll Place, Regent St..
1828	295	*Llantisilio Church, Vale of Langollen, North Wales*, 7gns., Sir W.W. Wynne.
1828	302	*Ruins of St. Germain's Church, Isle of Man*, 5gns.
1828	314	*Near Skelwith, Westmoreland*, 4gns.
1828	328	*View near Derwent Water, Cumberland*, 4gns., Hy. Cattley(?), Camberwell.
1828	341	*Near Rice, Yorkshire*, 5gns.
1829	20	*Near Magadino, Canton Tessin, Switzerland*, 5gns.
1829	21	*View near Stuhlingen, Shaffhausen*, 5gns.
1829	44	*Richmond, Yorkshire*, 8gns., Lady Chetwynd, All drawings to be sent to Mr. Prout and he will receive a draft.
1829	54	*View in Glen Moijj, Isle of Man*, 5gns.
1829	63	*Near Lecco, Lago di Como*, 7gns.
1829	92	*Part of Brougham Castle*, 5gns.
1829	98	*Fontaine de Tell, Altorf*, 8gns.
1829	106	*Mill at Wensley, Yorkshire*, 8gns., C. Barclay Esq.
1829	119	*Lago di Piano - Lake of Lugano in the distance*, 5gns., Mr. Dundee.
1829	128	*Near Capel Cûrig, North Wales*, 5gns.
1829	132	*Near Capel Cûrig, North Wales*, 5gns.
1829	134	*Derwent Water*, 5gns.
1829	136	*Donne Castle, Perthshire*, 5gns.
1829	176	*View near Kirkstall, Yorkshire*, 5gns.
1829	177	*Tower on the Lake of Lucerne*, 5gns.
1829	202	*Brougham Castle, Westmoreland*, 8gns.
1829	203	*View in Bilstane-Burn, Scotland*, 8gns.
1829	217	*View near Dolgelly, North Wales*, 8gns., H. Hungerford Esq., 16 L. Brook Street.
1829	234	*Remains of Glastonbury Abbey, Somersetshire*, 8gns.
1829	249	*Mer de Glace, Chamouni*, 25gns.
1829	304	*Part of Rydal Water, Cumberland*, 5gns.
1829	353	*Near Altorf, Switzerland*, 6gns.
1829	361	*Prittlewell, Essex*, 6gns.
1829	384	*Remains of St. Catherine's Chapel, Guildford, Surrey*, 5gns.
1829	400	*Via Mala, Splugen Pass, Switzerland*, 6gns.
1830	9	*Distant View of Ambleside, Westmorland*, 5gns.
1830	14	*View near Bettws, North Wales*, 5gns.
1830	27	*View near Birkinhead Ferry*, 7gns., Sold.
1830	29	*View near Magadino, Lago Maggiore*, 6gns., Sold.
1830	32	*View near Skiddaw, Cumberland*, 10gns., Olive Esq., 4 York Terrace, Regents Park.
1830	33	*Ouchey - Lake of Geneva*, 9gns.
1830	54	*York Cathedral, from the River Foss*, 5gns., Morant Esq.
1830	67	*Kirkstall Abbey, Yorkshire*, 5gns., Fras. Gibson Esq., Saffron Walden, Essex, To be packed and sent by coach from the Bull Inn, Aldgate.
1830	97	*View on the Tees, Near Ashalstone Abbey, Yorkshire*, 8gns., Sold.
1830	119	*Greenwich, from New Charlton*, 5gns., John Coindel Esq., 14 Newman Street.
1830	143	*View near Lugano*, 5gns.
1830	146	*View near Keswick, Cumberland*, 5gns.
1830	200	*Skelwith Force, Westmorland*, 5gns., Mr. Fay, See No. 47 [To be sent to Mr. E. Bernoulle, 3 Mildred's Court, Poultry].
1830	202	*Conway Castle, North Wales*, 5gns., E.E. Tustin Esq., 8 Fludyer St., Whitehall.
1830	232	*Landscape - Morning*, 5gns., John Coindet Esq., 14 Newman St..
1830	234	*Sion, in the Valais, Switzerland*, 50gns.
1830	251	*Hedon Church*, 6gns.
1830	253	*View on the Tees - Evening*, 5gns., A.J. Cresswell Baker, To be delivered to Mr. Shaw 28 Gower Street. Sold by Mrs. Christie when I was at Dinner.
1830	256	*Mill near Harlech, North Wales*, 5gns.
1830	337	*Entrance to Peel Harbour, Isle of Man*, 12gns., Sold.
1830	356	*Caernarvon Castle*, 6gns.
1830	359	*View near Lugano, Italy*, 7gns., H. Cattley Esq.
1831	5	*Menai Bridge, North Wales*.
1831	23	*Beaumaris, North Wales*.
1831	31	*View near Clackmannan, Scotland*.
1831	38	*Bridge, near Brougham Castle*.
1831	46	*Lower Fall of Caldron Lynn, Scotland*.
1831	101	*Machynlleth, North Wales*.
1831	129	*Bridge House, Ambleside*.
1831	146	*Barnard Castle*.
1831	156	*Village of Templon*.
1831	162	*View near Ragats, Switzerland*.
1831	191	*Rushin Castle, Isle of Man*.

1831	219	*Derwent Water, Cumberland.*
1831	254	*Anghiera Castle, Lago Maggiore.*
1831	269	*View near Applewaite, Cumberland.*
1831	284	*Bangor Iscoed, North Wales.*
1831	304	*Landscape - Morning.*
1831	315	*View on Loch Lomond.*
1831	317	*Melincourt Fall, Vale of Neath, Glamorganshire.*
1831	329	*Flint, North Wales.*
1831	368	*Winter.*
1831	371	*Harlech Castle, North Wales.*
1831	391	*Llanrwst Bridge, North Wales.*
1831	412	*Garth Ferry, near Bangor, North Wales.*
1831	416	*Tolbooth and Cross, Clackmannan, Scotland.*
1832	16	*At Mousehole - Mount's Bay, Cornwall,* 7gns.
1832	20	*At Marazion, Mount's Bay, Cornwall,* 7gns., Mr. E.E. Tustin, 8 Fludyer St., Whitehall.
1832	26	*Lake of Geneva - Night, "Far along From peak to peak the rattling crags among, Leaps the live thunder! . . ." Byron.* 8gns., Octavius Henry Smith, Thames Bank, Chelsea.
1832	33	*Penmaenmawr, North Wales,* 7gns.
1832	36	*Village of St. Paul, Cornwall,* 6gns.
1832	81	*Pont-y-Gawr, North Wales,* 7gns., J.L. Brown, 10 Leicester Place, Leicester Square.
1832	89	*Near Buckland on the Moor, Devon,* 7gns.
1832	101	*St. Michael's Mount, Cornwall,* 12gns., Sold.
1832	109	*Cardigan,* 12gns., Mr. Webb, 1 Cambridge Terrace.
1832	116	*Windsor Castle,* 12gns.
1832	140	*On the Tees, near Athelstone Abbey, Yorkshire,* 5gns.
1832	158	*Zurich,* 5gns.
1832	172	*Northope, Flintshire,* 5gns.
1832	175	*Near Lecco, Italy,* 10gns.
1832	180	*Near Linthall, Switzerland,* 9gns., Mrs. Bicknell, Marked by order of Mr. Gastineau.
1832	184	*St. Michael's Mount, Cornwall,* 8gns., Sold.
1832	196	*Barmouth, North Wales,* 6gns., Mrs. Richard Cancellor, Cambridge Place, Regents Park.
1832	228	*Moonlight,* 6gns., Mr. Wyatville, 38 Montague Square, Would like to take the frame.
1832	232	*Corfe Castle, Dorsetshire - Storm clearing off,* 45gns.
1832	259	*Bala Lake, North Wales,* 5gns.
1832	266	*Coast near Marazion, Cornwall,* 5gns.
1832	279	*Penzance, Cornwall,* 8gns., Sold.
1832	310	*Ancient Cross near Penzance, Cornwall,* 6gns., Miss Shepley, 28 Devonshire Place.
1832	316	*View in the Vale of Neath,* 7gns., J. Lewis Brown, 10 Leicester Place, Leicester Square.
1832	318	*View in Castle Howard Park, Yorkshire,* 7gns.
1832	387	*Tremadoc, North Wales,* 5gns., The Honble. Richard Cavendish, 1 Belgrave Square.
1832	393	*Lemorna Cove, Mount's Bay, Cornwall,* 6gns., Lord de Dunstanville, Knightsbridge, Price of the frame wanted.
1832	402	*Caergwrle, North Wales,* 6gns., Sold.
1832	406	*Dollwydelan Castle, North Wales,* 6gns.
1833	8	*Aberdour Castle, Firth of Forth,* 6gns.
1833	9	*Remains of Quarr Abbey, Hampshire,* 7gns.
1833	50	*Omegna Lago D'Osta,* 12gns., Sir W. Herries.
1833	51	*Geneva,* 12gns., Miss Shepley, 28 Devonshire Place.
1833	92	*Nant-y-Glo, Breconshire,* 20gns., Mr. Bayley.
1833	101	*Moonlight,* 10gns.
1833	108	*Copper Works, near Swansea,* 7gns.
1833	113	*Near Cadgwith, Cornwall,* 6gns., Sold.
1833	116	*View at the Head of Loch Long,* 12gns., Mr. Cancellor, Cambridge Place, Regents Park, Paid by Mr. Colnaghi.
1833	122	*At Nesso, Lago di Como,* 9gns., Liddiard Esq.
1833	127	*St. Anthony's Chapel, Edinburgh,* 7gns.
1833	135	*View near Rhiadyr, Radnorshire,* 7gns.
1833	143	*View near Dolwydelan Castle, North Wales,* 7gns.
1833	145	*Cwm Clydoch, Breconshire,* 9gns.
1833	148	*At Newlyn, Cornwall,* 7gns.
1833	149	*Kynance Cove, Cornwall,* 8gns.
1833	160	*Fishing Boats,* 6gns.
1833	164	*Falls of the Teipy,* 6gns.
1833	191	*View near Ragatz, Switzerland,* 8gns.
1833	202	*Llandovery Castle, Caernarvonshire - Moonlight,* 7gns.
1833	212	*Morning,* 6gns.
1833	213	*Dolgelly, North Wales,* 12gns., Sold.
1833	216	*Near Wareham, Dorsetshire,* 6gns.
1833	235	*Distant View of Oystermouth Bay,* 6gns., Sold.
1833	268	*A Road Scene,* 5gns.
1833	291	*St. Michael's Mount, Cornwall,* 8gns., Mr. Bernall.
1833	307	*Welsh Pool,* 6gns.
1833	310	*Llandovery Castle, South Wales,* 6gns., Mr. Chessall, 5 Nottingham St., Nottingham Place.
1833	362	*Turnpike Gate near Falmouth,* 5gns.
1833	381	*Studland Church, Dorsetshire,* 5gns.
1833	387	*Scarborough,* 6gns., Sold.
1833	393	*Grongar Hill, Caermarthenshire,* 7gns.
1833	406	*At Chester,* 6gns.
1833	418	*View near Skelwith, Westmorland,* 7gns., Mr. Bernall.

1833	425	*View near Barmouth, North Wales*, 7gns., Mrs. Ryman, Oxford, To Mr. Groves, Pall Mall.
1834	2	*Mill on the Trent*, 5gns.
1834	32	*Cardiff, Glamorganshire*, 12gns.
1834	51	*Barnard Castle, Durham*, 7gns.
1834	83	*Chirk Aqueduct, N. Wales*, 5gns.
1834	89	*Caldicot Castle, Glamorganshire*, 5gns.
1834	135	*Bridgend, Glamorganshire*, 6gns.
1834	161	*Aberdillis Mill, Vale of Neath, Glamorganshire*, 7gns., Sold.
1834	172	*Island of Inchkeith, Firth of Forth*, 5gns., Holford Esq., Lincolns Inn Fields.
1834	173	*Moel Siabod, N. Wales*, 7gns.
1834	196	*Rhaiadyr Bridge, Radnorshire*, 8gns., Joseph Walker Esq., Birmingham.
1834	202	*Mount's Bay, Cornwall*, 12gns., Sold.
1834	205	*Near Bridge End, Glamorganshire*, 8gns.
1834	210	*Vale of the Towy, from Grongar Hill*, 5gns.
1834	216	*Tretwr, Breconshire*, 6gns.
1834	219	*Ponte di Rabiosa Splugen, Italy*, 25gns.
1834	222	*On the Conway, N. Wales*, 5gns.
1834	226	*Near Newbridge, Vale of The Taff*, 7gns.
1834	235	*Criccaeth Castle, N. Wales*, 35gns., Sold.
1834	260	*Near Newlyn, Cornwall*, 7gns.
1834	274	*The Wye at Aber Eddow, S. Wales*, 7gns.
1834	276	*Carrew Castle, Pembrokeshire*, 6gns.
1834	282	*Near Marazion, Cornwall*, 7gns., Miss Shepley, 28 Devonshire Place.
1834	295	*At Kington, Herefordshire*, 7gns., Sir William Cooper, 57 Portland Place.
1834	303	*Goodrich Court, the Seat of Sir Samuel Meyrick, Goodrich Castle in the distance*, 7gns., Sir William Cooper, 57 Portland Place.
1834	308	*Vale of the Taff, Glamorganshire*, 6gns.
1834	318	*Old Harry Point, Dorset*, 6gns.
1834	334	*Wareham, Dorsetshire*, 12gns.
1834	361	*The Mumbles Light House, Glamorganshire*, 5gns.
1834	383	*St. Leven, Cornwall*, 12gns.
1834	384	*St. Catherine's Island, Tenby*, 5gns.
1835	2	*St. Dogmael's Priory, Cardigan.*
1835	15	*Part of Warwick Castle*, 15gns., Honble. W. Rous(?), Worstead(?) House, Norwich.
1835	17	*Near Harlich*, 6gns.
1835	28	*Narbeth Castle, Pembrokeshire*, 6gns.
1835	36	*Beddgelert Church, North Wales*, 6gns.
1835	71	*View on Loch Lomond*, 6gns.
1835	100	*Part of Barnard Castle, Durham*, 6gns., N. Wilkinson.
1835	119	*View on the Usk, Brecon*, 6gns.
1835	120	*Water Tower, Chester*, 5gns., R.P. Glyn Esq., 37 Upper Brook Street.
1835	123	*Distant View of Derwentwater, Cumberland*, 10gns.
1835	133	*Newcastle, in Emlyn, South Wales*, 12gns.
1835	150	*Brook Scene*, 10gns.
1835	164	*Sewd Enion Gam, Vale of Neath, Glamorganshire*, 6gns.
1835	222	*View on the Lake of Como*, 50gns., Horatio Holloway, 19 Upper Berkeley St., Portman Square.
1835	233	*Mill, near Crickhowel, Brecon*, 6gns., Mrs. Rennell, 39 Bryanston Square.
1835	235	*Near Keswick, Cumberland*, 6gns., Lady L??? Tighe(?) to the care of Lady Sophia Lennox, No. 5 Upper Portland Place.
1835	236	*Aberdour Castle, Frith of Forth*, 6gns.
1835	283	*View on the Taff, South Wales*, 7gns., Mr. Joseph Walker, Birmingham, To be sent to Mr. Cox, 9 Foxley Road, Kennington Court on Wednesday.
1835	303	*Lower Town of Fishguard, Pembrokeshire*, 6gns., Wilbraham Egerton, St. James's Sq., To be sent to Mrs. W. ??? Egerton, 43 Wilton Crescent.
1835	319	*Swansea Harbour*, 6gns., Mr. Holford, No. 1 Lincoln's Inn Fields.
1835	324	*Llanfihangel Church, near Cowbridge, South Wales*, 5gns., Mrs. Rennell, 39 Bryanston Square.
1835	326	*Llanstephen, Caermarthenshire*, 6gns.
1836	6	*Aqueduct on the Taff, South Wales*, 12gns., Sir Richard Hunter, 48 Charles St., Berkeley Square.
1836	8	*Newport Castle and Bridge, Monmouth*, 6gns., Jos. Bailey Esq., M.P..
1836	13	*Inner Harbour, Dover, Kent*, 15gns.
1836	14	*Upnor Castle, Kent*, 6gns.
1836	51	*Gateway at Corfe Castle, Dorsetshire*, 10gns.
1836	85	*Llaneltyd Church, North Wales*, 12gns., Higs(?) Esq., 5 Drummond Place, Edinboro'.
1836	86	*Penrith Castle*, 5gns.
1836	89	*Caerleon, Monmouth*, 6gns., George Hibbert Esq.
1836	93	*Cardigan*, 5gns.
1836	134	*View on the Conway, North Wales*, 7gns.
1836	139	*Nant-y-Glo, Monmouthshire*, 6gns., Jos. Bailey Esq.
1836	150	*View on the Rhontha, Glamorganshire*, 5gns., Liddiard Esq., Camberwell.
1836	159	*Dover Harbour, from a Sketch taken on the 6th of September, 1835, during the Visit of the Duchess of Kent and the Princess Victoria. And the Embarkation of the King and Queen of Belgium*, 35gns.

1836	177	*Coast Scene*, 5gns.
1836	214	*Cattle - North Wales*, 30gns., T. Wilson Esq., Bath, Notice of delivery Leggatt & Co., 85 Cornhill.
1836	269	*Derwentwater, Cumberland*, 6gns.
1836	294	*Bramber Church, Sussex*, 6gns.
1836	295	*Near Golden Grove, Vale of the Towy, Caernarvonshire*, 5gns.
1836	298	*Landsend, Cornwall*, 10gns., Liddiard Esq., Camberwell.
1836	304	*Tenby Harbour, Glamorganshire*, 6gns.
1836	308	*Llanblethan, Glamorganshire*, 5gns.
1836	320	*Dover Harbour - Morning*, 6gns., Private per order of Mr. Gastineau.
1836	328	*Baden, Switzerland*, 7gns.
1836	336	*At Ewell, Kent*, 5gns., J. Norice(?) Esq., 11 Upper Gower Street.
1837	16	*Near Vira, Lago Maggiore*, 35gns., The Marquis of Abercorn, 1 Carlton House Terrace.
1837	27	*Hornsea Meer, Yorkshire*.
1837	31	*Pille Priory, Pembrokeshire*.
1837	42	*Llanthony Abbey, Monmouthshire*, 15gns.
1837	52	*Kynance Cove, Cornwall, "Whose awful steep In terror lives, and on the shore . . ."* 35gns., Leaf Esq., Old Exchange?.
1837	54	*Ruins at Neath Abbey, Glamorganshire*, 6gns.
1837	58	*Llarhne Castle, Caermarthenshire*, 5gns.
1837	59	*Winaston Church, Monmouthshire*, 5gns.
1837	91	*Lane near Newlyn, Cornwall*, 10gns., Robinson Esq., 56 Wigmore Street.
1837	102	*Caermarthen*, 5gns., H. Robinson Esq., 56 Wigmore Street, Colnaghi's, Pall Mall East.
1837	128	*Near Penzance, Cornwall*, 6gns., Lady Rolle, 18 Upper Grosvenor Street.
1837	135	*Coast near St. Ives, Cornwall*, 5gns.
1837	147	*Part of Kirkstall Abbey, Yorkshire*, 12gns., T.G. Parry Esq., 9a Langham Place.
1837	148	*Coast near Eastbourne, Sussex*, 5gns., R.P. Glyn Esq., 37 Upper Brook Street.
1837	208	*Morning*, 5gns.
1837	228	*Part of St. Mary's Abbey, York*, 5gns.
1837	257	*Craig y Dinas, Brecon*, 7gns.
1837	281	*Machien in the Appenines*, 6gns., Henry Wilkinson, Clapham Comn., Frame and glass £1.14.0.
1837	314	*Near Capel Cûrig, North Wales*, 5gns.
1837	339	*Pont Neath Vaughan*, 6gns.
1837	358	*St. Gall, Switzerland*, 5gns.
1838	36	*Remains of the Nave of Llanthony Abbey, with Cattle*.
1838	55	*Glenarm Castle, County of Antrim, Ireland*.
1838	57	*Near Stone Mill Gower, Glamorganshire*.
1838	79	*Amalfi - Coast of Sorrento*.
1838	102	*Braida Head, Isle of Man*.
1838	110	*Red Bay, County of Antrim*.
1838	112	*View near Barmouth, North Wales*.
1838	120	*The Porch - Moonlight*.
1838	121	*Barnard Castle - Durham*.
1838	131	*Dolbadern Castle, North Wales*.
1838	135	*Carrickfergus Castle, County of Antrim*.
1838	140	*Inner Court, Manorbeer Castle, Glamorganshire*.
1838	201	*Sudbrook Chapel, Coldicott Level, Monmouthshire*.
1838	206	*Waterfall in the Valley of Linthall, Switzerland*.
1838	255	*Enniskillen Castle, Lough Eyne, County of Fermanagh*.
1838	286	*Remains of St. Patrick's Church, Trim, County of Meath, Ireland*.
1838	310	*Port Erin, Isle of Man*.
1838	314	*Fort at Penzance, Cornwall*.
1838	324	*Hadleigh Castle, Essex*.
1838	333	*Conway Castle, North Wales*.
1838	344	*Remains of Jervaux Abbey, Yorkshire*.
1839	30	*Priory at Newtown, near Trim, County Meath*, 6gns.
1839	64	*Lake of Wallenstatt, Switzerland*, 15gns.
1839	79	*Totnes, from Sharpham, Devonshire*, 5gns., Miss E. Clarke, ?????? Esq., Black Heath Park.
1839	87	*Ragland Castle, Monmouthshire*, 12gns.
1839	101	*Carrick-a-Rede, or the Rock in the Road, County Antrim, "This island is separated from the main land by a chasm full 60 feet in breadth, and of a depth frightful to look at, and is inaccessible on every side except one, where a fisherman's little cot is built . . ."* Hamilton's Antrim. Sold.
1839	103	*At Newlyn, near Penzance, Cornwall*, 12gns.
1839	176	*Loch Long, Argyllshire*, 5gns., F. Poynder Esq., Charterhouse, Charterhouse Square, Frame and glass £1.18.0.
1839	185	*Near Cairn Castle, County Antrim*, 10gns.
1839	202	*Monastery at Newton, near Trim, County Meath*, 35gns.
1839	207	*St. Albans*, 10gns.
1839	209	*View on Lago Maggiore*, Sold.
1839	214	*View on the Teivy, North Wales*, 5gns.
1839	220	*Brougham Castle, Durham*, 5gns.
1839	253	*Swords, County of Dublin*, Sold.
1839	290	*Landscape, with Cattle*, 6gns., H. Browning, 4 Glos.(?) Place, Portman Square.
1839	333	*Bray, County Wicklow*, 15gns., Bean(?) Esq., Camberwell.

1839	344	*View near Barmouth, North Wales, 15gns.*
1840	34	*York Minster, from the River Foss.*
1840	46	*Ruins of the Palace of St. David, Pembrokeshire.*
1840	59	*Dartmouth Castle, Devon.*
1840	65	*View on the Conway, North Wales.*
1840	80	*Newbridge, Vale of the Taff, Glamorganshire.*
1840	85	*Peel Castle, Isle of Man.*
1840	103	*Coast Scene.*
1840	110	*Loch Long, Scotland.*
1840	117	*Distant View of Glastonbury Tor.*
1840	129	*Dartmouth Cove - Moonlight.*
1840	136	*Coast Scene - Moonlight.*
1840	138	*Vale of Rhiedol, Cardiganshire.*
1840	152	*St. Andrew's Cathedral, Fifeshire.*
1840	160	*Goschenen, Switzerland.*
1840	178	*Glencrow - Highlands.*
1840	187	*Sion Castle, Switzerland.*
1840	223	*Dartmouth Cove, Devonshire.*
1840	264	*Monkstown, County of Dublin.*
1840	271	*Fountains Abbey, Yorkshire.*
1840	309	*Carlingford Castle, County of Louth.*
1840	310	*Aberystwith Castle, Cardiganshire.*
1841	39	*On the Banks of the Mersey, 5gns., H. Wilkinson Esq., Clapham.*
1841	70	*Penmaenmawr, from the Coast of Beaumaris, N. Wales, 6gns.*
1841	86	*Dunluce Castle, County Antrim, 60gns., Miss A. Walker, 23 Gt. Geo. St.*
1841	100	*The Bridge at Sydenham previous to the formation of the Croydon Railway, 10gns.*
1841	122	*Folkestone, Kent, 20gns., Miss Shepley.*
1841	136	*At Tenby, Caernarvonshire, 5gns.*
1841	140	*Round Tower and Ruins of Donoghmore Church, County of Meath, 20gns.*
1841	143	*View near Launceston, Cornwall, 5gns.*
1841	159	*Remains of St. Catherine's Chapel, Guildford, 6gns., Sir Richard Glyn, 37 Upr. Brook Street.*
1841	164	*Coast at St. Andrew's, Fifeshire, 15gns., Richd. Ellison Esq., Sudbrooke Holme, Lincoln.*
1841	170	*Trim, County of Meath - in the Distance to the left of the Dome is a Pillar to his Grace the Duke of Wellington, 40gns.*
1841	173	*View near Beddgelert, Caernarvonshire, 9gns., Mr. W. Garfit to be sent to Mr. Foorde, Wardour St., Soho.*
1841	180	*Remains of Sherbourne Castle, Dorsetshire, 35gns.*
1841	205	*Scwd Gwlndis, Pyrddin, Brecon, 6gns.*
1841	235	*Greenwich, from East Ham Marshes, 5gns.*
1841	240	*View near Wells, Somersetshire, 8gns.*
1841	283	*Penrhyn Castle, Caernarvonshire, 6gns., Chs. Burrow Esq., 12 Grove Terrace, Kentish Town.*
1841	304	*Near Berriew, Montgomeryshire, 6gns., Thos. Abbott Green, Pavenham, Bedr.*
1841	308	*Pembroke Castle, 10gns., Dr. Roget, 39 Bernard Street, Russell Square.*
1841	313	*The Beacon, Herefordshire, 5gns.*
1841	330	*Near Berriew, Montgomeryshire, 6gns., Revd. W. Gibson, Fawley, Southampton.*
1842	3	*Remains of Sudbrook Chapel, in the Bristol Channel, Monmouthshire.*
1842	14	*Criccaeth Castle, North Wales.*
1842	18	*Bridge on the Canal, Chester.*
1842	23	*Tintern Abbey, Monmouthshire.*
1842	31	*View on the Conway, North Wales.*
1842	48	*Castle Rushen, Isle of Man.*
1842	59	*Monument in the Park at Wynnstay, Denbighshire.*
1842	62	*Fall at Bracklin, Perthshire.*
1842	67	*Trent Church, Somersetshire.*
1842	69	*View near Crickhowel, Breconshire - in the distance Glanusk Park, the seat of Joseph Bailey, Esq., M.P.*
1842	77	*Newcastle Castle, in Emlyn, Cardiganshire.*
1842	83	*The Necropolis at Glasgow - The Pillar is a Monument to Knox; the next to it to Professor Dick; and the one under the trees to Mr. Lawrence, a young Sculptor of Glasgow.*
1842	93	*Barnard Castle, Durham.*
1842	95	*Dover Castle, from the Folkestone Road.*
1842	103	*Kilgerran Castle, Pembrokeshire.*
1842	166	*Nesso, Lake of Como.*
1842	172	*Scotch Peasants - Loch Etive.*
1842	187	*The South Stack Lighthouse, near Holyhead.*
1842	207	*Castell Coch, in the Vale of the Taff, Glamorganshire.*
1842	233	*View near Newport Pagnel, Northamptonshire.*
1842	256	*Lake of Garda.*
1842	291	*Cardiff, Glamorganshire.*
1842	311	*Chirk Aqueduct, Denbighshire.*
1842	321	*View near Tremadoc, North Wales.*
1842	322	*Dover Castle.*
1842	327	*Loch Leven, Kinross-shire.*
1843	23	*Old Harry Point, Dorsetshire, 6gns.*
1843	48	*Ostend, 20gns., Sir Henry Bunbury Bt., Barton Hall, Bury St. Edmunds, Frame and glass £4.13.0.*
1843	73	*Goschenen, Switzerland, 15gns., Frame and glass £2.13.-.*
1843	87	*Lharne Lough, County of Antrim, 20gns., W. Abbott Junr. Esq., 11 Wyndham Place, Bryanstone Sq., Frame and glass £3.12.0. Prize in the Art Union of London of 20£.*

| 1843 | 91 | *Ehrenbreitztein*, 80gns., Charles Goodall Esq., 5 Canterbury Villas, Maida Vale, Frame and glass £15.0.0 |

| 1843 | 98 | *Bellagio, Lake of Como*, 20gns., Wm. Forbes Esq., Frame and glass £4.10.0. |

| 1843 | 107 | *Watton Church, Herts, from the Park*, 15gns., Frame and glass £3.0.0. |

| 1843 | 115 | *Newtown, County of Meath*, 8gns., Frame and glass £1.12.0. |

| 1843 | 117 | *Viaduct, Eastern Counties Railway*, 5gns., Frame and glass £1.12.0. |

| 1843 | 124 | *View near Lough Erne, Ireland*, 15gns., Frame and glass £2.2.0. |

| 1843 | 129 | *St. Andrews, Fifeshire*, 6gns., E. Taylor Esq., 1 Cannonbury Square, Frame and glass £1.5.0. |

| 1843 | 158 | *Interior of Old Shoreham Church, Sussex*, 8gns., Frame and glass £1.5.0. |

| 1843 | 170 | *Near Glenorchy, West Highlands*, 7gns., Mr. G.Faulkner, York Chambers, St. James St., Frame and glass £1.1.0. |

| 1843 | 175 | *At Buckland, near Dover*, 7gns., ???????, 48 Eaton Place, Frame and glass £1.6.0. |

| 1843 | 192 | *Loch Etive*, 5gns., Frame and glass £1.6.0. |

| 1843 | 202 | *Dunstaffnage Castle, Loch Etive*, 5gns. |

| 1843 | 230 | *Ouchey, Lake of Geneva*, 10gns., Frame and glass £2.6.0. |

| 1843 | 231 | *Lake of Wellenstadt, Switzerland*, 7gns., Frame and glass £1.12.0. |

| 1843 | 243 | *Milton near Gravesend*, 5gns. |

| 1843 | 246 | *Shaw's Castle, County Antrim*, 6gns., Sir Henry Bunbury Bt., Frame and glass £1.16.0. |

| 1843 | 265 | *View in the Valley of St. John, Tyrol*, 50gns., Frame and glass £8.8.0. |

| 1843 | 278 | *Ancient Ruins in the Town of Dover*, 10gns., Frame and glass £2.9.0. |

| 1843 | 286 | *Workshops at Penzance*, 10gns., J. Maurice Esq., Marlborough, per George Pilcher Esq., 7 Gt. George St., Westminster , Frame and glass £2.12.0. Prize of 10£ in the Art Union of London. |

| 1843 | 295 | *Hermitage in the Bay of Naples*, 15gns., Miss Shepley, East Hill Wandsworth. |

| 1843 | 308 | *View on Loch Lomond*, 5gns., Frame and glass £1.0.0. |

| 1843 | 328 | *Dover Castle*, 15gns., Capt. Hotham, Frame and glass £2.17.0. |

| 1843 | 335 | *Ancient Cross in the Churchyard of St. Donnatt's, Glamorganshire*, 15gns., Ellison Esq., Warren's Hotel, Frame and glass £2.18.0. |

| 1844 | 23 | *View near Munich, Germany*, 6gns. |

| 1844 | 29 | *View near Belagio, Lake of Como*, 70gns., Frame and glass £9.14.0. |

| 1844 | 34 | *West Window, Tintern Abbey*, 15gns., Frame and glass £2.0.0. |

| 1844 | 37 | *Trim Castle, Ireland*, 5gns. |

| 1844 | 40 | *On the Dart, Devon*, 7gns. |

| 1844 | 41 | *Folkestone*, 5gns., Z. Watkins Esq., 108 Regent Street. |

| 1844 | 54 | *The Vesper Bell - Scene near Lugano*, 50gns., Frame and glass £8.5.0. |

| 1844 | 109 | *The Gap of Dunloe, Ireland*, 15gns., T.J. Ireland Esq., Owsden Hall, Newmarket. |

| 1844 | 158 | *Cloch Lighthouse, Coast of Scotland - Early Morning*, 25gns., Lady March, 41 Portland Place, Frame and glass £5.0.0 P.A.U. |

| 1844 | 171 | *Newbridge - Vale of the Taaf*, 10gns., Frame and glass £2.0.0. |

| 1844 | 172 | *The Plains of Waterloo from the Wood of Soigny; Quartre-Bras in the distance*, 6gns. |

| 1844 | 183 | *Near Betts y Coed, N. Wales*, 5gns. |

| 1844 | 185 | *Welch Pool*, 5gns., Sir John Swinburne. |

| 1844 | 189 | *Near Broadstairs*, 5gns., W.H. Roe Esq., 21 Princes St., Cavendish Sq. |

| 1844 | 191 | *Near Capel Cûrig, N. Wales*, 5gns. |

| 1844 | 195 | *Chapel at St. Gowan's, Pembrokeshire*, 6gns., Red. S.M. Traherne, Erevalls Hotel, Albemarle St. |

| 1844 | 209 | *View in the Sound of Mull*, 15gns., W. Efson(?) Esq. (per Committee), Frame and glass £3.1.6. P.A.U. |

| 1844 | 211 | *Carisbrook Castle*, 6gns. |

| 1844 | 231 | *Dalton, Lancashire*, 7gns. |

| 1844 | 253 | *Beddgelert, North Wales*, 15gns., Hamilton Cook Esq., Carr House, nr. Doncaster. |

| 1844 | 259 | *On the Rhine*, 6gns. |

| 1844 | 262 | *Tintern Abbey*, 15gns., Frame and glass £2.14.0. |

| 1844 | 311 | *Market Day*, 10gns., Baring Wall Esq., 44 Berkely Sq. |

| 1845 | 15 | *Coast near Ryde, Isle of Wight*, 15gns., Dr. Royle, 4 Bulstrode St., Cavendish Sq., Frame and glass £3.10.0 sent. P.A.U. £15. |

| 1845 | 17 | *View near Derwent Water, Cumberland*, 15gns., Dr. Haviland, Cambridge, care of Mr. Usher, 16 Suffolk Street, to write to at Clovelly, Frame and glass £3.3.0. |

| 1845 | 35 | *Monuments on the Field of Waterloo*, 20gns., Frame and glass £3.15.0. |

| 1845 | 57 | *Coast of Antrim, "Where darkness hears the booming echoes roar And caverned surges rock the pillard shore...*", 70gns. |

| 1845 | 61 | *On the Crinan Canal, Argyllshire*, 5gns., Neill Malcolm Esq., 7 Great Stanhope St., Frame and glass £1.12.0. |

| 1845 | 64 | *Doune Castle, Scotland*, 5gns. |

| 1845 | 81 | *Pendennis Castle, Cornwall*, 18gns., Frame and glass £3.10.0. |

| 1845 | 109 | *Pwll-y-Cwm, Brecon*, 10gns., Frame and glass £2.10.0. |

| 1845 | 126 | *Near Crawley, Buckinghamshire*, 6gns., Frame and glass £1.8.0. |

1845	134	*Narrow Water Castle, County Down*, 20gns., Mrs. Augustus Clifford, Stoke Newington, Frame and glass £3.3.0.
1845	147	*Larne Lough, with the Grounds of Magheramone House, County Antrim*, Sold.
1845	155	*Near Stock Gill Force, Ambleside, Westmorland*, 15gns., Wm. Hobson Esq., 43 Harley, Frame and glass £3.0.0.
1845	172	*Isola de San Guilio, Lago d'Orta*, 50gns., W. Hobson Esq., Frame and glass £9.0.0.
1845	180	*View near Brussels*, 5gns., Frame and glass £1.5.0.
1845	182	*Part of the Old Croydon Canal, at Sydenham*, 5gns., Frame and glass £1.12.0.
1845	190	*A Lane near Worthing, Sussex*, 5gns., Frame and glass £1.12.0.
1845	192	*St. Margaret's Bay, near Dover*, 5gns., Stanley Howard, Club Chambers, 15, Regent, Frame and glass £1.5.0.
1845	237	*Glencoe, Scotland*, 12gns., John Field Esq., 13 West Brixton, Frame and glass £2.12.6.
1845	243	*View near the Hawk-stone, Bolton Park, Yorkshire*, 12gns., Rev. Augustus Clifford, Stoke Newington, Frame and glass £2.10.0.
1845	261	*Goodrich Court and Castle, Herefordshire*, 7gns., Frame and glass £1.0.0.
1845	309	*On the Wharf, Bolton, Yorkshire*, 15gns., L. Loyd Jun., 6 Green St., Frame and glass £2.12.6.
1845	313	*At Worthing, Sussex*, 5gns., G. Mount Esq., 95 Wimpole St., Cavendish Sq., Frame and glass £1.12.0.
1845	320	*Cochelsea, Germany*, 12gns., Mrs. Augustus Clifford, Stoke Newington, Middlesex., Frame and glass £2.5.0.
1845	324	*Bangor, North Wales*, 6gns., Frame and glass £1.5.0.
1846	71	*Vale of the Taff, Glamorganshire*, 18gns., Rev. W. Baxter, Cheltenham, Frame and glass £3.4.6, AU. Com.
1846	82	*At Ilfracombe, North Devon*, 15gns.
1846	137	*Near the South Pier, Dover*, 5gns.
1846	147	*Conway Castle, North Wales*, 15gns., Wm. Wise Esq., Leamington Spa, Warwickshire.
1846	152	*At Balcarras, Fifeshire*, 7gns.
1846	153	*Corfe Castle, Dorsetshire*, 6gns.
1846	157	*Tanfield, Yorkshire*, "Tanfield, or as denominated in an early survey, Danefield, belonged to the illustrious family of Marmion from the time of Henry III. until Henry VI. The church, which contains many rich monuments. . ." Sold.
1846	175	*On the Rhine*, 5gns., Bonham Carter Esq.
1846	177	*Near Malham Cove, Yorkshire*, 5gns.
1846	181	*Entrance to Corfe, Dorsetshire*, 6gns.
1846	183	*Dover Castle, from the road to St. Radigund*, 7gns.
1846	185	*A Lane at Bowness*, Sold.
1846	187	*Skiddaw, from Borrowdale, Cumberland*, 16gns., Mrs. Anstruther per Miss Stevens, AU.
1846	192	*Near Crawley, Bucks*, 10gns., R.H. Solly Esq., 48 Gt. Ormond Street.
1846	236	*Near Dunach, Fifeshire*, 5gns., John Martin Esq., 14 Berkly Sq.
1846	237	*Distant View of Scarborough*, 5gns., E.M. Mundy, 19 Pall Mall.
1846	251	*Near Capel Cûrig, North Wales*, 18gns., R. Phillips Esq.
1846	253	*Twilight - Coast of Argyllshire*, 6gns., E.M. Mundy Esq., 19 Pall Mall.
1846	254	*At Newlyn, Cornwall*, 6gns.
1846	265	*Tenby, Glamorganshire*, 5gns., John Goodden, Compton House, Sherborne, Dorset.
1846	270	*Loch Etive*, Sold.
1846	302	*Red Bay, County Antrim*, 15gns.
1846	311	*Kilconquhar Loch - Balcarres in the distance*, 5gns.
1846	318	*Near Dunleary, County Dublin*, 10gns., Miss Ellen Barchard, East Hill, Wandsworth, P.AU.
1847	30	*Great Malvern, Worcestershire*, Sold.
1847	48	*Croxden Abbey, Staffordshire*, Sold.
1847	53	*View near Magadino - Lago Maggiore*, 18gns., N. Hobson Esq.
1847	92	*Croxden Abbey, Staffordshire*, 15gns., Mrs. Burgoyne, Frame and glass No.
1847	114	*Arley Castle, Staffordshire*, 16gns., R.J. Coles, Old Park, Clapham.
1847	120	*Scene in Hackfall, Yorkshire*, 16gns.
1847	139	*Ripon, Yorkshire*, 12gns.
1847	144	*Rock Walk, at Alton Towers, Staffordshire*, 5gns.
1847	152	*Port of Fleetwood, Lancashire*, 25gns.
1847	156	*Windermere, from the Woods of Ellery*, Sold.
1847	194	*Landovery Castle*, 5gns.
1847	195	*Lancaster*, 6gns.
1847	214	*Tilly Whym, Dorsetshire*, 6gns.
1847	217	*Bridgenorth, Shropshire*, 15gns., John Wild Esq., Clapham Lodge, Frame and glass £2.8.6.
1847	218	*Yeovil, Somersetshire, from Babylon Hill*, Sold, Mr. Hutton.
1847	219	*On the Rhine*, 7gns.
1847	220	*Glendalough, County Wicklow*, 12gns., Thos. Toller Esq., 6 Grays Inn Square.
1847	225	*Caernarvon Castle*, 12gns.
1847	240	*Vale of St. John, near Chiavena*, 15gns., W. Thorneyford(?) Esq., West Brixton, Frame and glass £2.12.0 Yes.

1847	246	*A Lane near Suttons, Essex*, 5gns., John Shaw Esq., 23 Montague St., Russell Sq.
1847	252	*Near Newlyn, Cornwall*, 18gns.
1847	273	*Builth, Breckonshire*, 15gns., Miss C.R.Solly, 10 Manchester Sq., Frame and glass £2.8.6 No, AU. 15£.
1847	284	*Doune Castle, Scotland*, 5gns., John Shaw Esq., 23 Montague St., Russell Sq.
1847	287	*Folkestone, Kent*, 15gns., W. Mc Hutton(?), Clapham Common, Frame and glass £2.8.6.
1847	289	*Part of Kenilworth Castle, Warwickshire*, 5gns.
1847	305	*Glastonbury Tor, Somersetshire*, 5gns., John Martin Esq.
1847	317	*On the Ouse, near Stantonbury, Buckinghamshire*, 5gns.
1848	9	*On the Teivy, South Wales*, 6gns.
1848	30	*The Thames at Putney*, 12gns., Wm. Hutton Esq., Lark Hall Lane, Clapham.
1848	57	*Montacute, Somersetshire*, 18gns.
1848	78	*In Glen Strathglass, Inverness-shire*, 7gns.
1848	103	*Cader Idris, from the Barnmouth Road*, 15gns., Rich. Ellison Esq., Frame and glass £2.2.0.
1848	107	*Loch Leven, with the Entrance to Glen Coe*, 18gns., The Earl of March, 51 Portland Place, AU. 30£.
1848	109	*Salzburg, from a Garden on the opposite side of the River*, Sold.
1848	150	*Berriew, Montgomeryshire*, 7gns.
1848	157	*Sion, Switzerland*, 25gns.
1848	159	*Tenby, South Wales*, 12gns., W. Winthrop Esq., 5 Argyll St., Frame and glass £2.10.0, 15 x 11.
1848	160	*On the Conway, North Wales*, 12gns.
1848	173	*Harbour at Ilfracombe*, 12gns., Tho. Toller Esq.
1848	182	*Dolbadern Tower, Lake of Llanberis, North Wales*, 6gns.
1848	191	*On the Liffey, Dublin*, 50gns.
1848	195	*Brathy Chapel, Longdale, Westmoreland*, 6gns.
1848	223	*Velin Maes-y-Gwaelod, on the Usk, Breconshire*, 15gns.
1848	238	*In the Tyrol*, 7gns.
1848	280	*Dover, from the London Road*, 20gns., Thos. Wright Esq., Croydon, Frame and glass Yes.
1848	324	*View near Barmouth, North Wales*, 6gns.
1848	325	*Urquhart Castle, Loch Ness*, 7gns.
1848	339	*Ilfracombe, North Devon*, 12gns., F.T. Rufford Esq., Frame and glass £2.2.0.
1849	20	*Dovedale, Derbyshire*.
1849	21	*Ravenscraig Castle, near Kircaldy, Fifeshire*.
1849	49	*On Loch Leven, near Balyhulish*.
1849	51	*The Bass Rock, from Canty Bay, N. B.*
1849	84	*Voreppe, on the Road from Grenoble to the Grand Chartreuse - from a Sketch by a Lady*.
1849	90	*View near the Vale of Newlands*.
1849	94	*Hospital, with the Pass of St. Gothard, Switzerland*.
1849	102	*The Bass Rock, North Berwick*.
1849	104	*St. Maurice, Switzerland*.
1849	118	*Barmouth, North Wales*.
1849	129	*Near Bowness, Windermere, Westmoreland*.
1849	147	*Glasgow Cathedral, from the Necropolis*.
1849	165	*Elian Agais, on the Beauly River, Inverness-shire*.
1849	195	*The Little Boat Adrift - Scene in Glen Dochart*, "So have I seen, upon a summer's even, Fast by the rivulet's brink, a youngster play ..." – Blair.
1849	228	*Near Inverness, N. B.*.
1849	249	*Redbridge, near Southampton*.
1849	304	*Kilchurn Castle, Loch Awe*.
1849	331	*Near Capel Cûrig, North Wales*.
1849	335	*In Glen Strathglass, Inverness-shire*.
1849	341	*Kennarth Bridge, Cardigan*.
1849	349	*At the Head of Loch Lomond*.
1850	19	*In Langdale, Westmoreland*, 18gns., Miss Swift, 19 Norfolk Crescent, Hyde Park, Frame and glass £3.15.0 Yes, AU. £10.
1850	46	*Edinburgh, from near Aberdour, Fifeshire*, 16gns., Frame and glass £3.14.0.
1850	65	*Heybridge, Staffordshire*, 18gns., Mrs. W. Wilson, East Hil, Wandsworth, Frame and glass £3.14.0.
1850	68	*Near Inverness, Scotland*, 6gns., Mrs. Collingwood Smith, 15a Addington Place, Frame and glass £1.0.0.
1850	70	*Steamers waiting to enter Dover Harbour*, 6gns., C.J. Baker Esq., Frame and glass £1.0.0.
1850	82	*Dunkeld, Scotland*, 1gns., Scott Smith Esq., Frame and glass £2.10.0 Yes.
1850	92	*Wallensee, Germany*, 18gns., Mrs. A. Morison, Frame and glass £3.10.0 No.
1850	99	*Furstenau Castle, in the Odenwald*, 15gns., Frame and glass £2.10.0.
1850	109	*Lake of Wallenstadt, Switzerland*, 150gns., with frame.
1850	131	*Near Rhaiadr, Radnorshire*, 15gns., Robert N. Philips Esq., The Park, near Manchester, Frame and glass £2.10.0.
1850	148	*Lilleshall Abbey, Shropshire*, 18gns., Frame and glass £3.15.0.
1850	150	*Urquhart Castle, Inverness-shire*, 18gns., Frame and glass £3.15.0.
1850	167	*Children and Donkey - Sea-shore*, 16gns., Rob. Hambury Esq., Frame and glass £2.10.0 Yes.

1850	169	*Near Arrochar, Scotland,* 6gns., Frame and glass £1.0.0.
1850	224	*Loch Etive, Argyllshire,* 15gns., Frame and glass £2.10.0.
1850	228	*Malvern Abbey, Worcestershire,* 16gns., Frame and glass £3.14.0.
1850	242	*St. Anthony's Chapel - Arthur's Seat, Edinburgh,* 6gns., Frame and glass £1.17.0.
1850	244	*Coniston Water Head,* 6gns., Frame and glass £1.0.0.
1850	277	*At Omegna, Italy,* 6gns., Frame and glass £1.17.0.
1850	282	*Entrance to the Village of Cowlinge, Suffolk,* 12gns., Frame and glass £2.10.0.
1850	347	*Convent of Betharran, Pyrenees,* 6gns., Frame and glass £1.5.0.
1850	349	*Mill at Thornton Park, Bucks,* 15gns., Frame and glass £2.10.0.
1850	380	*Dovedale, Derbyshire,* 5gns., Frame and glass £1.5.0.
1851	17	*Aberystwith, Cardiganshire.*
1851	55	*Caerlion, Monmouthshire.*
1851	68	*Sound of Kerrera, near Oban, Argyllshire.*
1851	89	*Entrance to Dovedale, Derbyshire.*
1851	91	*Glen Lyon, Perthshire.*
1851	110	*Near the Head of Loch Goil.*
1851	115	*Kilchurn Castle, Loch Awe.*
1851	118	*Maiden Rock, near Oban, Argyllshire.*
1851	122	*Croxden Abbey, Staffordshire.*
1851	127	*Coast of Cromer, Norfolk.*
1851	141	*Clert, Staffordshire.*
1851	151	*Peel Castle, Isle of Man.*
1851	214	*Near Reichenhall, in the Tyrol.*
1851	223	*Cairn Castle, County Antrim.*
1851	278	*Peel Castle, Isle of Man.*
1851	290	*Laugharne Castle, Caermarthenshire.*
1852	9	*Entrance to Faskally House, Perthshire,* 6G, J.C. Pfeiffar Esq., Wandsworth, Frame and glass £1.0.0.
1852	15	*Crummock Water, Cumberland,* 18G, Scott Smith Esq., Frame and glass £2.10.0.
1852	41	*Ben More, from Crienlarich, Perthshire,* 5G, John Henderson Esq., Frame and glass £-.10.-.
1852	80	*Goshenen, Switzerland,* 30G, Frame and glass £4.10.0.
1852	82	*Dolwydellan Castle, North Wales,* 30G, Scott Smith Esq., Frame and glass £5.7.6.
1852	93	*View in Exton Park, Rutlandshire,* 15G, Frame and glass £3.10.0.
1852	105	*Newbridge, Vale of the Taff, Glamorganshire,* 15G, Mrs. John Radley, Denmark Hill, Camberwell, Frame and glass £2.10.0 No.
1852	106	*Narrow Water Castle, Ireland,* 18G, Frame and glass £2.0.0.
1852	112	*Aysgarth Force, Yorkshire,* 50G, Frame and glass £6.0.0.
1852	135	*M'Duff's Cave, Fifeshire,* 16G, Frame and glass £2.10.0.
1852	144	*Lake in Woolley Park, near Wakefield, Yorkshire,* 18G, Frame and glass £2.0.0.
1852	149	*New Radnor, South Wales,* 15G, Frame and glass £2.5.0.
1852	160	*The Severn, near Arley - Morning,* 15G, Miss Shepley, Frame and glass £1.18.0 (to be sent without frame to Mr. Foord).
1852	174	*Kynance Cove, Cornwall - after a Wreck,* 60G, Frame and glass £7.18.0.
1852	196	*Holyhead Harbour, Anglesea,* 20G, Mrs. A. Morison, Frame and glass £2.10.0.
1852	222	*Bridge at Capel Cûrig, North Wales,* 5G, Mrs. Bacon, South Street, Frame and glass £1.0.0.
1852	240	*Lake in Narford Park, Norfolk,* 5G, Frame and glass £1.0.0.
1852	266	*Rhaidor Bridge, North Wales,* 6G, Frame and glass £1.0.0.
1852	304	*Loch Tummel, from above Fortingale, Perthshire,* 7G, Frame and glass £-.18.-.
1853	5	*The Terrace, Richmond Hill.*
1853	40	*The Klamme Pass, Styria (between Lendt and Gastein).*
1853	48	*View on the Rhine.*
1853	56	*Lake of Como.*
1853	65	*Olderfleet Castle, Larn Lough, Ireland.*
1853	70	*Pass of Lanberris, North Wales.*
1853	89	*Rothsay, Clyde.*
1853	92	*On the Cluden River, Dumfriesshire.*
1853	98*	*At Louisberg, Aix la Chapelle.*
1853	100*	*Keep of Scarborough Castle, Yorkshire.*
1853	106	*View at the Head of Loch Lomond.*
1853	115	*Wellington Pillar, Trim.*
1853	117	*Trim Castle, Ireland.*
1853	134	*View near Petlockrie, Scotland.*
1853	140	*View in Borrowdale, Cumberland.*
1853	154	*Southampton - from a Sketch in the year 1825.*
1853	178	*Waiting for the Steamboat at the Head of Loch Lomond. From a Sketch taken in the year 1846.*
1853	186	*The Ferry, Windermere.*
1853	213	*At Lendt, Styria.*
1853	236	*Pilot Boat pushing off.*
1853	240	*Urquhart Castle, Inverness-shire.*
1853	284	*Stray Cattle.*
1853	289	*Keep of Guildford Castle, Surrey.*
1853	309	*Near Loch Fechan, Argyllshire.*

1854 62 *Fluellen - Lake of the Four Cantons*, 6gns., Wm. Smith Esq., 20 Southwick St., Cambridge Square, Frame and glass £1.6.0.

1854 66 *At Netherfield, near Kendal, Westmoreland*, 6gns., H.F. Powell Esq., Ashbourne, Derbyshire, Frame and glass £1.18.0.

1854 68 *St. Andrew's Castle, Fifeshire*, 15gns., Frame and glass £2.12.0.

1854 73 *On the Dochart River, near Killin*, 6gns., Frame and glass £1.6.0.

1854 94 *Near Capel Cûrig, North Wales*, 15gns., Chas. A. Ely, Frame and glass £2.5.0.

1854 106 *Keswick, Cumberland "- Morning, Swiftly from the mountain's brow . . ."* 100gns., N.T. Horsfall(?) Esq., Liverpool, Frame and glass £12.0.0.

1854 135 *Blonay Castle, Lake of Geneva*, 20gns., C.W. Nevile(?), Llanelly, Carmarthenshire, Frame and glass £2.12.0.

1854 142 *Priory Barn, near Dover*, 5gns., Frame and glass £1.15.0.

1854 157 *Arth - Lake of Zug*, 15gns., Frame and glass £2.0.0.

1854 159 *Mont Blanc and Chamouni, from the Flegère*, 18gns., R.R.(?) Preston, 10 Abercrombie St., Liverpool, Frame and glass £2.5.0.

1854 173 *Vale of the Taff, South Wales*, 30gns., Frame and glass £5.10.0.

1854 198 *Harlech Castle, North Wales*, 50gns., Gurney, Norwich, Frame and glass £6.10.0.

1854 203 *At Great Malvern - Rainy Morning*, 5gns., Frame and glass £1.2.0.

1854 207 *Derwentwater, near Keswick*, 5gns, Scott Smith Esq., Frame and glass £1.6.0.

1854 229 *Pass of Killicrankie, N. B.*, Sold.

1854 259 *In Dove Dale*, £15.0.0, William Kemble, Leggatts, Potters Bar, Herts., Frame and glass £2.12.0.

1854 260 *Evening*, 5gns., Frame and glass £1.12.0.

1854 288 *Dove Dale*, 5gns., Frame and glass £1.4.0.

1854 297 *Tanfield, Yorkshire*, 5gns., Scott Smith Esq., Frame and glass £1.4.0.

1854 300 *Kynance Cove, Cornwall*, 7gns., Thos. Kent, 30 Queen Anne St., Cavendish Sq., Frame and glass £1.10.0.

1854 308 *Near Bowness*, 16gns., Frame and glass £2.8.0.

1854 315 *In Glen Lochy, N. B.*, 5gns., Dr. Heaton, 2 East Parade, Leeds, Yks., Frame and glass £1.15.0.

1854 324 *Ruins at Newtown, County Meath*, 8gns., Messrs. Rowney & Co., Frame and glass £1.14.0.

1854 339 *Larne Lough, Ireland*, 15gns., Frame and glass £2.8.0.

1854 345 *Through the Wood*, 8gns., Frame and glass £1.15.0.

1854 348 *On the Clyde - Moonlight*, 15gns., Frame and glass £2.10.0.

1855 11 *In Glen Finnan, Inverness-shire*, 12gns., Thomas Veasey(?) Esq., Baldock, Herts, Frame and glass £2.5.0.

1855 23 *Near Capel Cûrig*, 5gns., T.R. Cobb Esq., Banbury, Frame and glass 18/.

1855 99 *Carlingford Bay, Ireland, from the Ruins of the Castle*, 100gns.

1855 117 *Church at Didlington, Norfolk*, 15gns., Frame and glass £2.5.0.

1855 127 *Netley Abbey*, 36gns., Sir Thomas Gage, Hengrave Hall, Bury St. Edmunds, Frame and glass £3.15.0.

1855 131 *Near Preston, Lancashire*, 5gns., Thos. I. Ireland, 50 Upper Harley St., Frame and glass £1.5.0.

1855 143 *Near Golden Grove - Vale of the Towy, Carmarthenshire*, 10gns., Frame and glass £2.10.0.

1855 154 *Dove Dale, Derbyshire*, 5gns., Thomas Veasey, Baldock, Herts., Frame and glass £1.10.0.

1855 161 *Lake of the Brientz, Switzerland*, 25gns., W.A. Langland(?), Streatham, Frame and glass £2.10.0.

1855 169 *Grange, Cumberland*, 50gns., John Carrick Moore, 4 Hyde Park Gate, Kensington Gore, Frame and glass £6.0.0.

1855 195 *Distant View of Glastonbury Tor*, 18gns., F.J. Turner, Park Lane, Broughton, Manchester, chosen by Mr. Neville, Frame and glass £2.10.0.

1855 198 *Dinas, South Wales*, 20gns., Gryffydd Allen for Mrs. Chas. Lloyd Jones, Pd. £3.0.0 new frame.

1855 200 *View near Magadeno, Lago Maggiore*, 15gns., R. Caithe(?), The Grove, Epsom, Frame and glass £2.10.0.

1855 212 *Dover Harbour*, 16gns., Frame and glass £2.10.0.

1855 268 *Brandon Church, Norfolk*, 5gns., Frame and glass £1.10.0.

1855 272 *In Glen Lochy, N. B.*, 5gns., W.Reed Esq., Hanworth, Nr. Hownslow, Frame and glass £1.15.0.

1855 284 *Entrance to Ramsgate Harbour*, 6gns., Frame and glass £1.15.0.

1855 287 *Castle at Newcastle Emlyn, South Wales*, 6gns., W. Innes(?) Esq., 39A Wigmore Street, Hanover Square, Frame and glass £1.10.0.

1855 292 *Viaduct over the Lugan, Dumfries*, 6gns., Lady Overston, Frame and glass £1.15.0.

1855 298 *Distant View of Sandwich Haven*, 10gns., Messrs. Fuller, Rathbone Place, Frame and glass £2.2.0.

1855 300 *Near Beddgillert, North Wales*, 5gns., Mr. Grundy, Manchester, Frame and glass £1.10.0.

1855	301	*In the Pass of Llanberis, North Wales*, 6gns., Ebenezer Foster, The Elms, Cambridge, Frame and glass £2.2.0.
1855	305	*Loch Lomond - from a Field near Tarbet*, 6gns., L.H. Winckworth Esq., 1 Leinster Gardens, Hyde Park, Frame and glass £1.0.0.
1855	318	*Narrow Water Castle, Ireland*, 5gns., Thomas Veasey, Baldock, Herts., Frame and glass £1.10.0.
1855	321	*Killiney Bay, County Dublin*, 6gns., L.H. Winckworth Esq., 1 Leinster Gardens, Hyde Park, Frame and glass £1.0.0.

GILBERT JOHN

1852	220	*Richard, Duke of Gloucester, and the two Murderers*, "Glo. – 'Be sudden in the execution, Withal obdurate, do not hear him plead ...'" *King Richard III. Act I. Scene 3.* 40G.
1852	228	*The Standard Bearer*, 25G, B. Austen Esq., Frame and glass £2.2.0 No.
1852	236	*A Trumpeter*, 30G, H. St.John Mildmay Esq., Frame and glass £2.11.0 Yes.
1852	295	*The Toilet*, 25G.
1853	77	*Richard II, resigns his Crown to Bolingbroke*, "Give me that glass, and therein will I read ..." *King Richard II., Act. IV., Scene 1.*
1853	296	*The Violin.*
1854	6	*The Rosary*, Sold, W. Little Esq., Illustrated News.
1854	18	*Hudibras and Ralpho in the Stocks*, Sold.
1854	34	*The Drug Bazaar, Constantinople*, 150gns., Kay Esq., 36 Hill St.
1854	137	*A Turkish Water Carrier - Constantinople*, Sold.
1855	9	*Merchant of Venice*, "Jessica. 'Call you? What is your will?' ..." *Act II., Scene 5.* Sold, Rt. Rawlinson Esq., 17 Ovington Sq., Brompton.
1855	54	*An Alchymist*, 60gns., Wm. Hamilton Yatman, Wellesbourne, Warwick.
1855	136	*The Letter Writer - Constantinople*, 30gns., Galsworthy Esq., Club Chamber, Regent St..
1855	151	*The Stage Coach of the last Century*, 40gns.

GILLIES MARGARET

1852	66	*Jennie Deans' visit to Effie in Prison*, 25G, William James Clement Esq., Council House, Shrewsbury, Frame and glass £2.18.0.
1852	73	*The Absent Thought*, 20G.
1853	47	*Jeanie Deans pleading for her Sister's Life before Queen Caroline*, "Tear followed tear down Jeanie's cheeks, as, her features glowing and quivering with emotion, she pleaded her sister's cause with a pathos which was at once simple and solemn." *The Heart of Mid Lothian.*
1853	170	*"My father argued sair, My mother did not speak ..." – Auld Robin Grey.*
1853	279	*After the Festa.*

1854	154	*Jeannie, from the Ballad of Auld Robin Grey*, "My father could na work, my mither could na spin ..." 25gns., N.P. Simes(?).
1854	160	*The Rowan Tree*, "We sat aneath thy spreading shade, the bairnies round thee ran ..." – Old Scotch Ballad. 25gns.
1854	182	*The Mourner*, "I watch thee from the quiet shore ..." – Tennyson. 30gns., D. Hill(?), Parsons Green, Fulham.
1854	276	*Listening to the Nightingale,"* – Thy plaintive anthem fades Past the near meadows, over the still stream ..." – Keats. 15gns., Dr. Fripp, Albert Road.
1855	46	*Looking Back at the Old Home*, "Unforgotten, unforgetting, Footsteps faltering and slow ..." – B. R. Parkes. 35gns., Miss Robertson, Tettenhurst(?) Park, Sunning Hill.
1855	193	*The Past and the Future*, "Sighing as through the shadowy past ..." – Moore. "Hope, the brightest of the passionate choir ..." – Shelley. 40gns., Messrs. Fores, Piccadilly.
1855	281	*A Fisher-Girl*, 15gns., T. Bell Esq., FRS(?), New Broad St..
1855	299	*Portia Planning the Defence of Antonio*, 20gns., Colonel Linton.
1855	322	*Waiting for News*, 35gns., Miss Elizth. Clarke, 17 Royal Parade, Cheltenham.

GILPIN W

| 1807 | 184 | *Shakespeare's Cliff, Dover.* |

GILPIN W J

| 1810 | 236 | *A Scene in Dogmersfield Park, Hants.* |

GILPIN W S

1805	11	*Scene in Oxwich Bay, Glamorgan.*
1805	17	*Scene on the Welsh coast.*
1805	27	*The lakes of Coombe en Doove, near Killarney.*
1805	63	*Dover Castle, from the Deal road.*
1805	79	*A scene on Muckruss Lake, Killarney.*
1805	87	*Aldbury park, Surry, the seat of Samuel Thornton, Esq.*
1805	103	*Muckruss lake, Killarney, looking towards Glaunar and Eagle's Nest, from Ream Carrick.*
1805	114	*Unloading a charcoal waggon, a sketch from Nature.*
1805	115	*A scene in Aldbury Park, Surry.*
1805	124	*Scene in Aldbury Park, Surry.*
1805	158	*The fall of Turk on Muckruss lake, Killarney.*
1805	159	*View of Dogmersfield, Hants. the seat of Sir H. P. St. John Mildmay, Bart.*
1805	164	*The three cliffs, Oxwich Bay, Glamorgan: a hazy morning.*
1805	172	*Entrance of the Christchurch river, Hants.*
1805	193	*Scene in Dogmersfield Park, Hants.*
1805	247	*Shakespear's Cliff, Dover.*

1805	248	*A scene in the Earl of Kenmare's Park at Killarney.*
1805	264	*A scene at Lower Cheame, Surry.*
1805	270	*A scene in New Forest, Hants.*
1805	271	*A scene on Muckruss lake, Killarney.*
1806	29	*Mr. Smith's House, Dover.*
1806	48	*Scene near Briton Ferry, Glamorganshire.*
1806	68	*Scene near Calshot Castle, Hants.*
1806	111	*Wargrave Ferry, on the Thames.*
1806	115	*Shakespeare's Cliff, Dover.*
1806	123	*Dover Pier.*
1806	143	*Dover Cliffs, looking towards the South Foreland, low water.*
1806	153	*A Scene near Lyndhurst, in New Forest.*
1806	253	*Arch Cliff, Dover.*
1806	264	*A scene near Fawley, Hants.*
1807	162	*Dover coast.*
1807	166	*Scene in Norbury Park, Surrey.*
1807	197	*View up the Southampton River, from Calshot Castle.*
1807	282	*Calshot Castle.*
1807	283	*Fan Cliff, Dover.*
1807	284	*Oxwich Bay, Glamorgan.*
1807	296	*Hengistbury Head, Christ-Church Bay.*
1808	50	*Scene near Calshot Castle.*
1808	112	*Scene in Albury Park, Surry.*
1808	116	*Cookham, Berks.*
1808	125	*A study from nature.*
1808	151	*Study from nature.*
1808	240	*Scene near Fawley, Hants.*
1808	294	*Scene at Lower Cheam, Surry.*
1808	303	*A scene near Beaulieu, River Hants.*
1809	81	*Scene near Killarney.*
1809	145	*View of the lake of Killarney, from Lord Kenmare's park.*
1809	159	*View at Briton ferry, Glamorganshire.*
1810	60	*A Scene on the Beaulieu River, Hants.*
1810	138	*Scene in Moccas Park, Herefordshire.*
1810	175	*A Farm Yard, at Dowdswell, near Cheltenham.*
1810	310	*A Scene on the Beaulieu River, Hants.*
1811	9	*Farm Yard at Dowdswell, Cheltenham.*
1811	133	*Barton, Isle of Wight.*
1811	151	*Cowes Castle.*
1811	170	*Dover Harbour.*
1811	192	*Cowes Harbour, Isle of Wight.*
1811	207	*Cowes Harbour, Isle of Wight - Twilight.*
1811	210	*A Scene near Lady Stewart's Cottage, Maddiford.*

1811	212	*A Scene near Cuffnells, in the New Forest.*
1811	217	*Quar Abbey, Isle of Wight.*
1811	225	*Haven House, Christchurch.*
1811	240	*A Scene in Norbury Park.*
1811	243	*Lake of Killarney with Dunlor Castle.*
1811	299	*A Farm at Mickleham, Surrey.*
1812	14	*The Village of Presbury, near Cheltenham.*
1812	52	*A Farm Yard, at Little Marlow.*
1812	56	*Dover Cliffs.*
1812	60	*Scene near Britton Ferry.*
1812	114	*Shakespeare's Cliff, Dover.*
1812	179	*The Village of Charlton, near Cheltenham, a Study from Nature.*
1812	193	*A Farm Yard at Worthing.*
1812	194	*Study from Nature, at Paddington.*
1812	235	*Study from Nature, in Albury Park, Surrey.*
1812	248	*The Vale of Cheltenham, from Dowdeswell Hill.*
1812	281	*Study in Dogmersfield Park.*
1812	315	*Scene in Moccas Park.*
1812	331	*Study from Nature, in Dogmersfield Park.*
1814	123	*Harleyford, Bucks, Twilight.*
1814	124	*Charlton King's near Cheltenham, a Study from Nature.*
1814	149	*A Scene near Sandhurst, Berks.*
1814	166	*A Lane near Cheltenham.*
1814	255	*Scene at Britton Ferry, Glamorgan.*

GIRTIN T

1823L	5	*Landscape, W. Wells, esq.*
1823L	9	*Landscape, W. Wells, esq.*
1823L	18	*Coast Scene, Earl of Essex.*
1823L	21	*Mid-day, W. Leader, esq. M.P.*
1823L	40	*Durham, E.H. Locker, esq. F.R.S.*
1823L	47	*Morpeth, W. Wells, esq.*
1823L	59	*A Sketch, Earl of Essex.*
1823L	61	*Peterborough Cathedral, J. Vine, esq.*
1823L	70	*Bolton Abbey, W. Leader, esq. M.P.*
1823L	80	*View in France, Earl of Essex.*
1823L	97	*Town Scene, Earl of Essex.*
1823L	101	*Bamborough Castle, Earl of Essex.*
1823L	108*	*Jedborough, W. Wells, esq.*
1823L	122	*Rivaux Abbey, E.H. Locker, esq. F.R.S.*
1823L	130	*An Abbey, Earl of Essex.*
1823L	162	*Town Scene, J. Allnutt, esq.*
1823L	198	*Melrose Abbey, W. Leader, esq. M.P.*
1823L	199	*Litchfield Cathedral, J. Vine, esq.*
1823L	203	*Bridgenorth, W. Leader, esq. M.P.*
1823L	206	*Sketch, T. Tomkison, esq.*

GLENNI A
1837 244 *The Arch of Constantine, with Part of the Colliseum and the Palatine Hill*, Sold.

GLENNIE A
1837 89 *The Valley of Licenza, the Site of Horace's Sabine Farm*, Sold.

1837 118 *View in the Forum, Rome*, Sold.

1837 129 *The Cloister of the Convent of the Ara Celi, Rome*, Sold.

1837 136 *The Temple of Pallas, Rome*, Sold.

1837 149 *View in the Forum, Rome*, Sold.

1837 205 *Interior of the Church at Licenza*, 25gns., E.W. Smith Esq., Ottery St. Mary, Devon.

1838 31 *Rio Fontebello, under Mount Lucretelis, near the Fons Blansdusia.*

1838 34 *Interior of the Convent St. Benedetto, Subiaco.*

1838 51 *View on the Tiber - looking through one of the Arches of Ponte Molle.*

1838 231 *Scene in the Piazza at Atrona, Gulf of Salerno.*

1838 234 *View in the Forum, Rome.*

1838 241 *View in the Campagna Romana, looking towards Rome, from the Ostia Road.*

1839 177 *View of Sandwich, from the Salt-pans*, Sold.

1839 194 *An Interior, in Key Lane, Sandwich*, 20gns.

1839 242 *Entrance to Aversa from Naples*, Sold.

1839 273 *Interior of St. Thomas's Hospital, Sandwich*, 15gns.

1839 296 *Quarter-Day at St. Thomas's Hospital, Sandwich*, 15gns., John Marshall, 41 Upper Grosvenor St., To be delivered to Mr. Copley Fielding. Frame and glass £2.15.0.

1840 11 *The Temple of Ceres, Paestum - Morning.*

1840 76 *Pozitano, Gulf of Salerno.*

1840 142 *Castello di Sorrento.*

1841 25 *Interior - Licenza, near Tivoli*, 5gns.

1842 50 *Interior of the Kitchen in the Convent of the Ara Celi, at Rome, where soup is daily made for the poor.*

1842 198 *The Forum at Pompeii.*

1843 149 *View on the Tiber, near Rome*, 16gns.

1843 181 *Castle of the Frangipane and Village of Terzatto, above the Hungarian Road, Fiume - Croatia*, 12gns.

1843 250 *Chapel and Bridge of the Madonna, Montorio, Upper Abruzzo*, 10gns.

1844 2 *View of the Valley of the Recsina, Grobnik, near Fiume, Croatia*, 12gns.

1844 64 *View at Bosiliers, near Carlstadt, Croatia*, 10gns.

1844 69 *View of the Kamenjak Mountain and Plain of Grobnik, near Fiume, Croatia*, 10gns.

1844 76 *View of the Castle of Grobnik, near Fiume, Croatia*, 15gns.

1845 176 *View of the Amphitheatre at Pola, in Istria*, Sold.

1845 201 *View of the Amphitheatre at Pola, in Istria*, Sold.

1846 174 *View of the Forum, Rome, from the Tabularium*, Sold.

1846 199 *View of the Ponte Rotto, Temple of Vesta, and Palace of the Caesars, taken from the Convent of St. Bartholomew on the Island - Rome*, Sold.

1847 55 *View of the Forum of Rome, taken from the School of Xanthus*, Sold.

1848 181 *View in the Campagna di Roma, from the Via Appia*, Sold.

1848 199 *View in the Forum, Rome, from the Tabularium*, Sold.

1849 5 *View of the Temple of Neptune, at Paestum.*

1850 5 *View of the Temples at Paestum*, Sold.

1850 85 *View on the Tiber, near Rome, from Ponte Molle, Monte Mario and St. Peter's in the distance*, Sold.

1851 15 *View in the Forum, at Rome - painted on the spot.*

1851 65 *The Cloister of the Convent of St. Francisco, at Pola in Istria - done on the spot.*

1851 81 *View in the Forum at Rome - painted on the spot.*

1851 98 *The Arch of Titus, part of the Coliseum, at Rome - painted on the spot.*

1851 99 *Church of San Giovanni in Veneve - near Lanciano, Lower Abruzzo, kingdom of Naples.*

1851 176 *Part of the Interior of the Coliseum at Rome.*

1851 251 *The Temple of Vesta at Rome - painted on the spot.*

1851 274 *View on the Tiber, near Rome.*

1852 38 *View of the Temple of Neptune at Poestum - Painted in 1851*, Sold.

1852 40 *View of the Amphitheatre at Pola, in Istria - done on the Spot*, Sold.

1852 124 *View of the Amphitheatre at Pola, in Istria - Morning effect*, Sold.

1852 164 *View of the Amphitheatre at Pola, in Istria*, Sold.

1852 184 *View of the Amphitheatre at Pola, in Istria - Evening effect*, Sold.

1853 46 *View of the Ponte Rotto and Temple of Vesta at Rome, from the Terrace of the Convent of St. Bartolomeo - the Palace of the Caesars and Mount Albano in the distance.*

1854 102 *The Arch of the Sergi, commonly called the Porta Aurea, at Pola, in Istria*, £25.0.0.

1855 87 *View in Croatia, near Fiume*, Sold.

1855 147 *Chapel at Montorio, near Teramo, Kingdom of Naples*, Sold.

GLOVER F

1811	161	*Scene on the River Dee Llangollen and Castle Dinas Brann in the distance.*

GLOVER J

1805	1	*Crowland Abbey.*
1805	13	*The Ouse bridge at York.*
1805	30	*Inverary: Morning.*
1805	38	*Cattle and figures, Morning.*
1805	41	*A waterfall between Llanrwst and Conway.*
1805	71	*Stormy sun set, figures passing a ford.*
1805	81	*Wythburn lake, Cumberland.*
1805	89	*Evening, a composition.*
1805	92	*Ben Vennue, near Loch Catherine, Scotland.*
1805	98	*Mid-day, a composition.*
1805	116	*Cauldron Llyn, Scotland.*
1805	120	*Ben-Amoore, Scotland, a partial shower.*
1805	127	*Markland Gripps, Nottinghamshire.*
1805	137	*Thunder storm at sun-set, a composition; the sky from nature.*
1805	143	*Morning, a composition.*
1805	152	*Moonlight, a study from nature.*
1805	163	*Snow.*
1805	194	*York Minster, with cattle.*
1805	218	*Tweedale.*
1805	251	*Singular effect of a thunder storm.*
1805	259	*Glen Finglass, sunshine and distant rain.*
1805	263	*A lake, still warm evening: a composition.*
1805	267	*The rock, called the Cobler, at Arroquhar, Scotland.*
1806	14	*View in Osberton Park, Nottinghamshire.*
1806	19	*Composition, morning.*
1806	30	*Ulswater, Morning.*
1806	44	*Windermere, from above Low Wood.*
1806	64	*Keswick.*
1806	85	*Whitby Abbey, Yorkshire.*
1806	103	*Stirling Castle.*
1806	116	*Ulswater, from the road to Matterdale.*
1806	149	*Durham Cathedral and Castle.*
1806	178	*Ulswater.*
1806	208	*St. Nicholas's Church, Newcastle on Tyne.*
1806	233	*Durham. A storm.*
1806	242	*Durham, Morning.*
1806	256	*On the Greta, Yorkshire.*
1806	265	*Rydal Head, Westmoreland.*
1806	279	*Markland Gripps.*
1806	289	*Bridge at Buttermere.*
1806	299	*Ulswater.*
1806	300	*Near Oban, Scotland.*
1806	301	*Brough Castle.*
1807	2	*Lowdore, Col. Mellish.*
1807	4	*Skiddaw, storm passing off.*
1807	44	*Windermere.*
1807	80	*Wirksworth.*
1807	86	*Morning.*
1807	109	*Cottage in Marchington Woodlands, Needwood Forest.*
1807	120	*Durham - morning.*
1807	121	*View near Keswick.*
1807	122	*Morning.*
1807	128	*Sun set, Stow.*
1807	138	*Derwent water - mid-day.*
1807	142	*Pruddoe Castle.*
1807	145	*Near Coniston water.*
1807	147	*Patterdale.*
1807	154	*Evening.*
1807	160	*Near Ashbourne, Derbyshire.*
1807	172	*Lowdore.*
1807	194	*Barnard Castle, Northumberland.*
1807	203	*Derwent water, mid-day.*
1807	204	*Corsa Pike, at day-break.*
1807	212	*Sun set, a harvest field.*
1807	217	*Land storm, Col. Mellish.*
1807	218	*Kirkstall Abbey.*
1807	224	*At Buttermere.*
1807	226	*View on the Devonshire coast, the isle of Lundy in the distance.*
1807	261	*Lancaster.*
1807	293	*Evening.*
1807	295	*Durham.*
1807	300	*Lowdore, with part of Derwent water.*
1807	307	*View near Litchfield.*
1807	314	*Twilight.*
1807	316	*View on the grounds at Whitfield, the seat of W. Orde, Esq.*
1807	324	*Ulswater, from Gow Bay Park.*
1808	13	*Mercury, Argus, and Io.*
1808	14	*Montgomery Castle, Lord Dunstanville.*
1808	46	*Ulswater, 40gns., Mr. Kevin(?).*
1808	48	*Near Needwood Forest.*
1808	53	*In the vale of Newlands.*
1808	63	*Castle and port of Tenby, Mr. Fazackerly(?).*
1808	86	*Pembroke Castle, Lord Dunstanville.*
1808	98	*Neath Valley.*
1808	107	*Evening, Mr. Baily.*
1808	113	*St. Catherine's Isle, at Tenby.*
1808	118	*Pembroke Castle.*

1808	166	*In Wensley Dale*, Lord H. Petty.
1808	181	*At Chepstow.*
1808	194	*The parson's bridge.*
1808	195	*View at Pont Nedd Vaughan, South Wales,* 50gns., Mr. Beardmore.
1808	199	*The Devil's Bridge, a storm.*
1808	204	*Castle Mole, South Wales.*
1808	221	*Pont Nedd, Vaughan.*
1808	238	*St. David's Palace, South Wales.*
1808	243	*Part of Derwentwater, with cattle.*
1808	261	*Llanidloes Bridge,* 35gns., Mr. Stump(?).
1808	264	*Bridge at Yoxall.*
1808	265	*Sutton Coldfield.*
1808	270	*Loch Catherine.*
1808	271	*The Devil's Bridge.*
1808	274	*Kidwelly Castle.*
1808	275	*Windsor Castle.*
1808	283	*Chepstow Castle,* 35gns., Mr. Stump(?).
1808	285	*Bridge near Garstang.*
1809	3	*Farm yard, Winter.*
1809	43	*Twilight.*
1809	46	*Conway Castle, stormy sky.*
1809	51	*Falls on the Machno, N. Wales.*
1809	55	*Moel Siabod, N. Wales.*
1809	78	*Conway Castle - morning.*
1809	86	*Greenwich.*
1809	100	*Coldicott Castle, S. Wales.*
1809	108	*View on the Heder.*
1809	109	*Falls of the Conway.*
1809	112	*Evening, with cattle.*
1809	118	*Llanrwst Vale.*
1809	176	*Llanrwst market place.*
1809	179	*Conway Castle, moonlight, study from nature.*
1809	180	*Gwydier woods, study from nature.*
1809	223	*Summer evening, with cattle.*
1809	225	*Needwood Forest, Tutbury Castle in the distance,* Mr. Brooke.
1809	231	*View near Milthorp - evening.*
1809	247	*Conway Castle.*
1809	250	*Morning, with cattle and figures.*
1809	269	*Evening, near Sutton Coldfield.*
1809	271	*View near Sutton, Coldfield.*
1809	274	*Chepstow Castle.*
1809	283	*Conway Castle - evening.*
1809	301	*Greenwich.*
1809	314	*Caernarvon Castle.*
1809	317	*Boy and ass, study from nature.*
1810	125	*Windsor Castle, from Cranbourn Lodge.*
1810	132	*The new Bridge over the River Conway, in Llanrwst Vale.*
1810	139	*Eagle Cragg, Borrowdale.*
1810	143	*Evening.*
1810	150	*Caernarvon Castle.*
1810	181	*Morning.*
1810	191	*Moel Siabod, and Snowden, from near Dolwyddelan Castle, North Wales.*
1810	196	*Windsor Castle.*
1810	201	*Evening.*
1810	299	*Evening - Scene in Norbury Park, Surry.*
1810	304	*The Aquaduct, near Llangollen.*
1810	320	*The Devil's Bridge, South Wales.*
1811	15	*Durham Cathedral and Castle.*
1811	16	*Greenwich.*
1811	28	*Furness Abbey.*
1811	34	*Bridge over the Kennet at Reading.*
1811	51	*Rydal Head, Westmorland.*
1811	56	*Windsor, from Eton.*
1811	58	*Scene on the Rothay, near Wyndermere.*
1811	66	*Neath Valley.*
1811	78	*View near Tenby, South Wales.*
1811	88	*Gwyder Wood, North Wales.*
1811	98	*Ulswater with Cattle.*
1811	100	*Morning, a Scene near Chirk, North Wales.*
1811	106	*Kirkstall Abbey, Morning.*
1811	118	*At Milthorpe, Lancashire.*
1811	125	*Cattle and Figures.*
1811	131	*Ulswater - Morning.*
1811	140	*Furness Abbey.*
1811	193	*Distant View of Greenwich.*
1811	195	*Pont Abber Glasslyn, from the Tra Maddock River.*
1811	221	*Ulswater - Breaking up of a misty Morning.*
1811	241	*Between Corwen and Llangollen.*
1811	267	*Hampstead Heath.*
1811	304	*Morning.*
1811	345	*The new Bridge over the River Conway, near Bettus, North Wales.*
1812	19	*Early Morning.*
1812	74	*Neath Valley.*
1812	80	*Sundridge Church, Kent.*
1812	82	*Windsor.*
1812	88	*A Storm, near Keswick.*
1812	93	*Cattle and Figures - Evening.*
1812	146	*Waterfal at Ambleside.*
1812	183	*Durham Cathedral.*
1812	195	*Scene at the New Bridge over the River Conway.*

1812	199	Windsor, from Cooper's Hill.
1812	201	Morning.
1812	204	A Scene near the Devil's Bridge.
1812	209	View of Ulswater, and Lyulph's Tower.
1812	212	Scene near Capel Carig.
1812	223	Windermere.
1812	250	Cockermouth Castle.
1812	262	View of London, from Milbank.
1812	268	Windermere - Mist rising from the Lake.
1812	287	Torbay.
1813	195	Mary Church, Devonshire.
1813	205	View of Loch Katrine.
1813	214	View of Ben Venue.
1813	218	View of Lambton Hall, on the River Weir, near Durham - The Seat of John Lambton Esq.
1813	222	View of the Entrance of Torbay, Devonshire.
1813	234	View of Conniston Lake.
1813	240	View of Mount Olympus and Town of Brusa.
1813	249	Westminster Abbey, from the Green Park.
1814	45	Loch Katrine.
1814	47	Trossacks at Loch Katrine, £52.10.0, J.G. Lambton Esq., M.P.
1814	54	Scene near Montgomery.
1814	58	Moonlight. The Ouse River at York.
1814	75	Conway Castle.
1814	78	Sunset - Midsummer.
1814	102	At Matlock - Mist rising.
1814	107	Snow Piece - View at Mainie, near Sutton Coldfield, £6.6.0, Mr. Furbor.
1814	111	Benn Vennue.
1814	126	Llanidloes Church, £18.18.0, Lord Braybroke.
1814	135	At Matlock, £18.18.0, Mr. Willimotte.
1814	148	View near Keswick.
1814	180	Landscape, Cattle and Figures.
1814	207	Morning, at Matlock.
1814	211	Bridge at Old Windsor.
1814	220	At Matlock - Early Morning.
1814	222	View at Matlock, near the High Torr, £210.0.0, Rev. J. Bostock.
1814	229	At Matlock - Misty morning.
1814	236	At Matlock, from the Bridge.
1814	237	Kenilworth Castle.
1814	238	Elter Water, £18.10.0, J.G. Lambton Esq., M.P.
1814	252	Stirling Castle.
1814	256	Coniston Lake.
1815	2	Greenwich Hospital, London in the Distance, £12.12.0, J. Allnutt Esq.
1815	66	The River Bratha, Westmoreland, £6.6.0, T.G.
1815	68	Ulleswater. Moonlight, £52.10.0, Rt. honble. Manners Sutton.
1815	76	Moel Shabod, and Dolwyddelen Castle, North Wales.
1815	87	Ulleswater. Stormy, Sun set.
1815	90	Matlock Church, £31.10.0, Mr. Warren.
1815	138	Pevensey Castle, Sussex, £105.0.0, Lady Lucas.
1815	142	Lancaster, after Sun-set, £10.10.0, Earl of Buckinghamshire.
1815	157	Ulleswater, Cumberland, £26.5.0, Mr. Willimott.
1815	159	Conway Castle, North Wale, £26.5.0, Mr. Willimott.
1815	179	View of Matlock, High Torr, Derbyshire, £52.10.0, Mr. Willimott.
1815	205	View on the Rhine, Drackenfeldts and Gotesberg Castles.
1815	247	View near Stuarts house at Loch Katrine.
1815	252	Furness Abbey, £5.5.0, Mr. Willimott.
1815	283	The Rydale Mountains, Westmoreland.
1815	285	Roslyn Castle, Scotland, £10.10.0, Mr. Sergeant.
1815	322	Caernarvon Castle.
1816	1	View at the Village of Lech, near Kirby, Lonsdale.
1816	22	Greenwich Hospital, £12.12.0, J. Allnutt Esq.
1816	41	View of Mont Blanc, and Lake of Geneva, from the Jura.
1816	46	Cattle and Figures, Sun-set.
1816	47	View on the River Berrs, between Berne and Basle, Switzerland.
1816	54	Nant-y-Bellan, North Wales.
1816	65	Cattle. The last Gleam of the Setting Sun.
1816	79	Bala Lake, painted from Nature.
1816	81	Warwick Castle.
1816	105	Cattle Piece, passing Shower.
1816	110	Elter Water and Furness Fells. Study painted on the Spot.
1816	116	Landscape with Cattle.
1816	117	Mill near Newton, Devonshire.
1816	120	Randcomb Park, the Seat of Sir Wm. Guise, Bart. Gloucestershire.
1816	123	Sun-set. Dusty Road, £21.0.0, C. Long Esq.
1816	126	View near Cranbourn Lodge, Windsor Forest, with Cattle.
1816	127	Bala Lake. Painted on the Spot.
1816	137	Randcomb Park.
1816	146	Randcomb Park.
1816	150	Warwick Castle.
1816	155	Crucis Abbey, Vale of Llangollen.

1816	162	*Ereinbrightstein, from Coblentz.*
1816	181	*Day-break, Oxfordshire.*
1816	182	*Lake of Geneva, and Mont Blanc.*
1816	184	*View at Beenham, Berks.*
1816	187	*Ullswater.*
1816	218	*Ullswater, breaking up of a Misty Morning.*
1816	219	*View at Matlock.*
1816	220	*Snow Piece.*
1816	238	*View in the Vale of Munster. Mist rising. Switzerland.*
1816	243	*La Bathia, Switzerland, a Cottage covered with Vines.*
1816	311	*Lake of Geneva, and Lausanne.*
1817	29	*Gold Rill Beck, Patterdale,* £52.10.0, John Allnutt Esq.
1817	32	*Leathe's Water. Helvellyn in the distance.*
1817	34	*Windermere. Painted on the Spot.*
1817	35	*Landscape, composition. This Picture was painted in the Louvre at Paris, in the autumn of 1814, was exhibited in the biennial exhibition of that year with the works of the Parisian artists, and obtained for Mr. Glover the honour of a gold medal from his majesty Louis XVIIIth,* £315.0.0, Sir S. Clark.
1817	39	*Leathe's Water. Skiddaw and Saddleback in the distance.*
1817	44	*Ullswater. Painted on the Spot,* £105.0.0, Lord Darnley.
1817	51	*Moonlight.*
1817	63	*Barnard Castle, Northumberland.*
1817	100	*Landscape. Composition.*
1817	108	*Landscape. Morning.*
1817	121	*Landscape with Kenilworth Castle.*
1817	123	*Cattle painted from Nature,* £105.0.0, Douglas Esq., Twyford.
1817	125	*Landscape. Composition, with the Temple of the Sybil.*
1817	126	*Rendcomb Park, Gloucestershire, the seat of Sir William Guise, Bart.*
1817	129	*Goats, painted from Nature,* £21.0.0, Mr. Hopkinson.
1817	134	*Goats. Study from Nature.*
1817	209	*Windsor Castle from near Cranbourne Lodge.*
1817	230	*View near the Source of the River Conway, North Wales.*
1817	243	*Penmachno Mill, North Wales,* £6.6.0, Clement Strong Esq.
1817	304	*A Cow, modelled from Nature.*
1817	305	*Ass and Foal, modelled from Nature,* Casts from these Models [304 and 305] may be purchased of the Clerk who attends the Room.
1823L	1	*London,* Duke of Argyll.
1823L	10	*Morning,* Duke of Argyll.
1823L	19	*Windsor Castle, from Cranbourne Lodge,* T. Griffith, esq.
1823L	89	*Stormy - Twilight,* W. Blake, esq.
1823L	156	*Moel Shabod, North Wales,* W. Blake, esq.
1823L	166	*Lancaster,* Countess of Essex.

GLOVER S

| 1815 | 203 | *Miserdine, the seat of Sir Edwin Sandys, Bart. Gloucestershire.* |

GLOVER W

1815	141	*Sherriff Hutton Castle, Yorkshire,* £5.5.0, Mr. Dyson.
1815	211	*Evening.*
1815	256	*Ulleswater,* £2.2.0, Mr. Fuller.
1815	282	*Milthorpe, Lancashire,* J. Leader Esq.
1815	301	*Aldridge, Staffordshire.*
1815	342	*Ulleswater, from Gowbarrow Park,* £2.2.0, Mr. Fuller.
1816	115	*Conway Castle.*
1816	264	*Manorbeer Castle,* T.G.
1816	293	*Furness Abbey.*
1817	19	*Warwick Castle,* £4.4.0, Mr. Smith, Air Street.
1817	41	*Ullswater,* £21.0.0, Chas. Long Esq., Langley Park.
1817	195	*Grasmere,* £4.4.0, Lord Suffolk.
1818	51	*A Scene near Chepstow.*
1818	54	*Chepstow Castle.*
1818	71	*Chepstow Castle.*
1818	103	*Part of the Interior of Tintern Abbey.*
1819	36	*Beddgelert, North Wales,* £21.0.0, W. Haldimand Esq.
1819	46	*Near Llanrwst, N. Wales,* £21.0.0, W. Haldimand Esq.
1819	84	*Vevai, Lake of Geneva.*
1819	320	*Ulleswater,* £2.2.0, Rev. A.C. Hawtrey.
1819	343	*Ulleswater,* £3.3.0, Sir Geo. Madden.
1819	346	*Elter Water, near Ambleside.*

GLOVER W JUN

| 1814 | 183 | *Caerphilly Castle.* |
| 1814 | 277 | *View near Litchfield.* |

GOODALL W

1853	155	*Half-way Home.*
1853	251	*The Charcoal Burners.*
1854	244	*The First Brood, Sold.*
1854	269	*The Water Lilies, Sold.*
1854	287	*The Lesson, Sold.*
1854	321	*The Refreshing Draught, Sold.*
1855	12	*The Grandfather's Watch, Sold.*
1855	35	*The Careful Nurse, Sold.*
1855	302	*The Old Willow, Sold.*

1855	314	*The Milking Shed*, Sold.

GOODALL WALTER

1853	21	*The Shepherd.*

GOODWIN E

1814	230	*Kenilworth Castle.*
1814	259	*Bolton Abbey, Yorkshire.*
1814	302	*Bridgnorth Bridge.*
1814	308	*View from Liverpool Lighthouse, looking into Wales.*
1815	83	*Mill, near Liverpool.*
1815	86	*A Barn; Horse watering.*
1815	99	*Thornton Church, near Chester.*
1815	197	*Scene near Carshalton, Surrey.*
1815	202	*Maidenhead Bridge.*

GOULDSMITH MISS

1813	199	*A View of Norwood, Surrey.*
1813	200	*A Landscape.*

GOULDSMITH MISS H

1814	50	*View of the Receiving-House of the Humane Society, on the North of the Serpentine, in Hyde Park.*
1814	51	*A Sketch from Nature.*
1815	53	*A View at Norwood, Surrey, £21.0.0, J.M. Barrett Esq.*
1815	54	*A View from Nature.*
1815	146	*A Landscape.*
1815	166	*A Wild Duck, a Study.*
1816	229	*A Sketch from Nature, with Travellers.*
1817	46	*Study from Nature.*
1817	47	*Study from Nature.*
1817	57	*Landscape, £42.0.0, Bishop of Durham.*
1817	65	*A Sketch.*
1817	72	*Study from Nature.*
1817	81	*Cottage at Tunbridge Wells.*
1817	102	*The Gipsy Cottage, Harrow Weald.*
1817	114	*A Sketch from Nature, Richmond.*
1818	52	*View of St. John's Wood Lane, Paddington, £12.12.0, Lord Dartmouth.*
1818	72	*View near Kilbourne, £14.14.0, J. Allnutt Esq.*
1818	102	*A Landscape.*
1818	107	*View at Abbot's Leigh, Somersetshire.*
1819	29	*View on Lord Northwick's Estate at Harrow Weald, Middlesex, £21.0.0, J. Bullock Esq.*
1819	63	*A Frame containing Four Sketches from Nature.*
1819	70	*Second View of Claremont - The Concert Cottage of her late R. H. The Princess Charlotte (One of a set).*
1819	85	*Third View of Claremont - The Island with the favourite Swan (One of a set).*

1819	86	*A View of St. John's Wood Farm, Mary-le-bone.*
1819	101	*Fourth View of Claremont - The Park (One of a set).*
1819	102	*A Landscape.*
1819	109	*First View of Claremont - The Mansion (one of a set).*
1819	114	*A Hare and Pheasant - a Sketch.*
1820	77	*A View on the Paddington Canal.*
1820	79	*A Landscape.*
1820	93	*A Study of Trees.*
1820	114	*Paddington Wharf, Grand Junction Canal.*

GRAHAM J

1820	49	*View of Loch Lomond, from the Stockey Moor.*
1820	84	*View of the Pass of Lennie.*
1820	133	*View of Loch Vennachoir.*

GREEN J

1823L	187	*A Cherub, – Webb, esq.*

GRIMALDI W

1816	24	*Portrait of Sir Joshua Reynolds, an Enamel.*

GROVES MRS

1818	179	*Portrait of Master Crofts.*
1819	161	*Will you have a bit, Fan?*
1820	204	*"Take a poon, pig" from Maria Edgeworth's "Simple Susan".*

GROVES MRS J

1817	136	*A Young Lady as a Flower Girl.*
1817	159	*Portrait of a Lady.*

HAAG CARL

1850	15	*The Fishmarket at Rome*, Sold.
1850	39	*The Tambourine Girl*, Sold.
1850	59	*A Group of Pilgrims in sight of St. Peter's, Rome*, Sold.
1850	87	*The Remains of the Temple of la Fortuna Capitolina, known to some by the name of the Temple of la Concordia, or of Juno Moneta, or of Vespasian. This temple, situated on the Clivus Capitolinus at Rome, was burnt down under Maxentius, 45 Pounds, Lewis Pocock Esq., Regents Park, Frame and glass £5.15.0 No.*
1850	270	*The House of Cola di Rienzi - the last of the Roman Tribunes*, Sold.
1850	361	*Pifferari, 35 Pounds, Mr. T.J. Thompson, The Green, Prestbury, near Cheltenham, Frame and glass £5.0.0.*
1851	121	*A Tyrolese Poacher.*
1851	125	*At Oberwesel on the Rhine.*
1851	136	*Part of an Old Chapel.*
1851	137	*A Tyrolese Chamois Hunter.*
1851	178	*Revenge.*
1851	189	*The Schoene Brunnen (Beautiful Fountain) at Nuremberg, with the Steeples of St. Sebald's Church in the distance . . . painted on the spot.*

1851	282	*Reconciliation.*
1852	96	*Ruins of the Temple of Vesta at Tivoli*, 35G, Alex. Morison Esq., Frame and glass £3.0.0.
1852	195	*The Return from the Campagna*, Sold, T. Schunk(?) Esq., 13 Kensington Gate, Frame and glass £5.18.0.
1852	230	*Roman Peasant Girl at a Fountain*, 20G, G. Braine Esq., Frame and glass £2.0.0.
1852	287	*A Lady in the Costume of Coblentz*, Sold, Frame and glass £4.5.0.
1853	68	*Marino Faliero and the Spy.*
1853	76	*Siesta.*
1853	127	*An Italian Peasant Girl.*
1853	136	*A Roman Model.*
1853	172	*His Royal Highness the Duke of Saxe Cobourg and Gotha, and His Serene Highness the Prince Leiningen, returning from a Chamois Hunt in the Valley of the Inner-Riss,Tyrol - The property of Her Majesty.*
1853	181	*Remains of the Temple of Jupiter Tonans, at the Roman Forum.*
1853	270	*A Tyrolese Peasant Girl.*
1853	290	*Capuchin collecting Alms.*
1854	82	*The Ruins of the Temple of Vista, at Tivoli*, 150gns., Frame and glass £12.0.0.
1854	83	*Morning in the Highlands - the Royal Family ascending Loch-na-gar. Painted by command of H. R. H. Prince Albert*, Sold, His Royal Highness Prince Albert.
1854	114	*A Roman Monk - Study of a Head*, 50gns., Brown Esq., Ringston(?), Tetsworth, Oxon, Including frame £4.14.0, Art Union.
1854	131	*Un Campagnole*, 30gns., ??? Esq., Fulwood Pk., Liverpool, Frame and glass £4.8.6.
1854	201	*Evening at Balmoral Castle - The Stags brought Home - Painted by command of her Majesty*, Sold, Her Majesty the Queen.
1854	290	*A Tyrolese Composer*, Sold (20gns.?), Noble Esq.
1855	20	*On Guard - Montenegro*, 40gns., Alexr. Morison Esq., Frame and glass £4.9.0.
1855	39	*Outpost, Montenegro*, 40gns., P. Hardwicke Esq., Cavendish St., Frame and glass £4.9.0.
1855	65	*Ruins of Salona, Dalmatia - A Party of Morlacks listening to a Bard singing the History of the Destruction of that City*, 300gns., Frame and glass £14.0.0.
1855	75	*A Venetian Lady*, 50gns., Gussell(?) Esq., 36 Palace Rd., Lambeth, Frame and glass £4.18.0.
1855	85	*A Dalmatian Peasant*, 50gns., Leaf Esq., Frame and glass £4.18.6.
1855	88	*Una Cervara*, 35gns., Frame and glass £4.3.0.
1855	160	*Ruins of the Palace of Diocletian Spalatro*, 35gns., Ebenezer Foster, The Elms, Cambridge, Frame and glass £4.3.0.
1855	199	*Head of an Armenian*, 80gns., Her Majesty The Queen, Frame and glass £7.9.0.
1855	201	*Their Royal Highnesses the Prince of Wales and Prince Alfred returning from Salmon Spearing. (The property of His Royal Highness Prince Albert)*, Sold, Her Majesty The Queen.
1855	230	*Head of a Turk*, 30gns., Frame and glass £3.2.0.
1855	240	*A Peasant Girl, Montenegro*, 40gns., S. Labouchere Esq., Portland Place, Frame and glass £4.9.0.
1855	290	*A Montenegrin Lady*, 40gns., Frame and glass £4.9.0.
1855	293	*A Montenegrin Princess*, 30gns., The Rt. Hon. Labouchere, Belgrave Sq., Frame and glass £3.2.0.

HAINES W

1816	34	*A Lyrist.*
1816	58	*Hebe.*
1816	59	*A Study.*

HARDING D

1829	225	*The Corsair's Isle - The Parting of Medora and Conrad - Evening, "She look'd, and saw the heaving of the main . . . Slow sinks, more lovely ere his race be run . . ." Corsair, Canto First and Third.* 80gns., F.G. Moon Esq.

HARDING J D

1818	215	*Greenwich Hospital - Sunset.*
1818	350	*Windsor, from the Great Park.*
1818	360	*The Aqueduct at Chirk, North Wales.*
1819	191	*Winandermere, from Troutbeck, Westmoreland.*
1819	273	*The Conservatory at Cashiobury, lately completed for the Earl of Essex; from the Designs of P. F. Robinson, Architect.*
1819	294	*View in the Valley of Frutegen, Switzerland - From a Sketch by Major Cockburn.*
1819	334	*Rydal Park, Westmorland*, £2.2.0, Sir J. Swinburne.
1820	287	*View of Matlock, from the Heights of Quebec, Derbyshire - Evening.*
1820	334	*Windsor Castle - Evening*, £2.2.0, J. Allnutt Esq.
1821	100	*Loch Tay*, £12.12.0, J. Allnutt Esq.
1821	144	*Scene near Fort Roc, Valley of Aoste, Switzerland*, £8.0.0, Major Pym.
1821	169	*Scene on the Beach, Hastings*, £2.12.6, Mr. Ostervald.
1821	181	*Loch Achray*, £2.2.0, Major Cockburn.
1821	182	*Composition*, £2.2.0, Do.
1822	165	*Composition*, £3.3.0, Mr. Pugin.
1822	166	*Greenwich, from the Creek, the Hospital in the distance.*
1822	171	*Composition*, £3.3.0, Do. [J. Webster Esq.]
1823	53	*The Trout Stream*, £15.15.0, W. Blake Esq.

1823	55	*Dover, from the top of Shakespeare Cliff,* £3.3.0, J. Webster Esq.
1823	116	*Caen, Normandy, from the road to Allemand, from a Sketch by the late H. Edridge, Esq.*
1823	262	*St. Goar, on the Rhine - from a Sketch by her Grace the Duchess of Rutland.*
1823	266	*The Ruins of St. Engracia, Zaragoza, Spain - from a Sketch by Edward Hawke Locker, Esq.,* £2.2.0, A. Cooper Esq., R.A.
1823L	74	*View in Cumberland,* J. Allnutt, esq.
1824	6	*Greenwich Hospital.*
1824	34	*Knaresboro' Castle, Yorkshire.*
1824	40	*Middle Fall, Aysgarth, Yorkshire.*
1824	73	*View of Mayence on the Rhine, from a Sketch by Her Grace the Duchess of Rutland.*
1824	82	*View between Coblentz and Ems, from a Sketch by Her Grace the Duchess of Rutland.*
1824	85	*Malham Cove,Yorkshire.*
1824	122	*The Moselle, from the Road to Treves - from a Sketch by Her Grace the Duchess of Rutland.*
1824	132	*Coblentz, from Ehrenbreitstein - from a Sketch by Her Grace the Duchess of Rutland.*
1824	163	*Distant View of Treves, from a Sketch by Her Grace the Duchess of Rutland.*
1824	229	*Evening.*
1824	266	*Garsdale - Yorkshire.*
1825	20	*View of St. Andrews,* £5.5.0.
1825	154	*Town, Castle and Port of Monaco, on the Gulf of Genoa,* 35gns.
1825	188	*A Sketch,* 1gn., General Grey.
1826	182	*Woburn Abbey, the seat of His Grace the Duke of Bedford, for Mr. Robinson's new Vitruvius Britannicus,* Sold.
1826	203	*St. Martin in the Val d'Aosta, Piedmont,* 30gns., Griffiths Esq.
1827	3	*Finisso Val d'Aosta,* Sold.
1827	137	*Monaco, Coast of Genoa,* Sold.
1827	211	*Ivrea, Val d'Aosta,* Sold.
1827	225	*Peter Tavey, near Tavistock, Devonshire,* Sold.
1827	266	*St. Pierre, near Aosta, Val d'Aosta,* Sold.
1827	350	*Chatillon Val d'Aosta.*
1828	159	*Modern Greece, "And many a summer flower is there . . ." Childe Harold.* 80gns., J(?) Morrison Esq., 63 Portland Place.
1830	181	*Byron's Dream, "A change came o'er the spirit of my dream . . ." Vide The Dream.* 80gns., Chas. Heath Esq.
1830	284	*Fisherman at Hastings,* Sold.
1831	71	*"But my soul wanders, I demand it back . . ." 25th and 26th Stanzas, Canto IV. Childe Harold.*
1831	164	*A Sonanese.*
1832	365	*Naples - Santa Lucia,* Sold.
1832	390	*Hastings - Fisherman,* Sold.
1833	162	*Hastings Beach, Beechy Head in the Distance,* 80gns.
1834	300	*The Port of London,* Sold.
1835	177	*The Grand Canal, Venice,* Sold.
1836	232	*Jacob's Well,* Sold.
1836	282	*Mount Tabor,* Sold.
1837	174	*Venice,* Sold.
1837	265	*Whitby Harbour,* Sold.
1837	275	*Dunstanboro' Castle,* Sold.
1838	84	*Scene in the Valley of the Coln, between Watford and St. Alban's, with the House and Grounds of Munden - the Seat of the late G. Hibbert, Esq.*
1838	143	*Berncastel, on the Moselle.*
1838	313	*Rheus, on the Rhine.*
1839	13	*Snowdon, from the road between Capel Cûrig and Beddgelert,* Sold.
1839	132	*Cochem, on the Moselle,* Sold.
1839	144	*Riva - Lago di Garda,* Sold.
1839	295	*Oberlanstein, on the Rhine,* Sold.
1840	21	*Dorking, from Bury Hill, the Seat of Charles Barclay, Esq.*
1840	127	*Morning, 'The morn is up again, the dewy morn. . ." Childe Harold, Canto III.*
1840	139	*Zell, on the Moselle.*
1840	192	*Bradgate Park, Leicestershire.*
1841	29	*Distant View of Loughborough and Charnwood Forest, from Cotes Hill, Leicestershire,* Sold.
1841	121	*The Falls of the Tumel,* Sold.
1841	144	*Boats going off - Hastings,* Sold.
1842	70	*Hastings Beach - Sunset.*
1842	144	*Endsleigh - a Seat of his Grace the Duke of Bedford.*
1842	162	*Frederickstein on the Rhine - Morning.*
1842	178	*Cattle, returning from Milking.*
1842	255	*Distant View of Windsor.*
1843	353	*Killin, Scotland,* Sold.
1844	51	*Chateau de Marienberg, on the Moselle,* 25gns., T. Burgoyne Esq., 43 Welbeck St.
1844	217	*Beech Trees in Penshurst Park,* 12gns., H. Burton Esq.
1845	9	*Beilstein, on the Moselle,* 30gns., John Whichelo Esq., 26 Charles St., St. James's, P.AU. 25£.
1845	26	*Berne, Switzerland - Morning, as it sometimes wakes among the Alps, "On the 19th I slept at Berne on my way to Basle; at half-past three o'clock in the morning a peal of thunder awoke me suddenly . . ." Extract from a Letter dated Sep. 27, 1844* 75gns., L. Loyd (?) Esq., 6 Green Street, Frame and glass £12.0.0.

1846 118 *The Range of the High Alps, taken from the Road between Como and Lecco - Como in the distance*, 100gns., S. Rucker Esq., Frame and glass £11.0.0 (including frame and glass).

HARLEY G
1816 157 *Cottages on the Thames.*
1816 159 *Sketch from the Bridge, Kensington Gardens.*
1817 25 *Sketch on the Medway.*
1818 307 *Timon in Exile. (Timon of Athens, act iv. scene 3).*
1819 218 *Cowes Castle, Isle of Wight.*
1819 227 *The Close of a Stormy Day, Vide William and Ellen – Moore's Irish Melodies.*
1819 240 *Interior of Great Stretton Church, Leicestershire.*
1819 256 *"The Lady in the Desert dwelt," From Campbells's "O'Connor's Child".*
1820 311 *Gurnet Bay, Isle of Wight - a Sketch.*
1820 360 *Near Eton.*
1820 374 *Sketch on Hampstead Heath.*

HARLY G
1817 181 *A Landscape.*
1817 182 *View from Vauxhall Bridge.*

HARRISON A P
1816 151 *Fountains, Abbey, and Hall, Yorkshire.*

HARRISON G
1846 163 *The Weary Veteran*, 30gns., Frame and glass £2.10.0.

HARRISON G THE LATE
1847 2 *Scene at Fontainbleau*, 15gns.
1847 19 *Summer*, 5gns.
1847 26 *Avenue de Fontainbleau*, 30gns.
1847 154 *Autumn*, 5gns.
1847 190 *Chateau de Fontainbleau*, 20gns.
1847 262 *Avenue de Meudon*, 10gns.
1847 304 *Jealousy*, 25gns.

HARRISON GEORGE
1845 119 *Sir Roger de Coverley with the Gipsies - vide Spectator*, 35 Pounds, S.M. Pete Esq., Russell Sq., Frame and glass £6.6.0.
1845 129 *Deserted*, 15 Pounds, W. Straight Esq., Chelmsford, Frame and glass £2.0.0, P.AU. 15£.
1845 169 *A Quiet Afternoon in Kensington Gardens*, 15 Pounds.
1845 215 *A Fete à St. Cloud, 1745*, 5 Pounds, Baring Wall Esq., Frame included.
1845 223 *"Madam, I do, as is my duty, Honour the shadow of your shoe-tye."* 20 Pounds.
1845 327 *The Discovery, "Porteus. 'How! let me see: Why this is the ring I gave to Julia.'..." Two Gentlemen of Verona.* 10 Pounds, Mrs. Nightingale, Lea Hurst, Matlock, Derbyshire, Frame and glass £1.1.0.

1845 329 *Beatrice in the Garden, "For see where Beatrice like a lapwing runs..." Much Ado About Nothing.* 10 Pounds.
1846 11 *In the Parc reservé, St. Cloud*, 15 Pounds, Frame and glass £1.0.0.
1846 46 *Midsummer Night's Dream, "Bottom. 'I have an exposition of sleep come upon me.'..." Oberon advancing with Puck. – Act IV. Scene 1.* 100 Pounds, Frame and glass £6.15.0.
1846 78 *Piffereri, Naples*, 10 Pounds, Frame and glass £1.0.0.
1846 100 *Fontainbleau, in the days of Henri Quatre*, 50 Pounds, Frame and glass £6.10.0.
1846 112 *First Run of the Season – October*, 30 Pounds, Mrs. R. Denman, 50 Torrington Sq., Frame and glass £3.5.0.
1846 154 *Fontaine des Chiens, in the King's Private Gardens, St. Cloud*, 65gns., Frame and glass £7.10.0.
1846 198 *Orangery, St. Cloud – Memorable on account of the events of the 19th Brumiare, when Napoleon, aided by his guards, dissolved the Legislative assembly.*, 10 Pounds, Harford Battersby Esq., 20 Half Moon St.

HARRISON MARIA
1847 197 *Basket of Flowers*, 15gns.
1847 204 *Camellias*, 8gns.
1847 205 *Jar of Flowers*, 10gns.
1847 206 *Spring Flowers*, 20gns.
1847 288 *Roses*, 8gns.
1848 58 *Flowers*, 10 Pounds, B.B. Pegge Burnell Esq., Beauchieff Abbey, near Sheffield.
1848 74 *Primroses*, 10 Pounds.
1848 115 *Roses*, 10 Pounds.
1848 224 *Jar of Flowers*, 15 Pounds.
1848 233 *Basket of Flowers*, 15 Pounds.
1848 297 *Poppies*, 10 Pounds.
1849 68 *Jar of Flowers.*
1849 186 *Basket of Roses.*
1849 292 *Grapes.*
1849 310 *Roses.*
1850 204 *Fruit*, 20 Pounds.
1850 302 *Strawberries*, 6 Pounds, Robinson Esq., Frame and glass £1.15.0.
1850 334 *Flowers*, 8gns., Robr. Lang, Bristol.
1851 222 *Blue Vase of Flowers.*
1851 236 *Basket of Grapes.*
1851 239 *Green Vase of Flowers.*
1851 293 *Basket of Roses.*
1852 64 *A Vase of Flowers*, 8G.
1852 305 *Flowers*, 6G.
1852 308 *A Glass of Moss Roses*, 6P, Mrs. Horrocks, Lark Hill, Preston.

1852	314	*Fruit, 6G.*
1852	315	*A Bank of Poppies, 3G.*
1853	169	*Fruit and Flowers.*
1853	194	*Hollyhocks.*
1853	225	*Roses.*
1853	245	*Dahlias.*
1853	293	*Primroses.*
1854	88	*Roses, 6gns., W.H. Hudson, Town Clerke, Bradford, Yorkshire.*
1854	148	*Fruit, 10gns.*
1854	184	*Jar of Flowers, 6gns., John Shaw, Christs Hospital.*
1854	251	*Gathered Flowers, 6gns.*
1854	257	*Just Gathered, 10gns.*
1854	307	*Gathered Flowers, 5gns.*
1854	319	*Roses, 6gns.*
1854	323	*Bank of Primroses, £6.0.0, Mrs. Davison.*
1855	70	*Jar of Flowers, £15.0.0.*
1855	78	*Primroses, £6.0.0.*
1855	96	*Fruit, £25.0.0.*
1855	152	*Fruit and Flowers, £10.0.0.*
1855	217	*Preparing for Dessert, 14gns.*
1855	233	*Camellias, £6.0.0.*
1855	249	*Roses on a Mossy Bank, £8.0.0.*

HARTLEY T

| 1820 | 57 | *A Study of a Dog.* |

HASELER H

1816	242	*Carisbrook Village, Isle of Wight.*
1816	280	*Fresh-Water Village, Isle of Wight.*
1817	186	*Duncomb Cliffs.*
1817	226	*Harpford Wood.*
1817	233	*Branscomb Rocks.*

HASTINGS

| 1816 | 78 | *A Boat in high Surf, View on the Beach at Brighton.* |
| 1816 | 103 | *Sketch from Nature, made between the Cape of Good Hope and St. Helena.* |

HASTINGS E

1816	63	*Study from Nature, in Turzell Dean, the Seat of P. S. Selly, Esq. Northumberland.*
1816	83	*A Study from Nature, in Turzell Dean, the Seat of P. S. Selly, Esq. Northumberland.*
1817	37	*View of Bamburgh Castle, Northumberland.*
1817	58	*Study from Nature in the Dean at Twizell House, Northumberland.*
1817	60	*Study in the Dean at Twizell House.*
1817	73	*Sketch near Egham.*
1817	78	*Sketch near Egham.*
1818	84	*Interior of a Wood Loft.*
1818	101	*Study on the Sea Coast near Bamborough Castle.*

1818	133	*A Shipwreck.*
1819	49	*A Study in Twizell Dean, Northumberland, the Seat of P.I. Selby Esq.*
1819	58	*The Brae Side.*
1819	83	*A Study in Durham Park, the seat of – Trotter, Esq.*
1819	112	*A Study in the Grounds at Clare Hall, near Barnett.*
1819	131	*The Burn Side.*
1819	135	*Study of a Child's Head.*
1819	324	*A Study in the Grounds at Clare Hall.*
1820	118	*The Wreck of a Smuggler at Bamborough Castle, Northumberland.*
1820	126	*A Scene in the Grounds at Howick, the seat of Earl Grey.*
1820	132	*Craster Tower, Northumberland, the Seat of Shafto Craster, Esq.*
1820	164	*Portrait of Miss Compton.*
1820	210	*A Scene in the Grounds at Howick, the seat of Earl Grey.*

HAVELL E

1818	114	*Scene near Blake's Lock, Reading.*
1818	149	*Sunset from Caversham-Warren, near Reading.*
1818	270	*The Abbey Gateway, from the Forbury, Reading, £15.15.0, J. Quintin Esq.*
1819	339	*Chepstow Castle, Monmouthshire.*
1820	50	*South Window of Tintern Abbey - Study from Nature.*
1820	67	*Weir at Caversham Lock, Reading.*

HAVELL EDM.

| 1817 | 251 | *Study from Nature.* |

HAVELL EDMUND

1817	27	*Maynard's Wharf, Reading.*
1817	36	*View on the Thames near Reading, £15.15.0, J.H. Quintin Esq.*
1817	94	*Part of Reading Abbey.*

HAVELL R

1816	131	*View of Moulsey, Hurst.*
1816	132	*View at Hampton.*
1817	77	*View from Broken Brow, near Reading, Berks. Evening.*
1818	244	*Warren House, near Reading, and a Cottage near Reading.*
1819	242	*View of the Bristol Channel, from Clifton.*
1820	104	*View of Wargrove, near Henley.*
1820	142	*Himley Hall, the Seat of Viscount Dudley and Ward, Worcestershire.*
1823L	2	*Village of Clappersgate, J. Vine, esq.*

HAVELL W

| 1805 | 23 | *Composition.* |
| 1805 | 33 | *Llanberris, and part of Snowdon.* |

1805	95	*Carew castle, near Pembroke.*
1805	123	*Harlech Castle, North Wales.*
1805	145	*A composition.*
1805	153	*The weary traveller.*
1805	157	*View near Wokingham, Berks.*
1805	166	*Caldecot Castle, near Chepstow.*
1805	209	*Dolbadern Castle on Llanberris lake.*
1805	219	*The vale of Mawddach and Cader Idris.*
1805	245	*The invocation of Medea, a sketch.*
1805	252	*Moel Siabod, North Wales.*
1806	12	*Patterdale, "Let fleecy flocks the hills adorn, And vallies smile with wavy corn."*
1806	59	*"While the ploughman near at hand, Whistles o'er the furrow'd land." – L'Allegro.*
1806	72	*Conway Castle.*
1806	75	*Snowdonia, "Mountains, on whose barren breast, The lab'ring clouds do often rest."*
1806	106	*The Banks of the Thames, near Reading.*
1806	137	*A lane near Marlow, Bucks.*
1806	151	*The Wye, near Monmouth. Afternoon.*
1806	160	*A Forest scene.*
1806	172	*Windsor Castle. Morning.*
1806	284	*Kilgaran Castle. Sunset.*
1807	21	*Part of the village of Bisham.*
1807	22	*The fall of Dolymellyne, near Dolgelle, N. Wales.*
1807	35	*View near Reading.*
1807	49	*Scene in Windsor Forest.*
1807	50	*Harlech Castle, N. Wales - twilight.*
1807	60	*Pont y Pair, near Llanrwst, N. Wales.*
1807	83	*The bye road.*
1807	125	*The Warren House, near Wokingham.*
1807	129	*Shepherds reposing, 60gns., L.(?) Angerstein Esq.*
1807	155	*View of Nant Francon, N. Wales.*
1807	174	*Gathering walnuts, 40gns., Dr. Benk(?).*
1807	193	*Windsor Castle, Lord Essex.*
1807	206	*A brook near Reading.*
1807	301	*Wood scene, near Reading.*
1807	306	*A lane near Marlow.*
1807	308	*View on the Clyde.*
1807	319	*Village of Bisham.*
1808	36	*Caversham Bridge, near Reading.*
1808	49	*Scene on the banks of the Keswick Lake, 40gns., Mr. Wolfe.*
1808	65	*At the village of Troutbeck, Westmoreland.*
1808	90	*Windsor Castle.*
1808	114	*Stormy twilight, 60gns., L. Angerstein?.*
1808	182	*Rydall, near Ambleside.*
1808	205	*The Thames, near Henley, 40gns., Mr. Wolfe.*
1808	211	*Part of Tilberthwaite, near Coniston.*
1808	226	*Grassmere Lake.*
1808	233	*Clappersgate, Westmoreland.*
1808	244	*Shepherds destroying a snake, "And with sharp stones demolish from afar His haughty crest, the seat of all the war."*
1808	253	*The Beck, near Ambleside, Sir Thos. Gage(?).*
1808	263	*Scene near Keswick.*
1808	330	*A grove from the green, Ambleside.*
1809	5	*Eagle Crag, at Wast Water, Cumberland.*
1809	6	*The Thames, near Henley.*
1809	7	*Cottage scene, near Wast Water, Cumberland.*
1809	38	*The woodcutters.*
1809	42	*The farm yard.*
1809	63	*Sun set.*
1809	107	*Scene from the head of Windermere.*
1809	111	*On the banks of the Brathay, near Windermere.*
1809	116	*Scene near Keswick.*
1809	137	*Bursting of a cloud.*
1809	144	*Ploughing in Oxfordshire.*
1809	157	*An effect of sun-shine on Windermere.*
1809	239	*A wood scene at Troutbeck, near Ambleside.*
1809	245	*The Thames, from Caversham Bridge, near Reading.*
1809	320	*Making the corn rick.*
1809	327	*The straw yard.*
1809	334	*The Beck at Ambleside, after much rain.*
1809	336	*Kentmere Hall, near Ambleside.*
1809	337	*A scene in Windsor Forest.*
1810	2	*Scene at Binfield, near Reading.*
1810	98	*View in Binfield Park.*
1810	107	*The upper Waterfall, at Rydall, Westmoreland.*
1810	109	*The Woodman.*
1810	124	*A River Scene near Keswick, Cumberland.*
1810	140	*Una, from Spencer's Fairy Queen, "One day, nigh weary of the irksome way . . ." Canto III. Book I.*
1810	160	*A Wood Scene, near Reading.*
1810	187	*A Grove Scene on the Banks of Windermere, Westmoreland.*
1810	192	*The Islands on Rydal Lake, Westmoreland.*
1810	195	*A Scene in Windsor Forest.*
1810	247	*The Residence of Spencer the Poet, where he wrote his Fairy Queen, at Glencolman, in Ireland.*
1810	298	*A Carpenter's Yard at Reading.*
1811	4	*Part of Caversham, near Reading.*
1811	12	*Distant View of the Islands of Wyndermere.*

1811	35	*On the Banks of the Rothay, with the Rydal Woods.*
1811	36	*Goodrich Castle, on the Wye - Sun-set.*
1811	41	*The Saw-pit.*
1811	43	*Caversham Bridge on the Thames, near Reading.*
1811	52	*Lowdore, near Keswick.*
1811	76	*Castle Cragg, and other Mountains of Borrowdale.*
1811	108	*Scene on the River Kennet, at Reading.*
1811	144	*The Rain-bow - Evening.*
1811	188	*The Fall of the Wye at New Wier, near Monmouth.*
1811	211	*Near Ambleside.*
1811	248	*Kentmere Hall near Troutbeck, Westmoreland.*
1811	323	*View on the Castle Grounds at Wallingford.*
1811	330	*Ambleside Bridge.*
1811	339	*Cottage Scene.*
1811	367	*On the Banks of Keswick Lake.*
1812	31	*View of the Mountain, called Coniston Old Man, Lancashire.*
1812	65	*Hedsor Wharf, near Maidenhead.*
1812	89	*Cliefden Spring, near Maidenhead.*
1812	102	*Fishermen putting off in their Ferry Boat.*
1812	108	*Fishermen going to their Boats.*
1812	162	*Kilgarran Castle, on the River Tyvi, near Cardigan, South Wales.*
1812	173	*Skelwith Force, near Ambleside.*
1812	210	*Distant View of Lowdore, from the Banks of Keswick Lake.*
1812	214	*Scene on the Road between Kendal and Ambleside.*
1812	229	*Boats and Fishermen, with a View of the East Cliff, at Hastings.*
1812	236	*Bridge at the Isle of Formosa, near Maidenhead.*
1812	260	*Bridge over the Thames, at Sutton Courtney, near Abingdon.*
1812	263	*The Thames, near Henley.*
1812	293	*Bownas Church, and Part of Windermere.*
1812	320	*Caversham Bridge, near Reading.*
1813	13	*Evening.*
1813	44	*Part of Windsor Castle.*
1813	59	*Rhydland Castle, St. Asaph's Cathedral and Bridge, on the Banks of the Clwyd, North Wales.*
1813	61	*The Thames, from Richmond Hill.*
1813	80	*Wood Scene.*
1813	91	*Shrewsbury Castle.*
1813	93	*Llaugherne Castle, South Wales - Sun rise.*
1813	172	*Whitwell, Lancashire.*
1813	188	*Near Coniston, Lancashire.*
1813	201	*Scene on the Thames at Windsor.*
1813	202	*Hastings Castle, Sussex.*
1813	207	*The Thames, from Park Place, near Henly.*
1813	209	*View in North Wales.*
1813	219	*Part of Loughrigg Mountain, near Ambleside, Westmorland.*
1813	225	*Linlithgow Palace, Scotland.*
1813	235	*Thunder Storm, Rydale, Westmorland.*
1814	81	*Warren House, on the Estate of the Right Hon. Lord Braybrooke, near Oakingham, Berks.*
1814	108	*Billingbear, near Oakingham, Berks, Seat of the Right Hon. Lord Braybrooke.*
1814	231	*View on the Thames, at Hampton.*
1815	79	*Whalla Crag, on the banks of Keswick Lake, Cumberland.*
1815	128	*Walnut Gathering, at Petersham, near Richmond, Surrey.*
1816	253	*Head of Ullswater.*
1823L	13	*Bowness Church, and part of Windermere,* J. Gwilt, esq.
1823L	25	*Llanberris Lake and Dolbaddern Castle,* C.N. Baily, esq.
1823L	27	*River Scene,* J. Elliott, esq.
1823L	28	*Landscape,* T. Tomkison, esq.
1823L	29	*Windsor Castle,* Countess of Essex.
1823L	42	*Kenilworth Castle,* W. Leader, esq. M.P.
1823L	55	*View in Cumberland,* J. Allnutt, esq.
1823L	57	*Sun-rise,* J. Tomkison, esq.
1823L	75	*Rydal, Westmoreland,* W. Leader, esq. M.P.
1823L	82	*View from the Top of Cader Idris,* T. Griffith, esq.
1823L	90	*Road Scene,* J. Vine, esq.
1823L	98	*View at Wandsworth,* W. Leader, esq. M.P.
1823L	99	*View in Westmoreland,* W. Leader, esq. M.P.
1823L	123	*At Ambleside,* T. Griffith, esq.
1823L	127	*Kilgarren Castle,* J. Allnutt, esq.
1823L	147	*Landscape,* Mr. R. Havell.
1823L	151	*Evening,* J. Gwilt, esq.
1823L	153	*Windermere,* W. Leader, esq. M.P.
1823L	189	*A Corn Field,* Countess of Essex.
1823L	204	*Derwent Water,* T. Griffith, esq.
1827	27	*Garden Scene on the Braganza Shore, Rio de Janeiro,* 25gns., S. Smith Esq.
1827	37	*View of the River Brathay, near Ambleside, Westmoreland,* 25gns.
1827	57	*Sunset - View of the Harbour of Rio de Janeiro, taken from the Braganza Shore,* 25gns., Mr. Rennie, 21 Whitehall Place.

1827	80	*Sunrise - Entrance to the Grand Canal with the Junks employed in the late Embassy to China,* 25gns.
1827	82	*View in the Suburbs of the City of St. Sebastian, Rio de Janeiro,* 25gns., Mr. Moxon, No. 23 Lincolns Inn Fields, Wishes to take the frame and glass, £2.11.0.
1827	83	*East Cliff, Hastings - Sunrise,* 8gns., S. Walker Esq., Harpers Hill House.
1827	119	*Richmond Castle, Yorkshire,* 25gns., C. Barclay Esq.
1827	127	*Rydal Lake, Westmoreland,* 10gns.
1827	135	*Boulney on the Thames, taken from Park Place, Henley, Oxon,* 10gns.
1827	158	*Sunset, near Twickenham,* 8gns.
1827	300	*Wood Scene, Autumnal Morning; the new opening in Park Place, seat of E. Maitland, Esq., Henley, Oxon,* 15gns., G. Hibbert Esq.
1827	352	*View of the Thames, from Park Place, Henley, Oxon.*
1828	17	*The Temple of Vesta - Tivoli,* 25gns.
1828	84	*Ponte Lucano over the Anio, Tomb of Plautius near Tivoli,* 25gns.
1828	92	*St. Peter's, Monte Mario, from the Banks of the Tiber - Sunset, "But Rome is as a desert, where we steer Stumbling o'er recollections." –* Byron. 25gns.
1828	253	*Neptune's Grotto, Tivoli, "Horribly beautiful! but on the verge . . ."* Byron. 25gns.

HAWKINS H
1820	134	*Portrait of a Lady.*
1820	165	*Portrait of a Lady.*
1820	182	*Portrait of an Artist..*

HAYDON B R
1814	61	*The Judgment of Solomon, "Then came there two women, that were harlots, unto the king, and stood before him . . ." The 3d Chapter of the first Book of Kings.* £630.0.0, Sir. N. Elford and Mr. Tenycombe.
1816	26	*A Study for a Head.*
1817	124	*Study of a Head.*
1817	127	*Study of a Head, "Looking a loss that nothing can regain." Scott's House of Mourning.*
1817	148	*Study of a Head.*
1818	160	*Study of a Head.*
1818	161	*Study of a Head for the Picture of Christ entering Jerusalem.*
1818	164	*Listening to the Voice of the Angel of Death, "The angel of Death they call Duma, and say, he calls dying persons by their respective names, at their last hour." Sale's Koran.*
1818	180	*Study from a Polish Jew.*
1818	191	*Study of a Head.*
1818	192	*Study of a Gipsy.*
1818	193	*Portrait of Wordsworth, "While yet a child, and long before his time . . ." Excursion.*

HAYTER C
| 1820 | 238 | *Recollection - a Sketch of Mde. Saqui's Descent on the Rope from the Fireworks at Vauxhall.* |

HAYTER J
| 1820 | 76 | *"And nought was there but Wallace and his sorrows!."* |

HAYTER MISS
| 1820 | 173 | *Portrait of a Lady.* |

HAYTER MISS A
| 1817 | 151 | *A Miniature.* |

HAYTER T
| 1820 | 122 | *The Shunammite Woman before Elisha and his Servant Gehazi.* |

HEAPHEY T
1823L	84	*Chiding the favorite,* Earl of Tankerville.
1823L	92	*The Lout's Reward,* Earl of Tankerville.
1823L	110	*Game,* Earl of Essex.
1823L	125	*Boys disputing over their Day's Sport,* Marquis of Stafford.
1823L	152	*The Mother's Prayer,* G. Hibbert, esq.
1823L	161	*Returning from the Baker's,* G. Hibbert, esq.

HEAPHY T
1807	99	*Study from nature.*
1807	117	*Robbing a market girl,* Walsh Porter Esq.
1807	139	*Young gamblers, companion to 117.*
1807	273	*Woman with cabbage nets, "Industry, oh, couldst not thou provide for old age? Ah no! deep poverty marks her footsteps, and follows her to the grave."*
1807	315	*Gathering water-cresses,* 40gns., Lord Cawdor.
1808	26	*Disappointment, or the lease refused,* Lord Cawdor.
1808	66	*A study from nature.*
1808	74	*Fishermen,* Lord Essex.
1808	100	*The poacher alarmed, "The trembling of a leaf alarms the guilty mind."* 50gns. ????
1808	129	*Moor fowl and snipe.*
1808	145	*Game.*
1808	174	*Boys disputing over their day's sport,* 50gns., Marquis Stafford.
1808	183	*Inattention,* 70gns., Lord Kinnaird.
1808	206	*Return from the baker's,* 80gns., G. Hibbert.
1808	214	*Tired pedlar,* 50gns., Mr. Thos. Hope.
1808	241	*Chiding the favourite,* 40gns., Lord Ussulston(?).
1808	255	*Credulity, "When Love's epistle its sweet tale explains, Time flies untold, and wild confusion reigns."*
1808	290	*The lout's reward,* 60gns., Lord Ussulston.
1809	9	*Game.*

1809	22	Fish market, 400gns., Mr. Wheeler.
1809	69	Gleaners.
1809	72	Gamblers.
1809	91	Family doctress.
1809	146	Fisher children.
1809	192	Fish.
1809	224	The offer accepted (companion to credulity of last year).
1810	91	Wild Fowl Shooting.
1810	96	Red-legged Partridge, Plover, Snipe, &c.
1810	108	The Proposal, 120gns.
1810	154	Fisher Girl.
1810	166	Domestic Happiness.
1810	212	The Appointment, Mr. Nobford(?).
1810	218	Girl going to Market, 50gns., Mr. Birch.
1810	235	Marketing, 80gns., Lord Yarborough.
1810	282	The Mother's Prayer, 80gns., G. Hibberth Esq.
1811	20	Scene round a Fish Tub, symptoms of a Broomstick Wedding.
1811	39	Going to the Fair.
1811	79	Vanity, 50gns., Mr. Smith.
1811	89	Relieving the Blind, "And the King shall answer, and say unto them, Verily I say unto you . . ." Matthew, Chap. xxv. Verse 40.
1811	138	Scene in a Country Ale-House, Come live with me, and be my love.
1811	181	The Happy Meeting.
1811	209	Christmas Gambols, 200gns.

HEARNE T

1823L	32	View of Bath from Spring Gardens, E.H. Locker, esq. F.R.S.
1823L	190	Westminster Hall, Rev. Dr. Burney.

HEWLETT J

1813	23	Composition of Flowers.
1813	28	Portrait of a Young Lady.
1814	2	Composition of Flowers.
1814	7	Fruit and Flowers.
1814	21	Composition of Flowers.
1815	22	A Composition of Flowers.
1818	159	Fruit and Flowers.
1818	175	Fruit and Flowers.
1818	181	Fruit and Flowers.
1818	185	Fruit and Flowers.
1819	178	Composition of Flowers.

HIL R

1805	160	Cattle: characters of age and youth.

HILLS R

1805	2	Red deer.
1805	42	Cattle going to market.
1805	43	A forest scene, a sketch.
1805	51	Cattle at a ford, a sketch.
1805	54	A group of sheep.
1805	90	Cattle, Evening.
1805	100	A forest scene, with fallow deer, a sketch.
1805	101	Cattle, Noon.
1805	105	Cattle at a ford, a sketch.
1805	113	Cattle, a sketch.
1805	121	Cattle on a road.
1805	130	A scene in Windsor Forest.
1805	131	Stags and hinds, a sketch.
1805	139	Cattle, a sketch.
1805	178	Sheep, a sketch.
1805	180	Stag and hinds.
1805	186	A sketch.
1805	192	Fallow deer, a sketch.
1805	203	Deer, a sketch.
1805	211	A Staggerd.
1805	220	Cattle, a sketch.
1805	253	Cattle, a sketch.
1806	1	A Forest Scene, with Deer.
1806	6	Landscape and Cattle.
1806	11	Cattle on a road.
1806	21	The outlying Deer.
1806	34	Sketch from Nature, in Windsor Forest.
1806	43	Forest Scene with Deer.
1806	51	Ass and Foal.
1806	53	A Forest Scene, with Deer.
1806	58	Cattle on a road.
1806	60	Interior of a Cow-house.
1806	66	Stags.
1806	71	Landscape and Cattle, a sketch.
1806	100	Scene in Windsor Park.
1806	107	A Landscape, with Cows, a sketch.
1806	113	A group of Sheep.
1806	121	Cattle.
1806	131	Sheep.
1806	142	Stag and Hinds.
1806	147	Cattle, a scene between Buttermere and Crummock Water, Cumberland.
1806	155	Mare and Colt, a scene on Bagshot Heath.
1806	162	A Sketch from Nature.
1806	163	Cattle.
1806	164	Cattle.
1806	166	Cattle.
1806	167	Sheep.
1806	171	Sheep.
1806	193	Sheep.

1806	198	*Cattle.*
1806	209	*Landscape and Cattle.*
1806	210	*Cattle.*
1806	218	*A Kentish Plough.*
1806	226	*Design for a Frontispiece.*
1806	248	*Landscape and Cattle.*
1806	261	*A Sun-set, with Cattle.*
1806	263	*Stags fighting, a sketch.*
1806	266	*Stags in July, scene in Windsor Forest.*
1806	273	*Sheep, a sketch.*
1806	275	*Stags, a scene on the grounds at Thornville Royal, Yorkshire.*
1806	283	*Ploughing, a sketch.*
1806	291	*Cattle, a Sketch.*
1807	32	*Cottage at Troutbeck, near Ambleside, with cattle.*
1807	38	*A mountaineer, scene at the entrance of Borrowdale,* Lord Monson.
1807	67	*A sketch.*
1807	96	*Nookend Bridge, near Ambleside.*
1807	126	*Red deer.*
1807	134	*Fallow deer.*
1807	153	*A cow shed at Rigside, Borrowdale.*
1807	159	*At Troutbeck, near Windermere.*
1807	163	*A stag scene in Windsor Forest.*
1807	185	*Colonel Thornton making a remarkable shot at a deer in Thornville - Royal Park, from the Royal Tom Oak, a distant view of the Druid's Temple,* Col. Thornton.
1807	192	*On the Grange River, Borrowdale.*
1807	195	*Sketch from Nature.*
1807	196	*A sketch.*
1807	201	*Skelwith Bridge, near Ambleside.*
1807	223	*A group of sheep.*
1807	232	*Forest scene.*
1807	235	*Forest scene, with deer.*
1807	243	*Oxen.*
1807	247	*Landscape and cattle.*
1807	252	*Cattle.*
1807	253	*Cattle.*
1807	258	*A sketch.*
1807	263	*Oxen, a sketch.*
1807	268	*Cattle.*
1807	269	*Cattle.*
1807	275	*Cattle.*
1807	298	*Cow and calf.*
1808	8	*Harrowing.*
1808	21	*Ploughing.*
1808	78	*An ox team (Scene in Windsor Forest.),* 15gns., Lord Milford.
1808	96	*Cattle.*
1808	110	*Cattle.*
1808	119	*Cattle.*
1808	157	*Forest mare and foal.*
1808	167	*Forest horses.*
1808	217	*Cattle,* Sir C. Stanley.
1808	222	*Cattle on a road.*
1808	229	*Landscape and cattle.*
1808	232	*A straw yard,* 40gns., Dr. Clutterbuck(?).
1808	236	*A cow layer.*
1808	269	*Ass and foal.*
1808	277	*Forest scene, with fallow deer.*
1808	292	*Agriculture, a scene in Windsor Great Park.*
1808	301	*Ass and foal.*
1808	304	*Scene in Windsor Forest.*
1808	313	*Scene in Windsor Forest.*
1808	317	*Scene near Cranbourn Lodge, with cattle.*
1808	322	*Cattle.*
1808	328	*Cattle on a road.*
1808	332	*Frontispiece to a book of Etchings.*
1809	47	*Stags, scene near the banks of Loch Lomond.*
1809	50	*Pigs.*
1809	54	*Ass and foal.*
1809	56	*Mules, a scene on the banks of the Wye.*
1809	87	*Cattle.*
1809	94	*Asses.*
1809	104	*Cattle, scene near Bowdar Stone, in Borrowdale, looking towards Glenamatara, &c.*
1809	120	*Cattle.*
1809	127	*Cattle.*
1809	135	*Scene on the Grange river, Borrowdale, with cattle.*
1809	149	*A stag.*
1809	156	*Sow and pigs.*
1809	191	*Borrowdale, Derwentwater &c. from Sprinkling Tarn, with cattle.*
1809	254	*Cattle, scenery at Ambleside.*
1809	256	*Cattle.*
1809	267	*Interior of a cow-house.*
1809	289	*Cattle, in the distance Coniston Fells, from Rydall Park.*
1809	307	*Cattle.*
1809	308	*Cattle.*
1809	316	*Sheep.*
1809	322	*Cattle.*
1809	328	*Fallow deer.*
1809	329	*Cattle.*

1810	15	*Fallow Deer.*
1810	22	*Sun-set, with Cattle.*
1810	33	*Fallow Deer.*
1810	58	*Cattle.*
1810	65	*An old Barn, formerly part of St. Rhadagund's Abbey, near Dover, with Cattle.*
1810	72	*Scenery near Ambleside, with Cattle.*
1810	77	*Interior of a Stable.*
1810	100	*Asses.*
1810	106	*Scene between Keswick and Buttermere - with Cattle.*
1810	112	*Ass and Foal.*
1810	133	*Cattle.*
1810	142	*Scenery near the Entrance of Borrowdale, with Mountain Sheep.*
1810	144	*Asses.*
1810	163	*An Ox Team.*
1810	169	*Farm Yard with Cattle, &c.*
1810	178	*Cattle.*
1810	215	*The Hunted Deer.*
1810	233	*Scenery in Borrowdale, with Cattle.*
1810	254	*Harrowing.*
1810	263	*Ploughing.*
1810	283	*Ass and Foal.*
1810	287	*Old Acquaintance, Mr. Waites.*
1811	47	*Cattle.*
1811	53	*Cattle returning from Market.*
1811	61	*Fallow Deer.*
1811	90	*An old Cart Shed at Chapple, near Dorking.*
1811	109	*Fallow Deer.*
1811	115	*Landscape and Cattle.*
1811	121	*Cattle.*
1811	137	*Fallow Deer.*
1811	139	*Bull and Cow.*
1811	153	*Cattle.*
1811	157	*Fallow Deer.*
1811	163	*Asses.*
1811	172	*A Farm-Yard at Westhamble, near Box-Hill, Surrey.*
1811	213	*Scene on the River Mole, Surrey, with Cattle.*
1811	220	*Landscape and Cattle.*
1811	228	*Landscape and Cattle.*
1811	257	*Cattle.*
1811	265	*Stags.*
1811	266	*Landscape and Cattle.*
1811	276	*Cattle.*
1811	286	*Cattle.*
1811	292	*Cattle.*
1811	326	*Scene in Norbury Park, Surrey, with Cattle.*
1811	333	*An Interior.*
1811	337	*Scene in Langdale, with Cattle.*
1812	2	*An Ox Team, a Sketch.*
1812	9	*Asses.*
1812	26	*Road Scene, at Albury, Surrey, with Cattle.*
1812	30	*Scene in Ashted Park, Surrey, with Fallow Deer.*
1812	37	*A Man perishing in a Snow Storm, " – and down he sinks . . ." Thomson's Winter.*
1812	47	*Scene at Pollsden, Surrey, with Cattle.*
1812	59	*Scene in Norbury Park, Surrey, with Cattle.*
1812	66	*Road Scene, with Cattle.*
1812	78	*Scene at Cassiobury, with Cattle.*
1812	106	*Scene in Windsor Forest, with Horses.*
1812	112	*A Mill Stream, at Gommershall, Surrey, with Cattle.*
1812	119	*"Th' advent'rous Boy, that asks his little Share . . ." Rogers's Pleasures of Memory.*
1812	159	*A Farm Yard at Sheen, Surrey.*
1812	163	*A Farm Yard.*
1812	169	*Landscape and Cattle.*
1812	171	*A Farm Yard, near Newbury.*
1812	198	*The Roebuck, W. Fawkes Esq.*
1812	208	*Red Deer.*
1812	232	*Cattle - Langdale Pikes in the Distance.*
1812	249	*Skiddaw, from the Vale of Newlands, with Cattle.*
1812	252	*Sketch from Nature.*
1812	277	*A Sketch from Nature.*
1812	298	*Entrance of Dog Kennel-Lane, Albury, Surrey, with Cattle.*
1812	305	*Asses carrying Iron Ore on the Banks of the Wye - A Sketch.*
1812	306	*Scene in Albury Park, Surrey, with Fallow Deer.*
1813	6	*The Stag, "The antler'd monarch of the waste."* £15.15.0, Lord Milford.
1813	58	*A Farm Yard.*
1813	197	*Woodland Scene, with Cattle.*
1814	122	*Farm-Yard, Twilight.*
1814	208	*Road Scene, with Cattle,* £21.0.0, J.G. Lambton Esq., M.P.
1814	258	*Evening Effect on the Banks of Derwent Water, with Cattle,* £31.10.0, J.G. Lambton Esq., M.P.
1814	268	*Farm-Yard,* £21.0.0, Mr. Kinnaird.
1814	288	*Forest Horses.*
1814	303	*Landscape and Cattle,* £26.5.0, Mr. Willimotte.
1814	304	*Fallow Deer.*
1814	307	*Cattle crossing a Ford - Sunset.*

1815	118	*Landscape and Cattle*, £15.15.0, J. Dimsdale Esq.
1815	235	*From the Head of a Stag, modelled by himself.*
1815	265	*Stags, Sun-set*, £21.0.0, T. Garle Esq.
1815	269	*Scene in the Beck, near Ambleside, with Cattle.*
1815	286	*Scene on the River Mole, with Cattle.*
1815	298	*The Close of the Chace, the Stag taking Soil.*
1815	315	*Landscape and Cattle.*
1815	351	*Fallow-Deer, Scene in Windsor Forest,* £26.5.0, T. Garle Esq.
1816	100	*Landscape and Cattle*, £15.15.0, Mr. Serjeant.
1816	165	*Fallow Deer.*
1817	7	*Brood Mares.*
1817	26	*Scene at Oatlands, with Cattle.*
1817	183	*The Cervus Wapiti, or Great Stag of the Missouri, North America*, £31.10.0, J. Waite Esq.(?).
1817	213	*Scene in Borrow-dale with Cattle.*
1817	236	*Scene at Sundridge, Kent, with Cattle*, £15.15.0, Mr. Waite.
1817	248	*Boars Fighting*, £10.10.0, Walter Fawkes Esq.
1817	264	*A Shepherd Boy.*
1817	288	*Road Scene in Kent, with Cattle*, £15.15.0, Lord St. Helens.
1818	5	*Scene in Knole Park, with Fallow Deer.*
1818	44	*Road Scene, with Castle.*
1818	45	*Scene at Bowbeech, Chiddingstone, Kent.*
1818	254	*Cattle. - Twilight.*
1818	260	*Farm Yard, near Tonbridge*, £15.15.0, J.M. Belisario Esq.
1818	262	*Scene in Knole Park, with Fallow Deer.*
1818	273	*Farm Yard, near Seven Oaks, Kent.*
1818	338	*Road Scene near Bailey's Hill, Kent.*
1823	5	*Interior of a Cow House.*
1823	13	*Sheep.*
1823	23	*Stag and Hind.*
1823	29	*Landscape and Cattle - Evening effect.*
1823	77	*Stag and Hinds.*
1823	114	*Wood Scene, with Fallow Deer.*
1823	139	*Landscape and Cattle.*
1823	146	*Landscape and Cattle.*
1823	154	*Mountain Scene, with Stags*, £6.6.0, J. Webster Esq.
1823	158	*Scene in Knowle Park, with Fallow Deer*, £7.17.6, J. Webster Esq.
1823	160	*Cattle*, £7.17.6, J. Webster Esq.
1823	170	*Scene on Bagshot Heath, with Sheep.*
1823	174	*Cattle.*
1823	188	*Fallow Deer*, £31.10.0, G. Constable Esq.
1823	226	*Road Scene, with Cattle - Sun-set.*
1823	230	*Mountain Scenery, with Cattle.*
1823	231	*Lane Scene at Beddington, Surrey.*
1823L	149	*Deer*, J. Burbank, esq.
1823L	174	*An Interior*, The Artist.
1824	3	*Mountain Scenery, with Cattle.*
1824	10	*Park Scenery, with Fallow Deer.*
1824	60	*Ploughing.*
1824	61	*The Farmer.*
1824	84	*A Farm Yard.*
1824	96	*Cattle.*
1824	106	*Fallow Deer.*
1824	126	*Asses.*
1824	141	*Farm-yard.*
1824	154	*Scene in Knowle Park, with Fallow Deer.*
1824	164	*A Stag.*
1824	192	*Cattle - Twilight.*
1824	205	*Fallow Deer.*
1824	216	*A Farm Yard.*
1824	223	*Cattle - Sunset.*
1824	247	*A Gravel Digger.*
1824	254	*Haymakers.*
1824	255	*A Farm Yard.*
1824	256	*Cottagers.*
1824	269	*Reapers.*
1824	270	*Cottagers.*
1825	18	*Cattle*, 15gns.
1825	21	*Park Scene with Fallow Deer*, 30gns.
1825	59	*Cattle*, 15gns.
1825	67	*Cattle - Scene between Delft and the Hague*, 6gns., S. Griffith Esq.
1825	127	*Cattle - Scene on the River Mole*, 25gns.
1825	132	*The Father at Home*, 10gns.
1825	138	*The Father expected*, 10gns.
1825	142	*A Stag*, 30gns.
1825	147	*Barn Door*, 10gns.
1825	162	*Roe-buck*, 6gns., Sir Matthew Ridley, Frame and glass £0.10.6.
1825	173	*Cattle - Villevorde, between Antwerp and Brussels*, 15gns. pair, Companion 182.
1825	182	*Cattle, between Delft and Rotterdam*, 15gns. the pair, Companion 173.
1825	190	*A Squirrel in the Tree*, 5gns.
1825	200	*Cattle - Scene between Leyden and the Hague*, 15gns.
1825	229	*Alderney Cattle, the property of J. Allnutt Esq*, Sold 20gns.
1825	240	*Cattle - Scene on the Mole, Surrey*, 15gns.
1825	248	*Mountain Scenery, with Cattle*, 20gns.

1825	255	*Cattle*, 20gns.
1825	261	*Reapers*, 10gns.
1826	3	*Milking*, 30gns.
1826	5	*Lane Scene, near Watford*, 6gns.
1826	78	*Remains of the Priory at Tonbridge*, 12gns.
1826	99	*Farm Yard - Twilight*, 20gns.
1826	106	*Fallow Deer*, 20gns.
1826	115	*A Farm Yard*, 15gns.
1826	124	*A Hay Field*, 15gns.
1826	143	*Heifers*, 15gns.
1826	146	*Farm Yard, and Haymakers Returning*, 20gns.
1826	147	*Young Nurses*, 5gns.
1826	154	*Haymakers*, 10gns.
1826	158	*Winter*, 6gns., Holford Esq.
1826	178	*Haymakers*, 10gns.
1826	208	*Fallow Deer*, 15gns.
1826	230	*The Farmer*, 10gns.
1826	232	*Reapers*, 10gns., Sold.
1826	247	*Fallow Deer*, 20gns.
1826	251	*A Farm Yard*, 30gns.
1826	274	*Cattle*, £7.17.6, Mr. Whitmarsh, 37 Upper Baker Street.
1826	275	*Near Danton Castle, Herefordshire*, £7.17.6, W. Bowdless, Doctor Johnsons.
1827	24	*Fallow Deer*, 20gns.
1827	30	*"To the which place a poor sequester'd stag, That from the hunter's aim had ta'en a hurt, Did come to languish . . ." As you like it. Act II. Scene I.* 60gns.
1827	58	*Children feeding Poultry*, 10gns., S. Smith Esq.
1827	62	*Mountain Scenery, with Cattle*, 7½ gns., Countess De Grey.
1827	81	*Cattle*, 15gns.
1827	90	*Cattle*, 15gns.
1827	111	*Mountain Scenery, with Cattle*, 7½ gns.
1827	118	*Cattle*, 15gns.
1827	218	*Foresters*, 15gns.
1827	228	*Mountain Scenery, with Cattle*, 30gns.
1827	230	*Fighting Boars*, 20gns., Mr. Fairlie.
1827	261	*Cattle - Scene in Borrowdale, looking towards Glenamatara and Scawfell*, 30gns., N. Birch Wolfe, Wood Hall, Essex.
1827	269*	*Fallow Deer*, 6gns.
1827	286	*Cottagers*, 10gns., S. Smith Esq.
1827	292	*Cottagers*, Sold.
1827	308	*Farm Yard*, 10gns.
1827	321	*Wood Scenery, with Cattle*, 6gns., Mrs. Warren, 69 Charlotte Street, Portland Place.
1827	357	*Interior of a Cow-House.*
1828	3	*Wood Scenery, with Cattle*, 30gns.
1828	13	*Farm-yard*, 20gns.
1828	19	*Cottagers*, 10gns., Mr. Parrott, 13 Mill Bank Row, Westminster.
1828	23	*Children Feeding Poultry*, 10gns., John Coindez(?) Esq., 92 Dean Street, Soho.
1828	85	*Asses*, 15gns.
1828	93	*Sheep*, 15gns.
1828	112	*View in Glen Coe, by G F Robson; with Red Deer by*, 60gns., C. Barclay Esq.
1828	160	*Mowers*, 8gns.
1828	162	*A Haymaker*, 10gns.
1828	168	*Landscape and Cattle*, £7.17.6.
1828	191	*Rick-yard*, 15gns.
1828	193	*Mountain Scene with Cattle*, 12gns.
1828	201	*Fallow Deer*, 10gns., Mr. Parratt, 13 Milbank Row, Westminster.
1828	218	*An Old Hunter, the Property of J. Lockwood, Esq.*, Sold.
1828	233	*Mules - with Scenery on the Wye*, 15gns.
1828	238	*Cattle*, 20gns.
1828	286	*A Study*, 4gns., Sir M.W. Ridley.
1828	292	*Mountain Scenery, with Cattle*, £7.17.6.
1828	303*	*Near Tonbridge*, 6gns.
1828	322	*Fallow Deer*, 20gns.
1828	336	*Asses*, 6gns.
1829	6	*Farm-yard at Salvington, near Worthing*, 30gns.
1829	81	*Nina, "All pass'd away–all vanished–gone . . ." Conte à mon Chien.* 10gns.
1829	96	*Farm-yard at Sompting, near Worthing*, 15gns.
1829	151	*Fallow Deer*, Sold.
1829	188	*Fallow Deer*, 20gns.
1829	205	*Fallow Deer*, 18gns.
1829	218	*Cattle - Arundel Castle in the distance*, 12gns.
1829	247	*A Barn Door*, 15gns.
1829	274	*Farm Yard near Seven Oaks*, 15gns.
1829	283	*At Point*, 7gns.
1829	306	*Ploughing*, 6gns.
1829	315	*The Farmer and his Family*, 10gns.
1829	317	*Cottage Children*, 10gns.
1829	318	*Ass and Foal*, 8gns.
1829	324	*Forest Mare and Foal*, 5gns.
1829	338	*Fallow Deer*, 8gns.
1829	339	*Cattle*, 8gns.
1829	343	*Cattle*, 12gns.
1829	348	*Haymakers reposing*, 10gns., Heny. Seymour, 39 Upper Grosvenor Street.
1829	355	*Gleaners*, 15gns., Sold.

1829	370	*Mountain Shepherd*, 10gns.
1830	34	*Fallow Deer*, 7gns.
1830	43	*Bull and Cow*, 7gns.
1830	89	*Cottagers*, 10gns.
1830	91	*Cottage Children*, 10gns.
1830	156	*Cattle Scene, near Box Hill, Surrey*, 15gns.
1830	165	*Cattle - Twilight*, 12gns., Doughty Esq., 43 Lower Brook Street.
1830	169	*Fallow Deer*, 30gns.
1830	238	*Fallow Deer*, 20gns.
1830	258	*Landscape and Cattle*, 15gns.
1830	263	*A Stag*, 4gns., Sold.
1830	266	*A Corn Field*, 10gns.
1830	295	*A Corn Field*, 15gns.
1830	296	*The Gleaners' Return*, 10gns.
1830	316	*A Roebuck*, 15gns.
1830	320	*Cattle - Twilight*, 8gns.
1830	329	*Cattle*, 8gns.
1830	341	*Fallow Deer*, 6gns., I. Braithwaite Esq.
1830	364	*Fallow Deer*, 8gns., H. Stedman Esq.(?).
1831	7	*Sheep.*
1831	15	*Ancient Abreuvoir, at Mont Cochon, Jersey.*
1831	69	*Wood Scenery with Cattle.*
1831	81	*Cottagers.*
1831	96	*Heath Scene, with Sheep, &c.*
1831	124	*Pier at St. Helens, Jersey - Passengers preparing to embark.*
1831	150	*Farm Yard, at Pontifer, near Grosnez, Jersey - bringing home Vraick.*
1831	238	*An English Farm Yard.*
1831	247	*Fallow Deer.*
1831	265	*Cattle.*
1831	270	*Asses.*
1831	295	*Fallow Deer.*
1831	340	*A Corn Field.*
1831	344	*Horses.*
1831	359	*Mountain Scenery, with Cattle.*
1831	410	*Red Deer.*
1832	8	*Rustic Scene, with Cattle*, 8gns.
1832	61	*Landscape and Cattle*, 12gns.
1832	78	*A Farm Yard*, 20gns.
1832	171	*Farm Yard*, 15gns.
1832	234	*Fallow Deer - Scene near Penshurst, Kent*, 15gns., Sir Benjamin H. Malkin, 47 Conduit St.
1832	236	*Mountain Scenery, with Cattle*, 10gns.
1832	250	*Stags - Evening effect, from Robson*, 21gns.
1832	278	*Shepherd Boys*, 15gns., Mrs. Rothschild, Piccadilly.
1832	298	*Red Deer*, 10gns.
1832	328	*Fallow Deer*, 8gns.
1832	333	*Supper-time*, 8gns.
1832	342	*Fallow Deer*, 6gns., Sir Benjamin H. Malkin, 47 Conduit Street.
1832	344	*Fallow Deer*, 5gns.
1832	358	*The Sportsman - Morning*, 12gns.
1832	375	*Asses*, 10gns.
1832	379	*Cattle*, 8gns.
1832	412	*Asses*, 8gns.
1833	32	*Stag and Hind*, 15gns.
1833	75	*Fallow Deer*, 8gns.
1833	84	*Fallow Deer*, 7gns.
1833	111	*Cottagers*, 10gns.
1833	123	*Cattle*, 4gns., Mr. Repington, 19 Bury St., St. James's.
1833	138	*Fallow Deer - Landscape by Robson*, 10gns.
1833	140	*Cattle*, 8gns.
1833	147	*Fallow Deer*, 15gns.
1833	166	*Roebuck Shooting*, 12gns.
1833	188	*Mountain Scenery with Cattle*, 20gns.
1833	233	*Asses - Grassmere Lake by Robson*, 10gns.
1833	239	*Farm near the Town Mills, St. Helier's, Jersey*, 15gns.
1833	270	*Farm Yard near Harrow*, 20gns.
1833	343	*A Fishing Party*, 10gns., The Right Honble. Lady Rolle, 18 Upper Grosvenor St.
1833	395	*Landscape and Cattle*, 10gns.
1834	12	*Fallow Deer*, 7gns.
1834	63	*In the Vaux, St. Helier's, Jersey*, 12gns.
1834	78	*Forest Horses*, 7gns.
1834	85	*A Farm Yard*, 30gns., Reeve Esq., 11 Gt. Cumberland Place.
1834	110	*Asses*, 15gns., The Right Honble. Lady Rolle.
1834	141	*Stags*, 4gns.
1834	155	*Fallow Deer*, 20gns.
1834	185	*Near Mont Cochon, St. Helier's, Jersey*, 12gns.
1834	233	*Cottages near Winchester*, 12gns.
1834	238	*In St. Peter's Valley, Jersey*, 12gns.
1834	252	*Fallow Deer*, 20gns.
1834	265	*Cattle*, 8gns.
1834	269	*In the Vaux St. Heliers, Jersey*, 7gns.
1834	284	*Lane near Penshurst, Kent*, 8gns.
1834	290	*Red Deer*, 10gns.
1834	310	*Dog Kennel Lane, Aldbury, Surrey*, 8gns.
1834	348	*Farm Yard near Winchester*, 8gns.
1835	10	*Haymakers.*
1835	22	*Young Shepherds*, 15gns.

1835	30	*Cattle*, 7gns.
1835	38	*Fighting Boars*, 15gns., Mr. Ashlin, 22 Edwd. Street, Hampstead Road.
1835	82	*Winter*, 50gns.
1835	128	*Cottagers*, 10gns., Mr. Ashlin, 22 Edward Street, Hampstead Road.
1835	137	*Fallow Deer*, 15gns.
1835	190	*Swine*, 8gns., Mr. Ashlin, 22 Edwd. Street, Hampstead Road, Ask Mr. Hills if he will spare the frame.
1835	208	*A Chat*, 12gns.
1835	214	*Farm Yard - Twilight*, 15gns.
1835	243	*Horses at Water*, 7gns.
1835	246	*Red Deer*, 10gns., Mr. Ashlin, 22 Edward Street, Hampstead Road.
1835	271	*Cattle*, 8gns.
1835	278	*A Corn Field*, 5gns.
1835	300	*Fallow Deer*, 10gns., Mr. John Walker to be sent to Mr. Johnston, 6 Gray's Inn Square.
1836	20	*Milking - Scene near Ashtead, Surrey*, 12gns., Jacob Montefiore Esq., 24 Tavistock Square.
1836	45	*Cottage Children*, 10gns.
1836	50	*The Mountain Stream*, 10gns.
1836	64	*Cottagers, Westmorland*, 15gns.
1836	77	*Fallow Deer*, 18gns.
1836	155	*A Stag*, 20gns.
1836	176	*Landscape and Cattle*, 15gns., Mrs. Thos. Wilde, Guilford Street.
1836	180	*Wood Scene with Cattle*, 30gns.
1836	189	*Stags*, 15gns.
1836	196	*Red Deer*, 15gns.
1836	234	*Cattle*, Sold.
1836	246	*A Rick Yard*, 4gns., Lady Rolle.
1836	272	*Cattle*, 8gns., Mr. Ashlin, Edwd. St., Hampstead Road.
1836	278	*Fallow Deer*, Sold.
1836	311	*Ploughing*, 8gns.
1837	39	*Cattle on a Road - Sunset*, 30gns.
1837	45	*Stags*, 20gns., Lady Rolle, 18 Upper Grosvenor Street.
1837	53	*Mill at Gommershall, Surrey*, 12gns.
1837	92	*Roebuck*, 15gns., Kirkpatrick Esq., Hollydale, nr. Bromley, Kent, Frame and glass £3.0.0 purchased.
1837	98	*Cattle - Sunset*, 12gns.
1837	247	*Barn, &c near St. Helier's, Jersey*, 15gns.
1837	254	*Oak in Knowle Park, 28 Feet in Girth*, 8gns.
1837	259	*Fallow Deer*, 8gns.
1837	261	*Head of Roebuck - February - Horns in the Velvet*, 4gns., The Earl of Selkirk, 10 Upper Grosvenor St.
1837	278	*Asses*, 8gns.
1837	289	*At Mount Noireau, near St. Helier's, Jersey*, 15gns.
1837	293	*Farm-Yard near Harrow*, 7gns.
1837	295	*Sheep*, 8gns.
1837	332	*Mountain Scenery, with Cattle*, 10gns., Lord Willoughby de Cresby(?), 142 Piccadilly.
1837	360	*Sheep*, 8gns., H. Ashlin Esq., Edward Street, Hampstead Road.
1838	20	*Goat and Kids - Scene near St. Helier's, Jersey*.
1838	24	*A Corn-field*.
1838	42	*Landscape and Cattle*.
1838	50	*A Cow-lair, now part of the Regent's Park*.
1838	60	*Asses*.
1838	63	*Red Deer - the Sky and distant Mountains by W A Nesfield*.
1838	67	*Oxen at Plough*.
1838	161	*Fallow Deer*.
1838	162	*Fallow Deer*.
1838	187	*Fallow Deer*.
1838	209	*Fallow Deer*.
1838	211	*Stags*.
1838	213	*Sow and Pigs*.
1838	246	*Fallow Deer*.
1838	279	*Cattle*.
1838	332	*Sheep*.
1839	39	*Wood Scene with Cattle*, 15gns.
1839	199	*A Barn Door*, 10gns., Lady Rolle.
1839	222	*Cattle*, 10gns.
1839	231	*A False Alarm*, 10gns.
1839	238*	*Bull and Cow*, Sold.
1839	244	*Fallow Deer*, 8gns.
1839	263	*Forest Horses*, Sold.
1839	269	*Fallow Deer*, Sold.
1839	277	*Fallow Deer*, 20gns.
1839	298	*At Hunton, Kent*, Sold.
1839	307	*Beech in Knowle Park, with Fallow Deer*, Sold.
1839	312	*A Stag*, Sold.
1839	318	*At Ulcombe, Kent - with Cattle*, Sold.
1839	331	*Hinds and Calves*, Sold.
1840	27	*Cattle - Villevorde, between Brussels and Antwerp*.
1840	28	*Mountain Scenery, with Cattle*.
1840	37	*Fallow Deer*.
1840	55	*Farm Yard*.
1840	73	*Farm Yard*.
1840	146	*Evening - Oxen returning from Plough*.

1840	205	*Fallow Deer.*
1840	214	*Mountain Scenery, with Red Deer.*
1840	238	*Milking.*
1840	250	*Ploughing.*
1840	252	*Sheep.*
1840	261	*Fallow Deer.*
1840	281	*The young Giraffe born at the Zoological Gardens, taken within twelve hours of its birth.*
1840	302	*Blacksmith's Cottage in Kent.*
1840	323	*Does with Sorel, Prickets and Fawns.*
1841	18	*Ass and Foal,* 15gns.
1841	40	*Wood Scene, with Cattle,* Sold.
1841	51	*Sheep,* 15gns.
1841	74	*Shed, with Pigs, &c.,* 20gns., Own order - not sold.
1841	171	*Winter Sunset, Oxford Street,* 20gns. [deleted], Own order - not sold.
1841	230	*Farrier's Shop - a Sketch,* Sold.
1841	260	*A Corn Field,* 10gns.
1841	262	*Fallow Deer,* 10gns.
1841	271	*Fallow Deer,* 15gns.
1841	279	*Interior, with Calves,* 20gns.
1841	316	*Fallow Deer,* 10gns., R. Bremridge, Castle House, Barnstaple, Art Union.
1841	325	*Fallow Deer,* 10gns.
1842	4	*Cattle.*
1842	53	*A Farm Yard.*
1842	210	*Fallow Deer.*
1842	215	*A Barn Door.*
1842	219	*Cottage Children.*
1842	245	*Landscape and Cattle.*
1842	259	*Fallow Deer.*
1842	272	*Fallow Deer.*
1842	279	*Sheep.*
1843	55	*Forest Scene, with Fallow Deer,* 15gns.
1843	118	*Cattle,* 10gns.
1843	211	*Stag and Hinds,* 30gns.
1843	235	*Farm Yard at Birchington, near Margate,* 10gns., Wm. Strahan Esq., 34 Hill Street.
1843	247	*Sheep,* 8gns.
1843	262	*Farm, near Ticehurst, Sussex,* 15gns.
1843	271	*Cattle,* 8gns.
1843	276	*Stags,* 12gns.
1843	293	*Red Deer,* 15gns.
1843	299	*Stags,* 10gns., George Morant Junr. Esq., 91 Bond Street.
1843	320	*Cattle,* 10gns.
1843	325	*Aldbury Church &c. near Tring, Herts,* 10gns.
1843	342	*Fighting Bulls,* 8gns.

1844	101	*"To the which place a poor sequester'd stag . . ." As You Like It, Act II., Scene 1.* 60gns., Frame and glass £9.19.0.
1844	184	*The Herd,* 10gns., I.T. Simes Esq., Highbury Park.
1844	241	*A Farm Yard,* 10gns., W.H. Roe Esq., 21 Princes Street, Cavendish Sq.
1844	271	*Sheep - Stocks, near Aldbury, Herts.,* 15gns.
1844	310	*Stags, showing their Horns in the Velvet, at various stages of their growth, In the animal nearest to the left side of the picture, the experienced Forester will see the 'Brow Antler' and 'Royal' in a state nearly approaching completion . . .* 15gns., Jos. Feilden Esq., Frame and glass £2.5.6.

HILLS AND ROBSON

1832	179	*Cattle - Scene on the Banks of Loch Lomond,* 35gns., Countess of Rothy(?).

HILLS R & ROBSON G F

1831	60	*Asses.*
1831	120	*Scene near Beauley, Inverness-shire, with Sheep.*

[See also ROBSON G F & HILLS R]

HOLLAND J

1835	117	*A Study from Nature,* 12gns.
1835	215	*The Hedge Side,* Sold.
1835	230	*An Old Mill at Blackheath,* 15gns., Sold Mr. Holland.
1835	280	*On the River Tay,* 8gns., Sold by J.H.
1835	313	*Greenwich,* 18gns.
1835	320	*Charing Cross,* Sold.
1836	37	*Venice,* 25gns., J.J. Ruskin Esq., Herne Hill.
1837	18	*Venice - Evening,* Sold.
1837	55	*Tombs of the Scaligers, Verona,* Sold, Thos. Haviland Brocke Esq., 6 Old Square, Lincolns Inn, Order of Mr. Holland.
1837	125	*St. Georgio de Greci, Venice,* 35gns.
1837	145	*At Venice,* 20gns.
1837	155	*Landscape,* 12gns.
1837	173	*Airolo Pass of the St. Gothard,* 20gns.
1837	309	*Mont Blanc, from the Lake of Geneva,* 12gns.
1837	318	*Mont Blanc, from Ferney,* 10gns.
1838	141	*Convent of Santa Clara, at Ville de Conde, near Oporto.*
1839	91	*Ruins of the Monastery of Alcobaca,* 25gns., J.J. Ruskin Esq., Drawing to be sent to Foord's.
1839	168	*At Lisbon,* 10gns., C.H. Turner Esq., Rooks Nest, 15 Bruton Street, Berkeley Sq., Frame to be sent £2.2.0.
1839	236	*At the Cork Convent, Cintra, "Deep in yon cave Honorius long did dwell . . ." Byron.* 6gns.
1839	246	*The Moorish Palace at Cintra, "On sloping mounds, or in the vale of beneath, Are domes . . ." Byron.* 15gns.

1839	256	*The Pentra Convent, Cintra,* 12gns.
1840	54	*At Lisbon.*
1840	201	*Piazza Signori, Verona.*
1840	248	*At Venice.*
1841	28	*A Trout Stream - Kent,* 15gns.
1841	50	*Chapel of St. John the Baptist in the Church of St. Roque, Lisbon,* 35gns.
1841	63	*On the River Ravensbourne, Kent,* 15gns.
1841	83	*Milton Church, near Gravesend,* Sold.
1841	98	*Venice,* Sold.
1841	120	*Santa Cruz - Coimbra,* 40gns., Barnard Esq., Goffield Hall, Order of Mr. Holland.
1841	124	*Luzern,* 10gns.
1841	261	*Flowers,* Sold.
1842	61	*Remains of the Amphitheatre, Verona.*
1842	143	*Lisbon, from Porto Brandas.*
1842	194	*Antiques.*
1842	200	*Venice.*
1842	240	*Part of the Foscari Palace.*

HOLMES J

1813	63	*Hot Porridge.*
1813	156	*The married man.*
1814	28	*Still Life,* £157.10.0, N. Chamberlayne Esq., M.P.
1814	29	*Cottage Girl.*
1815	19	*Portraits of Mr Charles and Miss Louisa Cox.*
1815	28	*Portrait of Master Rowland Alston.*
1815	206	*Cinderella.*
1816	9	*Portrait of Lady Emily Drummond.*
1816	14	*Portrait of Major Wood, 10th Hussar Regiment.*
1816	254	*Gleaner Girl.*
1817	18	*Michaelmas Dinner, "He cannot hit the joint, but, in his vain efforts to cut through the bone, splashes the company." – Chesterfield's Letters.*
1817	153	*Portrait of the Right Hon. Lord Byron.*
1817	154	*Cottage Child.*
1818	29	*Going to School, "In every village mark'd with little spire . . ." Shenstone's Schoolmistress.*
1818	178	*Portrait of Master Ellice.*
1818	183	*Portrait of a Gentleman.*
1818	313	*A Girl protecting her Chickens from a Hawk,* 150gns., Mr. Holister(?).
1818	357	*Portraits of a young Lady and Gentleman.*
1819	170	*Portrait of Miss H. Gouldsmith.*
1819	173	*Portraits of Colonel Wood and Lady Caroline Wood.*
1819	177	*Portraits of Her Grace the Duchess of Argyle, and the Countess of March.*
1819	331	*Fisherman's Child.*
1819	338	*Interior of a Cottage.*
1820	75	*Portrait of Master James Taylor.*
1820	171	*Portrait of Miss Mieville.*
1820	176	*Portrait of Mr. Henry Allston.*
1820	180	*Portrait of Edward Ellice, Esq. M. P.*
1820	188	*Portrait of Mrs. Mieville.*
1820	193	*Portrait of an Officer of the 7th Hussars.*
1820	198	*Portrait of Mrs. Ellice.*
1820	382	*Portrait of C. S. Lefevre Esq.*
1823L	49	*The Spoiled Dinner,* Marquis of Hertford.
1823L	68	*The Doubtful Shilling,* – Robarts, esq.
1823L	106	*Going to School,* – Robarts, esq.
1823L	145	*The Michaelmas Dinner,* HIS MAJESTY.

HOLMES T

| 1820 | 185 | *Portrait of Lady Hannah Ellice.* |

HOLWORTHY J

1805	86	*Stone biers force, a fall on the Clyde.*
1805	104	*Corra Llyn.*
1805	155	*Distant View of Conway Castle.*
1805	169	*At Llanydloes.*
1805	221	*Goodrich Castle.*
1806	17	*Borrowdale, Cumberland.*
1806	45	*Conway Castle.*
1806	129	*Llangollen.*
1806	175	*Wortley.*
1806	262	*View on the Dee.*
1806	278	*View on the Dee.*
1806	288	*Ragland Castle.*
1807	66	*Lowdore Water-fall, Cumberland.*
1807	137	*Raven crag, with part of Wythbourne water.*
1807	181	*Windsor.*
1807	208	*On the Rhyddal, N. Wales.*
1807	216	*Kenilworth Castle.*
1807	286	*A landscape.*
1808	59	*Part of Chepstow Castle.*
1808	73	*Wharncliffe, Yorkshire.*
1808	88	*Gateway at Roach Abbey, Yorkshire.*
1808	99	*Glyn Diffwys, near Conway, South Wales.*
1808	165	*St. Donat's Castle, South Wales.*
1808	180	*Scene on the Thame, Warwickshire.*
1808	286	*Caerphilly Castle, South Wales.*
1809	325	*Kirkstall Abbey.*
1810	90	*Chepstow Castle.*
1810	167	*Tintern Abbey.*
1810	176	*Pont Neath, Vaughan.*
1810	184	*Chepstow Castle.*
1810	189	*Llangollen.*

1811	68	*Ferry on the Wye, at Goodrich, Monmouthshire.*
1811	185	*At Rydal, Westmorland.*
1812	137	*Landscape.*
1813	112	*A Landscape.*
1813	155	*Part of the Walls of Caerphilly Castle.*

HUNT W

1814	41	*View of Windsor Castle.*
1814	94	*View of the Bell Tower, Windsor.*
1815	25	*The Seat of John Barren, Esq. Westesham, Kent.*
1815	33	*Portrait of a Young Lady.*
1815	39	*Portrait of a young Gentleman.*
1815	210	*A View at Hastings*, £4.4.0, Mr. Dyson.
1815	229	*A View at Hastings.*
1815	336	*A View from Richmond Hill.*
1819	32	*A Sketch, from the East Cliff, Hastings.*
1824	62	*Gamekeeper.*
1824	286	*The Miller.*
1825	6	*Snipes.*
1825	133	*Gamekeeper*, 6gns., Sir Arthur Ridley.
1825	139	*A Poacher*, 6gns., C.B. Vale(?), M.P.
1825	194	*The Gardener*, 12gns., Allnutt Esq.
1825	276	*Rabbit*, Sold.
1825	309	*Pheasant*, Sold.
1825	333	*Woodcock*, Sold.
1825	335	*A Hare*, Sold.
1825	340	*A Sketch from Nature*, 5gns.
1825	341	*Gamekeeper.*
1825	343	*Sketch from Nature.*
1825	344	*A Sketch from Nature in Cassiobury Park.*
1826	6	*Dead Game*, Sold.
1826	69	*A Gamekeeper in the Service of Charles Dixon, Esq.*, Sold.
1826	108	*Tame Rabbit*, Sold.
1826	161	*The Can and Horn*, Sold.
1826	181	*A Brother of the Angle*, Sold.
1826	250	*Dead Game*, Sold.
1826	255	*Young Pigeon*, Sold.
1826	256	*Hen Pheasant*, Sold.
1827	55	*Cauliflower, &c.*, Sold.
1827	165	*Paper Lanthorn*, 12gns., Sold.
1827	181	*Irish Labourer*, 10gns., Mrs. B. Cochrane, 12 Portman Square.
1827	216	*Rabbit and Lobster*, Sold.
1827	223	*Flowers*, 4gns.
1827	224	*Rabbit*, 7gns., G. Hibbert Esq.
1827	227	*Flower Girl*, 6gns., Mr. Haldimand.
1827	234	*Grapes*, 5gns., Mrs. W. Cole Decker(?), 13 Osnaburgh Street.

1827	238	*Sea-Gull*, Sold.
1827	248	*A Sportsman*, Sold.
1827	267	*Brace of Partridges*, 6gns., Mrs. Powell.
1827	268	*Lettuce*, 4gns.
1827	276	*Study from Nature*, 5gns., G. Hibbert Esq.
1827	290	*Interior of a Cow-House*, 7gns., B. Smith Esq., 12 Jermyn Street.
1827	304	*Widgeon*, 6gns., C. Barclay Esq., 43 Grosvenor Place, Frame and glass £1.16.0.
1827	331	*Teal*, Sold.
1827	344	*Game.*
1828	18	*Westminster Scholar*, 7gns., Sold.
1828	27	*Sketch from Nature*, 8gns., Baring Wall Esq., 44 Berkeley Sq.
1828	40	*Sketch from Nature*, Sold, Sir Matthew White Ridley.
1828	82	*Study from Nature*, 15gns., C. Barclay Esq.
1828	94	*A Study from Nature, of an Old Man who sailed with Captain Cook on his first Voyage*, 25gns., W. Prior Esq.
1828	98	*A Sketch, from Nature*, 8gns., Broderip Esq., 1 Gower Street.
1828	142	*Sketch from Nature*, 6gns., The Rev. Edward Craven, Hawtrey, Eton.
1828	190	*An Interior*, 8gns., M. Shepley Esq., 20 Devonshire Place.
1828	195	*Fruit, from Nature*, 30gns.
1828	206	*Study from Nature*, 25gns.
1828	243	*Dead Game*, Hull Esq.
1828	284	*Grapes, from Nature*, Lady Dudley (?).
1828	304	*A Study from Nature*, 15gns., Olive Esq., North Terrace, Regents Park.
1828	307	*A Study from Nature*, 10gns., Countess of Mansfield, 34 Lower Grosvenor St.
1828	312	*A Butcher's Boy*, 12gns., W.F.F. Middleton, 35 Charles St., Berkeley Sq. To be delivered Lady Brownlow, 30 Hill St. Her Ladyship will pay for it.
1828	326	*Fishermen's Children looking out for their Father's Boat*, 10gns., M. Shepley Esq., 28 Devonshire Place.
1828	329	*A Paper Lanthorn*, 10gns., C. Barclay Esq.
1828	330	*Mary Queen of Scots' Room, Hardwick, the Seat of His Grace the Duke of Devonshire.*
1828	337	*Study from Nature*, 17gns., Duke of Norfolk.
1828	346	*Library of His Grace the Duke of Devonshire at Hardwick*, Sold.
1828	353	*Sketch from Nature*, 7gns., Sir Alexander Dickson, Royal Artillery, Frame £1.15.0.
1828	359	*A Game-keeper from Nature*, 10gns.
1828	365	*The Gallery at Hardwick, the Seat of His Grace the Duke of Devonshire*, Sold, Duke of Devonshire.

HUNT W

1829	7	*Saturday Evening*, Sold.
1829	8	*A Peasant Boy*, 12gns.
1829	13	*A Lady reading by Lamp-light*, 10gns., Mr. Henry Ph. Hope, 25 New Norfolk St., Park Lane, Frame and glass £2.17.0.
1829	18	*Cow Boy*, 15gns.
1829	30	*The Boudoir*, 12gns., Sir Alex Dickson, Royal Artillery. To go to Mr. Hunt.
1829	37	*The Sempstress*, 20gns., Mr. Thos. Norris (known to Mr. Hunt).
1829	45	*A Recess in the Drawing Room of John Shorter, Esq. at Hastings, Sussex*, Sold.
1829	52	*An Interior of a Mill, Cashiobury, Herts.*, 12gns., J. Burton Phillips, 25 Cavendish Square, Frame and glass £3.10.0.
1829	59	*A Blacksmith's Shop at Strathfieldsay, Hampshire*, 30gns.
1829	67	*A Cow-Shed*, 7gns.
1829	74	*Fruit*, 6gns., Miss Shipley, Devonshire Place, Frame and glass £2.0.0.
1829	91	*A Young Lady sleeping*, 15gns.
1829	109	*The Romp*, 17gns., Frame and glass £3.0.0.
1829	139	*Meditation*, 17gns.
1829	145	*A Water Carrier*, 15gns.
1829	149	*The Weary Traveller*, 17gns., Lord Northwick.
1829	189	*A Cottage Scene at Strathfieldsay, Hampshire*, 15gns.
1829	194	*Reading, by Lamplight*, 15gns., Mr. Henry Rope(?), New Norfolk St., Park Lane.
1829	214	*A Lady reading by Lamplight*, Mr. Barlow Hoy, Oriental Club, Hanover Square.
1829	227	*A Study from Nature*, 6gns.
1829	232	*An Interior of a Cow-house*, 20gns.
1829	242	*A Cottage at Bushy, Herts.*, 6gns.
1829	261	*A Young Lady Reading*, 5gns.
1829	271	*Children at a Cottage Door*.
1829	275	*A Blacksmith's Shop at Strathfieldsay, Hampshire*, Sold.
1829	280	*A Radish Stall*, 8gns., The Honble. Mrs. Cochrane.
1829	293	*A Water Carrier*, 17gns., J. B. Philips Esq.
1829	350	*Going to School*, 20gns., M. Shepley Esq.
1829	351	*Fruit*, Sold.
1829	360	*An Interior*, 17gns., Broderip Esq.
1829	366	*A Study*, 6gns., Richard Greene.
1829	377	*A Fisherman*, 25gns., Parrott Esq.
1829	378	*A Paper Lanthorn*, 10gns., Richard Greene, Lichfield, Staffordshire.
1829	394	*A Fisherman Mending Nets*, 17gns.
1830	25	*Scenery in Cassiobury Park*, 15gns.
1830	40	*An Interior*, 20gns., The Countess of Mansfield.
1830	49	*Lower Decks of the Ship Enchantress, in his Majesty's Preventive Service, Rye Harbour*, Sold.
1830	70	*Anticipation*, 10gns., Sir W. Middleton, 13 Whitehall Place.
1830	79	*Young Fishermen*, 10gns.
1830	112	*A Gardener's Store Room*, 6gns.
1830	130	*A Sketch*, 4gns.
1830	177	*Fishing Boys*, 40gns., Sold.
1830	196	*Bird's Nest and Lilac*, 15gns., Sold.
1830	207	*Cottages at Oxford*, 4gns.
1830	215	*A Sea Gull*, 12gns.
1830	222	*A Clay Pit*, 10gns.
1830	231	*A Brick Kiln*, 8gns.
1830	240	*A Sketch*, 4gns., John Martin Esq., 112 Mount Street, Grosvenor Square.
1830	246	*Fruit*, Sold.
1830	259	*A Gypsey Boy*, 12gns., Mr. W. Fox, Mayfield St., Dalton.
1830	268	*An Interior of a Potter's Shed*, 12gns.
1830	273	*A Fishing Boy*, Sold.
1830	283	*Sea Gull and Teale*, 8gns.
1830	302	*A Fishing Boy*, 12gns., Sir Thos. Baring, 21 Devonshire Place.
1830	314	*Fruit and Bird's Nest*, Sold.
1830	325	*A Brick Kiln*, 8gns.
1830	332	*Fruit, &c.*, 6gns., Birch Esq.
1830	339	*Grapes and Currants*, 5gns., I. Braithwaite Esq.
1830	343	*A Study*, 8gns.
1830	362	*A Girl reading to her Grandfather*, 17gns., Holford Esq.
1830	366	*A Paper Lanthorn*, 10gns.
1831	48	*A Fishing Boy*.
1831	68	*A Child with Pitcher*.
1831	86	*Prayer, "Prayer is the soul's sincere desire..."* Montgomery.
1831	130	*An Old Mariner*.
1831	133	*A Peasant Boy*.
1831	134	*An Old Smuggler*.
1831	141	*Pug - a Sketch*.
1831	165	*A Smuggler of Hastings*.
1831	166	*Little Red Riding Hood*.
1831	178	*A Peasant Girl*.
1831	189	*The Mendicant*.
1831	204	*A Peasant Girl*.
1831	213	*The Idle Boy*.
1831	239	*Taking Luncheon*.
1831	242	*A Boy with Prandle Net*.
1831	252	*Still Life*.

1831	253	*Study of an Old Man.*
1831	260	*A Fisherman.*
1831	262	*Still Life.*
1831	322	*Grapes &c.*
1831	331	*Melon and Grapes.*
1831	333	*Peasant Girls.*
1831	351	*Pine Apple, &c.*
1831	366	*Candle-light Effect.*
1831	376	*A Gipsey Girl.*
1831	378	*Grapes &c.*
1831	388	*Grapes.*
1831	400	*A Cottage Girl.*
1831	402	*Study of an Old Man.*
1831	403	*Hydrangea.*
1831	425	*A Fishing Boy.*
1831	426	*Bird's Nest.*
1832	9	*Study of a Head,* 12gns., Sold.
1832	18	*Head of a Smuggler - a Study,* 14gns., Mr. B.G. Windus, 61 Bishopgate Without.
1832	28	*An Old Man's Head - A Study,* 5gns., Sold.
1832	34	*The Gleaner,* 13gns., Sold.
1832	41	*A Smuggler,* 15gns., The Duchess of St. Albans.
1832	66	*The Lesson,* 6gns.
1832	93	*Interior of a Fisherman's Cottage,* 18gns., Sir Wm. Middleton, 13 Whitehall Place.
1832	128	*An Interior,* Sold.
1832	132	*A Boy - a Study from Nature,* 12gns., Sold.
1832	156	*The Lump of Pudding,* 15gns., Sold.
1832	165	*A Fisherman,* 12gns., Mrs. Webb, 1 Cambridge Terrace, Edgeware Road.
1832	167	*An Old Fisherman,* 13gns.
1832	170	*Hot Bread and Milk,* 20gns., Sold.
1832	219	*Hyacinth,* 5gns., Sold.
1832	226	*Interior of a Barn,* 10gns., Sold.
1832	227	*A Peasant Girl,* 8gns.
1832	237	*Pink and White Thorn,* 8gns.
1832	242	*Reading,* 5gns., Mr. E.E. Tustin, 8 Fludyer St., Whitehall.
1832	263	*An Interior of a Kitchen,* 25gns.
1832	282	*Blackberries,* 8gns.
1832	287	*A Bittern,* 7gns., Mr. W. Wells, Blenheim Hotel, Bond St.
1832	291	*Japanese Roses,* 8gns., Sold.
1832	305	*Poppies,* 8gns., Sold.
1832	314	*Interior, with Girl Sleeping,* 22gns., Mrs. F.M. Martyn, 45 Waterloo Place.
1832	319	*Sundries,* 6gns., Rev. Mr. Coleridge.
1832	334	*Grapes,* 6gns., Rev. E. Coleridge.
1832	339	*Bird's Nest,* 6gns.
1832	341	*The Page,* 15gns., Sold.
1832	355	*An Old Man Reading,* 10gns., Rev. E. Coleridge [Mr. J.F. Lewis pencilled in].
1832	360	*The Seamstress,* 8gns., Sold.
1832	371	*A Nap,* 10gns., Sold.
1832	376	*Blowing Bubbles,* 14gns., The Duchess of St. Albans.
1832	382	*An old Man's Head - a Study,* 13gns., Mr. J. Shaw, 1 Chatham Place.
1832	410	*Plums, &c.,* 8gns., Sold.
1833	23	*Still Life,* 16gns., Mr. W.B. Roberts.
1833	33	*Interior of a Kitchen,* 20gns., Mr. Bernall.
1833	42	*A Gypsey Girl,* 16gns., Sold.
1833	44	*A Study,* 10gns.
1833	93	*A Group of Models,* 35gns., Mr. R. Cancellor, Cambridge Place (Colnaghi).
1833	130	*Interior of a Barn,* 18gns., J.H. Maw, Esq., Aldermanbury.
1833	131	*An Amateur Musician,* 18gns., Mrs. Clarke, 65 St. James Street (Dr. Wilson, 38 Curzon St., May Fair), Country address Wigginton Lodge, Tamworth, Staffordshire.
1833	226	*Juvenile Students,* 8gns., Honble. J.T.L. Melville, 27 Park Crescent.
1833	236	*An Interior,* 10gns., Sold.
1833	237	*A Sempstress,* 6gns., Sold.
1833	287	*Ishmael,* 12gns.
1833	290	*A Peasant Girl,* 14gns., Mr. Wells, Redleaf, To Mr. F. Lees, 16 Norton Street.
1833	295	*Candlelight Effect,* 13gns., Mr. Bernall.
1833	297	*A Flower Girl,* 12gns., Sold.
1833	302	*Fruit,* 8ns., Mr. Prior.
1833	309	*Picking a Fowl,* 20gns., Mr. Bernall.
1833	313	*Grapes,* 5gns.
1833	326	*A Lady in Swiss Costume,* 10gns., Sold.
1833	340	*The Loiterers,* 10gns., Ruskin Esq., Herne Hill, Mr. Foorde to take 340 without the frame at the close of the Exhibition.
1833	345	*Sweet Peas, &c.,* 4gns., Mr. Hixon, 67 Quadrant.
1833	349	*A Young Negro,* 13gns., Mr. Bernall.
1833	352	*A Mendicant,* 12gns.
1833	354	*Lanthorn Light,* 6gns., Mr. Hixon, Quadrant.
1833	363	*A Sketch,* 8gns., Sold.
1833	364	*A French Peasant,* 13gns., Countess Dartmouth, 2 St. James Square, Frame and glass also.
1833	374	*Study of a Head,* 14gns.
1833	383	*Study of a Head,* 8gns., Mr. Hunt(?).
1833	386	*Boy with a Sea Gull,* 10gns., Mr. A. Baring, Bath House, Piccadilly, and the frame and glass home with it.

1833	388	*Study of a Head*, 8gns.
1833	392	*Devotion*, 8gns., Sold.
1833	398	*A Study*, 8gns.
1834	13	*Flowers*, 8gns.
1834	20	*The Maid and the Magpie*, 25gns., Henry Musgrave Esq.
1834	72	*An Interior*, 30gns., Mrs. Clarke, 38 Curzon St., May Fair.
1834	79	*A Sketch*, 8gns.
1834	147	*An Interior*, 8gns.
1834	160	*A Sketch*, 6gns., Mrs. Clarke, 38 Curzon Street, May Fair.
1834	253	*Winter*, 20gns., Sold.
1834	291	*A Fisher Boy*, 8gns., The Earl of Mansfield, Langham Row.
1834	293	*A Sketch*, 7gns., The Earl of Mansfield, Langham Row.
1834	301	*Candlelight Effect*, 10gns., Miss Langston, 32 Upper Brook Street.
1834	307	*A Negro Boy*, 8gns., Miss Langston, 32 Upper Brook Street.
1834	313	*Peasant Girls*, 40gns.
1834	323	*Boy with Pitcher*, 7gns., Holford Esq., Lincolns Inn Fields.
1834	341	*Fruit*, Sold.
1834	350	*Fruit*, 8gns.
1834	367	*The Conclusion*, 20gns., Sold.
1834	373	*The Father's Boots*, Sold.
1834	380	*A Peasant Girl*, 10gns., Mrs. D. Colnaghi.
1834	382	*The Commencement*, 20gns., Sold.
1835	11	*A Sailor Boy*.
1835	18	*A Woodcutter*, 14gns., Mr. J. Hewett, Leamington.
1835	62	*Wild Rabbit and Pheasant*, 6gns., Sold.
1835	79	*A Specimen of the Circular, Angular and Linear Principles of Composition*, 15gns., Sold.
1835	86	*Arithmetical Calculation*, 14gns., T. Ellis, 4 Cleave Place, Lark Hall Lane, Clapham Road.
1835	102	*A Candlelight Effect*, 10gns., Col. Sibthorpe, 3. C. Albany.
1835	112	*Candlelight*, 10gns., Sold.
1835	173	*Kitchen in the Rye House, North Hoddesdon*, 15gns., Mr. B.G. Windus.
1835	182	*An Interior at Strathfieldsay*, 15gns.
1835	189	*A Boy with a Shrimp Net*, 14gns., Mr. Holford, 1 Lincolns Inn Fields.
1835	192	*A Lady Reading*, 6gns.
1835	200	*A Lady Sewing*, 8gns., Sold.
1835	207	*A Rustic Scene at Strathfieldsay*, 35gns.
1835	234	*Birds*, 5gns.
1835	261	*Fruit*, 20gns., Sold.
1835	307	*Apple Blossoms &c.*, 5gns., Mr. Ashlin, 22 Edwd. Street, Hampstead Road.
1835	311	*Return from the Masquerade*, 8gns., Sold.
1835	315	*Peasant Girls*, 30gns., Sold.
1835	321	*Grapes*, 4gns., Mme. C. Rohe???, 249 Regent Street.
1835	323	*A Monk*, 12gns., Countess of Mansfield, Portland Place.
1836	12	*Interior of an Old Priory*, Sold.
1836	58	*Free and Easy*, 17gns.
1836	60	*Boy with Wild Ducks*, 17gns., R. Vernon Esq., 50 Pall Mall.
1836	88	*Scared*, Sold.
1836	95	*Contentment*, 18gns., T. Ellis Esq., No. 4 Cleave Place, Lark Hall Lane, Clapham Road.
1836	98	*Massa Sambo*, 20gns., Earl of Liverpool, Fife House, Whitehall.
1836	99	*A Sleeping Boy*, 17gns., Lady Rolle.
1836	132	*Girl with a Basket*, 8gns., Domett Esq., Balham Hill.
1836	154	*Devotion*, 12gns.
1836	163	*Fruit*, Sold.
1836	168	*The Idle Boy*, 8gns., D. Colnaghi Esq., Pall Mall East.
1836	192	*Boy with a Goat*, Sold.
1836	203	*A Peasant Girl*, Sold.
1836	210	*An Old Pilot*, Sold.
1836	222	*A Farmer's Boy*, Sold.
1836	229	*A Paper Lantern*, 12gns., Mrs. Durand(?), 12 Mansfield Street.
1836	236	*Flowers*, 5gns.
1836	245	*Flowers*, Sold.
1836	265	*Flowers*, Sold.
1836	268	*Flowers and Bird's Nest*, 8gns.
1836	277	*Candlelight*, Sold.
1836	313	*A Study of a Head*, 12gns.
1836	322	*Boy with Shrimp Basket*, 17gns., Sir Richd. Hunter, 48 Charles St., Berkley Sqre.
1836	331	*Interior of a Fisherman's Cottage*, 17gns.
1836	338	*The Cricketer*, 20gns., Lady Rolle.
1837	1	*An Oak Tree near Guildford*, order of Mr. Hunt.
1837	4	*A Cow House*.
1837	6	*Interior of a Kitchen*.
1837	9	*Girl in a Wood-house*, 35gns., Messrs. Cattermole & Stone.
1837	14	*Interior of St. Mary's Guilford*, 20gns.
1837	62	*Jim Crow*, 20gns., Lady Rolle, 18 Upper Street.
1837	69	*A Puffer*, 18gns., Lady Rolle, 18 Upper Grosvenor Street.

1837	84	*Trees near Guilford*, 12gns., Mrs. Sheepshanks, 30 Woburn Place.
1837	90	*The Toilet*, 55gns., S. Maw Esq., Aldersgate Street.
1837	105	*Piety*, Sold.
1837	109	*The Day of Rest*, 20gns., Lady Rolle, 18 Upper Grosvenor Street.
1837	126	*Interior of a Wood House*, 35gns.
1837	169	*Grapes*, Sold.
1837	180	*Tired*, Sold.
1837	184	*Fetching a Light*, Sold.
1837	187	*Begging*, 15gns., Harcourt Esq., Crawleys Hotel, Albemarle Street.
1837	195	*Winter*, Sold.
1837	213	*Morning*, 30gns., J.H. Maw Esq., Aldersgate Street.
1837	221	*Pied Pheasants*, 18gns.
1837	237	*A Fly Catcher*, 15gns., Lewis Pocock Esq., 3 Verulam Build., Grays Inn.
1837	251	*The Barber*, 35gns., Lady Rolle, 18 Upper Grosvenor Street.
1837	255	*Admiration*, 15gns., M. Ellis Esq., Cleave Place, Larkhall Lane, Clapham Wood.
1837	277	*A Study*, 18gns.
1837	285	*Going to Bed*, Sold.
1837	347	*Mischief*, Sold.
1837	356	*Doing Penance*, Sold.
1837	364	*Hide and Seek*, 18gns.
1838	32	*Flowers*.
1838	41	*Luncheon*.
1838	49	*A Marine Effect*.
1838	74	*A Peasant Girl*.
1838	82	*An Interior*.
1838	106	*The Young Mother*.
1838	108	*Dead Wood-Pigeon*.
1838	122	*A Student*.
1838	137	*An Incipient Smuggler*.
1838	156	*A Sleeping Match Girl*.
1838	182	*Cymon and Iphigenia*.
1838	192	*The Forlorn Sailor Boy*.
1838	200	*A German Stove*.
1838	218	*Flowers*.
1838	262	*Interior of a Wood House*.
1838	268	*Plums*.
1838	273	*A Laughing Boy*.
1838	278	*A Genius*.
1838	280	*The Village Chimes*.
1838	282	*Sleeping Girl*.
1838	290	*Bubbles*.
1838	295	*Milk Porridge*.
1838	301	*A Turnip Bogle*.
1838	318	*Spelling Book*.
1838	327	*Boy Reading*.
1838	343	*Fortune Teller*.
1839	6	*Bird's Nest, &c.*, 8gns., J. Maw Esq., Aldersgate Street.
1839	23	*Sailor Boy*, 15gns., J. Martin Esq., M.P., 22 Grafton Street.
1839	51	*A Rustic*, 15gns., Sir John Swinburne, No. 18 Grosvenor Place.
1839	67	*Juvenile Palmistry*, 55gns.
1839	84	*The Rustic Toilet*, Sold.
1839	92	*Interior of a Stable*, Sold.
1839	98	*Candlelight Effect*, 10gns., Lady Rolle.
1839	127	*All-Fours*, 45gns., Mr. R. Hodgson, Messrs. Hodgson & Graves, 6 Pall Mall.
1839	129	*Fruit*, 8gns.
1839	134	*Plums*, Sold.
1839	141	*A Hermit*, 25gns., Sir Richd. Hunter, 25 Hill Street.
1839	178	*Miss Jem-ima Crow*, 35gns., Lewis Pocock Esq., 29 Montague St., Russell Sqr.
1839	212	*Girl Sleeping*, 15gns.
1839	270	*A Cricketer*, 35gns., Sold.
1839	271	*Interior at Guildford*, 30gns.
1839	275	*Flowers*, 10gns., Mrs. Packe, 7 Richmond Terrace.
1839	276	*A Scrub*, 30gns., S.G. Moon Esq.
1839	278	*The Lesson*, 10gns.
1839	292	*Panic-struck*, 30gns., Ackerman Esq., Strand.
1839	308	*A Sketch*, 25gns.
1839	325	*The Narcotic*, Sold.
1839	332	*Grapes*, Sold.
1839	338	*A Kitchen*, 35gns.
1839	342	*Gooseberries*, 12gns., C.W. (?) Packe Esq., 7 Richmond Terrace.
1840	7	*A Pozer*.
1840	16	*A Cottage*.
1840	22	*A Popular Omen*.
1840	24	*Peasant Girl*.
1840	40	*Girl Sleeping*.
1840	45	*Fruit and Flowers*.
1840	48	*A Brother of the Angle*.
1840	58	*Camellia Japonica &c.*
1840	68	*Iris, &c.*
1840	100	*Grandmother's Spectacles*.
1840	107	*Astonishment*.
1840	116	*A Brown Study*.

1840	124	*Mulatto Girl.*
1840	133	*Lady and Mandolin.*
1840	165	*A Hard Word.*
1840	170	*Grapes &c.*
1840	173	*A Sand Boy.*
1840	177	*Master Izaac Walton.*
1840	208	*Hollyhock, &c.*
1840	217	*Peasant Boy.*
1840	236	*A Young Cricketer.*
1840	245	*A Young Archer.*
1840	259	*Pitcher of Flowers.*
1840	265	*Ploughboy.*
1840	276	*Fruit.*
1840	280	*Kingfisher &c.*
1840	287	*Interior - Girl Sleeping.*
1840	298	*A Long Song.*
1840	299	*Melon, &c.*
1840	305	*Boy Sleeping.*
1840	308	*Preserved Ginger.*
1840	313	*Miriam.*
1840	316	*Bottle of Minnows.*
1840	321	*An Interior.*
1841	4	*Remnants of the Tournament*, 30gns., Earl Brownlow, 12 Belgrave Square.
1841	13	*A Cottage Door*, 20gns.
1841	23	*Threading Birds' Eggs*, 20gns.
1841	60	*The Good Shepherd Boy*, 20gns.
1841	69	*A Young Fisherman*, 15gns., Revnd. Sir Vernon Harcourt, West Dean House.
1841	84	*Bullace*, 18gns.
1841	88	*A Winter Effect*, 30gns., Own order.
1841	99	*Asking a Blessing*, Sold, J. Hewett Esq., Leamington.
1841	105	*Giving Himself (II)airs*, 30gns.
1841	126	*An Irish Pilgrim Boy*, Sold.
1841	148	*Fruit*, 12gns., Mrs. Packe Reading, 7 Richmond Terrace.
1841	153	*Boy with Ballads*, Sold.
1841	162	*A Self taught Genius*, 20gns.
1841	166	*A Laboratory*, Sold, Jacob Bell Esq., Oxford St.
1841	168	*Whittington*, 20gns.
1841	178	*A Masquerader*, 20gns.
1841	189	*Birds' Nests, &c.*, Sold.
1841	193	*A Cockscomb*, 10gns.
1841	198	*Fruit and Flowers*, 20gns.
1841	203	*Bullfinch, &c.*, 6gns.
1841	249	*A Mulatto Girl*, Sold.
1841	267	*Models*, 25gns.
1841	273	*Flowers*, 18gns., Mrs. Rennell, 39 Bryanston Sqr.
1841	281	*Damascenes, &c.*, Sold.
1841	284	*Devotion*, 22gns., B. Austen Esq., 6 Montague Place, Russell Sqr.
1842	20	*A Sleeping Trooper.*
1842	38	*A Rollicking Trooper.*
1842	55	*An Unwelcome Visitor.*
1842	85	*A Peasant Boy.*
1842	107	*Apples and Plums.*
1842	108	*A Trooper.*
1842	121	*Fruit.*
1842	127	*A Monk.*
1842	140	*"2nd Carrier. 'Lend me thy lanthorn, quotha? Marry, I'll see thee hanged first.'"* – Shakspeare, first part of King Henry IV., Act 2, Scene 1.
1842	146	*Flowers.*
1842	151	*A Farmer's Boy.*
1842	159	*A Sleeping Boy.*
1842	167	*Saying Grace.*
1842	196	*An Oyster Eater.*
1842	218	*Study of a Boy.*
1842	229	*An Interior.*
1842	252	*Making the Pot Boil.*
1842	258	*Morning Prayers.*
1842	265	*A Sleeping Infant.*
1842	289	*Devotion.*
1842	296	*Grapes and Melon.*
1842	299	*Interior of West Hill House, the residence of J. H. Mawe, Esq.*
1842	304	*Fruit.*
1843	10	*Still Life*, Sold.
1843	53	*An Interior*, 50gns., Chs. Wm.(?) Packe, 7 Richmond Terrace.
1843	59	*A Cottage Interior*, 15gns., Revd. J. Stratton, Precincts, Canterbury, Prize of 10£ in the Art Union of London.
1843	70	*Grapes, &c.*, Sold, Mrs. S. Hoare, Hampstead.
1843	72	*Grapes and Melon*, Sold, S. Maro Esq., Aldersgate St.
1843	80	*Bird's Nest, &c.*, 10gns., Colnl. Sibthorp.
1843	82	*Sloes, &c.*, Sold.
1843	105	*A Poet*, 8gns.
1843	128	*A Study of a Head*, 12gns., C. Russell Esq., M.P., 27 Charles St., St. James'.
1843	185	*Apples &c.*, 10gns.
1843	190	*An Interior*, 20gns., George Morant Esq., 91 Bond St.
1843	200	*An Interior in Devonshire-place*, 15gns.

1843	216	*Roses*, Sold.
1843	251	*Bird's Nest*, 10gns., Walker Esq., Birmingham.
1843	268	*Lilac, &c.*, 10gns., Lady Erskine, Conway, N.W. per Sir Richard Bulkeley, 69 Eaton Sq., Prize of 10£ in the Art Union of London.
1843	273	*Damsons, &c.*, 10gns., Henry Wilkinson Esq., Clapham Common, Frame and glass paid £1.1.0.
1843	280	*The Shadow on the Wall*, 12gns., Strahan Esq., 34 Hill Street.
1843	288	*Waking up*, 12gns., Messrs. Fores, 41 Piccadilly, Prize of 10£ in Art Union of London.
1843	297	*Fruit*, 10gns., E. Taylor Esq., 1 Cannonbury Square.
1843	298	*Tulips, &c.*, 5gns.
1843	306	*A Pet*, 15gns., Francis Graves Esq., 6 Pall Mall.
1843	307	*Apples, Plums, &c.*, 8gns.
1843	315	*Plums, &c.*, 8gns.
1843	331	*Flowers*, 10gns., Austen Esq., 6 Montague Place.
1843	338	*Bird's Nest and Flowers*, 15gns.
1843	346	*Peonies*, Sold.
1843	348	*A Beggar Boy*, 12gns.
1843	356	*A Flower Girl*, 12gns., S. Rucker Esq., 12 Tower Street, City.
1843	360	*A Peasant Girl*, 15gns.
1843	362	*Melon, Plums, &c.*, 15gns., Rucker Esq., 12 Tower St., City.
1844	26	*A Flower Girl*, Sold, Munro Esq.
1844	35	*The Gardener's Daughter*, Sold, Mrs. Price, 46 Warren St., Fitzroy Sq.
1844	52	*An Interior*, 25gns., J. Ryman Esq.
1844	61	*A Study of Heads*, 10gns.
1844	67	*Fruit*, 10gns.
1844	84	*A Yew Tree*, 15gns., Evans Davis Esq., Pride Hill, Shrewsbury, P.AU.
1844	92	*The Toilet*, Sold, Lewis Pocock Esq.
1844	96	*A Peasant Boy*, 12gns.
1844	97	*Apricots and other Fruit*, 12gns., Henry Holland Esq., 46 Montague Sq.
1844	106	*Nutting*, 15gns.
1844	131	*Tulips*, Sold, Miss Sheepshanks.
1844	140	*Rose, Lily, &c.*, 10gns.
1844	162	*An Old Pollard*, 20gns.
1844	186	*A Rose, &c.*, 8gns.
1844	190	*A Bird's Nest*, 10gns., Rd. Cumming Esq., 1 Mannor Cottage, Upper Holloway.
1844	192	*Lilac, &c.*, 8gns.
1844	205	*A Jug of Flowers*, 8gns.
1844	210	*A Cottage*, 10gns.
1844	220	*The Forsaken*, 15gns.
1844	227	*Dahlia, &c.*, 8gns.
1844	237	*An Aspirant*, 40gns., J. Ryman Esq.
1844	237	*Done Up*, 12gns., Price Edwards Esq.
1844	249	*A Rose and Fruit*, 10gns.
1844	258	*Birds' Nests*, Sold, Mrs. Stewart.
1844	267	*Grapes &c.*, Sold.
1844	272	*Roses, Grapes &c.*, 10gns., Rev. W.A. Soames, Greenwich.
1844	281	*Fruit, Flowers, &c.*, 10gns., Sir John Swinburne.
1844	289	*A Group of Flowers*, Sold.
1844	293	*Flowers*, 10gns., Colonel Pennant.
1844	297	*Study of a Head*, 10gns.
1844	312	*A Penitent*, 10gns., H.B. Churchill Esq., 2 Raymond Buildings, P.AU.
1844	318	*Pineapple and other Fruit*, Sold.
1845	10	*Romish Devotion*, 30gns., Charles Russell, 87(?) Charles St., St. James's.
1845	38	*Interior of part of a Church*, 15gns.
1845	42	*Pigeons*, 15gns.
1845	44	*A Sea View*, 8gns.
1845	68	*Interior, with Still Life*, 15gns., J.J. Ruskin Esq.
1845	211	*A Stable Boy*, 15gns.
1845	218	*A Stable*, 15gns.
1845	226	*A Mishap*, 20gns.
1845	234	*Writing*, 15gns., Richd. Ellison Esq.
1845	244	*Pineapple and Grapes*, 20gns.
1845	246	*An Interior, in the Elizabethan style*, 50gns., Mrs. Veale, Papaford, nr. Hatherleigh, N. Devon, New frame with plate glass about £5, P.AU. 50.0.0.
1845	251	*Pineapple, Grapes, Melon &c.*, 25gns.
1845	256	*Birds' Nests*, 10gns., Sir John Lowther Bart.
1845	258	*A Quince, &c.*, 12gns., Richd. Ellison Esq., Frame and glass £1.5.0.
1845	266	*A Paper Lantern*, 15gns., Hon. Col. Douglas Pennant.
1845	270	*A Rabbit, &c.*, 15gns.
1845	279	*Drawing by Candlelight*, Sold.
1845	301	*Hollyhocks, &c.*, 20gns.
1845	310	*Flowers*, 8gns., E. Tayler Esq., Cannonbury Sq., Islington.
1845	312	*Candlelight Studies - a Sketch*, 10gns., Miss H. Crompton, 14 Bolton Street.
1845	319	*Candlelight*, 12gns., Sir John Lowther B.
1846	14	*Plucking a Fowl*, 45gns.
1846	123	*Saturday*, 20gns., T. Graves Esq.
1846	131	*Anticipation*, 30gns.
1846	211	*Melons, Grapes, &c.*, Sold.

1846	227	*Sunday*, 20gns., H. Graves Esq.
1846	233	*Peaches, Grapes, &c.*, 15gns., E. Bicknell Esq., Herne Hill.
1846	239	*Yellow Corridor - T. Mackinlay's Esq.*, 25gns., Richard Roe Esq., 14 Kings Parade, Cambridge.
1846	244	*A Primrose Girl*, 15gns., Dr. Whewell, Trinity Coll., Cambridge, Lord Monteagh, 37 Brook St.
1846	252	*Going to the Fair*, 20gns.
1846	255	*Boy Sleeping*, 15gns., T. Boys Smith(?) Esq.
1846	258	*Still Life*, 8gns., Gordon Esq., 9 Berkeley Square.
1846	260	*Veneration*, Sold.
1846	262	*Pineapple, &c.*, 12gns., John Vokins Esq., 5 John St., Oxford St.
1846	276	*Roses*, 6gns., Francis Fuller Esq., 29 Abingdon St., Westminster.
1846	287	*Drawing*, 12gns., Henry Holland Esq., 46 Montague Square, Frame and glass £1.12.6 sold.
1846	297	*A Peasant Girl*, 12gns.
1846	308	*Grapes, Pomegranates, &c.*, 15gns., John Bent Esq., Liverpool.
1846	309	*Prayer*, Sold.
1846	316	*An Interior, J. Maw's, Esq., Hastings*, 30gns.
1847	69	*A Hermit*, Sold, Mr. Vokins, With frame.
1847	160	*A Tramper*, 15gns., J. Hogarth, Frame and glass £2.2.0.
1847	188	*A Page*, 15gns., J. Hogarth, Frame and glass £3.0.0.
1847	211	*Birds' Nests*, 15gns., Gambin(?) Parry, Highnam Court, nr. Gloucester, Frame and glass £1.15.0.
1847	212	*Devotional Offerings*, 22gns., Mr. Colls.
1847	232	*Christmas Pie*, Sold, Hogarth?.
1847	233	*Lamplight*, 6gns., Col. Pennant, Frame and glass £1.1.0.
1847	245	*Black and Green Grapes*, 10gns., Gambin Parry, Frame and glass £1.10.0.
1847	267	*Drawing by Two Lights*, 20gns., Dr. Whewell, Frame and glass £3.3.0.
1847	276	*Trampers at Home*, 45gns., Frame and glass £5.10.0.
1847	285	*Hedge Sparrow's and Robin's Nests*, 15gns., J. Ruskin Esq., Frame and glass £1.15.0 No.
1847	290	*Plums*, Sold, Mr. Vokins.
1847	298	*A Monk*, 15gns., R. Ellison, Frame and glass £1.10.0.
1847	314	*Grapes*, Sold, Hogarth?.
1847	315	*Butcher Boy*, Sold, Hogarth?.
1848	39	*Flowers*, 10gns., Frame and glass £1.10.0.
1848	69	*An Interior, at the Residence of T. M'Kinlay, Esq., Soho-square*, Sold.
1848	104	*Fast Asleep*, 25gns., Frame and glass £3.0.0.
1848	112	*The Orphan*, 20gns., Louis Hayes Petit, 9 New Square, Linc. Inn, Frame and glass £2.16.0 Yes, AU. 20.
1848	137	*Flowers - the Crown Imperial &c.*, 18gns., Lewis Loyd Esq., 20 Hyde Park Gardens.
1848	225	*A Branch of May*, 18gns., Rev. Hare-Townshend, Frame and glass £2.0.0.
1848	242	*Cabbage Roses*, Sold.
1848	245	*Candlelight Effect*, 25gns., Miss Burdett Coutts, Frame and glass £2.5.0.
1848	246	*Grapes and Bird's Nest*, 20gns., Rev. W.A. Soames, Greenwich, Frame and glass £1.15.0 No.
1848	252	*Grapes and Peaches*, Sold, Frame and glass £2.0.0.
1848	268	*Geranium &c.*, 8gns., Frame and glass £1.6.0.
1848	276	*An Interior at the Residence of John Curteis, Esq., Devonshire Place*, Sold.
1848	278	*Roses*, 20gns., Chas. Dickens, Devonshire Terrace, Frame and glass £1.15.0 Yes.
1848	285	*May Blossom*, 20gns., Rd. Coles(?) Esq., Frame and glass £1.15.0 No.
1848	286	*Roses*, 8gns.
1848	289	*A Soap and Water Bubble*, 25gns.
1848	293	*The Sister's Pet*, 25gns., Frame and glass £2.6.0.
1848	295	*Apples and Plums*, 16 Pounds, R. Colls(?).
1848	296	*The Expectant*, 15gns., Mrs. Curteis(?), 39 Devonshire Place, Frame and glass £1.15.0 Yes.
1848	299	*An Interior*, 40gns., F. Atkinson, Rugby, Frame and glass £5.0.0, AU. 40.
1848	305	*Wild Roses*, 15gns., Rev. Hare-Townshend, Frame and glass £1.18.0 No.
1848	310	*Rehearsing the Lesson*, 35gns., Frame and glass £3.5.0.
1848	312	*Primroses &c.*, 25 Pounds, R. Ellis(?) Esq., Frame and glass £2.15.0.
1848	313	*Roses and Bird's Nest*, 12gns., R. Lloyd, Ludgate Hill, Frame and glass £1.5.0.
1848	316	*Birds' Nests and Primroses*, 20gns., N. Wetheread(?) Esq., Frame and glass £1.10.0, AU.15.
1848	327	*Boy with Paper Lantern*, Sold.
1848	337	*What shall I play?*, Sold.
1848	340	*Hot Bread and Milk*, 20gns., Cheffins.
1848	345	*Pine-apple, Peaches &c.*, 20gns., B.B. Pegge Burnell Esq., Beauchieff Abbey, near Sheffield, Frame and glass £2.18.0 No.
1849	78	*Wild Flowers*.
1849	227	*An Old Pollard*.
1849	234	*A Basket of Plums*.

1849	237	*Reading.*
1849	248	*A Pigeon.*
1849	259	*Plums and Grapes.*
1849	265	*Primroses &c.*
1849	266	*Candlelight Effect.*
1849	284	*Pineapple &c.*
1849	289	*Roses.*
1849	296	*May Blossoms.*
1849	306	*Lilac.*
1849	312	*Apricots &c.*
1849	315	*Grapes and Peaches.*
1849	319	*Sunday School Girl.*
1849	329	*Apple Blossom.*
1849	333	*Group of Flowers, &c.*
1849	339	*Plums.*
1849	344	*Mary.*
1849	347	*A Farm House Pantry.*
1849	354	*Bullace.*
1849	355	*A Lane Scene.*
1849	357	*A Basket of Primroses.*
1850	165	*Hare, Wood-pigeon, &c.,* Sold.
1850	240	*A Jug of Roses,* Sold, R. Ellison.
1850	241	*The Oratory,* 15gns.
1850	249	*A Masquerader,* 8gns.
1850	262	*A Female Head,* 20gns.
1850	275	*Primroses,* Sold.
1850	280	*Prayer,* 12gns., Tom Taylor.
1850	281	*Grapes, Figs, &c.,* 25gns., Rev. Thos. Prater, Middleton Stoney, Bicester.
1850	284	*Bird's Nest &c.,* 30gns., F. Astley Esq., Fellfoot.
1850	288	*Apple Blossom,* Sold, R. Ellison.
1850	300	*Roses,* 25gns., Revd. G.D. Bowles, Shrubbery, Gt. Malvern, Frame and glass £1.1.0 Yes.
1850	306	*Reading,* 15gns.
1850	319	*Blackberries,* 18gns., Francis Graves Esq., 11 Powis Place, Hampsted Rd.
1850	321	*A Broom Dasher,* 1gns.
1850	333	*Grapes, Apricots and Plums,* Sold.
1850	336	*Pineapples, Grapes &c.,* Sold.
1850	343	*Plums,* Sold.
1850	345	*Wild Roses,* 15gns., J.F. Bateman, Manchester.
1850	351	*Devotion,* 25gns., Francis Wilson Esq., 14 Widcombe Crescent, Bath.
1850	374	*The Emigrant's Daughter,* Sold.
1850	378	*Dead Birds,* 10gns.
1851	249	*Plums &c.*
1851	259	*May.*
1851	264	*Winter.*
1851	283	*Pineapple, Grapes and Quinces.*
1851	284	*Spring.*
1851	298	*Primroses and Bird's Nest.*
1851	304	*Apple Blossom.*
1851	308	*Jug of Flowers.*
1851	312	*Ivory Cup, &c.*
1851	322	*Grapes and Plums.*
1851	326	*Primroses.*
1852	223	*Remnants of Garlands,* 15.
1852	231	*Wood Pigeon, &c.,* Sold.
1852	234	*Grapes and Quince,* Sold.
1852	243	*The Village Pet,* 15G, Messrs Ackerman, Strand.
1852	248	*Snow Drops,* 25G.
1852	261	*Plums,* Sold.
1852	267	*Primroses,* Sold.
1852	282	*Apple Blossoms &c.,* 35G, John Mollett, Mr. Steadman, 35 Charles St., Hampstead Road.
1852	292	*Crocuses,* 30G.
1853	209	*A Young Rustic.*
1853	220	*A Masquerader.*
1853	250	*A Wood Pigeon.*
1853	254	*Devotion.*
1853	259	–
1853	280	*Apple Blossom.*
1853	283	*A Study.*
1854	232	*Fruit,* Sold.
1854	233	*May Blossom,* 20gns., George Fripp Esq., for C.B. ??? Esq., Bristol.
1854	263	*Primroses,* Sold.
1854	273	*Fruit,* Sold.
1854	296	Sold.
1854	298	*Diffidence,* Sold.
1855	155	*A Usurper,* Sold.
1855	229	*Le Malade Imaginaire,* Sold.
1855	247	*The Mendicant,* Sold.
1855	256	*Fruit,* Sold.
1855	262	*Primroses and Pear Blossom,* Sold.
1855	270	*Confidence,* Sold.
1855	271	*A Group of Fruit,* Sold.
1855	285	*From Nature,* Sold.

JACKSON S

1823	223	*View of the Hot Wells and part of Clifton, near Bristol.*
1823	267	*View of King's Weston.*
1824	13	*An Old Manor House - Composition - Twilight.*
1824	287	*Composition, Twilight.*

1824	288	Bristol, from St. Michael's Hill.
1824	306	Sun-set on the Coast of Somersetshire.
1825	270	St. Donats, Glamorganshire, 10gns.
1826	163	View of the Cathedral Church and part of Bristol, from Great George Street, 15gns.
1827	121	Composition - Hunters resting after the Chase, 30gns.
1828	50	A Composition of the Natural Scenery of the West Indies, in which the Silk-Cotton and Mountain-Cabbage Trees, are introduced, 35gns.
1829	131	Snowden, from near Llyn Gwynout, 4gns.
1829	192	Twilight, "Pale on the desert shore he lies, No wife beloved to close his eyes . . ." 20gns.
1829	216	Upper Lake, Llanberris, 5gns., Moxon Esq.
1830	28	A Scene at Lymouth, in North Devon, 10gns.
1830	48	A Study from Nature, 4gns.
1830	180	Composition, "A land of dreams, where the spirit strays . . ." 40gns.
1830	201	A Study at Lymouth, 4gns.
1831	89	The Islands forming the Dragon's Mouths of Columbus, with part of the Coast of Cumana in the distance - taken from the Anchorage Port of Spain, Trinidad.
1831	395	The Pitch Lake in the Island of Trinidad.
1832	25	Sun-set off Lymouth, Devon, 5gns.
1832	295	Chedder Cliffs, Somersetshire, 5gns., Rev. W.B. Roberts.
1833	215	Chedder Cliffs, 6gns., Mr. Moxon, 23 Lincolns Inn Fields.
1833	367	Derwentwater, looking towards Skiddaw and Bassenthwaite Water, taken from above Lowdore, 8gns.
1834	25	Obi Worship, scene in Man-of-War Bay, Island of Tobago, 8gns.
1834	171	Storm off the Mumbles, Swansea, 8gns.
1834	230	Porthege Cavern, Vale of Neath, 5gns.
1834	256	Patterdale Bridge and Head at Ulleswater, 10gns.
1835	113	Snowdon, from the Lower Lake of Llanberris, 8gns.
1835	118	Pont Aberglassllyn, North Wales, 6gns.
1836	7	The Downs, near Linton - Exmoor in the distance, 6gns.
1836	47	Snowdon, From Capel Cûrig, 8gns.
1836	164	Snowdon and Llyn Cwrllin, 6gns., Thos. Griffith Esq., Norwood.
1836	173	The Valley of Rocks, 6gns.
1837	103	A Thunderstorm over Llyn Ogwen, 6gns.
1837	282	Clifton, with the Situation of the Suspension Bridge, (now erecting) indicated by a faint Line in the Distance, which is the Iron Bar upon which a Passage is effected from Rock to Rock, 8gns.
1838	180*	The Marine Square, or Commercial Garden in the Isle of Trinidad.
1838	230	View of Kingston, in the Island of St. Vincent.
1840	229	The Llanberris Side of Snowdon.
1841	236	A Thunder Storm over Llynn Gwillin at the Foot of Snowdon and Myrridd Moil, 35gns.
1842	30	St. Vincent's Rocks and part of Clifton, with the Suspension Bridge, taken from Leith Wood.
1842	68	Ulswater, looking towards Patterdale.
1843	68	The Observatory, Clifton, from Nightingale Valley, 5gns.
1843	78	Stonehenge, 3gns.
1843	258	Keswick, on Derwent, and Bassenthwaite Lakes, 25 Pounds.
1844	80	Snowdon, from Capel Cûrig, 50 Pounds.
1845	197	An Indian Hut at Arima, Trinidad, near a Country Residence of the late Sir Ralph Woodford - from a Sketch made in the Year 1827, 5gns.
1846	203	Bath Abbey, 50 Pounds.
1847	155	Primitive Shepherds, alarmed, 60gns.
1848	164	Cwm Thlook, at the Foot of the Beacons of Brecon, 12gns.

JACKSON S P

1853	6	Wreck on the Coast, near the Mumbles, Glamorganshire.
1853	66	A Squally Day.
1853	67	On the Coast of North Devon - A Hazy Morning.
1853	145	Aberystwith, from the Sea - Evening.
1853	171	The Spartiate, Sheer Hulk, at Hamoaze, Plymouth.
1853	248	A Calm Evening on the Tamar.
1854	50	Coast Scene - Sunrise, £25.0.0, Sold, Frame and glass £2.0.0.
1854	57	Squally Weather, 8gns. [deleted], Sold, Frame and glass £1.1.0.
1854	79	St. Michael's Mount and part of Marazion, Penzance Bay, Cornwall, £40.0.0, Messrs. Vokins, Frame and glass £2.0.0.
1854	99	River Scene - Moonrise, Sold [£13.0.0 deleted], Frame and glass £1.14.0.
1854	105	A Light Breeze, Sold [10gns. deleted], Frame and glass £1.1.0.
1854	151	On the Sands, Swansea Bay, £17.0.0, Thomas Toller Esq., Frame and glass £1.0.0.
1854	169	Entrance to Fowey Harbour, Cornwall - Storm Clearing off, Sold.
1854	192	Frost Scene - Evening, £25.0.0, Sold, Frame and glass £2.0.0.
1855	72	Tintagel Castle - Evening, after a Storm, £60.0.0, S. Walker Junr., 40 Upper Harley St., Frame and glass £5.0.0.

1855	95	*Coast of Devon - Evening*, £30.0.0, George Gwyn Elgar Esq., Frame and glass £2.0.0.
1855	186	*A Summer Day on the Coast*, 30gns., Rev. H. Sibthorp, Frame and glass £2.12.6.
1855	307	*Off Hastings - Squally Weather*, Sold.

JENKINS J J

1852	56	*Shelter*, 50G, Frame and glass £2.10.0.
1852	100	*Wait for Me*, 25, John Wild Esq., Frame and glass £2.0.0.
1852	118	*Come Along*, 25, Frame and glass £2.0.0.
1852	126	*Play*, 40£, Alex. Morison Esq., Frame and glass £3.0.0.
1852	200	*A Pastoral*, *"Here a shepheard's boy piping, as though hee should never be old."* Sir P. Sidney's Arcadia. Sold.
1852	245	*Rebekah*, *"And the damsel was very fair to look upon – and she went down to the well and filled her pitcher."* Sold.
1852	268	*Ruth*, *"So she gleaned in the field until even."* Sold.
1852	320	*Thoughts of Home*, 25P, Frame and glass £2.0.0.
1853	87	*Affection*, *"Just as the twig is bent, the tree's inclined."* – Vide Pope's Moral Essays.
1853	143	*Prenez Garde*.
1853	214	*The English Side of the Channel*.
1853	223	*The French Side of the Channel*.
1853	262	*Sleepy Companions*.
1853	306	*Chit Chat*.

JENKINS JOS J

1849	95	*Shrimping - Coast of France*.
1850	61	*Prayer - Brittany*, 30gns., Bathurst.
1850	69	*"Come in"*, 30 Pounds, I. Anderson Ross(?) Esq. and Lady, 11 Salisbury St., ???, Frame and glass £1.10.0.
1850	115	*Study in a Fisherman's Hut, France*, Sold.
1850	181	*Shrimper - near Boulogne*, 25gns., William Fairbairn Esq., Manchester, Frame and glass £1.15.0 Yes.
1850	190	*The Angels' Whisper*, 50gns., Jos. Farratt Esq., Frame and glass £3.0.0 Yes.
1850	200	*The Storm - Brittany*, 50 Pounds, Frame and glass £2.10.0.
1850	222	*The Calm - Brittany*, 50 Pounds, Jos. Tarratt Esq., Bilbrooke House, Frame and glass £2.10.0 New.
1850	276	*The Sisters*, 15gns., Frame and glass £1.0.0.
1851	44	*A Gossip over the Wedding Dress - Brittany*.
1851	59	*What can it mean?*.
1851	208	*Our Saviour*.
1851	231	*Washing in the Rocks, near Boulogne*.
1851	254	*The Guide*.
1851	313	*The Lily*.
1851	327	*Waking Up*.
1854	31	*Evangeline at Prayer*, *"Many a youth, as he knelt in the church and opened his missal, fixed his eyes upon her as the saint of his deepest devotions."* Sold.
1854	97	*The Russian Serf*, Sold.
1854	237	*Put me Down*, Sold.
1854	258	*Take Me Up*, Sold.
1854	351	*Start*, Sold.
1855	76	*Hold-fast (Coast of France, near Boulogne)*, Sold.
1855	83	*Le Repos*, 30gns., Hanbury Esq., Poles, Frame and glass £1.10.0.
1855	86	*Heureux Moments*, Sold.
1855	237	*En Route*, Sold.
1855	244	*Le Retour du Marche*, Sold.
1855	266	*Hopes and Fears*, Sold.
1855	288	*Evening*, 10gns., Miss Hewett, Leamington, Frame and glass 10/s.

JENKINS JOSEPH J

1849	15	*The Rival's Wedding - Brittany*.
1849	69	*On the Way to England*.
1849	125	*Going against the Stream - Brittany*.
1849	162	*Jealousy*.
1849	208	*Devotion*.
1849	311	*After a Romp*.

JONES G

1820	30	*The Obsequies of Pompey performed by Cordus, who found the decapitated Body of his General floating near the sea shore,"* – summas dimovit arenas . . ." Pharsalia, Lib. VIII.
1820	33	*The last Interview of Pompey and Cornelia before the Battle of Pharsalia*, *"– nostros non rumpit funus amores . . ."* Pharsalia, Lib. V.
1820	147	*Giants of the South*, *"Les Dieux ont fait un pont que va de la Terre au Ciel . . ."* Edda, Fable VII.
1820	154	*The Goddesses of War riding to the Hall of Odin to announce the Death of Haquin*, *"Allons announcer a Odin qu'un roi va le visiter dans son palais."* Eloge de Haquin.
1820	218	*Freya and Frigga*, *"C'est à elle qu'est confiée la toilette et la chaussure de Frigga."* Edda. Fable XVIII.

JONES MISS

| 1820 | 175 | *Portrait of Mrs. Tarleton*. |

JONES MISS E

1819	162	*Cupid*.
1819	171	*Head of Her Royal Highness the Princess Charlotte*.
1819	182	*Lady reading*, £8.8.0, W. Fawkes Esq.
1820	177	*Love Derided*, *"So com' Amor saetta, e come vola . . ."*

1820	183	Devotion, "The maiden form that bends in prayer . . ."
1820	191	Portrait of Miss Hill.
1820	194	Studies of Children, from Nature.
1820	206	Agatha, La buona e bella.

KANGIESSER H F

1814	203	Leistley Craig, near Moreton Hampstead, North Devon.

KENDRICK MISS

1816	17	Cleopatra dissolving the Pearl.

KENDRICK MISS E

1815	23	Portraits of Lady Graham, and Thomas Carr, Esq.
1815	31	Cupid and Psyche.

KENDRICK MISS E E

1818	171	Mrs. Everard Bonomi.
1818	176	A Study.
1818	184	Going to Market, and a Study of a Head.
1818	190	Frame containing Portraits of Everard Bonomi, Esq. Sir W. Clayton, Bart. the Right Hon. the Earl of Denbigh.
1819	167	Portraits of a Lady and Gentleman.
1819	179	Portraits of Lady Graham and Mrs. Vansittart.
1819	183	Portraits of Miss Clayton, G. Vansittart, Esq and Mrs. Clayton.
1819	185	Agrippini bearing the Ashes of Germanicus, £21.0.0, Mr. Babington, Hampstead.
1820	174	Hebe and the Cousins, Portraits of Miss Sandilands and Miss Prince.
1820	179	Devotion.
1820	192	Andromache mourning over the Helmet of Hector.
1820	195	A Study of an Arab Chief - His Excellency the Persian Ambassador &c. a Study.
1820	196	A Portrait.

KENRICK MISS E E

1817	139	A frame containing portraits of Mrs. Starky, the Right Hon. Lord Erskine, and a Lady.
1817	150	Dido expiring on the Funeral Pile.

KIDD W

1818	137	Dead Game.
1818	148	Dead Game.

KING J

1814	62	A View from the upper part of the old Custom House of London Bridge, with Blackfriars Bridge, Somerset House, and Westminster Abbey, in the distance.
1820	46	The Parents of Moses placing him in the Bulrushes.

KNIGHT MISS

1820	197	Portrait of the Son of R. Parry Esq.
1820	203	Portraits of the Children of Wm. Rush, Esq.

LANDSEER E

1816	8	Study of a Dog's Head, from Nature.
1817	105	A Dog, painted from Nature.
1817	118	A Sleeping Dog.
1817	130	Portrait of an Alpine Mastiff, the property of G. Bullock, Esq.
1818	140	Fighting Dogs getting wind.
1820	80	Interior of a Nacker's Shop, £31.10.0.
1820	117	Rival Candidates.
1820	120	The expectant Dog - The Property of the Hon. F. Byng.
1820	123	Dog of the Marlborough breed - the Property of J. Warner Esq.

LANDSEER H

1820	69	View in Suffolk.

LANDSEER MISS

1817	101	View on Little Baddow Common.
1817	113	View in the Grounds of K. Kingsford, Esq. Essex.
1818	93	View on the River Colne.
1818	94	Sible Hedingham Church. Study from Nature.
1818	109	Part of the Village of Sible Hedington.
1818	119	Study from Nature.
1818	124	Southey Green.
1820	65	Hop Pickers.
1820	68	Hop Pickers.

LESLIE C

1817	52	Edwin, "And yet poor Edwin was no vulgar boy; Deep thought oft seem'd to fix his infant eye." Beattie's Minstrel, Book I.

LEWIS F C

1814	43	View near Enfield - Morning.
1814	55	Scene near Bettws Garman, North Wales.
1814	77	Morning - Wales.
1814	218	View at Enfield - Evening.
1816	28	A Study from Nature, Enfield.
1816	143	A Study from Nature.
1816	154	Sun-rise at Enfield.
1816	178	Brook Scene, at Enfield.
1816	183	Brook Scene, at Enfield.
1816	207	Pollard Oaks, Study from Nature.
1816	217	Mist on the New River, Enfield.
1816	222	Looking towards Beddgelart, North Wales.
1816	224	Waltham Cross, Study from Nature.
1817	30	Winchmore Hill, near Enfield.
1817	45	Llandegai, North Wales.
1817	85	Cheshunt Common, Study from Nature.
1817	99	Study from Nature at Enfield.
1817	107	Scene at Enfield.
1817	116	Noon, Scene at Enfield.
1818	112	Scene on the River Dart, on the estate of Sir B. Wrey; the residence of B. Calmady, Esq. in the distance. (One of the Twenty Views of the Dart now engraving for Publication.)

1818	150	*Scene on the River Dart, Devon, at Staverton Ford, on the Estate of Arthur Champernown, Esq. (One of the Twenty Views of the Dart now engraving for Publication.)*
1819	72	*A Study from Nature.*
1819	73	*Scene at Enfield.*
1819	78	*Afternoon Scene near Llandegai, North Wales.*
1819	99	*Morning - Scene at Enfield.*
1820	54	*Study from Nature.*
1820	58	*Morning - Study from Nature.*
1820	63	*Morning - the Remains of the Conduit at Islington.*
1820	310	*Scene at Marks Ridge, on the River Dart, Devon - on the Estate of Sir. B. Wrey, Bart.*

LEWIS G

1814	42	*Evening.*
1816	12	*Hereford, from the Haywood, Noon, painted on the Spot.*
1816	136	*A Frame containing Three Subjects. The first, Dynedor and Malvern Hills, Noon. The second, Dynedor and Malvern Hills, Morning. The third, Dynedor Hill, Noon. Painted on the Spot.*
1816	139	*Hereford, Dynedor, and Malvern Hills, from the Haywood Lodge, Harvest Scene, Afternoon. Painted on the Spot.*
1816	147	*A Frame containing Three Subjects. The first, Dynedor Hill, Noon. The second, Dynedor Hill, Noon. The third, near Hereford, Afternoon. Painted on the spot.*
1816	209	*A Frame containing Three Subjects. Dynedor Hill, Noon. Harcup and Garraways Hills, Noon. Aconbury Hill, Noon. Painted on the spot.*
1816	211	*A Frame, containing Three Subjects. Haywood, Morning. Dynedor Hill, Morning. Haywood Lodge, Morning. Painted on the spot.*
1817	71	*The Overthrow of the Amalekites, "And it came to pass, when Moses held up his hand, that Israel prevailed; and when he let down his hand, Amalek prevailed. But Moses' hands were heavy and they took a stone, and put it under him, and he sat thereon; and Aaron and Hur stayed up his hands. . ." Exodus, Chap. xvii. Ver. 11 and 12.*

LEWIS J F

1820	73	*Morning - Ploughing.*
1827	239	*The vanquished Lion, 18gns., Frame and glass 4gns.*
1827	251	*Dying Lioness, 15gns., Frame and glass 3gns.*
1827	319	*Mare and Foal, 15gns., Frame and glass 4gns.*
1827	343	*Gamekeepers reposing in Windsor Forest.*
1828	53	*Hawking, 10gns.*
1828	77	*Scene in a Vineyard, on the Italian Side of Mount St. Bernard, 30gns., Braithwaite Esq.*
1828	86	*Tyrolese Hunters, 30gns.*
1828	161	*Dead Plover, 8gns., T. Griffiths Esq.*
1828	202	*Scene near the Bridge of Sighs, Venice, 10gns., Mr. G. Basevi, 17 Saville Row.*
1828	309	*Gamekeeper and Boy ferreting Rabbits, 12gns., Mr. G. Basevi, 17 Saville Row.*
1828	356	*Pee-wit, 8gns.*
1829	68	*Cleaning the Duck-gun, Sold.*
1829	107	*An Otter, 25gns., Mr. Rd. Sykes, Westella, near Hull.*
1829	246	*The Bachelor - Oxford, 25gns., J.D. Harding Esq.*
1829	252	*Wild Ducks surprised by a Fox, 30gns., Munro Esq.*
1829	314	*Peasants of the Italian Tyrol at their Devotions, 40gns., Mrs. Mathews, Ivy Cottage.*
1829	357	*The Feeder, 15gns., E. Hull, Regent St.*
1829	385	*A Vineyard in the Val d'Aosta, 15gns., Griffiths Esq.*
1829	395	*Game-keeper's Assistant, and Boy Resting, 15gns., W. Prior Esq.*
1830	60	*Water Mill in the North of Devon, Sold.*
1830	95	*"Piscator. – 'Look you now, you see him plain . . . bring hither the landing-net . . . a good one, sixteen inches long . . .'" See Izaak Walton. 35gns., Chas. Burrow Esq., 49 Cumming St., Pentonville.*
1830	103	*The Squire, Sold.*
1830	160	*Interior of a Cottage in Devonshire, Sold.*
1830	197	*A Franciscan Monk at his Devotions, 8gns., His Grace the Duke of Norfolk.*
1830	245	*Ponte di Rialto, Venice, Sold.*
1830	280	*An Old Warrener, &c., Sold.*
1830	321	*Scene in the Village of Godisberg, on the Rhine, 10gns.*
1830	324	*Shetland Pony &c., Sold.*
1830	340	*The Recess, Sold.*
1830	350	*Waterfall, near Linton, Devonshire, 12gns., Sold.*
1830	358	*Scene in a Vineyard in the Italian Tyrol, 25gns., Tomkison Esq., Russel Place, Fitzroy Square.*
1830	363	*Interior of a Fisherman's Cottage, Sold.*
1831	17	*Interior of a Highland Cottage.*
1831	54	*Deer Shooting - A Scene of the Olden Time.*
1831	99	*Sleeping Hound.*
1831	142	*Interior of a Highland Cottage.*
1831	177	*Odds and Ends.*
1831	203	*Killin, Perthshire.*
1831	208	*Highland Peasants - Scene in the Neighbourhood of Loch Tay.*
1831	291	*Interior of a Scotch Cottage.*

1831	293	*Gamekeepers on the look-out.*
1831	300	*Sleeping Hound, &c.*
1831	314	*Fish-Wife, Newhaven.*
1831	341	*Highland Boy, Dogs &c.*
1831	342	*Fisherman.*
1831	354	*Fox and Duck.*
1831	381	*Exterior of a Venetian Curiosity Shop.*
1831	386	*Cottage Door, Highlands.*
1832	107	*Scotch Fisherman's Cottage Door*, 40gns.
1832	117	*Fishwives, Newhaven, Edinburgh*, Sold.
1832	192	*Highland Hospitality*, Sold.
1832	317	*Highland Shepherd &c.*, Sold.
1832	366	*Cottage Door*, Sold.
1832	399	*Market Boat - Grand Canal, Venice*, Sold.
1833	52	*Banditti*, 25gns., with frame.
1833	119	*An Interior*, Sold.
1833	338	*Fish*, Sold.
1833	351	*Vineyard*, 15gns.
1833	369	*An Andalusian Peasant begging at a Convent Door in Seville*, 20gns., Mr. Griffith, Norwood (Mr. Evans).
1833	400	*A Calasero of Andalusia*, 12gns., Mr. Windus.
1833	409	*Mass in a Moorish Chapel in the Cathedral of Cordova*, 60gns., Mr. Parrott, Mill Bank Row.
1833	412	*A Spanish Beggar - Grenada*, 12gns., Mr. Windus.
1834	33	*Ronda - Spain*, Sold.
1834	43	*Interior of a Spanish Posada*, Sold.
1834	139	*A Spanish Muleteer*, 10gns., Mrs. J.C. Powell, 32 Upper Harley Street.
1834	159	*Peasants of Andalusia Dancing the Bolero*, Sold.
1834	166	*Scene in Seville*, Sold.
1834	177	*Seville*, 75gns.
1834	186	*Peasant of the Pyrenees*, 10gns.
1834	314	*An Interior*, Sold.
1834	343	*Muleteers, &c. of Andalusia*, Sold.
1834	375	*Spanish Contrabandista, &c.*, 50gns., Ackerman & Co.
1835	131	*A Spanish Posada - supposed to be after a Bull Fight*, Sold.
1835	153	*The Tajo of Ronda, Spain, - Arrieros going down the Mountain*, Sold.
1835	254	*Vineyard Scene, Granada, Spain*, 25gns., Mr. D. Colnaghi.
1835	262	*A Friar of the Order of Los Trinitarios Descalzos, Spain*, 18gns., Captn. Harcourt, St. Leonards, near Windsor.
1835	266	*Spanish Mendicant Friars receiving Alms*, Sold.
1835	288	*A Spanish Lady - Painted for H. R. H. Prince George of Cambridge*, Sold.
1835	292	*Spanish Capuchin Monks Preaching for the Benefit of their Convent, Seville*, Sold.
1835	297	*A Spanish Peasant Girl - Painted for H. R. H. Prince George of Cambridge*, Sold.
1836	112	*A Bull Fight at Sevile, "The lists are oped, the spacious area cleared . . ." Childe Harold.* Sold.
1836	143	*A Bull Fight in Spain - the Death of the Bull. The men drinking in the foreground are Chulos, (literally cheats) whose occupation is to deceive and irritate the bull with their cloaks &c.; on the left are two gipsy girls (Gitanas); in the arena stand the fighters, &. . ., "Such the ungentle sport that oft invites The Spanish maid, and cheers the Spanish swain, &c." Childe Harold.* Sold.
1836	302	*The Suburbs of a Spanish City (Granada) on the Day of a Bull Fight. This scene is supposed to represent the immediate neighbourhood of the amphitheatre, the rendezvous of the fighters &c. . . ., "The Sabbath comes, a day of blessed rest! . . ." Childe Harold.* Sold.
1837	146	*A Fiesta Scene in the South of Spain - Peasants &c. of Granada dancing the Bolero*, 130gns., order of Mr. Lewis.
1837	269	*The Sacristy of a Cathedral in Spain - Devotional Peasants, &c*, Sold.
1837	316	*A Spy of the Christino Army brought before the Carlist General in Chief, Zumalacarregui, In the Basque provinces, Navarre, &c. the present seat of civil war in Spain, the peasantry were constantly pressed into the service of the contending powers to convey intelligence from one general to another . . . See A Twelvemonth's Campaign with Zumala* For price apply to Mr. Lewis, 78 Wimpole Street, Sold order of Mr. Lewis.
1838	129	*Murillo painting the Virgin, in the Franciscan Convent at Seville, Murillo is said to have lived two years with the Capuchin Monks of Seville, during which time he painted those famous pictures . . . Murillo is represented as painting, from his models, a peasant family.*
1838	322	*The Pillage of a Convent, in Spain, by Guerilla Soldiers.*
1841	141	*Easter Day at Rome - Pilgrims and Peasants of the Neapolitan States awaiting the Benediction of the Pope at St. Peter's*, Sold.
1841	296	*A Devotional Procession - Scene in Toledo, Spain*, Sold.
1852	139	*The Arab Scribe - Cairo*, Sold.
1854	248	*Halt in the Desert, Egypt*, Sold.
1854	305	*Camels and Bedouins - Desert of the Red Sea*, Sold.

1854	341	*Roman Peasants at the Entrance to a Shrine,* Sold.

LEWIS JOHN F

1850	147	*The Hhareem,* Sold.
1855	135	*The Well in the Desert, Egypt,* Sold.
1855	150	*The Greeting in the Desert, Egypt,* Sold.

LINNEL J

1813	213	*The Bird Catcher - A Scene from Nature.*
1814	76	*Morning - Crossing the River - A View in Wales.*

LINNELL J

1814	46	*Evening View in Wales.*
1814	219	*Afternoon - Going to milk.*
1814	227	*Windmill.*
1814	228	*Morning - Milking.*
1814	240	*Travellers - View in Wales.*
1814	244	*Snowden, from Dolwyddellan - Evening.*
1815	49	*Barges on the Thames.*
1815	56	*Fishing Boats, Hastings.*
1815	108	*A View in Dove Dale, Derbyshire.*
1815	116	*A View in Dove Dale, Derbyshire.*
1815	122	*Mid Day, A Scene in Wales,* £21.0.0, J.M. Barrett Esq.
1815	144	*A Fine Evening after Rain, a Scene in Wales,* £21.0.0, J. Leader Esq.
1815	152	*The Hay-Makers Repast, a Scene in Wales.*
1816	13	*View on the River Kennett, near Newbury, Berks.*
1816	36	*A View in Windsor Forest.*
1816	64	*A Portrait.*
1816	72	*Portrait of an Artist.*
1816	104	*Shipping,* £16.16.0, J. Frere Esq.
1816	114	*A View, from a Hill called Hanson Toot, in Derbyshire, looking into Dovedale. Vide Walton's Complete Angler.*
1816	122	*Evening, Shepherds' Amusement.*
1816	124	*View near Steep-hill, Isle of Wight.*
1816	129	*Digging Potatoes,* £8.8.0, Mr. Robertson.
1816	316	*Evening.*
1816	323	*A Portrait.*
1817	48	*A Portrait.*
1817	49	*A Portrait.*
1817	54	*Portrait of M. Bryan, Esq.*
1817	55	*A Portrait.*
1817	66	*View near Shanklin, Isle of Wight.*
1817	67	*View at Niton, Isle of Wight.*
1817	91	*A Fall of Timber,* £63.0.0, J. Allnutt Esq.
1818	68	*View of the Isle of Wight from Mount Pleasant, near Lymington, by Moonlight,* £8.8.0, J. Vine Esq.
1818	75	*Noon.*
1818	80	*Portrait of a Gentleman.*
1818	113	*A Forest Scene.*
1818	118	*Evening.*
1818	120	*St. John Preaching in the Wilderness.*
1819	59	*Portrait.*
1819	60	*Portrait.*
1819	61	*View near Windsor.*
1819	62	*Evening.*
1819	64	*Portrait.*
1819	65	*Portrait.*
1819	71	*Evening, Storm clearing off.*
1819	79	*The Windmill.*
1819	159	*Twilight.*
1819	160	*The Dairy - Morning.*
1819	164	*Portrait.*
1820	36	*Wood Cutters - a View in Windsor Forest.*
1820	107	*East Window &c. of Netley Abbey - a Sketch done on the spot.*
1820	201	*A Portrait.*

LINTON W

1818	53	*Carisbrook Castle, Isle of Wight.*
1818	61	*View on the Thames, near Harleyford, Bucks.*
1818	63	*View on the Thames, near Harleyford, Bucks.*
1818	82	*View on the Thames above Henley.*
1818	95	*Scene in Windsor Forest.*
1819	31	*Scene on the Coast near Lancaster.*
1819	108	*Scene in New Forest, Hants.*
1819	140	*Flint Castle, North Wales.*
1819	155	*Cottage Scene, near Hastings.*
1819	186	*The Fountain of Blandusia, O Fons Blandusiae, splendidior vitro, &c. Horace, Lib. III. Car. XIII.*
1820	235	*View of the New Town of Edinburgh, from the North.*

LONSDALE J

1817	122	*Dead Game.*

MACKENZIE

1825	334	*View of St. Pancras Church,* Sold.
1825	336	*Burlington Arcade,* Sold.

MACKENZIE F

1813	42	*Garden, Front of St. John's College, Oxford.*
1813	45	*Interior of New College Chapel (for the History of Oxford),* £42.0.0, Mr. Wheeler.
1813	136	*Entrance to Magdalen College Chapel (for the History of Oxford).*
1813	175	*Albany Hall, Oxford (for the History of Oxford).*
1813	183	*Divinity School, Oxford (for the History of Oxford).*

1813	185	*View of Oxford, from Radcliffe Library (for the History of Oxford).*
1814	85	*Lincoln College Chapel, Oxford.*
1814	96	*The Divinity School, Oxford.*
1814	131	*Nave of Christ Church Cathedral, Oxford, £42.0.0, G. Hibbert Esq.*
1814	155	*Choir of Christchurch Cathedral, Oxford, £42.0.0, Mr. Sedgewick.*
1814	226	*Vestibule of Radcliffe Library, Oxford.*
1814	273	*The Chapel of All Soul's College, Oxford.*
1814	282	*The Chapter-House, Christchurch, Oxford, £63.0.0, Sir J. Swinburne.*
1815	40	*The Confessional in Norwich Cathedral.*
1815	62	*St. John's College, from the Gardens.*
1815	73	*Public Library, Cambridge.*
1815	93	*View from a Window of Peter House.*
1815	106	*Court of Baliol College, Oxford.*
1815	114	*Library of Christchurch.*
1815	231	*South side of King's College Chapel, Cambridge.*
1815	240	*Anti Chapel, of Jesus College, Cambridge.*
1815	297	*Choir of Norwich Cathedral.*
1815	303	*The Old Court of King's College, Cambridge.*
1815	319	*Tom Tower, Christ Church, Oxford.*
1815	326	*Court of Emanuel College, Cambridge.*
1815	328	*Nave of Norwich Cathedral.*
1815	329	*West end of Kings College Chapel, Cambridge.*
1815	338	*Chapel of Trinity College, Cambridge.*
1815	339	*Trinity Chapel, Ely Cathedral.*
1816	91	*Choir of Winchester Cathedral.*
1820	309	*Wressel Castle, Yorkshire.*
1820	331	*Rivaulx Abbey, Yorkshire.*
1822	25	*Coronation of His Majesty King George the Fourth, in Westminster Abbey.*
1823	301	*Interior of Rouen Cathedral.*
1823L	66	*Interior of New College Chapel, Oxford, Mr. R. Ackermann.*
1823L	103	*The Divinity School, Oxford, J. Vine, esq.*
1823L	115	*Radclyffe Library, Oxford, Mr. R. Ackermann.*
1823L	117	*Choir of Norwich Cathedral, G. Hibbert, esq.*
1823L	124	*Nave of Oxford Cathedral, G. Hibbertt, esq.*
1823L	167	*Christchurch, Newgate Street, Mr. R. Ackermann.*
1823L	168	*King's College Chapel, Cambridge, Mr. R. Ackermann.*
1823L	171	*Chapter-house of Christ Church, Oxford, Mr. R. Ackermann.*
1823L	172	*Library of Winchester Cathedral, Mr. R. Ackermann.*
1824	274	*The Altar and the Chapel at Ashridge.*
1826	234	*Interior of St. Paul's Cathedral, 20gns.*
1827	166	*View of the New Buildings at King's College, Cambridge, now erecting under the direction of William Wilkins, Esq. R.A., Sold.*
1828	170	*Interior of Westminster Abbey, 60gns.*
1828	350	*Rivaulx Abbey, Yorkshire, 15gns.*
1828	362	*Kirkstall Abbey, Yorkshire, Sold.*
1829	55	*Interior of the Abbey of St. Ouën, at Rouen, 60gns.*
1830	78	*An Interior, Sold.*
1831	201	*Interior of a Cathedral - Composition.*
1832	257	*Interior of the Abbey of St. Ouën, showing the Jubé which formerly stood at the entrance of the Choir. The figures represent the Obsequies of the Cardinal d'Amboise, in 1510, 50gns.*
1833	41	*A Restoration of the Roman Forum, from a Composition sketched on the spot, from actual measurement of the Ground and Ruins, in 1826, by James Pennethorne, Esq. Architect, This Restoration is intended to represent the Forum, the Tarpean Rock and Palatine Hill . . . Sold.*
1834	16	*Strasburg Cathedral from the Market place, after a Sketch by Mr. Wild, 25gns., Mrs. Olive, York Terrace, Regents Park, Wishes to take the frame and glass. Price of frame and glass from Mr. ???? £4.10.0.*
1834	344	*The principal Room of the original National Gallery, formerly the residence of John Julius Angerstein, Esq. lately pulled down. This and the adjoining Room were built for Frederick Prince of Wales (Father of George the Third,) with an entrance from the Gardens of Carlton House, 150gns.*
1835	166	*One of the two richest Temples of Delwarra - from a Sketch by Mrs. Colonel Hunter Blair, 35gns., Not to be sold to any Publisher.*
1835	197	*Ruins of St. Stephen's Chapel, 10gns.*
1836	149	*Castle Acre Priory, Norfolk, 8gns.*
1837	99	*Staircase in Byland Abbey, 7gns.*
1837	104	*Rochester Castle, 12gns., Lady Rolle, 18 Upper Grosvenor Street.*
1838	263	*St. John's, Trinity, and King's Colleges &c. Cambridge, from the Castle Hill.*
1838	267	*Canterbury Cathedral.*
1839	238	*Versailles, from the Bois de Satory, 40gns.*
1840	180	*View of the Abbey Church of St. Denis, near Paris.*
1841	181	*Market-place, Cambridge, 60gns., Mr. Jas. Walker, 23 Great Geo St., Westminster.*
1841	206	*Ruins of the Old Chapter House, Rochester, 5gns., Richd. Ellison Esq., Sudbrooke Holme, Lincoln.*
1842	97	*Christ Church Gate, Canterbury. (The Turrets, which were taken down about thirty years ago, are represented as in their former state, from accurate authority.).*

1843	145	*Oxford, from Hinksy,* 8gns.
1843	321	*Interior of Westminster Abbey, near Henry the Seventh's Chapel,* 12gns., Jos. Feilden Esq., Whitton House, Blackburn, Lancashire, Frame and glass £2.10.0.
1844	74	*South Door of Lincoln Minster,* 60gns., Lord Brownlow.
1845	76	*North Aisle of Peterborough Cathedral,* 8gns., Lord Brownlow.
1845	99	*Erith,* 7gns.
1845	138	*The Abbey Gate, Reading,* 20gns., George Vaughan Esq., 28 Cumberland Terrace.
1845	184	*Peterborough,* 60gns.
1846	259	*Thornton Abbey, Lincolnshire,* Sold.
1847	235	*Lincoln Minster, from the Cloister,* Sold.
1847	238	*Magdalen College, from the Charwell,* 15gns.
1848	42	*Rivaulx Abbey, Yorkshire (Front of the Refectory),* 12gns.
1848	226	*Rivaulx Abbey, Yorkshire (the Transept),* 18gns.
1848	243	*Rivaulx Abbey, Yorkshire, from the South-east,* 18gns.
1848	263	*Rivaulx Abbey, Yorkshire (the Choir),* 18gns.
1848	328	*Byland Abbey, Yorkshire,* 10gns.
1848	333	*Byland Abbey, Yorkshire,* Sold.
1848	338	*Rivaulx Abbey, Yorkshire (Interior of the Refectory),* 15gns.
1849	171	*Evening.*
1849	324	*The Suffolk and Chaucer Monuments in Ewelme Church, Oxfordshire.*
1850	91	*Lincoln Minster, from the N. W.,* Sold.
1850	195	*Lincoln Minster, from the S. W.,* Sold.
1850	237	*Stow Church, Lincolnshire, the Saxon Cathedral of Sidnacester; build in the seventh century; the Episcopal Seat of the Diocese of Lindsey, and Mother Church of Lincoln; considerable portions of the original Saxon Edifice may still be traced,* Sold.
1851	9	*Entrance to the Great Hall of the Castle, Newcastle-on-Tyne.*
1851	144	*The Dungeon in the Castle, Newcastle-on-Tyne.*
1851	197	*Lincoln Minster, from Cottam's Terrace.*
1851	263	*Monks Lane, Lincoln.*
1852	115	*The Library of Stanmore Hall - the Seat of Robert Hollond, Esq.,* 100gns.
1853	146	*Herstmonceaux Castle, Sussex - from a Sketch taken in 1817.*

MACKENZIE FREDK

1851	120	*The Oratory in the Castle, Newcastle-on-Tyne.*

MACKENZIE J

1827	348	*Interior of Westminster Abbey - Tombs of Edward the Confessor, Edward the Third, Richard the Second, and Henry the Fifth.*

MAISEY J

1820	255	*View, from Nature, of Roundhay Park, Yorkshire, the Seat of Thomas Nicholson Esq.*

MAISEY T

1819	187	*Goodrich Castle.*

MANDY J C

1813	5	*Cottage, Carshalton, Surrey.*
1819	255	*View of the Green Park.*

MILLER J H

1816	259	*Design for completing the Window of All Hallow's, Barking Church, Tower-street. The upper tracery having been executed, in Stained Glass, by J. H. Miller.*

MOORE C

1822	53	*Interior of the Dome of the Hotel Royal des Invalides, Paris.*
1823	75	*View of Charing Cross.*
1824	293	*Interior of the Stables of His Majesty's Palace - Brighton.*
1825	66	*Interior of the West End of Lincoln Cathedral,* 8gns.
1825	246	*The Music Room Gallery - His Majesty's Palace Brighton,* Sold.
1826	179	*South View of Lincoln Cathedral,* 4gns.
1827	196	*Interior of Netley Abbey, Hampshire,* 12gns.
1828	30	*Fontaine des Innocents - Paris,* 15gns.

MORISON D

1844	223	*The Green Drawing-room, Buckingham Palace,* Sold.
1844	225	*The Saloon, Buckingham Palace,* Sold.
1844	230	*The Grand Staircase, Buckingham Palace,* Sold.
1844	232	*The Banqueting Room, Buckingham Palace,* Sold.
1844	234	*The Picture Gallery, Buckingham Palace,* Sold.
1844	252	*A Room in Windsor Castle,* Sold.
1844	261	*The Grand Staircase, from the Marble Hall, Buckingham Palace,* Sold.
1844	290	*Chatsworth,* Sold.

MORISON DOUGLAS

1845	43	*The Chapter-house, Furness Abbey, Lancashire,* Sold.
1845	52	*The Manor House,* 8gns.
1845	153	*A Cottage in Derbyshire,* 8gns., William Garfit Esq., Boston, Lincolnshire, Frame and glass £2.0.0.
1845	191	*Furness Abbey, Lancashire,* 8gns., C.H. Turner Esq., Rooksnest.
1845	196	*Ronhead, near the Coast, Furness, Lancashire,* 8gns.
1845	241	*Derwent Hall, Derbyshire,* 8gns., Samuel Sainsbury, 177 Strand, Frame and glass £2.0.0.
1845	321	*Furness Abbey - North View,* 8gns., I.H. Hawkins Esq., 16 Suffolk St., Frame and glass £2.10.0.

| 1846 | 281 | *Taynault Bridge, Western Highlands, Scotland*, 10gns., C.H. Turner Esq., Rooksnest, 15 Bruton St., Frame and glass £2.10.0 paid Fredk. Tayler. |

MORRISON D

| 1846 | 238 | *Falls of the River Dulnain*, 10gns., Richard Ellison Esq., Frame and glass £2.10.0 to go to Mr. Tayler. |

MORTON H

1814	110	*South Aisle of Henry the Seventh's Chapel.*
1815	14	*Game.*
1815	32	*Shrine of Edward the Confessor, Westminster Abbey.*

MULREADY MRS

1813	232	*Old Houses in Mary-le-bone Park.*
1813	245	*Cottage near Kensington.*
1814	35	*A Mill.*
1814	36	*A Cottage.*
1814	52	*Back of a Farm.*
1815	167	*Cottages.*
1815	168	*A River Scene.*
1815	195	*Cottages.*
1816	142	*A Scene from Nature.*
1817	110	*Sketch from Nature.*
1817	119	*Cottage near Hornsey.*

MUNN P S

1806	18	*Dovedale, Derbyshire.*
1806	77	*Western towers of York Minster.*
1806	105	*View at Matlock, Derbyshire, taken from the back of the Old Bath.*
1806	157	*Near the Ferry, Matlock.*
1806	197	*In Dovedale, Derbyshire.*
1807	108	*Rivaux Abbey, Yorkshire.*
1807	141	*Entrance to Peak's hole, Derbyshire.*
1807	209	*Middleton Dale, Derbyshire.*
1807	231	*Durham, from Crook mill.*
1807	256	*At Castleton, Derbyshire.*
1808	92	*Legberthwaite, near Keswick.*
1808	176	*Entrance to Pello Wood, Old Durham.*
1808	207	*Study near Benefield, Northampton.*
1808	219	*Crummock Water, from the village of Lowes Water, Cumberland.*
1808	284	*St. Oswald's well, Durham.*
1809	161	*Leatherhead, Surry.*
1809	169	*Stonethwaite, with Eagle Crag, Borrowdale.*
1809	229	*On the Mole, Leatherhead, Surry.*
1809	266	*Leatherhead Bridge, Surry.*
1809	288	*At Biggen, near Oundle, Northamptonshire.*
1810	128	*Part of Coniston Water, with Coniston Hall and Village in the distance.*
1810	136	*At Ambleside, Westmoreland.*

1810	183	*At Ambleside, Westmorland.*
1810	199	*Lower end of Rydalmere, Westmoreland.*
1810	301	*Bridge at Nookend, Ambleside - Evening.*
1811	77	*At Troutbeck, Westmorland.*
1811	201	*Coniston Waterhead, Lancashire.*
1811	308	*At Troutbeck, Westmorland.*
1811	341	*Near Coniston, Lancashire.*
1812	135	*Part of Buildas Abbey, Shropshire.*
1812	278	*On the Brathay, near Clappersgate, Westmorland.*
1812	283	*Cottage at Hastings.*
1812	296	*Mill at Ambleside.*
1815	42	*Coniston Water-head, Lancashire*, £3.3.0, Mr. Brooksbank.
1815	80	*At the Fish Ponds, Hastings*, £2.12.6, Mr. Brooksbank.
1815	95	*Between Ambleside, and Keswick, Cumberland.*
1815	182	*Near Hastings, Sussex.*
1815	219	*At Ambleside, Westmoreland.*
1815	224	*Llyn Ogwen, Nant Frankon, North Wales.*
1815	234	*Part of St. Mary's Abbey, York.*

NAFTEL J P

1852	46	*Looking up the Valley Moulin Huet*, 15P.
1852	94	*Old House, Bordeaux Harbour*, 15.
1853	25	*North Devon.*
1853	26	*Bettws-y-Coed.*
1853	64	*A Well-known Spot, North Wales.*
1853	86	*Entrance to Wookey Village, Somersetshire.*
1853	105	*Wells Cathedral.*
1853	122	*The Gleaners.*
1853	137	*Millford, at Highclew, the Seat of the Earl of Carnarvon.*
1853	192	*The Moor.*
1854	11	*The Fox Glove*, £25.0.0.
1854	17	*Road to the Mountain Farm, with Moel Siabod and Snowdon*, £21.0.0.
1854	48	*The Lyn - Upper part of Sir William Herries' Grounds*, £25.0.0.
1855	14	*The Queen landing at Alderney*, £30.0.0.
1855	68	*Sea Gulls' Haunt, Serk*, £40.0.0.
1855	97	*Evening at the Lake, High Clere*, 15gns.
1855	122	*Vraicking Time in Bordeaux Harbour, Guernsey*, £20.0.0, S. Dearle(?) Esq., 1 Cheyne Walk, Chelsea, AUP.
1855	125	*On the North-East Coast, Guernsey*, 20gns., Thos. Cobb, 4 Richmond Rd., Twickenham.
1855	129	*Looking East from Bordeaux Harbour, Guernsey*, 15gns., C. Goodfellow, 19 Fitzroy Square, AUP.
1855	203	*Guernsey Cottage*, 12gns., Major Munn, Throwley House, Faversham, Kent.

1855	209	*Bad Havest Weather*, £30.0.0.

NAFTEL P

1850	21	*Moel Siabod, North Wales*, 20 Pounds.
1850	43	*Interior of a Kitchen, Guernsey*, Sold.
1850	60	*Cottages near Bordeaux Harbour, Guernsey*, 15 Pounds.
1850	75	*Entrance to the Water Lane, Moulin Huet, Guernsey*, Sold.
1850	95	*Church Pool, Bettws-Coed, North Wales*, 20 Pounds.
1850	116	*Back View of a Farm House, Guernsey*, Sold.
1850	159	*Guernsey Cottage*, Sold.
1851	143	*La Planque, Guernsey.*

NAFTEL P J

1851	24	*Hotel at Handek, Switzerland.*
1851	34	*On the Aar, Switzerland.*
1851	78	*Between Handek and Grimsel, Switzerland.*
1851	191	*An Old Guernsey Road.*
1851	195	*Boideaux Harbour, Guernsey.*
1851	243	*Couture Lane, Guernsey.*
1852	137	*Love Lane, St. Martin's, Guernsey*, 10G.
1852	153	*Love Lane, Guernsey*, 10G, C.R. Welch Esq., The Royal Society, Somerset House.
1852	182	*The Old Fisherman at Pont du Moulin, Sark*, 15G, Miss Phillips, Penmoyle, nr. Chepstow.
1852	189	*The Old Gate*, 18G, Dr. Fripp, 9 Albert Road, Regents Park, Frame and glass £3.3.0 Yes.
1852	201	*Old Mill, St. Peter's Valley, Jersey, 1800 – from a Sketch by Mrs. Gen. Le Couteur*, Sold.
1854	118	*Stones of the Lyn*, £30.0.0.
1854	282	*Lyn Mouth*, 20gns., D.C. Marjoribanks, 29 Upper Brook St.
1854	342	*Vale Church, from near Grande Roque*, 12gns., B. Tomalin, 8 Adam St., Adelphi.

NASH F

1810	54	*A Shed.*
1810	70	*The Choir of St. George's Chapel, Windsor.*
1810	79	*The Chapel of Eton College.*
1810	257	*Shrine of Lewis Robsart, Standard-bearer to King Henry V, in the Abbey Church of Westminster*, 40gns., Lord Ussulston.
1810	272	*Poor Knights Houses, Windsor Castle.*
1811	60	*A View under the High Bridge, Lincoln.*
1811	65	*Windsor Castle.*
1811	67	*Roman Arch at Lincoln.*
1811	75	*Windsor Terrace.*
1811	103	*Inside of an Old Bell Tower at Windsor Castle.*
1811	105	*In Eton.*
1811	110	*A Crypt of Kirkstall Abbey.*
1811	134	*Remains of the Chapter House, Fountains Abbey, a Sketch.*
1811	145	*Part of the Ruins of Fountain's Abbey, a Sketch.*
1811	152	*Inside of the Temple Church London.*
1811	155	*Fountain's Abbey from the High Altar.*
1811	167	*Ruins of the Savoy Palace.*
1811	169	*Kirkstall Abbey a Sketch.*
1811	175	*St. Edmond's Chapel, Westminster Abbey.*
1811	187	*Ruins of the Bishop's Palace, Lincoln.*
1811	208	*Edward the Third's Tomb.*
1811	214	*Cow Houses - a Sketch.*
1811	218	*High Bridge, Lincoln.*
1811	236	*Ruins of Kirkstall Abbey.*
1811	237	*Windsor Bridge.*
1811	238	*Inside of Westminster Abbey, with Funeral Procession*, Mr. Wheeler.
1811	369	*Old Houses on the Banks of the Thames.*
1812	13	*The West Gate, Canterbury.*
1812	41	*Transept of Netley Abbey.*
1812	68	*St. Augustin's Gate, Canterbury.*
1812	84	*Knights of the Bath going to be installed.*
1812	200	*The Altar Screen in the Abbey Church at St. Alban's (to be engraved for the History of Hertfordshire, by R. Clutterbuck, Esq.).*
1812	271	*A Sketch from Nature: Ruins of St. Augustin's Monastery.*
1812	275	*At Eltham, Kent - A Sketch from Nature.*
1812	338	*A Sketch from Nature (in Lady Spencer's Grounds, St. Alban's).*
1812	339	*A Sketch from Nature, at St. Alban's.*
1813	76	*Oriel College, Oxford (for the History of Oxford).*
1813	128	*Merton College, Oxford.*
1813	150	*Foley Bridge, Oxford.*
1813	177	*View of Oxford, Radcliffe Library (for the History of Oxford).*
1817	187	*Ruins of Fountain's Abbey, Yorkshire*, £10.10.0, J.W. Quintin Esq.
1817	240	*Part of Tewkesbury Abbey.*
1817	242	*Glastonbury.*
1817	265	*Tewkesbury Abbey, from the Cheltenham Road.*
1819	76	*A Sketch of the Southwark Bridge, from Bankside.*
1819	81	*An old Crypt, with Cattle.*
1819	209	*View of the Southwark Bridge, in its unfinished state, before the Timber Centres were removed.*
1820	160	*Inside of the Great Hall of the Palace of Justice, Paris.*
1820	161	*Facade of the Louvre, Paris.*
1820	162	*Catacombs of Paris.*
1820	163	*Gardens of the Palais Royal, Paris.*

1820	214	*Bridge in Paris.*
1820	215	*Interior of the Louvre in Paris.*
1823L	3	*Tomb of Louis Robsart - Standard bearer to Henry the Vth - Westminster Abbey,* Earl of Tankerville.
1823L	50	*Covent Garden,* J. Slegg, esq.
1823L	56	*View in Paris,* J. Allnutt, esq.
1823L	177	*Interior of Exeter Cathedral,* The Artist.
1824	44	*The Inside of Westminster Abbey, with a Royal Funeral Procession.*
1824	206	*Crediton, Devon.*
1825	193	*View of Calais Harbour, to be engraved for Mr T. F. D'Ostervald's Work of the Coasts and Ports of France, now publishing,* Sold.
1825	207	*Distant View of Versailles from Verofley.*
1825	239	*The Baths of Apollo, in the Gardens of Versailles, Painted on the Spot,* 20gns.
1825	277	*Ruins of the Temple of Juno, at Agrigentum,* 35gns.
1825	328	*A Frame containing Eight views of the Palace and Gardens of Versailles and the Little Trianon, being part of a Series made for Mr J.F. D'Osterwald's Work of French Palaces, now preparing for Publication,* Sold.
1825	329	*A Frame containing Four Views of the Palace Fontainbleau, one of Versailles , the Entrance of Boulogne Harbour, a View in the Valley of Chamouni, for Mr. D'Osterwald's Work. Also a View of Pont Royal, Paris,* Sold.
1825	330	*A Frame containing Four views of the Chateau of Rambouillet, three of St. Cloud, and one from the Terrace of St. Germain, for Mr. D'Osterwald's Work,* Sold.
1826	20	*The Palace of the Tuileries and Pont Royal, Paris,* 25gns.
1826	88	*Lincoln Cathedral,* 15gns.
1826	207	*An Interior,* 40gns.
1826	248	*The Wine Market, and Pont Tournelle, with the Cathedral of Notre Dame in the distance, Paris,* 40gns., Mr. Charles Holford.
1827	85	*View, looking down the North Aisle of Westminster Abbey, with the Funeral Procession of Queen Elizabeth,* Sold.
1827	97	*Cookham Ferry, on the Thames, near Maidenhead,* 35gns.
1827	220	*Bath and Bristol Boats - View near Maidenhead - Clifden in the distance,* 35gns.
1827	221	*Interior of St. George's Chapel, Windsor, during the Apostles' Creed,* 60gns.
1827	338	*Rochester Castle.*
1828	67	*Interior of Durham Abbey, with a Monkish Procession, at a High Festival, 'The next morning being Holy Thursday, they had a general procession, with the 2 Cross's born before them . . ." See old MS. in the Library of Durham Abbey.* 100gns.
1828	96	*A View of Durham, from Giles's Gate,* 30gns.
1828	205	*Cheapside,* 50gns.
1828	221	*The Castle, &c. Durham,* 10gns.
1828	222	*Tramelgate Bridge, Durham,* 10gns., W.B. Kitchner Esq., Albany.
1828	269	*A View in one of the Chapels of Durham Abbey,* 10gns., Lord de Dunstanville, South Place, Knightsbridge.
1828	293	*Interior View, at the West-end of Durham Abbey,* 10gns., Lord de Dunstanville, South Place, Knightsbridge.
1829	3	*Old Tower, Manor Shore, York,* 8gns.
1829	75	*Interior of Malmsbury Abbey, Wilts,* 8gns.
1829	83	*Interior of Malmsbury Abbey, Wilts,* 8gns.
1829	94	*The Castle, Durham,* 10gns.
1829	129	*View of Bath, from Beechen-Cliff,* 12gns.
1829	142	*A View of York, from the City Walls,* 30gns.
1829	197	*View of Part of the Ruins of St. Mary's Abbey, York, discovered by the late excavations, and the Palace of King James the Second,* 15gns., Mrs. I. Braithwaite.
1829	198	*South-East View of the Remains of St. Mary's Abbey, York, as discovered by the late excavations,* 15gns.
1829	222	*Moonlight, View on the Manor Shore, York,* 15gns., Earl of Dartmouth, Cavendish Square.
1829	240	*Windsor, from Slough,* 7gns.
1829	256	*The Great Gallery of the Louvre, Pont Royal, Quai Voltaire, and part of the Palais des Beaux Arts, at Paris,* 60gns., I. Braithwaite Esq.
1829	260	*Pere la Chaise, Paris,* 7gns.
1829	276	*Distant View of Snelston Hall, near Ashbourne, Derbyshire, the Seat of George Harrison, Esq.,* Sold.
1829	282	*Windsor Castle, from Upton,* 7gns., Mrs. Wyatville.
1829	286	*Distant View of Snelston Hall, near Ashbourne, Derbyshire, the Seat of George Harrison, Esq.,* Sold.
1829	300	*Tewkesbury Abbey,* 4gns.
1829	305	*South-East View of Snelston Hall, near Ashbourne, Derbyshire, the Seat of George Harrison Esq.,* Sold.
1829	341	*View on the Seine, Paris,* 6gns., J. Moxon Esq., 23 Lincoln's Inn Fields.
1830	7	*Fountain in the Market-place, Liege, Netherlands,* 10gns., Sold.
1830	69	*The Mansion House, London,* 15gns.
1830	170	*At Brughes, Netherlands,* 8gns., Broderip Esq.
1830	175	*Hüy, on the Meuse - Going on Board the Barque for Liege,* 10gns., Mrs. Montefiore, 10 Park Lane.
1830	193	*Palace of Justice, Brughes,* 8gns.

1830	203	*Ghent, Netherlands,* 40gns.
1830	212	*Grande Place à Liege, Netherlands,* 30gns.
1830	218	*Bridge at Liege, Netherlands,* 6gns.
1830	230	*Bridge, Fortifications &c. Huy, Netherlands,* 12gns.
1830	235	*Palace and Garden of the Tuilleries, Paris,* 30gns., Broderip Esq.
1830	242	*Moonlight Scene on the Meuse, at Liege,* 30gns.
1831	43	*Study from Nature - at Caën.*
1831	155	*Study from Nature, at Caen.*
1831	170	*Interior of the Church of St. Julien, at Tours; now used as a Remise to the Hôtel de l'Europe.*
1831	223	*Cathedral, Nantes.*
1831	230	*Pont de la Poissonniere, Nantes.*
1831	237	*Nantes.*
1831	261	*Study from Nature - Nantes.*
1831	266	*Pont de la Belle Croix, Nantes.*
1831	278	*Church of St. Pierre, Caën.*
1831	357	*Angers - Twilight.*
1831	406	*Liege.*
1832	15	*Ruins of the Castle of Arques, near Dieppe - Early Morning,* 6gns.
1832	37	*York, from the Old Walls,* 8gns.
1832	55	*Hotel des Velociferes at Rouen, being a part of the Remains of an ancient Convent, with the Paris Diligence preparing to start.* 30gns.
1832	74	*Waterloo Bridge,* 8gns.
1832	95	*Huy, on the Meuse,* 8gns.
1832	124	*Caudebec, on the Seine,* 8gns., J. Lewis Brown, 10 Leicester Place, Leicester Square.
1832	129	*Ruins of the Castle of Arques, near Dieppe,* 6gns.
1832	134	*Ruins of the Abbey of Jumieges on the Seine,* Sold.
1832	141	*Market Place and Church of St. Jaques at Dieppe,* 35gns.
1832	162	*Church of St. Pierre at Caën,* 8gns.
1832	204	*Interior of the Ancient Church of St. Valentine at Jumieges, on the Seine,* 40gns.
1832	208	*The Broken Bridge at Dieppe,* 5gns.
1832	217	*Calshot Castle - Moon-rise,* Sold.
1832	243	*Cour de la Reine, Rouen,* 10gns.
1832	330	*Interior of the Church of Ducler, near Rouen,* 12gns., Lord de Dunstanville, opposite the Life Guard Barracks, Knightsbridge. N.B. Wishes to know the price of the frame.
1832	331	*Entrance to Dieppe Harbour,* Sold.
1832	338	*Landscape - View near Brighton,* 8gns.
1832	343	*Bramber Castle, Sussex,* 6gns.
1832	370	*A Study on Hampstead Heath, looking towards London,* 8gns.
1833	10	*Bruges,* 7gns., Mrs. Malony, 12 Gloucester Place.
1833	25	*Huy, on the Meuse,* 8gns.
1833	80	*Palais des Beaux Arts, Paris,* 6gns.
1833	95	*Clare Hall and Bridge, Cambridge,* 8gns.
1833	118	*Rouen,* 25gns.
1833	144	*Oxford, from Rose Hill,* 10gns.
1833	168	*North End, Hampstead,* 8gns., Sold.
1833	174	*An Old Bridge near Hendon,* 7gns.
1833	183	*At Hampstead,* 7gns.
1833	267	*At Hampstead,* 8gns., Domett Esq.(?). To be delivered at Mr. Leggat's, Cornhill.
1833	286	*The Market Place at Liege,* 8gns.
1833	319	*Christ Church Walk, Oxford,* 8gns., Sold Mr. Nash.
1833	333	*Wadham College and Garden, Oxford,* 8gns.
1833	348	*An Interior,* 8gns.
1833	391	*Interior of a Church near Caudebec,* 10gns., F.G. Howard, 16 Grosvenor Square, 1 June, purchased when Mr. Dewint was in the room.
1833	423	*An Interior,* 10gns., Mrs. Smith, 6 Portland Place.
1834	36	*Interior of Shoreham Church,* 10gns.
1834	60	*St. Nicholas Church, Brighton - early Morning,* 8gns.
1834	65	*On the Road to Hindon,* 5gns., Sold. Mr. Nash's order.
1834	74	*Rouen, from Mount St. Catherine,* 10gns., Sold by order of Mr. Nash - see his note.
1834	82	*View near Poynings, Sussex,* 8gns.
1834	100	*Liege from the River - Moonlight,* 10gns., Sold. Mr. Nash's order.
1834	107	*Port-royal, Island of Jamaica, from a Sketch made on the spot by Lieut.-Colonel Bernard,* 10gns.
1834	108	*Liege,* 10gns., The Right Honble. Lady Rolle.
1834	114	*Off Hastings,* 4gns., Sold Mr. Nash's order.
1834	117	*The Fruit Market, Pont de l' Hotel Dieu, Notre Dame, and the Archéveché, Paris,* 30gns., Mr. John G. Reeves, Moon Street, Frame and glass included.
1834	136	*View under one of the Arches of the Pont Tournelle, Paris,* 10gns.
1834	168	*Interior of the Church of Jumiéges on the Seine,* 7gns.
1834	207	*Arco Suro, near Rome, from a Sketch made on the spot by the late - Barnard, Esq.,* 15gns.
1834	224	*Mill at Arundel,* 7gns.
1834	229	*Interior at Caen, Normandy,* 10gns.
1834	243	*The Hermitage d'Ousebourne, near Sion, in the Valais, from a Sketch by the late -- Barnard, Esq.,* 20gns., Sold Mr. Nash.

1834 285 *Arundel Castle, from the Park,* 7gns., Sold Mr. Nash's order.

1834 320 *An Interior, near St. Wandrille, on the Seine, Companion to 168,* 7gns.

1834 329 *On the Beach at Brighton,* 4gns.

1834 332 *The Devil's Dyke, Sussex - a Shower coming on,* 7gns., Joseph Walker Esq., Birmingham.

1834 356 *On the Beach, Brighton,* 4gns., Sold Mr. Nash's order.

1834 365 *Fountain at Dieppe,* 6gns.

1835 34 *An Interior, with a Procession of Monks on a grand Festival Day,* 50gns.

1835 46 *Bolton Abbey, Yorkshire,* 8gns., Sold by order of Mr. Nash.

1835 55 *A Mill in Kent - Twilight,* 5gns., sold by order of Mr. Nash.

1835 56 *Near the Lake of Killarney,* 7gns.

1835 70 *Lewes Castle,* 5gns., Sold Mr. Nash.

1835 88 *Cottages at Bramber, Sussex,* 5gns., Sold Mr. Nash as per order.

1835 98 *In Lord Chichester's Park, Sussex,* 5gns., Sold Mr. Nash's order.

1835 99 *Askerton Abbey, County of Limerick,* 7gns.

1835 111 *The Cathedral of St. Denis, near Paris,* 6gns.

1835 115 *Boulevarde des Italiens, Paris,* 20gns.

1835 187 *The Louvre,* 8gns., Sold per order of F. Nash.

1835 196 *Entrance to Bramber from Brighton,* 5gns.

1835 206 *Nantes - Morning,* 25gns.

1835 210 *View off Hastings,* 5gns., Sold by Mr. Nash's order.

1835 227 *Preston, Sussex,* 7gns., Sold per order of F. Nash.

1835 275 *Cattle - Morning,* 6gns., Mr. Joseph Walker, Birmingham, To be sent to Mr. David Cox, 9 Foxley Road, Kennington Court on Wednesday.

1836 24 *Windsor Old Bridge - Twilight,* Sold.

1836 29 *View of Paris from the Heights of Passy, opposite the Champ de Mars, part of which with the Gilded Dome of the Invalides appears on the right hand of the Picture... From a sketch made on the Spot in the Year 1819,* 40gns.

1836 38 *Lake of Nemi,* 12gns., Sir Richd. Hunter, 48 Charles Street, Berkeley Square.

1836 43 *Study from Nature,* 4gns.

1836 55 *Grande Place, Prague,* 12gns., Vaughan Esq., 28 Cumberland Terrace, Regents Park.

1836 68 *A River Scene,* 15gns., Geo. Jelf Esq., Kings Bench, Temple.

1836 75 *Dale Turnpike Gate, near Brighton, on the London Road,* Sold.

1836 133 *Moonlight - Study on the Beach, Brighton,* Sold.

1836 171 *Hastings - Morning,* 5gns., Sir Richard Hunter, 48 Charles Street, Berkeley Sqr.

1836 172 *Brighton Fishing Boats,* 4gns.

1836 182 *Study from Nature,* 4gns.

1836 183 *Gathering Oats,* Sold.

1836 198 *View near Rome,* 7gns.

1836 199 *Ruins on the Hill at the back of Martigny,* 5gns.

1836 200 *A Mill in Sussex,* 4gns.

1836 205 *View on the Seine, Rouen,* 8gns., Mr. Morant. Junr.

1836 212 *View at Preston, near Brighton - Evening,* 7gns.

1836 223 *Lock, near Lewes, Sussex,* 4gns.

1836 231 *View near Brighton,* 4gns.

1836 240 *Bridge at Tours,* 6gns., W. Broderip, Esq.

1836 251 *Gipsy Scene on Hampstead Heath - Evening,* 4gns., Society Encouragement of British Art - at Colnaghi & Co.

1836 274 *Cattle on a Bank,* Sold.

1836 279 *Scene on the Boulevards, Paris,* 10gns., John Allnutt Esq., Clapham.

1836 316 *Fishing Boats, Brighton,* 4gns., Lady Rolle.

1853 35 *Twilight - Scene on the Wye.*

1853 54 *Grand Place at Prague.*

1853 71 *The Fountains of Neptune and Amphitrite, in the Gardens of Versailles.*

1854 42 *Arundel Castle - Morning,* £20.0.0. Frame and glass £3.0.0.

NASH FREDERICK

1847 8 *Tankerville Castle,* 20 Pounds.

1847 34 *Part of the Ruins of Cowdry House,* 6 Pounds.

1847 37 *At Bacharach on the Rhine,* 10 Pounds.

1847 44 *Caudebec on the Seine,* 25 Pounds.

1847 50 *Grande Place, Dieppe,* 8 Pounds.

1847 65 *Remains of the Banqueting Hall of Cowdry House, Sussex,* 10 Pounds.

1847 66 *Shoreham - Cloudy Morning,* 15 Pounds.

1847 75 *Porch leading to the Hall of Cowdry House,* 10 Pounds.

1847 91 *Shoreham Harbour - Evening,* 6 Pounds.

1847 108 *Byam Tower, Cologne,* 20 Pounds.

1847 143 *Oberwesel, on the Rhine,* 25 Pounds.

1847 153 *Oberwesel,* 10 Pounds.

1847 158 *Interior of Shoreham Church,* 20 Pounds.

1847 170 *Arundel Castle - Moonlight,* 15 Pounds.

1847 177 *Ruins in the Fountain Court of Cowdry House,* 10 Pounds.

1847 180 *Windsor Castle, from Slough,* 8 Pounds.

1847 182 *Fountains Abbey, Yorkshire,* 30 Pounds.

1847 203 *Windsor Castle, from the Thames,* 8 Pounds.

1847 229 *Windsor Castle, from Queen Adelaide's Tree,* 8 Pounds.

1847	234	*Marksburg, on the Rhine,* 8 Pounds.
1847	313	*Ghent,* 8 Pounds, John Martin Esq., 14 Berkely Sq.
1848	22	*Street Scene at Braubach, on the Rhine,* 8gns.
1848	43	*View from Hampstead Heath, looking over the Vale of Health,* 20 Pounds.
1848	65	*Stirling Castle, from a Sketch by Lieut. Colonel Eden,* 8gns.
1848	87	*An Old Watermill,* 25 Pounds.
1848	110	*Interior of an old Church near Rouen,* 25 Pounds.
1848	124	*Hove, near Brighton,* 8gns.
1848	156	*Dunkeld, from a Sketch by Lieut. Colonel Eden,* 8gns.
1848	177	*North Aisle of Westminster Abbey - Tomb of King Henry III. in the foreground,* 30gns.
1848	183	*Interior of Old Shoreham Church,* 10 Pounds.
1848	209	*View on the Coast of France - Clearing up after a Storm,* 35gns.
1848	218	*Kingston Harbour, near Shoreham,* 8gns.
1849	1	*Oberwesel, on the Rhine.*
1849	6	*The Remains of an Old Castle, by Moonlight.*
1849	12	*Tour des Rats, on the Rhine - Bingen in the distance.*
1849	48	*Ruins of a Gothic Chapel.*
1849	62	*Interior of Exeter Cathedral.*
1849	70	*Berncastle, on the Moselle.*
1849	74	*Viaduct near Houghton, Lancashire - from a Sketch made on the spot by Miss Rooper.*
1849	103	*Trèves, on the Moselle - Early Morning.*
1849	141	*Arundel Castle, from the River.*
1849	146	*Timber Vessels at Shoreham, near Brighton.*
1849	177	*Lancaster, taken from the Lower Walk - from a Sketch made on the spot by Miss Rooper.*
1849	221	*Huy on the Meuse.*
1849	231	*Viaduct at Brighton.*
1849	281	*Castle of Ehrenfels, on the Rhine.*
1849	299	*Grande-place, Bacharach, on the Rhine.*
1849	364	*Interior of the Church of Jumieges, on the Seine.*
1850	127	*Dalgetty Church, Fifeshire - from a Sketch made on the spot by Miss Rooper,* 7gns. Frame and glass £1.5.0.
1850	135	*Cowston Castle, Otterston - from a Sketch made on the spot by Miss Rooper,* 7gns. Frame and glass £1.5.0.
1850	173	*Salisbury Cathedral,* 20gns. Frame and glass £3.0.0.
1850	210	*Ruins of Holyrood Chapel - Moon Rising,* 20gns. Frame and glass £3.0.0.
1851	21	*Arundel Castle, from the Mill Pond.*
1851	52	*Cape Town, from the South-East. From a Sketch made on the spot, by Capt. E. Rooper, Rifle Brigade.*
1851	63	*Interior of an Old Church.*
1852	53	*Interior of the Church of St. Valentine at Jumieges, on the Seine,* 8G, Mrs. Mollett, Frame and glass £2.0.0.
1852	54	*Interior of an Old Church at Caen,* 8G, Frame and glass £2.0.0.
1852	102	*Netley Abbey,* 20G. Frame and glass £4.0.0.
1852	151	*Mantes la Jolie, on the Seine,* 20G Frame and glass £3.0.0.
1853	153	*At Boppart, on the Rhine.*
1854	24	*Shoreham - Sunset,* £20.0.0, Frame and glass £3.0.0.
1854	29	*Fort Beaufort, Cape of Good Hope - looking towards Waterkloof and Kromme Range - Early Morning, from a Sketch made on the spot by Captain E. Rooper, Rifle Brigade,* £20.0.0, Richard Till(?), Frame and glass £3.0.0.
1854	223	*"The moping owl doth to the moon complain . . ."* £25.0.0, Frame and glass £3.0.0.
1854	226	*Thames Boats - View near Cookham, Berks,* £30.0.0, Frame and glass £3.0.0.
1855	2	*The Bowder Stone in Borrodale, Cumberland,* 8gns.
1855	10	*Ruins of the once splendid Abbey of Jumieges, on the Seine,* 6gns.
1855	18	*The Market Place, Dieppe,* 8gns.
1855	40	*Keswick New Church, looking into the Vale of Borrodale, Cumberland,* 7gns.
1855	47	*Die Katz, on the Rhine,* 8gns.
1855	48	*View in Arundel Park,* 4gns.
1855	63	*Rivaulx Abbey, Yorkshire - Twilight,* 15gns.
1855	89	*Distant View of Brighton, from the Shoreham Road,* 6gns.
1855	92	*Windsor Castle, from Slough,* 5gns.
1855	93	*Part of the Remains of Fountains Abbey, Yorkshire,* 10gns.
1855	118	*Remains of the once splendid Mansion of the late Sir Gregory Page Turner on Blackheath, now taken down,* 5gns.
1855	148	*Clearing away a Wreck on the Coast of Sussex,* 20gns., John Hunter Esq., Belper, Derbyshire.
1855	171	*Derwentwater from Friars' Walk,* 5gns.
1855	172	*Windsor Old Bridge, now taken down,* 4gns.
1855	221	*A Peep into Derwentwater, looking towards Keswick,* 5gns.

NASH FREDK

1837	11	*A Sea-beach,* Sold.
1837	12	*Kemptown Brighton,* 9gns.
1837	13	*Strada Nova, looking over the Bay of Naples, (Moon Rising),* 8gns.

1837	36	*The Catacombs, Paris*, 5gns.
1837	43	*Durham Cathedral*, 20gns.
1837	63	*A Sea Beach - Sunset*, Sold.
1837	70	*Fishing Boats*, 5gns.
1837	74	*A Cornfield*, Sold.
1837	76	*Crypt of St. Denis, near Paris*, 20gns.
1837	80	*Notre Dame, Paris*, 6gns., Robinson Esq., 56 Wigmore Street.
1837	85	*Windsor Castle from Clewer - Sunrise*, 35gns.
1837	95	*Windsor Castle from Slough*, 16gns., by order of Mr. F. Nash.
1837	100	*Carnarvon Castle - Twilight*, 4gns.
1837	131	*Windsor Castle and the Brocas Clump, from the Towing Path - Morning*, 12gns.
1837	156	*Part of the Chain Pier, Brighton - Moon rising*, 6gns., order of Mr. J. Nash.
1837	157	*Windsor Castle, from the Great Park*, Sold.
1837	172	*Old Fishmonger's Hall and Southwark Bridge*, Sold.
1837	176	*Rivaux Abbey - Twilight*, 14gns., Henry Wilkinson, Clapham Comn.
1837	199	*Ronciglione, near Rome*, 18gns.
1837	223	*A Street at Liege*, 8gns., by order of Mr. F. Nash.
1837	245	*Fishing Boats at Sea*, Sold.
1837	283	*Eton College, from the Thames*, 10gns.
1837	287	*On the Beach, Brighton - Hazy Morning*, 6gns.
1837	291	*Boats and Figures on the Beach, Brighton*, 6gns.
1837	333	*A Mill near Shoreham, Sussex*, 5gns.
1837	340	*Ghent*, 10gns.
1838	7	*Remains of the Nunnery of Stuben, near Bremm, on the Banks of the Moselle (Morning) Sun Breaking through Mist.*
1838	15	*On the Beach at Brighton - Hazy Morning.*
1838	16	*Cliffs at Rottingdean, near Brighton.*
1838	26	*Berncastel.*
1838	28	*An Interior.*
1838	37	*Interior of Durham Cathedral.*
1838	46	*Rocks at Hastings.*
1838	47	*Old Houses.*
1838	70	*An Old Street at Berncastel.*
1838	88	*An Old Roman Entrance to Cochem, on the Road from Treves.*
1838	97	*Beilstein.*
1838	100	*Cochem, on the Moselle.*
1838	150	*A Study from Nature.*
1838	253	*Marienbourg - Ruins of an Ancient Monastery near Zell - Moonlight.*
1838	349	*Windsor Castle.*
1839	1	*A Study from Nature*, 6gns., Sold, own order.
1839	40	*Remains of a Roman Amphitheatre at Treves*, 8gns., own order.
1839	49	*Arundel Castle, from the South East, the Remains of the Maison Dieu in the Foreground*, 20gns., own order.
1839	61	*Arundel Castle from Swanbourn Lake*, 18gns.
1839	65	*On the Avon*, 7gns., own order.
1839	69	*A View in Arundel Park*, 20gns., own order.
1839	73	*An Interior*, 30gns.
1839	74	*Brighton Boats at Sea*, 5gns., own order.
1839	86	*Tankerville Castle*, 12gns., Sir Richd. Hunter, 25 Hill St.
1839	111	*Ruins - Cowdry, Sussex*, 8gns.
1839	135	*The Old Keep*, 8gns.
1839	137	*Off Dieppe*, 5gns.
1839	196	*A Water Mill*, 15gns.
1839	198	*Windsor Castle, from the Great Park*, 10gns., own order.
1839	213	*An Old Court-Yard*, 7gns.
1839	215	*Bielstein, on the Moselle*, 8gns., own order.
1839	216	*Porta Nigra, at Trèves*, 10gns., own order.
1839	226	*Interior of the Ruins of Netley Abbey - Autumnal Morning*, 50gns.
1839	234	*Arundel Castle, from the River*, 6gns.
1839	243	*View on the Moselle*, 5gns.
1839	257	*An Old Gateway*, 7gns., own order.
1839	260	*Road Scene*, 10gns., own order.
1839	314	*Cookham Ferry*, 5gns., Jacob Montefiore Esq., 24 Tavistock Square.
1839	315	*Moonlight*, 5gns., own order.
1839	319	*Tankerville Castle - Moonlight*, 4gns.
1839	320	*Twilight*, 4gns.
1840	1	*Ruins of the Nunnery of Stuben, near Bremm, on the Moselle - Moon Rising.*
1840	25	*Making the Railroad between Brighton and Shoreham.*
1840	32	*Ruins of a Gothic Chapel, with Cattle.*
1840	33	*Glastonbury - Morning.*
1840	42	*Fishing Boats at Sea.*
1840	43	*Scene in the Environs of London.*
1840	57	*Paris, from Passy.*
1840	86	*Durham.*
1840	92	*Nôtre Dame, Pont de la Tournelle, and the Wine Market, Paris.*
1840	93	*Trèves.*
1840	113	*Cattle - from Nature.*
1840	128	*Interior of Old Shoreham Church.*
1840	164	*Font in Shoreham Church.*
1840	171	*On Brighton Beach.*

1840	186	Arundel Castle, with part of the Remains of the Maison Dieu.
1840	188	Saxon Church at Old Shoreham.
1840	189	Hove Church, near Brighton.
1840	193	Nero's Tomb, near Rome.
1840	194	Nantes, on the Loire.
1840	304	Grande Place, Liege.
1840	307	Windsor Castle, from the Thames.
1841	32	Interior of Shoreham Church, Sussex, 18gns.
1841	52	Lane Scene, Glastonbury, Somersetshire, 12gns., Own order.
1841	75	Kingston Church, Sussex, 10gns., Own order.
1841	87	Remains of Fountains Abbey, Yorkshire, 14gns.
1841	92	Westminster Abbey, 60gns.
1841	138	Bramber, Sussex, 5gns., Own order.
1841	172	Mill on Addington Hill, near Croydon, Surrey, 8gns., Richd. Ellison Esq., Sudbrooke Holme, Lincoln.
1841	187	Remains of the once celebrated Abbey of Jumieges, on the Seine, 30gns.
1841	195	The Dyke House, near Brighton, 4gns., Hon. and Rev.(?) H. Legge, Blackheath.
1841	207	View near Shoreham, Sussex, 5gns., Own order.
1841	282	Tour des Rats, on the Rhine, 5gns.
1842	25	Garden of the Tuileries, Paris.
1842	32	Shoreham - Evening.
1842	35	Grange Bridge, Castle Crag, &c. Borrowdale, Cumberland.
1842	78	Old Buildings at Carden, on the Moselle.
1842	105	View from the Road to Lowdore, looking towards Borrowdale, Cumberland.
1842	110	Derwentwater, Cumberland.
1842	123	Trèves, taken under one of the Arches of Porta Nigra.
1842	137	Keswick Bridge.
1842	197	View near Stochgill Force, Ambleside.
1842	199	Arundel Castle.
1842	212	London, from Hampstead Heath - the Surrey Hills in the Distance.
1842	224	Pont Royal, and the Palace of the Tuileries, &c. Paris.
1842	231	The Great Bridge at Tours.
1842	297	Interior of the Church at Ducler, on the Seine.
1843	11	Netley Abbey - Morning, 30 Pounds.
1843	14	Distant View of Shoreham - Evening, 10 Pounds.
1843	25	The Viaduct on the Brighton Railway, 8 Pounds.
1843	51	Cattle - View near Brighton, 15 Pounds.
1843	60	Timber Vessels, 10 Pounds.
1843	85	Marché au Fruît, Notre Dame, Paris, 20 Pounds.
1843	99	Windsor Castle from Eton, 20 Pounds.
1843	112	Pont Neuf, Paris - Sun-rise, 25 Pounds.
1843	120	Hayward's Heath, Sussex, 8 Pounds.
1843	125	Old Houses on the Moselle, 8 Pounds.
1843	159	Shoreham - Morning, 10 Pounds.
1843	166	Ruins of the Nunnery of Marienburg, on the Moselle, 40 Pounds.
1843	169	Shoreham - Twilight, 10 Pounds.
1843	193	Kingston, near Brighton - Sunset, 10 Pounds.
1843	213	Arundel Castle - Moonlight, 15 Pounds.
1843	228	Interior of a Norman Church, 20 Pounds.
1843	282	Vale of Newlands, looking over Derwentwater, 8 Pounds.
1843	316	Wardanger, Norway, 8 Pounds.
1843	340	Vessel Unloading, 8 Pounds.
1844	5	Entrance to Bacharach, on the Rhine, 10 Pounds, Frame and glass 3 Pounds.
1844	8	Braubach, on the Rhine, 10 Pounds, Frame and glass 4 Pounds.
1844	18	The Old Mill at Arundel, Sussex, 25 Pounds, Frame and glass 5 Pounds.
1844	32	Arundel Castle, from the River, 20 Pounds, William Abbott Esq., Meadow Croft, Sydenham, Kent, Frame and glass 5 Pounds, P.AU.
1844	142	Cologne - Moonlight, 12 Pounds, Frame and glass £3.0.0.
1844	163	At Boppart, on the Rhine, 10 Pounds, Frame and glass £3.0.0.
1844	178	Arundel Castle and Mill, 20 Pounds, Frame and glass £5.0.0.
1844	193	Landscape and Cattle, 25 Pounds, Frame and glass £5.0.0.
1844	202	The Castle of Schonberg, Overwesel, on the Rhine, 40 Pounds, Frame and glass £10.0.0.
1845	78	Market Place at Bacherach on the Rhine, 26 Pounds, Frame and glass £4.0.0.
1845	103	A Calm - Vessels entering Shoreham Harbour, 44 Pounds, Frame and Glass £6.0.0.
1845	104	The Castle of Elz, Moselle, 10 Pounds, John Kirkpatrick Esq., 5 King ???? Frame and glass £2.0.0.
1845	154	Eton College - Evening, £8.10.0. Frame and glass £1.10.0.
1845	170	Timber Vessels, £8.10.0. Haviland Burke Esq., 27 Gloucester Place, New Road. Frame and glass £1.10.0.
1845	177	A Cottage near Worthing, 15 Pounds. Frame and glass £5.0.0.
1845	194	Interior of an Old Church in Sussex, 36 Pounds. Frame and glass £4.0.0.

1845 205 *Ruins, and an Old Elm Tree on the Banks of a River,* £17.10.0, Frame and glass £2.10.0.

1845 206 *Kingston, Sussex,* £12.10.0. Frame and glass £2.10.0.

1845 207 *Interior of Old Shoreham Church,* £13.0.0. Frame and glass £2.0.0.

1845 278 *Caub, on the Rhine,* £8.10.0. Frame and glass £1.10.0.

1845 295 *View in Shoreham Harbour - Morning.* £8.10.0. Frame and glass £1.10.0.

1845 332 *Distant View of Shoreham,* £8.10.0. Frame and glass £1.10.0.

1846 21 *Ancient Ruins of a Nunnery, on the Moselle,* 40gns.

1846 51 *Interior of Broadwater Church, Sussex,* 20 Pounds.

1846 64 *Town and Citadel of Corfu - the Mountains of Albania in the distance. - From a Sketch made on the spot by Captain Edward Rooper, Rifle Brigade.* 20 Pounds. Thomas Shepherd Esq., Beverly, Yorkshire.

1846 95 *Remains of Cowdry House, Sussex,* 20gns.

1846 116 *Ruins of the Old Palace at Andernach,* 20 Pounds.

1846 145 *Windsor Castle, from Eton - Hazy Morning.* 20 Pounds. Pascoe St. L. Grenfell Esq., 16 Hyde Park Sq.

1846 160 *Distant View of Brighton from the Shoreham road,* 8 Pounds.

1846 167 *Shoreham - Timber Vessels,* 10 Pounds.

1846 170 *Ruins of the Chapel of Cowdry House, Sussex,* Sold.

1846 171 *Preston Church, near Brighton,* 10 Pounds.

1846 173 *Town and Citadel of Corfu - the Mountains of Albania in the distance - From a Sketch made on the spot, by Captain Edward Rooper, Rifle Brigade,* 18 Pounds.

1846 189 *Boppart, on the Rhine,* 10 Pounds.

1846 206 *Distant View of Cowdry House,* Sold.

1846 241 *Fittleworth, Sussex,* 7 Pounds.

1846 286 *Derwent Water,* 7 Pounds.

1846 319 *Interior of the Old Monastic Church of Jumieges, on the Seine,* 12 Pounds.

1849 156 *Entrance to Houghton Tower, near Preston, Lancashire - from a Sketch made on the spot by Miss Rooper.*

1851 148 *Westminster Bridge.*

1851 194 *A Wheelwright's Shop at Henfield, Sussex.*

NASH J

1834 363 *Hamlet - Act 3d, Scene 1st."Ophelia - 'My Lord, I have remembrances of yours. . .'",* Sold.

1846 217 *Almshouse at Ewelme, Oxfordshire,* 12gns., W.J. Brodirip Esq.

NASH JOSEPH

1834 23 *Porch of St. Michael's Church, Vaucelles, near Caen,* Sold.

1834 30 *Monument at Arundel Church, Sussex - During the Civil Wars, this beautiful edifice, and everything it contained, was devastated by Cromwell's barbarous soldiery,* 30gns., To be sold again [Mr. Denham, 73 Pall Mall, Globe Insurance Office, deleted].

1834 153 *Hubert and Arthur, vide King John, Act 4th, Scene 1st, "Arthur – 'For Heavens sake, Hubert, let me not be bound!' . . ."* 15gns., Miss Langston, 32 Upper Brook Street.

1834 190 *King Lear, Act 5, Scene 3rd, "Kent – 'O my good Master' (kneeling) . . ."* Sold.

1834 201 *Entrance to St. Mary's Hall, Coventry,* 12gns.

1834 316 *Don Quixote giving Sancho instructions relative to the Government of his Island,* 10gns., Sir Edward Blackett, 29 Green Street, Grosvenor Square.

1834 387 *Taming the Shrew, Act 4th, Scene 5th,* Sold.

1835 13 *Chapel in the Church of St. Jacques, Dieppe,* 30gns.

1835 41 *Sir Halbert Glendinning, the Lady of Averel, and Roland Graeme, "'I will kiss no hand save yours, Lady,' answered the boy . . ." Vide Abbot, Vol. I. Chap. III.* 20gns.

1835 138 *South Porch of the Church at Louviers, Normandy,* 30gns. right if being engraved by C. Heath, Sold Mr. J. Nash, To be delivered after the close of the Gallery to Mr. C. Heath by J.E. and to receive the cash for it. Don't leave the drawing without the money. F.M.

1835 172 *Olivia and Malvolio, "Malvolio – 'Some achieve greatness' . . ." Twelfth Night, Act III.Scene 4.* 20gns., Sold [D.T. White deleted], This drawing to be sent to Mr. Nash at the close of the Gallery - see Mr. Nash's letter.

1835 181 *"Don Quixote, forgetting the respect he owed to the Duke and Duchess . . ." Don Quixote, Vol. II. Book II. Chap. 14 and 15.* 25gns., Mr. D. White, Not to be delivered without the cash.

1835 184 *Lady Elizabeth Gray Petitioning Edward the Fourth for the Restoration of her Deceased Husband's Estate, Vide Hume's History of England.* 30gns.

1835 226 *Hotel Bouthesoude, Place de la Pucelle, Rouen,* 15gns., Mr. Holford, 1 Lincolns Inn Fields.

1836 5 *Screen in St. Jacques, Dieppe,* 30gns., ???? Dickens Esq.

1836 27 *Louis XII., Quentin Durward and the Countess Isabella de Crove - from Quentin Durward, Chapter 4th., "'My kinswoman is ill at ease, and keeps her chamber,' answered Jacqueline in a hurried yet humble tone . . ."* Sold.

1836 74 *Interior at Abbeville,* Sold.

1836	175	*Charles Vth, Emperor of Germany, Visiting Francis I, in Prison after the Battle of Pavia,* 80gns., Wm. Hobson Junr. Esq., 43 Harley Street.
1837	20	*In the Cathedral, Bruges,* 30gns., Sold.
1837	46	*Falstaff, Bardolph and Hostess, "Hostess – 'You owe money here besides, Sir John, for your diet and by-drinkings and money lent you four and twenty pound.' . . ."* 30gns.
1837	134	*Market Place, Furnes, Belgium,* Sold, deliver to White Esq.
1837	159	*Hotel de Ville - Ghent,* 30gns., order of Mr. Nash deliver to White Esq. if unsold at the close of the Exhibition - delivered.
1837	190	*King Lear - Kent, Edgar and Fool, "Lear – 'Off off, you lendings.'"* 60gns.
1837	211	*Scene from Woodstock, Chap 13, Vol I. Alice Lee kneeled at the feet of her father, and made the responses with a voice that might have suited a choir of angels, and a modest and serious devotion that suited the melody of her tone, &c. &c.,* 25gns.
1837	218	*Taming the Shrew, "Petruchio. – 'Off with my boots, you villains . . .'"* 35gns.
1837	294	*Subject from Woodstock, Chap 4, Vol.2 , Albert Lee found the party consisting of his father, sister and the supposed page, seated by the breakfast table, at which he also took his place . . .* 30gns., E.E. Tustin Esq., 8 Fludyer Street, Whitehall.
1838	17	*Abbaye St. Amand, Rouen.*
1838	25	*Gateway Hotel, Boutheroulde, Rouen.*
1838	168	*Amiens Cathedral.*
1839	151	*Subject from the Merry Wives of Windsor,* 30gns.
1839	170	*Long Gallery, Haddon Hall, Derbyshire,* 50gns., Mrs. Smith, 6 Portland Place, to know price of frame.
1839	189	*Porch at Louviers, Normandy,* 12gns.
1839	203	*Terrace, Bramshill, Hants,* 40gns.
1839	204	*Chancel of Little Basing Church, Hants,* 10gns.
1839	245	*Monuments in Tewkesbury Church, Gloucestershire,* 20gns.
1839	327	*St. George's Chapel, Windsor,* 25gns.
1840	39	*Entrance to the Grand Staircase, Holland House, Kensington.*
1840	47	*Staircase, Crewe Hall, Cheshire.*
1840	140	*Room at Knowle, Kent, Seat of Earl Amherst.*
1840	155	*Bay Window Dining Room, Haddon Hall, Derbyshire.*
1840	202	*Long Gallery, Haddon Hall, Derbyshire.*
1840	212	*Hall at Beddington, Surrey.*
1840	283	*Entrance to the Long Gallery, Haddon Hall, Derbyshire.*
1840	296	*Entrance to Staircase - Wakehurst, Sussex.*
1841	11	*Drawing Room, Boughton-Malherbe, Kent,* 12gns.
1841	157	*The Cartoon Gallery at Knowle,* Sold.
1841	190	*Athelhampton, Dorsetshire,* 10gns., N. Forbes Mackenzie, Carlton Club.
1841	302	*Presence Chamber, Hampton Court - Wolsey's Entertainment of the French Ambassadors. (Vide Cavendish.),* 12gns., Charles Stone, 36 Paternoster Row.
1841	329	*Staircase, Hatfield, Herts - Seat of the Most Noble the Marquis of Salisbury,* 12gns.
1842	195	*Porch at Montacute, Somersetshire.*
1843	76	*Interior of the Drawing Room, Bramhall Hall, Cheshire,* 50gns., Henry Graves Esq., 6 Pall Mall.
1843	179	*Interior of the Hall, Hampton Court,* Sold.
1843	196	*Interior at Southam, Gloucestershire, Seat of the Right Hon. Lord Ellenborough,* Sold.
1843	302	*Milton Dictating to his Daughters,* 50gns., John Woomsley Esq., 6 Pall Mall.
1844	15	*Bay Window in the Drawing-room at Lyme Hall, Cheshire,* 45gns.
1844	43	*Interior of the Hall, Crew Hall, Cheshire, the Seat of the Right Hon. Lord Crewe,* 50gns., Rev. Edward Coleridge, Eton College, P.AU.
1844	248	*Scene from the Merry Wives of Windsor – Mrs. Quickly, Dr. Caius, and Simple, "Caius. – 'O diable, diable! vat is in my closet? Villany, larron' . . ."* 20gns., J. Ryman Esq.
1844	266	*Scene from King Lear – King Lear, Cordelia, Physician, "Cordelia. – 'O, look upon me sir . . .'" Act IV., Scene 7.* 18gns., Benjamin Field Esq., 20 Preston St., Brighton, P.AU.
1845	130	*At Bingham's Melcombe, Dorset,* 15gns., Rev. John Horner, 15 Harley St.
1845	225	*Carved Parlour, Crew Hall, Cheshire,* 18gns., ??? Davie, Yarmouth, P.AU. 10£.
1845	253	*Room in the Gatehouse, Kenilworth, Warwickshire,* 18gns., Lewis Pocock Esq.
1845	289	*Hall of Milton Abbey, Dorsetshire, the Seat of the Right Hon. G. Dawson Damer,* 18gns.
1845	311	*Hall, Addington, Cheshire,* 16gns., S.M. Peto Esq., 47 Russell Sq.
1846	24	*Interior of the New Hall, Lincoln's Inn, on the occasion of the visit of Her Majesty Queen Victoria, at the Opening the Building, November, 1845. - Painted by Order of the Benchers of the Honourable Society of Lincoln's Inn,* Sold.
1847	4	*Scene from the Fair Maid of Perth,* 12gns., Chas Heath(?) Esq.
1847	9	*Abbeville Cathedral, Picardy,* 45gns.
1847	15	*Cathedral Beauvais, Picardy,* 50gns.

1847	38	*Chapel in the Cathedral, Bruges, 50gns.*
1847	142	*The Black Knight and Jester riding through the Forest, Vide Ivanhoe. 40gns.*
1847	169	*Interior of the Church of Gisors, Normandy, 45gns.*
1848	303	*The Visit to the Tomb, 15gns.*
1849	32	*Interior at Levens, Westmoreland - the seat of the Hon. Mrs. Col. Howard.*
1850	20	*Galley at Aston Hall, Warwickshire, 45gns., Alex Morison Esq.*
1850	32	*The Noontide Rest, 30gns.*
1850	44	*Interior of the Hall at Speke, Lancashire, 50gns.*
1850	128	*Old House at Rochester, 20gns.*
1850	157	*Halbert Glendenning's first interview with the White Lady of Avenel, Vide The Monastery 25gns.*
1850	160	*Banquet given by Cardinal Wolsey to the French and Spanish Ambassadors at Hampton Court Palace, Vide Cavendish's Life of Wolsey 60gns.*
1850	246	*The Story of the Siege - Staircase of Aston Hall, Warwickshire - The fracture of the balustrade was the effect of a cannon-shot, during its temporary occupation by Charles the First, at the time of the civil wars; and, as a memento of the loyalty of the family of Legge, who at that time possessed the House, has never been restored, 25gns., Lord Brownlow, Belton House, Grantham, Lincolnshire.*
1850	331	*Hostess and Christopher Sly, "Hostess. 'You will not pay for the glasses you have broken?.' Sly. 'No, not a denier. Go by, says Jeronimy. Go to thy cold bed and warm thee.'" Vide Taming of the Shrew. 15gns., Joseph Millar Esq., 3 Verulam Terrace, Maida Vale, Frame and glass £2.5.0 New.*
1851	221	*Subject from the Antiquary - Isabella Wardour and Edie Ochiltree, "She came down accordingly, and found the mendicant half seated, half reclining, upon the bench beside the window." Vide Antiquary, vol. i. chap. xii.*
1852	68	*View of the Transept from the Turkish Department - Great Exhibition of 1851, 50G.*
1852	227	*The Indian Tent - Great Exhibition of 1851, 50G, E.E. Tustin Esq., Frame and glass £5.10.0.*
1853	297	*Gateway of the Abbey of St. Martin d'Auchi, near Aumale.*
1854	52	*Interior of Broadwater Church, Sussex, 40gns.*
1854	86	*Entrance to Speke Hall, Lancashire, 25gns.*
1854	188	*Abbaye St. Amand, Rouen, 25gns., Robt. Johnston, 36 Hill St., Berkeley Sq.*
1855	59	*Study from Nature, Sold.*

NATTES J C

1805	39	*The church under the choir of St. Denis.*
1805	47	*Interior view of Christ's church college, Oxford.*
1805	52	*Scene under the Pont Neuf, shewing Pont Notre Dame, &c. Paris.*
1805	85	*Lincoln, from the lower town.*
1805	274	*View of Florence and the vale of Arno, from the Pitti gardens.*
1806	10	*Mr. Newman's Colour Manufactory, Soho-Square.*
1806	40	*Belvoir Castle, the Seat of the Duke of Rutland.*
1806	89	*View of a Brook near the convent of Vallambrosa, a few miles from Florence, so surrounded by natural beauty, that Milton has elegantly described it in his Paradise Lost, Book I. lines 300 and320., "Legions of angel forms, who lay entranced . . ."*
1806	177	*Oxford, the Warden's House, New College.*
1806	191	*View of Notre Dame and all the Bridges of l'Hotel Dieu, for a Work now publishing.*
1806	203	*Lime Kiln, Sycomb Park, Herts.*
1806	211	*Liesley House, the Seat of the Countess of Rothes.*
1806	214	*Windsor, Eton Bridge, &c.*
1806	238	*Paris. Drawn for a work now publishing. View from under the Arch Givry, Pont aux Changes, les Tours de la Conciergerie, where the Queen was confined; Le Palais, where she was tried; La Tours de l'Horloge, the bell of which gave the signal for the horrid massacre of St. Bartholomew; Le Quai Dessaix. . .*
1806	243	*Oxford. Holywell Church.*
1806	294	*Interior of the first Court, at the Castle, Oxford.*
1806	298	*Paris, for a work now publishing, a view of the different Bridges of l'Hotel Dieu, &c.*
1807	29	*A store cellar belonging to Messrs. Calverts.*
1807	42	*A store cellar belonging to Messrs. Calverts.*
1807	46	*The Royal Military Asylum.*
1807	53	*Kew Palace, from Smith's Hill, Brentford.*
1807	55	*Eastwell Park, Kent.*
1807	74	*Interior of an Artist's study.*
1807	88	*Interior of a brewhouse at Englefield Green.*
1807	93	*The Devil's Cauldron, near Conway Park.*
1807	102	*Remains of the ancient palace of Richmond, in Surry.*
1807	105	*The great Trianon at Versailles.*
1807	110	*The North Bridge, Edinburgh.*
1807	146	*Interior of a barn, with a threshing machine at work, Lord Monson.*
1807	152	*Whitshall, from the porter's lodge.*
1807	180	*View on the Thames, from Pembroke house.*
1807	187	*Cavendish-mews, Cavendish-square.*
1807	234	*Windsor Castle.*

1807 271 *Rousseau's cottage at Montmorency.*

1807 320 *At Windsor.*

NEALE J P

1817 24 *Monuments in the Chapel of St. John the Baptist, Westminster Abbey.*

1817 191 *London and Harrow,* £5.5.0, Sir W. Pilkington.

1817 193 *North Porch Westminster Abbey, and Door of Temple Church.*

1817 202 *Henry the Fifth's Monument, Westminster Abbey.*

1818 226 *Waterloo Bridge.*

1818 235 *The Market. Narbeth, South Wales.*

1818 249 *Howden Church, Yorkshire.*

NESFIELD W

1824 24 *Study, near Burn Hall, Durham.*

1824 30 *A Brook Scene,* "But should you lure From his dark haunt, beneath the tangled roots Of pendant trees, the monarch of the brook . . ."

1824 32 *Birch Trees, from Nature.*

1824 63 *A Brood Mare and Foal, study from nature.*

1824 115 *Scene in Breadalbane,* "Around th' adjoining brook, that purls along . . . Rural confusion!"

1824 123 *Gordale Scar, near Malham - Yorkshire.*

1824 151 *Study above the High Force of the Tees - Yorkshire.*

1824 159 *Scene in Brancepeth Park, Durham.*

1824 242 *Falls of Niagara, from a Sketch taken on the spot in 1814,* "Down the steep It thundering shoots, and shakes the country round . . ."

1824 252 *North-West View of Brancepeth Castle, to be engraved for Surtees' History of Durham.*

1825 24 *Red-legged Partridge,* £12.0.0, Sold.

1826 164 *West Point of Staffa, called the Stirk Hill - Treshnish Isles, Coll, and Rum, in the Distance,* Sold.

1826 252 *Clam Shell Cave, Staffa - Coast of Mull in the distance,* Sold.

1827 29 *Fingal's Cave, Staffa,* Sold.

1827 167 *View from the Summit of Goatfell, Arran,* Sold.

1827 200 *Periwincle Bay, Staffa.,* Sold.

1827 236 *Fall of Fyers,* Sold.

1827 272 *Kirch-na-heen, at the head of Glen Sannox, Arran,* 20gns., Sold.

1828 6 *Framwelgate Bridge, Durham,* £20.0.0.

1828 89 *Glacier of Brenva - in the Distance Mont Blanc,* " – round whose stern cerulean brows White-winged snow, and cloud . . ." £45.0.0.

1828 104 *Druidical Temple at Tormore, Isle of Arran,* £20.0.0, Earl Brownlow.

1828 189 *Fall of the Tumel, near Blair, Athol,* £40.0.0.

1828 250 *Deer, in Brancepeth Park,* "Laid beside the crystal Brook." £50.0.0, T. Griffiths Esq.

1828 257 *Force of the Tees, Durham,* Sold.

1829 311 *Near Festiniog, North Wales,* 5gns., Prior Esq.

1830 171 *Mill at Inverrary,* 6gns., Thompson Esq., Refer to Mrs. Griffiths.

1831 157 *The Laird at the Dinner Spring, at Loch Etive, Argyllshire.*

1831 275 *Dressing a Fly at Stonebyers Falls, on the Clyde.*

1832 21 *The Head of Corra Lin, Clyde,* 25gns.

1832 59 *Hartlepool, near Durham,* 6gns., Mrs. Griffith, Norwood.

1832 71 *Milking,* 5gns.

1832 94 *Brancepeth Park, Durham,* 8gns.

1832 364 *Bamborough Castle,* 15gns., Mrs. Olive, 4 York Terrace, Regents Park.

1834 257 *Fingal's Cave, Staffa,* Sold.

1839 183 *Peat Bog, near Harlech Castle, North Wales,* Sold.

1839 192 *Kilchurn Castle, Loch Awe,* 30gns., Franz Baron v. Kreusser, 141 Regent Street.

1840 31 *Rhaiadyr y Mawdach, North Wales.*

1840 169 *Flint Castle.*

NESFIELD W A

1833 201 *Glen Coe,* 10gns.

1834 176 *Eagles of the Hebrides,* 25gns.

1834 189 *Castle Howard Park,* 25gns.

1835 51 *Kilchurn Castle, Loch Awe,* 8gns., J. Ryman, Oxford, To be sent to No. 6 Pall Mall.

1836 4 *Scene near Rothsay, Isle of Bute,* 8gns.

1836 32 *Loch Fad, Isle of Bute, and the House of the late Edmund Kean, Esq., Mountains of Arran in the distance,* 15gns., Wm. Hobson Junr. Esq., 43 Harley Street.

1836 40 *Head of Glen Sannox, Isle of Arran,* 20gns.

1836 169 *Kidwelly Castle, South Wales,* 10gns.

1836 213 *Interior of Fingal's Cave, Staffa. - Isle of Iona in the distance,* 20gns.

1836 329 *Farm Yard, near Durham,* 6gns., Wm. Hobson Junr. Esq., 43 Harley Street.

1837 5 *On Loch Leven, near Ballahulish, Highlanders landing Peat,* The Marquis of Abercorn, 1 Carlton Hse. Terrace.

1837 8 *Dovedale, Derbyshire,* Heny. Ashlin Esq., 22 Edward Street, Hampstead Road.

1837 33 *Insulated Rock on the Tumel, near Mount Alexander, Blair Athol,* 25gns.

1837 158 *Chatsworth Park,* 25gns.

1838 35 *Corra Castle, on the Clyde.*

1838 53 *Bamborough Castle.*

1838 80 *Fall near Dalmally, Argyllshire.*

1838 181 *Holy Island, Lamlash Bay, Arran.*

1839	4	*Gordale Scar, Yorkshire,* Sold.
1839	62	*Near the Village of St. Remi, Val d'Aosta, Glacier of Brenva and Mont Blanc in the Distance,* 50gns. [deleted], Sold.
1839	122	*In Windsor Park,* Sold.
1839	211	*Hartlepool Rocks,* 30gns., W. Strachan Esq., 34 Hill Street.
1840	104	*Stack Rocks, Pembrokeshire.*
1840	119	*Near L. Rannock, Shihallion in the Distance.*
1840	141	*Eton College.*
1841	9	*Gougan Barra, near Bantry (the Animals by R. Hills),* 50gns.
1841	17	*Fall of the Tumel,* Sold.
1841	64	*A Day in the Highlands,* 80gns., Chas. Burrow, 12 Grove Terrace, Kentish Town.
1842	88	*Torc Fall, Killarney - from a Sketch made during the clearing, under the superintendence of the Artist, in Sept. 1841.*
1842	201	*A Day on the Upper Lake, Killarney.*
1843	142	*Entrance to the Gap at Dunloe,* 60gns., Sold.
1844	50	*On the Wharfe, Bolton, Yorkshire,* Sold.
1844	63	*In the Vale of Neath,* 50gns.
1845	13	*Eagle's Nest, Glengariff, County of Kerry,* 50gns., James Coles Esq., Old Park, Clapham.
1846	60	*Ross Castle, Killarney,* 55gns., Hobson Esq.
1846	101	*Inverannan, Glen Falloch,* 45gns., Rev. E. Coleridge of Eton.
1847	56	*Drumadoun,* 60gns., Moon, Durham?, P.AU. 50£.
1847	124	*Ben Noosh, Arran,* 60gns., Chas. C. Perkins Esq., Brunswick Hotel, Frame and glass £9.10 0. No.
1848	63	*Aurora Borealis, Western Isles,* 80gns.
1848	125	*Glen Rossie, Arran,* 80gns.
1849	120	*Buchal Etive, Argyllshire.*
1850	136	*The Giant's Amphitheatre, near the Causeway,* 65gns.
1850	325	*The Swan's Nest,* 35gns., Rev. John Middleton, Kings Co., Cam. (Rev. S.F. Marshall, Eton College), Frame and glass £5.8.0 Yes.
1851	74	*Ben Noosh, Arran.*

NESFIELD W A & HILLS R

1839	11	*Red Deer,* Sold.

NESSFIELD W

1823	42	*Chateau di Jaro near Aosta, Piedmont.*
1823	45	*New Bridge near al Dazio Grande, Canton of Ticino, Switzerland.*
1823	54	*Study near Witton le Wear, Durham,* £5.5.0, Col. Greville.
1823	94	*Chateau de Dussel, near Chatillon, Val d'Aosta, Piedmont.*
1823	173	*Bridge over the Reichenbach, Canton of Berne, Switzerland.*

1823	187	*Falls of Teufels Bruke, Canton of Uri, Switzerland.*
1823	232	*Study from Nature,* £5.5.0, B. Windus Esq.
1823	236	*Study from Nature.*

NICHOLSON F

1805	14	*Summit of Cader Idris.*
1805	49	*Pont Aber Glass Lynn.*
1805	59	*Cascade near Pont Porthluyd, between Conway and Llanrwst.*
1805	107	*Allan Pit, in Ribblesdale.*
1805	108	*Kirkstall Abbey, Yorkshire.*
1805	135	*Gordale, Yorkshire.*
1805	149	*Source of the Bransil, in Ribblesdale.*
1805	161	*Rivaux Abbey, Yorkshire.*
1805	179	*Scarborough Castle, with a shipwreck.*
1805	182	*Pass between Wensleydale and Swaledale.*
1805	196	*Llandidno rock, great Orm's Head.*
1805	205	*Byland Abbey.*
1805	213	*Ruins of the King's Tower, Knaresborough.*
1805	273	*View near Llanrwst, North Wales.*
1806	2	*View near the Head of Windermere.*
1806	3	*Ruins of the Abbot's House, and part of the Abbey of Fountain's, in Yorkshire.*
1806	4	*Rippon.*
1806	5	*View near the Head of Hawse Water.*
1806	31	*Knaresborough.*
1806	32	*View near Llangollen.*
1806	46	*Rippon.*
1806	55	*Rhyddlan Castle.*
1806	63	*Nant Frankon, N. Wales.*
1806	67	*Llandidno Rock, in the Great Orms Head.*
1806	90	*Rivaux Abbey, Yorkshire.*
1806	110	*View near Abergele, N. Wales.*
1806	138	*Cascade at Hardrow, in Wensleydale.*
1806	140	*Cascade at Gayle, in Wensleydale.*
1806	176	*Roslin Castle.*
1806	188	*View on the Rhiddial, near the Devil's Bridge.*
1806	190	*Mills at Llanidloes, South Wales.*
1806	234	*Vale of Cluyd, with the Orms Head in the distance. Evening.*
1806	267	*View from the Light-house on the Isle of Plada, one of the Hebrides, the rock of Ailsa in the distance.*
1806	271	*Hardraw Cross, in Wensleydale.*
1806	280	*Loch Lomond.*
1806	282	*Cascade near Askrig, Wensleydale.*
1806	290	*York.*
1806	292	*Byland Abbey, Yorkshire.*
1806	296	*Scarborough Castle.*

1806	297	*Scarborough, from the Black Rocks.*
1807	1	*The summit of the rock called the Cobler, at the head of Loch Long.*
1807	7	*Lock Ketturin.*
1807	13	*Byland Abbey.*
1807	19	*Vale of the Rhiddiol, S. Wales.*
1807	24	*Boniton Lin, a fall of the Clyde.*
1807	62	*Wethercote Cave, Yorkshire.*
1807	63	*View in the Trosacks, Lock Ketturin.*
1807	95	*Brac-lyn Bridge, near Callander.*
1807	101	*View near the head of Lock Aird.*
1807	112	*Torrent from the mountains on the banks of Loch Lomond.*
1807	113	*Mill in Goatland, Yorkshire.*
1807	116	*The Castle of Doune, Scotland.*
1807	123	*The pass of Lenni, W. Highlands, Ben Ledi in the distance.*
1807	131	*Glen Lochy, W. Highlands.*
1807	171	*The dripping rock at Knaresborough, Yorkshire.*
1807	173	*Cefn Ogo, near Abergele, N. Wales.*
1807	179	*The mill at Corri Lin, Wallace's house, &c.*
1807	198	*Gateway of Kirkham Priory, Yorkshire.*
1807	200	*Whiskey Distillery, at the pass of Lennie, W. Highlands.*
1807	220	*York.*
1807	222	*Jasmond mill, near Newcastle.*
1807	230	*View on the Kelty, near Callander.*
1807	236	*Mill on the coast, near Scarbro'.*
1807	237	*View in the Trosacks, Loch Ketturin.*
1807	241	*View in the ascent of Cader Idris.*
1807	244	*Mill at Witton, Wensley Dale.*
1807	245	*Gwyrych, in Denbighshire.*
1807	276	*Stirling.*
1807	277	*Cork mill, near Whitby, Yorkshire.*
1807	285	*Glengyle.*
1807	313	*Edinburgh.*
1807	321	*Windmill, near Bromley.*
1808	56	*View between Christiana and Konigsberg, in Norway, from a sketch by Sir T. Ackland.*
1808	71	*The pass of Lennie, in the Grampian mountains.*
1808	75	*Bridge, &c. at Brecon.*
1808	76	*Mossdale in Yorkshire.*
1808	117	*Chedder Rocks, Somersetshire.*
1808	126	*Vale of Aberfoyle, West Highlands.*
1808	158	*View at Capel Carig, North Wales.*
1808	162	*Fall of the Clyde.*
1808	169	*Chedder Rocks, Somersetshire.*
1808	218	*Toffty in Norway, from a sketch by Sir T. Ackland.*
1808	220	*Shipwreck on the coast of Scarborough, "Borne o'er a latent reef, the hull impends . . ." — Falconer. Lord N. Petty.*
1808	223	*Mill near Festiniog.*
1808	237	*Summit of Cader Idris, Crag y Cae.*
1808	242	*Grimbald Cragg, near Knaresborough.*
1808	258	*Chepstow Castle.*
1808	266	*Interior view of Lamb row, Chester, formerly the Lamb Inn.*
1808	278	*Gordale.*
1808	291	*Head of Loch Tay, from the place said to be the grave of Fingal.*
1808	297	*Goydon Pitt, the sinking of the River Nedd.*
1808	299*	*Snowdon, from Capel Carig.*
1808	310	*Tintern Abbey.*
1808	319	*Dol y Melynlln.*
1808	326	*Tintern Abbey.*
1808	327	*The Water Tower at Chester - evening.*
1808	334	*The Devil's Bridge.*
1809	1	*Silver Mine in Norway, from a sketch by Sir Thomas Dyke Ackland, Bart.*
1809	14	*Harry Martin's tower, Chepstow Castle.*
1809	15	*Beeston Castle, Cheshire.*
1809	17	*Mill at Stourhead, Wilts.*
1809	25	*View in the Trosacks, Loch Ketturin.*
1809	26	*View in Langdale, Westmoreland.*
1809	29	*The dripping rock at Knaresborough, Yorkshire.*
1809	31	*Rippon, Yorkshire.*
1809	33	*Lymouth, North Devon.*
1809	40	*Pont Aberglaslyn.*
1809	45	*Wookey Hole, near Wells, Somerset, Lady Lucas.*
1809	59	*Chedder rocks.*
1809	61	*Nant mill.*
1809	68	*Nant mill.*
1809	79	*View between Caernarvon and Llanberis.*
1809	80	*Rosline.*
1809	93	*View of a smith's shop at Holnicote, near Minehead.*
1809	98	*Dunster Castle, Somersetshire.*
1809	103	*Sidmouth, N. Devon.*
1809	119	*Mountain torrent on Ben Vorleich, West Highlands.*
1809	125	*View at Limouth, North Devon.*
1809	129	*Allan pit, in Ribblesdale, Yorkshire.*
1809	133	*Chedder Rocks, Somersetshire.*
1809	136	*Linton, North Devon.*

1809	143	*York.*
1809	154	*View near Pont Porthluydd, N. Wales.*
1809	164	*View near Beddgelert, N. Wales.*
1809	168	*View in the vale of Aberfoyle, W. Highlands.*
1809	193	*View in Glengyle, W. Highlands.*
1809	194	*The fall of the Clyde at Stonebyers.*
1809	197	*View on the river Firth, in the vale of Aberfoyle, W. Highlands.*
1809	209	*St. Donat's castle, S. Wales.*
1809	237	*View in Norway, from a sketch by Sir Thomas Dyke Ackland, Bart.*
1809	244	*Sinking of the river Nidd, Yorkshire.*
1809	246	*Limouth, North Devon.*
1809	253	*Cascade at Gayle, in Wensley Dale.*
1809	261	*Byland Abbey, Yorkshire.*
1809	290	*Whiskey distillery, in the pass of Lennie, West Highlands.*
1809	299	*Rivaux Abbey, Yorkshire.*
1809	310	*Rhaide Mawr, N. Wales.*
1809	324	*View in the valley above Limouth, N. Devon.*
1810	5	*Byland Abbey, Yorkshire.*
1810	44	*View in Glengyle, at the head of Loch Keturrin.*
1810	50	*Rhyddlan Castle.*
1810	51	*Wethercote Cave at the foot of Ingleborough, Yorkshire.*
1810	63	*Pistil Rhaiader, North Wales.*
1810	121	*View above the fall of Lowdore on Derwentwater.*
1810	122	*View near Callander, in Scotland.*
1810	131	*View near the Head of Grasmere.*
1810	155	*Lanberris Lake.*
1810	156	*Chedder Rocks, Somersetshire.*
1810	159	*Caernarvon.*
1810	164	*View in the Vale of Rhydol, North Wales.*
1810	168	*Hardraw Force, in Wensleydale, Yorkshire.*
1810	172	*Langdale, Westmoreland.*
1810	185	*The Water Tower at Chester.*
1810	190	*York.*
1810	194	*Langdale, Westmoreland.*
1810	210	*Loughrigg Tarn, near Ambleside.*
1810	211	*Dunster, in Somersetshire.*
1810	216	*View near Horner, Somersetshire.*
1810	224	*View on the Banks of the Skell, Rippon, in Yorkshire.*
1810	225	*View near the Head of Hawes Water.*
1810	226	*York.*
1810	234	*Colbone, Somersetshire.*
1810	242	*Windermere.*
1810	245	*View in the Trosacks, Loch Ketturin.*
1810	246	*Edinburgh, from the Grass Market.*
1810	252	*Conway Castle.*
1810	269	*Pont y Pair, North Wales.*
1810	271	*Lymouth.*
1810	273	*Fall of the Clyde at Stonebyers.*
1810	279	*The Pass of Lennie in the Grampian Mountains.*
1810	305	*The Castle of Downe, between Stirling & Callander.*
1810	306	*A Paper Mill, near Richmond, Yorkshire.*
1810	309	*Lymouth.*
1810	317	*View near Linton, North Devon.*
1810	323	*Capo Della Cava, from a Sketch by Sir R. Hoare, Bt.*
1810	324	*Rippon, in Yorkshire.*
1811	1	*Roman Tower at Chester.*
1811	3	*Castle of Albuquerque in Spain.*
1811	10	*Cascade in Glen Locky, West Highlands.*
1811	13	*View between Doune and Callender, Scotland.*
1811	14	*Greenwich.*
1811	26	*The Mill at Ambleside.*
1811	33	*View on the Forth in Aberfoyle, West Highlands.*
1811	38	*View in the Trosacks, Loch Katrine.*
1811	42	*Richmond, Surrey - An Autumnal Morning.*
1811	44	*Lymouth, Devon.*
1811	57	*The Goblin Cave in Ben Venue, Loch Katrine, from a Sketch on the Spot in 1806, "Its Trench had staid full many a Rock . . ." Lady of the Lake, Canto III.*
1811	71	*The Military Road on the Banks of Loch Lomond.*
1811	80	*Castle of Zagala.*
1811	102	*Trosacks of Lock Ketrine.*
1811	132	*The Dripping Rock at Knaresborough, Yorkshire.*
1811	142	*The Shire Oak, near Leeds, Yorkshire.*
1811	143	*Rippon.*
1811	177	*Glen Lochy, West Highlands.*
1811	179	*Rhaidr Mowr, North Wales.*
1811	189	*View of the Rhydol, South Wales.*
1811	194	*Edinburgh, from Caulton Hill.*
1811	202	*Mill at Maes Mynan, Denbighshire.*
1811	205	*Castello di Vido, Portugal.*
1811	215	*Lymouth, North Devon.*
1811	216	*Conway.*
1811	226	*Dolbadern Castle, North Wales.*
1811	229	*Alegrete, in Portugal.*
1811	233	*Shipwreck on the Coast near Scarborough.*
1811	288	*Knaresborough.*

1811	312	Alan Pit, near Selside, Yorkshire.
1811	347	Cader Idris from the Road between Tan y Bwleh and Dolgelly.
1812	6	View in Mossdale, Yorkshire.
1812	7	Roman Tower, at Chester.
1812	12	View in the Glen of the Horse, near Killarney, from a Sketch by Sir Thomas Gage, Bart.
1812	20	Rosslin.
1812	33	Ruins of the Abbot's House, Fountain Abbey, Yorkshire.
1812	35	The Tomb of M. Plautia, near Tivoli.
1812	43	View on the River Nidd, opposite the dripping Rock of Knaresborough, Yorkshire.
1812	51	Loch Achray, West Highlands.
1812	69	View near Callander, Perthshire.
1812	70	Corie House, near Lanerk, the Residence of the renowned William Wallace.
1812	105	Richmond, Surrey - An Autumnal Morning.
1812	113	Tivoli.
1812	121	View in Glen Lochy; the Head of Loch Tay in the Distance.
1812	126	Loch Venachoir with Ben Venue in the Distance - Land Storm.
1812	134	View between Naples and Vietri, from a Sketch by Sir Richard Colt Hoare, Bart.
1812	161	View in Bridge Street, Chester.
1812	164	North View of York.
1812	175	View from the Ruins of the Theatre at Tormeno in Sicily, Mount Etna in the Distance.
1812	181	View near the Entrance of Richmond Park, Surrey.
1812	182	View in Glengyle, near the Head of Loch Katrine.
1812	188	View near the Head of Grassmere.
1812	189	Castle, &c. at Brecon.
1812	197	The Lake of Albano, and Castel Gandolfo, with the Campagna of Rome in the Distance.
1812	202	The Gateway of Kirkham Priory, on the Derwent, Yorkshire.
1812	203	Pyles's Mill, on the Road between Minehead and Portlock, Somerset.
1812	205	View on the Traeth Mawr, below Pont Aberglaslyn.
1812	207	View in Glen Lochy, West Highlands.
1812	211	View in the Vale of Aberfoyle, near the End of Loch Aird, West Highlands.
1812	240	Cotterforce in Cotterdale, near the Head of Wensleydale, Yorkshire.
1812	258	Bridge of Cameenaneshkrug on the Road between Killarney and Kenmere, from a Sketch by Sir Thomas Gage, Bart.
1812	261	Mill, &c. at Killin, West Highlands.
1812	265	View at Chester, at the time of the Jubilee.
1812	326	Kaia, near Sadak, on the South Side of the Crimea - from a Sketch by John Thornton, Esq.
1812	328	Loch Venachoir, West Highlands.
1813	11	Stonehenge.
1813	32	View in the Trossachs, Loch Katrime.
1813	37	The Castle of Doune, between Stirling and Callander.
1813	49	Gougane Barra, Ireland.
1813	53	View on the River Orchy, near Dalmally.
1813	56	Stonebyre Lin, a Fall of the Clyde, near Lanark.
1813	57	Castle Campbell, West Highlands.
1813	67	View of an ancient Temple, on the banks of the River Clitumnus, supposed to have been dedicated to that Deity.
1813	96	View near Horner, Somersetshire.
1813	99	Knaresborough, Yorkshire.
1813	100	Mountain Torrent, above Tarbet, on the Banks of Loch Lomond.
1813	104	The Bridge on the Anio, with Ruins of the Claudian Aqueduct, and the Convent of St. Cosimato.
1813	124	View at Stourhead, the Seat of Sir R. C. Hoare, Baronet, Alfred's Tower in the distance.
1813	132	Hermitage near Terracina.
1813	135	Kilchurn Castle, Loch Awe.
1813	141	Cottages at Selworthy, Somersetshire.
1813	143	Torrent on the Mountains of Loch Arkeg, Scotland.
1813	145	View from Blackheath.
1813	146	View on the Road between Doune and Stirling - The Castle of Stirling in the Distance.
1813	148	Chedder Cliffs, in the Mendip Hills, Somersetshire.
1813	158	Falls of the Clyde, at Stonebyre, near Lanerk.
1813	171	Piedo Lugo, from whence issues the River Velino, near the celebrated Cascade of Terni.
1813	178	Lymouth, Devonshire.
1813	189	View near Holnicote, Somersetshire.
1813	217	A Wreck on the Black Rocks, Scarborough, "Again she plunges! Hark! a second shock . . ." Vide Falconer's Shipwreck.
1815	94	Stirling, £4.4.0, Mr. Renwick.
1815	101	Mount Etna.
1815	140	York.
1815	143	View at Killin, Western Highlands.
1815	145	Rhaidr Mawr, North Wales, £15.15.0, Mr. Maud(?).
1815	151	Tower of Capri.
1815	153	Mill at Stonehead, Wilts.

| 1815 | 243 | *Ravine in Argyleshire, near the Ferry into Bute.* |

1815 243 *Ravine in Argyleshire, near the Ferry into Bute.*

1815 249 *Conway Castle.*

1815 270 *Bridge and Castle, in Funstermunst, in the Tyrol.*

1815 274 *Fall of the Clyde near Lanerk, painted in Water Colours.*

1815 279 *View in Aberfoyle, West Highlands,* £4.4.0, Mr. Maundrell, Ipswich.

1815 358 *View in the Pass of Funstermunst, in the Tyrol.*

1823L 182 *Stonebyers on the Clyde,* Rev. Dr. Burney.

1823L 188 *A Shipwreck, The Artist.*

NICHOLSON MISS

1815 123 *The Castle of Doune, near Stirling.*

1815 350 *View in the Pass of Lennie, Western Highlands, Scotland.*

NICHOLSON –

1819 149 *Portrait of the Hon. Mrs. Erskine.*

1819 150 *Portrait of Miss Erskine.*

OAKLEY O

1842 8 *Girl with Pitcher.*

1842 12 *Gypsies at the Tents.*

1842 46 *Study of Gypsies.*

1842 115 *Gypsy Travellers.*

1842 122 *A Match Girl.*

1842 202 *Gypsies at their Studies.*

1842 247 *Study of a Rustic Child.*

1843 9 *A Gipsy Child,* 15gns., Mrs. C.B. Bingley, 22 Gt. Marlborough St.

1843 96 *Love Birds,* 30gns.

1843 240 *Strolling Musicians,* 30gns., D. Gourlay Esq., Great Yarmouth, Prize of 30£ in the Art Union of London.

1843 310 *Study of Gipsies,* 40gns., C.B. Bingley Esq., 22 Gt. Marlborough St.

1843 324 *A Shrimper,* 16gns., Higgins Esq., 105 Piccadilly.

1844 31 *Gleaners at a Spring,* 30gns., Mrs. Smith, 6 Portland Place, ??? Frame and Drawing.

1844 33 *A Mulatto Boy,* 12gns., Lord C. Townshend.

1844 71 *Group of Young Gipsy Women,* 35gns., W.G. Roy Esq., P.AU.

1844 176 *A Dredging Boy,* 14gns., James Smith Esq., 1 Mannor Cotage, Upper Holloway.

1844 254 *A Ballad Singer,* 15gns., J. Ryman Esq.

1844 305 *A Rustic Piper,* 7gns.

1844 307 *Group of Gipsies with Cards,* 65gns.

1845 51 *A Castaway,* 12gns., Frame and glass £1.15.0.

1845 87 *Boy Fetching Water,* 15gns., J. Ryman Esq., Frame and glass £2.5.0.

1845 120 *Italian Boys at a Cottage,* 35gns., Mrs. Packe, 7 Richmond Terrace, Frame and glass £3.3.0.

1845 127 *Guernsey Fisher Boys at a Cottage,* 15gns., Alex. Ferrier(?) Esq., 3 Rothmines Mall, Dublin (Miss Laurie, Camberwell), Frame and glass £2.10.0, P.AU. 15£.

1845 139 *A Gleaner,* 15gns., Mr. Hebson, 48 Harley St., Frame and glass £2.0.0.

1845 148 *A Shrimper,* 14gns., Admiral Sir Charles Ogle, 44 Eaton Place, Frame and glass £2.5.0.

1845 167 *Vagabond Intruders,* 70gns., Frame and glass included.

1846 19 *Italian Boy Begging,* 18gns., AU. Com.

1846 31 *Harvest Boy,* 18gns., Cressingham Esq., The Grove, Carshalton, Surrey.

1846 142 *Reminiscence of Cairo,* Sold.

1846 219 *Italian Boy Dancing,* 16gns., Fred. Field Esq., 27 St. Audley St., AU.

1847 3 *The Primrose Gatherer,* 18gns., Acton Findal Esq., Aylesbury, Frame and glass £2.15.0, P.AU. 15£.

1847 11 *Derbyshire Cottage Children,* 25gns., Frame and glass £4.4.0.

1847 18 *A Child of the Hills,* 12gns., Frame and glass £1.10.0.

1847 100 *Prosperity,* 45gns., Miss M.A. Smith, 66 Harley Street, Frame and glass £5.11.0, P.AU. 50£.

1847 132 *Conversazione,* 30gns., Frances Countess of Holdeyrose(?), 33 Dover St., Piccadilly, Frame and glass £2.0.0 Paid.

1847 296 *The Gypsey Mother,* 35gns., B.Gosling, Frame and glass £1.12.0.

1847 306 *A Girl at a Spring,* 17gns., E.N. Mundy(?), Frame and glass £1.12.0 sold.

1847 312 *Gipsey Sisters,* 30gns., E.M. Mundy Esq., Frame and glass £2.15.0.

1848 2 *Buy my Spring Flowers,* 18gns., Revd. Hare Townshend, 9 Gt. Cumberland St., Hyde Pk., Frame and glass £1.10.0.

1848 4 *Caught in a Shower,* 30gns., Ed. L. Betts Esq., 29 Tavistock Sq. Frame and glass £2.0.0.

1848 41 *"Flowers and Wares for the Townsfolk",* 30gns., Rd. Ellison Esq., Frame and glass £2.0.0 No.

1848 55 *A Little Gleaner,* 15gns., James German Esq., Winkley Sq., Preston, Lancashire, Frame and glass £1.10.0 Yes.

1848 131 *A Fisherboy,* 17gns., J. Lockwood, Forest Hill, Frame and glass £1.10.0 No.

1848 171 *Gipsey Pastime,* 50gns., Miss Baker, per B. Little, Stratford, Essex, Frame and glass change, AU. 30.

1848 216 *The Gipsey Grandmother,* 25gns., Chas. Goodwin Esq., Lynn, Norfolk, Frame and glass £1.5.0 Yes.

1848	308	*Good Cheer!* 16gns., Mr. Thomas Halford, 2 Hanover Square. Frame and glass £1.10.0. Yes.
1849	22	*Harvest Boys.*
1849	43	*Return from Prawn Catching.*
1849	101	*Devotion.*
1849	114	*Preparation for the Absent.*
1849	205	*The Pride of the Camp.*
1849	211	*Root-gatherers.*
1849	277	*Encamped on the Common.*
1849	279	*Eurania and Corolenia Boswell, young Gipsey Sisters.*
1849	325	*Happiness.*
1850	25	*A Fisher Boy*, 17gns., Jos. Tarratt(?), Bilbrooke House, near Wolverhampton.
1850	107	*Child at a Well*, 16gns., Chas. Liddell Esq., Berwood House, Avenue Road, Regents Park, Frame and glass no.
1850	155	*A Fortune Teller*, 15gns., Mrs. Bacon.
1850	223	*Italian Boy*, 16gns., Thos. Fletcher Esq., Parker Street, Manchester.
1850	258	*St.Valentine's Day*, 30gns., Gambart(?) Esq.
1850	310	*Old Cottage near Windsor*, 8gns., C.J. Baker Esq., 2 Bloomsbury Place, Bloomsbury.
1851	14	*The Favorite Tune.*
1851	54	*Woodcutters.*
1851	67	*A Pedlar Boy.*
1851	71	*Italian Image Boy.*
1851	227	*Cottage at Reigate.*
1851	228	*Study at Charlton.*
1851	272	*Perplexity.*
1852	78	*A Shepherd*, 18G.
1852	101	*Old Farm House at Upton, near Windsor*, 8G.
1852	238	*The Dairy Door*, 16G, Bennett Gosling Esq., 61 Lowndes Square.
1852	274	*The Reverie*, 25G.
1853	256	*Leaving the Fair.*
1853	299	*Gipsies at a Well.*
1853	308	*La Joueuse.*
1854	121	*Valentine's Day*, 40gns., Frame and glass £5.5.0.
1854	168	*The Rising of the Lark*, 45gns., Frame and glass £5.5.0.
1855	61	*Palm my Hand*, 12gns., Frame and glass £1.10.0.
1855	71	*Delight*, 16gns., H. Tarrant, Ottery St. Mary, Devon, Frame £1.5.0(?) included.
1855	94	*Fisher Boy*, 18gns., Sir Hugh Hume Campbell Bart, 10 Hill St., Berkeley Sq., Frame and glass £1.10.0.
1855	280	*A Day-Dream*, 35gns., Honble. S.T. Carnegie(?), Albany, Frame (£3.3.0?) included.

OWEN S

1823L	71	*A Brisk Gale*, Earl of Essex.

PALMER S

1843	56	*The Colosseum and Alban Mount*, 10 Pounds.
1843	114	*Harlech Castle - Twilight*, "The Moon is up, and yet it is not night." 30 Pounds.
1843	131	*At Donnington, Berkshire, the Birth-place of Chaucer*, 15 Pounds.
1843	197	*Old Farm, near Thatcham, Berks*, 15Pounds.
1843	218	*Rustic Scene near Thatcham, Berkshire*, 15 Pounds.
1843	238	*Evening - the Ruins of a Walled City*, 30 Pounds, Mrs. Aaron per John Woodbourne, Bowhill House, Selkirk, Prize of 30£ in Art Union of London.
1843	304	*The Bay of Baiae, from Monte Nuovo*, 10 Pounds, William Coningham Esq., 42 Porchester Terrace, Bayswater.
1843	312	*The Campagna and Aqueducts of Rome*, 10 Pounds, William Coningham Esq., 42 Porchester Terrace, Bayswater.
1844	10	*Jacob Wrestling with the Angel*, "And he said, Let me go, for the day breaketh: and he said, I will not let thee go, except thou bless me." – Gen. xxxii, 26. 15 Pounds.
1844	75	*The Village of Papigno, on the Nar, between Terni and the Falls*, The river glideth at his own sweet will. 30 Pounds.
1844	89	*The Guardian of the Shores - Twilight, after Rain*, "The storm-rent vapours pass, and lurid shapes Fantastic hover o'er the dusky shore." 30 Pounds.
1844	133	*The Monastery - a Scene from Southern Italy*, 15 Pounds, Wm. Hobson Esq.
1844	246	*The Poet's Grave: - English Burial-ground at Rome - the Burial-place of KEATS*, "Belov'd, till verse can charm no more, And mourn'd till pity's self be dead." 10 Pounds, Wm. Dobson Esq., 13 Huntley Street, Bedford Sq., P.AU.
1844	264	*Mountain Pastures*, "Sometimes with secure delight The upland hamlets will invite." 10 Pounds, Hobson Esq., Harley St.
1844	278	*The Silver City - Morning, on the Jura Mountains, looking towards the Alps*, 10 Pounds, Hobson Esq., Harley St.
1844	286	*The Glimmering Landscape*, "The ploughman homeward plods his weary way." 10 Pounds, W. Coningham Esq., 42 Porchester Terrace, Bayswater.
1845	98	*La Vocatella - a Chapel built by a Hermit near Corpo di Cava, in the neighbourhood of Salerno and Naples*, 15 Pounds, Haviland Buske Esq., 27 Gloucester Place, New Road.
1845	122	*The City of Rome and the Vatican, from the Western Hills - Pilgrims resting on the last stage of their journey*, 40 Pounds, Frame and glass £2.0.0.

1845	158	*Evening in Italy - The Deserted Villa, "The sun sets red, and rises bright; but yon grey halls . . ."* 10 Pounds, Frame and glass £1.0.0.
1845	159	*Tivoli and Campagna of Rome; with the Water Organ and great Cypresses of the Villa d'Este - the City of Rome in the remote distance,* 40 Pounds, Frame and glass £2.0.0.
1845	272	*Florence and Val d'Arno, from the Cypress Grove of San Miniato,* 25 Pounds, Frame and glass £1.0.0.
1845	306	*Porta di Posilipo and the Bay of Baiae - with Ischia and the Promontory of Misenum, "The balmy spirit of the western gale, Eternal breathes on fruits untaught to fail."* 15 Pounds, Frame and glass £1.0.0.
1845	337	*At Sunset - the Mountains behind Paestum and Salerno, and a part of the Salernian Gulf, from the Slopes of Monte Finestre,* 15 Pounds, Frame and glass £1.0.0.
1846	108	*The Aged Oak,* 30 Pounds, Frame and glass £4.0.0.
1846	111	*The Corn Field,* 15 Pounds, Frame and glass £2.0.0.
1846	113	*Children Gleaning,* 10 Pounds, Frame and glass £1.11.0.
1846	120	*A Lane Scene,* 15 Pounds, Frame and glass £2.0.0.
1846	122	*The Listening Gleaner,* 10 Pounds, Frame and glass £1.11.0.
1846	141	*Crossing the Brook,* 30 Pounds, Frame and glass £4.0.0.
1846	201	*A Farm Yard, near Risborough, Bucks.,* 15 Pounds, Frame and glass £2.0.0.
1847	148	*The Broken Bridge,* 15 Pounds, Frame and glass £2.0.0.
1847	176	*A Landscape - Sunset,* 30 Pounds, Frame and glass £3.0.0.
1847	241	*The Corn Field - Cloudy Morning,* 10 Pounds, R. Ellison, Frame and glass £1.5.0.
1847	253	*The Gipsey Dell - Moonlight,* 15 Pounds, Frame and glass £2.0.0.
1847	259	*The Skirts of a Village,* 10 Pounds, Frame and glass £1.5.0.
1848	5	*Sion Hill, Underriver, Kent,* 10 Pounds, Frame and glass £1.10.0.
1848	51	*Mountain Flocks,* 15 Pounds, Frame and glass £2.0.0.
1848	122	*Woodland Scenery,* Sold.
1848	175	*The Ruins of a Monastery - Storm coming on,* 20 Pounds, John Moxon Esq., 8 Hanover Terrace, Regents Park.
1848	204	*Christian Descending into the Valley of Humiliation, Vide Pilgrim's Progress.* 30 Pounds, Frame and glass £3.0.0.
1848	217	*Mercury Driving away the Cattle of Admetus,* 30 Pounds, Ed. Enfield Esq., Royal Mint, Frame and glass £3.0.0 Yes.
1848	228	*Carting the Wheat,* 10 Pounds, Miss Burdett Coutts, Frame and glass £1.5.0.
1848	251	*Crossing the Common - Sunset,* 10 Pounds, Bishop of Winchester, Frame and glass £1.5.0 Yes.
1849	88	*Farewell to Calypso!*
1849	100	*Sir Guyon, with the Palmer attending, tempted by Phaedria to land upon the Enchanted Islands, Faëry Queen.*
1849	149	*SUN and SHADE – Arestorides.*
1849	175	*Sheltering from the Storm.*
1849	222	*King Arthur's Castle: Tintagell, Cornwall.*
1849	244	*Sylvan Quiet.*
1849	255	*Crossing the Heath.*
1849	334	*Gleaners Crossing a Shallow Stream.*
1850	58	*Children Nutting,* 20 Pounds, Frame and glass £3.0.0.
1850	177	*Wind and Rain,* 30 Pounds, Frame and glass £5.0.0.
1850	205	*St. Paul landing in Italy,* 50 Pounds, Frame and glass £5.0.0.
1850	217	*Robinson Crusoe guiding his Raft up the Creek,* 40 Pounds, Frame and glass £5.0.0.
1850	304	*Cattle in the Shallows - Summer Evening,* 15 Pounds, Frame and glass £2.0.0.
1850	326	*Carting the Wheat - Showery Weather,* 20 Pounds, Frame and glass £2.0.0.
1851	192	*The Windmill.*
1851	303	*Sheep in the Shade.*
1851	321	*The breezy Heath.*
1852	107	*A Showery Morning - Scenery of West Somerset,* 20G, Frame and glass £2.2.0.
1852	237	*The Forester's Horn,* 10G, Frame and glass £1.11.6.
1852	251	*Shady Quiet,* 10G, J.J. Jenkins Esq., Frame and glass £1.1.0.
1852	263	*The Approach of Dinner,* 10G, J. Ryman Esq., Frame and glass £1.11.6.
1852	275	*The Skirts of a Common,* 10G, Frame and glass £1.1.0.
1853	18	*The Rustic Dinner.*
1853	210	*Children and Sheep.*
1853	228	*Haste and Patience.*
1854	241	*Fast Travelling,* 12gns. [deleted], Gambart Esq.
1854	252	*The Folded Flock,* Sold.
1855	73	*The Dell of Comus, "This evening late, by then the chewing flocks . . ." – Milton.* 60gns., S. Dyce Nicols(?), 5 Hyde Park Terrace, Frame and glass £5.5.0.
1855	251	*The Rustic Conversazione,* Sold.
1855	255	*Sunset over the Gleaning Fields,* Sold.
1855	277	*The Bay of Naples,* Sold.

PAREZ J

1820	381	*Snow Piece - Composition.*

PASTORINI F E

1815	7	*Hebe.*
1815	8	*Cleopatra dissolving the Pearl.*
1815	27	*Holy Family.*

PAYNE W

1809	21	*View near Lidford, Devon.*
1809	65	*Fowey Harbour, Cornwall - sun-rise, Mr. Oliphant.*
1809	138	*View near Plymouth - moonlight.*
1809	152	*Chepstow Castle.*
1809	213	*Vicinity of Dartmoor, Devon - evening.*
1810	130	*Whitsand Bay, Cornwall.*
1810	229	*View in Cornwall, Moonlight.*
1810	238	*Pomlet Mill, Plymouth.*
1810	256	*Banditti.*
1810	308	*Coast and Channel, near Plymouth.*
1811	174	*Ivy Bridge, Devon, in the year 1790.*
1811	232	*Composition, from Nature.*
1811	255	*Orestone near Plymouth.*
1811	296	*On the Wye - Moonlight.*
1811	350	*Hall Down, Devonshire - Rain.*
1812	73	*Conway.*
1812	116	*View in Cardiganshire.*

PELLETIER A

1816	68	*Dead Birds and Fruit, on a Table.*
1816	199	*Flowers.*

PELLIGRINE

1815	196	*Psyche.*
1815	198	*Virgin and Child.*

PHILLIPS G H

1820	190	*Portrait of Miss Bennett.*

PICKERING G

1815	113	*Landscape.*
1815	120	*View near Matlock, Bath.*
1815	136	*View near Matlock, Bath.*
1815	137	*Landscape.*
1816	140	*View near Denbigh, North Wales.*
1816	164	*View near Aber.*
1816	240	*View at Matlock, Derbyshire.*
1816	248	*View near Aber, North Wales.*
1817	168	*View at Rosthwaite, in Borrowdale, £5.5.0, G. Cooke Esq.*
1817	178	*View of Conway Castle, £5.5.0, G. Cooke Esq.*
1818	214	*Ullswater.*

PLANT W

1819	142	*The Virgin and Child, an Enamel Painting, after Raphael.*
1819	154	*The Marriage of St. Catherine, an Enamel Painting after Parmigiano.*

POCOCK N

1805	6	*View on the Menai, with Plass Newydd, and part of the Carnarvonshire mountains in the distance.*
1805	8	*A fresh gale, a frigate coming to anchor, with a distant view of Liverpool.*
1805	21	*The British fleet, under Sir H. Parker, passing Cronenberg castle, March 31, 1801.*
1805	25	*Sea side view, Eastbourne, Sussex.*
1805	26	*Town and port of Tenby: a strong gale.*
1805	45	*Pevensea bay, a fresh gale.*
1805	48	*A strong gale, Ilfracombe, North Devon.*
1805	58	*The disabled situation in which the Guillaume Tell, of 84 guns (bearing the flag of Vice Admiral Decres) was found at day-break, on the 30th of March 1800, after having been engaged by his Majesty's ship Penelope, of 36 guns, comm. Hon. H. Blackwood.*
1805	80	*The boarding and taking the Spanish Xebecque frigate, El Gamo, by his Majesty's sloop, Speedy, commanded by the Right Hon. Lord Cochrane, off Barcelona, May 6, 1801. Speedy 14 guns, 54 men; El Gamo 32 guns, 319 men.*
1805	118	*A storm. His Majesty's ship Endymion, commanded by Hon. Charles Paget.*
1805	125	*A fresh breeze, View of the Black Rocks off Brest, with a portrait of his Majesty's ship Endymion.*
1805	142	*A landscape, with figures.*
1805	146	*Plass Newydd, Anglesea, the seat of the Earl of Uxbridge.*
1805	181	*Part of the port of Dartmouth, with shipping.*
1805	217	*The Flora leading the line in an engagement between a squadron of his Majesty's frigates and a squadron of French, on St. George's day, 1794 . . .*
1805	224	*Part of the harbour and ruins of the Castle at Aberystwith, North Wales.*
1805	250	*The Flora disabled, the Babet surrendered, La Pomone and L'Engageant strike to the Arethusa and Concorde, the Melampus and La Nymphe in chace of La Resolu.*
1806	28	*The Ten Frigates, stationed for the defence of the River (in the Lower Hope) under the Command of Lieutenant Colonel Cotton, Deputy Master of Trinity House Volunteers. Officered and manned by Trinity-house Volunteers.*
1806	42	*A Brisk Gale, with Ships of War, in the back ground the entrance of the Port of Ferrol.*
1806	56	*Southampton, from Hythe, calm Evening, with Shipping.*
1806	80	*Landscape, with Figures, taken from the Priory Walk Brecon.*
1806	98	*Port and Bay of Tenby, S. Wales.*

1806	102	*A strong gale, with the entrance of the Port of Brest; a British Frigate and Cutter reconnoitring.*
1806	109	*A strong gale, View of Ilfracombe, North Devon.*
1806	125	*His Majesty's Ships L'Hercule and Theseus, dismasted and nearly foundering in a tremendous hurricane in the West Indies, displaying blue lights to each other on the night of the 7th Sept. 1805.*
1806	127	*Caernarvon, from the Ferry in Anglesey.*
1806	148	*Mount Vesuvius, from the City of Naples.*
1806	156	*View of the Port of Tenby from the North, with Shipping and Figures.*
1806	174	*A moderate Breeze, with Shipping, and a View of Calshot Castle, from Southampton Water.*
1806	194	*Prince Rupert's Bay, in the Island of Dominica.*
1806	200	*His Majesty's Ship the Captain, of 74 Guns, then commanded by the late great Patriot and Hero Lord Nelson, Captures the San Nicholas of 84 Guns, and San Joseph 112 Guns, both of which he carried by Boarding, off Cape St. Vincent, 14 February 1797.*
1806	206	*Represents the Arrow sinking, the Acheron in running fight with, and leading the Enemy from the Convoy, which, for the greatest part escaped, by the very exemplary conduct and bravery of this great inferiority of Force. (See 216).*
1806	216	*His Majesty's Ship Arrow, 28 Guns, and Acheron Bomb of 8 Guns, engage L'Hortense of 48, and L'Incorruptible of 44 Guns, and 672 men each, in the Mediterranean, February 5th, 1805. (See 206).*
1806	245	*Westminster Abbey and Milbank, from the Surry side of the Thames.*
1806	246	*Ilfracombe, North Devon.*
1806	247	*King's Road, from King's Weston, near Bristol. Evening, after a shower. A sketch.*
1806	252	*Llanrwst Bridge.*
1806	268	*Rostillion, the seat of the Bishop of Cork, near Cork.*
1806	274	*Evening, with Boats and Figures.*
1806	281	*View of part of the Isle of Wight, looking westward towards Cowes, from the Motherbank, with Shipping.*
1806	295	*The Brunswick engaging Le Vengeur, June 1, 1794.*
1807	20	*View of Hastings - morning.*
1807	47	*Porto Leone, with Areopolis, His Majesty's ship Braakel at anchor.*
1807	127	*View of the island of Tortola, with Ginger island and Round rock - a fresh breeze.*
1807	135	*Port Morant, with the blue mountains, East end of Jamaica - a brisk gale.*
1807	165	*The town and harbour of St. John's, Antigua.*
1807	170	*View on the Thames, taken from Privy Gardens, Whitehall.*
1807	199	*East India Ships beating in the Straits of Lomboc - a gale.*
1807	219	*His Majesty's ship, the Pallas, after having run La Minerve on board; with a view of the Rochfort squadron, and two frigates sent out to assist La Minierve, and brigs.*
1807	239	*The St. Fiorenzo, Captain Sir Harry Neale, and the Amelia, the Hon. Captain Herbert, engaging three French frigates and a cutter: aided by the batteries on shore, they effected their escape, owing to the disabled state of the Amelia, who had, just before action, lost her main top-mast and top-gallant-masts in a squall, close in with the Belleisle April 9, 1799.*
1807	270	*His Majesty's sloop Diligence, Captain Tidy, in company with the Blood-hound, Fearless, Desperate, Pincher, and Sparkler gun brigs, attack an armed flotilla at Boulogne, of which they sunk two, and destroyed several others; the remainder made their escape.*
1807	281	*A strong gale, with shipping, and a view of Cape Tiberon, Hispaniola.*
1807	290	*A calm, with a view of Beaumaris, taken from the Menai.*
1807	297	*Port Royal, Jamaica, with shipping - a brisk gale.*
1807	299	*Southampton, a brisk gale with ships, taken from the sea beach, near Netley Abbey.*
1807	302	*Holyhead, a fresh gale, with shipping.*
1807	310	*The Port of Aberystwith, North Wales, twilight, a calm.*
1807	311	*Cape Colonne, His Majesty's ship Braakel in danger.*
1807	318	*His Majesty's ship Pallas, 32 guns, Captain the Right Honourable Lord Cockrane, engaging La Minerve of 44 guns, and three gun brigs, under the batteries of the Isle d'Aix, off Rochfort, in the presence of a Rear Admiral, with five ships of the line, 14th of May 1806.*
1808	3	*East-India ships beating in the straits of Lumbock, with a view of the island.*
1808	25	*Rio Janeiro, Brazils, South America, with shipping, Senor Thos. Volund(?).*
1808	34	*A brisk gale, with boats and figures, taken from the beach at Brighton.*
1808	43	*The Land's end, and Longship's Rocks, with a ship laying to - a storm.*
1808	52	*St. Catherine's Rock, in the bay of Tenby, with shipping in a gale.*
1808	69	*View from Beaumaris Bay, towards Priestholm, with shipping, &c.*
1808	101	*Plassnewydd, Anglesea, taken from M.D. with a race of cutters, &c.*

1808	102	*Ilfracombe, North Devon, with ships, &c.*
1808	104	*An East-India ship in great peril, laying to in a (typhon) or hurricane, off the island of Bally.*
1808	111	*A strong gale, with a view of St. Alban's Head, and a ship scudding up the Channel.*
1808	115	*Southampton, from the water, near Hythe, with shipping - a fresh breeze.*
1808	120	*The island of St. Eustatius, from Sandy Point, St. Christopher's, with shipping.*
1808	124	*Killiney Bay, near Dublin, a stormy day, with shipping, &c.*
1808	160	*Boats and shipping, a fresh breeze.*
1808	161	*Rocks near Ilfracombe, moonlight, with smugglers landing.*
1808	164	*A brig of war leading her convoy through the Needles, Isle of Wight - a fresh gale.*
1808	193	*View of the port of Brest, his Majesty's brig Childers reconnoitring, is fired at from the batteries at the commencement of the war, 1793. For Naval Annals.*
1808	228	*Captain Edward Pellew in H. M. frigate La Nymphe, captures the Cleopatra French frigate, by boarding after a close action of 55 minutes off the Start, June 18, 1793. For Naval Journals.*
1808	235	*A frigate laying to off Dunnose, making signals to her convoy to come under her stern.*
1808	273	*The breaking up of a storm on the sea coast, with ships in danger.*
1808	279	*View taken on the Strand, between Brighton and Shoreham, with boats and figures.*
1809	11	*A ship of war, of 74 guns, preparing to anchor at Spithead.*
1809	12	*H.M. ship Victory getting under weigh, with cutters.*
1809	76	*The Land's-end, and Longships Rocks, a strong gale with shipping.*
1809	82	*A storm, with the wreck of H. M. frigate Leda.*
1809	99	*Situation of H.M. frigate St. Fiorenza, with her prize, the Piedmontoise, as they appeared after the action, with a view of the island of Ceylon.*
1809	128	*Rocks, near Ilfracombe, North Devon, with a pilot boat running for the harbour.*
1809	139	*Ships driving from their anchorage in the Downs, with the wreck of an indiaman on the Goodwin Sands.*
1809	147	*A storm, with a ship scudding.*
1809	170	*View on the beach at Brighton, with shipping, &c.*
1809	175	*Ships of war beating out of Torbay, in a gale at South east.*
1809	184	*The Endymion under close-reefed topsails, with a view of the Eddystone light-house.*
1809	185	*The bay of Tenby, with boats and figures, a light breeze.*
1809	186	*The Folkstone lugger on the morning of the 27th of November, 1807, about thirty leagues off the coast of Northumberland.*
1809	220	*View on the coast of Lancashire, with shipping - evening.*
1809	221	*View of the East end of Jamaica, with a frigate in chace, a brisk gale.*
1809	222	*The Snowdon range of mountains, taken from the Menina - evening.*
1809	226	*View on the coast of Lancashire, Skiddaw in the distance, a fresh gale.*
1809	227	*Boats, &c. with Lord Craven's yacht, decorated with the colours of all nations, and saluting on the birth-day of H.R.H. the Prince of Wales - taken from the beach, Brighton.*
1809	228	*The Glyder mountain, with a view of Port Penrhyn, with the Augusta yacht, belonging to the Earl of Uxbridge.*
1809	259	*View on the Thames, near Gravesend, with various boats and ships, a fresh gale.*
1809	260	*View on the Thames, with boats, ships &c.*
1809	277	*Action between H.M. ship Greyhound, Capt. Elphinstone, the Harrier gun Capt. Banbridge and four Dutch ships, on the 26th of July, 1806, in the Java seas; the frigate and two others were captured, the corvette made her escape.*
1809	293	*Netley Abbey, from Southampton, water, with boats, &c. a brisk gale.*
1809	306	*A brisk gale, with shipping, &c. with a view of Cowes Castle, Isle of Wight, taken from the N. West.*
1809	330	*A strong gale, with shipping beating up to Spithead.*
1810	56	*Storm - attempt to veer, Head-yards braced aback, Fore Stay-sail hoisted, splits, the Mizenmast cut away, Falconer's Shipwreck, Canto II. p. 94.*
1810	81	*A Strong Gale - sending down Top-gallant Yards, furling Topsails, Falconer's Shipwreck, Canto II. p. 63.*
1810	135	*The Port of Tenby, South Wales, with Shipping and Figures - a Calm Evening.*
1810	141	*Lord Howe's Victory over the French Fleet on the 1st of June, 1794, taken at half past Ten o'Clock, Forenoon, when the Queen Charlotte passed through the Enemy's Line, and was hawling upon the lee-quarter of the Montagne, whose Fire she had totally silenced.*
1810	171	*A Storm, with a Ship carrying a press of Sail off the Fastnot, Cape-clear.*
1810	198	*A Ship in Distress endeavouring to reach Crookhaven, a Storm.*
1810	204	*View taken near Dover, with Boats and Figures.*
1810	255	*Dover Castle, with various Shipping and Boats, a fresh Gale.*

1806	102	*A strong gale, with the entrance of the Port of Brest; a British Frigate and Cutter reconnoitring.*
1806	109	*A strong gale, View of Ilfracombe, North Devon.*
1806	125	*His Majesty's Ships L'Hercule and Theseus, dismasted and nearly foundering in a tremendous hurricane in the West Indies, displaying blue lights to each other on the night of the 7th Sept. 1805.*
1806	127	*Caernarvon, from the Ferry in Anglesey.*
1806	148	*Mount Vesuvius, from the City of Naples.*
1806	156	*View of the Port of Tenby from the North, with Shipping and Figures.*
1806	174	*A moderate Breeze, with Shipping, and a View of Calshot Castle, from Southampton Water.*
1806	194	*Prince Rupert's Bay, in the Island of Dominica.*
1806	200	*His Majesty's Ship the Captain, of 74 Guns, then commanded by the late great Patriot and Hero Lord Nelson, Captures the San Nicholas of 84 Guns, and San Joseph 112 Guns, both of which he carried by Boarding, off Cape St. Vincent, 14 February 1797.*
1806	206	*Represents the Arrow sinking, the Acheron in running fight with, and leading the Enemy from the Convoy, which, for the greatest part escaped, by the very exemplary conduct and bravery of this great inferiority of Force. (See 216).*
1806	216	*His Majesty's Ship Arrow, 28 Guns, and Acheron Bomb of 8 Guns, engage L'Hortense of 48, and L'Incorruptible of 44 Guns, and 672 men each, in the Mediterranean, February 5th, 1805. (See 206).*
1806	245	*Westminster Abbey and Milbank, from the Surry side of the Thames.*
1806	246	*Ilfracombe, North Devon.*
1806	247	*King's Road, from King's Weston, near Bristol. Evening, after a shower. A sketch.*
1806	252	*Llanrwst Bridge.*
1806	268	*Rostillion, the seat of the Bishop of Cork, near Cork.*
1806	274	*Evening, with Boats and Figures.*
1806	281	*View of part of the Isle of Wight, looking westward towards Cowes, from the Motherbank, with Shipping.*
1806	295	*The Brunswick engaging Le Vengeur, June 1, 1794.*
1807	20	*View of Hastings - morning.*
1807	47	*Porto Leone, with Areopolis, His Majesty's ship Braakel at anchor.*
1807	127	*View of the island of Tortola, with Ginger island and Round rock - a fresh breeze.*
1807	135	*Port Morant, with the blue mountains, East end of Jamaica - a brisk gale.*
1807	165	*The town and harbour of St. John's, Antigua.*
1807	170	*View on the Thames, taken from Privy Gardens, Whitehall.*
1807	199	*East India Ships beating in the Straits of Lomboc - a gale.*
1807	219	*His Majesty's ship, the Pallas, after having run La Minerve on board; with a view of the Rochfort squadron, and two frigates sent out to assist La Minerve, and brigs.*
1807	239	*The St. Fiorenzo, Captain Sir Harry Neale, and the Amelia, the Hon. Captain Herbert, engaging three French frigates and a cutter: aided by the batteries on shore, they effected their escape, owing to the disabled state of the Amelia, who had, just before action, lost her main top-mast and top-gallant-masts in a squall, close in with the Belleisle April 9, 1799.*
1807	270	*His Majesty's sloop Diligence, Captain Tidy, in company with the Blood-hound, Fearless, Desperate, Pincher, and Sparkler gun brigs, attack an armed flotilla at Boulogne, of which they sunk two, and destroyed several others; the remainder made their escape.*
1807	281	*A strong gale, with shipping, and a view of Cape Tiberon, Hispaniola.*
1807	290	*A calm, with a view of Beaumaris, taken from the Menai.*
1807	297	*Port Royal, Jamaica, with shipping - a brisk gale.*
1807	299	*Southampton, a brisk gale with ships, taken from the sea beach, near Netley Abbey.*
1807	302	*Holyhead, a fresh gale, with shipping.*
1807	310	*The Port of Aberystwith, North Wales, twilight, a calm.*
1807	311	*Cape Colonne, His Majesty's ship Braakel in danger.*
1807	318	*His Majesty's ship Pallas, 32 guns, Captain the Right Honourable Lord Cockrane, engaging La Minerve of 44 guns, and three gun brigs, under the batteries of the Isle d'Aix, off Rochfort, in the presence of a Rear Admiral, with five ships of the line, 14th of May 1806.*
1808	3	*East-India ships beating in the straits of Lumbock, with a view of the island.*
1808	25	*Rio Janeiro, Brazils, South America, with shipping, Senor Thos. Volund(?).*
1808	34	*A brisk gale, with boats and figures, taken from the beach at Brighton.*
1808	43	*The Land's end, and Longship's Rocks, with a ship laying to - a storm.*
1808	52	*St. Catherine's Rock, in the bay of Tenby, with shipping in a gale.*
1808	69	*View from Beaumaris Bay, towards Priestholm, with shipping, &c.*
1808	101	*Plassnewydd, Anglesea, taken from M. D. with a race of cutters, &c.*

1808	102	*Ilfracombe, North Devon, with ships, &c.*
1808	104	*An East-India ship in great peril, laying to in a (typhon) or hurricane, off the island of Bally.*
1808	111	*A strong gale, with a view of St. Alban's Head, and a ship scudding up the Channel.*
1808	115	*Southampton, from the water, near Hythe, with shipping - a fresh breeze.*
1808	120	*The island of St. Eustatius, from Sandy Point, St. Christopher's, with shipping.*
1808	124	*Killiney Bay, near Dublin, a stormy day, with shipping, &c.*
1808	160	*Boats and shipping, a fresh breeze.*
1808	161	*Rocks near Ilfracombe, moonlight, with smugglers landing.*
1808	164	*A brig of war leading her convoy through the Needles, Isle of Wight - a fresh gale.*
1808	193	*View of the port of Brest, his Majesty's brig Childers reconnoitring, is fired at from the batteries at the commencement of the war, 1793. For Naval Annals.*
1808	228	*Captain Edward Pellew in H. M. frigate La Nymphe, captures the Cleopatra French frigate, by boarding after a close action of 55 minutes off the Start, June 18, 1793. For Naval Journals.*
1808	235	*A frigate laying to off Dunnose, making signals to her convoy to come under her stern.*
1808	273	*The breaking up of a storm on the sea coast, with ships in danger.*
1808	279	*View taken on the Strand, between Brighton and Shoreham, with boats and figures.*
1809	11	*A ship of war, of 74 guns, preparing to anchor at Spithead.*
1809	12	*H.M. ship Victory getting under weigh, with cutters.*
1809	76	*The Land's-end, and Longships Rocks, a strong gale with shipping.*
1809	82	*A storm, with the wreck of H. M. frigate Leda.*
1809	99	*Situation of H.M. frigate St. Fiorenza, with her prize, the Piedmontoise, as they appeared after the action, with a view of the island of Ceylon.*
1809	128	*Rocks, near Ilfracombe, North Devon, with a pilot boat running for the harbour.*
1809	139	*Ships driving from their anchorage in the Downs, with the wreck of an indiaman on the Goodwin Sands.*
1809	147	*A storm, with a ship scudding.*
1809	170	*View on the beach at Brighton, with shipping, &c.*
1809	175	*Ships of war beating out of Torbay, in a gale at South east.*
1809	184	*The Endymion under close-reefed topsails, with a view of the Eddystone light-house.*
1809	185	*The bay of Tenby, with boats and figures, a light breeze.*
1809	186	*The Folkstone lugger on the morning of the 27th of November, 1807, about thirty leagues off the coast of Northumberland.*
1809	220	*View on the coast of Lancashire, with shipping - evening.*
1809	221	*View of the East end of Jamaica, with a frigate in chace, a brisk gale.*
1809	222	*The Snowdon range of mountains, taken from the Menina - evening.*
1809	226	*View on the coast of Lancashire, Skiddaw in the distance, a fresh gale.*
1809	227	*Boats, &c. with Lord Craven's yacht, decorated with the colours of all nations, and saluting on the birth-day of H.R.H. the Prince of Wales - taken from the beach, Brighton.*
1809	228	*The Glyder mountain, with a view of Port Penrhyn, with the Augusta yacht, belonging to the Earl of Uxbridge.*
1809	259	*View on the Thames, near Gravesend, with various boats and ships, a fresh gale.*
1809	260	*View on the Thames, with boats, ships &c.*
1809	277	*Action between H.M. ship Greyhound, Capt. Elphinstone, the Harrier gun Capt. Banbridge and four Dutch ships, on the 26th of July, 1806, in the Java seas; the frigate and two others were captured, the corvette made her escape.*
1809	293	*Netley Abbey, from Southampton, water, with boats, &c. a brisk gale.*
1809	306	*A brisk gale, with shipping, &c. with a view of Cowes Castle, Isle of Wight, taken from the N. West.*
1809	330	*A strong gale, with shipping beating up to Spithead.*
1810	56	*Storm - attempt to veer, Head-yards braced aback, Fore Stay-sail hoisted, splits, the Mizenmast cut away, Falconer's Shipwreck, Canto II. p. 94.*
1810	81	*A Strong Gale - sending down Top-gallant Yards, furling Topsails, Falconer's Shipwreck, Canto II. p. 63.*
1810	135	*The Port of Tenby, South Wales, with Shipping and Figures - a Calm Evening.*
1810	141	*Lord Howe's Victory over the French Fleet on the 1st of June, 1794, taken at half past Ten o'Clock, Forenoon, when the Queen Charlotte passed through the Enemy's Line, and was hawling upon the lee-quarter of the Montagne, whose Fire she had totally silenced.*
1810	171	*A Storm, with a Ship carrying a press of Sail off the Fastnot, Cape-clear.*
1810	198	*A Ship in Distress endeavouring to reach Crookhaven, a Storm.*
1810	204	*View taken near Dover, with Boats and Figures.*
1810	255	*Dover Castle, with various Shipping and Boats, a fresh Gale.*

1810	262	*A Ship on Launch, with Boats and Figures, To be Engraved for a New Edition of Falconer's Shipwreck*
1810	264	*A Gale, Ships of War under Courses.*
1810	265	*A first-rate Man of War under weigh.*
1810	266	*A third-rate Man of War, with Boats, &c.*
1810	268	*A View on the Lake of Llanberris.*
1810	274	*Capture of the La Reunion French Frigate of 36 Guns, 320 Men, by the Crescent, Captain Sir James Saumarez, of 32 Guns, 260 Men, off Cape Barfleur, Octr. 20, 1793, after an Action of 2 Hours and 20 Minutes, in which La Reunion had 120 Men killed and wounded, the Crescent not a man hurt. To be Engraved for the Naval Records.*
1810	278	*View of Holyhead, with a Packet, and various other Vessels - a fresh Breeze.*
1810	285	*A strong Gale, a Pilot Boat conducting Ships into Cork Harbour.*
1810	286	*Storm, the Wreck, Falconer's Shipwreck. Canto III. p. 126. line 16 to 22.*
1810	295	*Destruction of H. M. Ship, Ajax, Captain the Hon. Henry Blackwood, by Fire, off the Dardanelles, Feb. 14, 1807.*
1810	302	*View at Eastbourne, with Shipping Boats, and Figures.*
1811	17	*Captain Horatio Nelson, in his Majesty's Ship Agamemnon, engaging four large French Frigates, and a Corvette, off Sardinia, 22nd October, 1793, For Naval Records.*
1811	18	*His Majesty's Ship Ocean, 98 guns, with various Shipping, a brisk Gale.*
1811	24	*Captain Cotes, in his Majesty's Frigate Thames, of 32 Guns and 220 Men, engaging the Proserpine, of 38 Guns and 320 Men; after a close action of five hours, the Frenchman hauled off, leaving the Thames too much disabled in Masts, &c. to follow...*
1811	25	*A Frigate of 38 Guns, with Cutters, Boats, &c.*
1811	69	*Fourth, Fifth, and Sixth Rate Ships of War under Courses - a strong Gale.*
1811	74	*A Cutter beating to Windward, a Third-Rate Man of War, with other Shipping in the Distance.*
1811	85	*Coast of Italy, with Shipping and Figures - A Calm.*
1811	93	*Prince Rupert's Bay, Island of Dominica, with Shipping, from the South East.*
1811	156	*A Wreck, lying among the Breakers, the Life-Boats hawling off to her by the Rope which has been fired off from the Mortar, and which has fixed itself on her Main-Stay.*
1811	162	*A Ship wreck'd near the Shore, the Machine for grappling her just projected from the Mortar, and the Life Boat preparing to launch and hawl off to the Wreck. Explanatory of Captain Manby's Invention for preserving the lives of Shipwrecked Mariners.*
1811	171	*The Triumph of Humanity exemplified in the conduct of Vice admiral Sir Edward Pellew who at great peril of his life caused himself to be hawled on board the Wreck of the Dutton East-Indiaman by the only rope of communication with the Shore, and by that means rescued many souls from certain death.*
1811	180	*A Brig of War on a Wind, with Boats, &c. - a stiff Breeze.*
1811	182	*Hog Boats beating off to Sea - Coast of Brighton.*
1811	199	*Landscape and Figures.*
1811	251	*A Brisk Gale with Ships, &c.*
1811	268	*Calm; Boats a head, towing the Ship out of the Bay of Candia, Falconer's Shipwreck*
1811	280	*A Brisk Gale, Designed for a New Edition of Falconer's Shipwreck.*
1811	293	*A fresh Breeze, with Shipping, the Steeple of Boston in the Distance, with Vessels at Anchor on the Scalp.*
1811	317	*His Majesty's Ship Thunderer, under a Press of Sail, off Mizen Head.*
1811	352	*A Calm, Moon-light. Engraved for a new Edition of Falconer's Shipwreck.*
1812	25	*View of Falmouth Harbour, from the North-West, with Shipping.*
1812	72	*View of His Majesty's Brig of War Philomel, Captain Guion, chased by a French Squadron of eight Ships of the Line, and four Frigates, and protected from Capture by the Intrepidity of Captain Halliday, in the Repulse, of 74 guns, who shortened Sail and...31st of August, 1810.*
1812	118	*View on the Beach, near the Sea Houses, East Bourne, Sussex.*
1812	120	*View at Matlock.*
1812	140	*The Pier at Broadstairs, with Shipping, &c.*
1812	142	*Distant View of Ramsgate Pier, from the Sea-side towards Broadstairs.*
1812	143	*The Harbour of Cork, taken from the Heights above the Cove.*
1812	149	*View at Matlock.*
1812	156	*View of Margate, from the Noyland Point - Evening.*
1812	157	*View taken near the Black Rock, Cork.*
1812	170	*Dangerous Situation of a Packet leaving the Pier of Calais in a Storm.*
1812	191	*View of Green Castle Estate, in the Island of Antigua, the Property of Sir Henry Martin, Bart.*
1812	196	*A Land Storm - View near Brecon, South Wales.*

1812	285	*View of Llandilo Vawr, Carmarthenshire.*
1812	290	*View of the Avon, taken below the Hotwells, at Bristol.*
1813	248	*Aberyistwith Bay.*
1813	250	*View on the River Thames.*
1814	90	*The Java in a sinking State, set fire to, and blowing up. The Constitution at a Distance, lying to, repairing her Masts, Sails, and Rigging.*
1814	209	*Situation of his Majesty's Frigate Java, Captain Lambert, at five Minutes past three P. M. on the Coast of Brazil, 29th Dec. 1812, after an Hour's close and severe Action with the American Frigate Constitution, in which she was so much disabled*
1814	234	*View of Llanstephan Castle, Entrance of the Towy Caermarthenshire, South Wales, with Shipping.*
1814	239	*Swansea Bay, looking towards the Mumbles, taken from the Sea Side near Swansea, with Shipping, &c., £21.0.0, Do. [J.G. Lambton Esq., M.P.]*
1814	243	*View at Broadstairs, Kent, with Shipping, Boats, &c.*
1814	272	*The Java, as she appeared at thirty-six Minutes past four, P. M. after having sustained several raking Broadsides from the Constitution, whilst closely engaging, until she became a perfect Wreck. The Main-mast alone standing, the Main-yard gone in the Slings, and the remaining Rigging shot to Pieces.*
1814	274	*The Java totally dismasted, endeavouring to wear by the Assistance of a Jury-stay sail hoisted to the Stump of the Fore-mast and Bowsprit; the Constitution crossing her Bow, compels her to surrender at fifty Minutes past five, P. M.*
1815	1	*A Calm, with Boats and Figures, £21.0.0, Sir W. Fraser.*
1815	88	*From Gravesend towards Long reach.*
1815	188	*Gravesend, with Shipping &c.*
1815	192	*Ramsgate Pier, with Shipping, £6.6.0, Sir W. Fraser.*
1815	222	*Commencement of the Engagement between three of the Hon. East India Company's Ships, Ceylon, Windham, and Astell, in the India Sea, and Two French Frigates, of 44 guns each, and a Corvette; the Bollona engaged with the Ceylon and Windham. . .*
1815	237	*The Bellona disabled and dropping astern, but soon enabled to get again into Action; the other Frigate and Corvette engaging the three Ships, when, after a long and desperate, though unavailing contest, the Ceylon and Windham, were compelled to surrender. . .*
1816	179	*Frigates of Thirty and Fifty Guns, and a Cutter.*
1816	180	*A Frigate of Thirty-two Guns, with Schooner and Cutter.*
1816	190	*Sea Piece. A First Rate Brig of War and Corvette.*
1816	198	*A Seventy-four in two Positions, and a Brig of War of eighteen guns.*
1816	206	*A Sixty-four coming to Anchor.*
1816	296	*A Forty-four in a Storm.*
1817	31	*View of Ramsgate Pier.*
1817	42	*View of Broadstairs, Kent. A Calm, with Boats and Figures.*
1817	64	*View near Margate.*
1817	83	*Storm. A Ship under Press of Sail on a Lee Shore. View the Fastnet Rock off Cape Clear.*
1823L	63	*Sea Piece, R. Hills, esq.*

POCOCK W J

1817	164	*The Queen Charlotte and Leander, with Gun-Boats.*
1817	165	*The Fleet on Fire; Destruction of the Batteries at Algiers.*
1817	166	*Bird's-eye View of the Early Part of the Engagement of the Battle of Algiers, These three drawings are intended to illustrate the account of the Battle of Algiers, now publishing by Lieut. W.J. Pocock.*

PORTER SIR ROB KER

| 1823L | 154 | *The Bandit, Rev. Dr. Burney.* |

POWELL G

| 1817 | 161 | *Study of Cottages.* |

POWELL J

1817	189	*The Beach at Worthing.*
1817	201	*Limekiln near Worthing.*
1817	279	*Beach at Worthing.*
1818	186	*Flowers enamelled on China.*

PRICE LAKE

1838	4	*The Sonnet.*
1838	48	*La Chapelle, St. Sepulchre.*
1838	83	*Scene at Lochleven, 25th July, 1567, "Melville now saw that there was no alternative and that Lindsay must be called in to his assistance . . ." Bell's Life of Mary Queen of Scots, Vol II., p. 134.*
1838	197	*The Oratory - Pryor's Bank.*
1838	216	*The Doomed, "Maiden, no remedy – he's sentenced – 'tis too late."*
1838	235	*Bay in Oak Withdrawing Room at Haddon.*
1838	245	*The Refectory, Pryor's Bank.*
1838	256	*In Dorothy Vernon's Walk at Haddon.*
1839	14	*Bay in the State Room, Hardwicke, 25gns., H. Ashlin Esq., 22 Upper Edwd. Street, Hampstead Road.*
1839	19	*The Discovery, 30gns.*
1839	26	*The Long Gallery at Hardwicke - the Seat of His Grace the Duke of Devonshire, 35gns.*

1839	36	*The Confession*, 40gns.
1839	81	*The Castle Hall - The Baron's Return*, 60gns.
1839	116	*An Apartment at Bolsover Castle, built by John Duke of Newcastle - Scene during the Civil Wars*, 25gns.
1839	133	*Mary Queen of Scots' Bedchamber at Hardwicke - She was Captive 16 Years at Hardwicke*, 20gns.
1839	217	*The Baron's Prayer Gallery, Church of Nôtre Dame, Bruges*, 18gns.
1841	169	*St. Mark's and the Piazetta, Venice, during the Carnival*, 100gns.
1843	104	*Church of San Giorgio dei Greci, Venice*, 15gns.
1843	140	*Hall, Casa Capello, Venice*, Sold.
1843	209	*Exterior Gallery round the Ducal Palace, Venice*, Sold.
1843	212	*Caterina Cornaro's Chamber, Palazzo Cornaro, Venice*, 15gns.
1843	217	*Court Yard, Casa Salviati*, 15gns.
1843	275	*Byron's Room, Palazzo Mocenigo, Venice*, 15gns.
1843	283	*The Rio San Trovaso, Venice*, 15gns., Lewis Pocock, 29 Montague Street, Russell Square.
1843	292	*Hall of the Great Senate, Venice*, 15gns.
1844	155	*Cabinet of Isabella d'Este, Marchioness of Mantua, 1527 - Ducal Palace, Mantua*, 30gns.
1844	169	*At Hardwicke, Derbyshire*, 12gns.
1844	180	*The Traghetto, Venice*, 20gns.
1844	187	*The Riva dei Schiavoni, Venice*, 40gns.
1844	196	*Convent of San Michele, Lagoon of Venice*, 6gns.
1844	214	*The Oratory, Pryorsbank*, 12gns., Lady Sykes, 6 Lower Grosvenor St.
1844	277	*In St. Mark's Church, Venice*, 15gns.
1844	292	*The Rialto, Venice*, 15gns.
1845	217	*Second Cabinet of Isabella d'Este, Marchioness of Mantua, in the Palace of the Gonzaga's, Mantua*, 20gns.
1848	56	*Florence, from the Uffcii*, Sold.
1848	76	*Genoa, looking towards Porto Fino*, Sold.
1849	82	*The High Altar, Cathedral of Toledo*.
1849	182	*Chapel of San Juan, and Entrance to the Winter Chapter House, Cathedral of Toledo*.
1850	134	*Ospedale Vecchia, Brescia*, Sold.
1851	162	*Moonlight - Venice*.
1852	309	*An Interior - Venice*, Sold.

PRICE W LAKE

1837	24	*The Farewell, "Tell me not, sweet, I am unkind . . ."* Sold.
1837	38	*Othello relating his Adventures*, 40gns.
1837	67	*The Elizabethan Staircase*, 15gns.

1837	182	*Charles the Fifth at the Court of Francis the First, 1533, "The influence of the Duchess d'Estampes appeared to have increased with Francis's advancing years and multiplied infirmities . . ." Bacon's Life and Times of Francis I.* 60gns.
1837	217	*Beauchamp Chapel, Warwick*, Sold.
1837	220	*Red Room, Knowle*, 15gns., Chs. Spencer Ricketts Esq., 2 Hyde Park Terrace, Cumberland Gate.
1837	312	*The Red Room, Knowle*, 15gns., Miss Aspinall, Standen(?), Clitheroe, Lancashire.
1837	321	*Bay in the long Gallery, Knowle*, 15gns., E.W. Smith Esq., Ottery St. Mary, Devon.

PROUT S

1815	177	*Part of Durham Bridge*.
1815	184	*Jedburgh Abbey*.
1815	272	*The Wreck*.
1815	289	*Kelso Abbey*.
1815	300	*Calm*, £4.4.0, Walter Fawkes Esq.
1815	308	*Jedburgh Abbey*.
1815	349	*Near Plymouth*, £4.4.0, Earl of Buckinghamshire.
1816	119	*Old Shoreham Church*.
1816	128	*Hastings, Boats*.
1816	130	*Willow, near Dulwich*.
1816	201	*Worthing Sands*.
1816	234	*Study at Worthing*.
1816	236	*Holy Island*.
1816	249	*Hastings, Boats*.
1817	12	*Cromer*.
1817	188	*Study at Worthing*.
1817	196	*View near Exeter*.
1817	199	*Hastings*.
1817	200	*Fishing Boats*.
1817	229	*Beachy Head*.
1817	257	*Greenlanders*, £8.8.0, Mr. Ward.
1818	6	*Melrose Abbey*.
1818	222	*Mounts Bay*, £6.6.0, Walter Fawkes Esq.
1818	264	*Ballast Barges*, £8.8.0, Walter Fawkes Esq.
1818	274	*Fisherman's Cottage*.
1818	328	*Scene on the Lara*, £9.9.0, Walter Fawkes Esq.
1818	335	*A Storm*, £4.4.0, Honble. Mrs. B. Cochrane.
1818	359	*Sunset*.
1819	8	*Brig in Distress at Bamborough Castle*.
1819	16	*Scene near Worthing*.
1819	123	*Dover Backwater*.
1819	269	*Fishing Boat*, £6.6.0, J. Vine Esq.
1819	277	*Cerne Abbas, Dorset*, £8.8.0, Earl Grey.
1819	278	*Dismasted Indiaman*, £12.12.0, J. Allnutt Esq.

1819	295	*Fordington, Dorset.*
1819	317	*Fishing Boats on Shore,* £6.6.0, Dr. Williams, Bedford place.
1820	5	*Fishing Boats.*
1820	11	*A Water Mill, Devon,* £6.6.0, T.G.
1820	13	*Old Pier, Dover.*
1820	15	*On the Seine at Duclair,* £5.5.0, E. Tattersall Esq.
1820	16	*At Fécamp, Normandy,* £5.5.0, J. Allnutt Esq.
1820	22	*Dismasted Indiamen,* £6.6.0, Walter Fawkes Esq.
1820	24	*Near Yvetot, Normandy.*
1820	28	*Scene on the Seine near Rouen.*
1820	250	*Croix de Pierre, Rouen,* £12.12.0, T.G.
1820	261	*St. Maclou, Rouen,* £12.12.0, Mr. Webster.
1820	273	*Six Sketches in Normandy, at Lillebonne, Montivilliers, Fécamp and Rouen.*
1820	282	*Wreckers under Plymouth Citadel,* £10.10.0, E. Tattersall Esq.
1820	291	*Dismasted Indiaman on Shore,* £12.12.0, Mr. Webster.
1820	297	*Harfleur, Normandy - a Sketch,* £6.6.0, Walter Russell Esq.
1820	299	*Etretat on the Coast of Normandy,* £7.7.0, J.C. Warner Esq.
1820	347	*Backwater, Dover.*
1820	372	*Hastings Fishing Boats.*
1821	1	*Montevilliers, Normandy,* £12.12.0, G. Giles Esq.
1821	6	*At Rouen, Normandy,* £12.12.0, G. Giles Esq.
1821	9	*Men of War,* £12.12.0, Honble. G. Nassaw(?).
1821	16	*An old House at Truro, Cornwall,* £8.8.0, Mr. Bacon.
1821	19	*Blore Church, Staffordshire,* £8.8.0, J.L. Chantrey Esq., R.A.
1821	34	*Place de la Pucelle, where Joan of Arc was burnt, at Rouen,* £26.5.0, Mr. Warner.
1821	62	*Pont de l' arche on the Seine,* £5.5.0, J. Taylor Esq.
1821	65	*On the Seine at Rouen,* £5.5.0, J. Allnutt Esq.
1821	70	*At Granville, Normandy - a Sketch,* £1.11.6, J. Taylor Esq.
1821	74	*At Aymville, Normandy - A Sketch,* £1.11.6, Mr. Utterson(?).
1821	98	*A Shipwreck,* £8.8.0, Walter Fawkes Esq.
1821	110	*Ruins of Howden Church, Yorkshire,* T.G.
1821	116	*Part of the Palais de Justice, Rouen - a Sketch,* £2.12.6.
1821	121	*A Sea Shore,* £8.8.0.
1821	123	*Part of Place de la Pucelle, Rouen - A Sketch,* £2.2.0.
1821	124	*Croyland Abbey, Lincolnshire,* £7.7.0, T. Godwin Esq.
1821	137	*A Man of War ashore,* £25.0.0, T.G., including frame and glass.
1821	159	*Walm Gate, York.*
1821	166	*Prison de St. Lo,* £2.2.0, Mr. Salvin.
1822	3	*At Lahnstein on the Rhine - a Sketch,* £1.11.6, Sir W.W. Wynne.
1822	4	*Metz,* £12.12.0, J.G. Lambton Esq., M.P.
1822	5	*At Strasbourg - a Sketch,* £1.11.6, G. Hibbert Esq.
1822	7	*Boats returning from a Wreck,* £12.12.0, Honble. Mrs. Grey.
1822	39	*Palais du Prince - Liege,* £10.10.0, J.G. Lambton Esq., M.P.
1822	41	*Fishing Boats,* £8.8.0, J.G. Lambton Esq., M.P.
1822	42	*Strasbourg,* £15.15.0, Do.
1822	46	*Mayence,* £15.15.0, J. Taylor Esq.
1822	50	*On the Lid, Devon,* £2.2.0, J. Taylor Esq.
1822	54	*Crypt at Kirkstall Abbey,* £2.2.0, G. Hibbert Esq.
1822	80	*St. Omer, Strasbourg - a Sketch,* £2.2.0, Rev. W. Long.
1822	85	*Strasbourg,* £36.15.0, B. Oakley Esq.
1822	92	*At Andernach on the Rhine - a Sketch,* £2.12.6, G. Hibbert Esq.
1822	101	*Part of the Cathedral, Rouen,* £6.6.0, G. Hibbert Esq.
1822	106	*Merchantmen setting sail,* £10.10.0, T.G.
1822	107	*St Vincent, Rouen,* £6.6.0, Lord Gower.
1822	117	*Rheinfels, from St. Gourshausen on the Rhine,* £5.5.0, J. Webster Esq.
1822	118	*Cat, from St. Goar on the Rhine,* £5.5.0, J. Newman Esq.
1822	139	*An Indiaman ashore,* £2.12.6, H. Brooke Esq.
1822	140	*Scarborough Castle,* £2.12.6, H. Brooke Esq.
1823	3	*Oberwesel on the Rhine.*
1823	26	*At Ghent,* £10.10.0, Marquis of Lansdown.
1823	28	*Maline, Flanders,* £42.0.0, Watts(?) Russell Esq.
1823	47	*Marine Subject,* £3.3.0, J. Webster Esq.
1823	52*	*Antwerp.*
1823	81	*Receiving Ships, Portsmouth,* £26.5.0, Marquis of Stafford.
1823	88	*St. Jacques, Antwerp. The church in which Rubens is buried,* £2.12.6, Lord Gower.
1823	90	*At Tournay, Flanders,* £2.12.6.
1823	98	*St. Etienne, Fecamp, Normandy,* £10.10.0, Mr. Broderip.
1823	113	*Castle at Heidelberg,* £12.12.0, G.H. Turner Esq.

1823	127	*Abbeville*, £15.15.0, General Grey.
1823	134	*At Andernach on the Rhine*, £2.2.0, Lord Gower.
1823	136	*Hotel au Corbeau, Strasbourg*, £10.10.0, Sir Abraham Hume.
1823	142	*Rouen Cathedral, destroyed by Fire 1822*, £15.15.0, General Grey.
1823	156	*At Rouen*, £2.2.0, Rev. W. Long.
1823	157	*Hotel de Ville, Louvain*, £42.0.0, G. Haldimand Esq.
1823	162	*Hotel de Ville, Ghent.*
1823	191	*At Andernach on the Rhine*, £2.2.0, Rev. W. Long.
1823	217	*At Ypres, Flanders*, £8.8.0, Marchioness of Stafford.
1823	237	*Marine Subject.*
1823	248	*At Cologne, on the Rhine*, £5.5.0, B. Windus Esq.
1823	276	*At Lahnstein on the Rhine.*
1823	291	*At Brussels.*
1823	299	*Notre Dame at Huy, on the Meuse.*
1823L	30	*An Indiaman*, J. Allnutt, esq.
1823L	137	*Indiaman ashore*, T. Griffith, esq.
1824	26	*Bequinage, Brussells.*
1824	38	*Chateau du Martinsburg, Mayence.*
1824	46	*View in Mayence.*
1824	64	*Mayence on the Rhine.*
1824	88	*Weil at Nuremburg.*
1824	90	*Cologne, on the Rhine.*
1824	98	*Hotel de Ville at Cologne.*
1824	103	*Porch at the Cathedral at Ulm.*
1824	105	*Marine.*
1824	108	*At Ratisbonne.*
1824	133	*Cathedral Well at Ratisbonne.*
1824	136	*Augsburg - Bavaria.*
1824	142	*At Nuremburg - Bavaria.*
1824	145	*Fishing Boats.*
1824	149	*At Strasburg.*
1824	150	*Marine View.*
1824	158	*Utrecht.*
1824	189	*At Basle.*
1824	196	*Church of the Holy Ghost - Nuremburg.*
1824	198	*Hotel de Ville, Ghent.*
1824	202	*Well at Strasburg.*
1824	203	*Hotel de Ville, Cologne.*
1824	207	*Indiaman dismasted.*
1824	222	*Munich, Bavaria.*
1824	235	*Porch of Harfleur Church, Normandy.*
1824	277	*At Frankfort.*
1824	278	*South Porch of Rouen Cathedral.*
1824	279	*Porch of Ratisbonne Cathedral.*
1825	40	*Ponte di Rialto, Venice*, Sold.
1825	57	*Ponte di Rialto, Venice*, 12gns., Sir Abraham Hume.
1825	108	*Portico di Ottavia - the Fish Market at Rome*, 12gns., George Hibberts.
1825	110	*Ponte della Canonica - Venice*, 20gns., Lord Brownlow.
1825	148	*Church at Arque, near Dieppe*, Sold 3gns.
1825	151	*Place St. Antoine, Padua*, 20gns., George Hibbert Esq.
1825	156	*At Ratisbonne*, 3gns., Giles Esq., Enfield.
1825	164	*At Lahnstein on the Rhine*, 2½ gns., C.H. Turner Esq.
1825	191	*At Braubach on the Rhine*, 2½ gns., Lady Stafford.
1825	192	*At Geneva*, 10gns., Sir Matthew Williams Wynn.
1825	227	*Maison de Ville, Louvain*, 15gns., Sold.
1825	244	*At Nuremburg, Bavaria*, 15gns., Sold.
1826	17	*Antwerp*, 30gns., Mr. Ellison, 79 Pall Mall.
1826	24	*Domo D'Ossola*, 12gns., Mr. Broderip.
1826	53	*Milan*, 50gns., Earl Surrey.
1826	67	*At Wurtzburg, Bavaria*, 20gns., Lady Charlotte Stafford, 8 Charles St., Berkeley Square.
1826	81	*Temple of Nerva, Rome*, 4gns., C. Wild Esq.
1826	114	*Porch of Ratisbonne Cathedral*, Sold.
1826	180	*Swiss Cottages, near St. Maurice*, 15gns., Mr. Olive, 4 York Terrace, Regents Park.
1826	224	*Palais du Prince, Liege*, Sold.
1826	233	*At Venice*, 12gns., Sir Watkin Williams Wynne.
1826	237	*Receiving Ships at Portsmouth*, 30gns.
1826	243	*The Campanile at Venice*, 20gns., Lord Brownlow.
1826	249	*At Nuremberg, Bavaria*, 15gns., Lord Northwick.
1827	25	*Arch of Constantine, Rome*, 15gns., Mr. I. Wyatville.
1827	26	*Ponte Realto, at Venice*, 60gns., Countess De Grey.
1827	31	*Como*, 18gns., Mrs. J. Braithwaite, 1 Bath Place, Fitzroy Square.
1827	32	*At Ulm*, Sold.
1827	39	*Nuremberg, Bavaria*, Sold.
1827	48	*Vicenza*, Sold.
1827	66	*Leaning Towers at Bologna*, 6gns., Mrs. J. Braithwaite.
1827	67	*Bridge of Sighs, Venice*, Sold.
1827	78	*Part of the Amphitheatre at Verona*, 6gns., Mrs. J. Braithwaite.
1827	91	*Temple of Nerva, Rome*, 6gns., G. Hibbert Esq., 62 Portland Place.

1827	105	*Portico di Ottavia, Rome*, 6gns., Prior Esq.
1827	141	*Church of St. Maclou, Rouen*, 18gns., G. Hibbert Esq.
1827	159	*Fountain at Basle*, 18gns., G. Hibbert Esq.
1827	171	*Temple of Jupiter Tonans, Rome*, Sold.
1827	172	*At Verona*, 20gns., Mrs. J. Braithwaite.
1827	260	*Ponte Realto, at Venice*, Sold.
1827	359	*At Venice.*
1828	21	*Campanile, Ducal Palace, Bridge of Sighs, Prison, &c. at Venice*, 50gns., F.G. Moon, 6 Pall Mall.
1828	24	*Rue Grosse-Horloge - Rouen*, 19gns., Earl Brownlow.
1828	37	*Mausolée de Mastin 2d famille de l'Escaille, Verona*, 18gns., Mr. W. Wells, Redhill(?) near Tonbridge.
1828	60	*Piazza Basilica, Vicenza*, Sold.
1828	69	*Piazetta - Venice*, Sold.
1828	97	*The Rezzonico, Two Foscari, and Balbi Palaces, at Venice*, 40gns., Duke of Devonshire.
1828	106	*Petrarch's House at Arqua, near Padua*, 6gns., Lord Farnborough.
1828	117	*Bayeux, Normandy*, 4gns., Mathews Esq., Ivy Cottage, Kentish Town.
1828	130	*Rue St. Jean, Caen*, 40gns.
1828	148	*Rue St. Amand, Lisieux, Normandy*, Sold.
1828	158	*Part of the Church of St. Mark, &c. at Venice*, 20gns., Matthews Esq.
1828	178	*Porch of the Church of Louviers, Normandy*, Sold.
1828	179	*Part of the Church of St. Pierre at Caen*, Sold.
1828	180	*Mausolée de Can Francais de l'Escaile, Verona*, 6gns., Sir Watkin Williams Wynne.
1828	237	*Porch of Ratisbonne Cathedral*, Sold.
1828	319	*Porch of the Cathedral of Lausanne*, 4gns., The Honble. G. Algèr. Ellis, Spring Garden.
1829	48	*Abbeville*, Sold.
1829	49	*At Venice*, 8gns., Duchess of Bedford.
1829	70	*Milan*, 8gns., Lady Chetwynd, To go to Mr. Prout.
1829	77	*On the Grand Canal at Venice*, 60gns., N.H. Harriott Esq.
1829	79	*At Verona*, 8gns., Parratt Esq.
1829	130	*At Caen, Normandy*, 8gns., D. Colnaghi Esq., J.B.P., All Mr. Philip's pictures to be sent to Mr. Colnaghi.
1829	140	*A Sketch*, 4gns., W. Prior Esq.
1829	153	*"As the tall ship, whose lofty prore Shall never stem the billows more . . ." Lady of the Lake.* 40gns., Sold.
1829	254	*Church of Louviers, Normandy*, 20gns., Sold.
1829	255	*At Nuremberg, Bavaria*, 20gns., Duke of Bedford.
1829	316	*Place de la Pucelle at Rouen, where Joan of Arc was burnt*, 10gns., Sold.
1830	13	*Part of an Ancient Palace at Bamberg*, 8gns., Samuel Angel Esq.
1830	35	*Church of Notre Dame, Dresden*, 20gns., Lord Stormont, 60 Lower Grosvenor St.
1830	58	*The Ducal Palace, Venice*, 60gns., Morrison Esq.
1830	111	*Part of the Cathedral at Abbeville*, 10gns., Lady Chetwynd.
1830	152	*At Brigg*, 8gns., Chas. Porchere(?), 18 Nottingham Place, New Road.
1830	189	*At Nuremberg, Bavaria*, 15gns., Ralph Bernard Esq.
1830	209	*At Bamberg, Bavaria*, 10gns., Ralph Bernard Esq.
1830	210	*Fountain at Ulm*, 10gns., W.H. Harriott Esq.
1831	2	*St. Mark's Place, Venice.*
1831	27	*Interior of a Church.*
1831	28	*Part of the Zwinger Palace, Dresden.*
1831	32	*At Lisieux, Normandy.*
1831	33	*Morning Prayers.*
1831	56	*At Venice.*
1831	83	*Fishing Boats.*
1831	84	*Porch at Rouen.*
1831	107	*At Verona.*
1831	110	*An Indiaman ashore.*
1831	139	*Wurtzburg, Bavaria.*
1831	174	*Part of St. Mark's Church, Venice.*
1831	185	*Fish Market, Rome.*
1831	198	*Evening Prayers.*
1831	199	*At Rome.*
1831	226	*At Rouen.*
1831	228	*Beauvais.*
1831	249	*The Palace and Prison, Venice.*
1831	258	*At Coblentz on the Rhine.*
1831	264	*Ruben's House, Antwerp.*
1831	285	*Porch at Louviers, Normandy.*
1831	303	*Greek Church and College, Venice.*
1831	306	*Church of St. Pierre, Caën.*
1831	328	*The Rialto, Venice.*
1831	405	*At Venice.*
1831	420	*At Mayence, on the Rhine.*
1832	10	*Lord Byron's Residence on the Grand Canal, Venice*, 10gns., Mrs. Bernal.
1832	23	*At Venice*, 6gns., Harding Esq.
1832	24	*At Ulm*, 6gns., Rev. C. Terror.
1832	27	*St. Etienne, Beauvais*, 5gns., Sold.

1832	42	*Near Caën*, 5gns., Mr. D. Colnaghi.
1832	45	*Piazetta, Venice*, 60gns., Harding Esq.
1832	48	*At Rouen*, 5gns., W.B. Roberts.
1832	60	*At Ratisbonne*, 18gns., R. Ellison Esq.
1832	80	*Tomb of Can Fancois de l'Escaile, Verona*, 6gns., H.B. Roberts.
1832	88	*At Wurtzburg*, 6gns., W.B. Roberts.
1832	99	*Zeringer Palace*, 8gns., W.B. Roberts.
1832	154	*Place St. Domingo, Bologna*, 6gns., W. B. Roberts.
1832	161	*Ponte dei Sospiri, Venice*, 20gns., Earl Brownlow.
1832	178	*At Wurtzburg*, 18gns., R. Ellison Esq.
1832	187	*Portico di Ottavia, Rome*, 7gns., Mr. Hixon(?).
1832	199	*Temple of Pallas, Rome*, 7gns., W.B. Roberts.
1832	211	*St. Spiridion, Venice*, 8gns., W.B. Roberts.
1832	214	*La Madonna della Salute, Venice*, 20gns.
1832	220	*On the Moselle*, 8gns., Rev. C. Terrot.
1832	384	*St. Loo*, 5gns., W. Hixon.
1832	396	*At Venice*, 6gns., Harding Esq.
1832	405	*At Cologne*, 6gns., Mrs. I.V. Thompson, 4 Belgrave St., Belgrave Square.
1832	408	*Pisa*, 6gns., W. Hixon.
1833	4	*Place Pucella, Rouen*, 6gns., T.J. Ireland, 14 Cadogan Place, Belgrave Square.
1833	76	*Bridge at Prague*, 6gns., Earl of Tankerville.
1833	97	*On the Rhine*, 8gns., Mr. J.V. Thompson, 4 Belgrave Street, Belgrave Square.
1833	102	*At Verona*, 8gns., Sold.
1833	110	*On the Rhine*, 8gns., Mr. Hodgson, 9 Gt. Marylebone St.
1833	132	*At Bamberg*, 6gns., Sold.
1833	142	*S. M. della Salute, Venice*, 6gns., Sold.
1833	189	*Mausolée de Mustin, Il Famille de l'Escoile, Verona*, 15gns., Mrs. Tustin, Fludyer St., Whitehall.
1833	199	*At Caen in Normandy*, 6gns., Mrs. Fielden, 36 Montague Square.
1833	203	*Montevilliers, Normandy*, 6gns., Lady Cawdor, 16 Berkeley Square.
1833	274	*At Evreux, Normandy*, 5gns., Sold.
1833	315	*La Chiesa dei S. Miracoli, Venice*, 6gns., Sold.
1833	355	*At Evreux, Normandy*, 6gns., Sold.
1833	384	*On the Rhine*, 5gns., Mr. J.L. Brown, 10 Leicester Place, Leicester Square.
1834	28	*At Milan*, 10gns., C.H. Turner Esq.
1834	50	*At Rome*, 6gns., Jolly Esq.
1834	62	*Part of the Cathedral at Rouen*, 18gns., B. Austen Esq.
1834	91	*Venice*, 10gns., B. Austen Esq.
1834	92	*Vicenza*, 10gns., B. Austen Esq.
1834	116	*At Abbeville*, 6gns., Miss Wharton, Oakley, near Bromley, Kent.
1834	119	*At Amiens*, 5gns., Sir William Pilkington, at Mrs. Bennets, Blenheim Hotel.
1834	137	*At Venice*, 6gns., Miss Harriott.
1834	195	*At Geneva*, 9gns.
1834	197	*On the Grand Canal, Venice*, 5gns., ???? Corbett, 7 Suffolk Street, Pall Mall East.
1834	198	*A Shipwreck*, 10gns., C.H. Turner Esq.
1834	263	*Part of the Cathedral at Chartres*, 25gns., Mr. G. Akerman.
1834	272	*Columns of the Lower Ages at Venice*, 7gns., ?Fitzjames Watt Esq., Stevens Hotel.
1834	278	*On the Grand Canal, Venice*, 6gns., Rev. J. Clowes, To be sent to Mr. Tiffin's(?) Engraver Strand.
1834	322	*At Liseux*, 9gns., Ruskin Esq., Herne Hill.
1834	330	*At Caen*, 5gns.
1834	357	*At Rouen*, 5gns., Miss Harriott.
1834	368	*At Lahnstein on the Rhine*, 6gns., Miss Harriott.
1834	370	*La Halle au Blè at Tours*, 7gns., Miss Langston, 32 Upper Brook Street.
1834	377	*At Leudersdorf, on the Rhine*, 7gns., Miss Harriott.
1834	389	*Part of the Palais de Justice, at Rouen*, 6gns., The Honble. Miss Cust(?), 30 Hill Street.
1835	27	*On the Grand Canal, Venice*, 50gns., H.G. Moon.
1835	47	*At Verona*, 6gns., R. Ferguson Esq. M.P., 10 Portman Square.
1835	54	*At Antwerp*, 15gns., Mr. S???? Dickens, Stoke, near Chichester.
1835	61	*At Caen*, 15gns., Fitzjames Watt, Steven's Hotel.
1835	77	*Part of the Zuringer Palace, Dresden*, 8gns., Mr. Houghton, Poultry.
1835	84	*Croix de Pierre, Rouen*, 8gns., Mr. Henry Harrison, 1 Percy Street.
1835	91	*At Chartres*, 6gns., Mr. Houghton, Poultry.
1835	95	*On the Rhine*, 6gns., Sir Willoughby Gordon, Horse Guards or Chelsea.
1835	110	*Church at Venice*, 5gns., Mr. Hixon, 45 Leicester Square.
1835	116	*At Verona*, 6gns., R. Ferguson Esq. M.P., 18 Portman Square.
1835	121	*Liseux*, 6gns., Jolly Esq., 29 Belgrave Place.
1835	130	*Interior*, Sold.
1835	174	*At Martigny*, 5gns., Major General Sir Charles Greville, 15 Chesterfield Street.
1835	198	*On the Rhine*, Sold.
1835	212	*At Orleans*, 8gns., J.J. Ruskin, Herne Hill.

1835	285	*On the Rhine*, 6gns., I.C. Clifton, Theresa House, Hammersmith.
1835	289	*St. Jacques, at Antwerp, the Church in which Rubens lies buried*, Sold.
1835	295	*At Venice*, Sold.
1835	309	*An Interior*, Sold.
1836	35	*At Nuremburg*, 7gns., Sir Willoughby Gordon, Horse Guards.
1836	63	*Temple of the Sybils at Tivoli*, 8gns.
1836	81	*At Venice*, 7gns., Mr. Fuller, Rathbone Place.
1836	97	*Abbeville*, 10gns., J. Hewitt Esq., Leamington.
1836	136	*An Interior*, 7gns., CC at Colnaghi's.
1836	161	*A la Barbe blanc at Tours*, 6gns., H.R.H. Duchess of Kent.
1836	174	*At Venice*, 6gns., J.T. Simes Esq., Highbury Park.
1836	202	*An Interior*, 7gns.
1836	209	*At Venice*, 8gns.
1836	226	*Market Place at Tours*, 7gns., Lady Rolle.
1836	283	*At Venice*, 6gns., T. Bodley Esq., Brighton.
1836	317	*Dresden*, 10gns., J. Ruskin Esq., Herne Hill.
1836	340	*Louvain*, 10gns., Hewitt Esq., Leamington.
1837	28	*Antwerp*, J. Hewett Esq., Leamington.
1837	50	*Lavey, near St Maurice*, 12gns., Hon. Revd. H. Legge, Blackheath.
1837	71	*At Padua*, 6gns., Tyrrell Esq., Lincolns Inn.
1837	72	*Bridge of Sighs, Venice*, 12gns., J. Hewett Esq., Leamington.
1837	160	*At Nuremberg, Bavaria*, 8gns., F. Hewett Esq., Leamington.
1837	186	*At Evreux, Normandy*, 8gns., John Hewett Esq., Leamington.
1837	189	*An Interior*, 6gns.
1837	194	*St. Symphorien, at Tours*, 8gns.
1837	197	*Part of the Interior of the Cathedral at Chartres*, 7gns., Colnaghi Esq., Pall Mall East.
1837	222	*At Verona*, 6gns., H. Cary Esq., 20 Jermyn Street.
1837	284	*At Nuremburg*, 6gns., Lady Rolle, 18 Upper Grosvenor Street.
1837	297	*At Chartres*, 6gns.
1837	299	*On the Rhine*, 6gns., Lady Rolle, 18 Upper Grosvenor Street.
1837	337	*Entrance to the Bridge at Prague*, 7gns., Vaughan Esq., Cumberland Terrace, Regents Park.
1837	361	*Chapel at the Castle of Amboise*, 7gns., T.G. Parry Esq., 9a Langham Place.
1838	33	*La Chiesa dei S. Miracoli, Venezia.*
1838	101	*Piazetta del Molo, Venezia.*
1838	123	*Part of the Amphitheatre at Verona.*
1838	130	*At Bamberg, Bavaria.*
1838	133	*Street View, at Baccharah, on the Rhine.*
1838	134	*At Evereux, Normandy.*
1838	138	*At Domo d'Ossola.*
1838	157*	*Well at Lahnstein, on the Rhine.*
1838	175	*La Halle au Blè, Tours.*
1838	188	*Ducal Palace, Venice.*
1838	194	*Part of the Castle at Blois.*
1838	202	*Church at Louviers, Normandy.*
1838	219	*On the Rhine, at Neider Lahnstein.*
1838	222	*Rialto &c. Venice.*
1838	284	*At Frankfort, on the Maine.*
1838	311	*At Verona.*
1838	315	*At Venice.*
1838	325	*St. Etienne, Beauvais, Picardy.*
1838	334	*At Rouen, Normandy.*
1839	21	*Entrance to the Cathedral, Abbeville*, 8gns., Price Edwards Esq., Weston ?, Bath.
1839	54	*On the Rhine, at Welmich*, 8gns.
1839	77	*Croix de Pierre, Rouen*, 8gns., Her Majesty. The Marquis of Conyngham, Dudley House(?).
1839	99	*On the Rhine at Kapelle*, 6gns.
1839	131	*Part of Zevinger Palace, Dresden*, 6gns.
1839	138	*Thein Church, Prague*, 6gns.
1839	140	*Abbeville*, 14gns., The Earl of Liverpool, Fife House, Whitehall.
1839	147	*Rue de la Pucelle D'Orleans, Rouen*, 8gns., T.J. Thompson Esq., 23 Southampton Buildings, Chancery Lane.
1839	155	*Palais de Justice, Rouen*, 8gns.
1839	159	*After the Storm*, 50gns., Sold.
1839	179	*Hotel de Ville, Louvaine*, 14gns., Miss Lockwood, Forest Hill.
1839	221	*At Ypres, Flanders*, 10gns.
1839	230	*Zwinger Palace, Dresden*, 10gns.
1839	268	*At Nuremburg, Bavaria*, 8gns., Price Edward Esq., Weston, Nr. Bath.
1839	286	*At Orleans*, 8gns., Heny. Hobson Esq., 43 Harley Street.
1839	305	*Hotel de Ville, Ghent*, 10gns., Lady Rolle.
1839	309	*Casa Nani, Venice*, 14gns., Sir Richd. Hunter, 25 Hill St.
1839	321	*At Venice*, 14gns.
1840	9	*At Cologne, on the Rhine.*
1840	60	*S. M. Dei Frari, Venice.*
1840	70	*Bequinage, Brussels.*
1840	111	*Prague, Bohemia.*
1840	120	*At Mayence, on the Rhine.*
1840	151	*At Ratisbonne.*

1840	159	*At Venice.*
1840	204	*On the Rhine.*
1840	213	*Godesberg.*
1840	239	*Dome at Frankfort.*
1840	249	*Piazetta, Venice.*
1840	253	*At Coblentz, on the Rhine.*
1840	260	*At Trèves.*
1840	266	*S. Maria delle Salute, Venice.*
1840	274	*Stadt-haus, Wiesbaden.*
1840	285	*Strasbourg.*
1840	292	*Antwerp.*
1840	303	*At Nuremburg.*
1840	324	*Fountain at Ulm.*
1841	12	*Part of the Cathedral, Rouen,* 14gns., D.I. Robertson, Tunbridge Wells. Art Union.
1841	31	*Port of Como,* 12gns.
1841	47	*Hotel de Ville, Cologne,* 12gns., J. Beaumont Swete Esq., Oxton, Exeter.
1841	59	*Nôtre Dame, from Place de la Calende, Rouen,* 8gns., W. Mason, 74 Westbourne Terrace, Bayswater.
1841	66	*At Baccharah on the Rhine,* 5gns.
1841	68	*La Croix de Pierre, Rouen,* 5gns., Sir John Buxton, 05(?) Harley St.
1841	78	*L'Eglise Nôtre Dame, Dresden,* 12gns., Charlies William Packe Esq., M.P., 7 Richmond Terrace.
1841	108	*L'Eglise St. Pierre, Caen,* 14gns., Mr. J. Hewett, Leamington.
1841	123	*Liviana, near St. Maurice, Switzerland,* 8gns., J. Beaumont Swete, Oxton, Exeter.
1841	154	*Temple of Nerva, Rome,* 9gns., Price Edwards Esq., Weston, Nr. Bath.
1841	177	*At Brieg, Switzerland,* 8gns.
1841	179	*Nieden Lahnstein, on the Rhine,* 8gns.
1841	197	*On the Rhine,* 5gns., The Earl of Uxbridge, 32 Bruton Street, To be sent to the Lord Chamberlains Office.
1841	202	*An Interior,* 9gns., Price Edwards Esq., Weston, nr. Bath.
1841	221	*St. Spiridian, Venice,* 8gns.
1841	259	*At Coblentz, on the Rhine,* 8gns., J. Beaumont Swete, Oxton, Exeter.
1841	264	*At Ulm, Bavaria,* 5gns., ? Hardwick Esq., 60 Russell Square.
1841	268	*Part of the Castle of Heidelberg,* 8gns., Mr. B. Benton, 9 Grays Inn Square.
1841	286	*Hotel de Ville, Utrecht,* 8gns., Mr. J.C. Birkinshaw, Craven Hotel, Craven St.
1841	289	*La Grosse Horloge, Rouen,* 9gns., Dr. Chambers, 46 Brook Street, Art Union.
1842	2	*Hotel De Ville, Brussels.*
1842	63	*Hotel de Ville, Cologne.*
1842	74	*At Ulm, Bavaria.*
1842	119	*Abbeville.*
1842	128	*Augsburgh, Bavaria.*
1842	147	*At Bamberg, Bavaria.*
1842	155	*Porch of the Church at Louviers, Normandy.*
1842	163	*Ferrara.*
1842	185	*At Geneva.*
1842	204	*At Cologne.*
1842	214	*Petrarch's House, at Arqua.*
1842	221	*Nuremberg, Bavaria.*
1843	15	*Il Fondaco dei Turchi, Venice,* 12gns.
1843	26	*At Nuremberg, Bavaria,* 20gns., Revd. W. Edge, Nedging Hall, Bildeston, Suffolk, Prize in the Art Union of London of 20£.
1843	38	*At Ulm, Bavaria,* 20gns., T. Griffith Esq., 14 Waterloo Place.
1843	62	*Munich,* 60gns., Miss Burdett Coutts, 1 Stratton Street, Piccadilly.
1843	83	*San Francesco della Vigna, Venice,* 8gns.
1843	92	*At St. Maurice, Switzerland,* 8gns., J.J. Ruskin Esq.
1843	95	*At Ghent,* 15gns.
1843	136	*Arch of Constantine, Rome,* 15gns., Henry S. Simes Esq., College House West Islington.
1843	146	*Portico di Ottavia, Rome,* 15gns., Capt. Hotham, Bessingby, Bridlington, Yorkshire.
1843	171	*Church of Symphorien, Tours,* 8gns.
1843	207	*Place de la Pucelle, Rouen, where Joan of Arc was burnt,* 8gns., The Honble. Mrs. Vernon Harcourt.
1843	236	*Part of the Cathedral at Huy, on the Meuse,* 8gns.
1843	347	*Entrance to the Giant's Stairs, Venice,* 9gns., Mrs. W. Wilson, East Hill, Wandsworth.
1843	357	*At Verona,* 8gns., C.H. Turner, Rooksnest, 15 Bruton Str., Berkeley Sq.
1843	361	*At Liseux, Normandy,* 12gns., W.S. Blackstone Esq., M.P., 28B Albemarle St., Prize of 10£ in the Art Union of London.
1844	9	*West Porch of the Cathedral at Ratisbonne,* 20gns., Bishop of Lichfield, 39 Harley St.
1844	60	*Liege,* 12gns., The Hon. Mrs. Vernon Harcourt.
1844	66	*On the Lahn,* 12gns., Sir John Hobhouse, Frame and glass £2.3.0.
1844	95	*Croix de Pierre, Rouen,* 8gns., Rev. W.A. Soames, Greenwich.
1844	129	*Interior at Caen, Normandy,* 8gns., C.H. Turner, Rooksnest.
1844	138	*An Interior,* 8gns.

1844	194	*Albert Durer's House, Nuremberg*, 8gns., Vernon Wentworth Esq.
1844	207	*Colonnades of the Ducal Palace, Venice*, 20gns., Miss Coombe, 3 Hertford Street, May Fair, P.AU.
1844	255	*A la Barbe Blanc, Tours*, 8gns.
1844	273	*Rue Nôtre Dame, Caen*, 8gns., Alex. Allen Esq., Sidmouth, P.AU.
1844	294	*Interior, at Chartres, France*, 8gns., Miss Richardson, 85 Jermyn Street, P.AU.
1844	301	*Temple of Pallas, Rome*, 15gns., Thomas Avison Esq., Cook Street, Liverpool, Frame and glass £2.7.6.
1844	315	*From the Terrace of the Zwinger Palace, Dresden*, 15gns., Lady Sykes, 6 Lower Grosvenor St.
1845	22	*Street View at Nuremberg, Bavaria*, 25gns., Charles(?) Packe Esq., 7 Richmond Terrace, Frame and glass £5.5.0.
1845	30	*Café de la Place, Rouen*, 25gns., Henry Wilkinson, Clapham Common, Frame and glass £5.5.0.
1845	53	*Palais de Justice, Rouen*, 6gns., John Dent Esq., 8 Fitzroy Sq., Frame and glass £1.10.0.
1845	67	*Hotel de Ville, St. Quentin, France - From a sketch by S. Ruskin. Jun. Esq.*, Sold, J.J. Ruskin Esq.
1845	71	*On the Moselle*, 6gns., Sir John Lowther B., Frame and glass £1.10.0.
1845	136	*Ancient Tombs at Verona*, 15gns., Miss Colville of Duffield Hall, Derby (for Col. Colville), Frame and glass £2.2.0, P.AU. 20£.
1845	145	*Part of a Palace at Dresden*, 15gns., W.J. Broderip, Frame and glass £2.2.0.
1845	181	*On the Bridge at Prague*, 10gns., W.S. Broderip Esq., Frame and glass £1.10.0.
1845	189	*Church of St. Jacque, Antwerp, in which Rubens was Buried*, 10gns., S.M. Peto Esq., Frame and glass £1.10.0.
1845	231	*La Grosse Horloge, Rouen*, 25gns., Col. Pennant, Frame and glass £5.5.0.
1845	233	*St. Mark's Place, Venice*, 8gns., Frame and glass £1.10.0.
1845	240	*Interior at Blois*, 6gns., J.C. Sharpe Esq., 19 Fleet Street, Frame and glass £1.10.0.
1845	255	*Stone Pulpit attached to the Cathedral at St. Lo, Normandy*, 8gns., W.I. Broderip, 2 Raymond Bgs., Gray's Inn, Frame and glass £1.10.0.
1845	265	*The Parson's Window at Nuremberg, Bavaria*, 10gns., Earl Brownlow, Frame and glass £1.13.0.
1845	281	*Part of the Cathedral at Abbeville, Picardy*, 12gns., S.M. Peto Esq., 47 Russell Sq., Frame and glass £1.13.0.
1845	287	*Interior at Venice*, 6gns., G.C. Loftus Esq., 3 St. James Place, Frame and glass £1.10.0.
1845	322	*At Abbeville, Picardy*, 8gns., John Vance Esq., at John E. Vance's, 17 Dorset Sq., Frame and glass £1.12.0.
1845	333	*Domo Dossola*, 8gns., John Dent Esq., 8 Fitzroy Square, Frame and glass £1.12.0.
1846	5	*Church of St. Pierre, Caen, Normandy*, 25gns., Rev. H.A. Soames, Frame and glass £5.5.0 enquire.
1846	56	*Tours, France*, 18gns., Geo. Pownall Esq., 5 Gordon Square, Mr. Pownall will send frame and glass.
1846	121	*At Prague*, 18gns., S.C. Grundy Esq., Manchester.
1846	196	*Hotel de Ville, Louvain, Flanders*, 25gns., The Hon. Mrs. Seymour Bathurst(?), 8 ???.
1846	204	*Hotel de Ville, D. Audendarde, Flanders*, 40gns., J. Wild Esq., Clapham Lane (?).
1846	242	*At Verona*, 15gns., Lady H.H. Campbell, 72 Portland Place.
1846	250	*Part of Stein Church, Prague*, 15gns., Mrs. Halsey, 16 Hereford St., AU.
1846	294	*Post-house, Martigny, Switzerland*, 8gns.
1846	306	*At Trèves*, 8gns., I.T. Simes Esq., Highbury Park.
1846	314	*Church at Tours, France*, 14gns., H.S. Simes, Eagle Cottage, Hornsey.
1847	28	*Strasbourg*, 25gns., Thos. Ashton Esq., Reform Club, Hyde, W. Manchester.
1847	51	*Croix de Pierre, Rouen*, 18gns., John Greg Esq., Lancaster.
1847	58	*The Lady Chapel, St. Pierre, Caen*, 18gns., I.T. Simes, Frame and glass £3.16.0 No.
1847	89	*Augsburgh, Bavaria*, 60gns., Colonel Pennant, Frame and glass £10.18.6 (Received above amt. Geo. Foord).
1847	137	*Church St. Maclou, Rouen*, 25gns., N.J. Broderip Esq.
1847	168	*At Nuremburg*, 30gns., Thos. Burgoyne Esq.
1847	183	*Milan Cathedral*, 30gns., Mrs. Fuller, 29 Abingdon Street, Westminster, to be framed.
1847	207	*An Interior*, 8gns., Thos. Fairbairn Esq. [deleted in pencil], 7 Furnivals Inn.
1847	277	*North Isle of the Church at Ville d'Eau*, 12gns., Miss Hicks Beach, Oakley Hall, Basingstoke.
1847	292	*The Headsman's House at Bruges*, 8gns., R. Ellison Esq.
1848	25	*Distant View of the Bridge of Sighs, Venice*, 25gns., W. Duckworth Esq., Beechwood, Southampton.
1848	33	*The Lady Chapel in the Church of St. Jacque, Dieppe*, 25gns., W. Duckworth.
1848	40	*Part of the Castle of Heidelberg*, 8gns.

| 1848 | 54 | *At Ober Lahnstein, on the Rhine*, 6gns., Col. Blore, 4 Manchester Sq. |

1848 54 *At Ober Lahnstein, on the Rhine*, 6gns., Col. Blore, 4 Manchester Sq.

1848 73 *At Sion, Switzerland*, 12gns., P.(?) Hardwick R.A., 60 Russell Sq.(?).

1848 83 *Washing Scene at Nuremburg*, 30gns., C.F. Cheffin Esq.

1848 93 *A Market Place at Strasbourg*, 30gns., J. Wild Esq., Clapham Lodge, Frame Mr. Foord to be retouched.

1848 136 *At Nieder Lahnstein, on the Rhine*, 6gns., Dean(?) Burton Esq.

1848 185 *Sibyl's Temple at Tivoli*, 10gns., I.T. Simes, 30 Montpelier Crescent, Brighton.

1848 187 *Part of the Choir at Chartres*, 12gns., Tho. Toller, 6 ???.

1848 212 *The Cloisters at St. Paul's, Rome*, 10gns., The Countess de Waldegrove, 24 St. James' Place.

1848 229 *At Mechlin*, 6gns., J.L. Grundy, 26 Soho Square.

1848 274 *Part of the Ducal Palace, Venice*, 8gns., G. Pownell, 3 Mecklenburg(?) St.

1848 315 *Palais du Prince, Liege*, 8gns., R. Alexander Esq., 39 Grosvenor Street.

1848 323 *A la barbe blanc, at Tours*, 6gns., Mrs. Geo. Forbes, 26 Chester Ter., Regents Park.

1848 342 *La Bourse, Antwerp*, 8gns., R. Lloyd Esq., Ludgate Hill.

PROUT SAMUEL

1849 9 *Behind the Choir of St. Pierre, Caen.*

1849 10 *Rue St. Jean, Caen.*

1849 25 *At Lavey, Switzerland.*

1849 37 *Temples of Jupiter Tonans and Concorde, Rome.*

1849 53 *Porch of Ratisbonne Cathedral.*

1849 66 *At Ulm, Wurtemberg.*

1849 76 *Interior at Mechlin, Flanders.*

1849 83 *Interior of a Church.*

1849 113 *Desecrated Chapel of St. Jacque, Orleans.*

1849 190 *Cathedral of Beauvais.*

1849 229 *St. Etienne, Beauvais.*

1849 238 *Temple of Pallas, Rome.*

1849 262 *Notre Dame, Caen.*

1849 287 *Part of the Cathedral, Cologne.*

1849 290 *Interior at Dieppe.*

1849 316 *Porch of St. Vincent's, Rouen.*

1849 345 *Porch of Louviers, Normandy.*

1849 352 *At Lisseux, Normandy.*

1849 365 *Gothic Window at Cologne.*

1850 10 *Palais Ducal et petite Place sur le Môle, Venice*, 30gns., C.M. Packe, 7 ????, Whitehall, Frame and glass £5.0.0 No.

1850 52 *Pont de Rialto, Venice*, 30gns., Mrs. Packe Reading, 7 Richmond Terrace, Frame and glass £5.0.0.

1850 94 *The Protestant Church at Ulm, Bavaria*, 25gns., Miss Robertson at C.S. Whitmoore Esq., 2 Wilton Crescent, Frame and glass £5.0.0 No.

1850 98 *Part of the Church of St. Mark, Venice*, 8gns.

1850 251 *At Dresden*, 12gns., Decimus Burton.

1850 263 *The Sibyls Temple, Tivoli*, 12gns., J.L. Grundy Esq., Regent(?) St.

1850 308 *At Ulm*, 8gns., Joseph Goff Jun. Esq., Hale House, Nr. Salisbury.

1850 338 *Arch of Constantine, Rome*, 10gns., Rev. C.H. Townshend.

1850 346 *Fountain at Ulm*, 8gns., C.S. Whitmore Esq., Wilton Crescent, Frame and glass to Mr. Foord.

1850 379 *At Mayence, on the Rhine*, 10gns., C.S. Whitmore Esq., Frame and glass £2.0.0 No.

1851 38 *At Mayence, on the Rhine.*

1851 45 *At Falaise, Normandy.*

1851 61 *Malines, Flanders.*

1851 79 *St. Pierre, Caen.*

1851 112 *Augsburg, Bavaria.*

1851 152 *Basle.*

1851 205 *La Halle au Blé, Tours.*

1851 301 *Schafhausen, on the Rhine.*

1851 319 *At Cologne, on the Rhine.*

PUGIN

1817 223 *High Street, Oxford.*

PUGIN A

1807 64 *Interior of St. Paul's.*

1808 33 *A street in Lincoln, with part of the West front of the Cathedral.*

1808 55 *A kitchen*, 20gns., Marquis Stafford(?).

1808 213 *The church and market place of Sleaford, Lincolnshire.*

1808 309 *Chapel of the Temple Church, a sketch.*

1809 77 *Magpie lane, Oxford.*

1809 190 *An archway in Merton College, Oxford.*

1809 234 *A view in Lincoln.*

1809 255 *Newport gate, Lincoln.*

1809 287 *Interior of a manufactory.*

1810 67 *Entrance to Vicar's Court, Lincoln.*

1810 89 *West and South Fronts of the Bank.*

1810 97 *The new Statue Gallery, British Museum.*

1810 165 *Interior of Westminster Abbey, taken from the North Aisle.*

1810 209 *A Furniture Magazine.*

1811 83 *The Ruins of King John's Palace, near the Minster, Lincoln.*

1811	141	*Interior of the Principal Library, at Cashiobury, the Seat of the Earl of Essex.*
1811	164	*Interior of the West entrance of Lincoln Minster.*
1811	223	*Interior of the Paper Manufactory at Two Waters, with the Patent Machine for Making the Paper.*
1812	48	*The Adelphi Terrace and adjacent Buildings, taken from Beaufort Wharf.*
1812	122	*West Front of St. Edmund's Chapel (for the History of Westminster Abbey and its Monuments).*
1812	124	*East Front of St. Edmund's Chapel (for the History of Westminster Abbey and its Monuments).*
1812	139	*Edward the Confessor's Monument (for the History of Westminster Abbey and its Monuments).*
1812	325	*Charing Cross.*
1813	41	*Merton Chapel, Oxford.*
1813	51	*View in Oxford, taken near Wadham College; (for the History of Oxford).*
1813	62	*View in Oxford taken from the Corn Market; (for the History of Oxford).*
1813	78	*View in Lincoln, taken near the Entrance to the Castle.*
1813	84	*The old Gateway, facing the West Front of Lincoln Minster.*
1813	89	*Monuments in St. Nicholas Chapel, Westminster Abbey.*
1814	105	*The Library of All Soul's College, Oxford.*
1814	109	*The Chapel of Magdalen College, Oxford.*
1814	133	*View of the Thames, taken from Blackfriars Bridge.*
1814	253	*A Kitchen.*
1814	293	*Christchurch Hall, Oxford.*
1815	9	*Pembroke Hall, in Trumpington Street, Cambridge.*
1815	91	*The Hall of Trinity College, Cambridge.*
1815	155	*South Porch to Kings College Chapel.*
1815	220	*St. Botolph's Church in Trumpington Street, Cambridge.*
1815	226	*The Hall of Sidney College, Cambridge.*
1815	294	*Senate House, Cambridge.*
1816	15	*Prince Regent's Supper Room, White Fete, Burlington Gardens.*
1816	210	*Supper Rooms, White's Fete, Burlington House.*
1816	212	*Ball Room, White's Fete, Burlington House.*
1817	184	*Louth Church, Lincolnshire.*
1817	204	*St. George's Tower, Oxford, £5.5.0, Mr. Knowlys.*
1817	220	*Trinity Street, Cambridge, £6.6.0, Mr. Knowlys.*
1817	278	*Caius College, Cambridge.*
1819	27	*Trinity Street, Cambridge.*
1819	290	*Magpie Lane, Oxford.*
1819	328	*Lincoln Minster, from the Castle Hill.*
1820	211	*Kitchen - Pavilion, Brighton.*
1820	213	*Yellow Drawing Room - Pavilion, Brighton.*
1820	216	*Blue Drawing Room - Pavilion, Brighton.*
1821	2	*Interior View of the Guildhall, London.*
1821	26	*View of Paris, taken from the Quai de Louvre.*
1821	48	*The Library at Cashiobury, the Seat of the Earl of Essex.*
1821	55	*The Gallery of His Majesty's Palace, Brighton, Mr. Nash(?).*
1821	104	*Sketch of Lincoln Minster, taken from the Cattle Market.*
1821	157	*View of Paris, taken from the Pont Neuf.*
1821	165	*The Saloon of His Majesty's Palace, Brighton.*
1821	175	*Market, St. Germains - Sketch.*
1822	164	*Gallery in Dr. Fisher's Apartments, Charter House School.*
1823	11	*Roman Wall and Tower, Lincoln - a Sketch.*
1823	106	*Interior of the Church of St. Sulpice at Paris.*
1823L	113	*Lincoln,* Earl Brownlow.
1824	302	*Red Drawing Room, King's Palace, Brighton.*
1825	158	*Sleaford Church, Lincolnshire,* 25gns.
1825	259	*Saloon of His Majesty's Palace, Brighton,* Sold.
1826	183	*Minster Gate, Lincoln,* 4gns.
1826	257	*Interior of a Room, in the Queen's Head Place, Lower Road, Islington, built during the reign of Q. Elizabeth,* 4gns.
1827	116	*The King's Kitchen, at the Pavilion, Brighton,* Sold.
1828	196	*Music Room of the Royal Palace, Brighton,* 40gns., Sold.
1829	259	*West Front of Lincoln Minster, taken from the Castle,* 5gns., Revd. Archdeacon Bayley, Westmeon, Alton, Hants, A frame to be ordered and packed.
1830	20	*College Gate, Bristol,* 6gns., Revd. John Ward, 34 Brook Street, Grosvenor Square.
1831	257	*St. Botolph's Church, Boston, Lincolnshire.*
1831	268	*Entrance Porch, Bishop's Palace, Lincoln.*

PYNE G

1827	20	*Village of Great Staughton, Huntingdonshire,* 6gns.
1827	47	*Barns at Great Staughton, Huntingdonshire,* 8gns., G. Morant Esq.
1827	89	*Mill at Great Staughton, Huntingdonshire,* 8gns.

1828	213	*All Saint's Vicarage, Canterbury, 4gns.*
1828	220	*Farm Yard near Canterbury, 5gns.*
1828	228	*Culand House, Bucham, Kent, 7gns.*
1828	239	*Farm House, Datchet, 12gns.*
1828	300	*Aylesford, Kent, 4gns., Rev. J. Brown.*
1829	101	*Aylesford, Kent, 8gns.*
1829	116	*Morning, 8gns.*
1829	233	*The Red Lion, 12gns., John Hornby Maw Esq.*
1829	381	*Farm Yard near Canterbury, 5gns.*
1830	104	*Cottage, Caernarvon, 4gns., H. Smart, 10 Tichborne Street.*
1830	338	*London Bridge, 1730, 12gns., Mr. Webb, 30 Coventry St.*
1831	22	*London Bridge as it appeared in 1740, before the Houses were taken down.*
1831	192	*Rochester Castle, from Chatham.*
1831	286	*On the River Stour, Canterbury.*
1832	244	*Rochester Castle, 5gns.*
1832	312	*At Maidstone, 7gns.*
1833	2	*Old Hungerford Market, 8gns.*
1833	280	*Old Hungerford Stairs, 8gns.*
1834	129	*Rochester Castle and Bridge, 4gns.*
1836	1	*Gundulph's Tower and part of the Walls of Rochester Castle, 12gns., Wm. Hobson Junr. Esq., 43 Harley Street.*
1836	79	*London Bridge, 1740, before the Houses were taken down, 5gns., Delafield Esq., 39 Bryanston Square.*
1836	217	*At Willesden, Middlesex, 6gns.*
1837	154	*Interior of Bradstone Church, on the Banks of the Tamar, Devon, 9gns.*
1837	207	*The Old Ouse Bridge, York, South View, now pulled down, 8gns.*
1838	8	*Caernarvon Castle, North Wales.*
1838	9	*Mill at Peter Tovy, near Tavistock.*
1838	258	*Miners' Cottages - Peter Tavy, near Tavistock.*
1839	12	*Water Mill, near Tavistock, Devon, 12gns.*
1839	181	*Hill Bridge, Dartmoor, 12gns.*
1840	5	*Taking down the Houses on Old London Bridge.*
1840	97	*Old House, Canterbury.*
1840	311	*London Bridge, 1830.*
1841	35	*Wandsworth, 7gns.*
1841	96	*Kilworthy Devon, 4gns., Sam. Morton Peto Esq., York Road, Lambeth.*
1841	137	*At Millbank, 8gns., Revd. John Woollercombe, Stowford Rectory.*
1842	180	*View near Guildford, Surrey.*
1843	267	*Brentnor, from Kilworthy, near Tavistock, a celebrated Landmark in Devonshire, 5.10.0 Pounds.*

PYNE W H

1805	3	*View in Scotland.*
1805	12	*A tanner. (For the costume of England).*
1805	18	*Herald. (For the costume of England.).*
1805	24	*View of Magdalen College, Oxford, by Moonlight.*
1805	28	*View upon the Thames.*
1805	31	*Millbrook, Bedfordshire.*
1805	34	*Fishermen: a scene on the coast of Kent.*
1805	35	*Landscape, a sketch.*
1805	50	*Westminster Abbey, from Dean's yard, Mr. Willby.*
1805	55	*Distant view of Salisbury from the Avon.*
1805	56	*Interior of the buttery at the Charter-house.*
1805	117	*Yeoman of the King's body guard. (For the costume of England.).*
1805	122	*Shepherd boys.*
1805	128	*A fireman. (For the costume of England).*
1805	141	*Chelsea Pensioner. (For the costume of England.).*
1805	144	*View in Scotland.*
1805	154	*Sailors in a boat, a sketch.*
1805	175	*Launching a fishing boat, a sketch.*
1805	177	*Landscape, a sketch.*
1805	191	*Fishermen, a sketch on the coast.*
1805	202	*Sketch on the sea coast.*
1805	254	*A ship's boat.*
1805	255	*A sketch.*
1805	256	*A cottage at Penton Mewsey, Hants.*
1805	261	*A country ale-house door.*
1805	262	*A landscape.*
1805	269	*Winter piece.*
1805	272	*Bedford bridge and town.*
1806	52	*Landscape, a sketch.*
1806	84	*A Landscape, a sketch.*
1806	87	*The Pig Market, Bedford, with a view of St. Mary's Church.*
1806	124	*Fishermen at a Capstan.*
1806	141	*Cottage at Winkfield, Berks.*
1806	201	*View of Magdalen Tower, Oxford.*
1806	258	*View of St. Paul's, taken from under Blackfriars' Bridge.*
1806	269	*View on the Thames.*
1806	277	*Cottage in Wiltshire.*
1806	287	*Cottage in Wiltshire.*
1807	17	*The water mill.*
1807	76	*A village scene.*
1807	97	*A village scene, 15gns., Admiral Wells.*
1807	168	*Cottage in Cumberland.*

1807	257	*Scene in the village of Kempston, Bedfordshire.*
1807	266	*The Castle of Udolpho.*
1807	267	*A village scene.*
1808	42	*Cottages from nature.*
1808	54	*View of Edinburgh.*
1808	60	*Cottage in Cumberland.*
1808	67	*Cottage from nature.*
1808	84	*Evening.*
1808	149	*Cottage in a wood.*
1808	184	*Cattle market.*
1808	191	*Cottage from nature.*
1808	201	*Cottage at Troutbeck.*
1808	225	*Cottage in Kent.*
1808	262	*Fishermen.*
1815	15	*Portrait of a young Nobleman.*
1815	21	*Portraits of the late Lady Herbert her Son, and Sister.*

RAYNER NANCY

1850	6	*The Queen's Birth-day,* Sold.
1850	17	*Sleeping Italian Boy, "His soul is far away, In his childhood's land perchance . . ."* Sold.
1850	104	*The Gleaners,* 16gns.
1850	142	*The Vow,* 20gns., N.F. Roe.
1850	170	*Girl at the Spring,* 20gns., Alex. Wylie Esq., 6 Burlord(?) Place, Frame and glass No.
1850	206	*The Savoyard,* 16gns., George Hanbury Esq., Brewery.
1850	328	*Boy Feeding Rabbits,* Sold.
1851	154	*The Spangled Bed-chamber - Knole.*
1851	171	*A Weary Traveller.*
1851	174	*Tamborine Woman.*
1851	225	*Lady Betty Germaine's Bed Chamber, Knole.*
1852	17	*"But yet she Listened",* 15G, W. Hobson Esq.
1853	168	*An Italian Beggar Boy.*
1854	54	*A Spanish Lady,* Sold.
1855	67	*An Equestrian Portrait of an Officer in Her Majesty's Service, taken at St. Martin's-le-Grand,* 15gns., Her Grace The Duchess Dowager of Northumberland, Mount Lebanon, Twickenham.

RAYNER S

1845	39	*West Door, Jedburgh Abbey,* 15gns., John Martin Esq., 14 Berkeley Sq.
1845	47	*Oratory, Naworth,* 20gns., Thos. Griffith Esq.
1845	91	*Lanercost Priory, Cumberland,* 25gns., J. Hewett Esq., Leamington.
1845	128	*Haddon Hall, Derbyshire,* 25gns., The Revd. Edward Coleridge, Eton College, P.AU. 20£.
1845	175	*The Chapel, Naworth,* 15gns., Richd. Ellison Esq.

1845	195	*The Retainers' Gallery, Knowle,* Sold.
1845	216	*Interior of St. Peter's Church, Caen,* 12gns., Lord Brownlow.
1845	252	*Saturday Evening - the Labourer's Reward, "The fagot crackles on the fire; The children run to meet their sire . . ."* 12 Pounds, Frame and glass £1.0.0.
1846	76	*White Horse Inn, Edinburgh,* 30gns., Rd. Cumming Esq.
1846	105	*Haddon Hall - Sunset,* Sold.
1846	110	*Court Yard, Haddon Hall,* 25gns.
1846	128	*The Shrine,* 35gns., Mrs. Wise, Leamington Spa, Warwicksh.
1846	165	*North Aisle of St. Pierre, Caen,* 20gns., Wyatt Esq., Oxford.
1846	197	*Upper Gallery, Knowle, looking towards the Dormitory,* Sold, Miss Burdett Coutts.
1847	10	*The Royal Palace, Linlithgow,* 20gns.
1847	21	*Heidelberg - Sunset,* 30gns.
1847	98	*White Horse Close, Canongate, Edinburgh,* 30gns., Her Majesty the Queen Dowager.
1847	109	*The Eagle Tower, Haddon,* Sold.
1847	184	*The Belfry, Haddon,* 30 Pounds.
1848	117	*"– Marble monuments were here displayed . . ." –The Excursion.* 15 Pounds, Miss Burdett Coutts.
1848	134	*Lindsay's Hall, North Britain,* 10 Pounds.
1848	186	*Belted Will's Tower, Naworth Castle,* Sold.
1848	255	*West Porch, Lichfield Cathedral,* Sold.
1848	291	*Interior - Beauvais Cathedral,* 15 Pounds.
1849	63	*A View on the North Esk, near Roslin.*
1849	164	*The Ivy-covered Walls of the Banquetting Gallery, Kenilworth Castle, "Huge trunks! and each particular trunk a growth Of intertwisted fibres, serpentine . . ."*
1849	194	*The Leicester Buildings, Kenilworth Castle.*
1849	204	*The Ruins of Kenilworth Castle, " – Shade of departed power, Skeleton of unfleshed humanity."*
1849	220	*The Garden Terrace, Haddon Hall.*
1849	297	*Salisbury.*

RAYNER SAMUEL

1850	232	*Monks at the Shrine of their Founder,* Sold.

REINAGLE R

1806	65	*View of Monte Tri Pozzi, taken near Sorrento, in the Bay of Naples, (The great reservoirs of ice which supply Naples, are on the top of this mountain)*
1807	183	*View of the Castle and part of the Town of Boltzena.*

REINAGLE R R

1806	23	*A Composition, scene on the banks of a river in a mountanious country. Evening.*

1806	76	*View of Monte Fenestra, and the town of La Cava, near Vitri, in the gulf of Salerno.*
1806	136	*View of the Fortress of Civita Castellana, taken near the double-arched Bridge, distant twenty-five miles from Rome.*
1807	14	*View of part of the Claudian Aquaduct, near Tivoli, taken on the road to Horace's villa.*
1807	30	*View of the bridge across the river Agno, at Subiacco, in the Roman state, with the convent of St. Francisco - evening.*
1807	36	*View at Civita Castellana, and of the bridge said to have been built by Augustus - morning.*
1807	136	*A ruined aqueduct, composition.*
1807	158	*View on the side of the road between Vietri and La Cava, of the fallen grotto near the gulf of Salerno, kingdom of Naples, early in the morning.*
1807	259	*Solitude, a composition.*
1807	309	*View of Monte Fenestra, from the great road leading into the Town of La Cava, kingdom of Naples.*
1807	312	*View of Equa Point, on the shore of Vico, with the Island of Capra in the distance, bay of Naples.*
1808	30	*Fishermen's houses near Sorrento, with Capo di Paolo and Caprea in the distance, Bay of Naples - mid-day breeze coming in.*
1808	41	*Loughrigg mountain and River Brathy, near Ambleside - sun-set.*
1808	77	*St. John's Vale, looking towards Saddleback, near Keswick, 40gns., Lord Aylesford.*
1808	93	*Mill Pond, with cattle, near Harrison's Rocks, Tunbridge Wells, 40gns., Mr. ???????.*
1808	153	*A storm, effect towards the close of the day, with a view of the rocks near Capo di Paolo, with Caprea in the distance, Bay of Naples.*
1808	186	*A bridge, distant view of Grassmere and Loughrigg mountain, from the road leading to Rydall, 35gns., Dr. Forrester.*
1808	198	*Entrance to the village of Troutbeck, near Ambleside.*
1808	231	*Mecaenas's Villa, Temple of La Tossa, and the Villa d'Este at Tivoli, early in the morning, 60gns., Dr. Monro(?).*
1808	254	*View from the South gate of Sorrento, with part of the walls, and a distant view of the mountain of Castelmara, Naples - mid-day.*
1808	287	*Castle Crag in Borrowdale, from the West side of Keswick Lake.*
1809	10	*Part of Keswick Lake, with Grange Fell and Castle Crag, in Borrowdale - noon.*
1809	20	*Part of the Claudian aquaduct, between Tivoli and Vico Varro - morning.*
1809	24	*Cattle - sun-set.*
1809	52	*The Head of Rydall Lake, effect of afternoon, Westmoreland, 50gns., Mr. Roby.*
1809	83	*Ruins of an hippodrome, that joined the temple of Bacchus, on which the church of St. Agnes is now built, near Rome.*
1809	101	*The river Rothay, as it enters the lake of Windermere, taken from the bridge, near Ambleside - twilight.*
1809	102	*From Patterdale, at the head of Ulswater - sun-set.*
1809	198	*Scene on the river Rothay, looking to Ambleside and Rydal Head - sun-set.*
1809	203	*Scene above a water-fall, amidst mountains, with wolves - sun-set.*
1809	207	*General view of Rydall Lake - twilight.*
1809	272	*Scene on the river Brathay, looking towards Langdale - forenoon.*
1809	284	*Home Fell, or Raven Crag, at the head of Coniston Lake - sun-set.*
1809	309	*Composition - evening.*
1810	86	*Mountain Scenery, near Scalewith Force, Westmoreland - Evening.*
1810	105	*Scene taken from Grasmere Bridge - Afternoon.*
1810	111	*A Slate Wharf, with the Village of Clappersgate, and Coniston Fells, near the Head of Windermere -Forenoon.*
1810	173	*Scene on Hampstead Heath - Afternoon.*
1810	182	*Scene on the Banks of the River Derwent, looking to the foot of the Lake of Keswick - Morning.*
1810	253	*Skelwith Force, Westmoreland - Sunset.*
1810	276	*Scene in the Brook, or Gill, near the Watermill at Ambleside, with Cattle - Morning.*
1810	316	*Remains of the Temples of Paestum, situated about 60 miles South of Naples, on a pestilential Plain in the Gulph of Salerno, 60gns., Lord Brownlow.*
1811	22	*Capo di Paolo, in the Bay of Naples, with the Remains of the Villa of C. Assinius Pollio, a Roman General, who was Consul in the Year of Rome, 714. He was the great Friend and Patron of Virgil and Horace.*
1811	50	*Rydal Lake, from the Upper Park of Sir Daniel Le Fleming - Sun-set.*
1811	64	*Scene on the River Rothay, at Rydal, with Part of Lougrigg Mountain - Early in the Morning.*
1811	107	*A Scene on Keswick Lake, under Wallaw Crag, including the Mountains of Lowdore, Evening, 50gns., Hon. R. Peel.*
1811	114	*Cattle in a Brook - Evening, 60gns., Lord Carlisle.*
1811	120	*Scene from Ambleside Bridge, shewing the Junction of the River Rothay with the Head of Wyndermere - Twilight.*

1811	127	*Scene in Gisburne Park, Yorkshire - Sun-rise.*
1811	159	*A Scene at Tivoli, called the Syrens' Grotto, including the Sybils' Temple, and Part of the Town - Early in the morning.*
1811	166	*A Scene at the Extremity of Ambleside, on the road to Lowwood Inn - Morning.*
1811	178	*Remains of Furness Abbey, near Ulverstone, on the Borders of Lancashire - Sunset.*
1811	368	*Scene near Espierre in Savoy.*
1812	24	*Scene on the Grand Junction Canal, at Two Waters, in Herts - Afternoon.*
1812	87	*Preparing to milk - Hazy Morning,* 40gns., Mr. Leader.
1812	90	*Cattle - Afternoon.*
1812	129	*Derwent Fells, usually called Catbells, and part of Keswick Lake - Forenoon.*
1812	186	*A Neapolitan Felucca, in the Bay of Sorrento, Gulf of Naples - Evening.*
1812	206	*Neapolitan Fishermen, hawling their Net under the Cliffs and Town of Vico, in the Bay of Naples, with a Group of Tunny and other Fish - Evening.*
1812	233	*A Scene on the Banks of Keswick Lake, at Portinscale - Early in the Morning.*
1812	241	*Woodcutters, a Scene on the Hawkshead Road, with Windermere in the Distance - Forenoon.*
1812	272	*Lowdore Mountains, from the Extremity of Barrow Common - Forenoon.*
1812	332	*The Village of Bonsal in Bonsaldale, near Matlock, Derbyshire - Evening.*
1812	336	*A Ruin, called the School, being part of Furness Abbey, Lancashire - Morning.*
1823L	69	*Preparing to Milk - Hazy Morning,* W. Leader, esq. M.P.
1823L	89*	*Milking,* T. Tomkison, esq.
1823L	121	*A scene on Keswick Lake - Evening,* Rt. Hon. R. Peel, M.P.
1823L	128	*Scene in Cumberland,* Geo. Hibbert, esq.
1823L	148	*Cattle - Afternoon,* Earl of Carlisle.
1823L	155	*Ruins of Paestum, in Calabria,* Earl Brownlow.
1823L	163	*Head of Rydal Lake,* Major Downs.

RICHARDSON J M JUN

1843	223	*The Cathedral from South Street, Durham,* 30 Pounds.
1843	229	*On the Road between Keswick and Ambleside, near the Dunmail Raise Stones,* 15 Pounds.
1843	234	*On Stainmoor, Yorkshire,* 5 Pounds, E. Fry, Plymouth, 17 Warkwich Sq.

RICHARDSON M

1818	50	*Part of Ullswater, from a Point near Gobarrow Park, on the Road to Patterdale,* £26.5.0, J. Quintin Esq.
1818	58	*Hermitage at Warkworth.*
1818	65	*An approaching Storm, Bamborough, Northumberland.*
1818	66	*View of the Port and Town of Newcastle.*

RICHARDSON T M

1819	88	*Old Custom House Quay, South Shields, Pilot Boat entering the Harbour.*
1819	104	*A Brig stranded on the Coast near Bamborough, Northumb.*
1820	56	*Misty Morning - Laden Colliers leaving Shields - a Study.*
1820	74	*Glen of the Trosachs, "Where twin'd the path, in shadow hid . . ."*
1820	101	*Dunstanborough Castle, Northumberland - Storm clearing off.*
1820	108	*Low Lights, North Shields.*
1820	139	*Dunkeld, Perthshire, from the Road to Couper, in Angus.*
1848	92	*The Cheviots, Northumberland,* 30gns., Frame and glass £5.0.0.
1848	145	*Harlech Castle, North Wales - Passing Storm,* 60gns., Mr. Robert Hanbury Junr., Truman's Brewery, Spitalfields, Frame and glass £7.0.0 Yes.
1848	166	*Ben Lomond, from the Hills between Arrochar and Tarbet,* 18gns., Rev. Hare Townshend, Frame and glass £2.15.0.
1848	168	*Village of St. Pierre, Great St. Bernard,* 35gns., 1 Belgrave Sq., 103 Marina, St. Leonards by Sea, Sussex, Frame and glass £5.0.0 No.
1848	176	*At Luveno, Lago Maggiore,* 18gns., The Hon. ?? Bathurst, 8 Grosvenor(?) Sq., Frame and glass £3.0.0 No.
1848	190	*On the Moors, near Aberfelldy, Ben Lawers and Schehallion in the distance,* 60gns., R. Aitcheson Alexander, 3 Lower Grosvenor Street, Frame and glass £8.0.0 No.
1848	200	*Bealach-nam-bo, or Pass of Cattle, with Benvenue in the distance, "It was a mild and strange retreat . . ." Vide Lady of the Lake.* 65gns., Frame and glass £8.0.0.
1848	215	*Scotch Peasants washing, on the Banks of the Lochy, Killin, Perthshire,* 65gns., William Brook Esq., Chiddingstone, Tunbridge, Frame and glass £8.0.0, AU. 70.
1849	56	*Bellaggio, Lago de Como.*
1849	71	*Highland Shooting Pony - Ben-y-Glo in the distance.*
1849	81	*Haymakers Resting - Ben Nevis in the background, Inverness-shire.*
1849	93	*Edinburgh Castle, from the Grassmarket, with Baggage Waggons.*
1849	122	*On the Beach at St. Leonards, Coast of Sussex.*
1849	202	*Jungfrau - from Lauterbrurmen, "The glassy ocean of the mountain ice . . ." – Manfred.*

1849	272	*Highland Reapers, Loch Leaven, Inverness-shire - Evening.*
1849	336	*Peat Moss, near Ballachulish, Inverness-shire.*
1850	13	*Village of Grange, Borrowdale, Cumberland,* 65gns., Hugh Taylor Esq., 29 Cumberland Terrace, Regents Park, Frame and glass £8.0.0 Yes.
1850	30	*Wreckers - Dunstanborough Castle, Coast of Northumberland,* 60gns., T. Dowell(?), Buxton(?), Frame and glass £8.8.0.
1850	166	*Early Morning - Ben-y-Glo,* 45gns., Miss Copley, 13 Carlton Ter., Frame and glass £5.5.0 Yes.
1850	189	*Scene in Glencoe,* 65gns., Mrs. R. Hanbury, Frame and glass £9.0.0 Yes.
1850	211	*Bamborough Castle, Coast of Northumberland - Gathering in the Wreck,* 60gns., Mrs. Hugh Taylor, 29 Cumberland Terrace, Regents Park, Frame and glass £9.0.0 Yes.
1850	213	*Bellaggio, Lago di Como,* Sold, R. Ellison Esq. (?).
1850	278	*Glen Kinglas, Argyllshire,* 16gns., Lord Bishop of Winchester, Frame and glass £2.5.0.
1850	327	*Dunstanborough Castle, Northumberland,* 16gns., Rev. Chas. John Sale, Holt Rectory, Worcester, Frame and glass £2.0.0 No.
1851	31	*Scene on the River Tay, from above Aberfeldy, Perthshire.*
1851	159	*Como.*
1851	182	*Scene in Glen Beg, on the road between Spital and Glen Shee, and Castletown and Braemar, Aberdeenshire.*
1851	184	*Rumbling Bridge, on the River Braan, Perthshire.*
1851	190	*Scene in Glencoe, Argyllshire.*
1851	226	*On the Coast near St. Leonards - looking towards Beechy Head.*
1851	235	*Huts at Tomgarrow, on the River Braan, Perthshire.*
1851	255	*Moors near Ballachulish, Inverness-shire.*
1852	60	*Lake of Como, from above Bellaggio,* Sold, M. Hobson, Frame and glass £7.15.0.
1852	85	*Bridge of Badia, Tuscany,* 55G, Captain Hotham, 82 Oxford Terrace, Frame and glass £6.10.0 No.
1852	108	*In Glen Lui, Mar Forest, Aberdeenshire,* 18G, The Honble. F?? Byron, 21 Eaton Place, Frame and glass £2.10.0.
1852	146	*River Dee, from the Forest of Balloch Bowie, Aberdeenshire,* 50G, Frame and glass £6.10.0.
1852	154	*The Wetterhorn - Snow Storm,* 20G, Frame and glass £3.0.0.
1852	191	*Interior of a Highland Cottage, Braemar, Aberdeenshire,* 20G, Lady Catherine Cavendish, Burlington House, Frame and glass £3.0.0.
1852	194	*Ben Venue, Loch Katrine, Perthshire,* Sold.
1852	202	*Cottages on the Banks of Loch Leven, Inverness-shire,* 60gns., Frame and glass £7.15.0.
1852	212	*On the Cluny, Aberdeenshire,* Sold, Richard Ellison, to Vokins, with Frame.
1852	256	*Capuchin Monastery, Sorrento,* 35G, ?? Lyle, 17 Bloomsbury Street, Frame and glass £4.0.0.
1852	285	*Hay Boats - Locarno, Maggiore,* 20G, Rt. Hon. Pemberton Leigh Esq., 3 Spring Gardens Terrace, Frame and glass £3.0.0 Yes.
1852	289	*At. St. Leonard's, Coast of Sussex,* 18G, Frame and glass £2.10.0.
1853	13	*Hastings, Sussex.*
1853	36	*At Amalfi, Gulf of Salerno.*
1853	43	*On the Island of Caprée, Gulf of Naples.*
1853	62	*Highland Peat Girl, Banavie, Inverness-shire.*
1853	80	*Castle of Melissa, Calabria.*
1853	82	*Italian Landscape - Composition.*
1853	111	*Glen Shee, from the Devil's Elbow, Aberdeenshire, looking towards the Spital.*
1853	173	*Mountain Stream, Ben Nevis, Inverness-shire.*
1853	185	*Deer Stalkers, Glen Nevis, Inverness-shire.*
1853	224	*Keeper's Cottage, near Aviemore, Inverness-shire.*
1853	257	*Cairngorm Hills, from Aviemore, River Spey, Inverness-shire.*
1854	14	*Val St. Nicolia, on the Range of Mount Rosa,* 110gns., Jones, Cirencester, Gloucest., Frame and glass £12.0.0.
1854	25	*Sorrento, from the Capo di Monte,* Sold, Messrs. Vokins.
1854	108	*The Cocomella, Sorrento,* Sold [18gns. deleted], The Rt. Honble. H. Labouchere M.P.
1854	116	*On the River Arno, near Florence,* Sold, Messrs. J. & W. Vokins.
1854	132	*Looking up Strath Tay - Ben-y-Glo and Ben-y-vrachie in the distance,* Sold, Miss Emily Baring, 23 Princes Gate, Without frame.
1854	145	*La Filatrice,* Sold, Messrs. J. & W. Vokins.
1854	149	*La Cantatrice,* Sold, Messrs. J. & W. Vokins.
1854	179	*View of the Town of Lagonegro, in the District of Basilicata, in the Kingdom of Naples, situated at the extremity of a narrow Glen, and overhung by the lofty Heights of Monte Coceizzo, Monte de Papa, and Monte Seveno,* Sold, Jas. E.C. Bell Esq., Westbourne Terrace.
1854	250	*At St. Leonards-on-Sea, Coast of Sussex,* 18gns., I. Adshead(?), North End Mile, Stalybridge (Herbert Usher), Frame and glass £2.2.0, Art Union Prize.
1854	261	*Highland Herd Boy,* 16gns., Frame and glass £2.2.0.

1854	295	*Ben-y-Glo, Glen Tilt, Perthshire*, Sold.
1854	311	*On the Moors, Rothiemurcus, Inverness-shire,* Sold, Messrs. J. & W. Vokins.
1855	5	*The Return - Scene on the Black Mount, Argyllshire*, Sold.
1855	30	*In the Bay of Naples*, Sold.
1855	53	*Beach at Hastings, Sussex*, Sold.
1855	66	*Palace of the Queen Juanna, Naples*, Sold.
1855	81	*Scene in Glencoe, Argyllshire*, 120gns., Mr. White, Maddox St.
1855	128	*On the Black Mount, Argyllshire*, 45gns., E. Romilly Esq., Frame and glass £5.0.0.
1855	142	*Girl at the Well - The River Spey, near Aviemore, Murrayshire*, Sold.
1855	146	*The Trout Stream - Killin, Perthshire*, 15gns., George Forbes Esq., Bereleigh, Hants (to Alton Station care of George Bennett Carrier), Frame and glass £2.2.0.
1855	182	*On the Moors, near Delmacardock - Ben-y-glo Ben-y-Mackie in the distance, Perthshire*, 45gns., His Grace The Duke of Argyll, Frame and glass £4.10.0.
1855	202	*Dieci Miglia, on the Road between Tivoli and Subiaco*, 65gns., Messrs. Vokins, Frame and glass £6.0.0.
1855	210	*In the Forest of Rothiemurcus, Loch Morlech and Cairngorm*, 70gns., Alexr. Morison Esq., Frame and glass £7.10.0.
1855	238	*The Peat-Moss Banavie, Inverness-shire*, 18gns., Frame and glass £2.2.0.
1855	260	*The Fish Girl*, 12gns., John Elgar Esq., Frame and glass £1.5.0.
1855	282	*The Cloister*, 16gns., Robert Hayes, 60 Russell Square, Frame and glass £1.10.0.
1855	283	*St. Leonard's-on-Sea*, 10gns., Richard Ellison Esq.

RICHARDSON T M JUN

1843	7	*Como - from the Milan Road*, 50 Pounds.
1843	61	*Ulleswater, from Gowbarrow Park, Cumberland*, 50 Pounds.
1843	161	*Castle of Katz, St. Goarhausen, Rhine*, 10 Pounds, Hy. Vaughan, 28 Cumberland Terrace, Regents Park.
1843	176	*Elvet Bridge, Durham*, 30 Pounds.
1843	191	*Bala Lake, North Wales*, 10 Pounds, E. Fry, Plymouth, 17 Warkwich Square, in Warwick.
1844	25	*Devil's Bridge, Mont St. Gothard*, 10 Pounds, Bonham Carter Esq., Frame and glass £1.1.0.
1844	27	*Castle of Chillon, near Villeneuve, Lake of Geneva, "Lake Leman lies by Chillon's walls . . ." Byron's Prisoner of Chillon.* 30 Pounds, Frame and glass £2.4.0.
1844	36	*Looking towards Bellingham from Tone Crag, North Tyne, Northumberland*, 25 Pounds, Colonel Pennant, Frame and glass £2.4.0.
1844	108	*Moor Scene, near Bellingham, Northumberland*, 18 Pounds, Blake Esq., 62 Portland Place, Frame and glass £1.15.0.
1844	116	*Durham, from Crook Hall*, 25 Pounds, John Parsons Esq., High Street, Oxford, Frame and glass £2.2.0, P.AU.
1844	213	*Sunset - Bambrough Castle - Northumberland*, 60 Pounds, Colonel Pennant, 36 Belgrave Sq., Frame and glass £6.18.0.
1844	265	*Sand's End, near Whitby, Yorkshire*, 6 Pounds, Lord C. Townshend, Frame and glass £1.5.0.
1845	73	*Entrance to Borrowdale, Cumberland*, 30gns., Captain R.A. Olive R.N., Frame and glass £3.5.0.
1845	75	*Danseneau, on the Lahn, 2½ miles from Ems, Nassau - Morning*, 60 gns., Miss C. Craven, Stamford Hill, Frame and glass £6.0.0.
1845	97	*Derwentwater, Cumberland - Effect after a Shower*, 40gns., W.F. Moore Esq., Cronkbourne, Douglas, Isle of Man (Ewan Christian Esq., 44 Bloomsbury Sq.), Frame and glass £4.10.0, P.AU. 40£.
1845	131	*On the Moors, North Tyne, Northumberland*, 20gns., Thos. Burgoyne Esq., 48 Welbeck St., Frame and glass £2.5.0 (no).
1845	141	*On the Yorkshire Coast, near Whitby - Sunset*, 42 Pounds, Peter Fairbairn Esq., Woodsley(?) House, Leeds, Frame and glass £4.10.0 (touched up and regilded).
1845	144	*Wetterhorn - Grimdewald, Switzerland*, 25gns., C. Wm.(?) Packe Esq., 7 Richmond Terrace, Frame and glass £2.5.0.
1845	149	*In the Village of Sayn, on the Pretscz Bach, Prussia*, Sold.
1845	171	*Derwentwater, from above Lowdore - Skiddaw and Bassenthwaite Lake in the distance, Cumberland - Sunset*, 60gns., W. Hobson Esq., Frame and glass £6.0.0.
1846	8	*Brougham Castle, on the River Eamont, Cumberland - Evening*, 40gns., Frame and glass £6.5.0.
1846	28	*Trarbach, and Castle of Grafenburg, Moselle*, 65gns., Frame and glass £6.0.0.
1846	59	*Sallanche, Savoy, destroyed by Fire in 1841*, 65gns.
1846	69	*Castle of Grafenburg, Moselle, once the Residence of the Counts of Sponhiem - Built in the Fourteenth Century with an Archbishop's Ransom*, 65gns., Charles Prater Esq., 2 Charing Cross, Frame and glass £8.0.0 Sd.
1846	93	*Dunstanborough Castle, Northumberland*, 65gns., Lewin Loyd Esq., Connaught Place, Frame and glass £6.0.0 Not.
1846	126	*Cheviots, from Alnwick Moor, Northumberland*, 28gns., Mr. Nickolay(?).
1846	144	*Moor Scene, Lanarkshire - Rain passing away*, 40gns., To Mr. Griffiths with frame, Frame and glass £6.5.0.

1846	151	*Minnow Fishers, Mill in Borrowdale, Cumberland,* 35gns., Mr. Griffiths, frame also, Frame and glass £3.15.0.
1847	29	*Pont Aberglaslyn, North Wales,* 45gns., Mrs. Whewell, Cliff Cottage, Lowestoff, Frame and glass £6.0.0.
1847	47	*Fresh Breeze - Bass Rock,* 35gns., Frame and glass £6.0.0.
1847	79	*On the Coast of North Durham, with the Abbey of Lindesferne and Fern Islands in the distance,* 60gns., Frame and glass £9.0.0.
1847	97	*The Necker, from the Konigstuhl, Heidelberg,* 70gns., W.M. Dansey Esq., 41 Green St., Grosvenor Sq., Frame and glass £9.0.0, P.AU. 60£.
1847	112	*Old Gateway, Mayence,* 18gns., B. Gosling Esq., Frame and glass £3.3.0.
1847	123	*Castle of Chillon, Lake of Geneva,* 65gns., Frame and glass £9.0.0.
1847	171	*Goatfell Glen, Rossie, Isle of Arran,* 65gns., John Wild Esq., Clapham Lodge, Frame and glass £9.0.0, P.AU. 50£.
1847	249	*Snow Drift, Valley of Chamouni, Savoy,* 18gns., Lady Louise Pennant, Frame and glass £3.3.0.

RICHTER H

1813	224	*The Rod.*
1814	210	*The splendid Acquisition of Mambrino's Helmet by the Knight of the Rueful Countenance.*
1816	66	*Christ giving Sight to the Blind. An Attempt to improve upon a former Picture on the same subject, exhibited, in 1812, at the Rooms of the Associated Painters, in Old Bond-Street, and purchased from thence by the Directors of the British Institution.*
1819	13	*Falstaff acting the King. From the first part of Henry the Fourth, painted for W. Chamberlayne, Esq. M.P., "Falstaff. This chair shall be my state, this dagger my sceptre, and this cushion my crown.'"* 500gns., Mr. Chamberlayne.
1820	17	*The Tight Shoe. Painted for W. Chamberlayne Esq. M.P.,* £2.12.6.
1823	263	*A Picture of Youth; or, the School in an Uproar, A Second Picture of the Subject, painted by permission of W. Chamberlayne, Esq. M.P. from the original in his possession, for the purpose of being engraved.*
1823L	143	*The Logician's Effigy, "A dispute on a disputable subject . . ."* J. Allnutt, esq.
1823L	186	*The Dedication, "My Lord, – Not to know your Lordship were an ignorance beyond barbarism . . ."* – Webb, esq.
1825	77	*The School in Repose,* 250gns., Sold.
1826	32	*Annette and Lubin, painted for W. Chamberlayne, Esq. M.P. as a companion to the Brute of a Husband by the same Artist,* 300gns., Sold.
1827	101	*Taming of the Shrew, "Petruchio – 'Come I will bring thee to thy bridal chamber' . . ." Act IV.* Sold.
1827	349	*Maternal Advice.*
1828	261	*The Letter,* 25gns.
1828	267	*The Two Dromeo's, "Dromio of Ephesus.– 'Methinks, you are my glass, and not my brother: I see by you, I am a sweet-faced youth.'" – Comedy of Errors.* Sold.
1828	268	*A Study from the Life,* Sold.
1828	291	*The Wedding of Touchstone and Audrey, "Sir Oliver Mar-text. – 'Is there none here to give the woman?' . . ." As You Like It.* Sold.
1828	316	*Anne Page and Slender, "Anne. – 'I pray you, Sir, walk in.' . . ." Merry Wives of Windsor.* 25gns.
1828	324	*The Adventure of Gadd's Hill, "Prince Henry. – 'Falstaff, you carried your guts away as nimbly, with as quick dexterity, and roared for mercy, and still ran and roared, as ever I heard bull-calf.'" First Part of Henry IV.* 25gns.
1829	347	*Juliet,* Sold.
1829	369	*The Witch, "A sailor's wife had chesnuts in her lap . . ." Macbeth, Act I. Scene 3.* Sold.
1829	386	*Falstaff and Bardolph, "Falstaff. – 'Do thou amend thy face, and I'll amend my life . . .'" First Part of Henry IV. Act III.* Sold, Moon, Boys, & Graves, 6 Pall Mall.
1831	383	*The Witch's Flight.*
1831	424	*Childe Harold, "Oh! that the desert were my dweling-place . . ." Canto IV. CLXXVII.*
1832	3	*King Cophetua and the Beggar Maid, Vide Shakspeare, Old English Ballad.* 50gns.
1833	407	*Head of a Greek Girl,* 15gns., Mrs. Robert Mitfield, Fladongs(?) Hotel, The address may be found at any future time by applying to Hammersleys, Pall Mall.
1834	232	*Merry Wives of Windsor, "Bardolph – 'Sir John, there's one Master Brook below would fain speak with you and be acquainted with you . . .'"* 50gns.
1834	240	*Byron's Don Juan,* Sold.
1835	40	*A Greek Lady,* 10gns.
1835	59	*The Musical Amateur, "If music be the food of love, play on."* 65gns.
1835	75	*Juan and Haidee,* 20gns.
1835	122	*Juvenile Study,* 5gns., Col. Sibthorpe, No. 3 Albany, letter C.
1836	191	*The Dromios, "There is a fat friend at your master's house . . ." The Comedy of Errors.* 40gns., Private per order of Mr. Richter.
1837	248	*The Proposal,* Sold.
1837	253	*The Discovery,* 10gns.
1837	290	*The Lover's Asylum,* Sold.

1837	296	*Sacred Music*, 10gns.
1837	305	*The Young Zoologist*, Sold.
1837	323	*Reflection*, Sold.
1838	10	*A Woman Knitting.*
1838	221	*Reflexion.*
1838	228	*A Gypsey Girl.*
1838	238	*A Scene from Pickwick - The Fat Boy discovering Mr. Tupman and the Spinster Aunt in the Spider Bower.*
1838	247	*The Goldfinch.*
1838	292	*The Grapes.*
1838	306	*Evening Prayer.*
1839	153	*The Amateur*, 8gns., Wm. Hobson Esq., 43 Harley Street.
1839	163	*A Girl Plaiting her Hair*, 10gns., Jacob Montefiore Esq., 24 Tavistock Square.
1839	232	*The Ringlet*, 10gns., John Poynder, Bridewell Hospital, New Bridge Street.
1839	248	*Gypsies*, 40gns., own order.
1840	18	*The Reverie.*
1840	115	*The Artist.*
1840	211	*Girl with a Pitcher.*
1840	277	*Il Penseroso.*
1841	224	*The Witch's Progress. (A Pictorial Romance; one of a Series of Designs Illustrative of the Demoniacal Superstition of the Middle Ages), "I will as soon believe, with kind Sir Roger, That old Moll White took wing with cat and broomstick . . ." Old Play – See Walter Scott's Monastery.* 70gns.
1841	263	*Head of a Gypsy Girl*, 6gns., Col. Sibthorpe M.P., 2 Delahay Street.
1841	285	*The Youthful Saviour*, 10gns., Own order.
1842	98	*The Billet-Doux.*
1842	135	*The Bouquet.*
1842	269	*Annot Lyle.*
1842	283	*Contemplation.*
1842	308	*"Touchstone. 'And how, Audrey? Am I the man yet? . . .'" As You Like It.*
1842	325	*Nouzhatoul Aouadat, the favourite of the Princess Zobeide, bringing to her husband Abou Hassan the purse of gold and the piece of brocade given by her mistress to provide for his pretended funeral. "Get up, said she, and behold the fruits of my imposition upon Zobeide; we shall not die of hunger to day." Arabian Nights' Entertainments.*
1842	335	*The Peasant Girl.*
1843	300	*Hebe*, 20gns.
1843	349	*A Scene from the novel of The Trustee, " 'Come, Kate, we will sign the contract at once;' and he laid the parchment before her". Vol. 1, page 329.* Sold.
1843	358	*A Scene from the Novel of The Trustee – The Return of Father Lawrence, "The two sisters led their revered friend to a seat, and one sat by his side and the other at his feet, each holding a hand, and looking in his venerable face, while the bright drops ran down their own youthful cheeks." Vol. 2, page 231.* Sold.
1844	121	*A Peasant Girl*, 25 Pounds, Robert Johnston Esq., 87 Lower Gardiner St., Dublin (63 Ebury Street, Pimlico), Frame and glass £4.2.6.
1844	166	*A Scene from the Merry Wives of Windsor, "Shallow. – 'Break their talk, Mistress Quickly; my kinsman shall speak for himself.' . . ." Act III., Scene 4.* Sold.
1844	263	*A Child with Grapes*, 20 Pounds.
1845	41	*A Peasant Girl*, Sold.
1845	79	*Contemplation*, 40gns.
1845	203	*The Parting of Romeo and Juliet*, 90gns.
1846	6	*La Jardinière*, Sold.
1846	73	*Sancho Panza's consolatory advice to his Master, after the misadventure, in which they have been overrun by the Bulls*, 80gns., Frame and glass £5.10.0.
1847	151	*The Grandmother*, Sold.
1847	159	*A Cottage Girl*, 35gns.
1847	291	*Evening*, Sold.
1848	7	*Justice Shallow entertaining Falstaff in the Arbour, 2nd Part King Henry IV.* 100 Pounds.
1848	232	*Head of a Child*, Sold.
1849	318	*The Capuchin Father.*
1849	346	*The Gipsey.*
1850	196	*The Tempest*, Sold.
1851	49	*The Sailor's Yarn.*
1852	163	*Devotion*, Sold.
1853	234	*Lavinia.*
1854	268	*A Girl's Head*, £6.0.0.
1854	350	*Castles in the Air*, 14gns., W. Duckworth, 38 Bryanston Square.
1855	309	*The Fool and Audrey from As You Like It, "Well, Audrey, am I the man yet?" – Shakspeare.* 16gns., Miss E.Clarke, 17 Royal Parade, Cheltenham, Frame and glass £2.12.6.

RIGAUD S

1805	140	*Satan discovered at the bower of Adam and Eve, "Back stepp'd those two fair angels half amaz'd . . ." Milton's Paradise Lost, Book iv.*
1805	150	*Oegle, Chronis, and Mnasylus binding Sileuus's hands, and dying his face with mulberries, Virgil's Sixth Pastoral.*
1805	173	*Leucades leap.*
1805	174	*Madona and child.*

1805	195	*Genius and Labour rewarded, a design for a new gold medal of the Society for the encouragement of Arts, &c.*
1805	197	*Genius roused by the voice of Fame: a design for a new gold medal of the Society for promoting Arts, &c.*
1806	49	*The Temple of Venus, a sketch.*
1806	88	*The Death of Nelson, allegorically represented by the figure of Death with the inverted torch, crowned by Victory and eternal Fame.*
1806	97	*Damon and Musidora, a sketch, "Thrice happy swaine! A lucky chance . . ." Thompson's Seasons – Summer.*
1806	108	*Christ appearing to the two Marys, after his Resurrection, St. Matthew, ch. xxviii. v. 9.*
1806	112	*Lavinia and her Mother, Thompson's Seasons.*
1806	120	*Martha and Mary - St. Luke, ch. x, v. 41 and 42.*
1806	222	*The Miller's Maid, from Bloomfield's Tales.*
1806	259	*Vinvela's Ghost, from Ossian's poem of Carric Thura, "She fleets, she sails away as grey mist before the wind . . ."*
1807	18	*"Hark! they whisper - Angels say, Sister spirit, come away." Pope's Dying Christian.*
1807	26	*From the ballad of "The dead of the night."*
1807	39	*From the ballad of "The dead of the night."*
1807	52	*"Lend, lend your wings! I mount, I fly! O grave, where is thy victory? O death, where is thy sting?"*
1807	54	*Sin and Death passing through the universe, "They with speed Their course through thickest constellation held . . ." Milton's Paradise Lost, Book X.*
1807	103	*The penitent, "There is joy in the presence of the angels of God over one sinner that repenteth." St. Luke, ch. xv. verse 10.*
1807	221	*Belphoebe - Vide Spencer's Fairy Queen, Book IV. Canto 8.*
1807	287	*Belphoebe. – Vide Spencer's Fairy Queen Book IV. Canto 7.*
1807	288	*Belphoebe. – Vide Spencer's Fairy Queen, Book IV. Canto 8.*
1807	294	*The Genius of painting contemplating the rainbow.*
1808	87	*The airy hall of Fingal, "Malvina rises in the midst, a blush is on her cheek . . ." Ossian's Poem of Berrathon.*
1808	109	*A sketch from the songs of Selma. – Ossian.*
1808	202	*Malvina lamenting the death of Oscar, "The virgins saw me silent in the hall, and they touched the harps of joy . . ." Ossian's Poem of Croma.*
1808	247	*Joseph's brethren discovering the money in their sacks, Genesis, chap. xlii.*
1808	248	*The dream of Fingal, Ossian's Poem of Fingal, Book IV.*
1808	252	*Mary at the sepulchre, St. John, chap. xx. 11 and 12.*
1808	267	*Jesus at the tomb of Lazarus, "Then when Mary was come where Jesus was, and saw him . . ." St. John, chap. xi. 32.*
1808	276	*Mary anointing the feet of Christ, St. John. chap xii. v. 2 and 3*
1809	18	*The pursuit, "He wond'ring views the bright enchantment bend . . ." Vide Thompson's Seasons, Spring.*
1809	27	*The disappointment, "Amaz'd, Beholds the amusive arch before him fly . . ." Vide Thompson's Seasons, Spring.*
1809	113	*The well in Hyde Park.*
1809	124	*Telemachus discovers the priest of Apollo. – Book II.*
1810	101	*St. Cecilia, Dryden's Alexander's Feast.*
1810	161	*Belphoebe, "And ever when she nigh approach'd, the dove . . ." Spencer's Fairy Queen, Book IV. Canto 8.*
1810	270	*"And Nathan said unto David, Thou art the Man," Second Book of Samuel, Chap. XIII. Verse 7.*
1811	11	*Cornelia shewing her Children as her Jewels.*
1811	130	*The Death of Hyacinthus.*
1811	148	*Hannah's Prayer, The first book of Samuel, Chaper 1.*
1812	3	*Malvina listening to the Song of Ossian.*
1812	4	*Ossian presaging his own Death, "Does the wind touch thee, O Harp, or is it some passing Ghost? It is the hand of Malvina!"*
1812	101	*Ericthonius discovered by the Daughters of Cecrops, Ovid's Metamorphoses, Book II, Fable 8.*
1812	117	*Venus presenting Cupid to Calypso, Fenelon's Telemachus, Book VII.*
1812	160	*Electra at the Tomb of Agamemnon, having poured Libations to his Shade, discovers the Hair of Orestes on the Tomb.*
1812	242	*The Virgins consoling Malvina for the loss of Oscar, "The Virgins saw me silent in the Hall; they touch'd the Harp of Joy . . ." Ossian's Poem of Croma.*
1812	269	*Diana and Endymion.*
1812	304	*Then was Jesus led up of the Spirit into the Wilderness. St. Matthew, Chapter iv. Verse 1.*

RIVIERE H P

1852	6	*A Turn of the Scale - See-saw*, 70G, Frame and glass £8.8.0.
1852	123	*Girl at the Spring*, 1G, Frame and glass £2.0.0.
1852	229	*The Latest Intelligence*, 25G, J. Ryman Esq., Frame and glass £2.2.-, Riviere returns from Ireland about 10 August.

1852	306	*A Doubt about the Flavour*, 25, Foord(?), Frame and glass £2.2.0.
1853	29	*Good Humour.*
1853	42	*The Village Dance.*
1853	110	*A Bit of Blarney.*
1853	121	*A Little Botheration.*
1853	161	*A Letter from the Diggings.*
1853	260	*Oh, Sleep thee, my Darling.*
1854	5	*The First Notice*, Sold.
1854	23	*Recollections of the Past*, 25gns., S.E.(?) Behrens, 5 Lansdowne Crescent, Cheltenham.
1854	47	*Pleasant Companions*, 25gns.
1854	165	*St. Patrick's Day in the Morning*, "Success to you, Pat, With your sprig of shillelah and shamrock so green." 60gns., ?? Bull, Didsbury Lodge, Nr. Manchester.
1854	217	*The Irish Milk Girl*, "Pretty maidens, here am I, With my milk and rattling cry . . ." 30gns.
1854	224	*St. Patrick's Day in the Evening*, "With his own darling Kate, So neat and complete, And he dancing a tight Irish jig." 60gns., Josh. Bull, Didsbury Lodge, Nr. Manchester.
1854	228	*The Top of the Morning to You!*, Sold.
1854	234	*An Irish Peasant Girl*, 10gns.
1855	52	*A Stop on the Road*, 40gns.
1855	60	*The Effects of Single Life, or a Stitch in Time saves Nine*, 15gns., James Dunlop, Priory Lodge, Largs, by Greenock.
1855	189	*The Little Favourite*, 50gns.
1855	214	*Ducks*, 30gns.
1855	216	*Taste It*, 50gns.
1855	218	*Peggy on her Low-backed Car*, "Sweet Peggy round her car, Sir, Has strings of ducks and geese . . ." 60gns.

ROBERTS J A

1813	2	*A Drawing from Spenser's Fairy Queen - The Red Cross Knight comes to the House of Pride.*

ROBERTS T S

1816	45	*Mountain View, Shower passing off the County of Wicklow, Ireland.*
1816	73	*A View from Nature, Old Court, Ireland.*

ROBERTSON A

1816	18	*Portrait of Mr. Travers.*
1816	19	*Portrait of Mrs. Travers.*
1816	32	*Portrait of Mrs Gordon.*
1816	192	*Portrait of Mr. J. Speyer, a Sketch.*
1816	204	*Portrait of a Young Lady, Sketch.*
1817	137	*Portrait of a Lady.*
1817	138	*Portrait of Mrs Carter.*
1817	155	*Portrait of a Lady.*
1817	156	*Portrait of a Gentleman.*

1817	157	*Portrait of Miss Tate.*
1817	158	*Portrait of Edward Bovill, Esq.*
1818	162	*A Frame containing the Portraits of Mrs Archibald Constable, Archibald Leslie, Esq. and Miss A. Hunter.*
1818	170	*Portrait of a Lady. A Sketch.*
1818	194	*A Frame containing the Portraits of Mrs. T. Glyn, Mr. Gisborne and Miss Bigge.*
1819	163	*Portrait of the Right Hon. Lord Weymouth.*
1819	168	*Portrait of Mrs. Scott.*
1819	169	*Portrait of Mr. Templeman.*
1819	174	*Portraits of G .Strickland Esq. Miss Sherlock, and J. Fraser Esq.*
1819	180	*Portraits of the Rt. Hon. Earl of Denbigh, J. A. Warre, Esq and of a Lady.*
1820	167	*Portrait of a Lady, Henry Wilkinson, Esq. and David Hunter Esq.*
1820	186	*Portraits of Mrs. Martin Ware, George Broaderick Esq. and Mrs. Broaderick.*
1820	200	*Portrait of George Abercrombie Robinson, Esq. Jun.*
1820	202	*Portraits of Miss Charlotte Smith, Martin Barraud, Esq. and William Moir Esq.*

ROBERTSON C J

1813	15	*Portrait of Lady Anderson.*
1813	113	*Portrait of J.P. Clarke Esq. of Welton-Place.*
1813	116	*Portrait of Mrs. Clarke, of Weston-Place.*
1813	241	*Portrait of Sir Henry Nelthorpe.*
1813	246	*Portrait of Lady Nelthorpe.*
1815	10	*Portrait of Leigh Hunt, Esq.*
1815	26	*Portrait of Miss Lucy Cracroft.*
1817	140	*Portraits of the Children of the Hon. Charles Pelham.*
1817	152	*Portrait of Mrs. Robertson.*
1818	157	*Portrait of the Hon. Mary Coventry.*
1818	167	*Portrait of the Daughter of John Cox, Esq.*
1818	169	*Portrait of John Cox, Esq.*
1818	173	*Portrait of a Young Lady.*
1818	174	*Portrait of Miss Matilda Hodges.*
1818	187	*Portrait of Mrs. William Robertson, of Quebec.*
1818	188	*Portrait of George Brummel, Esq.*
1820	151	*Ariel*, "I come To answer thy best pleasure; be't to fly . . ."
1820	166	*Portrait of her Grace the Duchess of St. Alban's.*
1820	172	*Portrait of a young Lady.*
1820	199	*Portrait of T. R. Gower, Esq.*
1820	207	*Portrait of Mrs. Frederic Johnston.*

ROBERTSON J

1817	185	*View in Darley Dale, Derbyshire.*

1817 197 *View in Darley Dale, Derbyshire.*

ROBSON & HILLS

1832 98 *The Charlton Woods, near Greenwich, (a Study from Nature) with Fallow Deer, 30gns., Mr. R. Lugar(?), 53 Gt. Marlborough St.*

ROBSON F

1829 127 *Loch Corisken and the Coolin Mountains, in the Isle of Sky, "Stranger! if e' er thine ardent step hath traced The northern realms of ancient Caledon . . ." Scott's Lord of the Isles. 65gns.*

ROBSON G

1822 34 *Y-Trivaen Mountain, Caernarvonshire, £42.0.0, G.H.D. Pennant Esq.*

1825 232 *Pont Aberglaslyn, Sold.*

ROBSON G F

1813 34 *Ben Lodi, Scotland.*

1813 75 *Richmond Castle, Yorkshire.*

1813 79 *The upper end of Loch Lomond, from Glen Falloch, Ben Lomond in the distance.*

1813 157 *Ben Lomond from the West.*

1813 160 *Ben Nevis and Loch Eil.*

1814 27 *View in the Interior District of the Grampian Mountains, on the Banks of Loch Avon.*

1814 281 *Ben More and Glen Dochart, from the Road between Loch Earn Head and Killin.*

1815 89 *Dunkeld, Perthshire.*

1815 100 *The Firth of Clyde, near Dumbarton.*

1815 104 *View near Loch Tumel, £3.3.0, Mr. Wilby.*

1815 105 *Ben Lomond, from Loch Ard, £3.3.0, Do.*

1815 110 *Tennoch side, Clydesdale.*

1815 112 *Durham Cathedral.*

1815 119 *Ben Vorlich, from Loch Earn, Perthshire.*

1815 124 *Durham.*

1815 125 *Bishops Auckland, Durham.*

1815 131 *Doune Castle. Stirling in the Distance, £5.5.0, G. Hibbert Esq.*

1815 132 *Stirling Castle, £5.5.0, Do.*

1815 149 *Boniton Linn, on the Clyde.*

1815 156 *Upper Fall of Moness, Perthshire.*

1815 158 *Conisborough Castle, Yorkshire.*

1815 169 *Rainbow, Castle Eden Dean, Durham.*

1815 250 *Southampton.*

1815 271 *Falls of Moness, Perthshire.*

1815 281 *Ben More, a Mountain in Perthshire.*

1815 305 *Hamilton, Clydesdale.*

1815 311 *Loch Katrine and Ben Lomond, £5.5.0, G. Hibbert Esq.*

1815 312 *Ben Venue, from the head of Loch Achray, £5.5.0, Do.*

1816 88 *Cascade, on the Banks of Loch Tay.*

1816 90 *View near Durham.*

1816 92 *Distant View of Carisbrook Castle, Isle of Wight.*

1816 94 *Waterfall at Inversnaid, on the Banks of Loch Lomond.*

1816 96 *View near Hastings.*

1816 98 *View near Hastings, Beachy Head in the Distance.*

1816 99 *Dunkeld.*

1816 102 *Hastings, a Study from Nature.*

1816 108 *View on the Coast, at Hastings.*

1816 167 *The Upper end of Loch Catherine.*

1816 168 *Ben Venue and the Trosacks.*

1816 171 *Durham.*

1816 175 *View on the Tay, near Dunkeld.*

1816 176 *View on the Garry, near Blair in Atholl.*

1816 185 *View on Windermere.*

1816 186 *View on Windermere.*

1816 213 *Hastings Castle.*

1816 214 *Rocks, near the Priory, Hastings.*

1816 232 *The Peak Castle, Derbyshire.*

1816 239 *Ben Ledi, Perthshire.*

1816 247 *Scene at the Upper End of Loch Long, Dumbartonshire.*

1816 252 *Loch Katerine and Ben Lomond.*

1816 255 *Cascade at Inversnaid, on the Banks of Loch Lomond.*

1816 260 *Ben Venue, and Loch Katerine.*

1816 261 *Ben Venue, Loch Achray, and the Trosacks.*

1816 286 *Ben Lomond, from the Upper End of Loch Lomond.*

1816 287 *Stirling Castle.*

1816 291 *Salisbury.*

1816 310 *Cascade, near the Trosacks.*

1816 322 *Scottish Firs, in the Church-yard at Killin, Perthshire.*

1817 3 *View on Loch Katerine, £6.6.0, Honble. Mrs. Basil Cochrane.*

1817 4 *Stirling Castle.*

1817 13 *View on the upper part of Loch Lomond, with Ben Lomond, £12.12.0, Lord Suffolk.*

1817 15 *Roslin Castle.*

1817 16 *Scene on the Clyde, at the top of Corri Lyn. A Study from Nature.*

1817 17 *Doune Castle, Perthshire.*

1817 21 *Loch Achray and Ben Ledi, from the east side of Ben Venue, "The minstrel came once more to view . . ." Lady of the Lake. £14.14.0, Walter Fawkes Esq.*

1817 22 *Boniton Lin, one of the Falls of the Clyde, Lanarkshire.*

1817	23	*A Study from Nature, near the Trosachs, Perthshire.*
1817	173	*St. Alban's Abbey, Herts.*
1817	174	*Edinburgh.*
1817	175	*London.*
1817	194	*Landscape, Ben Nevis in the distance; the Figures by J. Cristall, "With morning we awaked the woods, and hung forward on the path of the roes . . ." Ossian.* £52.10.0, Walter Fawkes Esq.
1817	211	*Waterloo Bridge from Privy Gardens. Early Summer Morning,* £31.10.0, T.G.
1817	212	*View near Callander, Perthshire. Benledi in the distance,* £14.14.0, R. Maundrell Esq., Ipswich.
1817	227	*Doune Castle, Perthshire, Stirling in the Distance.*
1817	232	*Bothwell Castle, Lanarkshire.*
1817	237	*View near Digswell, Herts.*
1817	247	*Trees studied from Nature,* £2.2.0, Mr. Chipchase.
1817	277	*Imogen entering the Cave, "But what is this? Here is a path to't – 'tis some savage hold." Cymbeline.* £6.6.0, Lord Suffield.
1817	284	*The Heath Scene from the Tragedy of Macbeth,* £6.6.0, Do. [Lord Suffield].
1817	286	*An Old Oak.*
1817	290	*The Bridge at Callander, Perthshire, Benledi in the Distance.*
1817	291	*View near Digswell, Herts.*
1817	292	*View near Digswell, Herts.*
1818	1	*Under Cliff, near St. Lawrence, Isle of Wight.*
1818	12	*Hagar and Ishmael.*
1818	14	*The Upper Part of Loch Lomond. Ben Lomond in the Distance.*
1818	36	*Black Gang Chine, Isle of Wight.*
1818	212	*Brook Church, Isle of Wight.*
1818	216	*St. Alban's Abbey.*
1818	218	*Landscape - Evening.*
1818	219	*View at Bear Park, Durham.*
1818	237	*View at Invercauld, Aberdeenshire - Ben-y-bourd in the Distance.*
1818	238	*Scene at the head of Glen Dee, Aberdeenshire.*
1818	241	*Loch Tumel, Perthshire.*
1818	242	*Loch Lomond.*
1818	243	*Scene on the Road at Bonchurch, Isle of Wight.*
1818	245	*View on Loch Katerine,* £52.10.0, T.G.
1818	246	*Bishop's Aukland, Durham.*
1818	251	*Loch Avon, Aberdeenshire.*
1818	252	*Ben-y-Gloe, Perthshire.*
1818	258	*Kilchurn Castle, on Loch Awe; Ben Loi in the Distance.*
1818	259	*Ben Lomond, from Loch Ard,* £5.5.0, J. Holden Esq.
1818	263	*Corfe Castle, Dorsetshire.*
1818	272	*Durham.*
1818	277	*Cottages at Bonchurch, Isle of Wight.*
1818	290	*Durham Cathedral,* £26.5.0, T.G. (Mr. Griffiths).
1818	294	*Fall of the River Tumel near Fascaly, Perthshire,* £12.12.0, Lord Suffolk.
1818	301	*View in Brae-Mar, Aberdeenshire.*
1818	311	*Undercliff, near Sandrock Spring, Isle of Wight.*
1818	314	*View near Newport, Isle of Wight, Carisbrook Castle in the Distance.*
1818	330	*Doune Castle, Perthshire, Stirling in the Distance,* £12.12.0, Mr. Knowlys.
1818	343	*Corfe Castle, Dorsetshire. Misty Morning.*
1818	364	*View of St. Lawrence, Isle of Wight.*
1818	365	*Under Cliff near Nighton, Isle of Wight.*
1819	21	*Durham.*
1819	145	*Lock Katerine - Ben Venue, &c.*
1819	146	*Loch Achray.*
1819	147	*Cadets Barracks, Woolwich.*
1819	151	*View on Loch Lomond.*
1819	152	*Ben Venue.*
1819	153	*The Royal Artillery Barracks, Woolwich.*
1819	176	*Corfe Castle, Dorsetshire.*
1819	193	*View from the Artillery Barracks, Woolwich.*
1819	195	*View from Maidenhead Bridge.*
1819	199	*Scene near Loch Tumel, looking towards the Pass of Killicrankie, Perthshire.*
1819	220	*Corfe Castle, Dorsetshire.*
1819	223	*Cane Grove in the Island of St. Vincent, the property the Hon. James Wilson.*
1819	235	*The Upper Part of Loch Lomond.*
1819	244	*Boniton Lin - a Fall of the River Clyde.*
1819	246*	*Ben Lomond from Loch Ard, Perthshire.*
1819	262	*Glen Falloch, the upper part of Loch Lomond, and Ben Lomond in the distance,* £78.15.0, T.G., including frame and glass.
1819	267	*View near Shooter's Hill, Kent.*
1819	268	*View near Woolwich, the Sydenham Hills in the distance.*
1819	272	*View on the River Wear, at Sunderland, Durham.*
1819	279	*Richmond, Yorkshire.*
1819	299	*Whale Chine - Isle of Wight.*
1819	305	*The Rumbling Brig, near Dunkeld.*
1819	306	*Black Gang Chine - Isle of Wight.*
1819	311	*Black Gang Chine - Isle of Wight.*
1819	313	*Shanklin Chine - Isle of Wight.*

1819	321	*Luccomb Chine - Isle of Wight.*
1819	325	*Luccomb Chine - Isle of Wight.*
1819	332	*Walpan Chine - Isle of Wight.*
1819	333	*Luccomb Chine - Isle of Wight.*
1820	2	*The Pass of Aberfoyle, Scotland.*
1820	3	*The Pass of Killicrankie.*
1820	12	*Morning Twilight.*
1820	23	*Sun Set.*
1820	223	*View on Loch Lomond.*
1820	229	*Llyn Idwal, North Wales, £15.15.0, Walter Fawkes Esq.*
1820	233	*Loch Katerine, "And thus an airy point he won . . ." Vide Lady of the Lake.*
1820	258	*Arundel Castle, Sussex.*
1820	271	*Distant View of Penrhyn Castle, North Wales.*
1820	280	*Snowdon, £63.0.0, G.H.D. Pennant Esq.*
1820	286	*Aqueduct in the Vale of Llangollen, £21.0.0, T.G.*
1820	290	*A Water-fall at Inversnaid, on the Banks of Loch Lomond, £10.10.0, T.G.*
1820	319	*Durham.*
1820	335	*Stratford Church, the Burial-place of Shakespeare, "This night, methinks, is but the daylight sick . . ." Merchant of Venice.*
1820	337	*St. Lawrence, Isle of Wight.*
1820	339	*View from the Grounds of Penrhyn Castle, looking towards Nant Frangon.*
1820	352	*Penman-Mawr, from the Grounds of Penrhyn Castle.*
1820	361	*View on Loch Lomond.*
1821	5	*Twilight, "The west yet glimmers with some streaks of day . . ." Shakspeare. £42.0.0, Rt. honble. R. Peel.*
1821	10	*View on Loch Lomond, Ben Lomond in the distance, £21.0.0, E. Harman Esq.*
1821	14	*The Mountains of Carnedd - Llewelyn and Carnedd Dafyd, from the Road near the Slate Quarries in Nant Frangon, North Wales, £21.0.0.*
1821	32	*Llyn Idwel, North Wales, £63.0.0, G.H.W. Pennant Esq.*
1821	37	*Winchester Cathedral, from the Andover Road, £12.12.0, J.G. Lambton Esq., M.P.*
1821	39	*Scene at Killin, Perthshire; the Burial Place of the Chiefs of Mac-Nab, Ben Lawers in the distance - Twilight, £26.5.0, J. Allnutt Esq.*
1821	40	*Stirling Castle, £36.15.0, T.G.*
1821	41	*The Aqueduct in the Vale of Llangollen, North Wales, £12.12.0.*
1821	46	*All Saints Church, Hastings, £3.3.0.*
1821	53	*Study at the Fish Ponds, Hastings, £2.2.0.*
1821	63	*Doune Castle, Perthshire; Stirling in the distance - Morning, £42.0.0, Mr. Windus.*
1821	66	*East Cliff, Hastings - Sun-rise.*
1821	73	*View on Loch Erne, Perthshire - Ben Vorlich in the distance, £14.14.0, F. Holbroke Esq.*
1821	76	*Hastings, £5.5.0.*
1821	85	*Study near Fairlight, Hastings.*
1821	94	*The Dripping Well, near Hastings, £2.2.0.*
1821	103	*The Aqueduct at Chirk, North Wales, £12.12.0.*
1821	114	*Loch Avon, Aberdeenshire.*
1821	117	*Study of Trees on Clapham Common.*
1821	122	*Durham - Evening, £63.0.0, J. Allnutt Esq.*
1821	126	*Study from Nature.*
1821	136	*Lock Katerine, from an eminence on the Trosacks - Sun-set, £21.0.0, E. Harman Esq.*
1821	145	*Pembroke Castle, South Wales.*
1821	152	*Scene near Hastings.*
1821	183	*View at Stratford upon Avon - The Tomb of Shakespeare is situated between the Windows seen in the Church, "Thou soft flowing Avon, by thy silver stream . . ." Garrick. £16.16.0, Mrs. Jones.*
1821	186	*The Bridge at Callander, Perthshire - Ben Ledi in the distance.*
1822	1	*Norwich.*
1822	9	*Edinburgh, "Such misty grandeur crown'd the height . . ." £16.16.0, Mrs. Jones.*
1822	20	*York, £52.10.0, J.G. Lambton Esq., M.P.*
1822	29	*Ely, £21.0.0, E. Tattersall Esq.*
1822	51	*The upper part of Loch Lomond, £7.7.0, Mr. Ware ??????.*
1822	52	*Waterloo Bridge, £7.7.0, Mr. Hicks.*
1822	55	*Vale of Llangollen, £14.14.0, E. Tattersall Esq.*
1822	57	*Kilchurn Castle, Loch Awe, £7.7.0, Mr. Ware.*
1822	58	*Park Scene - Morning, £21.0.0, J. Walters Esq.*
1822	60	*Doune Castle, Perthshire, £42.0.0, Mr. Windus.*
1822	62	*Dunkeld.*
1822	65	*View near Oakingham, Berks, £5.5.0, Mr. Walters.*
1822	84	*Llyn Ogwen, Caernarvonshire, £42.0.0, G.H.D. Pennant Esq.*
1822	105	*Pont Aberglaslyn.*
1822	125	*Worcester, £17.17.0, J. Webster Esq.*
1822	127	*Fall of the Clyde, at Stone Byers, £4.4.0, Mrs. Jones.*
1822	162	*View from the Doune, Rothiemurchus, Invernesshire, £5.5.0, J. Vine Esq.*
1822	174	*East Cliff, Hastings.*
1823	8	*View on Loch Awe, Argyleshire, Kilchirn Castle and Ben Loi in the distance.*
1823	17	*Stirling Castle.*
1823	25	*Cottage in the Isle of Wight.*

1823	30	*Grange Chine, Isle of Wight.*
1823	31	*View on the Road between Callander and Loch Earn-head, Perthshire; part of Ben Ledi and Loch Lubnaig in the distance.*
1823	33	*View from the Ferry of Inversnaid, on the Banks of Loch Lomond,* £12.12.0, Countess of Mansfield.
1823	36	*Carisbrooke Church, Isle of Wight.*
1823	38	*Gateway at Carisbrooke Castle, Isle of Wight.*
1823	48	*The Pass of Killicrankie, near Blair Athol, Perthshire, "The western waves of ebbing day . . ."* £36.15.0, T.G.
1823	87	*Forest Glade - a Study from Nature.*
1823	92	*Solitude, a Scene in the interior range of the Grampian Mountains, on the Banks of Loch Avon, Aberdeenshire,* £63.0.0, G. Haldimand Esq.
1823	93	*Durham.*
1823	95	*View in Berkshire.*
1823	99	*Wood Scene - Study from Nature.*
1823	104	*Corn-field - a Study from Nature.*
1823	105	*View on Loch Katerine, Perthshire - Ben Lomond in the distance.*
1823	117*	*View on the Coast near Brixton, Isle of Wight.*
1823	133	*Bearns Chine, Isle of Wight.*
1823	140	*Cowlease Chine, Isle of Wight.*
1823	145	*Sneaton Castle, near Whitby, Yorkshire, the Residence of – Wilson Esq.*
1823	147	*View at the bottom of the Ravine through which the River Clyde flows, between the Falls of Boniton and Corri-lin.*
1823	150	*Shipledge Chine, Isle of Wight.*
1823	153	*Ladder Chine, Isle of Wight.*
1823	166	*Aqueduct in the Vale of Ceiriog near Chirk, North Wales.*
1823	169	*Shanklin Chine, Isle of Wight.*
1823	171	*Brook Chine, Isle of Wight.*
1823	175	*Beech Trees - Morning.*
1823	180	*Canterbury - Evening.*
1823	181	*Study of Trees near Oakingham, Berks.*
1823	183	*Study near Oakingham, Berks.*
1823	186	*Chilton Chine, Isle of Wight.*
1823	197	*Boniton Lin, a Fall of the River Clyde.*
1823	212	*The Falls of Ben Glog and Trivaen Mountain, from the head of Nant Frangon.*
1823	224	*Evening.*
1823	233	*Glyder Vawr, from the Outlet of Llyn Ogwen, with the new Bridge over which the Holyhead Road passes at the Head of Nant Frangon.*
1823	240	*Cascade near Aberfoyle, Perthshire.*
1823	246	*Upper Fall of Moness, Perthshire.*
1823	255	*Falls of the River Lochay, near Loch Tay.*
1823	277	*Chips Chine, Isle of Wight.*
1823	278	*Druidical Stone near Motteston, Isle of Wight.*
1823	281	*Luccomb Chine, Isle of Wight.*
1823	289	*The East End of Loch Katerine.*
1823L	34	*Twilight, "The west yet glimmers with some streaks of day:– Now spurs the lated traveller apace, To gain the timely inn."* Rt. Hon. R. Peel, M.P.
1824	1	*Scene on the Clyde, near the Falls, Lanarkshire.*
1824	16	*View on the River Yore, near Aysgarth, Wensley Dale, Yorkshire.*
1824	25	*View on Loch Lomond.*
1824	28	*Lincoln.*
1824	45	*View from Maidenhead Bridge.*
1824	49	*Aysgarth Force, a fall of the river Yore, Wensley-dale, Yorkshire.*
1824	51	*Shanklin Chine, Isle of Wight.*
1824	52	*Durham.*
1824	55	*Glyder Vawr Mountain, from the outlet of Llyn Ogwen, Caernarvonshire.*
1824	58	*Grange Chine, Isle of Wight.*
1824	66	*Finchale Abbey, Durham.*
1824	69	*Durham.*
1824	75	*Loch Venachar, Perthshire.*
1824	77	*Durham.*
1824	78	*View in the Trosachs, Perthshire.*
1824	89	*The Head of Nant Frangon, and Falls of the river Ogwen, North Wales.*
1824	93	*St. Lawrence, Isle of Wight.*
1824	95	*Dunkeld, from the junction of the rivers Bran and Tay.*
1824	107	*Ben Ledi, and the Bridge at Callander - Perthshire.*
1824	113	*Llanberis Lake - Caernarvonshire.*
1824	127	*Snowdon, from Capel Cûrig - Caernarvonshire.*
1824	134	*View on Loch Katerine - Perthshire - Ben Lomond in the distance.*
1824	138	*Loch Katerine, and Ben Venue.*
1824	143	*Castle-Eden, Dean - Durham.*
1824	144	*Durham.*
1824	147	*The upper part of Loch Lomond.*
1824	152	*Conisborough Castle, Yorkshire.*
1824	153	*Study from Nature, at Layton, Essex.*
1824	157	*Doune Castle, Perthshire - Stirling in the Distance.*
1824	171	*View on the River Tees, near Rokeby, Yorkshire.*
1824	190	*Barnard Castle, Durham.*

1824	201	*Llyn Idwal, North Wales.*
1824	244	*Glen Dochart, Perthshire.*
1824	264	*View on the Banks - Durham.*
1824	290	*Ben Vorlich, and Loch Earn - Perthshire.*
1825	2	*Glen Dochart, Ben More &c. Perthshire,* 20gns., Frame and glass £5.18.0.
1825	7	*Ben Ledi, Perthshire,* 8gns.
1825	16	*Ben Nevis, Loch Eil, Invernesshire,* 20gns.
1825	31	*Kilchurn Castle, Loch Awe, Argyleshire,* Sold.
1825	39	*Barnard Castle, Durham, "Far sweeping in the west, he sees . . ." Rokeby.* £42.0.0.
1825	42	*Study from Nature, Isle of Wight,* 5gns.
1825	44	*Durham,* 25gns., F. Webb Esq.
1825	49	*Ben Lomond, from near Tarbet,* 9gns., N. Hebberts Esq.
1825	63	*Bala Lake, North Wales,* 10gns.
1825	86	*View near Brixton, Isle of Wight,* 10gns.(?), Lord Northwaite, No. 2 Connaught Place.
1825	96	*Ben Lomond from Loch Ard, Perthshire,* Sold.
1825	98	*Study from Nature,* 5gns., E. Durant Esq.
1825	116	*The upper part of Loch Katrine - Ben Venue in the distance,* 25gns.
1825	130	*Undercliff, near St. Lawrence, Isle of Wight,* Sold.
1825	131	*Box Hill and the surrounding Scenery from the new Road of W. J. Denison, esq M.P.,* Sold.
1825	143	*The Head of Nant Frangon - N. Wales,* 14gns., Francis Denver(?), Berkley Square.
1825	157	*View of Cnight, a Mountain seen from the Road between Pont Aberglaslyn and Tan-y-Bwlch,* 6gns.
1825	166	*Loch Lubnaig, Perthshire,* Sold.
1825	175	*West End of Durham Cathedral,* 40gns., Mr. Botcherby, Darlington.
1825	185	*Loch Lomond,* Sold.
1825	201	*View in Berkshire,* 6gns.
1825	202	*Loch Rannoch and Shichallion, Perthshire,* 14gns.
1825	205	*The East End of Loch Katrine, "The summer morn's reflected hue To silver changed Loch-Katrine blue . . ."* 60gns., Lord Willoughby de Broke, 21 Hill Street, Mr. Morant of Bond Street will pay and take away, frame and glass £12.12.0.
1825	208	*Snowden, from Capel Cûrig,* 6gns., Willimott Esq., H.M. Customs.
1825	212	*View near Bedale, Yorkshire,* Sold.
1825	257	*Ely,* 60gns., T. Griffith Esq.
1825	258	*Durham,* Sold.
1825	286	*View in the Pass of Killicrankie,* 5gns.
1825	290	*Falls of the Lochy, Perthshire,* 4gns.
1825	294	*View near Niton, Isle of Wight,* Sold.
1825	300	*East End of Loch Katrine,* 6gns., Whitmarsh Esq., Hampstead Heath.
1825	321	*Jervois Abbey, Yorkshire,* 9gns.
1825	323	*Shanklin Chine, Isle of Wight,* Sold.
1825	326	*Durham,* Sold.
1826	4	*Ulles Water, Cumberland,* 25gns., Sold.
1826	21	*Scene at the outlet of Llyn Ogwen, North Wales,* 40gns.
1826	27	*City of Norwich, from the East - to be engraved for Picturesque Views of the Cities of England from a Series of Drawings by,* 8gns., Sold.
1826	41	*Ulles Water, from Pooley Bridge, Cumberland,* 25gns., Sold.
1826	43	*Grouse Shooting, in Bredalbane, North Highlands,* 25gns., Sold.
1826	55	*View of the Upper Part of Loch Lomond,* 7gns., Sold.
1826	60	*Derwent Water and Walla Crag,* 5gns., Sold.
1826	68	*Bala Lake, North Wales,* 18gns.
1826	86	*Ulles Water, near Gowbarra Park,* 25gns., Sold.
1826	96	*Loch Avon, Aberdeenshire,* Sold.
1826	97	*Derwent Water,* 25gns., Sold.
1826	102	*Loch Lubnaig, Perthshire,* 20gns., Sold.
1826	136	*Loch Coruisk and the Cuchulin Mountains, in the Isle of Sky, "Stranger! if e'er thrine ardent step hath traced The northern realms of ancient Caledon, When the proud Queen of Wilderness hath placed By lake and cataract her lonely throne . . ." Scott's Lord of the Isles.* 60gns., Sold.
1826	145	*Ben Vorlich and Loch Earn, Perthshire,* 6gns., Rev. Dr. Sleath(?), St. Pauls School.
1826	152	*Trivaen, Caernarvonshire, North Wales,* 25gns., Sold.
1826	174	*Loch Lomond,* 20gns., Sold.
1826	188	*Ben Nevis and Loch Eil, Inverness-shire,* 25gns., Sold.
1826	194	*Grassmere Lake, Westmoreland,* 25gns., Sold.
1826	200	*Loch Katerine, from the Trosacks,* 7gns., Sold.
1826	206	*Scene at the outlet of Loch Tumel, Perthshire,* 6gns., Rev. Dr. Sleath(?), St. Pauls School, Frame and glass £1.5.0.
1826	209	*Loch Achray and Ben Venue,* 7gns., Sold.
1826	210	*Barnard Castle, Durham,* 12gns., Sold.
1826	228	*Ulles Water, near Gowbarra Park,* 25gns., Sold.
1826	259	*Ben More, Perthshire,* 25gns., Rev. Dr. Sleath, St. Pauls School, Frame and glass £5.10.0.
1826	272	*Llynn Idwal, North Wales,* 6gns.
1826	279	*Loch Katerine and Ben Venue,* 7gns., Sold.

1827	1	*Falls of the Keltie, near Callander,* 16gns.
1827	5	*Cruachan Ben, from the upper part of Loch Etive, Argyleshire,* 25gns., Sold.
1827	7	*Scene near Llyn Ogwyn, Caernarvonshire,* 25gns., Lord F. Leveson Gower, 12 Albemarle Street.
1827	19	*Barnard Castle, Durham,* 40gns., Mr. Fairlie, 49 York Terrace, Regent's Park.
1827	33	*View on Loch Achray, Perthshire,* 8gns., Sold.
1827	42	*Cuchulin Mountains, Isle of Sky,* 8gns., Sold.
1827	44	*View in St. John's Vale, Cumberland,* 7gns., Sold.
1827	46	*Scene at the Head of Nant-Frangon, North Wales, "O lover of the desert, hail! Say in what deep and pathless vale, Or on what hoary mountain side, Midst falls of water you reside, Midst broken rocks - a rugged scene, With green and grassy dales between, Where nature loves to sit alone, Majestic on a crag"* 40gns., Beaumont Swete, Jordans Hotel, St. James's Street.
1827	64	*Scene near the head of Loch Hourn, Inverness-shire,* 8gns., Sold.
1827	73	*Fall of Fyers, Inverness-shire,* 8gns., Sold.
1827	87	*Upper Fall of Fyers, Inverness-shire,* 8gns., Sold.
1827	107	*Ben Ledi, Perthshire,* 10gns., Lt. General Alexander Adams.
1827	112	*Newcastle,* 28gns., Sold.
1827	114	*Cnicht Mountain, North Wales,* 8gns., Sold.
1827	120	*Dunolly Castle, Obon, Argleshire,* 8gns., D. Campbell Esq., 70 Welbeck Street.
1827	122	*York - for the Work on the Cities of England, now publishing,* 9gns., Sold.
1827	123	*Canterbury, ditto,* 9gns., Sold.
1827	124	*Lincoln, ditto,* 9gns., Sold.
1827	139	*Blaven, from the head of Loch Slapin, Isle of Sky,* 8gns., Sold.
1827	152	*Derwent Water,* 8gns., Sold.
1827	191	*Brougham Castle, Westmoreland,* 25gns., Lord Brownlow.
1827	204	*Loch Feochan, Argyleshire - Cruachan-Ben in the distance,* 60gns., Sold.
1827	215	*Dunolly Castle, Argyleshire,* 4gns., J. Walker Esq., Harpers Hill House, Birmingham.
1827	226	*Dunstafnage Castle, Argyleshire,* 8gns., Sold.
1827	231	*Derwent Water,* 6gns., J.T. Parkinson, 24 Bryanston Square.
1827	240	*Loch Avon, Aberdeenshire,* 20gns., Mr. H. West.
1827	263	*Edinburgh, from Salisbury Craggs, "Such misty grandeur crown'd the height . . ." Scott.* 25gns.
1827	265	*Iona,* 8gns., Sold.
1827	284	*London - for the Work of the Cities of England, now publishing,* 9gns., Sold.
1827	358	*Brotherswater, Cumberland.*
1828	12	*Snowden, from the Nantile Pools,* 60gns.
1828	25	*Shichallien, from Loch Raunoch,* 14gns., Braithwaite Esq., New Road.
1828	38	*Loch Feochan and Cruachan Ben,* 14gns., Le Vicomte D'Anchald, 25 Hill Street, Berkeley Square.
1828	54	*View from Innisfallen Island, Killarney,* 7gns.
1828	58	*Snowdon, from Capel Curig, North Wales,* 15gns., Sold.
1828	66	*View on Ulleswater,* 25gns.
1828	75	*Glen Coe, Argyllshire,* 17gns.
1828	83	*Llyn Idwal, N. Wales,* 8gns., Mr. J.G. Swainson, 8 Portland Place, New Kent Road.
1828	91	*Snowdon, from Capel Cûrig,* 7gns. Mr. J.G. Swainson, 8 Portland Place, New Kent Road.
1828	95	*The Suspension Bridge near Bangor,* 15gns., Sold.
1828	99	*Cuchulin Hills, Isle of Skye,* 25gns.
1828	100	*View from Innisfallen Island, Killarney,* 7gns.
1828	101	*Ben Vorlich, from Loch Earn,* 7gns.
1828	103	*Aysgarth Force, Winsley Dale, Yorkshire,* 28gns.
1828	111	*The Reeks, Killarney,* 25gns.
1828	116	*Bridge, near the Fall of Fyers,* 6gns.
1828	123	*Durham - engraved for the English Cities,* 8gns., Sold.
1828	125	*Scene on the Clyde, near the Falls,* 25gns.
1828	127	*Salisbury - engraved for the English Cities,* 8gns., Sold.
1828	133	*Chichester - engraved for the English Cities,* 8gns., Sold.
1828	138	*Litchfield - engraved for the English Cities,* 8gns., Sold.
1828	139	*Norwich - ditto.,* 8gns., Sold.
1828	146	*Dacre Castle, Westmoreland,* 10gns.
1828	147	*Loch Corouisk, Isle of Skye,* 20gns.
1828	152	*View on the Tyne, at Bywell,* 15gns.
1828	164	*Skiddaw and Derwent Water,* 15gns., Sold.
1828	175	*Beaufort Bridge, Killarney,* 12gns., Major Channel, 45 Upper Bedford Place, Russell Square.
1828	186	*Westminster - engraved for the English Cities,* 8gns., Sold. Cities to be sold altogether at 79s. each.
1828	194	*Timon of Athens,* 10gns.
1828	200	*Scene in Cymbeline,* 8gns., Lord W. Russell, Chapel Street East, MayFair.
1828	204	*Glena Mountain, Killarney,* 24gns.

1828	217	*Ben Lomond from Loch Lomond*, 15gns., Sold.
1828	224	*View on Ulleswater*, 15gns.
1828	225	*London, from London Bridge*, 15gns., Sold.
1828	231	*Cader Idris*, 15gns., Sold.
1828	241	*Edinburgh, from Salisbury Craggs*, 15gns., Sold.
1828	248	*Vale of Llangollen, North Wales*, 15gns., Sold.
1828	249	*Dublin*, 15gns., Sold.
1828	263	*Ben Lomond, from Loch Lomond*, 7gns., Thos. Moxon Jr., Walthamstow, Essex.
1828	271	*View near the Head of Loch Hourn*, 7gns., W. Prior Esq., Calverts Brewhouse.
1828	279	*Chester - engraved for the English Cities*, 8gns., Sold.
1828	280	*Canterbury - ditto - ditto*, 8gns., Sold.
1828	281	*Gloucester - ditto - ditto*, 8gns., Sold.
1828	285	*Snowden, from Capel Curig, North Wales*, 5gns., Sold.
1828	287	*Llyn Idwal, North Wales*, 7gns., J. Moxon Esq., Lincoln's Inn Fields.
1828	299	*View on Derwent Water*, 7gns., George Hammersly Esq., Bolton Row, Piccadilly.
1828	311	*View on Loch Leven, Argyllshire*, 6gns., Viscount Stormont, 34 Lower Grosvenor St.
1828	339	*Conisbro' Castle, Yorkshire*, 7gns.
1828	347	*Ely - engraved for the English Cities*, 8gns., Sold.
1828	366	*York - engraved for the English Cities*, 8gns., Sold.
1829	2	*Bywel, on the River Tyne*, 25gns.
1829	9	*View from Ross Island, Killarney*, 8gns., Mr. Rd. Sykes(?), Lord ????
1829	16	*View on Ulleswater - Morning*, 30gns., Parrott Esq.
1829	34	*Glen Coe*, 18gns.
1829	43	*Loch Tumell, Perthshire*, 14gns., H. Davidson Esq., Bruton St.
1829	46	*View from Ross Island, Killarney*, 8gns., Mrs. Alaric Watts.
1829	65	*The Reeks Mountains, Killarney*, 30gns.
1829	71	*Upper Lake, Killarney*, 6gns., Birch Wolfe Esq.
1829	72	*Pass of Killicrankie, Invernesshire - Twilight*, 7gns., Stewart Esq.
1829	78	*Glena Mountains - Killarney*, 30gns.
1829	80	*Glen Coe, Perthshire*, 7gns.
1829	85	*Scene near Mells - Somersetshire*, 8gns.
1829	88	*Cuchulin Mountains, Isle of Sky*, 30gns.
1829	99	*Fall of Tumel, Perthshire*, 14gns., Mr. Forster, Carey St., Chancery Lane.
1829	111	*Loch Katerine*, 15gns., J. Shaw Esq., Junr., Gower St.
1829	114	*Durham Cathedral*, 20gns.
1829	133	*Distant View of Mells, Somersetshire*, 8gns., Sold before the exhibition.
1829	141	*View on Ulleswater*, 8gns., J. Winstanley Esq., 4 Chatham Place.
1829	148	*Scene near the Mouth of the Lower Lake, Killarney*, 18gns.
1829	150	*Ben Lomond from Loch Lomond*, 8gns., Miss Shipley, Devonshire Place.
1829	155	*Stirling Castle*, 12gns., M. Shipley Esq., Devonshire Place.
1829	157	*Barnard Castle, Durham*, 10gns.
1829	171	*Distant View of the Lower Lake, Killarney*, 25gns.
1829	174	*View on Ulleswater*, 15gns.
1829	178	*View from Innisfallen, towards Ross Castle*, 7gns., Mrs. Alaric Watts.
1829	187	*Upper Lake, Killarney*, 8gns., Sold.
1829	195	*Ross Castle, Killarney - Twilight*, 15gns.
1829	204	*Durham*, 70gns., Bishop of Durham.
1829	213	*Loch Laggan, Inverness-shire*, 15gns., H. Davidson Esq., 24 Bruton St.
1829	226	*Bridge, near the Fall of Fiers*, 6gns.
1829	228	*Loch Corouisk, Isle of Sky*, 20gns.
1829	229	*Cascade near Aberfoyle*, 6gns.
1829	236	*Lower Lake, Killarney - Sun-set*, 18gns.
1829	237	*Turk and Mangerton Mountains, Killarney*, 15gns.
1829	264	*Chedder Cliffs, Somersetshire*, 4gns., Roberts Esq., 6 Percy Street.
1829	265	*Boniton Lin, a Fall of the Clyde*, 7gns.
1829	266	*View in Glen Lyon, Perthshire*, 8gns.
1829	267	*Ben More, Perthshire*, 8gns.
1829	272	*Chedder Cliffs, Somersetshire - Glastonbury in the distance*, 5gns., Rev. Jas. Bullver, 27 York Crescent, Clifton.
1829	285	*View on Innisfallen Island, Killarney*, 8gns.
1829	310	*Chedder Cliffs, Somersetshire*, 5gns., Mr. Stanfield.
1829	322	*Chedder Cliffs, Somersetshire*, 4gns.
1829	331	*Eagle's Nest, Killarney*, 6gns.
1829	332	*Chedder Cliffs, Somersetshire*, 7gns., Stanfield Esq.
1829	335	*Lower Lake, Killarney*, 8gns., H. Davidson Esq., 24 Bruton St.
1829	345	*Bywell on the Tyne*, 9gns.
1829	379	*View from Innisfallen Island, Killarney*, 8gns.
1829	380	*Chedder Cliffs, Somersetshire*, 8gns., James Winstanley, 4 Chatham Place.
1829	383	*View from Innisfallen Island, Killarney*, 8gns., C.B. Plestow Esq., Watlington Hall, Stoke Ferry, Norfolk.

1829	387	*Ben Lomond*, 15gns.
1829	388	*Ross Castle, Killarney*, 8gns., Lord Darnley.
1829	391	*View from the Pass of Killicrankie, Perthshire*, 8gns., E. Hull Esq.
1830	8	*Pass in St. John's Wood, Westmorland*, 8gns., G.J. Morant Esq. Junr., 88 New Bond St.
1830	16	*Glen-Coe*, 20gns.
1830	31	*Loch Corouisk, Isle of Sky*, 20gns., A. Alison Esq., St. James Hotel, Jermyn St.
1830	44	*Durham Cathedral*, 25gns.
1830	47	*Durham, from Castle Chair*, 8gns., Mr. H. Fay. To be sent to Mr. E. Bernoulle, 3 Mildred's Court, Poultry.
1830	57	*Sterling Castle*, 45gns.
1830	59	*View on Loch Lomond - The Island of Inch Calliach, &c.*, 8gns.
1830	63	*Distant View of the Lower Lake, Killarney*, 30gns.
1830	74	*View from Innisfallen Island, Killarney - looking towards Turk and Maugerton Mountains*, 15gns., Mr. Webb, 30 Coventry St.
1830	87	*View near the Mouth of the Lower Lake, Killarney*, 18gns., Doughty Esq., 43 Lower Brook St.
1830	88	*Durham*, 60gns., E. Parratt Esq.
1830	92	*Bristol*, 7gns.
1830	98	*View near the end of the Lower Lake, Killarney*, 30gns.
1830	100	*View on the Tyne, Northumberland*, 30gns., Marquis of Ailsbury (?), Grosvenor Square.
1830	105	*Bala Lake, N. Wales*, 18gns.
1830	131	*Sun-set Lower Lake, Killarney*, 20gns.
1830	134	*Ben Lomond, from the Cobbler*, 15gns.
1830	142	*Loch Tumel, Perthshire - Schichallien on the left - Mountains of Glen-Coe in the extreme distance*, 65gns.
1830	144	*Bridge at the Fall of Fyers, Inverness-shire*, 8gns., Sir Wm. Herries, 35 Clarges St.
1830	147	*Lane Scene*, 8gns., Sold.
1830	153	*Windermere, from Rydal Woods*, 7gns., Miss Shepley, Devonshire Place.
1830	162	*Mucrus Abbey, Killarney*, 7gns., G.J. Morant Junr. Esq., 88 New Bond St.
1830	166	*Ben Vortich, from Loch Earn, Perthshire*, 8gns.
1830	176	*Lambton Castle, Durham, the Seat of the Right Honourable Lord Durham*, 18gns., Sold.
1830	179	*Lambton Castle, Durham*, 18gns., Sold.
1830	184	*Lambton Castle, Durham*, 18gns., Sold.
1830	186	*Lambton Castle, Durham*, 18gns., Sold.
1830	195	*Misty Morning - View in St. John's Vale, Westmorland - with Cattle by R Hills*, 60gns.
1830	208	*Durham*, 7gns., A.J. Cresswell Baker. To be delivered to Mr. Shaw, 28 Gower Street.
1830	213	*Framwell-gate Bridge, Durham*, 15gns.
1830	223	*View on Innisfallen Island, Killarney, looking towards Glena*, 8gns., Mr. Fay. See No. 47.
1830	248	*View - Glen Lion, Perthshire*, 8gns., G. Pitman Esq., 34 Bernard St., Russel Square.
1830	250	*Aqueduct in the Vale of Llangollen*, 15gns.
1830	252	*Durham from Little High Wood*, 8gns.
1830	271	*Scene near Keswick, Westmorland*, 7gns.
1830	278	*Timon of Athens*, 10gns., Mrs. Tyrrell, Lincolns Inn.
1830	288	*Eagle's Nest, Killarney*, 7gns., E.E. Tustin, Esq.
1830	289	*Twilight - Bywell, Northumberland*, 12gns., W. Fielden, 44 Queen Sqre., Bloomsbury.
1830	292	*Falls - the Lochy, near Killin, Perthshire*, 8gns., H. Penn Esq., Gt. Ealing, Middlesex.
1830	307	*View on the Clyde above Cori Lin*, 7gns.
1830	352	*Twilight - Ross Castle, Killarney*, 15gns.
1830	355	*Oxford*, 7gns.
1831	11	*Brathay Bridge, near Ambleside.*
1831	14	*View from the Caledonian Canal at Fort Augustus, towards Loch Ness.*
1831	20	*Grouse Shooting in the Isle of Sky.*
1831	34	*Durham - Misty Morning.*
1831	52	*Distant View of the Aqueduct near Llangollen.*
1831	55	*Derwent Water.*
1831	59	*Llyn Idwal, North Wales - Twilight.*
1831	70	*Durham Cathedral - Early Morning.*
1831	73	*Grasmere Lake, Westmorland.*
1831	77	*View under Framwelgate Bridge, Durham.*
1831	92	*View from the Prebend's Bridge, Durham.*
1831	94	*View near Callander, Perthshire.*
1831	98	*Bridge of Don, near Aberdeen.*
1831	103	*Dunkeld Cathedral - Evening.*
1831	113	*Loch Maree, Ross-shire.*
1831	136	*Bothwell Bridge, Lanarkshire.*
1831	144	*Loch Lomond, from Inversnaid.*
1831	148	*Conway Castle.*
1831	153	*Ben Vorlich and Loch Erne, Perthshire.*
1831	160	*View from Richmond Hill.*
1831	163	*Upper Lake, Killarney.*
1831	167	*Dunolly Castle, Argyllshire.*
1831	169	*Grove Scene, near Killarney - Lower Lake in the distance - Sun-set.*
1831	193	*High Force - a Fall of the River Tees.*
1831	200	*Loch Lubnaig, Perthshire - Twilight.*
1831	210	*Ben More, Perthshire.*

1831	214	*Moel Shadbod, North Wales.*
1831	229	*View on the River Erne, Near Comrie, Perthshire.*
1831	233	*Part of Ben Ledi and Loch Lubnaig.*
1831	241	*Loch Achray, Perthshire.*
1831	244	*Stratford on Avon - Moonlight.*
1831	259	*Scene in the Mountains near Pol Euc, Ross-shire.*
1831	277	*Conway, from the Old Road to Bangor.*
1831	302	*Blaven, from Loch Slapin, Isle of Sky.*
1831	307	*Lane Scene near Keswick, Westmorland.*
1831	312	*Gap of Dunloe, near Killarney.*
1831	321	*Loch Etive, and Cruachan Ben, Argyllsire.*
1831	330	*View on Loch Maree, Ross-shire.*
1831	345	*View from Ross Island, Killarney.*
1831	353	*Conisbro' Castle, Yorkshire.*
1831	356	*Junction of the Rivers Tees and Greta, from the Durham shore.*
1831	370	*View on the Clyde, near Lanark.*
1831	373	*Barnard Castle, Durham.*
1831	375	*Dunolly Castle, Argyllshire.*
1831	384	*Scene on Loch Leven, Argyllshire.*
1831	394	*Ross Castle, Killarney.*
1832	1	*Dunkeld,* 30gns.
1832	5	*View on the Tyne at Bywell, Northumberland,* 15gns.
1832	7	*Imogen entering the Cave,* 10gns.
1832	17	*Entrance to Glen Morison from Loch Ness,* 8gns., Miss Shepley, 28 Devonshire Place.
1832	22	*The Welsh Harper,* 30gns.
1832	46	*Scene in the Braes of Balquidder, Perthshire - Evening,* 15gns.
1832	50	*View near Callander, Perthshire,* 15gns.
1832	85	*Doune Castle - Stirling in the Distance,* 12gns.
1832	105	*Blaven, Isle of Sky,* 8gns., Mr. Thompson, 22 Geo ????
1832	114	*Approach to Glen Coe from Ballahulish, Argyllshire,* 8gns.
1832	183	*Harlech Castle, North Wales,* 8gns.
1832	191	*Loch Maree, Ross-shire,* 50gns.
1832	200	*West Front of Durham Cathedral,* 25gns., Mrs. Swindell, 9 Fortiss Terrace, Kentish Town.
1832	215	*"'This lake,' said Bruce, 'whose barriers drear Are precipices sharp and sheer . . .'" Scott.* 60gns.
1832	225	*Glen Falloch and the Head of Loch Lomond,* 30gns.
1832	233	*View from Westminster Bridge, "The sun Had set some time and night was on the ridge Of twilight . . ." Byron.* 45gns., Mr. Webb, 1 Cambridge Terrace, Edgeware Road.
1832	256	*The Loch Toridon, Mountains from Loch Maree,* 15gns.
1832	261	*Evening - distant view of the Lower Lake, Killarney,* 10gns.
1832	268	*The Trosachs of Loch Katerine, "The Minstrel came, once more to view The eastern ridge of Ben Venue . . ." Scott.* 65gns.
1832	288	*Loch Toridon Mountains from Loch Maree, Ross-shire,* 7gns., Mr. Ryman, Oxford, To be sent to Moon Boys & Graves.
1832	292	*Harlech Castle, North Wales,* 7gns.
1832	301	*Inverlochy Castle, Inverness-shire,* 7gns.
1832	306	*Hereford,* 8gns., J. Lewis Brown, 10 Leicester Place, Leicester Square.
1832	307	*View on Loch Katerine, Ben Lomond in the Distance,* 8gns.
1832	311	*View in Nant Gwinant, North Wales,* 7gns., Mrs. Ryman, To be sent to Moon Boys & Graves.
1832	315	*Scene near the Outlet of Loch Tumel, Perthshire,* 8gns., Mr. Scott.
1832	320	*Distant View of Caernarvon Castle,* 7gns.
1832	321	*View in Glen Levin, Argyllshire,* 8gns.
1832	322	*View on the Clyde, near Lanark - Twilight,* 7gns.
1832	326	*Study from Nature at Charlton, Kent,* 7gns., Mr. Wilkinson, Walsham, Suffolk.
1832	335	*Stone Byers Lin, a Fall of the Clyde,* 8gns.
1832	336	*Brothers Water, Westmorland,* 7gns., Mrs. Bicknell, By order of Mr. Gastineau on 5th May.
1832	353	*The Head of Loch Achray, Ben Venue, in Perthshire,* 8gns.
1832	368	*Ben Lomond, from the Head of Loch Long,* 15gns.
1832	373	*Macfarlane's Island, on Loch Lomond,* 7gns., Mr. Thompson, 22 Geo ????.
1832	374	*Val Crusis Abbey, North Wales,* 8gns.
1832	401	*Loch Archy, Inverness-shire,* 8gns.
1833	11	*View in Glen Leven, Argyllshire,* 8gns., Fras. Gibson Esq., Saffron Walden, Essex.
1833	14	*Study from Nature, near Stratford,* 10gns.
1833	17	*Arundel Park, with Deer, by R Hills,* 30gns.
1833	26	*View in the Grounds of Sir Thomas Wilson, Bart. at Charlton, near Woolwich,* 12gns.
1833	43	*View in the Vale of Dolwyddelan, North Wales, with Goats by R. Hills,* 25gns., W. Grant.
1833	47	*Pass of Killicrankie, with Red Deer by Hills,* 30gns.
1833	48	*Thirlemere and Helvellyn,* 14gns., Mrs. Swindell, 9 Fortess Terrace, Kentish town.
1833	55	*London - Evening,* 40gns.
1833	61	*Scene near Chedder, Somersetshire,* 8gns.
1833	63	*Kilchurn Castle, Loch Awe,* 7gns.

1833	65	*Distant View of the Head of Loch Lomond, from Glen Fralloch*, 30gns.
1833	71	*View of Derwentwater*, 6gns.
1833	72	*Morning - a Study from Nature at Stratford on Avon*, 14gns., Mrs. Swindell, 9 Fortess Terace, Kentish Town.
1833	73	*Mackfarlane's Islands, Loch Lomond*, 8gns., Mrs. Swindell, Do.
1833	104	*Schihalien, from the Banks of the Tumel, with the Mountains of Loch Rannock and Glen Coe in the Distance, "The towering cliffs each deep sunk glen divides . . ."* 60gns., Morison Esq., Marked by order from Mr. Robson.
1833	128	*Corfe Castle, Dorsetshire*, 15gns.
1833	151	*Cruachan Ben, from Loch Etive*, 7gns.
1833	155	*Scene near Mels, Somersetshire*, 6gns.
1833	158	*Bridge near Capel Carig, North Wales*, 6gns.
1833	170	*Roslin Castle*, 6gns.
1833	192	*Study in Charlecote Park, Warwickshire*, 8gns.
1833	195	*Scene in the Vale of Dolwyddelan, North Wales*, 6gns.
1833	197	*Rhaidr Wenol, North Wales*, 16gns.
1833	200	*The Upper End of Loch Lomond*, 6gns.
1833	210	*The City of Durham from the North East*, 60gns., Mr. Leaf(?), Park Hall, Streatham, Mr. Moon said he would pay for it.
1833	217	*View from the Mountains at the Head of Loch Long, looking towards Ben Lomond*, 15gns., Mr. Rositter, Kensington Terrace.
1833	220	*Stratford Church, a Study from Nature*, 8gns., Miss How, Swan Walk, Chelsea.
1833	240	*View on Derwent Water*, 15gns., Mr. F. Cooper, Barton Grange, near Taunton, Wishes for frame and glass.
1833	241	*Distant View of Snowdon and the Nanthill Pools, North Wales*, 6gns.
1833	246	*Scene near Beauley, Inverness-shire*, 8gns.
1833	247	*Study from Nature at Capel Carig, North Wales*, 5gns., Mrs. C.H. Turner (Mr. Barret).
1833	250	*Rock of the Grey Eagle, Loch Maree, Ross-shire*, 15gns., Mr. C.H. Turner, Rooks Nest, Godstone, and 15 Bruton Street.
1833	258	*Scene near Loch Earne Head, Perthshire*, 8gns.
1833	262	*Cnight near Beddgelert, North Wales*, 7gns.
1833	283	*Study in the Grounds at Kent House, Knightsbridge*, 9gns.
1833	292	*The Arochar Mountains, Loch Lomond*, 6gns., M. Fielden, Witton House, Blackburn, Lancashire.
1833	294	*Vallis-Crucis Abbey, North Wales*, 10gns.
1833	303	*Bowder Stone, Borrowdale*, 6gns.
1833	341	*Pont Aberglasslyn, North Wales*, 6gns.
1833	344	*View on the River Tees near Barnard Castle*, 7gns.

| 1833 | 356 | *Slevgach, Loch Maree, Ross-shire*, 7gns. |
| 1833 | 417 | *Loch Ard and Ben Lomond*, 6gns., W. Bray, 57 Great Russell St.(?). |

ROBSON G F & HILLS R

| 1829 | 22 | *"The antler'd monarch of the waste . . ." Lady of the Lake.* 60gns., Frame and glass £16.15.0. |

ROBSON G J

| 1829 | 290 | *Chedder Cliffs, Somersetshire - Glastonbury in the distance*, 6gns. |
| 1830 | 347 | *Worcester*, 7gns. |

ROE MISS

| 1820 | 205 | *Cottage Children.* |

ROOKER N

| 1823L | 200 | *Cottage Scene*, J. Burbank, esq. |

ROSENBERG G

1851	10	*Flower-piece.*
1852	19	*Winter Morning*, 5.
1852	65	*Fruit on a Buffet*, 8G, Sir W. Herries, 14 Bolton St., Frame and glass £1.10.0 No.
1852	70	*Pineapple, Grapes, &c.*, 10G, Thomas Bothamley Esq.,, Frame and glass £2.0.0 No.
1852	71	*Flowers and Fruit*, Sold.
1852	214	*Game*, 25.
1852	221	*Desert*, 6G, W.H. Freeman Esq., Elm Lodge, Notting Hill, Frame and glass £1.1.0.
1852	250	*Apricots*, 5, N.P. Simes Esq., Brighton.
1853	202	*Cottage Flowers.*
1853	216	*Dessert.*
1853	217	*The Recess.*
1853	253	*Apricots and Grapes.*
1853	268	*Melon, Lilies, &c.*
1853	295	*Pomegranate, Rasin, &c.*
1853	300	*Fruit and Flowers.*
1853	304	*Cloth of Gold, Rose, Peaches, &c.*
1854	36	*Interior of a Barn, Kilston, near Bath*, 10gns., Geo.(?) Rae(?) Manager, North & South Wales Bank, Liverpool, Frame included £1.10.0.
1854	85	*Fruit and Flowers*, 10gns., Richard Ellison Esq., Frame and glass £1.10.0.
1854	190	*Mine Host of the Swan, Llantwith, North Wales*, 10gns., Frame and glass £1.10.0.
1854	220	*Fruit and Flowers*, 25gns., Miss Bell, 1 Devonshire Place, Frame and glass £3.15.0.
1854	230	*Pineapples*, 15gns., Frame and glass £1.1.0.
1854	272	*Dead Kingfishers*, 15gns., Bullock Esq., Frame and glass £2.15.0.
1854	303	*Fruit*, 10gns., Frame and glass £1.1.0.
1854	326	*Cut Melon*, 7gns., Frame and glass £1.10.0.
1855	3	*The Bay Window*, 15gns., Mrs. Morison, Montblairy House, ???, Frame and glass £1.15.0.
1855	64	*St. Donats, South Wales*, £20.0.0, Frame included.

1855	79	*Old Market Woman, Bath*, 10gns., Frame included.
1855	134	*Ludlow Castle, Hampshire*, 10gns., Frame and glass £1.10.6.
1855	194	*The Smithy, Stokesay Castle*, 10gns., Frame and glass £1.10.0.
1855	222	*Stokesay Castle, Shropshire*, 12gns., Frame and glass £1.8.0.
1855	223	*The Entrance to the Conservatory*, 25gns., Frame included.

ROSENBERG G F

1850	352	*Hock Glass, Raisins, &c.*, 5gns., Sold.
1851	202	*Study of a Woodcock.*

ROSENBERG GEORGE

1848	1	*Still Life*, 18gns., Frame and glass £2.2.0.
1848	14	*Small Birds*, 15gns., Frame and glass £1.5.0.
1848	62	*Fruit*, 10gns., Charles Dobson Esq., 3 Billeter Square, City, Frame and glass £1.10.0 Yes.
1848	121	*Game and Fish*, 30gns., Mrs. Beale, Tenterden, Kent, Frame and glass £2.2.0 Sold, AU. 30.
1848	227	*Early Morning in the neighbourhood of Bath, looking towards the Wiltshire Downs*, 4gns., R. Rawlinson Esq., 6 Old Trafford Terrace, Stratford New Rd., Manchester, Frame and glass £1.1.0 No.
1848	237	*Fruit - a Composition*, Sold.
1848	301	*Plums*, 10gns., Frame and glass £2.12.6.
1848	329	*Fruit on a Sideboard*, 10gns., Frame and glass £1.10.0.
1849	191	*Autumn.*
1849	201	*Winter.*
1849	214	*Summer.*
1849	225	*Dead Peacock.*
1849	300	*Spring.*
1849	351	*Sunset near Bath.*
1849	360	*Study of Fruit.*
1850	102	*A Dead Pea-hen*, 20gns.
1850	168	*Reflections*, 5 Pounds.
1850	192	*Lane Scene near Bath*, 4gns.
1850	216	*Fruit Piece*, 40 Pounds.
1850	236	*Melon, Grapes &c.*, 12gns.
1850	268	*Winter Scene near Bath*, 5 Pounds, Robinson, Frame and glass £1.11.6, 2½ inch margin, ??? with ornament.
1851	180	*Jamaica Pine and Grapes.*
1851	196	*Dead Teal, &c.*
1851	212	*Fruit Piece.*

ROUW P

1813	19	*Portrait of the late Matthew Bolton Esq.*
1813	20	*Portrait of His Majesty.*
1813	21	*Portrait of His Royal Highness the Prince Regent.*
1813	22	*Portrait of Her Majesty.*
1813	29	*Portrait of H. Roxby, Esq.*
1814	11	*Portrait of the late G. Smith Esq.*
1814	12	*Portrait of Lucien Bonaparte, unfinished.*
1814	13	*Portrait of a Gentleman.*
1814	14	*Portrait of Warren Hastings, Esq.*
1814	15	*A small Bust in Wax of a deceased Baron.*
1814	16	*Portrait of Sir Mark M. Sykes, M.P.*
1814	17	*Portrait of W. Egerton Esq., M.P.*
1814	18	*Portrait of a Lady, deceased.*
1815	3	*Portrait of a Gentleman.*
1815	4	*Portrait of the Infant Son of Robert Williams, Esq. M.P.*
1815	5	*Portrait of a Clergyman.*
1815	6	*Portrait of a Gentleman.*
1815	20	*Portrait of a Gentleman deceased.*
1816	2	*Portrait of a Young Lady, in Wax.*
1816	3	*Portrait of a Lady.*
1816	4	*Portrait of the Prince Regent of Portugal.*
1816	5	*Portrait of the Infant Son of R. Morris, Esq.*
1816	6	*Portrait of a Gentleman.*
1816	16	*Portrait of a Gentleman.*
1817	144	*Portrait of the Bishop of Norwich.*
1817	145	*Portrait of Doctor Uwins.*
1817	146	*Portrait of Lady Thorold.*
1817	147	*Portrait of an Italian Greyhound, the property of Sir John Thorold., Bart.*

SAUERWEID A

1815	267	*A View in Hyde Park, representing His Royal Highness the Prince Regent, accompanied by their Imperial, and Royal Majesties, the Emperor of Russia, and King of Prussia, Marshal Blucher, the Hetman Platoff, and several distinguished Foreign and British Officers, after the Review on the 20th June, 1814.*

SCHETKY A

1816	135	*Salion, in the Pyrennees, Arragon.*
1816	221	*Pass, on the River Gallegos, Arragon.*
1816	272	*Cascade of Gavornie, Mount Perdu.*
1817	120	*Scene in the Serra de Estrella, in Portugal, with the Flight of the Peasantry on Massena's Invasion.*

SCHETKY J C

1816	177	*View of the Rock of Lisbon, a British Squadron, working to windward.*
1816	188	*Portrait of the Blue-eyed Maid.*
1816	200	*View of the Mouth of Portsmouth Harbour, with a Frigate coming out.*
1816	203	*View of the Lizard Point, a Frigate and Convoy.*
1816	216	*A Man of War Brig at Anchor, Tide Road, Mouth of Portsmouth Harbour.*

1817	167	*Portrait of his Majesty's Ship Victory.*
1817	177	*A Cutter coming out of Portsmouth Harbour.*

SCHOENBERGER

1816	21	*View of Terracina, on the road from Rome to Naples.*
1816	144	*Landscape, Sun-rising.*

SCOT W

1843	332	*The Bridge at Trèves, 25gns.*

SCOTNEY F

1814	44	*Water Mill, Moonlight.*

SCOTT MISS

1823	58	*Plums, £5.5.0. Marchioness of Stafford.*
1823	214	*Flowers.*
1823	216	*Fruit.*
1824	148	*Fruit.*
1824	275	*Flowers.*
1824	276	*Plums.*
1824	280	*Flowers.*
1824	281	*Fruit.*
1825	230	*Fruit, 25gns.*
1825	243	*Plate of Gooseberries, 3gns. [Miss Scott deleted and replaced by] Miss Barret.*
1825	322	*The Prince Regent and Viper Gooseberries, exhibited at the Brighton Horticultural Society, 1824, 8gns.*
1826	245	*Fruit, 20gns.*
1826	284	*Fruit, 10gns.*
1827	301	*Fruit and Flowers, 15gns.*
1828	156	*Fruit and Flowers, 4gns.*
1829	281	*Fruit and Flowers, 5gns.*
1830	262	*Cherries, 5gns., I. Braithwaite Esq.*
1831	232	*Fruit.*
1831	287	*Fruit.*
1832	383	*Fruit, 4gns.*
1833	320	*Fruit, 6gns.*

SCOTT W

1811	8	*Bookham Church, Surrey.*
1811	124	*Old Houses at Dorking, Surrey.*
1811	313	*Mickleham Church, Surrey.*
1811	321	*Cottage at Dorking, Surrey.*
1811	357	*View of Hertford Heath.*
1812	16	*Bookham Church, Surrey.*
1812	29	*View of Benledi, West Highlands, "'T were long to tell what Steeds gave o'er . . ." Lady of the Lake, Canto I.*
1812	54	*View at Cramond, near Edinburgh.*
1812	244	*Edinburgh, from Calton Hill.*
1812	274	*View at Dumblane, near Stirling.*
1813	69	*Ruins at Slaugham, Sussex.*
1813	106	*Bridge at Dinas Mwthy, North Wales.*
1813	127	*Callender bridge.*
1813	131	*Cottage at Warnham, Sussex.*
1814	31	*Albury Church, near Guildford, Surrey.*
1814	103	*Rice Bridge, Betchworth, Surrey.*
1814	195	*Old Forge, at Cramond.*
1814	199	*The old Bridge, at Brockham, Surrey.*
1814	221	*Franchwood Bridge, near Ryegate.*
1814	267	*View at Hanmers.*
1815	55	*View at Ware, Herts, £3.0.0, J. Holcombe Esq.*
1815	78	*View at Wonham, near Ryegate.*
1815	139	*Paper Mill, at Wiers, near Oxford.*
1815	230	*Foley Bridge, Oxford.*
1815	292	*Henfield Church, Sussex.*
1815	306	*Franchwood Mill, near Ryegate.*
1815	318	*Scene at Buckland.*
1816	35	*Ferry, Hinksey, near Oxford.*
1816	111	*On the Thames, near Battersea.*
1816	112	*Sandy End, near Fulham.*
1816	121	*View on Box Hill, near Dorking.*
1816	148	*Castle of Dieppe.*
1816	160	*View on Mont St. Catherine, Rouen.*
1818	10	*Cottage at Donnington, near Chichester, £3.3.0.*
1818	96	*View on the Seine, near Rouen.*
1818	208	*The Castle and Borough of Bramber, Sussex.*
1818	247	*Cottages at Bramber, Sussex.*
1818	248	*View of Rouen, from Mount St. Katherine.*
1818	253	*Cottage, at Pulborough, Sussex.*
1818	289	*Cottage, at Storrington, Sussex, £12.12.0, J. Quintin Esq.*
1819	237	*Cottage at Pulborough, Sussex.*
1819	241	*Shoreham Harbour, Brighton, £4.4.0, T.G.*
1819	264	*The Atheral Farm, West Grinstead, Sussex.*
1820	26	*Cottage at Stonington, Sussex.*
1820	96	*Threlkeld Bridge, Cumberland.*
1820	129	*Bridge near Godalming, Surrey.*
1820	130	*Bridge at Killin, West Highlands.*
1820	212	*Cottage at West Grinstead, Sussex.*
1820	262	*Cottage near West Grinstead.*
1820	289	*Bramber, near Brighton.*
1820	300	*Cottage at Amberley, Sussex.*
1821	11	*Cottage at Donnington, £4.14.6, R. Carter Esq.*
1821	24	*Mount St. Catherine, Rouen.*
1821	50	*Place Robec, at Rouen.*
1821	67	*Whackham Common.*
1821	91	*Croix de Pierre, Rouen.*
1821	125	*An old House at Rouen.*
1821	149	*Part of Lausanne.*
1822	16	*Edinburgh Castle, from the Grass Market, £12.12.0, T.G.*

1822	90	*Arundel, from the Brighton Road.*
1822	144*	*Cottage at Sutton, Shropshire.*
1823	207	*Bramber Church, Sussex.*
1823	268	*Castle Clift, Newhaven, Sussex.*
1824	97	*Part of Pevensey Castle.*
1824	188	*The Red House, Battersea.*
1824	199	*Beachy Head, Sussex.*
1824	208	*Rouen, from St. Sever.*
1824	234	*The Castle and Town of Dieppe.*
1824	243	*The Harbour and Town of Dieppe.*
1824	282	*Sketch at Ratton, Sussex.*
1825	41	*Edinburgh Castle,* 15gns.
1825	155	*The Farm House at Ratton, Sussex,* 3gns., I. Thomas Esq. at Visct. Middleton's, 107 Park Street, Grosvenor Square, The frame etc. to be sent home with the drawing.
1825	215	*Part of the Market Place, Norwich,* 8gns.
1825	221	*St. Nicholas Church, Colchester,* 8gns.
1825	256	*The Breakwater, Harwich,* 8gns., Rev. G. Preston, Little Deans Yard.
1825	264	*Edinburgh, from the Road to Arthur's Seat,* 8gns., Wilby Esq.
1826	36	*Rope House, on the Beach of Brighton,* 8gns.
1826	126	*The Porch of Bunted Church, Sussex,* 5gns.
1826	211	*Sompting Church, Sussex,* 8gns., Dowr. Lady Suffield, 6 Cavendish Square.
1827	11	*The Butlets, near Uckfield,* 10gns., Sold.
1827	117	*Shoreham Harbour,* 8gns.
1827	149	*Grande Rue, Caudebec, Normandy,* 20gns.
1827	173	*Gateway of the Jesuits' College, Amiens,* 10gns., Sold.
1827	199	*Brighton Trawl Boat,* 4gns.
1827	273	*Rue des Drapiers, Havre,* 20gns.
1828	2	*On the Quai, at Dieppe,* 8gns.
1828	46	*Rue Notre Dame - Calais,* 20gns.
1828	169	*Rue St. Romain, Amiens,* 20gns.
1828	256	*Cottage, at Crowhurst,* 8gns.
1829	27	*Rustall Common, near Tunbridge Wells,* 6gns., Countess of Pembroke, 7 Gt. Stanhope St., Mayfair.
1829	58	*The Quai at Amiens,* 20gns.
1829	93	*Study at Tunbridge Wells,* 5gns.
1829	244	*The Old Capstern on the Beach at Aldborough, Suffolk,* 10gns.
1829	258	*Petworth Church,* Sold.
1830	42	*Part of Hampstead House, Sussex - formerly the Residence of Judge Jeffreys,* 8gns.
1830	157	*On the Canal at Dunkirque,* 14gns.
1830	199	*The Market Tower at Bergue,* 20gns.
1831	19	*The High Street, Boulogne.*
1831	62	*Cottage at Bletchingly, Surrey.*
1831	154	*Cottage at Uckfield.*
1831	271	*Brighton Fishing Boats.*
1831	281	*The Market Place at Dunkirk.*
1832	2	*Brighton - Fishing Boats,* 6gns., Mr. Fielden, 36 Montague Square.
1832	68	*Cottage at Uckfield,* 7gns.
1832	145	*Cottage at Horsham, Sussex,* 5gns.
1832	159	*Rottingdean Cliff,* 5gns., Mr. Fielden, 36 Montague Square.
1832	194	*Boats on Brighton Beach,* 5gns.
1832	246	*Caudebec,* 25gns., Sold.
1832	260	*Heath Scene near Bracknell, Berks,* 7gns., Mr. Fielden, 36 Montague Square.
1833	6	*Study of Trees at Bletchingley,* 4gns.
1833	34	*Old Houses at Buxted, Sussex,* 8gns.
1833	60	*Copperas Gap, near Brighton,* 8gns.
1833	156	*Saxon Arch, Shoreham Church, Sussex,* 4gns.
1833	264	*An Old House at Southover, Sussex, formerly the Residence of Anne of Cleves,* 8gns.
1834	3	*Mill near Buxted,* 4gns.
1834	58	*Brighton Boats,* 6gns.
1834	96	*Part of Old Shoreham Church,* 5gns.
1834	98	*Cottage at Bramber,* 7gns., William Hobson, Markfield, Stamford Hill.
1834	199	*Old Houses at Tintern,* 20gns., William Hobson, Markfield, Stamford Hill.
1834	211	*Beech Trees in Tilgate Forest,* 6gns., Miss Swinburne, 18 Grosvenor Place.
1834	246	*Edinburgh Castle,* 18gns.
1834	251	*Lille Bonne, Normandy,* 20gns., Belcher Esq., Highgate.
1835	16	*Cottage at Hurst, Sussex,* 15gns.
1835	25	*Cottage at Albourne, Sussex,* 15gns.
1835	50	*Study in Dauny Park,* 6gns., Mr. Domett, Balham Hill.
1835	93	*Old Houses at Rochester,* 20gns., Mr. G. Cooke, Doncaster.
1835	201	*Leatherhead Church,* 20gns.
1835	217	*Bolney Church in Sussex,* 15gns.
1836	46	*Sompting Church, near Worthing,* 8gns., Labouchere Esq., 4 Hamilton Place, Piccadilly.
1836	61	*Cottage at Albourne, Sussex,* 20gns., Wm. Payne Esq., 163 ???? Street.
1836	142	*In a Lane, at Bracknell, Berks,* 7gns., G. Morant Esq.
1836	185	*Cottages at Bletchingley, Surrey,* 7gns.
1836	201	*Dover,* 25gns., Wm. Hobson Junr. Esq., 43 Harley Street.
1836	215	*Cottage near Horsham, Sussex,* Sold.

1837	51	*Bramber, Sussex,* 8gns., The Duchess of Northumberland.
1837	66	*Cottages at Dawney, Berks,* 7gns.
1837	81	*Cottages at Bolney, Sussex,* 7gns.
1837	88	*Cottage at Hurst, Sussex,* 7gns.
1837	198	*Cottages at Hazelmere,* 25gns.
1837	203	*Gateway of Cowdry, Sussex,* 20gns.
1837	214	*Cottage at Old Shoreham,* 20gns.
1837	227	*Old Buildings at Godalming,* 25gns.
1838	2	*Windmill - Isle of Dogs.*
1838	19	*West Street, Chichester.*
1838	43	*Windmill - Chigwell.*
1838	93	*Porchester Castle, Hants.*
1838	118	*Llantrissent Church.*
1838	232	*Cottage at Bramber.*
1838	233	*Gateway, Caerphilly Castle.*
1838	264	*Water Mill, Hickstead.*
1839	16	*Rocher Bayard, on the Meuse,* 25gns.
1839	139	*Dover Castle, from the Folkestone Road,* 7gns.
1839	172	*Chingford Church, Essex,* Sold.
1839	180	*The Curfew Tower at Barking, Essex,* 8gns.
1839	186	*Namur, on the Meuse,* Sold.
1839	205	*Cottage at Hoddesdon, Herts,* 7gns.
1839	208	*Dinant, on the Meuse,* 25gns., Mr. T. Thorby(?), 1 Wharncliff Terrace, St. John's Wood.
1839	240	*Huy on the Meuse,* 25gns.
1840	14	*Richmond Hill.*
1840	61	*Street in Berncastel on the Moselle.*
1840	71	*Mill near Cowbridge, Glamorganshire.*
1840	81	*Water Mill at Berncastel, on the Moselle.*
1840	183	*Gateway at Colchem, on the Moselle.*
1840	222	*Huy - on the Meuse.*
1840	235	*Brunon - on the Meuse.*
1840	246	*Old Houses at Trebach, on the Moselle.*
1841	8	*Berncastel on the Moselle,* 25gns.
1841	16	*Entrance to Cardiff, South Wales,* 8gns.
1841	81	*On the Medway - Sheerness in the Distance,* 25gns.
1841	89	*Bovingnon on the Meuse,* 25gns.
1841	129	*Remains of the Roman Baths at Treves,* 6gns.
1841	208	*Trowback, on the Moselle,* 25gns.
1841	211	*Near Boulogne, on the Road to Calais,* 8gns.
1841	234	*Ruins at Portslade, Sussex,* 6gns.
1842	24	*Scene from the Place Royale, Pau.*
1842	27	*Pierfitte, Pyrenees.*
1842	118	*Moulineaux, near Rouen.*
1842	124	*Cauterets, in the Pyrenees.*
1842	173	*Cottages at Catherine Hill, near Guildford.*
1842	182	*Old Houses at Pau, Pyrenees.*
1843	2	*At Liege,* 8gns.
1843	45	*Cottage at Pulborough, Sussex,* 6gns., Wm. Strachan Esq., 34 Hill St., Berkeley Square.
1843	64	*Scene from Traveller's Rest, between Cardiff and Caerphilly,* 8gns.
1843	90	*Bridge at Lourdes, Pyrenees,* 20gns., Rev. Sydney Smith, 56 Green Street, Grosvenor Square, Frame and glass £5.17.6.
1843	94	*On The Rhine, at Cologne,* 6gns.
1843	141	*Mills at Pallion, near Treves,* 25gns.
1843	224	*The Pyrenees from Pau,* 25gns.
1844	17	*Ruins near Edinburgh,* 7gns.
1844	73	*Huy, on the Meuse,* 25gns.
1844	93	*Eau Bonnes, Pyrenees,* 20gns.
1844	111	*Cottage at Cuckfield, Sussex,* 7gns.
1844	146	*Old Houses at Steyning, Sussex,* 7gns.
1844	175	*The Pyrenees, from Pau,* 25gns., G. Walker Esq., Norton Villa, Worcester, P.AU.
1844	203	*Ben Venue, from the Callender Road,* 20gns.
1844	206	*Ambleside Beck, Westmorland,* 7gns.
1845	12	*Mantes, on the Seine, France,* 25gns., Frame and glass £5.10.6.
1845	45	*Le Chateau la Ville de Pau, Pyrenees,* 25gns., Frame and glass £6.12.6.
1845	55	*Needles - Isle of Wight,* 7gns.
1845	118	*Copperas Gap, Brighton, Sussex,* 25gns., Frame and glass £4.15.6.
1845	165	*The Valley of Argelez, Pyrenees,* 25gns., Frame and glass £4.4.6.
1845	187	*South Downs, from Cuckfield, Sussex,* 25gns., Frame and glass £5.0.0.
1845	208	*Brumers, near Pulborough, Sussex,* 6gns., Frame and glass £1.11.6.
1846	38	*Brunon, on the Meuse,* 25gns., Frame and glass £4.10.0.
1846	54	*Pangbourne Lock, Berkshire,* 25gns., Frame and glass £5.5.0.
1846	74	*Cottages at Berucastel, on the Moselle,* 25gns., Frame and glass £5.5.0.
1846	99	*Cottage at Pangbourne, Berks,* 20gns., Frame and glass £4.10.0.
1846	140	*Ayot St. Lawrence, Hertfordshire,* 20gns., James Smith Esq., Manor Cottage, Holbury, Frame and glass £4.10.0.
1846	202	*Beeding Church, Sussex,* 8gns., Frame and glass £3.0.0.
1846	249	*Barnes Church, on the Thames,* 7gns., Frame and glass £2.10.0.
1847	25	*Bridge at Lourdes - Pyrenees,* 20gns.
1847	40	*Scene at Tidmarsh, Berks,* 25gns.

1847	71	*Scene in the Pyrenees, near Pierfitte*, 25gns.
1847	99	*Ruin at Shermanbury, near Henfield, Sussex*, 20gns.
1847	131	*Beeding Church, Sussex*, 7gns.
1847	149	*Mapledurham Church, Oxon*, 20gns.
1848	82	*Lock at Newbridge, Glamorganshire*, 20gns.
1848	179	*Cauterets Pyreneen*, 20gns.
1848	197	*The Old Hulk on the Beach at Harwich*, 20gns., George Lang Esq., 5 St. Dunstans Hill, AU. 20.
1848	214	*Nutfield, near Bletchingley, Surrey*, 25gns.
1849	17	*Rodborough near Stroud, Gloucestershire.*
1849	87	*Near Pau, Pyrenees.*
1849	99	*Trarbach Castle, on the Moselle.*
1849	200	*Scene near Stroud, Gloucestershire.*
1850	3	*Sonning Church, near Reading*, 20gns.
1850	175	*Rustall Common, Tunbridge Wells*, 20gns.
1850	194	*On the Thames at Wargrave, Berks*, 20gns.
1850	203	*On the Thames at Wargrave, Berks*, 20gns.
1850	215	*Scene in the Pyrenees, near Pierfitte*, 20gns.

SEVERN JOSEPH

1817	135	*Hermia and Hellena, "Hel. - 'We Hermia, like two artificial Gods . . .'" Midsummer Night's Dream*

SEYFFARTH LOUISA

1836	23	*The Secret Discovered*, 50gns., Rev. B.H. Kennedy, Shrewsbury.
1836	31	*Sunday Morning*, Sold.

SEYFFARTH MRS

1837	191	*An Evening in Miss Stewart's Apartments, "'Do not - 'replied the Chevalier de Grammont: 'but tell me what put it into your head to form a design upon that inanimate statue, Miss Stewart?'" Memoirs of Count Grammont, London, 1811, Vol. 2. Chap, II. p.277* 100gns., John Loman Esq., Clayton Hall, Blackburn.
1837	209	*The Soldier's Widow*, 25gns., Lady Rolle, 18 Upper Grosvenor Street.
1837	219	*The Stroll in the Woods*, 30gns., T.G. Parry Esq., 9a Langham Place.
1838	40	*Persuasion.*
1838	52	*Gemile, "So nur halb zum Orientalen umgekleidet trat Andronikos seinem Bruder Hassan entgegen . . ." Andronikos, von Seyffarth, Th. I., s. 47.*
1838	99	*The Tourney, "It was evident to the spectators that a few more blows would now decide the conflict, and their interest rose in proportion . . ." Crichton, by Ainsworth, Vol. II. p.100.*
1838	152	*The New Page "He has always been kind to his little brother and sister, and I trust he will be as true to your Ladyship as his father was, my poor husband." Blackwood's Magazine.*

1839	5	*The Sisters, "Wrapt in such thoughts, she feels her mind astray . . ." Vide Crabbe's Tales of the Hall.* 40gns., Franz Baron v. Kreusser, 141 Regent Street.
1839	115	*A German Lady, with her Nurse, coming from Church*, Sold.
1839	206	*Public Garden at Charlottenburgh, near Berlin*, 100gns.
1840	209	*Will Honeycomb's Dream, "The general refused any other terms than those granted to the town of Weinsberg. - - - Immediately the city gates flew open and a female procession appeared . . ." Vide Spectator, Vol. VII. No. 499.*
1840	227	*From the Abbot, "And leading Roland Graeme to the Queen's seat, they both kneeled down before her . . ." Vide The Abbot, Vol. iii. Chap. 5.*
1840	255	*The Babes in the Wood, "Their pretty lips with blackberries Were all besmeared and dyed . . ."*
1840	270	*William and Betty, "We saw a young woman sitting in a personated sullenness just over a transparent fountain – opposite to her stood Mr William, Sir Roger's master of the game . . ." Vide Spectator, Vol. ii. No. 118.*
1841	103	*Constancy*, 14gns., A.J. Canham, Summerhill, Tenterden.
1841	104	*Inconstancy*, 14gns.
1841	199	*The Glove, "Francis the First, with his assembled Court, Mary Tudor, Dowager Queen of France, and Charles Brandon, Duke of Suffolk, were being amused with the fighting of wild beasts, when the Lady Kunigund, throwing her glove into the arena . . ."* 100gns.
1841	227	*Paul and Virginia*, 25gns.
1841	266	*The Alarm in the Night*, 12gns., Mr. Thomas Baring, 40 Charles St., Berkely Sqr.
1842	216	*The Wedding, "Oh! what's to me a silken gown. Wi' a poor broken heart? . . ." Ballad – Oh, ye shall walk &c.*
1842	264	*The Fortune Teller.*

SEYFFARTH MRS, LATE MISS L SHARPE

1835	24	*"Here, while as usual the Princess sat listening anxiously with Fadladeen in one of his loftiest moods of criticism . . ." Lalla Rookh.* 100gns.
1835	241	*The Good Offer, "O what a plague is an obstinate daughter!" – Old Song.* Sold.

SHARPE ELIZA

1838	68	*The Flight of Lot and his Daughters.*
1838	94	*Christ and the Mother of Zebedee's Children, "She saith unto him: Grant that these my two sons may sit, the one on thy right-hand and the other on the left, in thy kindom . . ." St. Matthew, Chap. xx.*
1839	223	*Mother and Children*, 12gns.

1839	241	*Christ Raising the Widow's Son, "Now when he came nigh to the gate of the city, behold, there was a dead man carried out, the only son of his mother, and she was a widow: and much people of the city was with her . . ." St. Luke, chap. vii., v. 12-15.* 90gns.
1839	289	*A Bavarian Girl,* 10gns., Sharpe, deliver to Creswick & Ruans, New Compton Street.
1842	206	*Noureddin and the Beautiful Persian, "Touching the lute, and continuing to look upon him, her eyes bathed in tears, she sang some verses . . ." Arabian Nights' Entertainments.*
1843	110	*The Little Dunce,* 40gns., Mrs. Col. Tulloch (the Prizeholder), Frame and glass £4.14.0, Prize in the Art Union of London 50£.
1843	241	*Una, "It fortuned out of the thickest wood A ramping lyon rushed suddenly . . ." Spencer's Fairie Queene.* 35gns.
1843	284	*Domestic Scene,* Sold.
1844	86	*Little Nell showing the old Church to the Visitors, "And those who came, speaking to others of the child, sent more; so that they had visitors almost daily . . ." Vide The Old Curiosity Shop, by Boz.* 40gns.
1844	119	*Gleaners - Evening,* 25gns.
1845	325	*The Bouquet,* Sold.
1845	328	*Childhood, "Gaze on, 'tis childhood's blooming lips and cheek . . ." Mrs. Hemans.* 18gns.
1845	336	*The Eldest Son, "I have a son, a pretty son, a boy just seven years old . . ." Moultree.* Sold.
1846	212	*St. Valentine's Morning,* 8gns.
1846	234	*The Mourner,* 8gns., Bishop of Chester, College Durham.
1847	157	*The Ten Virgins, "Then shall the kingdom of heaven be likened unto ten virgins, which took their lamps, and went forth to meet the bridegroom . . ." – Matthew, chap. xxv.* 100gns., Frame and glass £10.0.0.
1848	60	*Recollections,* 16gns.
1848	282	*A Lady in the Costume of the Sixteenth century,* 6gns.
1849	363	*Prayer, "Prayer is the breathing of a sigh, The falling of a tear . . ."*
1850	230	*"Rich and rare were the gems she wore . . . that a young lady, of great beauty, adorned with jewels and costly apparel, undertook a journey alone, from one end of the kingdom to the other, with only a wand in her hand, at the top of which was a ring of immense value."* 45gns., Miss Morgan, Pembroke House, Ryde, Isle of Wight, Frame and glass £3.6.0.
1851	273	*A Gipsey Mother.*
1851	318	*Charity, "She stretcheth out her hands to the poor; yea, she reacheth forth her hands to the needy . . ." Proverbs, xxxi. 20, 27, 28, 29.*

1852	61	*"Perdita. – 'And give me leave' . . ." Winter's Tale, Act V. Scene 3.* 45G, Frame and glass £3.0.0.
1852	169	*Solitude,* 15G.

SHARPE MISS

1832	369	*The Widow, "Lord William woos with jewels rare . . ." Old Ballad.* 40gns., Sold.
1833	115	*"Just as he spoke they came in, and approaching the bed where I lay, after previously informing me of their employment and business, made me their prisoner, bidding me prepare to go with them to the county jail . . ." Vicar of Wakefield.* 45gns.
1833	390	*Cleopatra,* Sold.
1833	410	*The Mother,* 45gns.
1833	419	*Portia and Nerissa,* Sold.
1836	178	*Ruth and Naomi, "And she said, Behold, thy sister-in-law is gone back unto her people, and unto her gods: return thou after thy sister-in-law . . ." Book of Ruth, Chap. I. v. 15, 16.* 35gns., Tustin Esq., 8 Fludyer Street, Whitehall.
1837	212	*"'Myself! O madam I was not wishing for bracelets, I was only thinking that – ' . . ." Madame de Fleury, by Maria Edgeworth.* 35gns., T.G. Parry Esq., 9a Langham Place.

SHARPE MISS E

1829	346	*The Unhoped-for Return,* 20gns., C. Heath Esq.
1830	6	*Child on the Cliff, "While on the cliff with calm delight she kneels . . ." Rogers's Poems.* Sold.
1830	73	*A Domestic Scene,* 70gns.
1831	3	*Belinda, "This nymph, to the destruction of mankind . . ." Pope's Rape of the Lock, Cantos II. and III.*
1833	13	*A Child at Play,* Sold.
1835	308	*The Phrenologist,* 35gns.
1835	322	*The Dying Sister,* 30gns., ?Mr. G.R. Smith, 4 Gt. Cumberland Place, To be sent to Sir Wm. De Bathe, 16 Gt. Cumberland St.
1836	167	*The Sleep Walker,* Sold.
1841	185	*Curiosity,* 25gns., W.J. Wilkinson, 21 Coles Terrace, Islington for Mr. Lackworthy Esq., Art Union.
1853	53	*The Soldier's Widow, opening for the first time the Wardrobe of her late Husband.*
1853	57*	*Lucy Ashton.*
1853	59	*Cleopatra.*
1853	94	*The Playmates.*
1853	201	*Rowena.*
1854	92	*The Widowed Lady Richildi, consulting the Magic Mirror, trusting to be assured that she is still the most beautiful Woman in Brabant, is struck with dismay when the silken curtains rustling apart show her the image of her step-daughter. – German Story.,* 30gns.

1854	216	*"All the earth doth worship thee,"* 25gns.
1854	271	*"The path of sorrow, and that path alone, Leads to the land where sorrow is unknown."* 8gns.
1855	220	*A Dame's School - the Bible Lesson,* 38gns.

SHARPE MISS L

1829	358	*The Wedding,* 35gns., C. Heath Esq.
1829	365	*Juliet,* 30gns., C. Heath Esq.
1830	127	*Girl with a Guitar,* 40gns.
1830	211	*Scene in the Vicar of Wakefield, "My wife, therefore, was resolved that we should not be deprived of such advantages for want of assurance . . ."* Sold.
1830	225	*Girl with a Letter,* Sold.
1831	149	*The Arrival of the New Governess.*
1831	181	*Jenny Deans imploring Queen Caroline to save her Sister's Life, Vide Heart of Mid Lothian.*
1831	279	*Rebecca at her Evening Devotions in the Preceptory of Templestowe, Vide Ivanhoe.*
1831	327	*"No: gayer insects fluttering by Ne'r droop the wing o'er those that die . . ."* Lord Byron's *Giaour.*
1832	224	*"Brunetta was now prepared for the insult, and came to a public ball in a plain black silk mantua, attended by a beautiful negro girl in a petticoat of the same brocade . . ." Spectator, Vol. I. No. 80.* 100gns., Sold.
1832	272	*Two Sisters contemplating the Portrait of their deceased Mother,* 25gns., Mr. Broderip, Sold before sent to the Gallery.
1833	74	*Children Sheltering from a Shower,* Sold.
1833	79	*"I mean to appeal to you, whether it is reasonable that such a creature as this shall come from a jaunty part of the town, and give herself such violent airs, to the disturbance of an innocent and inoffensive congregation . . ." Vide Spectator, No. 503.* 100gns., R.H. White Esq., United Service Club, Known to Mr. Bernall.
1833	260	*The Ghost Story,* Sold, Mr. William Broderip, 9 New Square, Lincolns Inn.

SHELLEY S

1805	69	*Hope and Love banish Fear.*
1805	72	*To the memory of Sir Joshua Reynolds, Knt. ded. by perm. to the most noble the Marchioness of Thomond - Painting, overcome with Grief, is consoled by Sculpture, who presents her with a medallion of Sir Joshua for the Genii of Taste to convey to the Temple. . . "Still guard his fame! and when. . .". Mrs. Robinson's Monody.*
1805	73	*Psyche having disobeyed Cupid, consults Pan in her misfortunes.*
1805	74	*Nymphs feeding Pegasus.*
1805	77	*Major Perryn.*
1805	78	*Laura sleeping, "Oh! sleep now doth my Laura close. &c." Rev. - Collier.*

1805	151	*Rasselas, Prince of Abyssinia, his sister, &c. conversing in their summer rooms, on the banks of the Nile.*
1805	228	*Captain Sydenham, Hon. East-India Company's Service.*
1805	229	*Cupid turned watchman.*
1805	230	*An Hamadryad.*
1805	231	*Corinthian maid.*
1805	232	*Mrs. Cuff.*
1805	233	*Love's complaint to Time.*
1805	235	*"By the rivers of Babylon, there we sat ourselves down; yea, we wept, when we remembered Zion. We hanged our harps upon the willows in the midst thereof." Psalms.*
1805	236	*Amoret chained, "But lo! No living wight was seen in all that room . . ." Vide Spencer's Fairie Queene.*
1805	237	*Mrs. Pierson.*
1805	238	*Welbore Ellis Agar, Esq.*
1805	239	*Mercury, when a child, steals Admetus' cattle.*
1805	240	*Right Hon. Lady Andover.*
1805	241	*Cupid solicits new wings.*
1805	242	*Miss White.*
1805	243	*A fancy head.*
1805	258	*Abra and Royal Abbas, "Oft as she went she backward turn'd her view, And bade that crook and bleating flock adieu." Collin's Eclogues.*
1805	266	*Nymph and Dove, from Anacreon.*
1806	96	*Mrs. Thornton, as she rode at York Races.*
1806	179	*Sylvia, Portrait of a Young Lady.*
1806	180	*A Holy Family.*
1806	181	*Love disappointed, from a favourite Song, "Hope told a flattering tale . . ."*
1806	182	*Donald Trail, Esq.*
1806	183	*An Old Man's Head.*
1806	184	*Dr. Hamilton.*
1806	185	*Two Children of C.N. Bayley, Esq.*
1806	186	*H. Repton Esq.*
1807	68	*Hermit, from Parnell.*
1807	69	*Eunomia.*
1807	70	*Lady and child.*
1807	71	*Youth.*
1807	79	*Rinaldo and Armida's appearance in the enchanted wood. Tasso's Jerusalem.*
1807	90	*Angel, from Parnell.*
1807	91	*Miranda.*
1807	92	*Young Neptune.*
1807	175	*Infant Shakespeare, "Betwixt the tragic and comic muse, courted of both, and dubious which to choose, the immortal Shakespeare stands." - Cumberland.*

1808	127	*Joy and Peace.*
1808	130	*The cave of Trophonius, "Who ever entered, were never afterwards seen to smile."*
1808	131	*A female head.*
1808	132	*A study.*
1808	133	*Portrait of a gentleman.*
1808	134	*A Madona.*
1808	140	*Erminia and Guido discover Tancred wounded in battle with Argantes. - Vide Tasso.*
1808	141	*Portraits of children.*
1808	142	*Portrait of a gentleman.*
1808	143	*Portrait of a young lady.*
1808	146	*Chloe in the grotto, preparing to bathe. - Vide Longus.*
1808	148	*A female head.*
1808	305	*Selim, or the shepherd's moral. Vide Collin's Eclogues.*
1808	311	*Master Stanley Miller.*
1808	314	*Julie praying with her children.*
1808	331	*The bard. Vide Gray, "Visions of glory, spare my aching sight."*

SHELLY S

1805	64	*Mr. Beckwith.*
1805	65	*Eve, For softness she, and sweet attractive grace.*
1805	67	*Subject from an epitaph on a child who died suddenly, "When we behold an opening rose ..." Gent. Mag. 1799*
1805	162	*Memory gathering the flowers cropped by Time.*
1808	333	*Amoret chained by the enchanter, is relieved by Britomart.*

SHEPHEARD G

1815	194	*The Crown at Penn, Bucks.*

SMITH G

1816	152	*Beeston Castle, Cheshire.*
1816	158	*Monte Rotunde, in the Campagnia of Rome.*

SMITH G W

1819	228	*Lowes Water, Cumberland, from a Sketch by Thomas Greatorix, Esq.*
1820	18	*On the River near Thun, Canton of Berne, Switzerland, £2.12.6, Rev. W. Cooke.*
1820	20	*Lake of Lungern, Canton of Unterwald, Switzerland, £2.12.6, Walter Fawkes Esq.*
1820	71	*Part of the Isle de Barbe, on the River Saone, near Lyons - France.*
1820	100	*Landscape, a Sketch, £5.5.0, T.P. Ripley Esq. .*
1820	209	*A Study from Nature.*
1820	252	*Fluelen Church, Lake of Lucern, Switzerland, £3.3.0, Mr. Broderip, Chelsea.*
1820	308	*On the River Saone, near Lyons.*
1820	365	*Cathedral, and part of the City of Lyons, on the river Saone, France.*

SMITH H C

1845	286	*Saltwood Castle, near Hythe, Kent, 5gns., Frame and glass £1.0.0.*

SMITH J

1807	5	*Inside of a cavern, with cattle, a view of nature in the bay of Salerno, kingdom of Naples.*
1807	31	*General view of the Coleseum, Arch of Constantine, and Baths of Titus, from Mount Palatine, Rome.*
1807	37	*Distant view of St. Peter's, and the Vatican Palace at Rome.*
1807	48	*Cittario, a small fishing village, near Amalfi, in the bay of Salerno.*
1807	51	*Gordale Scarr, an extraordinary chasm in the neighbourhood of Skipton, Yorkshire.*
1807	72	*General view of Fonthill Abbey, Wiltshire.*
1807	78	*General view of the Pays de Valais, and course of the Rhone, from above Martigny, Switzerland.*
1807	144	*The source of the Arveron, from the glaciers of Monterrvert, valley of Chamouny, Switzerland.*
1807	167	*Tivoli, near Rome.*
1807	178	*General view of Rome.*
1807	189	*Clum Castle, Shropshire.*
1807	190	*Distant view of Snowden, North Wales.*
1807	207	*Ruins of an ancient monument, usually called the tomb of the Horatii and Curatii.*
1807	214	*The convent of La Trinita, near La Cava, kingdom of Naples.*
1807	233	*An hermitage near La Cava, kingdom of Naples.*
1807	249	*The shore of Posilipo, and part of the city of Naples.*
1807	250	*Ruins of the Claudian Aqueduct in the Campania of Rome.*
1807	279	*A hermit in his cell, at his evening devotions. Scene from nature in the Appenines.*
1807	292	*View at Terracina, on the road between Rome and Naples.*
1808	80	*Ruins of the Temple of Venus, on the coast of Baia, near Naples.*
1808	83	*General view of the castle and town of Windsor.*
1808	94	*Convent near Perugia.*
1808	128	*On the great terrace, Windsor.*
1808	144	*Beeston Castle, Shropshire.*
1808	177	*Part of the City of Bologna.*
1808	178	*Convent near Amalfi.*
1808	190	*Convent at Vietri, near Salerno.*
1808	196	*Islands in the Bay of Salerno, where the galley slaves are confined.*
1808	215	*Ponte Lucana, near Tivoli.*

1808	272	*Remains of the Claudian Aqueduct in the Campania of Rome, with cattle.*
1808	282	*Besoni, in the lake of Lugano, 15gns., Mr. Walker.*
1808	316	*Vico Varro, near Tivoli, in the Appenines.*
1809	178	*Rhudlan Castle, in the vale of Clwyd, N. Wales.*
1809	195	*Bradby Hall house, in its present unfinished state.*
1809	210	*View in Bradby Hall Park, Derbyshire.*
1809	235	*A cedar tree in Bradby Hall Park, planted in the year 1676.*
1809	276	*The gamekeeper's lodge in Bradby Hall Park, Derbyshire.*
1809	282	*View of Bradby Hall Farm, in Derbyshire.*
1809	294	*Near Amalfi, in the bay of Salerno.*
1809	305	*An hermitage near Frescati, twelve miles from Rome.*
1809	315	*Otranto, in the bay of Salerno.*
1809	321	*A convent in the Appenines, near Salerno, in the kingdom of Naples.*
1809	333	*View of a mill in ruins, in Bradby Hall Park, Derbyshire.*
1809	339	*Castle and town of Joinville, in France.*
1810	52	*Near Port Hamel, Island of Anglesey.*
1810	57	*Looking across the Menai, from the Island of Anglesey, towards Penmacnmewr.*
1810	59	*From the Park at Plassnewyd, Island of Anglesey.*
1810	61	*Looking across the Menai, from the Island of Anglesey, towards Snowdon, North Wales.*
1810	68	*A Forest Scene with Cattle.*
1810	74	*Beaumaris Castle, Island of Anglesea, North Wales.*
1810	78	*Caernarvon Castle from the Water.*
1810	83	*Distant View of Plassnewyd, in the Island of Anglesey, and the surrounding Scenery.*
1810	95	*Eagle Tower, Caernarvon Castle.*
1810	151	*Villa in the Campania of Rome.*
1810	153	*In the Neighbourhood of Naples.*
1810	174	*Beau Desert, near Litchfield.*
1810	307	*Plassnewyd, in the Island of Anglesey.*
1810	311	*Plassnewyd, in the Island of Anglesey.*
1811	40	*In the Park at Clovelly Court.*
1811	73	*Clovelly Court, North Devon, the Seat of Sir James Hamlyn, Bart. with the surrounding Scenery and distant View of Lundy Island.*
1811	81	*Bishop's Court, near Exeter, the Seat of the Rt. Hon. Lord Graves.*
1811	82	*Bishop's Court.*
1811	86	*Chudleigh Rock, Devon.*
1811	87	*In the Valley of Bal, near Dulverston.*
1811	126	*View down the Menai towards Caernarvon from the Grounds at Veynold, the Seat of Thomas Asheton Smith, Esq.*
1811	247	*On Exmoor, Devon.*
1811	250	*Clovelly Harbour, Bay, &c. and distant View of Lundy Island.*
1811	253	*Torr Steps on the River Bal, near Dulverton, Somersetshire.*
1811	259	*Harlech Castle, North Wales.*
1811	281	*Dawlish, Devonshire.*
1811	291	*Barnstaple, North Devon.*
1811	294	*On the River Bal, near Dulverton.*
1811	297	*Pixton, near Dulverton, in Somersetshire, a Hunting Seat, belonging to the Rt. Hon. Lord Porchester.*
1811	300	*Porlock, Somersetshire.*
1811	315	*The Rocks at Tenby, South Wales.*
1811	316	*A Cottage Ornee, Back of the Isle of Wight.*
1811	322	*Clovelly Court, and the adjacent Country, near Biddeford, N. Devon.*
1811	342	*In the Park at Clovelly Court, North Devon.*
1811	349	*Mr. Garrow's Cottage at Pegwell Bay, near Ramsgate.*
1811	355	*Clovelly, a small Fishing Town, on the North Coast of Devonshire.*
1811	359	*Lymouth, North Devonshire.*
1811	363	*Torr Quay in Torbay, Devon.*
1812	58	*Chudleigh Rocks, Devonshire.*
1812	81	*An extensive View over the Country near Agrigentum, in Sicily, in which are seen Remains of the ancient Temples of Concord, of Juno, and of Hercules - Morning.*
1812	94	*The Castle and Cathedral, at Durham.*
1812	220	*Bologna in Italy.*
1812	264	*City of Florence.*
1812	299	*City of Berne, Switzerland.*
1812	307	*La Santa Casa at Loretto, Italy.*
1813	18	*Careig Cennin Castle, near Llandilo, South Wales.*
1813	48	*View of a Welsh Church, Conway, North Wales.*
1813	77	*A Bridge on the Pass over Mount Simplon from the Pays de Valais in Switzerland into Italy.*
1813	82	*View near Snowdon, North Wales, a Sketch.*
1813	114	*A General View of the City and Bay of Naples, with the surrounding scenery, including the Castle of St. Elmo, Palace of Capo de Monte, Mount Vesuvius and the Sites of the ancient Cities of Herculaneum and Pompeia, with the opposite shores of Sorrento.*
1813	138	*Fonthill Abbey, Wiltshire, the Seat of William Beckford Esq.*

1813	152	*Near the Falls of the River Conway, North Wales.*
1813	187	*A Scene in the Alps, on descending from the Grand St. Bernard into Italy.*
1814	4	*The Town of Porto Ferrajo, on the Island of Elba, the place allotted by the Allied Sovereigns for the future Residence of Bonaparte.*
1814	8	*The Coast and Fort of Ferrajo, on the Island of Elba.*
1814	22	*Fort l'Ecluse, situated on the banks of the Rhone, in the Road from Geneva to Lyons.*
1814	101	*Remains of the Temple of Diana, on the Coast of Baia, near Naples.*
1814	130	*A Scene in the Appennines, between Milan and Genoa.*
1814	154	*Descending from the Mont Simplon, in Switzerland, to Domo d'Ossala, situated on the Lago Maggiore.*
1814	164	*Near the Porto del Popolo, at Rome; in the Distance are the Villas Milani and Madama.*
1814	165	*The Town of Geneva, in Switzerland, taken from the Banks of the Rhone, below the Junction with the Averon.*
1814	169	*The Castle and Town of Joinville, in France, situate in that part of Champagne recently occupied by the Allied Armies, 7.7.0, Lady Lucas.*
1814	170	*A distant View of St. Peter's Church and the Vatican Palace, at Rome.*
1814	181	*Remains of the Temple of Diana, on the Coast of Baia, near Naples.*
1814	182	*View of the Appennines, between Bologna and Florence.*
1814	185	*Perte du Rhone, or Pont de Lucelle, on the road between Geneva and Lyons. This small bridge separates the territory of France from Savoy. The river Rhone is here lost under the rocks, finding a subterraneous passage, and rises again below the bridge with considerable violence and agitation.*
1814	275	*City of Laon, in France, recently occupied by the Army of Marshal Blucher, £6.6.0, Lady Lucas.*
1814	283	*Scene in the Apennines, near Salerno, in the Kingdom of Naples.*
1814	286	*Remains of an ancient Aqueduct near Naples.*
1815	314	*Capel Cerrig and distant view of Snowdon, North Wales.*
1815	320	*Distant View of Fonthill Abbey, from the Downs, above Hindon.*
1816	215	*Convent of Benedictines, near La Cava, in the Kingdom of Naples.*
1816	223	*Remains of an Amphitheatre at Taormina, in Sicily, Mount Etna in the Distance.*
1816	262	*In the Bay of Salerno.*
1816	284	*Convent of Benedictines, at Mont Serrat, in Spain.*
1816	319	*Longleat, in Wiltshire, the Seat of the Marquis of Bath.*
1817	214	*Bologna, as seen from the Convent of St. Michele in Bosco, with the Plains of Lombardy in the Distance, looking towards Venice.*
1817	217	*Cortona, Italy.*
1817	218	*The Holy House at Loretto.*
1817	221	*The Old Bridge, and Part of the City of Florence.*
1817	238	*View from the Summit of Snowdon, North Wales, looking down the Peninsula towards Bardsey Island and St. George's Channel.*
1817	244	*Chapel of St. Bruno, near the Convent of La Grande Chartreuse, in France.*
1817	255	*Narvarin, on the Coast of the Morea; the Ancient Pylos.*
1817	262	*General View of the Bay and Town of Porto Ferrajo, in the Island of Elba; a Promontory of the Island of Corsica in the extreme Distance.*
1817	266	*The Town of Majore, in the Bay of Salerno, Italy.*
1817	274	*Town and Lake of Lugano, in Lombardy.*
1817	289	*Caernarvon Castle, North Wales.*
1818	297	*Sheep, £6.6.0, Lady de Grey.*
1818	304	*The Approach to Clovelly Court, North Devon, from a Sketch by Lady Hamlyn Williams.*
1818	321	*Banditti in a Cavern.*
1818	337	*Gipsies. A Scene from Nature, in Switzerland.*
1818	340	*View in the Appennines above Tivoli, £10.10.0, Lord Suffolk.*
1819	158	*Mont Blanc, in Switzerland, as seen from the Valley of Salenche.*
1819	231	*In the Gardens at Stourhead, Wilts, the Seat of Sir Richard Colt Hoare, Baronet.*
1819	270	*On the South Shore of the Island of Caprea, in the Bay of Naples.*
1820	307	*The Town of Caprea, in the Island of Caprea, Bay of Naples.*
1820	320	*The Town of Amalfi, in the Bay of Salerno, Kingdom of Naples.*
1820	329	*Convent on the Grand St. Bernard, Pays de Valais, Switzerland.*
1820	330	*Mount Sion, Pays de Valais, Switzerland.*
1820	353	*Bridge on the old Road over Mont-Simplon - a Sketch.*
1821	42	*The Lake and Town of Lugano in Lombardy.*
1821	43	*Approach to the City of Como, from Milan.*
1822	18	*A general View of the Coliseo, the Arch of Constantine, and Remains of the Claudian Aqueduct, as seen from the Ruins on Mont Palatine, at Rome, £8.8.0, J. Dimsdale Esq.*

1822	19	*Interior View of the Coliseo, at Rome, as it remained in the Year 1781*, £8.8.0, Do.

1822 35 *A General View of the City and Bay of Naples, from the heights above Capo di Monte. On the right is the Castle of St Elmo and Carthusian Convent; on the left Mount Vesuvius and Village of Portici, the site of the ancient Herculaneum; (This Picture was painted in consequence of Mr. SMITH receiving the sum, which is allotted by the Society at the close of each Season, for the purpose of inducing the Artist to undertake a Work of elaborate composition for the ensuing Exhibition.)*, £42.0.0, J. Dimsdale Esq.

1822 68 *View in the Chaija at Naples, including Pizzi Falcone, the Castello del' Ovo and distant shores of Sorrento across the Bay*, £6.6.0, J. Dimsdale Esq.

1823 164 *South Gate of the Town of Conway, North Wales.*

1823 208 *Remains of Maecenas' Villa, the Cascatelli, and Villa D'Este, at Tivoli.*

1823 210 *Mont Blanc, from Salenche.*

1823 211 *General View of the City of Naples, in which is seen the Castello del Ovo, the Castle of St. Elmo, and Carthusian Convent - in the extreme distance the Camaldoli Convent of Franciscans - View taken from the foot of Vesuvius.*

1823 227 *Cascade on the Side of the Lake of Lugano in Lombardy.*

1823 282 *La Cava, on the Road to Salerno, kingdom of Naples.*

1823 286 *Caldicot Castle, Monmouthshire.*

1823 290 *City of Salerno in the Kingdom of Naples.*

1823 297 *Ruins of Paestum in Calabria.*

SMITH W

1814 66 *Head of a Fox.*

1815 200 *Landscape with Sportsmen.*

1816 163 *Rabbits, from Nature.*

1818 123 *A Hare*, £6.6.0, J. Holford Esq.

1818 125 *Study.*

1818 127 *Singing Birds.*

1819 66 *Rabbit Shooting.*

1820 44 *A Shot Mallard.*

1820 136 *Spaniel and Wild Duck, &c.*

SMITH W C

1843 1 *Men of War in Ordinary, at Hamoaze*, 30 Pounds, Frame and glass £4.4.0.

1843 3 *The Eagle Tower at Caernarvon, during the Fair*, 15 Pounds, H. Humphreys Esq., Buckingham, Frame and glass £2.19.0, Prize of £10 with Art Union of London.

1843 13 *Clovelly Fishing Boat making for the Pier in a fresh Breeze*, 15 Pounds, Hon. and Rev. Atherton Legh Powys, Titchmarsh Rectory, Thrapstone, Northamptonshire, Frame and glass £2.12.6.

1843 20 *Greenwich Hospital from the Marshes*, 15 Pounds, Hon. & Rev. Atherton Legh Powys, Titchmarsh Rectory, Thrapstone, Northamptonshire.

1843 39 *View from the Ramparts of Dover Castle*, 15 Pounds, Frame and glass £2.12.6.

1843 108 *Clovelly, North Devon*, 35 Pounds, Frame and glass £6.5.0.

1843 256 *Vessels at the Nore in Shoal Water*, 15 Pounds, Benjm. Austin Esq., 6 Montague Place, Russell Square, Frame and glass £2.12.6.

1843 322 *The Dreadnought, Seaman's Hospital Ship off Greenwich*, 5 Pounds, C.H. Turner, Rooksnest, 15 Bruton St., Berkeley Sq., Will keep the frame and glass £1.10.0.

1844 6 *London, from Waterloo Bridge*, 8gns., Frame and glass 2gns.

1844 7 *Woodhouse Church, Leicestershire*, 10 Pounds, Frame and glass 2 Pounds.

1844 44 *Brig on Tynemouth Bar, Northumberland, in a Gale of Wind*, 18 Pounds, Lord March, 41 Portland Place, Frame and glass 4 Pounds, P.AU.

1844 58 *North End of the Hall at Speke, near Liverpool*, 15gns., Frame and glass £2.10.0.

1844 100 *H.M.S. Dreadnought, Seaman's Hospital, off Greenwich*, 40gns., John Wild Esq., Clapham Common, Frame and glass £9.9.0.

1844 149 *Clovelly Herring Boat at Low Water*, 18gns., Frame and glass £4.0.0.

1844 177 *Speke Hall, near Liverpool*, 15 Pounds, Frame and glass £2.10.0.

1844 283 *Brig standing into Dover Harbour in a Stiff Breeze*, 15gns.

1845 1 *Old Vessel in the Sand, at Bamborough Castle, Northumberland*, 40 Pounds, Frame and glass £6.6.0.

1845 6 *St. Michael's Mount, from the Sands near Penzance, Cornwall*, 8gns., Frame and glass £1.5.0.

1845 14 *Penrhyn Castle, and the Pass of Nant Frangon, from Beaumaris, North Wales*, 20 Pounds, Frame and glass £4.0.0.

1845 20 *Homeward Bound - West Indiaman and River Craft in Woolwich Reach - the Dockyard in the distance*, 15 Pounds, Frame and glass £3.10.0.

1845 56 *French Herring Boat at Anchor in the Flats of Holy Island, Northumberland*, 10 Pounds, Mrs. Grimshawe, Biddenham, Beds., Frame and glass £1.10.0.

1845 185 *Old Hulk, on Shore, in the River Medway - Sheerness in the distance*, 30 Pounds.

1845 232 *Dumbarton Castle, on the Clyde*, 20 Pounds, Miss Coswell, 6 Lower Berkeley Street, Portman Sq., Frame and glass £4.4.0.

1846	2	*Ben Nevis, from Loch Eil*, 30 Pounds, Frame and glass £4.0.0.
1846	39	*Fish Market, Hastings*, 15 Pounds, Frame and glass £2.17.0.
1846	44	*Fresh Breeze, off Beachy Head*, 15 Pounds, Francis Fuller Esq., 29 Abington St., Frame and glass £2.17.0 new frame £3.8.0.
1846	57	*Village of Grange, Derwentwater*, 10 Pounds, Frame and glass £1.11.0.
1846	65	*Near the Parade, Hastings - a Squall coming on*, 15 Pounds, Frame and glass £2.17.0.
1846	83	*Battle of the First of June, 1794 - the French Line-of-Battle Ship Le Vengeur sinking, Le Vengeur was at this time not more than two ships' length from the Alfred; so that she went down almost under her quarter . . . From an Eye Witness.* 50 Pounds, Frame and glass £8.0.0.
1846	186	*London, from Greenwich Park*, Sold.
1846	288	*Charlton House, Kent, the Seat of Sir Thomas Maryon Wilson, Bart.*, 7gns., Frame and glass £1.3.0.
1847	68	*H.M.S. Caledonia, 120, Guard Ship at Plymouth, Signaling Vessels in the Offing*, 15 Pounds, Frame and glass £3.0.0.
1847	96	*Brig carrying away her Spars in a Squall, off the Eddystone Light*, 25 Pounds, Frame and glass £5.0.0.
1847	101	*Mill Wall, Isle of Dogs*, 15 Pounds, Mrs. Brand, Burlington ?, Frame and glass £3.0.0.
1847	133	*Haddon Hall, Derbyshire*, 30 Pounds, C.S. Busby Esq., Chesterfield, Derbyshire, Frame and glass £5.0.0 Sold, P.AU. 30£.
1847	138	*Gibraltar - Sunrise*, 20 Pounds, C. Russell Esq. M.P., 27 Charles St., St. James, Frame and glass £3.0.0.
1847	164	*Dartmouth - Passengers waiting for the Ferry Boat*, 35 Pounds, Frame and glass £5.0.0.
1847	166	*Staffa*, 15 Pounds, Frame and glass £3.0.0.
1847	230	*St. Catherine's Island, at Tenby*, 10 Pounds, Frame and glass £2.0.0.
1848	8	*The Town and Castle of Hastings, Sussex, from the East Hill*, 30gns., Frame and glass £4.4.0.
1848	26	*View from Fairlight Downs, looking towards Beachy Head - Shower clearing off*, 35gns., Frame and glass £5.5.0.
1848	77	*The East Cliff, Hastings*, 15gns., Frame and glass £3.3.0.
1848	96	*Vesuvius at Sunrise*, 20gns., Frame and glass £3.3.0.
1848	102	*Tower of All Saints Church, Hastings*, 15gns., Frame and glass £3.3.0.
1848	111	*Lobster Fishermen at Clovelly, Devon*, 10gns., Frame and glass £2.2.0.
1848	127	*Vessels in a brisk Gale at Spithead*, 20gns., Frame and glass £3.3.0.
1848	180	*Wreck on the Longships, near the Land's End, Cornwall*, 60gns., Frame and glass £6.6.0.
1849	13	*The Cathedral of Iona, "Serene and bright the glowing heavens smile O'er thee, Iona . . ." – Ellen Wood.*
1849	42	*Frigate running into Plymouth - Mount Edgecombe in the distance.*
1849	115	*Derwent Water.*
1849	152	*Honiston Crag and Buttermere, from Crummock Water.*
1849	159	*Greenwich, from One Tree Hill.*
1849	196	*Penrhyn Castle - from the road to Nant Fraugon, North Wales.*
1849	198	*The Land's End, Cornwall.*
1849	216	*Admiral Collingwood Breaking the Line at Trafalgar, "The Royal Sovereign, having in the most gallant manner passed under the stern of the Santa Ana (giving her a broadside which killed and wounded 400 men) . . ." James's Naval History.*
1850	9	*The Terrace at Haddon*, 15gns., Lord Carlisle, 12 Grosvenor Place, Frame and glass £2.5.0 Yes.
1850	34	*Snowdon, from the Sands, near Tremadoc*, 30gns., Frame and glass £3.0.0.
1850	42	*The East Cliff, Hastings*, 12gns., Frame and glass £1.15.0.
1850	51	*The Lizard Lighthouse, Cornwall*, 18gns., Frame and glass £2.2.0.
1850	78	*French Boat at Hastings*, 15gns., Frame and glass £1.18.0.
1850	79	*Windsor, from the Beeches on the road to Virginia Water*, Sold.
1850	89	*Ben Nevis, from Loch Eil*, 50gns., T.F. Armistead Esq., Bank of England, Frame and glass £6.0.0, AU. 40.
1850	96	*Catania*, 15gns., Saville Onley Esq., Stistead Hall, Essex, Frame and glass £2.16.0 Yes.
1850	97	*Near the Long Walk, Windsor*, 12gns., Miss Leigh Smith, Frame and glass £1.16.0.
1850	101	*A Squall off St. Maw's, Falmouth Harbour*, 20gns., Frame and glass £2.10.0.
1850	108	*Cader Idris, from Dolgelly*, 40gns., Frame and glass £5.0.0.
1850	123	*The Mumbles Lighthouse, Swansea Bay*, 18gns., Frame and glass £2.5.0.
1850	132	*Greenwich*, 10gns., Frame and glass £1.10.0.
1850	138	*Study on the Wye, at Tintern*, 5gns., Frame and glass £1.5.0.
1850	139	*On the River Lynn, Linton, North Devon*, 8gns., Frame and glass £1.10.0.
1850	145	*The Darnley Chapel, Cobham Church, Kent*, 18gns., Frame and glass £2.5.0.

1850	154	*The Fitzalan Chapel, Arundel, Sussex*, 18gns., Miss Shepley, Wandsworth, Frame and glass £2.16.0.
1850	158	*Vessels off the North Foreland*, 5gns., Frame and glass £1.10.0.
1850	186	*Moonlight at the Trosachs*, 5gns., Frame and glass £1.10.0.
1850	208	*St. Saviour's Church, Southwark*, Sold.
1850	239	*Shrimpers - Hastings*, 10gns., Frame and glass £1.8.0.
1850	248	*Garden Scene*, 5gns., Frame and glass £1.8.0.
1850	260	*Camber Castle, near Winchelsea*, 4gns., T. Lushington Esq., 5 Paper Bds., Temple, Frame and glass £1.14.0.
1850	272	*Haddon*, 8gns., C. Jeffery, Limehouse, Frame and glass £1.13.0 Yes, AU: Com.
1850	279	*Clovelly, North Devon*, 15gns., Frame and glass £2.16.0.
1850	290	*The Pretender's Column, Glen Finnan*, 18gns., Thos. Toller Esq., 6 Grays Inn Sq., Frame and glass £2.5.0 No.
1850	303	*Dolbadern Castle, Llanberris*, 7gns., Frame and glass £1.13.0.
1850	307	*Garden Scene*, 7gns., Frame and glass £1.10.0.
1850	320	*Boats on Hastings Beach*, 5gns., Rev. Richd. Sale, Epping, Essex, Frame and glass £1.10.0 No.
1850	358	*Clovelly Pier, North Devon*, 7gns., Frame and glass £1.1.0.
1850	363	*Sunset at Mortlake*, 4gns., Frame and glass £1.14.0.
1850	364	*Holy Island Castle*, 5gns., Frame and glass £1.10.0.
1851	2	*Cornelian Bay, Scarborough, Yorkshire*.
1851	23	*Windsor Castle, from the Great Park*.
1851	47	*Attack by English Gun Brigs on a Spanish Flotilla, at Cape Oropisa, under the command of the Right Hon. the Earl of Dundonald, during the Spanish War*.
1851	106	*The Vale of the Lynn, Lynton, Devonshire*.
1851	123	*On the Coast, Scarborough*.
1851	128	*Barnard Castle, on the Tees*.
1851	133	*Filey Bay, looking towards Flamborough Head*.
1851	139	*Parade, on the Queen's Birthday - Horse Guards*.
1851	173	*Gibraltar*.
1851	200	*Scarborough, from Filey Bay, Yorkshire*.
1851	201	*The Head of Loch Lomond, looking towards Tarbet*.
1851	209	*Colliers Unloading - Hastings*.
1851	217	*Northfleet, near Gravesend*.
1851	218	*A Summer Shower at Fairlight, Sussex*.
1851	219	*Tomb of Sir Hugh Fitz-Allan - Arundel, Sussex*.
1851	234	*Hearne's Oak, Windsor Forest*.
1851	241	*The River Lynn, Lynton, North Devon*.
1851	261	*Sunrise - at Hastings*.
1851	281	*View from Richmond Hill*.
1851	310	*Fishermen on the Coast at Hastings*.
1852	20	*The Market Place, Rouen, with South Door of the Cathedral*, 15G, Frame and glass £2.15.0.
1852	25	*H. M. S. the Nymph, at Blackwall - a Squall passing off*, 12G, Frame and glass £2.10.0.
1852	37	*The Storm of September 1847, as seen from Woolwich*, 12G, Frame and glass £2.10.0.
1852	43	*Richmond, Yorkshire*, 8G, Frame and glass £1.12.0.
1852	74	*Craig-y-'llyn, in the Vale of Neath, South Wales*, 15G, Frame and glass £2.15.0.
1852	76	*The Town and Castle of Dieppe*, 50G, Algernon Fredk. Greville, 43 Lowndes Square, Frame and glass £7.17.6, AU. 50.
1852	88	*The Golden Altar, Rouen Cathedral*, 30G, Frame and glass £3.3.0.
1852	91	*The Great Door, Rouen, from the Flower Market*, 25G, John Moxon, 8 Hanover Terrace, Regents Park, Frame and glass £2.15.0.
1852	97	*A Limekiln at Croydon, Kent*, 6G, Frame and glass £1.15.0.
1852	99	*The Avenue - Haddon*, 25G, Frame and glass £3.3.0.
1852	110	*Aberglasslyn, North Wales*, 6G, Miss Leigh Smith, 5 Blandford Square, Frame and glass £1.10.0.
1852	120	*Interior of the Lady Chapel, St. Remi, Dieppe*, 12G, Frame and glass £1.15.0.
1852	142	*A Glade near Cranbrook Lodge, Windsor Forest*, 15G, Frame and glass £3.0.0.
1852	168	*Lowestoffe harbour, at Night*, 10, Frame and glass £2.0.0.
1852	172	*Whitby, from the Sea*, 10G, Frame and glass £1.18.0.
1852	183	*Rue St. Remi, with the Church, Dieppe*, 12, Frame and glass £1.15.0.
1852	188	*The South Aisle, Rouen Cathedral*, Sold, Frame and glass £2.10.0.
1852	213	*The Lake of Thun*, 50G, G.F. Young Esq., M.P., Northbank, Walthamstowe, Essex, Frame and glass £7.7.0, AU.
1852	225	*Holy Island Castle, on the Coast of Northumberland*, 5G, A. Peyton Esq., Frame and glass £1.15.0.
1852	249	*Loch Lomond - the Upper Reach*, 5G, Frame and glass £1.18.0.
1852	254	*Whitby, from the Sea*, 10.
1852	255	*Glencoe, Scotland*, 5G, Abel Peyton Esq., Frame and glass £1.15.0.

1852	316	*Eltham, from Shooter's Hill.*
1853	8	*Windsor Park.*
1853	11	*Way through the Wood, Fairlight, Sussex.*
1853	41	*Ben Cruachan, from Glen Orchy.*
1853	61	*Black Sale, Wastwater, Cumberland.*
1853	75	*The Highest Peak of the Cuchullins, Skye.*
1853	85	*Windsor Castle, from Bishopsgate.*
1853	104	*Tomb of Edward the Black Prince, Trinity Chapel, Canterbury Cathedral.*
1853	149	*Garden of the Tuileries.*
1853	166	*The Colosseum, from the Palace of the Caesars, Rome.*
1853	176	*Straits of Messina, from the Capuchin Convent.*
1853	179	*Boats on the Beach, Hastings.*
1853	189	*Pont Neath Vaughan.*
1853	215	*The Madrigal.*
1853	229	*Arundel, Sussex.*
1853	233	*John Knox's House, Edinburgh.*
1853	255	*Dolbadern Castle, Llanberris, North Wales.*
1853	275	*River Neath Vaughan.*
1853	307	*On the Coast, near Rye, Sussex.*
1854	27	*Alpine Travellers resting on the Mayenwand above the Glacier of the Rhone,* 60gns./£60, George J. Barham, Wolverhampton, Frame and glass £7.0.0.
1854	61	*The Bay of Uri, Lake of Lucerne, from near Tell's Chapel, where Mass is said annually on the Friday after Ascension, "That sacred lake withdrawn among the hills . . ."* Rogers. 100gns., Alexander Morison Esq., Mont??? House, Frame and glass £5.0.0.
1854	110	*Study of Fern in Richmond Park,* 10gns., Frame and glass £2.2.0.
1854	113	*The Interior of St. Maclou, Rouen,* £50.0.0, Frame and glass £4.10.0.
1854	129	*Ockham Heath,* 12gns., Wells Esq., 30 Ebury St., Eaton Square, Frame and glass £2.5.0.
1854	133	*Bridge at Neath Vaughan,* 12gns., Frame and glass £1.15.0.
1854	134	*A Squall at Hart-o'Corry, in the Cuchullins, Skye,* 15gns., Frame and glass £2.2.0.
1854	146	*Chillon, Lake of Geneva,* 7gns., Mr. H. Hopley White, 13 Old Square, Lincolns Inn, Frame and glass £1.10.0.
1854	156	*Sunset at Richmond,* 14gns., Frame and glass £1.1.0.
1854	175	*A Hawking Party Returning,* 25gns., Miss Roche, 58 South Mall, C??? - selected by Miss Augusta Cole, 52 Upper Norton St., Portland Place, Frame and glass £3.10.0.
1854	177	*Fishermen on the Coast of Kent,* 30gns., Frame and glass £2.15.0.
1854	185	*Near Woodhouse, Leicestershire,* 5gns., Frame and glass £-.10.6.
1854	195	*A Sunny Day at Scarborough,* 14gns., Brown Esq., Brathay Lodge, Frame and glass £1.18.0.
1854	235	*Sunset at Lynmouth,* 5gns., Henry Hessill(?) Diss, Frame and glass £1.5.0.
1854	245	*Richmond Park, looking towards Kingston,* 10gns., R. Ellison Esq., Frame and glass £1.14.0.
1854	246	*Storm at Hastings,* 10gns., Frame and glass £2.0.0.
1854	256	*Keep of Scarborough Castle,* 5gns., Frame and glass £1.0.0.
1854	265	*Composition,* 6gns., Frame and glass £1.10.0.
1854	270	*Scarborough, from Cornelian Bay, looking towards Filey,* 10gns., W. Rowland, Wrexham [in deposit column], Frame and glass £2.0.0, Art Union Prize, selected by Lewis Pocock Esq.
1854	279	*A Scene on Glen Sligachan, Skye,* 12gns., Frame and glass £2.5.0.
1854	284	*Scarborough Castle,* 5gns., The Rev. C. Sale, with frame 15/.
1854	299	*Chateau d'Arques, near Dieppe,* 5gns., Frame and glass £1.10.0.
1854	301	*Evening,* 8gns., Frame and glass £1.8.0.
1854	302	*Pont Neath Vaughan,* 14gns., Frame and glass £2.2.0.
1854	332	*Boats on the Sands at Bude Haven,* 10gns., Frame and glass £2.0.0.
1854	336	*The Valley of the Grimsel,* 7gns., Abel Peyton, Frame and glass £1.10.0.
1854	343	*In Glen Orchy, looking towards Ben Cruachan,* 20gns., Frame and glass £2.5.0.
1854	355	*Ben Nevis, from Loch Eil,* Sold, S.D. Harding Esq., 3 Abercorn Place, Maida Hill.
1855	22	*Moel Siabod, Capel Cûrig,* 7gns., Sold, Frame and glass £1.15.0.
1855	28	*The Devil's Bridge, Pass of St. Gothard - A Detachment of Swiss Troops crossing the Reiuss,* 80gns., Frame and glass £7.7.0.
1855	42	*At Bettwy's-y-Coed,* 14gns., Frame and glass £1.15.0.
1855	101	*Dorking, Surrey,* 14gns., Frame and glass 30/.
1855	119	*Valley of Dallydellau - Moel Siabod in the distance,* Sold.
1855	149	*Pont-y-Pant, Dallydellau,* 25gns., Frame and glass £4.0.0.
1855	159	*A Day in Windsor Park, "Alone in green woods would I roam, Amid the woods I'd make my home . . ." – Old Ballad.* 57gns., Frame and glass £5.5.0.
1855	163	*Pont-y-Gyffyn, Capel Cûrig,* 24gns., Frame and glass £3.0.0.
1855	167	*Arundel Park, Sussex,* 7gns., Frame and glass £1.10.0.

1855 190 *The Golden Horn, Constantinople, from the Cemetery of Pera, The white building on the left, backed out by the mountains of Asia, is the great Hospital of Scutari; the Cemetery near which it is placed is the last resting-place sought by all good Mussulmans. Seraglio Point, the Sultan's Palace, the Mosques of . . .* 110gns., Francis Fuller Esq., 29 Abingdon St., Frame and glass £10.10.0.

1855 207 *Portrait of an Old Friend at Windsor,* 25gns., C.W. Packe Esq., 7 Richmond Terrace, Whitehall, Frame and glass £4.4.0.

1855 234 *The Pools, Capel Cûrig,* 7gns., William Pilleau(?), 9a Lord(?) Road, Brighton(?), Frame and glass £1.15.0.

1855 241 *A Glade at Windsor, the Stag's Hunt,* 12gns., G. Pridham, Plymouth, Frame and glass £1.15.0.

1855 254 *Corn Field near Erith, Kent,* 7gns., Frame and glass £1.5.0.

1855 264 *Holy Island, from the Bamborough Sands,* 6gns., Josh. Robinson Esq., Berkhampstead, Frame and glass £1.10.0.

1855 279 *Birch Wood, Capel Cûrig,* 15gns., Frame and glass £1.15.0.

1855 295 *Ecclesbourne Glen, Hastings,* 12gns., Frame and glass £1.10.0.

1855 303 *The Countess,* 7gns., Mrs. Osborne, Admiralty, Frame and glass £1.5.0.

1855 310 *Snowdon, from Capel Cûrig,* 10gns., Mr. Milwark, 97 Goswell Road, Islington, Frame and glass £1.15.0 (with frame).

1855 317 *Lythe, near Whitby,* 7gns., Ellison Esq., Frame and glass £1.5.0.

1855 320 *Lake of Thun,* 12gns., Joseph Robinson, Berkhampstead, Frame and glass £1.10.0.

STANLEY C R

1820 70 *Arundel Castle, from the Brighton Road,* £6.6.0, Suffield Brown Esq.

1820 78 *Cottage at Hardum, Sussex,* £6.6.0, Suffield Brown Esq.

1820 81 *A Scene in Penge Wood, Surrey,* £7.7.0.

STARK J

1817 43 *Keswick. Morning.*

1817 68 *Boatbuilder's Yard,* £12.12.0, J.H. Quintin Esq.

1818 99 *Landscape and Cattle. Spring,* £21.0.0, Sir G. Beaumont.

1818 115 *Scene on the Beach at Cromer,* £21.0.0, J. Bullock Esq.

1818 117 *Grove Scene, near Norwich. Autumn,* £21.0.0, F.L. Chantrey Esq., R.A.

1818 131 *Lane Scene,* £10.10.0, Mr. Sergeant.

1819 34 *Cottage Scene near Norwich,* £31.10.0, Bishop of Oxford.

1819 53 *Landscape and Cattle,* £28.7.0, Bishop of Oxford.

1819 67 *Grove Scene.*

1819 110 *Grove Scene.*

STEIN R

1820 90 *Ruins of Burley Castle, Kinross-shire - the ancient Seat of the Balfours of Burley.*

1820 99 *View of Holyrood House, from St. John's Hill, Edinburgh.*

1820 102 *View of Arrochar, Head of Loch Long, Scotland.*

STEPHANOFF

1837 331 *"Gardyn is crowned with garlands gay, As Mary's hand the victor crowned . . ." Vide Hogg's Queen's Wake* 8gns., Frame and glass £1.12.6.

1837 359 *King Edward's Dream, "He saw the Scots' banner red streaming on high, And Wallace's spirit was pointing the way." Hogg's Queen's Wake.* 5gns., Frame and glass 2gns.

STEPHANOFF F P

1813 244 *The Guard-Room, "Some weary snor'd on floor and bench . . ." Vide Lady of the Lake.*

1815 64 *The examination of Don Quixote's Library.*

1815 163 *Robert, Duke of Normandy, discovering his Father on the Field of Battle. Vide History of England.*

1819 89 *The Discovery,* £42.0.0, W. Haldimand Esq.

1819 98 *Portraits of two Ladies, and a Young Gentleman.*

1819 214 *Second Drawing Room, Buckingham House.*

1819 215 *Blue Velvet Room, Buckingham House.*

1820 115 *The Afternoon Nap.*

1820 116 *Clandestine Correspondence discovered.*

1820 141 *Trial of Algernon Sydney, in the Court of King's Bench, before Judge Jeffries, with Portraits of some other eminent political Characters of the time.*

STEPHANOFF J

1813 4 *Portrait of Miss Smirnove.*

1813 17 *Portrait of Gentleman.*

1813 31 *Falstaff, Peto, Gadshill, and Bardolph, attacking the Travellers at Break of Day, on their Road to the King's Exchequer, "Fal. 'Strike! Down with them! - They hate us, youth! - Down with them! - Fleece them!' . . ."* £15.15.0, H.R.H. The Princess Charlotte.

1813 83 *A Musical Conversation.*

1814 93 *A Musical Conversation.*

1814 106 *Bowzybeus, having sung at the Desire of the Shepherds, exacts his Reward from the surrounding Nymphs, "Sudden he rose, and, as he reels along . . ." Gay's Pastorals.*

1814 296 *Epicures, "Fill the bowl with rosy wine . . ." Cowley* £10.0.0, J.G. Lambton Esq., M.P.

1815	170	*The Fair, held on the 1st of August, in Hyde Park, £26.5.0, J. Bramwell Esq.*
1815	275	*Sir Toby, Sir Andrew Aguecheek, with their licentious companions, carousing in the house of Olivia, "Malvolio. - 'Sir Toby, I must be round with you! My Lady bid me tell you, that, though . . .'" Vide Twelfth Night. £20.0.0, T.G.*
1817	224	*The Exhibition of Italian Masters at the British Institution in 1816 - The Figures by T.P. Stephanoff, £15.15.0, J. Allnutt Esq.*
1817	258	*The Connoisseur - The Antiquities are from the Townely and Elgin Collections at the British Museum.*
1818	17	*Queen's State Bedchamber, Windsor Castle.*
1818	18	*The Grand Saloon, Buckingham House, In this Room the Nuptials of Her Royal Highness the Princess Elizabeth with His Serene Highness the Prince of Hesse Homberg were solemnized.*
1818	22	*Queen's Closet, Kensington Palace.*
1818	24	*Grand Staircase, Buckingham House.*
1818	38	*The Queen's Drawing Room, Buckingham House.*
1818	354	*An Apartment containing the Phygalion, and a Selection of the Elgin Marbles at the British Museum.*
1818	358	*Evening, £10.10.0, J. Allnutt Esq.*
1818	367	*A Musical Conversation.*
1819	202	*Antient Kitchen, Windsor Castle.*
1819	204	*The Queen's Breakfast Room, Buckingham House.*
1819	206	*The King's Presence Chamber, Windsor Castle.*
1819	210	*Ancient Bell Tower, Windsor Castle.*
1819	212	*Old Guard Chamber, Round Tower, Windsor Castle.*
1819	296	*Interior of the Picture Gallery of Sir J.F. Leicester, Bart.*
1819	318	*Interior of His Majesty's Supreme Court of Judicature in the Island of Ceylon; with the Trial of four men of the Yellate, or first caste of the Cingalese for Murder, by a Native Jury; and also representing the act of Abolition of Slavery by the Planters of the Island, and exhibiting some of the various costumes seen in Colombo.*
1819	327	*A Party returning from Angling, on the Lakes, "And, as our little Bark swift glides along. . ." Vide "The Angler," page 181.*
1820	315	*The Vicar of Wakefield seeking his Daughter at the Race Course, "The next day I walked forward to the races, and about four in the afternoon I came upon the course . . ."*
1821	18	*Portrait of a Lady and Child.*
1821	23	*Portrait of Miss S. Roland.*
1821	177	*Bacchanalia.*
1821	185	*Portrait of a Lady.*
1822	109	*The Introduction of Waverley to the Pretender at Holyrood House, "Waverley, kneeling to Charles Edward, devoted his heart and sword to the vindication of his rights." Vide Waverley. £21.0.0, Marquis of Stafford.*
1823	4	*The Ceremony of the Recognition, at the Coronation of His Majesty King George the Fourth. (Painted for R. BOWYER, Esq. Pall Mall.) , His Majesty is represented in the distance near the Altar, surrounded by the Noblemen bearing the Regalia: above are the Seats . . . The Figures by J. Stephanoff, the Architecture by A Pugin.*
1823	59	*Three Designs - The Inhabitants of Drinkallia. Vide Gentleman's Magazine, 1791. The Meeting of Francis I. and Henry VIII. at the Tournament of the Cloth of Gold. A Design from Milton's Comus.*
1823	159	*The Masquerade given by the French Queen in honor of Henry the VIII and his suite, vide Hollinshed's Chronicle.*
1823	239	*Drinkallia, "As soon as a Traveller arrives at Drinkallia, he must drink, or be carried before a Magistrate to render account of his obstinacy." Vide Gentleman's Magazine, 1791.*
1823L	194	*"Epicures, Fill the bowl with rosy wine. . ." Cowley. J.G. Lambton, esq. M.P.*
1824	7	*The Porter and the Three Sisters of Bagdad, "After they had eat a little, Amine filled out wine, and drank first herself; then she filled the cup . . ." Vide Arabian Nights.*
1824	125	*The Lord Chamberlain deputed by Henry the VIIIth to inform Anne Boleyn of her elevation to the rank of Marchioness of Pembroke, Anne Boleyn, Lady Denny and Lord Chamberlain. "Chamb. . . 'The king's majesty . . .'" Vide Shakspeare's Henry the VIIIth.*
1824	246	*Interior of the House of Lords, during the important Session of 1820.*
1824	262	*A Knight preparing for a Tournament.*
1825	28	*The Reconciliation of Selim and Nourmahal during the Feast of Roses at Cashmere, "The mask is off, the charm is wrought . . ." Vide Lalla Rookh. 80gns., Sold.*
1825	50	*Sir Walter Raleigh throwing his Cloak at the Feet of Queen Elizabeth, "The night had been rainy, and just where the young gentleman stood . . ." Vide Kenilworth. 30gns.(?).*
1825	307	*The Bolera, 10gns., Marquis Stafford.*
1826	165	*Rubens and the Alchymist, "A Chymist tendered him a share of his laboratory, and of his hopes of the philosopher's stone - Rubens carried the visionary into his painting room, and told him his offer was dated twenty years too late . . ." Vide Walpole's Anecdotes of Painting, vol. ii. 100gns., Sold.*

1826	219	*Scene from the Two Gentlemen of Verona, "Julia. – 'Madam, he sends your Ladyship this ring.' Silvia. 'The more shame for him that he sends it.'" – Act 4. Scene 4.* Sold.
1826	277	*Feramorz relating the story of a Peri, to the Princess Lalla Rookh and her Attendants, in the Valley of Gardens; Fadladeen, in one of his most lofty moods of Criticism, "As they sat in the cool fragrance of this delicious spot, and Lalla Rookh remarked, that she would fancy it the abode of one of those Peri's, those beautiful creatures of the air, and to whom a place like this would make some amends for the Paradise they. . ."* 60gns., Mr. Staveley, 7 Hans Place, Sloane Street, Will take the frame and glass at £7.7.0.
1827	288	*Rembrandt in his Study,* Sold, Harriott Esq.
1827	297	*Berengaria, with Edith and her attendants, interceding with Richard Coeur de Lion for the life of Sir Kenith, Vide Tales of the Crusaders.* 20gns.
1827	310	*A Nautch Girl dancing before an Indian Prince and his Attendants,* Sold.
1827	316	*Mary Queen of Scots (attended by the Four Maries) in her retirement at St. Andrew's, receiving Randolph, sent by Elizabeth to negotiate a marriage between Mary and the Earl of Leicester, "Having continued in this sort with her Grace, I thought it time to utter that which I received in command from your Majesty . . ." Vide Miss Benger's Life of Mary Queen of Scots. – Letter of Randolph to Cecil, Page 191, Vol. II.* 120gns., Frame and glass 15gns.
1828	344	*The Proposal,* Sold.
1828	364	*The Bride,* Sold, May 16 Memorandum. Small drawing of Mrs. Barret, do. do. of Mr. Robson for the Rev. J. Brown.
1829	278	*A Study,* 10gns., Mrs. F. Nicholas, Gt. Ealing, Middlesex, Frame included.
1829	292	*The Rival Suitors,* Sold.
1829	333	*The Discovery,* 21gns., Mrs. Rothschild, 107 Piccadilly, Frame and glass £2.11.6.
1829	342	*Waverley introduced to the Baron of Bradwardine.*
1829	354	*Feramorz relating the Story of Paradise and the Peri, to the Princess Lalla Roohk, in the Valley of Roses, Fadladeen in one of his loftiest moods of criticism,* 30gns.
1829	362	*The Introduction of Randolph to Mary Queen of Scots, who is attended by the four Maries sent by Queen Elizabeth, to negotiate a Marriage between her and Leicester, "'I see now well,' said the Queen 'that you are weary of this company and treatment . . .'" – Miss Benger's Life of Mary Queen of Scots.* 20gns., Frame and glass £2.8.0.
1830	68	*Mary Queen of Scots - The Morning of her Execution, attended by Sir A. Paulet, accompanied by the Earls of Kent and Shrewsbury, Vide Miss Benger's Life of Mary Queen of Scots.* Sold.
1830	254	*Mary Queen of Scots Presenting her Infant Son to the Protestant Deputies, Vide Miss Benger's Life of Mary Queen of Scots* Sold.
1830	305	*A Party of Pleasure,* Sold.
1830	315	*Four Subjects, intended to illustrate the following lines from The Lay of the Last Minstrel, "In peace, Love tunes the shepherd's reed; In war, he mounts the warrior's steed; In halls, in gay attire is seen; In hamlets, dances on the green."* 90gns. the set or No. 315 In Hamlets 25gns.
1830	318	*See No 315,* 90gns. the four or No. 318 In Peace 20gns.
1830	327	*See No 315,* 90gns. the four or No. 327 In Halls 30gns.
1830	330	*Madge Wildfire and Jeannie Deans, Vide Heart of Mid Lothian* Sold.
1830	333	*See No 315,* 90gns. the four or No. 333 In War 30gns.
1830	353	*Rembrandt and his Models, "It has been said, that if Rembrandt had visited Rome his taste would have been more refined . . ."* 150gns.
1831	42	*Infant Bacchus.*
1831	131	*The Page.*
1831	309	*Rembrandt shewing his Models.*
1831	355	*Portia satirising her Lovers, "Nerissa. – 'How say you by the French Lord, Monsieur Le Bon?' . . ." Vide Merchant of Venice, Act I. Scene 2.*
1831	358	*The Circassian Slave, Vide The Arabian Nights.*
1831	361	*From the Merchant of Venice, "The Duke was given to understand, 'that in a gondola were seen together, Lorenza and his amorous Jessica.'"*
1831	382	*Abon Hassen in the Palace of the Khalif of Bagdad - a Sketch, Vide The Arabian Nights*
1831	392	*Sunday Evening.*
1832	56	*The Banquet Scene, "King Henry – 'The fairest hand I ever touched . . .'" Play of Henry VIII. Act I. Scene 4. Painted by command of his Majesty.* Sold.
1832	276	*Boabdil el Chico, King of the Moors arming against the Spaniards, "Boabdil's Mother the Sultana Aysa la Harrah, armed him for the field . . ." Vide Washington Irving's Conquest of Grenada.* 40gns.
1832	293	*The Countess of Montford presenting her Infant Son to the Inhabitants of Rennes, exhorting them to avenge her cause, Vide Hume's History of England. Sketch of a Picture to be executed by command of her Majesty.* 10gns., Frame and glass £2.2.0.

| 1832 | 332 | *Rubens and the Alchymist*, 5gns. |

1832 332 *Rubens and the Alchymist*, 5gns.

1832 337 *An Interior*, 10gns.

1832 413 *Abon Hassan in the Palace of the Caliph., Vide Arabian Nights* 5gns., Baring Wall Esq.

1833 64 *Interior of the House of Commons*, 4gns., Frame and glass £1.1.0.

1833 244 *The Virtuosa, "The surrounding antiquities are a selection from the Elgin marbles, the Hamilton vase, and the Mosaic pavements, in the British Museum . . ."* 60gns., Frame and glass £6.6.0.

1833 296 *Roman Antiquities from the British Museum*, 4gns., Frame and glass £1.1.0.

1833 370 *Charles I. presenting Rubens with a Sword, Vide Life of Rubens.* 8gns., Frame and glass £3.3.0.

1833 396 *A Study*, 10gns., Mr. Henry Penn, Great Ealing, Middlesex, Frame and glass £2.12.6.

1834 124 *A Music Party*, 10gns., Frame and glass £2.2.0.

1834 244 *Abon Hassan in the Palace of the Caliph of Bagdad, "Abon Hassan was inexpressibly perplexed – 'Can I really be Caliph and Commander of the Faithful?' said he to himself." Vide Sleeper Awakened, Arabian Nights' Entertainments.* 60gns., Order.

1834 275 *A Sketch*, 5gns.

1835 92 *A Music Party, "The corentes of Signor Corelli are at present all the fashion." Vide Spectator.* 10gns., Frame and glass £2.12.6.

1835 205 *The Page*, 5gns.

1835 209 *The Companions of Falstaff lamenting his Death, "Pistol – 'Falstaff, he is dead, and we must yearn therefore.' . . ." Henry V. Act II. Scene 3.* 16gns., Frame and glass £4.4.0.

1835 228 *Visit of Charles II to the Duchess of Portsmouth, "I this morning sauntered with his Majesty into the apartments of the Duchess of Portsmouth . . ." Vide Evelyn's Diary.* 40gns., Frame and glass £4.4.0.

1835 276 *The Visit of Lieutenant Allen, and Messrs. Lander and Oldfield, to the Princess Bibi at Atta, during the late Expedition to Africa, from a Sketch taken on the Spot by Lieutenant Allen, R. N.*, 15gns., Frame and glass £3.3.0.

1836 17 *The Banished Duke, "Oliver – 'Where will the old Duke live?' . . ." As You Like It, Act I. Scene I.* 20gns., Frame and glass £5.5.0.

1836 21 *A Burgomaster and his Family*, 6gns., Frame and glass £1.11.6.

1836 41 *The Arrest of Falstaff by Fang and Snare, "Fang – 'Sir John I arrest you at the suit of Mistress Quickly.' . . ." Henry IV. 2nd Part, Act II. Scene 1.* 40gns., Frame and glass £5.5.0.

1836 54 *Commodore Trunnion hearing that Admiral Bower was to be elevated to the Peerage, "'Overhaul that article again.' It was no sooner read the second time than, smiting the table with his fist, he started up in the most violent rage and indignation.'" Vide Peregrine Pickle.* 8gns., Sir Richd. Hunter, 48 Charles Street, Berkley Square, Frame and glass £1.11.6.

1836 102 *The Procession of Aladdin to the Sultan, to request the hand of the Princess Badroulboudour in Marriage, Vide Arabian Nights' Entertainment.* 35gns.

1836 162 *The Visit of Louis XIth. and Quentin Durward to the Astrologer*, 5gns., Mr. Thompson, Frame and glass £1.11.6.

1836 256 *A Music Party*, 6gns., Frame and glass £1.1.0.

1836 288 *Rip Van Winkle and the Ghosts of Hendrick Hudson and his Crew, 'They were a company of odd looking personages, playing at nine pins . . ." Vide Sketch Book.* 8gns., Frame and glass £2.2.0.

1836 312 *A Fête Champêtre*, 4gns., Frame and glass £2.2.0.

1837 202 *Pray remember the Grotto*, 25gns., Frame and glass 3gns.

1837 225 *The Triumphal Entry of Don Quixote and Sancho Pança into Barcelona, "By this time the horsemen came up at full gallop, and one of them said in a loud voice, 'Welcome to our city, the mirror, the beacon of knight-errantry; welcome, I say, the valorous Don Quixote de la Mancha;' and enclosing them in the midst of them . . ."* Sold.

1837 229 *Zulicka*, 6gns., Frame and glass £1.11.6.

1837 231 *The Antiquary, "What are you about here? . . ."* 40gns., Frame and glass 4gns.

1837 239 *Ann Boleyn, Lady Denny and Lord Chamberlain, "Cham. 'Fair Lady, The King's Majesty Commends his good opinion to you . . .'" Vide Henry 8th.* 8gns., Frame and glass £1.11.6.

1837 252 *Celia, Rosalind, Le Beau, and Touchstone, "Cel. 'Bon jour, Monsieur Le Beau, what's the news?' . . ."* 10gns., Frame and glass £1.11.6.

1837 286 *Imogene, "Post. 'For my sake wear this' (putting a bracelet on her arm) . . ." Vide Cymbeline.* 10gns., Frame and glass £1.11.6.

1837 292 *Katharine, Bianca and Baptista, "Bap. 'How now dame! whence grows this insolence? – Poor girl! She weeps.'" Vide Taming of the Shrew.* 5gns., Frame and glass £1.11.6.

1837 300 *Queen Elizabeth and Sir Walter Raleigh*, 4gns., Lady Rolle, 18 Upper Grosvenor Street, Frame and glass £1.1.0.

1838 21 *Lady Capulet, Juliet and Nurse, "Juliet. – 'Sweet, my mother, cast me not away.' . . ."*

1838 113 *The Arrival of Mary Queen of Scots at Holyrood House, Vide Hogg's Queen's Wake.*

1838	144	*Lucentio, Hortensia and Bianca, "Hor. – 'Madam, my lute's in tune.' . . ." Taming the Shrew.*
1838	174	*The Abbot of Westminster presenting a Monk, disguised as Richard II., to the Inhabitants of Oxford.*
1838	190	*Hamlet, Queen and Ghost, "Queen. – 'Whereon do you look?' . . ."*
1838	210	*Salvator Rosa Studying from the Banditti of Ebruzzé by whom he had been taken Prisoner.*
1838	229	*The Reception of Her Most Gracious Majesty at Guildhall, by the Lord Mayor and other Civic Authorities on the 9th November 1837.*
1838	239	*The Brides of Venice, "There existed formerly a custom in Venice, that the marriages of the nobles and citizens should be celebrated on the same day in the church of Olivolo . . ." Vide Sismondi, Romance of History.*
1838	335	*Banquet Scene, "Macbeth. – 'Thou canst not say I did it! Never shake thy gory locks at me.'"*
1839	45	*The Adventure of Don Quixote and Sancho with the Shepherdesses, "Break not these nets, placed here, not for your hurt, but our diversion . . ." Vide Don Quixote. 10gns., Frame and glass 5gns.*
1839	55	*The Triumph of Aladdin, 4gns.*
1839	63	*A Tournament, 14th Century. (One of a series intended to illustrate the Customs and Manners of the Olden Time), 10gns., Frame and glass 4gns.*
1839	105	*A Study - Romeo, "Many a morning hath he there been seen, Adding to clouds, more clouds with his deep sighs". 5gns., own order.*
1839	259	*"Jane of Flanders, Countess of Mountford, was roused by the captivity of her husband and the falling fortunes of her family . . ." Hume's History of England. 50gns., Frame and glass 6gns.*
1839	261	*Covenanters, 17th Century. (One of a series intended to illustrate the Customs and Manners of the olden Time), 8gns., Jacob Montefiore Esq., 24 Tavistock Square.*
1840	84	*A Baron's Hall (One of a Series of Subjects, entitled Reliques of the Olden Times, – intended for publication.).*
1840	96	*Storming an Ancient Fortress. (One of a Series of Subjects, entitled Reliques of the Olden Times, – intended for publication.).*
1840	114	*The Companions of Falstaff lamenting his Death, "Bardolph. – 'Would I were with him.'"*
1840	167	*The Ceremony of the Doge wedding the Adriatic. (One of a Series of Subjects, entitled, Reliques of The Olden Times, intended for publication.).*
1840	200	*The Night Watch.*
1840	221	*The Arrest of Falstaff by Fang and Snare.*
1840	233	*Columbus before the Council at Salamanca, "What a striking spectacle must the hall of the old convent have presented! a simple mariner, standing forth in the midst of an imposing array of professors, friars, and dignitaries of the church, and, as it were, pleading the cause of the New World! . . ."*
1840	263	*An Interior – Here's to you.*
1841	57	*The Armoury, 4gns., Chas. Baring Wall Esq., M.P., 44 Berkeley Square.*
1841	79	*The War Horse, 4gns.*
1841	128	*Rubens and the Alchymist, 4gns., Own order.*
1841	150	*Il Tempesta, Sold.*
1841	151	*Pastorale, Sold.*
1841	182	*Ringrazamente, Sold.*
1841	183	*La Danza, Sold.*
1841	188	*Halt of Bohemian Gypsies, 40gns.*
1841	201	*Arming for the Tournament, 4gns.*
1841	219	*The Chateau. (One of a Series of Subjects intended for publication, entitled Reliques of the Olden Times.), 6gns.*
1841	311	*A Carnival, 20gns., Own order.*
1842	333	*The Countess of Montfort presenting her Infant Son to the Inhabitants of Rennes, exhorting them to defend her cause.*
1843	28	*Salvator Rosa, and the Banditti of Abruzzi. (One of a Series of subjects illustrative of Art), 6gns., Frame and glass £1.0.0.*
1843	29	*Charles I, Henrietta Maria and Vandyke. (One of a Series of Subjects illustrative of Art), "The King took pleasure in seeing Vandyke frequently, sitting to him himself, and bespeaking pictures of the Queen, his children, and courtiers". Vide Walpole's Anecdotes. 8gns., Frame and glass £1.0.0.*
1843	30	*Reubens and the Alchymist, "An alchymist went to Reubens and told him that he had at length found out the philosopher's stone . . ." 8gns., Frame and glass £1.0.0.*
1843	31	*Etruscan Artists - The Vases are from the Hamilton Collection in the British Museum. (One of a Series of Subjects illustrative of Art), 5gns., Frame and glass £1.0.0.*
1843	32	*The Interior of the Tombs at Thebes are painted with representations of the customs of the Egyptians. The subject is an Artist delineating a Feast superintended by some Priests of the Temple (One of a Series of Subjects illustrative of Art), 5gns., Frame and glass £1.0.0.*
1843	40	*Gainsborough and his Models. (One of a Series of Subjects illustrative of Art), 6gns., Frame and glass £1.0.0.*
1843	41	*Rembrandt showing his Models, which he facetiously called his Antiques, 8gns., Frame and glass £1.0.0.*

1843	42	*Titian, while painting the Equestrian Portrait of Charles the Fifth, dropped his Pencil; the Emperor picked it up, and in presenting it to him observed, that Titian deserved to be waited on by an Emperor*, Sold.
1843	43	*Schalken, while painting the Portrait of William the Third, very unceremoniously gave the King a candle to hold in his fingers. (One of a Series of Subjects illustrative of Art)*, 5gns., Frame and glass £1.0.0.
1843	44	*Interior of a Barn at Shorne, Kent*, 6gns., Frame and glass £1.5.0.
1843	50	*A Museum, containing a selection of some of the Antiquities brought from Xanthus, and now in the British Museum. Immediately under the Pediment is a very early specimen of Greek art from the Tomb of Pandarus, supported by a series of subjects . . .*, 15 Pounds, John Moxon, 8 Hanover Terrace, Regents Park, Frame and glass £3.0.0.
1843	206	*Justice Shallow, Falstaff, Silence, Bardolph, Feeble, &c., "Shallow. – 'Francis Feeble!' . . ." Henry IV.* 6gns., Frame and glass £1.11.6.
1843	221	*A Carnival at Venice, "Of all the places where the Carnival was most facetious in the days of yore, for dance, and song, and serenade, and ball, and masque, and mime, and mystery." – Beppo.* 40 Pounds, Frame and glass £10.0.0.
1843	311	*The Pageant of the Lord of Misrule in the Time of Queen Elizabeth, "First, all the wilde heads of the parish chuse them a graunde captaine, whome they innoble with the tittle of My Lord of Misrule . . ." Stubbes's Anatomie of Abuses.* 10 Pounds, Charles Pope Esq., 22 Abchurch Lane, City, Frame and glass £3.0.0, Prize of 10£ in Art Union of London.
1843	326	*Lane near Cobham, Surrey*, 5gns., Frame and glass £1.5.0.
1843	336	*The Brides of Venice - A Sketch*, 8gns., Frame and glass £1.11.6.
1843	343	*Twilight*, 5gns., Frame and glass £1.5.0.
1844	122	*On the overthrow of the Roman Empire, the Arts found a refuge in the Cloister, to whose inmates we are indebted for the beautifully illuminated missals*, 5 Pounds, Joseph Feilden Esq., Frame and glass £0.15.0.
1844	236	*A Tournament, "At that time the Duke of Brabant held a tournament, to which many good lances resorted".* 10 Pounds, Frame and glass £2.0.0.
1844	300	*Autolycus, Clown, Dorcas and Mopsa, Perdita and the Prince disguised as a Shepherd, "Clown.– 'Come on, lay it by: and let's first see more ballads.' . . ."* 20 Pounds, Frame and glass £5.0.0.
1845	200	*An Assemblage of Works of Art in Sculpture and Painting, from the earliest period to the time of Phydias, At the base of the picture are specimens of Hindu and Javanese sculpture, and on either side are the colossal figures and bas-reliefs from Copan and Palengue; those above them are from Persepolis and Babylon, followed by the Egyptian, Etruscan, and early Greek remains. . .* 50 Pounds, John Hugh Smyth Pigott, Brockley Hall, Somersetshire, Frame and glass £6.0.0.
1845	202	*Henry VI after the Battle of Towton, "Prince. 'Fly, father, Fly! for all your friends are fled.' . . ." Third Part of Henry IV. Act. II, Scene 5.* 25 Pounds, Wm. Hobson Esq., 43 Harley St., Frame and glass £5.0.0.
1845	204	*The Duchess of Gloucester doing Penance for Witch-craft, preceded by Sir John Stanley, a Sheriff and Officers, "Serv. 'So please your grace, we'll take her from the sheriff.' . . ." Second part of Henry VI. Act II. Scene 4.* 60 Pounds, Frame and glass £10.0.0.
1845	212	*Fruit*, 5 Pounds, Frame and glass £1.0.0.
1845	342	*Jack Cade and his Rabblement, "Cade. 'Up Fish-street, down St. Magnus Corner, kill and knock down, throw them into the Thames.'" – Second Part of Henry VI. Act IV. Scene 7.* 6 Pounds, T.E. Johnston Esq., 48 Dover Street, Frame and glass £-.10.0.
1846	1	*"And the Beast was taken, and with him the false prophet that wrought miracles before him, with which he deceived them that had received the mark of the Beast, and them that worshipped his image . . ." Revelations, chap. xix., verse 20.* 20 Pounds, James Jackson Esq., Kendal, Frame and glass £5.0.0, P.AU. 20£.
1846	52	*Money Changers, The tables of the money changers, and the seats of them that sold doves.* 20 Pounds, Frame and glass £5.0.0.
1846	166	*Iconoclasts, The Iconoclasts of the middle ages destroyed indiscriminately the monuments of Art, leaving posterity to regret the destruction of works that had been the admiration of centuries.* 50 Pounds, Frame and glass £10.0.0.
1846	209	*Jack Cade, "Up Fish-street, down St. Magnus Corner, kill and knock down, throw them into the Thames." – Henry VI., Scene 8.* 5 Pounds, J.L. Grundy, Exchange St., Manchester, Frame and glass £-.10.6.
1847	57	*Raffaelle and his Pupils, "The imagination displayed by Raffaelle in his designs, the kindness with which he treated his pupils, and the liberality of the Pontiff in rewarding their labours, all combined to render the Vatican, at this period, a perfect nursery of Art . . ." Roscoe's* 40 Pounds.
1847	145	*War*, 4 Pounds.

| 1847 | 174 | *Scene from Shakspeare – Enter King Henry, Queen Margaret, Gloucester &c.,* "K. Edward. 'Bring forth the gallant, let us hear him speak.' Prince. 'Resign thy chair, and where I stand, kneel thou.' . . ." *3rd Part Henry VI.* 4 Pounds, Frame and glass £-.10.6. |

| 1847 | 179 | *Scene from Shakspeare – Enter King Henry, Queen Margaret &c.,* "Suffolk. And humbly now upon my bended knee Deliver up my title in the queen' . . ." *1st Part Henry VI.* 5 Pounds, Frame and glass £-.10.6. |

| 1847 | 199 | *An Armoury,* "Suffolk. 'Please your majesty, this is the man that says that your majesty was an usurper.' . . ." *2nd Part Henry VI.* 20 Pounds, Frame and glass £5.0.0. |

| 1847 | 224 | *Lord Talbot,* "More than three hours the fight continued . . ." *1st Part Henry VI.* 4 Pounds, Frame and glass £-.10.6. |

| 1848 | 201 | *Interior of a Gallery of Paintings, containing some of the finest specimens of the Italian, Venetian, Dutch, and Flemish Schools, The decorations of the ceiling are imitated from the Farnese Gallery and the Banqueting Room, Whitehall* . . . 80 Pounds, Frame and glass £11.11.0. |

| 1848 | 288 | *Jack Cade and his Followers,* "Cade. 'Now is Mortimer lord of this city, and here, sitting upon the London Stone, I charge and command that it shall be treason henceforward for any that calls me other than Lord Mortimer.' . . ." *Vide Second Part of King Henry VI., Act IV., Scene 3.* 10 Pounds, Frame and glass £1.8.0. |

| 1849 | 232 | *Touchstone and Jane Smile,* "I remember, when I was in love, I took two pea-shells, and giving her them, said, with weeping eyes, Wear these for my sake." *As You Like It, Act II., Scene 4.* |

| 1849 | 257 | *Raphael and his Pupils.* |

| 1850 | 312 | *The Lords in Waiting,* "The Queen was pleased in being surrounded by persons conspicuous for personal and intellectual acquirements." – *Life of Queen Elizabeth.* 10 Pounds, Miss E. Taylor, East India Road, Frame and glass £1.1.0, AU. 10£. |

| 1850 | 316 | *Venice,* "Nor yet forget how Venice once was dear . . ." *Childe Harold's Pilgrimage.* 20gns., Frame and glass £3.0.0. |

| 1850 | 335 | "Come, thou monarch of the vine, Plumpy Bacchus, with pink eyne . . ." 6 Pounds, Frame and glass £1.0.0. |

| 1850 | 362 | *Le Marchand des Antiques,* 15 Pounds, Frame and glass £1.10.0. |

| 1851 | 5 | *Covenanters - a Scene from Woodstock.* |

| 1851 | 100 | "There were also women looking on afar off: among whom was Mary Magdalene, and Mary the mother of James the less and of Joses, and Salome." – *St. Mark, ch. xv. 40.* |

| 1851 | 169 | *Sir Roger de Coverly,* "I must tell you that among the festivities of Boxley Court, we have given a fancy ball in the splendid but formal costume of the seventeenth century. 'Sir Roger de Coverly' was danced to admiration . . ." – *Letters to the Countess.* |

| 1851 | 244 | "Blessed is the man that walketh not in the counsel of the ungodly, nor standeth in the way of sinners, nor sitteth in the seat of the scornful." *Psalm i. verse 1.* |

| 1851 | 268 | *A Coursing Party refreshing.* |

| 1851 | 270 | *An Interior.* |

| 1852 | 170 | *Interior of a ruined Bone Mill, Oldlands, Gloucestershire,* 5, Frame and glass £1.10.0. |

| 1852 | 178 | *Peasant Girl,* 5, including frame. |

| 1852 | 224 | *The Lord of Misrule,* 'The Pageant of 'The Lord of Misrule' was celebrated in the sixteenth century with great magnificence, his train was borne up by pages of honour, and attended by heralds and trumpeters, a host of buffoons, musicians, other characters followed. . .'. Frame and glass £1.5.0. |

| 1852 | 239 | *The Disgrace of Wolsey,* "K. Henry. – 'Read o'er this . . .'" *Henry VIII. Act III. Scene 2.* 15, Frame and glass £2.0.0. |

| 1853 | 22 | *Near the Quarries at Hanham, Gloucestershire.* |

| 1853 | 49 | *Jack Cade,* "And now, henceforward, it shall be treason . . ." *Second Part of Henry VI.* |

| 1853 | 93 | *The Triumph of Aladdin, &c.* |

| 1853 | 190 | *A Party of Huntsmen annoying a Congregation in a Church,* "A German writer of the fifteenth century, severely reprobates the indecency of his countrymen in bringing their hawks and hounds into the churches, and interrupting divine service." – *Vide Smith's Games and Amusements.* |

| 1854 | 64 | *The Witch Acrasia Charming her Lover in the Bower of Bliss,* "The joyous birds shrouded in cheerful shade . . ." *Spenser's Faery Queen, Book II. Canto 12.* £25.0.0, Frame and glass £3.0.0. |

| 1854 | 180 | *Shylock and Tubal,* "Tubal. But Antonio is certainly undone.' . . ." – *Merchant of Venice.* £4.4.0. |

| 1854 | 191 | *Interior of a Carpet Bazaar at Cairo - from a Sketch taken on the spot by Captain W. Allen R.N.,* £15.0.0, T. Porter, Lutterworth [in deposit column], Frame and glass £2.10.0, Art Union Prize, selected by Louis Pocock Esq. |

| 1854 | 231 | *Love* – "In peace love tunes the shepherd's reed," £5.0.0, Frame and glass £1.0.0. |

| 1854 | 291 | "Jesus saith unto her, Mary. She turned herself, and saith unto him, Rabboni; which is to say, Master." – *John xx. 16.* £4.0.0, Frame and glass £1.0.0. |

| 1854 | 314 | *Love in Hamlets - Dances on the Green,* £8.0.0, Frame and glass £1.0.0. |

1854	328	*Argantes, at the head of a host of Paynim Warriors, challenging a Christian Knight to Single Combat, Tasso, Jerusalem Delivered.* £10.0.0, Frame and glass £1.11.6.
1855	113	*The Gate of Galata, from the Petit Champs des Morts, with the Mosque of Sulimanyah, Constantinople,* £10.0.0, Frame and glass £2.0.0.
1855	145	*The Vizier Saouy, "The Vizier Saouy purchasing the fair Persian at the slave market for 4000 pieces of gold, with an expression of countenance that forbade farther competition." – Arabian Nights.* £8.0.0, N.A. Combs Esq., 1 Holland Road, Kensington.
1855	226	*Camacho's Wedding, "At the preparations for Camachio's wedding, Sancho's hunger was so great that he could hold out no longer; and accosting one of the busy cooks, he requested of him to sop some bread in one of the pans . . ." – Vide Don Quixote.* £25.0.0, Frame and glass £2.0.0.
1855	227	*Don Quixote and Sancho refreshing themselves at Camacho's Wedding,* £5.0.0.
1855	245	*Abou Hassan, "The astonishment of Abou Hassan on awaking to find himself surrounded by the attendants of the Caliph." – Arabian Nights.* £10.0.0, Frame included.
1855	253	*Les Pages d'Honneur,* £8.0.0.
1855	296	*George Ferrers, the Lord of Misrule. In the Reign of Edward VI.; he was attended by Pages and Heralds, and a host of Buffoons to add splendour to the pageant,* £10.0.0, Including frame.

STEPHANOFF J P

| 1818 | 26 | *The Library, Buckingham House.* |

STEPHENOFF J

| 1816 | 23 | *Retirement.* |
| 1816 | 267 | *The Rescue of the Lady, from the Enchantments of Comus.* |

STEVENS F

1806	8	*Fishergate, Postern, York.*
1806	73	*Part of Bolebrook House, Sussex, formerly a seat of the Earls of Dorset.*
1806	130	*The Cottage.*
1806	192	*A view near Uxbridge.*
1806	244	*Cottage at York.*
1807	25	*View at Orton, Huntingdonshire.*
1807	56	*Cottage at St. Alban's.*
1807	65	*The bridge over the Ellesmere Canal, at Chester.*
1807	238	*View on Uxbridge Common.*
1807	322	*Morning.*
1808	212	*View of Twydale Wortley, Yorkshire.*
1808	256	*Cottage at St. Alban's.*
1808	259	*View near St. Alban's.*
1808	293	*Orton Forest.*
1808	295	*Twilight, a view near Sheffield.*
1809	37	*Morning, "See, how morning opes her golden gates, and takes her farewel of the glorious sun."*
1809	117	*View near Wortley, Yorkshire, "And now behold the sun's departing ray o'er yonder hill . . ."*
1809	167	*Cottage at Wortley.*
1809	279	*View near Wortley Hall, Yorkshire.*
1809	338	*Cottage at Wortley, Yorkshire.*
1810	13	*Study at Lakenham, near Norwich.*
1810	48	*Remains of the Earl of Surrey's Chapel, near Norwich.*
1810	62	*A Cottage on Bromley Common, Kent.*
1810	75	*View near Norwich.*
1810	82	*View on Moushold Heath, near Norwich.*
1810	103	*Composition.*
1810	115	*A Cottage at Orton.*
1810	116	*View at Orton, Huntingdonshire.*
1810	117	*Study from Nature.*
1810	147	*The Devil's Tower, Norwich.*
1810	148	*Landscape, "Here waving groves a chequer'd scene display, And part admit, and part exclude the day."*
1810	180	*View at Wortley, Yorkshire.*
1810	249	*A Study at Wortley.*
1810	251	*A Cottage at Wortley.*
1810	281	*A Study of Rocks under Warncliffe.*
1810	296	*View of the Village of Trowse, near Norwich.*
1810	297	*The Devil's Tower, Norwich.*
1811	70	*An Out-House at Warncliffe Lodge, Yorkshire.*
1811	95	*At Bromley, Kent.*
1811	99	*View of Smithyfold, Wortley, Yorkshire.*
1811	146	*Cottages at Ordsall, Notts.*
1811	147	*Part of Bolebrook House, Sussex.*
1811	165	*Plaistow, near Bromley, Kent - a Thunder Storm approaching.*
1811	203	*Retirement.*
1811	206	*Supholme Abbey, Lincolnshire.*
1811	246	*Composition, "But yet from out the little Hill . . ." Vide Scott's Marmion.*
1811	271	*A Mill at Worksop, Notts.*
1811	272	*View near Hayes, Kent.*
1811	279	*A View on Uxbridge Common.*
1811	290	*View of Rippon, Yorkshire.*
1811	320	*View at Garnston, Notts.*
1811	331	*View at Orton, Huntingdonshire.*

1811	336	*Landscape - Composition.*
1811	354	*Part of Fountains Abbey, Yorkshire.*
1811	364	*View at Bromley, Kent.*
1812	32	*Simpson's Place, Bromley, Kent.*
1812	92	*View near Vallis Crucis, North Wales - Morning.*
1812	107	*Landscape and Figures, "Hylas and OEgon sang their rural lays."*
1812	110	*This Ev'ning Tale, "by then the chewing Flocks . . ." Milton's Comus.*
1812	219	*View at Bromley, Kent.*
1812	267	*View at Norwich.*
1812	273	*View near Glassthorpe, Northamptonshire.*
1812	280	*Old Houses at Norwich.*
1812	323	*A Cottage at Wortley, Yorkshire.*
1816	25	*A Study.*
1816	48	*Study at Norwich.*
1816	49	*A Study.*
1816	314	*Study at Haler, Somersetshire.*
1819	117	*Cottage at Halse, Somersetshire.*
1819	250	*Rhudlan Castle, North Wales.*
1819	257	*The Hermit, "Far in a wild, unknown to public view . . ." Vide Parnell's Poems.*
1819	259	*Cader Idris, North Wales.*
1819	260	*View at Mount Edgcumbe, with the Breakwater in the Distance.*
1819	266	*View near Cothelston, Somersetshire.*
1819	276	*Cader Idris, North Wales.*
1823	24	*On the Coast of Somersetshire, between Minehead and Porlock,* £6.6.0, Sir T.D. Acland.
1823	80	*On the River Lyn, near Lymouth, Devon.*
1823	112	*Framlingham Castle, Suffolk.*
1823L	4	*Retirement,* J. Allnutt, esq.
1823L	197	*Landscape,* J. Allnutt, esq.

STEWART MISS M

| 1819 | 172 | *Fruit, from Nature.* |
| 1819 | 181 | *Fruit, from Nature.* |

STONE F

1833	207	*The Massacre of Glencoe, "Beadalbane had represented Macdonald of Glencoe, with whom he was at feud . . ." Vide Smollett's History of England.* 35gns.
1833	227	*The Arrest of Zilia di Mon ada, Vide Surgeon's Daughter, by the Author of Waverley.* Sold.
1833	373	*The Toilet,* Sold.
1834	49	*The Accusation,* 25gns, Subject to be engraved in the Forget me nots.
1834	277	*Wild Flowers,* 25gns., Mr. E. Tustin, Fludyer Street, Whitehall.
1834	298	*The Reverie,* Sold.

1834	325	*Girl Sleeping,* 17gns., The Marquis of Lansdowne.
1835	32	*Falstaff. Mrs. Ford, Mrs. Page and Robin, "Mrs. Page – 'Help to cover your master, boy . . .'" Merry Wives of Windsor.* 60gns.
1835	165	*Scene from Macbeth, "Macbeth – 'Hark! who lies in the second chamber?' . . ."* 12gns.
1836	156	*Scene from Kenilworth, "'May not my poor poinard serve, honoured Madam,' said Varney . . ."* 35gns.
1837	192	*Scene from Macbeth, "Murderer. 'Where is your husband?' . . ."* Sold.
1837	240	*Lady and Duenna,* Sold.
1837	298	*Spanish Girls,* Sold.
1838	266	*A Lady Reading.*
1838	285	*The Stolen Sketch.*
1839	154	*Danger,* 17gns.
1839	165	*"How fared that love? the tale so old . . ." Vide Philip Van Artavelde, a Dramatic Romance, By Henry Taylor Esq.* 30gns.
1839	281	*The Gentle Teacher,* 20gns., Mr. Thos. H. Wilkinson, Walsham le Willows, Suffolk, to know price of frame, £1.18.0.
1840	275	*"Oh dear! what can the matter be? . . ."*
1841	258	*The Selected Flower,* 25gns., Richd. Ellison Esq., Sudbrooke Holme, Lincoln, Art Union.
1842	306	*"And looks commercing with the skies Thy rapt soul setting in thine eyes." Milton.*
1842	316	*"From the gay throng a while retired She mused."*
1843	269	*"Ce n'est que le prémier pas qui coûte,"* 30gns., T.H. Lowther, 32 Grosvenor Sq.
1844	314	*The Treacherous Shot,* 30gns., Mr. Ryman, Oxford.
1845	339	*The Evening Walk,* 25gns., £21.0.0 offered, Frame and glass £3.0.0 Yes.
1846	279	*The Lesson,* 25gns., L. Pocock Esq., Gloucester Road, Gloucester Gate, Regents Park.

STOWERS T

1813	192	*Study, in the Gill at Ambleside.*
1813	215	*Summers Morning, Cottage, Bucks.*
1813	223	*Ruins.*
1814	53	*Scene above the Fall in the Gill, Ambleside.*
1814	74	*Cottages at Beddington, Surrey.*

STUMP J

| 1818 | 182 | *Angelica.* |

STUMP S J

1814	6	*A Rose without a Thorn.*
1815	11	*Portrait of a Lady.*
1815	12	*Portrait of Miss Stephens.*
1815	13	*Portrait of Lieutenant Ramsay, of the 15th Dragoon Guards.*

1815	190	*A Scene on the River Kennet, near Hampstead Park, Berkshire, a Seat of the Earl of Craven.*
1816	29	*Pyrrha, from Horace, Ode v. Lib. 1, "While liquid odours round him breathe . . ."*
1816	30	*Portrait of Two Sisters: Julia come let us play this Duet.*
1817	84	*Noon Day. Scene in Cumberland.*
1817	86	*A Storm in a Mountainous Country.*
1817	87	*Evening. Clearing up after a Storm.*
1817	88	*Evening. Scene in North Wales.*
1817	96	*Evening, with Cattle.*
1817	149	*Rosetta,* £12.12.0, Lord Darnley.
1818	168	*Portrait of Mrs. Ride.*
1818	177	*Angelina.*
1819	30	*Scene on the River Dee, North Wales.*
1819	77	*Scene on the River Conway, near Llanrwst, North Wales.*
1819	192	*Portrait of Miss Caroline Grey.*
1820	187	*Lord Weymouth as James Fitz-James, from the Lady of the Lake, "Woe worth the chase, woe worth the day . . ."*

STUMP S T

1814	3	*A Frame, containing a Family Group, and Two Ladies.*

SUMPTER H

1817	115	*Still Life.*
1820	144	*Still Life.*

SWINBURNE E., ESQ

1823L	160	*Remains of an Ancient Bridge, on the Volturno, near Capua,* Sir J. Swinburne, Bart.

TAYLER F

1831	72	*The Huntsman's Boy.*
1831	100	*Young Fishermen.*
1831	127	*The Breakfast - Good News.*
1831	267	*The Admonition, from Lines by the Ettrick Shepherd.*
1831	299	*The Dead Pigeon.*
1831	324	*Scotch Boys.*
1831	422	*Scotch Fisherwomen.*
1832	39	*A Study made in the Barracks of the 2nd Regiment of Life Guards,* 12gns.
1832	52	*Study in the Barracks of the 2nd Regiment of Life Guards,* 15gns.
1832	54	*The Guardsman's Guard,* Sold.
1832	67	*A Scotch Group,* 7gns., Her Royal Highness the Duchess of Kent.
1832	113	*The Spectator reading his Papers to Sir Roger de Coverley,* 40gns.
1832	139	*Scotch Peasantry,* 10gns.
1832	144	*Children,* Sold.
1832	299	*Rich Relations,* 25gns.

1833	125	*Interior of a Trooper's Stable,* 8gns.
1833	228	*French Children,* 12gns.
1833	312	*Group of Children, Coast of France,* 15gns.
1833	323	*Beggar and Girl,* 12gns.
1833	331	*The Trumpeter's Stable,* 10gns., Lord F. Leveson Gower, Stafford House, To be sent to Smith Picture dealer New Bond Street.
1833	378	*Fish Children, Coast of France,* 7gns., Mr. Domett, To be delivered to Mr. Leggatt, Cornhill.
1834	70	*Little Red Riding Hood,* 10gns., Mr. Holland, 35 Montague Square, Wishes to take the frame.
1834	127	*Young Travellers,* 10gns., Marquis of Lansdowne.
1834	143	*Horse, Drinking,* 20gns., William Hobson, Markfield, Stamford Hill.
1834	174	*Huntsman's Cottage Door,* 20gns.
1834	296	*An Interior,* Sold.
1834	358	*Highland Peasants,* 8gns., The Right Honble. Lady Rolle.
1835	8	*Market Cart.*
1835	129	*Return from the Plough,* 8gns., Mr. D.J. White.
1835	146	*Carrying the Kid, "Oh, Nanny, wilt thou gang with me."* Sold.
1835	156	*Study from Nature in the Highlands,* 10gns., N. Wilkinson.
1835	176	*An Interior,* 10gns.
1835	247	*Crossing the Mountain Brook,* 25gns., Mrs. Windus, Tottenham.
1835	250	*Boy and Highland Pony,* Sold.
1835	258	*Interior,* 8ns.
1835	264	*An Interior,* 8gns., The Countess of Mansfield.
1835	268	*Girl and Highland Stot - Scotch Rebellion,* Sold.
1835	272	*Peasants - Coast of Scotland,* Sold.
1835	290	*A Cottage Scene,* 15gns., C. Birch Esq., Burnt Tree, Birmingham.
1836	87	*Highland Shepherdess,* 12gns., L. Houghton Esq., 30 Poultry.
1836	94	*Highland Peasant Girl,* 12gns., D. Colnaghi Esq., Pall Mall East.
1836	109	*Going to School,* 10gns., Lady Rolle.
1836	114	*Peasantry - Coast of Scotland,* 10gns., T. Ellis Esq., 4 Cleave Place, Larkhall Lane, Clapham Road.
1836	126	*Going to Plough,* 15gns.
1836	128	*Flower Girl,* 10gns., Wilkinson Esq.
1836	140	*Farm Stable - Horses going out,* 18gns., Col. Sibthorpe, Carlton Club House.
1836	228	*Highland Shieling with Cattle,* 6gns., John Hewett Esq., Leamington.
1836	242	*Evening - Cattle in the Water,* Sold.

1836	253	*Weary Travellers*, Sold.
1836	273	*Interior of a Highland Cottage*, 10gns., D. Colnaghi Esq., Pall Mall East.
1836	276	*Calling Hounds out of Cover*, 7gns., C. Birch Esq., Tipton, nr. Birmingham.
1836	285	*A Market Cart*, 10gns., C.B. Wall Esq.
1836	289	*Highland Goatherds*, Sold.
1836	314	*Highland Boy with Setters and Black Game*, Sold.
1836	318	*Early Morning - Hounds going out*, 10gns., Wm. Blake Esq., 62 Portland Place.
1836	330	*Gipsies*, 40gns.
1836	341	*Evening - Hounds coming Home*, 10gns., G. Hibbert Esq.
1837	10	*Scotch Cattle*, 20gns.
1837	68	*The Trumpeter*, 25gns., Chs. Birch Esq., Tipton, nr. Birmingham.
1837	115	*Morning of the 12th of August. Sportsmen going to the Moors*, Sold.
1837	123	*Evening of the 12th of August - Return from the Moors*, Sold.
1837	170	*Highland Pastoral*, 25gns., order of Mr. Taylor.
1837	179	*Cottage on the Findhorn River, Scottish Highlands*, 25gns., order of Mr. Taylor.
1837	242	*Highland Lassie with Cow and Calf*, 20gns., Lady Rolle, 18 Upper Grosvenor Street.
1837	264	*Cottage in the Grampians*, Sold.
1837	270	*The Regimental Farrier*, 30gns., T.G. Parry Esq., 9a Langham Place.
1837	311	*The Keeper's Boy*, 25gns., Miss Aspinall, Standen(?), Clitheroe, Lancashire.
1837	320	*Unkennelling*, Sold.
1837	336	*Girl at a Fountain*, Sold.
1837	342	*Girl driving Cattle - Highlands*, Sold.
1837	352	*Highland Harvest Cart*, 25gns.
1837	355	*Take Me Up*, 15gns., Ruskin Esq., Herne Hill.
1850	259	*Dogs and Game*, Sold.

TAYLER FRED

| 1847 | 295 | *Mountain Stream in Braemar*, 20gns., G. Loftus, 3 St. James Place, Frame and glass £1.10.0 Hanbury's, 60 Lombard St. |

TAYLER FREDK

1839	33	*Grouse Shooting in Harvest Time, Highlands of Scotland*, Sold.
1839	38	*Children and Dogs - Studies from the Children of Lord Howard de Walden*, Sold.
1839	43	*Scene on the Coast of France*, 25gns. [deleted], Sold.
1839	57	*Huntsman of Sixty Years since*, sold.
1839	160	*King Charles the First conveyed a Prisoner from Newcastle to Holmby House, Northamptonshire, by the Parliamentary Army*, Sold.
1839	184	*Ritt-Master Dugald Dalgetty of Drumthwacket, and his Horse Gustavus*, "Having said this, he filled a large measure with corn and walked up with it to his charger, who began to eat his provender with an eager dispatch, which showed old military habits &c." *Vide Legend of Montrose*. Sold.
1839	187	*Fisherwomen returning from Market across the Sands - Coast of Scotland*, 25gns., Mrs. Morton Carr, 8 Princes Court, Storey's Gate, Westminster.
1839	188	*Huntsman's Boy*, Sold.
1839	227	*A Donkey Party - Studies from the Children of Lord Howard de Walden*, Sold.
1839	266	*Highland Piper*, Sold.
1839	284	*The Vicar of Wakefield conveying his Daughter Olivia home to her Family*, "The next morning I took my daughter behind me, and set out on my return home . . ." *Vide Vicar of Wakefield*, chap. xx. Sold.
1839	302	*Knight and Pages*, 25gns., J. Ruskin Esq., Drawings to be sent to Foord's.
1839	336	*Evening - Return of Sportsmen from the Moors*, Sold.
1840	149	*The Morning of the Chase*.
1840	237	*Highland Piper*.
1840	267	*A Page in Waiting*.
1840	268	*A Baggage Waggon*.
1840	289	*Autumn - Highlands of Scotland*.
1840	306	*Tending Goats, Highlands*.
1840	320	*Fern Cutter*.
1841	24	*The Sentinel*, Sold, Captn. Gill.
1841	34	*Interior, with Dogs and Game*, Sold, Captn. Gill.
1841	54	*Early Morning - Unkennelling - painted from the Huntsman and Hounds of his Grace the Duke of Rutland*, 35gns., Thomas Baring, 40 Charles St., Berkeley Square.
1841	117	*The Highland Keeper's Bothy*, Sold, Captn. Gill.
1841	242	*Page, with Falcon and Blood Hounds*, 20gns., Price Edwards Esq., Weston, Nr. Bath.
1841	265	*Scotch Cart*, 15gns., Chs. Russell Esq., 27 Charles St., St. James's Square.
1841	276	*Sunset - Return from the Fish Market*, 25gns., H. Davidson Esq., 24 Bruton Str.
1841	290	*Girls at a Fountain*, 20gns., The Earl of Uxbridge.
1841	300	*Scene from the Abbot of Sir Walter Scott*, "The reply to this sarcasm was a box on the ear, so well applied, that it overthrew the falconer into the cistern in which water was kept for the benefit of the hawks . . ." Chap. iv. p. 55. 25gns., H.R.H. Prince Albert.

1841	331	*Return from Hawking*, 18gns., Earl of Mansfield, Ken Wood.
1842	71	*The Moss Trooper - a Sketch.*
1842	89	*Going to Market.*
1842	246	*Scene from the Black Dwarf*, "He went to his little garden, and returned with a half-blown rose . . ." Vide Sir W. Scott's Black Dwarf, chap. v., p. 54.
1842	254	*Trampers Getting Wood.*
1842	261	*The Old Admiral and his Daughter.*
1842	270	*Sophia Western playing the Squire to Sleep*, "She took this opportunity to execute her promise to Tom, in which she succeeded so well, that the 'squire declared, if she would give t'other bout of 'Old Sir Simon' he would give the gamekeeper his deputation . . ." Vide Tom Jones, chap. v., vol. i.
1842	277	*Calling out the Guard.*
1842	285	*Interior of the Keeper's Cottage.*
1842	288	*Market Girl.*
1842	312	*The Young Falconer.*
1842	317	*Interview between Miss Wardour and old Eddie Ochiltree*, "The young lady, as she presented her tall and elegant figure at the open window, might be supposed, by a romantic imagination, an imprisoned damsel . . ." Vide Sir W. Scott's Antiquary, chap. xii., p. 156.
1842	336	*Fishing Boys on a Trout Stream, Highlands of Scotland.*
1843	36	*Morning of 12th of August, Unkennelling for the Moors. - The Figures and Animals are Portraits*, Sold, James Hall Esq.
1843	167	*Too Late for Church - Scene from the Vicar of Wakefield*, "After that one of the horses took it into his head to stand still, and neither blows nor entreaties could prevail with him to proceed . . ." Vide Vicar of Wakefield, chap. x. Sold, Mr. Hensh(?), Leamington.
1843	314	*"If he have luck He'll bring a buck Upon his lusty shoulders home." – Iron Chest.* 15gns., Edwards Esq., Oxford Place, Reading.
1844	12	*A Hawking Party - The Flight*, 15gns., Colonel Sibthorp.
1844	257	*Interior of a Larder*, 40gns., Lord C. Townshend.
1844	276	*Houseless Wanderers*, "Round and round, in wild distraction . . ." Vide The Ballad of Scotland's Scaith, or the History of Will and Jean, (page 29). 25gns., Lord C. Townshend.
1844	285	*Dogs and Game*, 15gns., Lord C. Townshend.
1844	291	*A Fair Maid of Perth*, 25gns., Tustin Esq., Fludyer Gate, Whitehall.
1844	316	*Crossing a Brook*, 15gns., Lord C. Townshend.
1845	18	*Interior of a Cow-house*, 30gns., Lord Chas. Townshend, Frame and glass £2.6.0.
1845	23	*Ploughboy and Cart-horses*, 35gns., Ric Ellison Esq., Frame and glass £3.5.0.
1845	31	*Group of Horses*, Sold.
1845	162	*Interior of a Highland Cottage*, 25gns., Wm. Hobson Esq., 43 Harley St., Frame and glass £2.12.6.
1845	239	*Highland Cottage Door*, Sold, Drawing to Mr. Fuller.
1845	254	*The Ride*, 40gns., Lord Chas. Townshend, Frame and glass £2.12.0.
1845	268	*Gipsy Girl*, 25gns., Charles Brown Esq., Croydon, Frame and glass £2.6.0, P.AU. 15£.
1845	274	*Counting the Game Bag*, 35gns., Sigismund Rucker Esq., Frame and glass £3.5.0? No.
1845	284	*Calling Hounds out of Cover*, Sold, Mr. Fuller drawing, frame to Mr. Tayler.
1845	296	*Return from the Chase*, Sold, Mr. Fuller drawing and frame, Frame and glass £1.15.0.
1845	298	*First of September*, Sold, Wm. Catherow Esq., 42 Weymouth St., Portland Place, frame and drawing, Frame and glass £2.15.0.
1845	302	*A Cottage Door*, 10gns., R. Cary Esq., 6 Bloomsbury St., Frame and glass £1.2.0, P.AU. 10£.
1845	305	*Interior of a Stable*, Sold, Jacob Bell Esq., Oxford St.
1846	34	*The Poultry Yard*, Sold.
1846	49	*Gleaners*, 40gns.
1846	106	*Horses*, Sold.
1846	117	*A Ride in the Forest*, Sold, Mr. Allnutt.
1846	222	*Roadside Travellers*, Sold, S. Rucker Esq.
1846	225	*Scene from Waverley - The Baron of Bradwardine takes Waverley out Roebuck Hunting*, "In this guise they ambled, both over hill and valley till 'low down in a grassy vale' they found David Gellatley, leading two tall deer grey-hounds . . . &c. &c." 35gns., Miss Hewett.
1846	247	*On the Highland Moors*, 40gns., John Hewett Esq.
1847	121	*Setters and Game*, Sold, Mr. Vokins.
1847	130	*On the Highland Moors*, Sold, M. Fuller.
1847	216	*Bringing Home the Deer*, 30gns., R.Ellison Esq.
1847	228	*Bridge in Glen Clunie, Aberdeenshire*, 25gns., Mrs. Faulkner, ???.
1847	236	*Fording the Stream*, Sold, Hewitt?.
1847	251	*Stag at Bay - the scene a Rocky Glen in Braemar, Aberdeenshire*, Sold, S. Rucker Esq., Jun., 12 Tower St., Tower Hill.
1847	261	*The Mountain Spring*, 40gns., Henry Graves Esq.
1847	286	*The Blind Piper*, Sold, Hogarth?.

1847	303	Evening - Waiting for the Drovers, Sold, Hewitt?.
1847	311	Sunset - Return from the Chase, Sold, ? [pencilled in].
1848	146	Interior of a Highland Larder - Weighing the Stag, Sold.
1848	235	Harvest Time - Lowlands of Scotland, 60gns., Thom. Bridges Esq., Frame and glass £3.17.0 Yes.
1848	260	Scene from Waverley - the Baron of Bradwardine takes Waverley out Roebuck Hunting, "After half an hour's search a roe was started, coursed, and killed, the Baron following on his white horse, like Earl Percy of yore, &c. &c." Vide Waverley, Vol.1., Chap. 13. Sold, Hogarths.
1848	275	A Happy Scene in the Highlands, Sold.
1848	294	A Hawking Party Going Out, Sold, Fuller from Mr. Taylers.
1848	304	A Hawking Party - Feeding the Falcon after the Flight, 25gns., Richd. Ellison Esq., Frame and glass £1.2.0.
1848	326	Scotch Peasants returning from Market, 30gns., T. Griffith (J. Wild Esq.), Frame and glass £2.7.0 Yes Foord.
1848	336	"Oft list'ning how the hounds and horn Cheerily rouse the slumb'ring morn." – Milton. Sold.
1849	28	Morning.
1849	39	Evening.
1849	144	The Chase in the Time of Charles II.
1849	154	Stag Hunt in the Last Century.
1849	235	Page and Horses.
1849	258	Woodland Scene, with Horn and Hound.
1849	269	A Lesson on the Pipes.
1849	274	Evening - Returning from Market.
1849	293	Scotch Reapers.
1849	301	The Highland Keeper's Daughter.
1849	323	Going to the Chase.
1849	338	Cattle and Figures Crossing a Ford.
1849	342	Tired Travellers.
1850	317	Driving Cattle through a Highland Glen, Sold.
1850	329	Return from Otter Hunting, Sold.
1850	356	A Hawking Party, Sold.
1850	367	Bridge Scene, Highlands, Sold.
1851	129	Fête Champêtre in the time of Charles II.
1851	230	Highland Boy with Game - Banks of Loch Laggan, Inverness-shire.
1852	34	A Stag Hunt in the time of George the Second, Sold.
1852	95	Morning - Going out, Sold.
1852	235	Hunting in the Woodlands, Sold.
1852	257	A Day with the Mountain Hares, Sold.
1852	283	Folding Sheep - Scotland, Sold.
1852	293	Calling Hounds out of Cover, Sold.
1852	312	Evening - Coming Home, Sold.
1853	131	Bringing Home the Deer.
1853	231	Highland Gillie, with Deer Hounds and Game.
1853	266	Scene from Waverley vol.i. chap. 13., "These Gillie wet foots, as they were called, were destined to beat the bushes, which they performed with so much success, that after half an hour's search, a roe was started, coursed, and killed. The Baron, following on his white horse, like Earl Percy . . ."
1854	76	Scotch Ferngatherers, Sold.
1854	124	October, "See! from the brake the whirring pheasant springs . . ." Vide Pope's Windsor Forest. Sold.
1854	144	Festival of The Popinjay, "The Green Marksman, as if determined to bring the affair to a decision, took his horse . . ." Vide Old Mortality, Vol. I., chap. 3. Sold.
1854	293	Return from the Chace - Passing the Gypsies, Sold.
1854	306	Troopers on the March - Fording, Sold.
1854	312	Highland Shepherdess, Sold.
1854	318	Woodland Hunting, Sold.
1854	338	Sir Roger de Coverley cheering on his Hounds, "The dogs pursued her, and these were followed by the jolly knight, who rode upon a white gelding, encompassed by his tenants and servants . . ." Vide Spectator, Vol. II., No. 116. Sold.
1854	347	Hawking - The Flight, Sold.
1855	29	Marauding Troopers - A Skirmish, Sold.
1855	206	Stag Hunt - Full Cry, Sold, John Hewett Esq., Leamington.
1855	289	Highland Keeper's Return, Sold.
1855	311	Woodland Hunting, Sold.

TAYLER J F

1838	77	Halt of Cavalry.
1838	281	Bringing Home the Deer.
1838	293	The Young Chieftain's First Ride.
1838	321	A Luncheon on the Moors.
1838	337	A Trooper of the Olden Time.
1838	347	Highland Bridge, Loch Laggan.
1838	351	On the Coast of Scotland.
1838	353	Fishwoman - Coast of Scotland.
1838	355	A Trooper of the Present Day.

THOMPSON W J

| 1819 | 189 | Girl at a Brook. |

THOMSON W J

1819	283	*The Peasant's Grace, "This decent piece of devotion is the daily practice of the Scottish Labourer over his humble meal of milk and porridge, brought to him by his Children to the place of Labour."*
1820	72	*Boy, Fishing.*
1820	111	*Frolick at the Toilette.*
1820	208	*Hebe.*

THURSTON J

1806	36	*King John, Act 3. Scene 4.*
1806	37	*Scene in Cymbeline Act 4. Scene 2.*
1806	132	*The Two Gentlemen of Verona.*
1806	133	*"What's that face of anguish there, Pale as its surrounding shroud?" – Moore's Poems p.73.*
1806	134	*A scene from the Comedy of Errors.*

TOPHAM F W

1848	88	*"Arrah, Kathleen, my darlint, you've teaz'd me enough", Vide Ballad of Rory O'More. Sold.*
1848	100	*Near Capel Cûrig, North Wales, 30gns., F.T. Rufford Esq., Frame and glass £3.5.0.*
1849	148	*The Fisherman's Home, The dawn of the morning saw Dermot returning.*
1849	247	*Making Nets.*
1850	31	*Highland Pastime, 150gns.*
1850	125	*Home, Sold.*
1850	130	*The Return, Sold.*
1850	298	*Highland Interior, Sold.*
1851	69	*Highland Smugglers leaving the Hills with their Whiskey.*
1851	114	*"Whistle, and I'll come to thee, my lad."*
1851	238	*Barnaby Rudge and his Mother, "She took his arm, and they hurried through the village street. It was the same as it was wont to be in old times, yet different too, and wore another air . . ."*
1852	86	*The Morning of the Pattern - a Holyday in the West of Ireland, 150gns., R. Lloyd Esq.*
1852	272*	*Study from Nature, 8G, Ellis Esq., Birchin Lane.*
1852	302	*The Cabin Door, Sold.*
1853	246	*Wild Flowers.*
1854	26	*Fortune-Telling - Andalusia, Sold.*
1854	81	*A Gipsy Festival, near Granada, Sold.*
1854	147	*Gipsies, Sold.*
1854	281	*Spanish Gipsies, Sold.*
1854	334	*Mendicants, Sold.*
1855	141	*The Andalusian Letter Writer, Sold.*
1855	319	*The Posada, Sold.*

TURNER JWM RA

1823L	88	*Tivoli, J. Allnutt, esq.*

TURNER W

1808	64	*On the River Charwell, Oxfordshire.*

1808	79	*Porch at Shipton on Charwell, near Oxford.*
1808	216	*Scene near Witney, with part of Whichwood Forest, Oxfordshire.*
1808	227	*Ottmoor, near Oxford.*
1808	234	*Corn field, near Woodstock, Oxfordshire, 10gns., Marquis Stafford.*
1809	13	*Norbrook Heath, a sketch.*
1809	66	*Campsfield, near Woodstock.*
1809	75	*Long Compton Hill, Warwickshire, a sketch.*
1809	110	*Scene near Woodstock.*
1809	115	*Long Compton, Warwickshire.*
1809	218	*A corn field, a sketch.*
1809	243	*Whichwood Forest, Oxfordshire.*
1809	257	*Ramsden Heath, Oxfordshire.*
1809	268	*Rollrich Stones, Oxfordshire.*
1810	104	*A View looking towards the Bristol Channel, from Clifton.*
1810	110	*View of Bristol.*
1810	170	*A Saxon Door at Quinnington, Gloucestershire.*
1810	188	*Scene near Woodstock, Oxfordshire.*
1810	205	*Scene on the River Charwell, near Woodstock, Oxon.*
1810	231	*View from King's Weston Down, near Bristol.*
1810	260	*Scene on the River Charwell, near Oxford.*
1810	275	*Scene on the River Charwell, Woodstock, Oxon.*
1810	313	*View of Oxford.*
1811	48	*View from Dowdeswell Hill, near Cheltenham, looking across the Vale of Severn towards Malvern.*
1811	62	*Chepstow Castle.*
1811	84	*View of Oxford, from Botley Hill.*
1811	92	*View from the Marshes, near Shirehampton, Gloucestershire, looking down the Bristol Channel.*
1811	112	*Scene in Whichwood Forest, Oxfordshire.*
1811	235	*North Door of Quinington Church, Gloucestershire.*
1812	28	*Ott-Moor, near Oxford.*
1812	61	*Bristol, from Kingswood.*
1812	85	*Beverston Castle, Gloucestershire.*
1812	86	*View from near Dowdeswell, Gloucestershire, looking towards Cheltenham and Malvern.*
1812	190	*Scene on the River Avon, near Bristol.*
1812	192	*Scene at Abingdon, Berks.*
1812	251	*Blenheim, Oxfordshire.*
1813	36	*View from Birlip Hill, looking towards Gloucester.*
1813	68	*Scene at Nether Haven, Wiltshire.*
1813	94	*Turner - Evening.*
1813	194	*A Wood Scene, with Gypsies - Evening.*

1813	208	*Oxford, from Ferry, Hincksey.*
1813	231	*A Landscape.*
1814	38	*Oxford, from Ifley.*
1814	39	*Village Scene, Evening.*
1814	49	*Tom Tower, from the Bathing-place, Oxford.*
1814	64	*Windsor.*
1814	129	*View of Oxford.*
1814	205	*Scene near Oxford - Showery Day, £42.0.0, Mr. Willimotte.*
1814	279	*Windsor Castle.*
1815	92	*St. Vincent's Rocks, and part of Clifton, from Leigh Wood, Somersetshire.*
1815	98	*Windsor Castle.*
1815	160	*View of Oxford, from Headington Hill.*
1815	189	*Whichwood Forest, Evening.*
1815	193	*Near Oxford, Mid-day.*
1815	216	*Port Meadow, Oxford.*
1815	238	*Langdale, Westmoreland, £6.6.0, J. Allnutt Esq.*
1815	290	*View of Bristol from Kings Wood, Evening.*
1816	55	*View from the Down, near Charlton Kings, Gloucestershire.*
1816	80	*Goodrich Castle, on the Wye, near Ross, Herefordshire, £26.5.0, C. Long Esq.*
1816	134	*View from Wynd Cliff, Chepstow, Monmouthshire.*
1816	268	*Scene in Westmorland.*
1816	278	*Heath Scene.*
1816	305	*Twilight.*
1817	28	*View from Wynd Cliff, near Chepstow. Storm passing off.*
1817	33	*Goring and Streatley, on the Thames near Wallingford. Showery Evening.*
1817	40	*Vale of Gloucester.*
1817	75	*Goodrich Castle, Herefordshire. Evening.*
1817	76	*Chepstow Castle, Monmouthshire. Sunrise.*
1817	80	*Bagley Wood, near Oxford.*
1818	9	*Old Tower of the Castle, Oxford.*
1818	13	*Evening.*
1818	43	*Scene near St. John's College, Oxford, £10.10.0, Walter Russell Esq.*
1818	98	*Wood Scene.*
1818	151	*View of Conway. The Summits of Snowden and Moel-siabod in the distance.*
1818	209	*Scene near Coniston Lake, Lancashire.*
1818	230	*Evening.*
1818	232	*Windsor Castle, from near Clewer.*
1818	256	*Snowdon, from Capel Curig.*
1818	257	*Twilight.*
1818	275	*Entrance to Oxford, from Abingdon.*
1818	351	*Beverston Castle, near Tetbury, Gloucestershire.*
1819	122	*Via-Mala, Canton of the Grisons, from a Sketch by the Rev. C. Annesley.*
1819	337	*Dove Dale, Derbyshire.*
1819	349	*Haddon Hall, near Bakewell, Derbyshire.*
1820	149	*Llanberis Lake and Dolbadern Castle, North Wales.*
1820	285	*Scene near Birdlip, looking towards Gloucester.*
1820	294	*Hawk Combe, near Porlock, Somersetshire.*
1820	298	*Warwick Castle, with the Ruins of the Old Bridge.*
1821	44	*Llanberis Lake, North Wales - An Autumnal effect, £15.15.0.*
1821	45	*The Shepherd - Scene near Gloucester, £17.17.0, W. Cotton Esq.*
1821	80	*Oxford, from Headington Hill.*
1821	99	*Scene near Cumner, Berkshire, £15.15.0, P.J. Miles Esq., Bristol.*
1821	108	*Salisbury Plain.*
1822	14	*Ramsden Heath, near Witney, Oxfordshire - the White Horse Hills in the Distance.*
1822	21	*Gipsies - Twilight.*
1822	30	*Pope's Tower, the Old Kitchen, &c. Stanton-Harcourt, Oxfordshire.*
1822	124	*Scene near St. Ann's Well, Great Malvern, Worcestershire, Edge Hill in the extreme distance, £21.0.0, J. Dimsdale Esq.*
1823	49	*The Vale of Gloucester, from Robin Hood's Hill, "Now suns are clear, now clouds pervade . . ." (Clare.)*
1823	65	*Lymouth, North Devon.*
1823	69	*Oxford.*
1823	122	*Road Scene near Islip, Oxfordshire.*
1823	199	*Scene near Newnham, on the Severn, Gloucestershire, "We with the sun our flocks unfold, Whose rising makes their fleeces gold. Shepherd's Song" - T. Heywood.*
1823L	54	*Scene in Gloucestershire, T. Griffith, esq.*
1823L	164	*Evening, J. Allnutt, esq.*
1823L	195	*Landscape, J. Sedgwick, esq.*
1824	27	*Wood Scene.*
1824	110	*Scene near Oxford - November 1st, 1823.*
1824	241	*Scene near Great Malvern.*
1824	251	*Oxford, from Ifley.*
1825	241	*View of Oxford - Evening, Sold.*
1826	9	*A Forest Scene, 15gns.*
1826	100	*A Stormy Effect- Scene near Cheltenham, 15gns.*
1826	246	*Windsor Castle, from near Salt Hill, 15gns.*

1827	170	*View on the South Sands, Tenby*, 7gns., W. Wells.
1827	189	*On the Coast near Clovelly, North Devon*, 4gns.
1827	235	*The Boldre Stream, New Forest*, 15gns.
1827	244	*Peveril's Castle in the Peak, Derbyshire*, 4gns.
1827	249	*View from Broadway Hill, Worcestershire*, Sold.
1827	255	*View near Pont Llyn yr Afrange, looking towards Llanurst, North Wales*, 5gns., Lord Calthorp(?), ??? Square.
1827	258	*A Woodman's Cottage*, 15gns.
1827	296	*View near Birdlip, Gloucestershire*, 5gns.
1827	337	*Shot-over-Hill, Oxfordshire*.
1828	32	*Harlech Castle - Snowden in the distance*, 7gns.
1828	33	*Barmouth Pier - Cader Idris in the distance, on the right*, 7gns.
1828	88	*Entrance to Oxford, over Magdalen Bridge*, 15gns.
1828	135	*Clovelly, North Devon*, 20gns.
1828	157	*Snowdon, from Capel Cûrig*, 15gns.
1828	207	*Composition*, 4gns.
1828	252	*View of Oxford*, Sold.
1829	1	*Scene on South Sands at Tenby*, 7gns.
1829	10	*A Scene on the Marshes near the Tide-lock at Cardiff, the Steep and Flat Holmes, &c. in the distance*, 20gns.
1829	87	*Scene near Beaulieu, New Forest*, 15gns.
1829	160	*Twilight*, 15gns.
1829	243	*The Old Gateway of Magdalen College, Oxford - painted on the Spot*, Sold.
1829	251	*Shepherd Boys - a Scene on Bullingdon Green, near Oxford*, 20gns.
1830	1	*A Scene in the vicinity of a Baronial Residence in the reign of Stephen*, 40gns.
1830	80	*Snowden - the Glyder and the Trifaen Mountains, seen from an eminence near Capel Cûrig*, 6gns.
1830	82	*Scene in the New Forest*, 7gns., J.F. Lewis Esq.
1830	93	*The Lighthouse at Ilfracombe*, 7gns., Holford Esq.
1830	101	*High Street, Oxford - painted on the Spot*, 10gns.
1831	10	*A View from the Downs, near Charlton on Kings, Gloucestershire, the Malvern Hills in the distance*.
1831	57	*A View from the Top of the Cliff, near the Valley of Rocks - Linton, North Devon*.
1831	78	*A Windmill at Charlton Ottmoor, Oxfordshire - Showery Day*.
1831	106	*Snowden, and other Mountains, as seen from near Harlech, Merionethshire*.
1831	171	*A Scene on the Coast, near Lynmouth, North Devon*.
1831	190	*Ottmoor, Oxfordshire - as it occasionally appeared previous to the Enclosure*.
1831	195	*A View near Minstead, in the New Forest, looking towards Southampton*.
1831	227	*A Scene near Beaulieu, New Forest*.
1831	282	*A Heath Scene in the New Forest, the Isle of Wight Hills in the Distance*.
1832	12	*The Old Windmill in Milton Field, Oxfordshire, Cuddesdon in the Distance*, 15gns.
1832	38	*The Severn, near Newnham, Gloucestershire*, 5gns.
1832	51	*The Vale of Ffestiniog, from the Wood near Tan y Bwlch Hall, Merionethshire*, 5gns.
1832	62	*Windsor from the Brockhurst - clearing up after a shower*, 25gns.
1832	76	*Scene near St. Anne's Well, Great Malvern*, 8gns., J. Moxon Esq., 23 Lincolns Inn Fields.
1832	96	*The Descent of Stoken Church Hill, Oxfordshire*, 8gns.
1832	104	*View from King's Weston Down, near Bristol, looking towards King Road*, 5gns.
1832	115	*Near Lustleigh Cleeve, on the River Teign, Devonshire, Dartmoor in the Distance*, 4gns., Lord Rolle, 18 Upper Grosvenor St.
1832	157	*Scene on the Sands at Barmouth, Merionethshire the Caernarvonshire Mountains in the Distance*, 6gns.
1832	248	*A Heathy Scene in the New Forest, looking towards Southampton*, 15gns.
1832	270	*A Scene on the Coast near St. Gowan's Chapel, Pembrokeshire*, 7gns.
1833	28	*Llanberis Lake, North Wales*, Sold.
1833	57	*Clovelly, North Devon*, 8gns.
1833	88	*Scene in the New Forest*, 30gns.
1833	109	*View of Oxford*, 6gns.
1833	204	*Llawhaden Castle, Pembrokeshire*, 4gns.
1833	208	*Scene near Lynmouth, North Devon*, 8gns.
1833	209	*Peverel's Castle in the Peak, Derbyshire - Evening*, Sold.
1833	214	*Kilgarren Castle on the River Teivy, South Wales - Morning*, 5gns.
1833	230	*Stonehenge*, 15gns.
1833	243	*Moonlight*, 15gns.
1833	255	*View from Charlton Down, looking towards Cheltenham and Malvern*, 8gns., Mr. W.B. Roberts.
1833	259	*A Mountain Torrent near Ffestiniog, North Wales*, 16gns.
1834	1	*A Retired Scene near Beaulieu, New Forest*, 15gns.
1834	19	*Portsmouth Harbour and the Isle of Wight, as seen from Portsdown Hill*, 20gns., Beaumont Swete Esq., Oxton, Exeter.

1834	38	*Harvest Scene near Garsington, Oxfordshire,* 16gns.
1834	76	*Old Houses which formerly stood near St. Mary Magdalen's Church, Oxford, taken down in the year 1820,* 4gns.
1834	184	*A Secluded Scene in Leigh Wood, near Clifton,* 8gns.
1834	203	*Oxford, Twilight,* 8gns.
1834	234	*View from Halnacker Down, near Chichester, looking over Goodwood towards the Isle of Wight - Evening,* 15gns., R. Ferguson M.P., 18 Portman Square.
1834	262	*Corn Field, near Charlton-on-Otmoor, Oxfordshire,* 6gns.
1834	312	*Shepherds descending with their Flocks from the South Downs, near Chichester - Evening,* 5gns., Bernal Esq.
1834	337	*Snowdon, from Capel Carig,* 5gns., Bernal Esq.
1834	342	*Langdale, Westmoreland,* 5gns.
1834	376	*A Heathy Scene near Minstead in the New Forest, looking towards the Isle of Wight,* 8gns., Mr. Leggatt, Cornhill.
1835	4	*Scene near Minstead, in the New Forest, looking towards Southampton.*
1835	5	*Scene in the Vale of Festiniog, Merionethshire.*
1835	9	*View from an Eminence near Capel Carig, Snowdon in the distance.*
1835	12	*Scene near Brockenhurst, in the New Forest.*
1835	58	*The Old Windmill near Porchester Castle, Hants - Sun-set,* 20gns., Mr. Davison, No. 1 Grove End Place, St. John's Wood.
1835	83	*View from the Sussex Downs, looking over Kingly Bottom towards Chichester,* 20gns.
1835	89	*High Street, Oxford - Evening,* 15gns., Sir William Herries, 11 Clarges Street, Will Mr. Turner sell the frame. What will be the price, the glass also.
1835	104	*Winter - Cumner Hill in the distance,* 5gns., D.T. White.
1835	127	*View from the South Downs near Chichester - looking towards the Isle of Wight - Sun-set,* 8gns., Mr. D.J. White.
1835	140	*Port Penrhyn - Low Water - Beaumaris, Puffin Island, Great Orme's Head, and Penmaenmawr in the distance,* 5gns., D.T. White.
1835	160	*Spring - painted from Nature,* 5gns.
1835	188	*Salisbury Plain,* 5gns., Mr. D.T. White.
1835	219	*Scene near Skipton on Cherwell, Oxfordshire - a Study from Nature,* Sold.
1835	221	*View from St. John's near Ryde, Isle of Wight - looking towards Spithead and Portsmouth,* 20gns.
1835	223	*Moel Siabod, as seen from the Vale of Llugwy, Caernarvonshire,* 5gns.
1835	240	*View from St. Catherine's Down, Isle of Wight, looking towards the Freshwater Cliffs and the Dorsetshire Coast,* 8gns.
1836	18	*Llanberris Pass, Caernarvonshire, as it appeared before the New Road was made,* 8gns., Signor La Blacke, 53 Regent Quadrant.
1836	65	*Windmill Hill, Gravesend - Sun-rise,* 20gns., Jos. Bailey Esq. M.P.
1836	67	*Dover Castle, the Heights and part of the French Coast as seen from the Downs, near Buckland,* 15gns.
1836	72	*View near the Observatory in Greenwich Park,* 25gns.
1836	106	*View near St. Ann's Hill, Great Malvern - Edgehill in the extreme distance, "Now suns are clear, now clouds pervade . . ." Clare.* 8gns., Jacob Montefiore Esq., 24 Tavistock Square.
1836	146	*Winter Morning Scene, near Kidlington, Oxfordshire,* 5gns., W. Domett, Balham Hill.
1836	157	*Heath Scene with Gipsies - close of Day,* 5gns., Domett, Balham Hill.
1836	170	*The Cow Boy's Retreat - Showery Day - on the Cumner Meadow, near Oxford,* 4gns.
1836	181	*Sheepfold - Evening - Scene near Bloxham, Oxfordshire,* 8gns.
1836	186	*Stonehenge - Twilight,* 5gns., Dr. Merriman, 34 Brook St., Grosvenor Sq.
1836	193	*Pembroke Castle - Moonlight,* 6gns.
1836	197	*Entrance to Oxford from London,* Sold.
1836	211	*Arundel Castle, Sussex - Twilight,* 5gns.
1837	2	*Scene on the South Downs near Bignor, Sussex,* Miss Duckworth, 35 Woburn Place, Russell Square.
1837	19	*View from Wynd Cliff, near Chepstow - Morning,* 8gns.
1837	22	*Winter Morning, vide Cowper's Task, Book 5,* 5gns., Sold.
1837	35	*Shepherds returning with their Flocks - Evening Scene, Halnacker Down, near Goodwood, Sussex,* 20gns.
1837	47	*The Entrance to Fowey Harbour Cornwall,* 15gns.
1837	87	*Arthur's Castle, Tintagel, Cornwall,* 20gns.
1837	106	*View from Pordenak Castle, near the Land's End, Cornwall, "Thy awful height, Bolerium, is not loved By busy man . . ." Sir H. Davy.* 30gns.
1837	117	*Sun-set Scene on the Down near the Needles Light House, Isle of Wight,* 8gns., Lady Milton, Halkin St., Grosvenor Place.
1837	206	*Scene near Tan-y-Bwlch, Vale of Festiniog, N. Wales,* 6gns., The Lord Bishop of Clogher, Woodstock, N.S. Mt. Kennery, Ireland, Case £0.3.6.

1837	210	*Pont Aberglaslyn, North Wales - Evening*, 8gns.
1837	224	*Scene near Charlton on Otmoor, Oxfordshire – Stormy Weather*, 5gns.
1837	235	*Sun-set, "Hast thou left thy blue course in heaven, golden-haired son of the sky! . . ." Ossian*. 30gns.
1837	236	*The River Cherwell, near Woodstock, Oxfordshire, "Know that the lilies have spread their bells . . ." Mrs Hemans*. 30gns., Geo. Kirkpatrick Esq., Hollydale, nr. Bromley, Kent, Frame and glass £7.0.0 purchased.
1837	354	*Gypsies - Twilight*, 5gns.
1838	3	*Stratford-on-Avon, "Thou soft flowing Avon, by thy silver stream . . ."*
1838	39	*The Woodman - Winter Morning, Vide Cowper's Task, Book V.*
1838	105	*Snowdon, from near Harlech, Merionethshire.*
1838	117	*Sun-set - Shepherds Returning with their Flocks - Scene on the South Downs, near Arundel, Sussex.*
1838	147	*Salisbury Plain - Showery Day.*
1838	163	*Snowdon, from an Eminence near Capel Cûrig, Caernarvonshire.*
1838	164	*The Logan Stone, near the Land's End, Cornwall - Stormy Twilight - Moon rising.*
1838	217	*Scene near St. Anne's Well, Great Malvern - Sunrise.*
1838	224	*Looking over Kingly Bottom and Part of the South Downs, Goodwood and Chichester in the Distance, "Blest is yon Shepherd on the turf reclin'd, Who on the varied clouds which float above Lies idly gazing." C. Smith.*
1838	226	*Heath Scene near Beaulieu, New Forest.*
1838	251	*Sudely Castle, near Winchcomb, Gloucestershire.*
1838	252	*Llanberis Lake and Dolbaddern Castle.*
1838	257	*Florence - from a Sketch by the Rev. J. C. Stafford.*
1838	304	*The Boldre Stream, near Brockenhurst, New Forest, Hants.*
1839	8	*View from Querang, Isle of Skye, the Mountains of Garelock, Applecross, and Kintail, and Islands of Rona and Raasay in the Distance*, 20gns.
1839	25	*Winter Scene in Ross-shire, North Britain*, Sold.
1839	95	*Vale of Glen Coe, near Loch Leven, Argyllshire*, Sold.
1839	158	*View near Chinner, Oxfordshire, looking towards Thame and Brill*, 8gns.
1839	173	*Loch Coruisk, Isle of Skye - Stormy Evening, A scene so rude, so wild as this, "Yet so sublime in barrenness . . ." Scott's Lord of the Isles.* 30gns.
1839	200	*Scene near Brockenhurst, New Forest, Hants - Sun-rise*, 15gns.
1839	247	*Loch Lomond - Morning*, Sold.
1839	252	*Scene near Porchester Castle, Hants - Sun-set*, 8gns.
1840	30	*The Land's End, the Longship's Light-House, and Scilly Islands, as seen from Pedenmean du Point, Cornwall.*
1840	87	*Loch Fainich, Ross-shire - the Mountains near Loch Maree and Loch Broom in the Distance - Sunset. (One of an intended Series of Views of the Mountains in Ross-shire and Inverness-shire).*
1840	95	*View from Bullingdon Green, near Oxford - Sunset.*
1840	148	*View from Shanklin Down, Isle of Wight, looking towards the Culver Cliff.*
1840	158	*Oxford, from near Iffley - Evening.*
1840	166	*Holm Chase, near Buckland in the Moor, Devonshire.*
1840	168	*Drovers traversing a heathy part of the Isle of Skye, Blaven and the Cuchullin Hills in the Distance. (One of an intended Series of Views of the Mountains in Ross-shire and Inverness-shire, North Britain).*
1840	176	*View near Dowdeswell, looking towards Cheltenham and Malvern.*
1840	232	*Winter Morning (Vide Cowper's Task).*
1841	36	*Buckland, near Broadway, Worcestershire - Autumnal Afternoon*, 8gns.
1841	45	*View from the Summit of Scawfell Pike, Cumberland, "We now beheld the great mass of Great Gavel from its base, the den of Wast Dale at our feet – a gulph immeasurable: Grasmere and other mountains of Crummock – Ennersdale and its mountains . . ." Wordsworth.* 20gns.
1841	61	*View near Uig, Isle of Skye - the Mountains of Harris in the Distance*, 8gns.
1841	91	*Scene near the Rochester Lodge in Blenheim Park - Autumn*, 20gns.
1841	97	*View from above the Fall of Lodore, Cumberland - the Vale of Keswick and Skiddaw in the Distance*, Sold.
1841	114	*Salisbury Plain - Evening effect after a rainy Day*, 18gns.
1841	127	*Scene near St. John's College, Oxford, as it appeared in the year 1812; the site of the Martyr's Memorial is where the old houses formerly stood which are represented in the middle of the picture*, 5gns.
1841	174	*Blenheim from near the Rochester Lodge - Autumn*, Sold.
1841	186	*Drovers waiting for the Ferry Boat near Hyle Haken Castle, Isle of Skye - the Mountains of Kintail in the Distance - Morning*, 20gns.

1841	191	*Scene near Broadford, Isle of Skye - the Islands of Pabba, Scalpa, Raasay, and Rona, and part of the District of Applecross, in the Distance,* 8gns., R.W. Lumley, 9 Charles St., By. Square.
1841	204	*Returning from Market - Winter Evening,* 5gns.
1841	217	*View of Bow Hill, near Chichester - looking over Kingly Bottom, towards Langstone and Portsmouth Harbours, and the Isle of Wight, "The upland shepherd, as reclined he lies . . ."* C. Smith. 20gns., Charles Stone, 36 Paternoster Row.
1841	223	*View of the Upper Reach of Ulswater from Gowbarrow Park, Patterdale in the Distance - Morning,* 16gns.
1842	17	*Returning from the Moors - Scene near Tomandown, above Loch Garry, Inverness-shire - the Mountains of Loch Hourn in the Distance.*
1842	36	*View in the Valley of Tournache, looking towards the Peak of Mont Cervin or Matterhorn, in Piedmont - from a Sketch by the Rev. J.A. Cramer, D.D., Principal of New Inn Hall, Oxford.*
1842	41	*View from the Dover Road, near Gillingham, Kent - Sheerness and the Junction of the Thames and Medway in the Distance.*
1842	72	*View of Monte Viso and the Source of the Po - from an original sketch by the Rev. J.A. Cramer D.D,. Principal of New Inn Hall, Oxford.*
1842	96	*The Highlanders' Burying Ground, on an Island in the Loch Maree, Ross-shire. – N.B. Sixty years since.*
1842	104	*A Winter Morning Scene.*
1842	142	*View from Halnacker Down, Sussex, looking over Goodwood Park, towards the Isle of Wight and Portsmouth Harbour, "Now suns are clear, now clouds pervade . . ."* Clare.
1842	160	*Bamborough Castle, Northumberland - Sunset.*
1842	174	*Scene in Glen Shiel, Ross-shire, North Britain.*
1842	186	*Loch Duich, and the Mountains of Glen Shiel, Ross-shire, North Britain.*
1842	193	*Dornie Castle, Ross-shire, the Mountains of the Isle of Skye in the Distance - Sunset.*
1842	243	*An April Shower, View from Binsey Ferry, near Oxford, looking towards Port Meadow and Godstow.*
1843	*1	*A May Morning,* 20 Pounds.
1843	34	*Caledonia - Sun-set,* 20 Pounds, Miss Wyatt Edgell, 40 Lower Grosvenor St.
1843	67	*Keswick Lake from Castle Head - Moonlight,* 20 Pounds, Miss Wyatt Edgell, 40 Lower Grosvenor Street.
1843	84	*Bamborough Castle, Northumberland,* 15gns.
1843	222	*The Upper Reach of Loch Etive, Argyllshire - Morning of the 12th of August,* 15gns., Miss Ritchie, 45 York Terrace, Regents Park.
1843	260	*"Rudely o'erspread with shadowy forests lay Wide trackless wastes . . ." Vide Aboriginal Britons. – Oxford Prize Poem.* 30gns.
1843	263	*Loch Coruisk, Isle of Skye, "The day was calm, and the water glossy and dark; not even a bird was to be seen; no fish dimpled in the water; it appeared as if all living beings had abandoned this spot to the spirit of solitude. The white torrents were foaming down the precipices . . ."* 20 Pounds.
1844	28	*The Yew Trees near Scathwaite, in Borrowdale, Cumberland,* 18 Pounds, Frame and glass not for sale.
1844	87	*Scene near the Head of Loch Maree, Ross-shire, N. Britain, the white quartz rock summit of Ben Eye in the Distance,* 18 Pounds.
1844	90	*Winter Sabbath Morning, Wastdale Chapel, Cumberland,* 8gns., Frame and glass £2.0.0.
1844	147	*Loch Eil and Ben Nevis, Inverness-shire, North Britain,* 30 Pounds, Frame and glass £8.0.0.
1844	164	*Windermere, from near Low-wood Inn, Westmorland - Sunset,* 20 Pounds, Frame and glass £4.0.0.
1844	170	*Scene near Luccombe Chine, Isle of Wight, the Culver Cliffs in the distance,* 8gns., Sir John C. Hobhouse, Frame and glass £2.0.0.
1844	188	*Loch Maree, Ross-shire, N. Britain - Summer Moonlight,* 20 Pounds, J. Heighington Esq., 2 Hatfield St., Blackfriars, Frame and glass £5.0.0, P.AU.
1844	215	*View from Bow-hill, near Chichester, looking towards the Isle of Wight,* 15gns., Honble. James Howard, D2 Albany, Frame and glass £3.0.0.
1844	306	*A Heath Scene - Showery Day,* 15gns., Frame and glass £2.5.0.
1845	5	*View near Ryde, Isle of Wight, looking towards Spithead and Portsmouth - Autumn,* 20 Pounds.
1845	80	*The Groves of Yew Trees in Kingly Bottom, a part of the South Downs near Chichester, "The upland shepherd, as reclined he lies On the soft turf . . ."* Charlotte Smith. 20 Pounds, E.E.Tustin Esq., Fludyer Gate.
1845	84	*Ellandonan Castle, Loch Dwich, and the Mountains of Glen Shiel, Ross-shire, North Britain - Summer Moonlight,* 20 Pounds.
1845	93	*Salisbury Plain - Showery Day,* 8gns., Rev. S.M. Traherne, Coedriglen(?), Cardiff.
1845	94	*Connal Ferry, across a contracted part of Loch Etive, Argyllshire - Ebb-tide - Dunstaffnage Castle and the Mountains of the Isle of Mull in the distance,* 8gns.
1845	107	*The Broad Walk, Christ Church Meadow, Oxford,* Sold.
1845	140	*Arthur's Castle, Tintagel, Cornwall - Evening,* 15 Pounds.

1845	198	*Ellandonan Castle, Ross-shire; the Mountains of the Isle of Skye in the distance - Sunset, "Ellandonan Castle was built by Alexander II as an 'overband' against the Danes and Norwegians". Vide Anderson's Guide.* 20 Pounds.
1845	220	*The Moors, near Tomandoun, above Loch Garry, Inverness-shire - the Mountains near Loch Hourn in the distance,* 15gns.
1845	227	*View near Gillingham , Kent, the Junction of the Thames and Medway in the distance - Morning,* 30 Pounds.
1845	230	*Hartie Corrie, in the Cuchullin Hills, Isle of Skye, well known to the Deer stalkers of that part of the country,* 8gns., I.T. Simes, Highbury Park.
1846	41	*Stanton Harcourt, Oxfordshire - Winter Morning,* 8gns.
1846	43	*The Vale of Gloucester, from Robin Hood's Hill - the Malvern and Breedon Hills in the distance, "Now suns are clear, now clouds pervade . . ." T. Clare.* 30 Pounds.
1846	63	*The Upper Reach of Ullswater, from Gowbarrow Park, looking towards Patterdale - Summer Moonlight,* 20 Pounds.
1846	85	*The River Cherwell, near Woodstock, Oxfordshire, where the white Water Lilies grow abundantly, "Stilly and lightly their vases rest . . ." Mrs. Hemans.* 20 Pounds, His Grace the Duke of Sutherland.
1846	91	*The Moors near the Head of Loch Luichart, Ross-shire, North Britain - Scuirvullin and other Mountains in the distance,* 15 Pounds.
1846	129	*Oxford, from Ferry Hinksey - Evening,* 8gns.
1846	156	*A distant view of Loch Maree, Ross-shire, North Britain, before the fir forests of that district were cut down - Sunset,* 40 Pounds.
1846	184	*Stonehenge - Stormy Day,* 15 Pounds.
1846	195	*Scene at the Head of Loch Lochy, Inverness-shire, looking towards Fort William,* 8gns.
1846	269	*St. Michael's Mount, Cornwall,* 7gns.
1847	6	*Kyle Haken Castle, Isle of Skye - Evening - Moon rising,* 20 Pounds.
1847	24	*Glenco, Argyllshire - Evening,* 5 Pounds, C. Saltmarshe Esq., Middleton Lodge, Leeds.
1847	33	*Iffley Mill, near Oxford - painted on the spot,* 5 Pounds, C.J. Pulling Esq., Brasenose Coll., Oxford.
1847	61	*Ben na Caillick, and other Mountains of the Isle of Skye, Pabba Island, and part of Scalpa, as seen from near Longa - Evening,* 8gns.
1847	70	*A Mountain Torrent in the Isle of Skye - Rainy Weather,* 15 Pounds.
1847	88	*Morning - on the Mountains of Loch Etive, Argyllshire, North Britain, "O wake, while Dawn, with dewy shine, Wakes Nature's charms to vie with thine! Lord of the Isles.* 30 Pounds.
1847	105	*View from Shanklin Down, Isle of Wight, looking towards the Culver Cliff, "Blest is yon shepherd, on the turf reclined . . ." C. Smith.* 20 Pounds.
1847	135	*Peveril Castle, in the Peak, Derbyshire,* 8gns.
1847	181	*The Floods on the Meadows, near Oxford,* 15 Pounds.
1847	196	*Heath Scene - Stormy Twilight, "Now spurs the lated traveller apace".* 5 Pounds.
1847	200	*Recollection of a Scene in the district of Applecross, Ross-shire, North Britain,* 20 Pounds.
1847	256	*View looking over the Groves of Yew Trees in Kingley Bottom - a part of the South Downs, near Chichester,* 8gns., Thos. Toller Esq., 6 Grays Inn Square.
1847	274	*Cader Idris, North Wales,* 6gns.
1848	15	*Scene on the Moors between Loch Roshk and Loch Maree, the Mountains at the head of Loch Torridon, Rosshire, in the distance,* 8gns.
1848	49	*Loch Garry, Inverness-shire - Evening,* 5 Pounds.
1848	70	*Keswick Lake, Skiddaw and Saddleback, from an eminence near the entrance to Borrowdale,* 15 Pounds.
1848	81	*Sunday in the Ross-shire Highlands,* 5 Pounds.
1848	91	*View near Middleton Hall, looking towards Langley Ford and Hedgehope, one of the highest of the Cheviot Hills, Northumberland,* 8gns.
1848	99	*Loch Lomond - Morning,* 15 Pounds.
1848	172	*View of Oxford, from Hinksey Hill - Storm passing off - Evening,* 25 Pounds.
1848	184	*The Falls of Rogie, near Strathpeffer, Ross-shire,* 5 Pounds.
1848	189	*The Highlanders' Burying Ground, on a small Island in Loch Maree, North Britain - Moonlight Evening,* 20gns. [Pounds in pencil].
1848	192	*Ben-na-Bear and the Mountains of Ardgower, as seen across the Linnhe Loch, from Balahulish - Sunset,* 8gns.
1848	196	*Scene near Hulne Abbey, in Alnwick Park, Northumberland,* 5gns. [Pounds in pencil].
1848	203	*Akeld Bridge near Wooler, Northumberland, Yeavering Bell, one of the Cheviot Hills in the distance,* 5gns. [Pounds in pencil].
1849	80	*The Dawn - Loch Torridon, Ross-shire, N. B.*
1849	107	*Dunstanborough Castle, Northumberland - the Fern Island and Bamborough Castle in the distance.*
1849	133	*Ulleswater, from Gowbarrow Park - Morning.*
1849	150	*The Resting-place – 12th of August - Scene near Auchnault Inn, Ross-shire, N. B.*
1849	151	*Edlingham Castle, Northumberland.*

1849	155	*Kingley Bottom, near Chichester.*
1849	176	*Iffley Mill, near Oxford - painted on the spot.*
1849	193	*Glencoe, Argyllshire - Evening.*
1849	218	*Cherwell Water Lilies, "Stilly and lightly their vases rest . . ." – Mrs Hemans.*
1849	263	*Scene in Deepdale, Westmoreland - painted on the spot.*
1849	282	*Brinkburn Priory, Northumberland.*
1849	285	*Study from Nature - Scene in Bagley Wood, near Oxford.*
1850	11	*The Cheviot Hills, as seen from Alnwick Moor, Northumberland, 20 Pounds.*
1850	16	*Yew Trees in Kingley Bottom, a part of the South Downs, near Chichester - the Tumuli on Bow Hill in the background, 8gns.*
1850	18	*View of Derwent Water, from Castle Hill, Cumberland - Evening, 5 Pounds.*
1850	37	*Study from Nature, in Bagley Wood, near Oxford, Sold.*
1850	40	*Bercaldine Castle, near Loch Creran, Argyllshire, 5 Pounds.*
1850	50	*Scene near the junction of the rivers Isis and Cherwell - Evening, 8gns.*
1850	54	*Grouse Shooting - scene on the Moor, near Dalmally, Argyllshire - Kilchurn Castle in the middle distance, 15 Pounds.*
1850	80	*View from Afton Down, Isle of Wight, looking towards the Freshwater Cliffs - Sunset, 8gns.*
1850	156	*Castle Treryn, near the Land's End, Cornwall, 5 Pounds.*
1850	188	*View from Edge Hill, Warwickshire - the Village of Tysoe in the middle distance, beyond which is seen the Hill near Brailes; to the right of it, and more distant, the high ground about Northwick, Campden, Broadway, and Ilmington; and in the extreme distance the north end of the Malvern Hill - Evening, 25 Pounds.*
1850	197	*The Cuchullin Hills, Isle of Skye, 5 Pounds.*
1851	13	*Scene on the River Cherwell, near Woodstock, Oxfordshire, where the White Water Lilies grow in abundance, "Conscious of the earliest beam . . ." Mrs C Smith.*
1851	72	*Drovers resting, after ascending from Cluany, towards Tomandoun and Glen Garry, Inverness-shire - Mam Soul in the distance.*
1851	77	*View from an eminence near the outlet of Loch Fannich, Ross-shire - looking over the Dirie Moor, towards Sutherlandshire - Deerstalkers surveying the Corries of Cairn-na-Beast, and Ben Eigen, &c.*
1851	82	*Looking towards the Caernarvonshire Mountains from the Barmouth Sands - Children collecting Shells, &c. - Sunset.*
1851	88	*View near Tysoe Windmill, Warwickshire, looking over the Village of Tysoe towards Edge Hill, and the Field of Battle - Showery Day.*
1851	117	*The Lower portion of Thirlmere, Cumberland - Evening.*
1851	157	*Brinkburn Priory, on the River Coquet, Northumberland.*
1851	179	*View looking over Cowley Marsh from Bullingdon-green, near Oxford.*
1851	188	*Loch Lomond, from near Balloch - Morning.*
1852	2	*Warkworth, Northumberland - Evening, 5.*
1852	3	*Keswick Lake - Moonlight, 5.*
1852	16	*Alnwick Castle, Northumberland, 5 Pounds, Lady Caroline Graham, 2 Portugal Street, Grosv. St.*
1852	27	*A Heathy Scene near Sligachan, Isle of Skye, the Mountains Blaven, Marscodh, Scuir-nan-Stree, and the Cuchullin Hills in the distance - Drovers proceeding South, 15, W.C. Turner, Bicester, nr. Oxford, AU. 10£ Com.*
1852	32	*View from the Gravel Pits in Bagley Wood, near Oxford - Autumn, 15.*
1852	36	*John Cameron, the Highland Shepherd, in his native Country, before he went as an Emigrant to Australia, 8G, N.P. Simes Esq., Brighton (2 Eaton Place).*
1852	44	*The Land's End, and the Longships Lighthouse, Cornwall, 5.*
1852	45	*View from Halnacker Down, near Chichester - looking over Goodwood towards the Isle of Wight - Sunset, 5, Capt. Peel, 4 Whitehall Gardens.*
1852	84	*Glen Dhu, between Jeantown, and Applecross, Ross-shire, North Britain - Evening, after a rainy day, 8G.*
1852	117	*The Village of Grange, at the entrance to Borrowdale, Cumberland, 6G, Dr. Heaton, Leeds, to be delivered to Mr. Strange, 60 Cambridge Terrace, Hyde Park.*
1852	179	*View from the descent of the old London Road, over Shotover Hill, looking towards Oxford - Sunset, 8G.*
1852	197	*View from the side of Bow Hill, on the South Downs, near Chichester, looking over the Groves of Yew Trees, and Stoke Park, toward the Sea, 20.*
1852	208	*The Middle Reach of Ullswater, from Gowbarrow Park, Helvellyn in the distance - Evening, Sold.*
1853	16	*On the Cornish Coast - the Longship Lighthouse in the distance.*
1853	24	*Scene near Maentwrog, Merionethshire.*
1853	31	*A Fishing Village at Courthill on Loch Kishorn, Ross-shire, North Britain - part of the Isle of Skye in the extreme distance, and the Pass of Beallachnaba, leading to Applecross, on the right - Emigrants assembling to go off to the Steamer, July, 1838.*
1853	34	*View from Brill Hill, Bucks - looking over Wooton Park, towards Oving.*

| 1853 | 107 | *Ben na Cailich, Blaven, Glamich, the Cuchullin, and other Hills in the Isle of Skye, the flat Island Pabba, and part of Scalpa, as seen from the Sea.* |

1853 107 *Ben na Cailich, Blaven, Glamich, the Cuchullin, and other Hills in the Isle of Skye, the flat Island Pabba, and part of Scalpa, as seen from the Sea.*

1853 141 *Arundel Castle, Sussex.*

1853 144 *Spring Study from Nature, at Ferry Hinksey, near Oxford.*

1853 158 *Wast Water, Cumberland.*

1853 162 *View from Mount Edgecumbe, looking towards the Plymouth Breakwater - as it appeared in the year 1836.*

1853 197 *The Dawn - View from near the summit of Cader Idris, looking over Llyn-y-Cae.*

1853 199 *Loch Carron, from near Jeantown, Ross-shire, North Britain.*

1853 203 *Windsor Castle, a few minutes before Sunrise.*

1854 1 *Loat a Corry and Art o'Corry, near the highest Peaks of the Cuchullin Hills, Isle of Skye - Evening, £25.0.0, Mrs. Cooper, Wetherell Place, Hampstead.*

1854 2 *The Pharos and Keep of Dover Castle, as it appeared in time of Peace, 5gns.*

1854 37 *A View near the Keeper's Lodge in Unwell Wood, Berkshire - looking over Moulsford Down and across the Valley of the Thames, towards Nettlebed, Oxfordshire, 8gns.*

1854 41 *A Scene near Grudie, Ross-shire, N. B. - Scuir Vullin in the distance, 5gns.*

1854 59 *The Middle Reach of Ulleswater, Cumberland - Helvellyn in the distance - Evening, 5gns.*

1854 74 *Cottages at Sunningwell, Berks - Painted on the spot, 5gns.*

1854 78 *Haymaking - a Study from Nature, in Osney Meadow, near Oxford, looking towards Iffley, 5gns.*

1854 93 *Folding Sheep - Scene near Garsington, Oxfordshire, Sold.*

1854 174 *Autumn - A view looking over Newell Plain, in Wychwood Forest, Oxfordshire - a spot well known in that part of the country to the frequenters of the Forest Fair, £15.0.0.*

1854 225 *A Scene near Shipton-on-Cherwell, Oxfordshire, where the White Water Lilies grow abundantly, £20.0.0.*

1854 236 *Harvest - Scene near Warborough, Oxfordshire, 6gns., T. Griffith Esq., Norwood.*

1855 8 *Drovers traversing Rimside Moor, near Rothbury, Northumberland - Simonside and other Hills in the distance, 15gns.*

1855 24 *A distant View of Oxford, from near Bagley Wood, 6gns.*

1855 25 *Flocks and Herds fording the Streams at Kinloch Ewe, near the Head of Loch Maree, Ross-shire, North Britain - the White Quartz Rock Peaks of Ben Eye, and the Mountains near Loch Clair in the distance, 20gns., R. Tile(?) Esq., Clapham.*

1855 37 *The Hedge-bank, Traveller's Joy, Brambles &c. - A Study from Nature, Sold.*

1855 62 *Loch Coiruisg, Isle of Skye, "The evening mists, with ceaseless change . . ." Sold.*

1855 112 *Christ Church Cathedral, from Merton Meadow, Oxford - Evening, 5gns.*

1855 124 *View near Little Malvern, Worcestershire, looking towards Bredon HIll - Edge Hill in the extreme distance , 8gns., Henry Ball, Lathbury, Newport Pagnell.*

1855 213 *A Scene on Brill Hill, Bucks, 5gns.*

TURNER WILLIAM

1850 231 *Glencoe, Argyllshire, 5 Pounds.*

TYTLER G

1819 350 *Interior of King's College Chapel, Cambridge.*

UNDERWOOD –

1823L 108 *In the High Street, Oxford, Rev. Dr. Burney.*

UWINS T

1809 67 *A frame, containing three subjects, The philosopher Square discovered by Tom Jones in Molly Seagrim's garret – From Tom Jones. The interview between Parson Adams and Parson Trulliver – From Joseph Andrews. The man in despair – From Pilgrim's Progress.*

1809 241 *Rape of the Lock - Canto I, "What guards the purity of melting maids Safe from the treacherous friend . . ." 13gns.(?), Mr. Roby.*

1809 263 *Cottage door.*

1809 292 *Gleaners resting on their way home.*

1810 12 *The little Nurse.*

1810 35 *The little Housewife.*

1810 55 *A Cottage Door in Buckinghamshire, "Yon cottager, who weaves at her own door, Pillow and bobbins all her little store . . ." Vide Cowper's Poems. S. Dimsdale Esq.(?).*

1810 84 *A little Gypsey.*

1810 318 *A Lace Maker's School at Quainton, Bucks.*

1811 7 *Returning from School.*

1811 31 *Hertfordshire Children going to the Plat School.*

1811 32 *A Gleaner resting on her Way Home.*

1811 135 *King Henry VIII and Anna Boleyn, "Sweatheart, I were unmannerly, to take you out, and not to kiss you . . ." King Henry VIII, Act I, Scene 4.*

1811 136 *King Lear, Glo'ster and Edgar, "Glo'ster. 'The trick of that voice I do well, remember . . .'" King Lear, Act 4, Scene 6.*

1811 231 *Imogen in the Cave, "I thought he slept, and put my clouted Brogues from off my Feet, whose Rudeness answered my Steps too loud." Cymbeline, Act IV. Scene 2*

1811 264 *A Girl on a Stile.*

1811 309 *Falstaff and Bardolph, "Bard. 'Why you are so fat, Sir John, that you must needs be . . .'" First Part of King Henry IV. Act III. Scene 3.*

1811	314	*Gleaner leaving the Field.*
1811	319	*The Murder of Clarence, "2d Murd - 'What! shall we stab him as he sleeps? . . .'" King Richard, Act I. Scene 4.*
1811	325	*Titania and Fairies, "But she, perforce, withholds the loved Boy, Crowns him with Flowers, and makes him all her Joy." Midsummer Night's Dream, Act II. Scene 1.*
1811	328	*An old Furze Cutter.*
1811	332	*Interior of a Plat School at Aldbury, Herts.*
1811	340	*Firdinand and Miranda, " – How Features are abroad I am skilless of . . ." Tempest, Act 1, Scene 1.*
1811	360	*Macbeth returning from the Murder of Duncan, "Macbeth - 'One cried God bless us, and Ament he other . . .'" Macbeth, Act 2, Scene 2.*
1812	17	*One of the Windows of Weverly Abbey, Surrey.*
1812	53	*A Walk through a Hop Garden, Farnham, Surrey.*
1812	57	*Yorick and the Grisette, "There are worse Occupations in this World than feeling a Woman's Pulse."*
1812	62	*Haymakers at Dinner,* 35gns., Genl. Ramsey.
1812	99	*The Nun, from Pope, "To sounds of heavenly Harps she dies away, And melts in Visions of eternal Day."*
1812	152	*A Frame containing four Designs - The Cottage Girl, from Goldsmith; the pretended Philosopher, from Marmontel; an Anacreontic Scene; and, the Old Batchelor.*
1812	154	*Sketch in Betchworth Park, Surrey.*
1812	155	*Millhill, Brockham, Surrey.*
1812	216	*Sketch of a Platting School in Hertfordshire.*
1812	256	*Hop-Picker, preparing to leave the Garden.*
1812	279	*Sleeping Infant.*
1812	284	*Children gathering Raspberries.*
1812	291	*Higgler's Boy, going to Market.*
1812	313	*The Entrance to the Choir, and West Entrance of Westminster Abbey, for the History of Westminster Abbey and its Monuments.*
1812	316	*Girl going to the Hop-Garden.*
1813	120	*The Poor's Box, Westminster Abbey, in the back-ground is the entrance to Henry VII. Chapel, with the Prebends and Choristers going to divine service.*
1813	137	*Girl in a Wood,* £7.7.0, Lady Lucas.
1813	176	*Girl decorating her head with Hops,* £5.5.0, J. Allnutt Esq.
1813	184	*Girl reading a Ballad,* £5.5.0, Mr. Dimsdale.
1814	112	*Magdalen Walk, Oxford, the Scene in which Addison composed his Spectators.*
1814	176	*The Theatre, Oxford, at the Annual Commemoration with the Ceremony of conferring the Degree of Doctor in Civil Law . . . ,* £52.10.0, F. Webb Esq.
1814	178	*West Window of New College Chapel, Oxford.*
1814	245	*Hop-pickers.*
1814	265	*Portrait of a Young Lady as a Cottage Girl with Field Flowers.*
1814	280	*Hop Pickers, a Sketch,* £5.5.0, Lady Lucas.
1814	287	*Girl making Lace, a Sketch.*
1815	323	*Hop-picking on the Farnham Plantations.*
1816	7	*Gleaner Boy.*
1816	33	*Girl with a Child.*
1816	37	*Frame, containing a Design from Paul and Virginia: Peregrine's reconciliation with Emilia, and Trunnion's Courtship, from Peregrine Pickle; and Bolton surprised by Miss Sindall, from Mackenzie's Man of the World.*
1816	40	*Gleaner.*
1816	43	*Frame, containing The Scholar's first acquaintance with Asmodeus, from Le Diable Boiteux; the Lady of the Lake, and the Vision of St. Percivale, from the Romance of King Arthur; and Nourjahad, after awaking from his Trance, . . . from Mrs. Sheridan's Nourjahad.*
1816	44	*Sketch of Westmorland Wife,* £2.2.0, J. Nash Esq.
1816	51	*Sketch of a Swiller's Cottage, at Loughrigg, Westmorland.*
1816	89	*Girl with Sticks.*
1816	93	*Christ Church Walk, Oxford, a Sketch,* £3.3.0, Mr. Gosden.
1816	95	*Girl Shelling Peas.*
1816	285	*Gleaner's Child.*
1816	290	*Hop-picker.*
1817	8	*Cottage Girl.*
1817	9	*Sketch from Nature.*
1817	142	*Portrait of a Young Lady.*
1817	143	*Portrait of the Bishop of Chichester.*
1817	231	*Nobody coming to marry me.*
1817	256	*A Girl Platting Straw.*
1817	263	*Girl with a Kitten.*
1817	281	*Mother Ludlam's Cave, or the Maiden's Wish, There is a cavern not far from the ruins of Weverly Abbey, which is said to communicate with Farnham Castle by a subterraneous passage of nearly two miles in length. Of this place many wonderful stories are told by the neighbouring villagers . . .*
1817	294	*Thelismar relating to his Daughter Dalinda the Story of Ines (Tales of the Castle).*
1817	295	*"Though I walk through the Valley of the Shadow of Death, I will fear no Evil." (Psalm xxiii. 4).*
1817	296	*"Death loves a shining Mark." (Young's Night Thoughts).*
1817	297	*The Funeral of Atala (Chateaubriand's Atala).*

1817	299	*Solitude.*
1817	300	*The Yellow Dwarf proposing himself as a husband for the Princess Allfair. (Fairy Tales of the Countess D'Anois).*
1817	301	*Charles the XIIth, making his last desperate Attack on the Turks at Bender. (Voltaire's Charles).*
1817	302	*Olympia at the Tomb of Euphrasia. (Tales of the Castle).*
1818	158	*Portrait of Mr. B. Rolls.*
1818	163	*Sketch of the Annual General Meeting of the British and Foreign Bible Society at Freemasons' Hall, May 1817.*
1818	172	*Portrait of Miss Galley.*
1818	189	*Portrait of the Rev. W. Harris, resident Tutor of Hoxton Academy.*
1818	205	*Portrait of Mademoiselle Josephine Meyer, of La Rochelle.*
1818	206	*Portrait of the Artist's Mother.*
1818	296	*Three Designs - Dakianos destroyed by a Serpent in the presence of his People, and on the Throne which he had erected for the purpose of personating the Deity. (Tale of the Seven Sleepers) - Allahua conveyed by the luminous Arm to the Pavilion of the Moon. (Peruvian Tales) - The Enchanter Amerdin making love to the Fairy of Pleasures. (Fairy Tales by the Countess D'Anois.)*
1818	300	*Grape Gleaner. Peasant of St. Julien in Medoc, After the Vintage is over, the Country People are allowed to go into the Vineyards, from which they sometimes bring away very abundant Gleanings.*
1818	353	*Puck. From the Original, by Sir Joshua Reynolds in the possession of S. Rogers, Esq.*
1818	362	*Three Designs - Nekayah and Pekuah watching the approach of Dinarbas, (Continuation of Rasselas) - Constantia with the Letter of Theodosius, (Theodosius and Constantia) - Ulysses, receiving with cautious suspicion the Orders of Calypso to leave the Island.*
1818	363	*Peasant of St. Julien in Médoc, eight leagues from Bordeaux , The Vineyards of Médoc are those which produce the fine Claret, known to the Amateur by the names of the different Plantations, Chateau Margot, Lafite, La Rose, La Tour, La Grange, &c. &c.*
1823L	67	*Peasant of St. Julien, in Medoc, Bordeaux,* J. Vine, esq.
1823L	73	*Girl decorating her head with Hops,* J. Allnutt, esq.
1823L	100	*A Plat School,* J. Allnutt, esq.
1823L	133	*Girl on a Style,* Sir J. Swinburne, Bart.
1823L	178	*The Commemoration at Oxford in the year 1813,* – Webb, esq.

VAN WORRELL A B

1820	55	*Cattle in a Landscape.*

1820	121	*Landscape and Figures.*
1820	127	*A View in Switzerland, with Cattle and Figures.*

VARLEY C

1805	4	*Ross Market Place, Herefordshire: a sketch on the spot.*
1805	60	*Cottages at Conway, North Wales.*
1805	66	*A wood scene in Wales.*
1805	75	*Wood scenery, North Wales.*
1805	109	*Cottage at Stanstead, Essex.*
1805	119	*View at Wimbledon.*
1805	170	*S. E. View of St. Alban's, a sketch on the spot.*
1805	183	*Cottage at Hatfield, Herts.*
1805	185	*View near St. Albans.*
1805	206	*Entrance to a wood.*
1805	214	*A wood scene.*
1805	225	*A landscape.*
1806	33	*Llanllyfni, Carnarvonshire.*
1806	50	*Solitude, "Nor undelightful is the ceaseless hum, to him who muses through the woods at noon."*
1806	57	*Sawyers clearing timber from its knots.*
1806	92	*Timber Waggon coming loaded from the Wood.*
1806	219	*A Composition.*
1806	220	*Sopwell, Ruins near St. Alban's.*
1806	225	*North Transept of Westminster Abbey.*
1807	58	*Cattle fording a brook.*
1807	119	*Evening, an effect from Nature.*
1807	177	*Monnow Bridge, Monmouth.*
1807	182	*Evening "– The curfew tolls the knell of parting day."*
1807	191	*Cattle - afternoon.*
1807	289	*Windsor and Eton, from Chalvey, an effect from nature.*
1808	91	*Returning from market.*
1808	97	*Forenoon - trees from nature.*
1808	173	*View of Cader Idris on the approach from Machynlleth.*
1808	185	*A sea piece - evening.*
1808	300	*Cottage on the road to St. Alban's.*
1809	240	*Scene on the Thames towards evening.*
1809	300	*Mountain pastoral.*
1810	88	*Irish Cow Boy and Shed, near Market Hill, County of Armagh.*
1810	149	*The Sleeping Shepherd, "Amid his subjects safe, Slumbers the monarch swain . . ." Vide Thomson's Summer.*
1810	314	*Landscape and Cattle.*
1811	150	*Evening.*
1811	183	*Palemon and Lavinia.*
1811	242	*View in Shrewsbury.*

1812	141	Wood Scenery, with Cattle.
1812	176	On the Road from Bala to Dolgelly, Cader Idris in the Distance, North Wales.
1813	186	Water Mill, North Wales (in Black Lead Pencil).
1813	228	Hoops, Yawls, and Herring Boats ashore, at Lowestoffe, Suffolk - Forenoon.
1813	237	An old Gothic Door; Girl Sewing.
1814	34	Cabin at Market Hill, Armagh, Ireland.
1814	214	Welch Cottages.
1814	242	Child reading at a House Door, Market-hill, Armagh, Ireland.
1814	251	Water-Mill, North Wales.
1814	278	Children at a Cottage Door.
1815	207	View in Ardfort, with the Ruins of its Abbey, and the Church adjoining, near Tralee, Kerry, Ireland.
1815	223	Cottage Door.
1816	50	Evening, "Beside some water's rushy brink . . ." Vide Gray.
1816	70	Welsh Houses, Cloudy Day.
1816	195	Sloops ashore, Coast of Suffolk.
1817	104	Tintern Abbey, Monmouthshire, "As the stern grandeur of a Gothic tower . . ." Pleasures of Memory.
1818	135	Ellen and Fitz-James, "A stranger I, the huntsman said . . ." Lady of the Lake.
1819	50	Hay Stacking - Preparing for Dinner.
1819	113	Ruins of Troy, "Still let the curst, detested place, Where Priam lies . . ." Horace.
1819	119	Lavinia, "She with her widow'd mother, feeble, old . . ." Thomson's Seasons.
1820	41	The Vale of Tempe, "High in the vale a spacious temple stood . . ." 30gns., Premium.
1820	83	Morning, after a Cloudy Night, "And while yon little bark glides down the bay . . ." Vide Lady of the Lake.

VARLEY J

1805	5	View of Harlech Castle and Teguin ferry, North Wales.
1805	9	View near Bodenham, Herefordshire.
1805	19	View of Carnarvon walls, North Wales.
1805	22	View of Moel Hedog, North Wales.
1805	29	View near Pont Aber Glass Lynn, N. Wales.
1805	37	View of Bedd Gellert bridge, North Wales.
1805	40	Pont Aber Glass Lynn, North Wales.
1805	57	View of Harlech Castle, North Wales.
1805	62	Denbigh Castle, North Wales.
1805	70	Part of Ouse bridge, York.
1805	83	One of the arches of Ouse bridge, York.
1805	84	Harlech castle, and Snowdon, North Wales.
1805	88	Distant view of Bolton abbey, Yorkshire.
1805	94	Ouse bridge, York.
1805	96	Knaresborough castle, Yorkshire.
1805	97	Handborough porch, Oxford.
1805	106	St. Peter's Well, in York Minster.
1805	110	Cottage at Carnarvon, North Wales.
1805	111	Snowdon, from Moel Hedog, North Wales.
1805	132	St. Winifred's Well, North Wales.
1805	133	A study from nature.
1805	136	Cottage at Conway, North Wales.
1805	138	Llanberris lake, North Wales.
1805	147	Bolton Abbey, Yorkshire.
1805	156	Fortress of Gavi in Italy, from a sketch by E.Lomax, Esq.
1805	168	Llanberris lake, with Dolbadern Castle.
1805	187	View at Nasing, Essex.
1805	188	Conway Castle, from the Llanrwst road.
1805	189	View near Conway.
1805	190	Composition.
1805	198	View of Llynn Ogwen, North Wales.
1805	199	Llangollen bridge.
1805	200	View near Bedd Gellert, North Wales.
1805	201	Harlech Castle.
1805	204	Conway Castle, North Wales.
1805	207	View near Carnarvon, North Wales.
1805	212	Conway Castle, with the broken tower.
1805	215	View near Pont Aber Glaslyn, North Wales.
1805	223	Village and Abbey of Rivaux. (For C. Fothergill's Natural and Civil History of Yorkshire.).
1805	249	View opposite the castle, York.
1805	257	View in Knaresborough, Yorkshire.
1805	275	View of the Mumbles, near Swansea, from a sketch by J. Wathen, Esq.
1806	7	St. Alban's Abbey.
1806	9	Composition.
1806	16	A distant Shower.
1806	25	View near the Locks at Windsor.
1806	27	Part of Snowden, from Bedd Gelert.
1806	38	The Shepherd's Boy.
1806	39	Composition.
1806	41	Bolton Abbey, Yorkshire.
1806	47	New Weir, near Monmouth.
1806	69	View from Eton Play Grounds.
1806	79	Composition.
1806	82	View near Windsor.
1806	93	Composition.
1806	95	Part of Cader Idris, from near Barmouth, N. Wales.

1806	99	*Evening, Composition.*
1806	118	*A View of Harlech Castle, from Tegwin Ferry, N. Wales.*
1806	126	*View of Windsor, from near Clewer.*
1806	139	*Composition.*
1806	145	*Composition.*
1806	159	*Morning, a composition.*
1806	161	*View in Llanberris Pass, N. Wales.*
1806	165	*Composition.*
1806	170	*Harlech Castle, N. Wales.*
1806	173	*Christ Church, Oxford.*
1806	189	*Snowden, from near Bangor.*
1806	196	*A Composition.*
1806	221	*Evening, a Composition.*
1806	223	*Llyn Dinas, with Moel Hedog.*
1806	224	*The Salmon Leap at Pont Aber-glass-llyn.*
1806	227	*Evening, a composition.*
1806	228	*Evening, a composition.*
1806	229	*Evening, a composition.*
1806	230	*A composition.*
1806	231	*A composition.*
1806	232	*Evening, a composition.*
1806	235	*View of the Castle at Chester.*
1806	236	*View on the Thames.*
1806	237	*Composition.*
1806	239	*Composition.*
1806	240	*Composition.*
1806	241	*Composition.*
1806	276	*Boat house at Reading, Berks.*
1806	286	*Cottage at Brighton.*
1807	3	*Llyn Ogwin, N. Wales.*
1807	6	*A mill.*
1807	27	*View near Windsor, a sketch.*
1807	28	*A corn field.*
1807	40	*Evening, a sketch.*
1807	41	*Evening.*
1807	45	*The Devil's Bridge, and Hafod Arms, S. Wales.*
1807	59	*A river scene, a sketch.*
1807	61	*View of Conway Castle, from the Llanrwst road, North Wales.*
1807	87	*A landscape.*
1807	98	*A sketch for a composition.*
1807	100	*Evening.*
1807	106	*Morning, a composition.*
1807	114	*Sketch of a cottage.*
1807	124	*Part of Kirkstall Abbey, Yorkshire.*
1807	132	*A landscape.*
1807	133	*A composition.*
1807	148	*Llanberris lake.*
1807	149	*Scene near Brighton.*
1807	150	*Sketch of the Ouse Bridge, York.*
1807	156	*A landscape.*
1807	202	*Barmouth, N. Wales, a sketch.*
1807	211	*A landscape, Lord Ussulston(?).*
1807	215	*View of Goodrich Castle, Herefordshire.*
1807	229	*Scene on the Thames.*
1807	240	*Cottage near Bayswater.*
1807	246	*A door way at York.*
1807	251	*Evening, view of Eton College from Windsor, a sketch.*
1807	272	*A fisherman's house.*
1807	278	*View of Cader Iris, from Llanelltid.*
1807	280	*Scene near Beddgelert, N. Wales.*
1807	303	*A view of Eton College.*
1807	317	*Handborough, Oxfordshire.*
1807	323	*View near Bedd Gelest, North Wales.*
1808	2	*Snowdon, from near Harlech.*
1808	4	*Old building, a composition.*
1808	10	*Porch of a cottage, Bolton.*
1808	11	*Flint Castle.*
1808	12	*Cottage in Windsor Forest.*
1808	16	*Llyn Dinas.*
1808	17	*Barmouth.*
1808	18	*Ferry house, Teddington.*
1808	23	*Interior of part of the paper mill, Ensham, Oxon.*
1808	27	*Buildings in York, near Middlegate.*
1808	29	*View of Windsor Castle.*
1808	31	*Evening.*
1808	35	*Conway.*
1808	39	*View at Windsor.*
1808	40	*Harlech Castle.*
1808	44	*Scene in a mountainous country.*
1808	51	*Morning, a sketch.*
1808	81	*From a ruined window in Bolton Abbey.*
1808	85	*View on the Thames, near Kingston.*
1808	103	*Cottage at Watford.*
1808	105	*A sketch.*
1808	108	*Old buildings at Watford.*
1808	122	*Evening, a composition.*
1808	123	*A mountain scene.*
1808	135	*Composition.*
1808	147	*River scene.*
1808	150	*A sketch.*
1808	156	*A composition.*
1808	159	*Evening.*

1808	163	*Suburbs of an ancient city, 40gns., Thos. Hope Esq.(?).*
1808	168	*Twilight.*
1808	170	*View of St. Margaret's Porch, York.*
1808	172	*Fishing boats at Brighton.*
1808	175	*Cottage at Watford.*
1808	179	*Door-way at Dolgelly.*
1808	187	*Landscape.*
1808	189	*Stanton Harcourt.*
1808	197	*Morning, a sketch.*
1808	203	*Clewer church, near Windsor.*
1808	208	*Composition, from tile kilns, Brighton.*
1808	209	*Fisherman's cottage.*
1808	246	*A lane scene near Richmond.*
1808	251	*Gleaners returning home.*
1808	257	*Gateway at Vallis Cruce's Abbey.*
1808	260	*Evening.*
1808	280	*View at Watford.*
1808	299	*Snowdon, from Beddgelert.*
1808	306	*Evening.*
1808	307	*View of Lambeth.*
1808	315	*Brecknock Bridge.*
1808	324	*Conway Castle.*
1808	329	*River scene.*
1809	8	*Ferry-house, York.*
1809	16	*Ouse Bridge, York.*
1809	30	*View from Warksworth Castle.*
1809	32	*A river scene.*
1809	35	*A landscape.*
1809	36	*A river scene.*
1809	39	*View of Cader Idris, near Towyn.*
1809	41	*A thunder storm.*
1809	48	*Conway Castle, N. Wales.*
1809	49	*Evening.*
1809	57	*A tower at Dunstanborough, Northumberland.*
1809	58	*Conway Castle.*
1809	64	*Evening.*
1809	70	*Snowdon Capel Carig, N. Wales.*
1809	73	*Windsor Castle.*
1809	74	*Windsor.*
1809	84	*A river scene.*
1809	85	*A sea port.*
1809	90	*Dunstanborough Castle.*
1809	92	*Llanberris lake, with Dolbadern Tower.*
1809	97	*Landscape.*
1809	105	*Evening.*
1809	106	*Cader Idris.*
1809	114	*View from Llaneltid, near Dolgelly.*
1809	121	*York, from the Castle.*
1809	122	*View of Eton.*
1809	132	*Bamborough Castle, from Holy Island.*
1809	141	*A cottage.*
1809	142	*Chillingham church, Northumberland.*
1809	151	*Flint Castle.*
1809	153	*An evening scene.*
1809	158	*Snowdon, near Teguin ferry, N. Wales.*
1809	177	*Landscape.*
1809	182	*Part of Byland Abbey, Yorkshire.*
1809	199	*Barmouth, N. Wales.*
1809	200	*Warksworth Castle, Northumberland.*
1809	215	*A cottage.*
1809	216	*River scene.*
1809	219	*Snowdon, from near Harlech.*
1809	230	*Landscape.*
1809	248	*Snowdon, from near Bedgelert.*
1809	249	*Evening.*
1809	251	*Castle in Holy Island.*
1809	252	*Windsor.*
1809	262	*A river scene.*
1809	264	*Bamborough Castle.*
1809	280	*A castle on Holy Island, Northumberland.*
1809	295	*A cottage, near Windsor.*
1809	296	*A cottage at Watford.*
1809	297	*A cottage.*
1809	298	*Bamborough Castle, a sketch.*
1809	302	*Evening.*
1809	303	*A castle on Holy Island.*
1809	311	*Bamborough Castle.*
1809	313	*Byland Abbey, Yorkshire.*
1809	323	*Lindisfarne Abbey, Holy Island.*
1809	331	*Bala Lake.*
1809	335	*A scene on the Thames.*
1809	340	*A cottage scene.*
1809	341	*A composition.*
1810	4	*Brecknock Castle, South Wales.*
1810	6	*Ouse Bridge, York, a Sketch.*
1810	9	*Dunstanborough Castle.*
1810	14	*Part of Snowdon, near Bedgelert.*
1810	16	*Keswick Lake, looking towards Lowdore.*
1810	28	*Bedgelert Bridge, North Wales.*
1810	30	*View on the Thames.*
1810	32	*Caernarvon Castle, North Wales.*
1810	34	*Barmouth, North Wales.*
1810	36	*Harlech Castle, North Wales.*

1810	40	*A River Scene.*
1810	43	*View at Bedgellert, North Wales.*
1810	64	*View near Bedgellert, North Wales.*
1810	66	*Gateway at Helmsley Castle.*
1810	71	*A River Scene.*
1810	76	*View of Eton College.*
1810	92	*A Landscape.*
1810	94	*Evening.*
1810	99	*Cader Idris, North Wales.*
1810	102	*Cottages at Watford.*
1810	113	*Evening.*
1810	118	*Snowdon, from Capel Carig, North Wales.*
1810	119	*Cottage at Watford.*
1810	123	*A Country Scene.*
1810	127	*Holy Island and Lindisforme Abbey.*
1810	137	*A Composition.*
1810	152	*Composition.*
1810	158	*A River Scene, Evening.*
1810	177	*Scene in a Mountainous Country.*
1810	179	*View of Chester.*
1810	200	*An Oratory at Shrewsbury.*
1810	221	*Llanberris Lake, North Wales.*
1810	222	*Scene on a Common.*
1810	223	*Fisherman's Cottage.*
1810	227	*A River Scene.*
1810	228	*Bamborough Castle, Northumberland.*
1810	230	*Cottage Scene.*
1810	232	*A Landscape.*
1810	244	*Morning, a Composition.*
1810	248	*A Heath Scene.*
1810	250	*A Landscape.*
1810	267	*Harlech, from near Teguin.*
1810	277	*Holy Island.*
1810	284	*View on Millbank.*
1810	288	*Fisherman's Cottage.*
1810	303	*Conway Castle, North Wales.*
1810	325	*Doorway at Bolton, Yorkshire.*
1810	326	*River and Fishing Boat.*
1810	327	*Rhydlan Castle, North Wales.*
1811	21	*Llanberis Lake, North Wales.*
1811	23	*Torr Abbey, Devon, the Seat of G. Cary, Esq.*
1811	37	*A Sketch.*
1811	59	*Chillingham Castle, Northumberland, the Seat of the Right Hon. The Earl of Tankerville.*
1811	91	*York Minster.*
1811	94	*River Scene.*
1811	97	*Chapel, near Killarton.*
1811	149	*View from the Gate of Dunstanborough Castle.*
1811	158	*View near Vallis Crucis Abbey, North Wales.*
1811	168	*An Old House in Yorkshire.*
1811	204	*Fisherman's Cottage.*
1811	224	*Harlech Castle, North Wales.*
1811	234	*View near Llangollen, North Wales.*
1811	245	*Composition.*
1811	252	*Composition.*
1811	256	*Cottage Scene.*
1811	258	*View under Eton Bridge.*
1811	260	*Chiswick.*
1811	261	*Landscape.*
1811	274	*Benton Castle, Somersetshire.*
1811	275	*Harlech Castle.*
1811	282	*Distant View of York.*
1811	310	*Landscape.*
1811	335	*View on the Thames, near Battersea.*
1811	344	*View near Watford, Herts.*
1811	351	*View of Morpeth Town.*
1811	353	*River Scene.*
1812	18	*Cottage at Tunbridge Wells, near the Road to the High Rocks.*
1812	27	*View of Conway, North Wales.*
1812	44	*Eagle's Nest, Killarney.*
1812	76	*Evening.*
1812	77	*Composition.*
1812	91	*Landscape.*
1812	96	*Conway.*
1812	103	*View of Battersea Bridge.*
1812	104	*Composition.*
1812	109	*A River Scene.*
1812	127	*Coimbra, Portugal.*
1812	132	*Cader Idris, North Wales.*
1812	178	*Dolgelly, North Wales.*
1812	180	*Cheney Walk, Chelsea.*
1812	187	*Beddgelert Bridge, North Wales.*
1812	225	*A Ferry Boat with Mules.*
1812	226	*Tork Lake, Ireland.*
1812	227	*An Oak Tree.*
1812	230	*Morning.*
1812	231	*View on the Thames at Chelsea.*
1812	234	*Inverary.*
1812	238	*Kilchern Castle, Scotland.*
1812	239	*Stirling Castle.*
1812	247	*Castle in Holy Island.*
1812	253	*Composition.*
1812	255	*Bala Lake, North Wales.*

1812	257	*A Sketch.*
1812	282	*Cottage from Nature.*
1812	286	*Caernarvon Castle.*
1812	288	*Llanelted Bridge, North Wales.*
1812	289	*Cottage from Nature.*
1812	292	*Byland Abbey, Yorkshire.*
1812	295	*A Cottage at Edmonton.*
1812	297	*Composition.*
1812	301	*Scene on a Common.*
1812	309	*Cader Idris, from Bala.*
1812	310	*Moel Hedog, North Wales.*
1812	312	*River Scene.*
1812	317	*Honister Cragg, Cumberland.*
1812	318	*Kilchern Castle, Scotland.*
1812	321	*Bridgenorth, Shropshire.*
1812	322	*A Cottage.*
1812	324	*Cottage.*
1813	24	*The Lake of Albano.*
1813	26	*Ben Lomond, Scotland.*
1813	30	*Cottage in Caernarvon, North Wales.*
1813	38	*View of a Forge, between Barmouth and Dolgelly.*
1813	39	*View on Millbank, near the Regent's Bridge.*
1813	40	*View of Llanberris Lake, North Wales.*
1813	54	*Dunmally Castle, Oben.*
1813	55	*View of Snowdon, from Capel Careig.*
1813	73	*View of Brusa, and Mount Olympus, in Bithynia, from an Original Sketch, taken on the Spot, in June 1812.*
1813	86	*Beddgelart, North Wales.*
1813	88	*Bamborough Castle, Northumberland.*
1813	102	*Durham Cathedral.*
1813	103	*Shepherd's Boy, a Sketch.*
1813	105	*View of Teguin Ferry, North Wales.*
1813	126	*View of Cader Idris, North Wales.*
1813	129	*View of Cader Idris, from near Towy.*
1813	130	*View of Snowdon, from Moel Heydog.*
1813	149	*Cottage near Edmonton.*
1813	204	*Castle of Dunmally Oben, Scotland.*
1813	227	*A Sketch.*
1813	233	*View of Harlech Castle and Snowdon.*
1813	239	*Caernarvon Castle.*
1814	23	*"Oft on a plat of rising ground . . ."*
1814	32	*Thomson's Grave, from Collins's Elegy, "In yonder grave a Druid lies . . ."*
1814	65	*Burgos, Spain.*
1814	127	*View of Salamanca, in Spain, from a Sketch by Captain Dumaresq, of the 9th Regiment, in the Possession of the Quarter-Master-General.*
1814	139	*The Bridge at Alcantara, in Spain, from a Sketch by Captain Dumaresq, of the 9th Regiment, in the Possession of the Quarter-Master-General.*
1814	140	*Barmouth, North Wales.*
1814	144	*Harlech Castle, North Wales, a Sketch.*
1814	152	*View of the Escurial, in Spain, from a Sketch by Captain Dumaresq, of the 9th Regiment, in the Possession of the Quarter-Master-General.*
1814	157	*Cader Idris.*
1814	159	*Mondego River, in Portugal, from a Sketch by Captain Dumaresq, of the 9th Regiment, in the Possession of the Quarter-Master-General.*
1814	168	*Figueras, in Spain, from a Sketch by Captain Dumaresq, of the 9th Regiment, in the Possession of the Quarter-Master-General.*
1814	175	*Sketch of a Cottage.*
1814	186	*Ross Castle on the Lake of Killarney.*
1814	187	*View of Chester.*
1814	196	*Harlech Castle, North Wales - A Sketch, £31.10.0, Mr. Dimsdale.*
1814	197	*Ciudad Rodrigo, from a Sketch by Captain Dumaresq, of the 9th regiment, in the possession of the Quarter-Master-General.*
1814	270	*Beddkelert Bridge, North Wales.*
1814	290	*View on the Douro, Portugal, from a Sketch by Captain Dumaresq, of the 9th Regiment, in the Possession of the Quarter-Master-General.*
1814	291	*River Scene.*
1814	292	*Bolton Abbey, Yorkshire.*
1814	295	*Madrid, from a Sketch by Captain Dumaresq, of the 9th Regiment, in the Possession of the Quarter-Master-General.*
1814	298	*View on the Mondego River, from a Sketch by Captain Dumaresq, of the 9th Regiment, in the Possession of the Quarter-Master-General.*
1814	299	*A Cottage.*
1814	300	*Moel Heydog, North Wales.*
1815	63	*Barmouth, North Wales.*
1815	69	*Tintern Abbey, Monmouthshire.*
1815	70	*Snowdon from Capel Cerrig, North Wales.*
1815	71	*Valle Crucis Abbey, near Llangollen, North Wales.*
1815	77	*Calcada, from the causeway, leading from St. Sebastian to Passages in Spain. From a Sketch, by Captain C. Paget, late of the 52d Regiment.*
1815	81	*St. Sebastian, in Spain, from a Sketch, by Captain Dumaresq.*
1815	82	*Lake of Killarney, Ireland.*
1815	96	*View of Rondo, in Spain.*
1815	111	*View of Conway Castle, North Wales.*
1815	126	*Bala Lake, North Wales, Mr. Griffiths.*

1815	133	*Beddgelert Bridge, North Wales.*
1815	225	*Snowden, North Wales, from near Harlech.*
1815	236	*Berry Pomeroy, Devonshire.*
1815	241	*Moel Hedog, North Wales.*
1815	253	*Cader Idris, from Llanelltydd.*
1815	347	*View of Cader Idris, from the Road of Barmouth.*
1816	82	*View of Villa Franca, in Spain, from a Sketch, by J. D. King, Esq.*
1816	166	*View on the Wye, South Wales.*
1816	241	*View of Chiswick, from Barnes.*
1816	245	*A Sketch.*
1816	246	*Ross Castle, Killarney.*
1816	257	*View of Cividad Rodrigo, in Portugal, from a Sketch by Major Dumaresque.*
1816	283	*View of Passages in Spain, from a Sketch by Colonel Halicomb.*
1816	315	*Kilchern Castle, Loch Awe, Scotland.*
1817	1	*View near Lewel at Chudley, Devon.*
1817	190	*Cheyney Row, Chelsea.*
1817	208	*View between Barmouth and Dolgelly, £10.10.0, Lord Suffolk.*
1817	234	*Bamborough Castle, Northumberland.*
1817	276	*A Frame containing four Drawings.*
1817	283	*View on the River Tay, Perthshire, £10.10.0, Lord Suffield.*
1817	298	*A Frame containing four Drawings.*
1818	46	*Westminster Abbey, from Old Ranelagh, painted on the spot.*
1818	195	*River Scene.*
1818	217	*Conway Castle, £8.8.0, J. Holden Esq.*
1818	234	*Cottage, at Watford.*
1818	261	*Holy Island, Northumberland.*
1818	287	*A Thunder Storm - The Towers designed from a Persian Gateway, near to Mount Ararat.*
1818	299	*Gateway at Totness, Devonshire, £6.6.0, Lady de Grey.*
1818	303	*Cader Idris, North Wales.*
1818	305	*Cottages.*
1818	327	*River Scene, £3.3.0, Lady Mary Bennett.*
1818	346	*Conway Castle, North Wales.*
1818	347	*View from Holy Island, looking Northward.*
1818	369	*Snowdon, from near Harlech.*
1819	3	*Eton College, £5.5.0, Mr. Wall.*
1819	93	*The Burial of Saul, "The beauty of Israel is slain upon thy high places: how are the mighty fallen! . . ." Samuel, Book 2d, Chap. 1st.*
1819	138	*Eton College.*
1819	148	*Cader Idris, North Wales.*
1819	188	*Chiswick - on the Thames.*
1819	198	*Turk Lane, Killarney.*
1819	258	*View near Harlech, North Wales.*
1819	316	*View near Marseilles, France.*
1819	330	*River Scene.*
1819	336	*Barnes.*
1820	91	*Eton.*
1820	94	*View of Coniston Lake.*
1820	103	*Windsor.*
1820	113	*View of Battersea Bridge from Millbank.*
1820	217	*Scene near Battersea.*
1820	242	*Evening, "Oft on a plot of rising ground . . ."*
1821	47	*Skipton Castle, Yorkshire.*
1821	54	*Turk Lake, Killarny, Ireland.*
1821	72	*Scene from the Bride of Abydos, "Within the place of thousand tombs . . ." From the Bride of Abydos Canto xxviii. (This Picture was painted in consequence of Mr. VARLEY receiving the last annual Premium, which is given by the Society at the close of each Season, for the purpose of inducing the Artist to undertake a Work of elaborate composition for the ensuing Exhibition.*
1822	17	*Conway Castle, Caernarvonshire.*
1822	59	*Destruction of the City of Tyre, "Now, thou son of man, take up a lamentation for Tyrus." Ezekiel, chap 27, ver.2. [Also Revelation, chap. 18, ver. 5 and 8.]*
1822	146	*Landscape, £3.13.6, Dr. Blake.*
1822	147	*Cottage Scene, £3.13.6, Honble. Mrs. Grey.*
1822	148	*Chingford Church, Essex - Study from Nature.*
1822	150	*Greenwich from the Observatory.*
1822	152	*A Forest Scene, £5.5.0, Do. [G. Hibbert, Esq.]*
1822	153	*Putney on the Thames.*
1822	154	*Brecknock Castle, South Wales.*
1822	155	*Waltham Abbey, Essex.*
1822	156	*Snowdon, £3.13.6, Dr. Blake.*
1822	158	*Battersea Bridge.*
1823	57	*View near Battersea.*
1823	60	*Evening.*
1823	61	*River Scene, £6.6.0, Lord Charles Townshend.*
1823	62	*Conway Castle.*
1823	63	*Cottage Scene.*
1823	64	*Mountains of Mourne, in the County of Downe, Ireland.*
1823	66	*Glenna Cottage, Killarney.*
1823	67	*Turk Lake, Killarney.*
1823	71	*Turk Lake, Killarney.*
1823	72	*London, from Greenwich.*
1823	73	*Sandgate, Kent.*
1823	74	*St. Every - a Sketch.*

1823	78	*Composition.*
1823	79	*Conway Castle - A Study.*
1823	132	*Aqueduct near Langollen.*
1823	137	*Thomson's Tomb, "In yonder grave a Druid lies . . ." Collins.*
1823	149	*Vanburgh House, Greenwich Park - Study from Nature,* £8.8.0, Lady Swinburne.
1823	167	*Thrasimene - where Hannibal defeated the Romans, "Far other scene is Thrasimene now, Her lake a sheet of silver, and her plain Rent by no ravage, save the gentle plough." Lord Byron.*
1823	168	*Harlech Castle, North Wales,* £5.5.0, Miss Harman.
1823	257	*Wilsdon - Twilight.*
1823	258	*A Study,* £3.3.0, Marchioness of Stafford.
1823	273	*Composition.*
1823	275	*A Study.*
1823	280	*Chingford Church, Essex.*
1823	284	*Trimmingham, near Cromer, Norfolk.*
1823	288	*View in Leyton, Essex - Study from Nature.*
1823	295	*Evening - Compositon.*
1823	296	*River Scene.*
1823L	16	*A Thunder Storm,* T. Griffith, esq.
1823L	24	*York,* Sir J. Swinburne, Bart.
1823L	38	*Beth Gellart Bridge,* J. Allnutt, esq.
1823L	62	*Cottages,* T. Griffiths, esq.
1823L	120	*Chillingham Castle, Northumberland,* Sir J. Swinburne, Bart.
1823L	145*	*Composition,* Earl Tankerville.
1823L	150	*View on Millbank,* J. Gwilt, esq.
1823L	159	*View - Cheyney Walk, Chelsea,* J. Gwilt, esq.
1823L	173*	*Bamborough Castle,* Sir J. Swinburne, Bart.
1823L	179	*Composition,* T. Griffith, esq.
1823L	181	*Scene from the Bride of Abydos, "Within the place of thousand tombs . . ." From the Bride of Abydos, Canto xxviii.* The Artist.
1823L	196	*Suburbs of an ancient City,* Thomas Hope, esq.
1823L	202	*Composition,* The Artist.
1824	4	*Tintern Abbey, Monmouthshire.*
1824	11	*Cromer, from the Light House.*
1824	42	*Egripo, in Greece - from a Sketch by J. Rennie, Esq.*
1824	50	*View of Athens looking towards the Morea, from a Sketch by J. Rennie, Esq.*
1824	71	*Tower at Berkhampstead, from a Sketch by Lieutenant Dawson, of the Royal Engineers.*
1824	72	*Constantinople, looking towards the Bosphorus, from a Sketch by J. Rennie, Esq.*
1824	80	*View of Chelsea, from Battersea Meadows.*
1824	81	*View of Essouan, looking up the Nile, from a Sketch by J. Rennie Esq.*
1824	211	*Days of Peace, "How sweet's the product of a peaceful reign . . ." Vide the Odyssey.*
1824	227	*Cromer, Norfolk.*
1824	228	*Holy Island and Bamborough Castle, Northumberland.*
1824	236	*London, from Greenwich Park.*
1824	253	*Glamis Castle, the reputed scene of Duncan's Murder.*
1824	260	*Sandgate, Kent.*
1824	261	*Cottage Scene.*
1824	267	*Bamborough Castle - Northumberland.*
1824	268	*North End - Hampstead.*
1824	273	*Tegwin Ferry, near Harlech - N. Wales.*
1825	70	*Waltham Abbey, Essex - A Study from Nature,* 35gns., C.B. Vale M.P.
1825	72	*Landscape,* 6gns.
1825	82	*View of Durham,* 3gns., J. Theobald, 42 Carmarthen Street.
1825	90	*Byland Abbey, Yorkshire,* 4gns.
1825	99	*View of Ephesus in Asia Minor, from a Sketch by J. Rennie Esq.,* Sold.
1825	118	*Bafee, in Asia Minor - from a Sketch by J. Rennie Esq.*
1825	121	*Belgrave House - Milbank,* Sold.
1825	129	*Gypsey Scene, near Hounslow,* $2^1/_2$ gns., Mr. John Theobald, 42 Carmarthen St.
1825	135	*General Hart's Castle - County of Donnegal,* 4gns., Sir Charles Forbes Bart., Surrey Square.
1825	141	*View in Switzerland - from a Sketch of J. Rennie, Esq.,* 3gns., Lord C. Townshend.
1825	146	*The Bears destroying the Children who mocked Elisha, "And there came forth two she bears out of the wood, and tare forty and two of them." 2d Book of Kings, Chap. ii. Verses 23, 24.* 70gns.
1825	170	*Hove Church, near Brighton,* 8gns., Lord Northwick.
1825	179	*Study from Nature, near Paddington,* 7gns.
1825	187	*View of Bangor, from a Sketch by R. Dawson, esq.*
1825	209	*Eagle's Nest - Killarney.*
1825	217	*View of Chelsea, from the Banks of the Thames,* 7gns., Lord C. Townshend.
1825	218	*View of Harrow, from near Hampstead,* £5.5.0.
1825	225	*View of Pisa, from a Sketch by J Rennie Esq.*
1825	235	*Argos, from Mycene.*
1825	251	*Tangier, from the Moorish Burying Ground, with Gibraltar in the extreme Distance - from a Sketch by Lieut. Larcomb, Royal Engineers.*
1825	267	*View on the River Conway,* 6gns., Smith Esq.
1825	293	*Tetuan, Africa.*

VARLEY J

1826	12	*Bamborough Castle, Northumberland, "Thy tower, proud Bamborough; marked they here, King Ida's castle . . ." Marmion, Canto II, St. 8.* 35gns.
1826	16	*View of Harlech, Merionethshire,* 25gns., Lord Northwick.
1826	30	*Cottage Scene,* Sold.
1826	49	*Eagle's Nest, Lake of Killarney,* Sold.
1826	52	*Gap of Dunhoe, Ireland - from a Sketch by Genl. S. Brown,* Sold.
1826	54	*Nice,* 5gns., Sold.
1826	56	*Landscape, with Cottage,* 4gns., H. Harrison Esq., 41 Bedford St., Covent Garden.
1826	65	*Ouse Bridge, York,* 4gns.
1826	74	*View near Chiswick,* 5gns., Dr. Le Mann, 16 Montague Street, Portman Square.
1826	105	*Caernarvon,* Sold.
1826	109	*Elisha,* 8gns.
1826	123	*Landscape and Mill,* 8gns., Tho. Bigwold ?????, 4 Bridge St., Blackfriars.
1826	160	*Bala Lake, Merionethshire,* 8gns.
1826	166	*Teddington,* 9gns.
1826	171	*Kilchurn Castle on Loch Awe,* 6gns., Lord C. Townshend.
1826	176	*View between Barmouth and Dolgelly, North Wales,* 30gns., D. Mildred Esq. Junr., Nicholas Lane.
1826	187	*View at Frognall, Hampstead,* 4gns.
1826	196	*View of Moel Hedog, near Beddgelert, North Wales,* 7gns.
1826	198	*Knaresborough, York,* 8gns.
1826	201	*Cottage Scene,* 6gns., Mr. T.I. Ireland, 5 Verulam Buildings, Gray's Inn.
1826	268	*Eagle's Nest, Lake of Killarney,* 9gns., Lord Northwick.
1826	280	*Ross Castle, Killarney, Kerry,* 8gns., Lord Northwick.
1826	282	*Goodrich Castle, Herefordshire,* 6gns.
1827	40	*St. Aghadoe's Ruins, near Killarney Lake,* 7gns., Mr. Willimott, 9 Ryder Street, St. James's.
1827	77	*Cottage Scene,* Sold.
1827	79	*View of the Town and Harbour of Nice, with the Castle of Antibes, and the Mountain L'Estrelles in the distance,* Sold.
1827	110	*Glenna Cottage, Killarney,* 12gns.
1827	153	*View of the Town and Harbour of Nice, from a Sketch, by A. R. Barclay, Esq,* Sold.
1827	155	*Dunstanborough Castle, Northumberland,* 8gns.
1827	169	*Ross Castle, Lake of Killarney,* 15gns.
1827	182	*Lake and Town of Killarney, with Ross Castle,* 35gns., J. Beaumont Swete Esq., Jordan's Hotel, St. James Street.
1827	306	*York Minster,* 6gns., Wm. Taylor, No. 10 Birchin Lane.
1827	327	*Bamborough Castle, Northumberland,* 8gns., G. Hibbert Esq.
1827	351	*Harlech Castle.*
1828	7	*Barnes, on the River Thames,* 10gns., Sold.
1828	8	*Harlech Castle - Snowden in the distance,* 17gns., Mr. Munro, 113 Park Street.
1828	47	*Cottage Scene,* 8gns., Sold.
1828	65	*Greenwich - Study from Nature,* 10gns.
1828	71	*A River Scene,* 7gns.
1828	74	*Dunstanborough Castle,* 4gns.
1828	199	*Bamborough Castle, Northumberland,* 6gns., Major Channel, 45 Upper Bedford Place, Russell Square.
1828	234	*Lindisfarne Abbey,* 4gns.
1828	255	*Tumulus of the Greeks, who fell in the battle of Marathon, "How sleep the brave who sink to rest . . ."* 10gns.
1828	333	*View on the Thames,* 8gns., Sold.
1829	40	*View in the Isle of France,* 35gns.
1829	42	*Composition,* 10gns.
1829	120	*Moel-Hedog, North Wales,* 6½ gns.
1829	146	*Harlech Castle - Composition,* 45gns.
1829	207	*Willsden Church, Middlesex,* 5gns., J.B. Philips Esq.
1830	138	*Harlech Castle, North Wales,* 10gns.
1830	161	*Pont Abberglaslynn, North Wales,* 7gns.
1830	309	*Cottage near Knaresborough, Yorkshire,* 4gns.
1831	39	*Sketch of the Old Tower at Hackney.*
1831	117	*A View of Vauxhall Bridge, from Millbank, finished on the spot.*
1831	151	*Composition.*
1831	196	*Study from Nature.*
1831	235	*Composition.*
1831	369	*Composition.*
1831	390	*Rustic Scene.*
1831	397	*Cottage Scene.*
1831	423	*View at Millbank.*
1832	65	*A Study from Nature - Carshalton, Surry,* 12gns., Sold.
1832	177	*Cottage at Carshalton, Surry,* 4gns., Sold.
1832	181	*A Welsh Cottage,* 10gns., Sold.
1832	229	*Looking towards London from Craven Hill, Bayswater,* 6gns.
1832	347	*A Landscape,* 4gns., Sir John Swinburne, 18 Grosvenor Place.
1833	58	*Chepstow Castle, Monmouthshire,* Sold.
1833	94	*Tintern Abbey, Monmouthshire,* Sold.
1833	223	*Andromache, "Not Priam's hoary hairs defiled with gore . . ." Pope's Homer's Iliad, Book VI. v.576.* 60gns.

| 1833 | 238 | *Conway Castle*, 10gns. |

1833 238 *Conway Castle*, 10gns.

1833 248 *The Walls of Caernarvon Castle*, 4gns., Mrs. Fielden, Montague Square.

1834 5 *Turk Lake, Killarney*, 25gns.

1834 42 *Harlech Castle, N. Wales, looking towards the Coast of Caernarvon*, 10gns.

1834 170 *Richmond Hill, Surrey*, 4gns., Lady Mary Murray.

1834 255 *Pont Aber Glaslynn*, 7gns., Mr. Ashlin.

1834 347 *Oft on a plot of rising ground, I hear the far-off curfew sound . . . Milton's Penseroso.* 4gns., Sold (Mr. Varley).

1834 359 *Lake Scene*, 6gns.

1834 364 *Beddgelert Bridge*, 7gns., Countess of Charlemont, 59 Lower Grosvenor Street.

1835 186 *Snowdon, from Traethmawr*, 7gns.

1835 211 *View near Ensham, Oxon*, Sold.

1835 232 *Hove, Near Brighton*, Sold.

1835 302 *View at Windsor*, 8gns., Sold.

1836 56 *"As some tall cliff that rears its awful form . . ." Goldsmith.* 50gns.

1836 115 *Study from Nature in Wooton Park, near Dorking, Surrey*, Sold.

1837 86 *Mountainous Scenery*, 45gns., Heny. Ashlin Esq., per order of Mr. Varley.

1837 262 *Bamborough Castle, from Holy Island, Northumherland*, 4gns.

1837 271 *Mountain Scene*, 4gns.

1837 272 *Composition*, 5gns.

1837 301 *Moel Hedog, from Llyn Dinas, North Wales*, 4gns., Lady Mary Monck, 20 Duke St., Westminster.

1837 322 *Sunset*, 4gns., R.H. Solly Esq., 48 Great Ormond Street.

1838 65 *The Disobedient Prophet Slain, "And when he was gone a lion met him on his way, and slew him." I Kings, Chap. xiii. v. 24.*

1838 116 *Mountainous Scene.*

1838 126 *Composition.*

1838 176 *Mountainous Scene.*

1838 199 *St. Allesia, Sicily.*

1838 240 *View on the Croydon Canal.*

1838 277 *A Landscape.*

1838 289 *Landscape.*

1838 291 *Evening.*

1838 308 *View on the Thames, near Battersea.*

1838 329 *Loch Long.*

1839 28 *Gap of Dunlow, Ireland*, 4gns., Sir R.P. Glyn, Bart., 37 Upper Brook Street.

1839 48 *Llanberis Lake, North Wales*, 9gns.

1839 201 *Evening - Composition*, 30gns.

1839 228 *Carisbrook Castle, from the Mill Dam*, 20gns.

1839 262 *Winchester Tower, Windsor*, 5gns., Mrs. Rennell, 39 Bryanston Sqre.

1839 282 *Cottage Scene*, 5gns., own order.

1839 303 *Boyle Abbey, County of Roscommon, Ireland*, 5gns., Chas. B. Warner, 9 Crescent ??? St., Cripplegate.

1839 326 *St. Paul's and Westminster Abbey - View taken from Chelsea Creek*, 5gns., Miss Chandler, 9 Oriental Place, Brighton.

1840 41 *Twickenham.*

1840 137 *Bamborough Castle.*

1840 196 *Harlech Castle, North Wales.*

1840 206 *Twilight.*

1840 210 *Mountain Scene.*

1840 215 *Landscape.*

1840 224 *Evening.*

1840 282 *Evening.*

1840 319 *Chiswick.*

1841 6 *Composition*, Sold.

1841 20 *Evening*, Sold.

1841 21 *Composition*, Sold.

1841 49 *Landscape*, 8gns., Saml. M. Peto(?), Lambeth.

1841 56 *Sunset*, Sold.

1841 71 *Twilight*, 8gns., Edwd. ???? Esq., Ryde, I.W.

1841 80 *Landscape, with Cottage*, 5gns., J. Shaw Esq., Christ's Hospital.

1841 134 *Composition*, Sold.

1841 142 *Landscape - Composition*, 50gns., B. Bernasconi, 19 Alfred Place, Bedford Sqre., Art Union.

1841 146 *Evening - Composition*, Sold.

1841 176 *Composition - Evening*, 35gns., H.R.H. Prince Albert.

1841 192 *Landscape, with Bamborough Castle*, 7gns., Col. C.W. Sibthorpe M.P., 2 Delahay Street.

1841 243 *Mountainous Pass*, 9gns., Mr. Thomas Staveley, 20 Earl's Terrace, Kensington.

1841 245 *Composition*, 10gns., B. Austen Esq., 6 Montague Place, Frame and glass Mr. B. Austen, 6 Montague Place.

1841 248 *Landscape, with Ruins*, Sold.

1841 251 *Lake Scene, with Ruins*, Sold.

1841 252 *Welsh Scenery*, 9gns., Honble. M.H. Clive, M.P., 53 Grosr. Street.

1841 253 *Composition*, 10gns., Lewis Pocock Esq., 29 Montague Street, Russell Squre.

1841 274 *Landscape - Composition*, 12gns., Own order.

1841 288 *Composition*, 15gns., P. Hardwick, 60 Russell Square.

1841 295 *Composition*, Sold.

1841	301	*Evening*, 8gns., S. Angell Esq., 2 Southampton St., Bloomsbury.
1841	303	*Mountainous Landscape*, 15gns., Richd. Ellison Esq., Sudbrook Holme, Lincoln.
1841	306	*Mountainous Landscape*, Sold.
1841	309	*Twilight*, Sold.
1841	312	*Landscape - Evening*, Sold.
1841	318	*Composition*, 12gns., M.J. Keighley, Hull, Art Union.
1841	322	*Cintra*, 8gns., Saml. M. Peto, Lambeth.
1841	327	*Landscape*, 5gns., J. Shaw Esq., Christ's Hospital.
1841	332	*River Scene, with Ruins*, Sold.
1842	7	*Sun-set.*
1842	19	*Composition.*
1842	37	*Landscape, with Ruins.*
1842	40	*View in Spain.*
1842	56	*Mountainous Scenery.*
1842	92	*Composition.*
1842	106	*Banditti lying in Ambush.*
1842	120	*Boyle Abbey, Ireland.*
1842	131	*Landscape, "I climbed a cliff Whose ridge o'erlooked a shady length of land."*
1842	136	*Landscape.*
1842	138	*Rocky Scenery.*
1842	149	*"A Palace in a woody vale we found, Brown with dark forest and with shades around."*
1842	154	*"Mountains on whose barren breast The labouring clouds do often rest." – Milton.*
1842	157	*Bolton Abbey, Yorkshire.*
1842	168	*Classic Landscape.*
1842	188	*Sunset.*
1842	190	*Evening.*
1842	191	*Evening.*
1842	192	*Landscape.*
1842	217	*Landscape.*
1842	220	*Composition.*
1842	225	*Composition.*
1842	226	*On the Coast of Cornwall.*
1842	232	*Composition.*
1842	244	*Landscape.*
1842	249	*Mountainous Landscape.*
1842	260	*Landscape.*
1842	267	*Landscape.*
1842	268	*Composition.*
1842	274	*Sunset.*
1842	281	*Composition.*
1842	284	*Evening.*
1842	292	*Landscape.*

1842	301	*River Scene.*
1842	305	*Storm Clearing Off.*
1842	310	*Composition.*
1842	318	*River Scene.*
1842	320	*"The castle was most goodly edifyde, And plaste for pleasure nigh that forest's syde." – Faëry Queen.*
1842	323	*Composition.*
1842	328	*Mountain Scenery.*
1842	330	*View near Richmond, Yorkshire.*

VARLEY J THE LATE

1843	5	*Composition*, 20gns., His Royal Highness Prince Albert, Frame and glass £1.15.0.
1843	24	*Distant View of Bamborough Castle and the Fern Islands, the scene of Grace Darling's heroic exertions*, 9gns., Wm. Gordon Esq., Tyrie(?) Castle, N.B., Frame and glass £1.5.0.
1843	157	*View on the Croydon Canal previous to the making the Railroad*, 30 Pounds, His Royal Highness Prince Albert, Frame and glass £3.10.0.
1843	201	*Plains of Marathon, from the Tumulus of the Greeks and Persians, looking towards Euboea, "The mountains look on Marathon, and Marathon looks on the sea . . ." Byron.* 12gns., George Vaughan Esq., 28 Cumberland Terrace, Frame and glass £2.10.0.
1843	252	*Evening - Composition*, 10gns., Her Majesty the Queen, Frame and glass £1.10.0.
1843	274	*Scene near the Mendip Hills, Somersetshire*, 7 & half gns., Frame and glass £1.5.0.
1843	291	*View of Part of Snowdon*, 7gns., Bishop of Winchester, 19 St. James Square, Will keep the frame and glass £1.1.0.
1843	301	*River Scene - Composition*, 12gns., Ellison Esq., Sudbrooke Holme, Frame and glass £1.0.0.
1843	309	*View on the River Wharf, Yorkshire*, 10gns., Her Majesty the Queen, Frame and glass £1.5.0.
1843	317	*Windermere*, 9 gns., Miss Hicks Beach, Oakley Hall, Basingstoke, Frame and glass £1.4.0.

VILLIERS H

1813	3	*Portrait of Mrs Crompton.*
1813	16	*The Dowager Marchioness of Sligo, in the Costume of the Court of Henry VIII.*
1813	27	*Portrait of a Lady.*
1813	115	*Sappho, "Je sens de veine en veine une subtile flamme . . ." Sortie de Sappho, traduit par Boileau.*
1813	151	*Portrait of a Lady in the Character of Hebe - Miniature on Marble.*

VINCENT G

1818	56	*A Landscape.*

1818	57	*View near Norwich.*
1818	67	*View on the River Yare.*
1818	76	*Road Scene.*
1820	170	*London, from the Surrey side of Waterloo Bridge*, £136.10.0, Sir John Leicester.

WALKER W

1813	8	*A View of the Old Steeple, Hackney, from the Downs.*
1813	154	*Richmond Hill, from the River.*
1814	56	*Sea Fish.*
1814	206	*River Fish.*
1815	59	*Fishermen of the West Coast sorting their Fish.*
1816	101	*View from Pont du Gard, near Renvoulin, South of France.*
1816	269	*View of Napoli di Romania, on the Coast, near Argos, with Native Fishermen.*
1817	172	*Algerines reconnoitering off the Gut of Gibraltar. Morning.*
1817	179	*The Site of Sparta, seen from the Mountains of Misistra.*
1817	192	*Algerines in Chase.*
1818	8	*A Scene within the Gates of Genoa*, £15.15.0, J. Quintin Esq.
1818	11	*View of Argos.*
1818	139	*Boy and Rabbits.*
1818	227	*The Acropolis of Athens.*
1818	271	*View of a Turkish Mosque*, £15.15.0, Do. [J. Quintin, Esq.].
1819	20	*The Town of Livadia in the Morea.*
1819	208	*A Greek Woman receiving a Blessing from a Greek Priest.*
1819	247*	*Women of the Island of Cephalonia, with a View of the Port of Argostoli.*
1819	282	*The Greek Town of Andrussa, in the Morea.*
1819	303	*A Turkish Mosque, at Vostizza.*
1820	227	*View of the Interior of the Island of Zante.*
1820	272	*The Turkish Governor's House at Corinth.*
1821	8	*A View in Sicily, near Messina.*
1821	27	*A View near Genoa.*
1821	129	*A Turkish Mosque - Argos.*
1822	97	*A Harvest Scene.*
1823	27	*A Greek Soldier and Peasant.*
1823	39	*Greek Soldiers going on Duty.*
1823	179	*A View near Genoa.*
1824	101	*Rasselas, Prince of Abyssinia, "At length their labour was at an end; they saw light beyond . . ." Vide Johnson's Rasselas, Ch. 14.*
1824	299	*A View near Pisa.*
1826	264	*Greeks driving their Cattle from an approaching Enemy to a place of safety*, 20gns.

1827	86	*Boys returning Home in a Shower of Rain*, 15gns.
1827	262	*A View of the Plains of Zante, with Inhabitants of the Island*, 25gns.
1827	325	*A Greek Soldier and Family*, 12gns.
1827	333	*Port of Argostoli, in Cefalonia*, The Drawings upon this Screen having been made expressly for the Album of a Lady, who has kindly permitted them to be exhibited, are not for Sale. [Third Screen, nos. 333 to 359. The Lady was Mrs. G. Haldimand.].
1828	223	*Coast Scene, Morning, with Fishermen sorting their Fish*, 15gns.
1829	64	*A View of Mount Parnassus, about six hours journey from Lividea to Castre*, 25gns., Rob. Adair, Charlotte St., Bloomsbury N12.
1829	231	*Richmond Hill, from the River*, 10gns.
1830	2	*A View of the Town of Andrussa, Greece*, 10gns.
1830	194	*Greek Women of the Morea - with a View of the Town of Calamata, thirteen miles west of Mysistra*, 30gns.
1830	219	*Greek Women, with a View of the Port of Argostoli, in the Island of Cephalonia*, 15gns.
1830	241	*A Greek Priest bestowing a blessing, with a View of a Turkish Mosque at Argos*, 20gns.
1831	111	*Boys Feeding a Swan.*
1831	128	*Greek Fishermen on the Coast near Argos, with a view of Napoli di Romania - Morning.*
1831	263	*A Farm House near Tottenham Hall.*
1831	272	*A Greek Woman Gathering Currants.*
1832	30	*A Fort on the Genoese Coast, with Native Fishermen*, 20gns.
1832	280	*The inquiring Pilgrim on his way to Mecca*, 8gns.
1833	1	*View of Mount Parnassus, six hours' journey from Castri, ancient Delphi with Travellers halting, attended by Shepherds of the mountain*, 25gns.
1834	47	*View near Genoa, leading to the Mountains, from the Gate of St. Thomas*, 25gns.
1834	239	*Livadea, a Town in the Morea, anciently called Lebadea, formerly one of the principal cities of Boeotia, celebrated for the Oracle in the Cave of Trophonius*, 20gns.
1836	70	*On the Coast of Sicily*, 10gns.
1836	78	*Mount Etna*, 10gns.
1836	83	*View in the Island of Zante, with Cephalonia in the distance*, 15gns.
1838	96	*The Woodman.*
1838	109	*A Coast Scene.*
1838	242	*Albanian Soldiers.*
1840	102	*Morning Scene - Going to the Mosque.*

1840	109	*View in Sicily.*
1842	236	*Hampton, on the Thames.*
1842	242	*A Spanish Shepherd.*
1844	49	*Corinth,* 15gns.
1844	99	*Remains of an Antique Wall on the site of Sparta,* 12gns.
1846	12	*A Greek Vineyard,* 15gns.
1846	27	*Coast Scene,* 15gns.
1849	127	*Gold Finders, California.*

WALTON M A

1816	20	*Flowers in a Glass,* £6.6.0, Earl Gower.
1816	56	*Goldfinch and wild Flowers,* £10.10.0, Earl Gower.
1816	57	*Flowers in a Window,* £8.8.0, Do.
1816	62	*Snow Drops,* £6.6.0, Earl Gower.

WALTON MISS

1815	129	*A Fruit, and Flower Piece.*
1817	50	*Group of Flowers.*
1817	53	*Study of Fruit.*
1817	56	*Primroses, and Lilies of the Valley,* £6.6.0, Mrs. Edwards, Harrow.
1819	56	*Red Trout, after Nature,* £4.4.0, Mr. Brown.
1819	103	*Group of Flowers,* £21.0.0, J. Bull Esq.
1819	127	*Flowers in an antique China Jug,* £8.8.0, Mr. Richardson.

WALTON MISS M A

1818	79	*Hellebore, or Christmas Rose.*
1818	85	*Flowers and Fruit after Nature.*
1818	88	*Crocus and Polyanthus.*

WARD J

| 1820 | 85 | *Dutch Boats in a Calm,* £15.15.0, Duke of Northumberland. |

WATSON T

| 1819 | 130 | *Peggy, "Dear was the spot, the sweet retreat . . ." Old Ballad.* |
| 1819 | 137 | *Portrait of a Gentleman and his Son, as a Shepherd and his Boy.* |

WATTS W H

1816	39	*Portrait of Mr J. W. Thompson.*
1816	193	*Portrait of the Rev. George Bonner.*
1816	196	*Portrait of Miss Thompson.*
1816	197	*Portrait of Master Henry Thompson.*
1816	205	*Portrait of Mr. Gullan.*
1820	128	*The Veteran, "Shoulder'd his crutch, and show'd how fields were won."*

WEBSTER M

1818	156	*Flowers.*
1818	201	*Flowers.*
1818	203	*Flowers.*

WELLS W F

1805	7	*View of Chepstow, with the junction of the Severn and Wye, Bristol Channel in the distance.*
1805	20	*View near Onstad, on the eastern side of the Fillefield, Norway.*
1805	36	*Fortress of Frederickshall on the frontier of Norway, where Charles the XIIth of Sweden lost his life.*
1805	44	*View between Lerol and Quien, on the eastern side of the Fillefield, Norway.*
1805	46	*Vale of Terni, taken near Papinio, Italy.*
1805	61	*Town and fortress of Warberg, Sweden.*
1805	82	*The dismantled fortress of Bahûus near Gottenburg, Sweden.*
1805	102	*The Cascatella Tivoli.*
1805	112	*Hau Cataract Etne, between Stavanger and Bergen, Norway.*
1805	167	*Study, in the park of the Right Hon. Earl Stanhope, at Chevening, Kent.*
1805	208	*Cottage instruction.*
1805	210	*A frame, containing two views in Norway.*
1805	216	*Gypsey girl and child.*
1805	222	*Study from nature.*
1805	226	*A frame, containing a view in Kent, and the vale of Festiniog, North Wales.*
1805	234	*A landscape.*
1805	244	*View of Hastings Castle and Cliff.*
1805	246	*Study from nature.*
1805	260	*View near Nye Stuen, Norway.*
1805	265	*Study of Beech, in Knole Park, Kent.*
1805	268	*View between Nye Stuen and Skogstad, on the eastern side of the Fillefield, Norway.*
1806	13	*Tivoli, with part of the Campania, Rome.*
1806	70	*View in Chevening Park, Kent.*
1806	74	*Distant View of Knole in Kent, the Seat of the Duke of Dorset.*
1806	114	*Arundel Castle, Sussex, the seat of the Duke of Norfolk.*
1806	122	*Stavanger, in Norway.*
1806	144	*View near Etna, Norway.*
1806	154	*Ludlow Castle, Shropshire.*
1806	168	*View between Lerici and Sarzano, Italy.*
1806	187	*View, looking towards Schonivig Fiord, Norway.*
1806	202	*View at the back of Portland Place.*
1806	204	*A Landscape Norwegian Scenery.*
1806	212	*View between Skogsted and Elveton, Norway.*
1806	215	*View in the Tyrol.*
1806	254	*Cockham Hill, Kent.*
1806	257	*A lane at Knockholt, Kent.*
1806	270	*A lane near Knockholt, Kent.*
1806	272	*View in Leicestershire.*
1807	12	*Study from nature.*

1807	16	*View in the Fillafield, Norway - morning.*
1807	23	*Seven Oaks, Kent.*
1807	43	*The dawn.*
1807	75	*Goodrich Castle.*
1807	82	*A Kentish farm.*
1807	107	*Study from Nature.*
1807	111	*Homesdale, Kent, taken from Madam's Court Hill.*
1807	118	*Laholm, Sweden.*
1807	140	*Warburgh, Sweden.*
1807	161	*A mill in Merionethshire.*
1807	164	*A woodman.*
1807	188	*A cottage girl.*
1807	225	*Village saw-pit.*
1807	254	*A landscape, composition.*
1807	255	*A landscape, composition.*
1807	260	*Landscape, a composition.*
1807	264	*A landscape, composition.*
1807	265	*Twilight, a study from nature.*
1807	274	*Study from nature.*
1808	1	*A Landscape, composition.*
1808	5	*A mill near Llanwer, North Wales.*
1808	7	*View near Quien, Norway.*
1808	20	*Cottages at Knockholt.*
1808	28	*View in North Wales.*
1808	38	*Elsineur, with the fortress of Cronenburg, distant view of the Sound, and coast of Sweden.*
1808	136	*Landscape, a composition.*
1808	137	*Landscape, a composition.*
1808	171	*View over Biewerdale, Norway.*
1808	296	*View near Bergen, Norway.*
1809	2	*A cottage in Kent.*
1809	4	*A view at Medenham.*
1809	88	*Pont Dolorcan, N. Wales.*
1809	89	*Frog-hole cottage, Kent.*
1809	148	*A cottage at Sandrich, Kent.*
1809	155	*A lane scene, near Beddington, Surry.*
1809	173	*Landscape, composition.*
1809	174	*Landscape, composition.*
1809	189	*Landscape, composition.*
1809	196	*View from Thoys hill, Kent, looking over the vale of Sussex.*
1809	204	*Landscape, composition.*
1809	206	*View looking towards North-end, Hampstead.*
1809	214	*Distant view of the town and fortress of Frederickshall, in Norway, before which place Charles XII of Sweden lost his life.*
1809	232	*View at Hampstead, taken near the mansion of the Right Hon. Lord Erskine.*
1809	238	*Tintern Abbey.*
1810	87	*Goodrich Castle.*
1811	200	*Distant View of Dolgelly, from the Barmouth-Road.*
1812	145	*Wigedahl Fossen and Saw-Mill, Norway.*
1812	147	*Velanessa Mill, Glen Dourdy, North Wales.*
1812	148	*Pont Ddee, near Festiniog, North Wales.*
1812	151	*View between Nye Stuen and Skrogstad on the Eastern Side of the Fellefield, Norway.*
1812	333	*View from Madam's Court Hill, looking over the Vale of Homesdale, Kent.*

WESTALL W

1811	104	*London Bridge, from the Surrey-side,* 50gns., Hon. R. Peel.
1811	160	*View on a Branch of the Pe Kiang River about sixty Miles inland and five above Canton, China,* Lady Lucas.
1811	190	*The Thames, from Scotland-Yard.*
1811	191	*View of the High Mountains, to the Southward of Peak o Reivo, in the Pass between Coral das Frieras and Ponta Dalgada, on the North Side of the Island of Madeira.*
1811	239	*A Landscape.*
1812	15	*A Cottage Scene, with Children.*
1812	45	*View of Port Jackson, New South Wales.*
1812	128	*View near Rivaux Abbey, Yorkshire.*
1812	130	*Interior of Rivaux Abbey, Yorkshire.*
1812	131	*Southampton, from the Beach below Weston.*
1812	133	*View from a Garden on the River Pe Kiang, China.*
1812	185	*View near Shutlingloo, Cheshire.*
1812	222	*Rivaux Abbey, Yorkshire.*
1823L	7	*Rivaux Abbey, Yorkshire,* J. Broderip, esq.
1823L	48	*Keswick Bridge,* E.H. Locker, esq. F.R.S.

WHICHELO J [See also **J M, J W** and **Wichelo**]

1825	184	*Shoreham Harbour, from the Brighton Road - Evening,* 3gns.
1826	167	*Fishing Boats unloading at the Pollet, Dieppe,* 5gns., Rev. G. Ford, Hake's(?) Hotel, Duke Street, Manchester Square.
1826	263	*The Harbour of Dieppe from the Pollet Pier,* £20.0.0.
1827	50	*The Naval Arsenal, Portsmouth,* 10gns.
1827	185	*The Port of Havre, with the Departure of the New York Packet,* 10gns.
1827	299	*Unloading Fishing Boats, Dieppe,* 10gns.
1827	353	*Shipping - Moonlight.*
1828	188	*Dutch Market Boats - a fresh Breeze,* 20gns., J. Morton Jones, Albany.
1828	236	*Shipwreck,* 35gns.
1829	102	*Old Hulks, in Portsmouth Harbour,* 40gns., Frame and glass £15.0.0.

1829	182	*An Embarkation*, 30gns., Frame and glass £8.8.0.
1829	396	*A Calm - Man of War Drying Sails*, 4gns., Morant Esq.
1834	163	*Dutch Boats in a Calm, near Dort*, 10gns.
1835	101	*A Fresh Gale*, 5gns.
1835	108	*Stormy Sun-set*, 5gns.
1835	170	*Scene on the Scheldt, near Antwerp*, 10gns.
1835	229	*Fredrickstein on the Rhine, the Residence of Prince Frederick of Prussia*, 5gns.
1836	145	*Study from Nature in Bluebottle Lane, Norwood, Surrey*, 8gns.
1836	158	*Study from Nature, in Penge Wood, Norwood*, 10gns.
1836	190	*Evening - on the Coast of England, "Just o'er the verge of day."* 15gns.
1836	218	*Morning - on the Coast of Messina, "Lo now apparent all".* Thomson. 25gns., Wm. Hobson Junr. Esq., 43 Harley Street.
1837	15	*Interior of Putney Old Church*, 12gns., Frame and glass 3gns.
1837	57	*Vessels Running for a Port in a Squall*, 15gns., Frame and glass 5gns.
1837	171	*Gravel Carting, Norwood*, 10gns., Miss Craven, Stamford Hill.
1838	92	*The Turnpike Gate, Pershore.*
1838	215	*Scene in the New Forest, Hants.*
1840	50	*Ruins of the Rheinfels, " - - - at length the day departed, And the moon rose . . ."* Rogers.
1840	51	*The Bridge of Coblentz across the Moselle, at its confluence with the Rhine.*
1840	182	*A Merchant Ship coming up the Swin off Dort.*
1841	58	*Evening - a Study from Nature - Norwood, Surrey*, 5gns.
1841	67	*A Gale coming on - Vessels running for Port*, 4gns.
1841	85	*The Bombardment of St. Jean d'Acre, Seen from the Phoenix steam ship, from which Admiral Sir R. Stopford directed the whole of the operations; showing the relative positions of Her Majesty's ships Revenge, 76 guns . . .* 50gns.
1841	196	*Sunset at Sea - off the Land's End*, 5gns.
1841	228	*Moonlight - a Line-of-Battle Ship just come to Anchor, Men Furling Sails*, 6gns.
1841	231	*Southampton Water - Moon Rising*, 5gns.
1841	233	*Morning after the Gale - a Vessel Stranded*, 4gns., J. Beaumont Swete Esq., Oxton, Exeter.
1842	44	*Waiting for the Boat, near Terneuse on the Scheldt.*
1842	205	*Scene in the New Forest, near Lyndhurst.*
1842	235	*Market Boats, near Dort - Morning.*
1843	19	*A Frigate Lying-to for a Pilot off the Texel - a Gale coming on*, 15gns.
1843	33	*Evening on the Rhine, with the ancient Castle of Vogtsberg, the Rhine residence of his present Majesty Frederick of Prussia*, 15gns.
1843	154	*Misty Morning - on the Banks of the Maas, near Rotterdam*, 15gns.
1843	226	*Morning on the Rhine, with the ancient Castle of Vogtsberg, now called Nieu Rheinstein*, 15gns.
1843	242	*Moonlight - on the Meuse near Dort*, 6gns.
1843	249	*Birch Trees*, 10gns., Strahan Esq., 34 Hill Street.
1844	105	*Dutch Boats off Helvoetsluys - Light Breeze*, 10gns., Frame and glass £3.3.0.
1844	124	*The Glorious Battle of the Nile, 9 o'clock at Night, in the Bay of Aboukir, 1st of August 1798, "In the centre, the Vanguard, Lord Nelson; the l'Orient (Admiral Bruies) on fire; the Swiftsure (Captain Hallowell) clewing up her sails; and the Alexander (Captain Ball), having just got into action . . ." Vide Williams's Naval History.* 20gns., Frame and glass £4.4.0.
1844	182	*A Scene in the Beech Wood near Lyndhurst, New Forest, Hampshire*, 50gns., Frame and glass £15.15.0.
1845	7	*Hampton Court Palace, from the River Mole - A Sketch from Nature*, 7gns.
1845	54	*The Watermill in Lord Winterton's Park*, 25gns.
1845	66	*Fish Ponds near Haslemere, Surrey - A Sketch from Nature*, 5gns.
1845	163	*Emerey Down, near Lyndhurst, New Forest, Hants - A Sketch from Nature*, 10gns.
1845	214	*A Rustic Bridge at the Fish Ponds, Haslemere, Surrey - a Sketch from Nature*, 5gns.
1845	267	*Fish Ponds, near Haslemere, Surrey - a Sketch from Nature*, 5gns.
1846	32	*The Old York (Convict Hulk), in Portsmouth Harbour*, 12gns.
1846	72	*The Pass over the Tête Noire, Switzerland*, 14gns.
1846	125	*The Tower of Unspunnen, across the Aar, at Interlachen, Switzerland*, 25gns., Mrs. Staples, Highlands, near Dartford, AU.
1847	1	*The Fall of the Reichenbach at Rosenlaui, Switzerland*, 35gns.
1847	74	*The High Alps, as seen across the Lake from Ouchy (Lausanne) - Passengers waiting for the Steamboat, "The head of the lake lies open to the spectator, and it offers one of the grandest landscapes . . ." - Cooper.* 15gns., J. Masson Esq., 39 Nicholas Lane, Lombard St., AU. 15£.
1848	10	*Emery Down, near Lyndhurst - Study from Nature*, 10gns.
1848	61	*A Pass in the Munster Thal, Jura*, 15gns.
1848	86	*The Timber Waggon - Scene in the New Forest*, 25 Pounds.

1848	106	*Scene in Windsor Forest*, 20 Pounds.
1848	188	*In the Beech Wood, New Forest - Study from Nature*, 10gns., Revd. I.M. Traherne, Coedriglan, Cardiff.
1849	60	*Scene on the Scheldt, near Antwerp.*
1849	181	*Morning, with Cattle on the banks of the Maes, near Rotterdam.*
1849	192	*Dutch Boats in a Calm on the Coast of Holland.*
1850	1	*The Beacon*, 30gns.
1850	73	*Furstenberge on the Rhine*, 10gns.
1850	178	*Scene on the Thames near Putney - Sketch from Nature*, 5gns.
1850	199	*The Way through the Wood - Mid-day*, 25gns.
1850	243	*Marksberg on the Rhine*, 5gns., Richard Ellison Esq., Sudbrooke Holme.
1851	12	*A Study from Nature, on the Coast near St. Helens, Isle of Wight.*
1851	64	*H. M. Ship Victory in the Battle of Trafalgar, bearing down to the relief of the Temeraire, and firing her first broadside into the Redoutable.*
1851	76	*Fishing Boats, Drying Nets - Brighton.*
1851	96	*A Study from Nature - from Blackhouse Point, Portsmouth Harbour.*
1851	149	*Unloading a Collier on the Beach - Brighton.*
1851	170	*The Jungfrau and the Engle-Horner, from the Valley of Rosenlaui - soon after Sunrise.*
1852	1	*Evening - from the Chain Pier, Brighton, "Just o'er the verge of day."* – Thompson. 15G.
1852	13	*Mont Blanc, and Valley of Chamouni - from the Col de Balme*, 20G.
1852	18	*Old Men-of-War on the Medway, near Sheerness - Fresh Breeze*, 8G.
1852	26	*Misty Morning - Fishing Boats in a Calm*, 10G, Abel Peyton Esq.
1852	50	*H. M. Ships Illustrious, 74, and Alfred Frigate, in Portsmouth Harbour*, 15G, Maj. Gen. C.R. Fox, 1 Addison Road.
1852	192	*Morning - Scene on the Coast near Messina, from a Sketch by Lieut. Williams*, 10G, Revd. H. Sibthorp, Haslingboro, nr. Lincoln, Frame and glass £2.5.0.
1852	207	*Mid-day – Scene on the Farm of – Durant, Esq., Putney*, 15G.
1853	1	*Morning - Scene on the Maes, off Dort.*
1853	38	*Fish Market on the Sands at Scheveling, on the Coast of Holland.*
1853	108	*A Study from Nature on the Usk, near Crickhowell, South Wales.*
1854	28	*Mont Orguiel Castle, from Ann Port, Jersey*, 20gns.
1854	33	*The British Fleet, under the command Sir C. Napier, entering the Baltic, 1854 - Foggy Morning*, 15gns.

1854	56	*The Farm Yard*, 10gns.
1854	89	*Geoffroy's Leap, from Ann Port, Jersey - Study from Nature*, 10gns.
1854	183	*The "Despatch" Mail Steam Packet in Distress, off the Corbière Rocks, Jersey, H. M. Steam Ship "Dasher" coming to her relief, Oct. 17, 1853*, 8gns.
1854	196	*St. Brelade's Bay, Jersey - Morning*, 15gns.
1855	1	*A Summer Study in the Wood, near the Common*, 45gns.
1855	7	*The Cathedral and Quai of Dordrecht, at the Junction of the Rhine and Meuse*, 20gns., Chas. Jellicoe, 5 Wimpole St.
1855	98	*A Fresh Gale off the Coast of Holland*, 15gns.
1855	123	*Summer Evening on the Meuse, off Dordrecht*, 15gns.

WHICHELO J M

1830	15	*A Gale coming on*, 5gns., Frame and glass £1.10.0.
1830	37	*Ghent*, 40gns., Frame and glass £12.12.0.
1830	76	*Snow Scene, Wimbledon Common*, 4gns., James Field, 32 Newington Place, Kennington.
1830	83	*A Moonlight Scene in the Mediterranean*, 5gns., J.A. Frampton, 29 Tavistock Square.
1830	217	*A Stern Chase, or Ten Minutes too late*, 5gns., Frame and glass £1.10.0.
1830	229	*Night*, 4gns.
1831	40	*Rotterdam Boats passing Dort in a Fresh Breeze.*
1831	172	*Coast Scene.*
1831	211	*His Majesty's Ship Victory, Firing a Salute on the Queen's Birthday, 1830, in Portsmouth Harbour.*
1831	311	*Scene on the Beach at Brighton.*
1831	343	*A Squall coming on.*
1831	389	*Boat in a Squall.*
1832	110	*Fishing Boats in a Squall*, 12gns.
1832	230	*St. Vallery, on the Coast of Normandy*, 5gns.
1832	255	*A Sicilian Sea Port*, 40gns.
1832	274	*Scheveling, on the Dutch Coast*, 5gns., J. Lewis Brown, 10 Leicester Place, Leicester Square.
1833	27	*Moonlight*, 4gns.
1833	62	*A Calm Morning*, 5gns.
1834	223	*A Fresh Breeze, Dutch Boats getting under Weigh*, 10gns.
1834	283	*A Fresh Gale*, 5gns.
1834	371	*Dutch Boats*, 5gns., John Temple Leader(?), 8 Stratton(?) St.

WHICHELO J W

1854	170	*Bouley Bay, Jersey*, 12gns.

WHITE MRS

1813	242	*Scene in Langdale, Westmorland.*

1813	247	*Scene in Langdale, Westmorland.*

WHITE MRS C

1813	203	*View on the Banks of the River, at the Foot of Scale Hill, Crommock Lake, Cumberland.*

WHITE W

1819	125	*A View of the Rögfossen, or Smoke-Waterfall in Upper Tellemarck, Norway - the highest fall of water known, being 940 feet perpendicular, taken on the spot. August 1817, by.*

WHITEHEAD J

1820	52	*Bauldy seeing Mause, " – A cottage in a glen, Anauld wife spinning at the sunny end . . ." Bauldy his lane. Vide Gentle Shepherd.*

WICHELO J

1823	1	*A Morning Scene on Brighton Beach.*
1823	34	*The Morning Gun.*
1823	89	*The Evening Gun.*
1823	108	*A Plymouth Packet and Frigate going into Portsmouth Harbour.*
1823	189	*A Coast Scene, £3.3.0, Mr. Arrowsmith.*
1823	194	*A Frigate sailing into Portsmouth Harbour.*
1823	247	*Portsmouth Point.*
1824	43	*The Tree Crona - a Danish Ship, taken by Lord Nelson, at Copenhagen.*
1824	83	*Scene in Portsmouth Harbour.*
1825	26	*Early Morning - the Brighton Fleet coming in, £10.0.0.*
1825	37	*Foggy Morning at Spithead - Salvage Boats fishing for Anchors off the Buoy of the Spit, 10gns.*
1825	165	*The New Moon, March 29th, 1825, off Spithead - Isle of Wight in the Distance, 3gns., ? Talbot Esq., Conduit St.*

WILD C

1809	28	*St. Augustin's Gate, Bristol.*
1809	53	*Interior view of Salisbury Cathedral, taken from the South side of the altar.*
1809	71	*Entrance to the lower rooms, Bath.*
1809	126	*The choir, one of a series of views now publishing, of York cathedral.*
1809	134	*An interior view at the East end of Winchester cathedral.*
1810	114	*The Choir of Gloucester Cathedral, "The storied window richly dight, Casting a dim religious light."*
1810	213	*View in Winchester Cathedral.*
1810	243	*View in Canterbury Cathedral, with Pilgrims, "For speially from every spire's end Of England to Canterbury they wend." Chaucer's Prologue.*
1810	312	*Part of St. Mary's, Redcliffe, Bristol.*
1810	322	*Transept of York Cathedral.*
1811	2	*The Beauchamp Chapel at Warwick.*

1811	45	*Principal Entrance to the Nave of Litchfield Cathedral.*
1811	117	*The Choir of Chester Cathedral - Evening.*
1811	119	*View at the East End of Tewkesbury Abbey.*
1811	196	*Part of the South Side of Litchfield Cathedral.*
1812	8	*Entrance to the Choir of Canterbury Cathedral.*
1812	123	*The Trial of Constance de Beverley, "The Cresset in an Iron Chain . . ." Marmion, Canto II. Mr. Forbes.*
1812	125	*The Lady Chapel of Chester Cathedral.*
1812	136	*Part of the Nave of Litchfield Cathedral.*
1812	138	*Part of the Cloister of Gloucester Cathedral, "Along the Cloister's painted Side The silent Monks their Studies plied." Economy of the Monastic Life.*
1814	37	*Chichester Cross.*
1814	83	*Part of the South Side of Litchfield Cathedral.*
1814	116	*Choir of Chester Cathedral.*
1814	250	*The West Front of Litchfield Cathedral.*
1815	30	*View at the East end of Lincoln Cathedral, with the Monuments of Wymbish, Cantalupe, Burgeish, and Flemming.*
1815	51	*View in Tewkesbury Abbey.*
1815	52	*View at Bath.*
1815	58	*View in Oxford Cathedral.*
1815	72	*View under the Rows, Chester.*
1815	74	*Entrance to St. Mary's Hall, Coventry.*
1815	154	*View in Wells Cathedral.*
1815	248	*View in Salisbury Cathedral.*
1817	169	*Crimson Drawing Room, Carlton House, In this Apartment the Marriage of the Princess Charlotte of Wales with the Prince Saxe-Cobourg was solemnized. This is one of the series of drawings intended for the illustration of Pyne's History of the Royal Palaces of England.*
1818	16	*Blue Velvet Room, Carlton House.*
1818	19	*St. George's Hall, Windsor Castle.*
1818	23	*Conservatory, Carlton House.*
1818	25	*Queen's Presence Chamber, Windsor Castle.*
1818	28	*Circular Room, Carlton House.*
1818	30	*Rose Satin Drawing Room, Carlton House.*
1818	33	*Queen Anne's Bed, Windsor Castle.*
1818	34	*Alcove Golden Drawing Room, Carlton House.*
1818	35	*King's Great Drawing Room, Kensington Palace.*
1818	40	*Anti Room, Carlton House.*
1818	41	*Golden Drawing Room, Carlton House.*
1818	320	*View of St. George's Chapel, Windsor, looking East.*
1818	336	*View of St. George's Chapel, looking West.*

1819	7	*Interior of the Presbytery of Lincoln Cathedral.*
1819	19	*Part of the Circular Room, Carlton House.*
1819	132	*South East View of Lincoln Cathedral.*
1819	302	*The Library of the late Rev. Dr. Burney, Deptford.*
1819	309	*The Library of the late Rev. Dr. Burney.*
1819	347	*Interior of the Transept of Lincoln Cathedral.*
1820	380	*View of the Choir of Worcester.*
1821	51	*Interior of the Saloon at Willey Hall, Shropshire, the Seat of Cecil Forester, Esq.*
1821	92	*The Choir of Lincoln Cathedral.*
1821	95	*The Altar of St. Sebastian, in the Cathedral of Amiens, £10.10.0, G. Giles Esq.*
1821	118	*The Transept of Amiens Cathedral, £10.10.0, R. Holford Esq.*
1821	127	*The Altar of Notre Dame du Puy, in the Cathedral of Amiens, £10.10.0, J. Newman Esq.*
1821	132	*The Choir of Worcester Cathedral.*
1821	148	*The Nave of the Cathedral Church of Amiens, £21.0.0., Bishop Ferns.*
1821	151	*Merton Chapel, Oxford.*
1821	155	*The West Front of the Cathedral Church of Amiens.*
1821	161	*The Choir of the Cathedral Church of Amiens, £21.0.0, W. Beckford Esq., Fonthill.*
1822	10	*View in the Cathedral Church of Amiens, embracing a part of the Nave, Choir, and Transept, with the Procession of the Aspergus.*
1822	33	*The Presbytery of Lincoln Cathedral.*
1822	36	*South Entrance to Lincoln Cathedral.*
1822	43	*Part of St. George's Chapel, Windsor.*
1822	70	*View in the Church of St. Remi at Dieppe, £6.6.0, J. Dimsdale Esq.*
1822	74	*Portail de la Calende, Rouen Cathedral.*
1822	77	*High Altar at Chartres, with the ceremony of blessing bread at High Mass.*
1822	103	*View at the East end of the church at Calais, £8.8.0, W. Blake Esq.*
1822	108	*View in the Church of St. Remi, at Rheims, £8.8.0, W. Blake Esq.*
1822	160	*Sketch in the Abbey Church of Tewkesbury.*
1822	172	*Sketch in the Cathedral of Oxford.*
1823	6	*View in the Church of Calais, £8.8.0, Mr. Broderip.*
1823	22	*View in the East Transept of Worcester Cathedral; one of the Subjects for the Illustration of the Architecture and Sculpture of Worcester Cathedral (now in the press).*
1823	68	*Chapel of the Virgin in the Church of the Jesuits at Antwerp - A specimen of the Architecture of Peter Paul Rubens, In this representation the Artist has introduced, above the Altar, a copy of the celebrated Assumption of the Virgin in the Cathedral of Antwerp, that subject, painted by Rubens, having originally adorned this Chapel.*
1823	118	*View in the North Aisle of the Nave of the Cathedral Church of St. Bavon, at Ghent.*
1823	152	*View in the Church of the bare-footed Carmelites, Ghent.*
1823	165	*View in the Cathedral Church of St. Ramboud, Mechlin.*
1823	200	*The Choir of Beauvais, £15.15.0, Marquis of Stafford.*
1823	204	*The West Front of the Cathedral of Rheims (one of a series of Views, illustrative of French Ecclesiastical Architecture, now publishing), £5.5.0, Earl of Essex.*
1823	209	*The Cathedral of Chartres, with the Entrance to the City by the Port Chatelet, £21.0.0, Marquis of Lansdowne.*
1823	220	*Interior View at the East end of the Cathedral of Chartres, £12.12.0, Marquis of Stafford.*
1823	222	*South Entrance to the Cathedral of Chartres.*
1823	243	*Part of the South side of Rheims Cathedral.*
1823L	83	*Interior of the Choir of St. George's Chapel, Windsor, Mrs. Dry.*
1823L	91	*Interior of the Choir of St. George's Chapel, Windsor, Mrs. Dry.*
1824	8	*View of the Abbey Church of St Ouen, at Rouen.*
1824	35	*Kirmesse, in the Archiepiscopal Church of St. Rambaut, at Mechlin, "When twilight o'er the sacred fane Throws its mysterious gloom."*
1824	53	*The Nave of the Church of St. James at Antwerp.*
1824	70	*Interior of the Abbey Church of St. Ouen at Rouen.*
1824	79	*Interior of the Cathedral at Rheims.*
1824	118	*View of the East End of St. Peter's Church at Louvain.*
1824	128	*View of the West End of the Church of St. Peter, at Louvain.*
1824	173	*The Altar of the Holy Sacrament, in the Church of St. James, at Antwerp - In the extreme distance the Sepulchral Chapel of Peter Paul Rubens.*
1824	245	*Sepulchral Chapel of Peter Paul Rubens in the Church of St. James, at Antwerp.*
1824	291	*The Choir of the Cathedral of Worcester, looking East - For the illustration of the Architecture and Sculpture of Worcester Cathedral, lately published.*

1824	292	*Exterior View of the Cathedral of Worcester, for the above Publication.*
1824	295	*The Choir of the Cathedral of Worcester, looking West - for the Illustration of the Architecture and Sculpture of Worcester Cathedral, lately published.*
1825	10	*View in the Jesuits Church at Bruges,* 8gns., J. Webster Esq., Whiteheads Grove, Sloane Street, Frame and glass £1.11.6.
1825	17	*View of the East End of the Cathedral Church of Chartres,* 15gns., E. Durant Esq.
1825	61	*Porches adjoining the north end of the Transept of the Cathedral Church of Chartres,* 15gns., Mr. Monteith, Frame and glass £3.10.0.
1825	74	*Part of the East End of the Church of St. Ouen at Rouen,* 8gns.
1825	81	*Part of the Exterior of the Cathedral Church of Lincoln,* 8gns., J. Webster Esq., Frame and glass £1.11.6.
1825	89	*West Front of the Cathedral of Chartres,* 12gns., Mr. R. Williams Junr., Companion to 120. Frame and glass £2.2.0.
1825	91	*Part of the Nave of the Church of St. Remi at Dieppe,* 10gns., Marquis Stafford, Frame and glass £2.2.0.
1825	100	*View in the Nave of the Dominican Church at Antwerp,* 25gns.
1825	103	*Interior of a Church,* 8gns., J. Morrison Esq., Frame and glass £3.13.6.
1825	113	*Interior of a Flemish Church,* 8gns., J. Morrison Esq., Frame and glass £3.13.0.
1825	120	*Part of the Cathedral Church of Rouen,* 12gns., Mr. R. Williams, Companion to 89. Frame and glass £2.2.0.
1825	122	*Part of the Choir of St. Remi, at Dieppe,* 10gns., Frame and glass £2.2.0.
1825	136	*View at the East End of the Cathedral Church of Lincoln, considered retrospectively as it may have appeared before the removal of the Shrine of St. Hugh, with preparation for an Episcopal High Mass,* 40gns., Mr. Monteith, 9 Craig's Court, Charing Cross.
1825	172	*View in the Cathedral of Worcester,* 8gns., C. Birch Esq., Lee Road, Black Heath, Frame and glass £1.11.6.
1825	181	*Part of the East End of the Church of St. Ouen, at Rouen,* 8gns., Newman Esq., Frame and glass £1.11.6.
1825	268	*View in the Church of St. Bavon, at Ghent,* 10gns., Frame and glass £2.2.0.
1826	15	*Transept of the Cathedral Church, Cambray,* 8gns., Mr. T.I. Ireland.
1826	63	*Entrance to the Church of St. James at Liege,* 8gns.
1826	72	*View in the Cathedral Church of Cambray,* 8gns., Mr. Morant.
1826	87	*The Choir of the Cathedral Church of York,* 40gns., T. Griffiths Esq.
1826	92	*The Market Place at Liege,* 10gns.
1826	98	*An Interior View of the Choir of the Cathedral Church of Cologne,* Sold.
1826	119	*Interior of the Transept of the Church at St. Oüen, at Rouen,* 15gns., Lord Brownlow.
1826	159	*The Church of St. Gery, at Cambray,* 10gns., Mr. Birch, 15 Sussex Place.
1826	170	*The Shrine of the Three Blessed Kings in the Cathedral Church of Cologne,* 10gns.
1827	2	*Terrace, Front of the Castle of Heidelberg,* 25gns., Lord Brownlow.
1827	59	*View in the Cathedral Church of Malines,* Sold.
1827	75	*View in the Cathedral Church of St. Bavon, Ghent,* Sold.
1827	113	*The Penance of Jane Shore, in the old Cathedral of St. Paul, London, AD 1483, "In conclusion, she was laid into Ludgate, and by the Bishop of London put to open Penance for incontinency, going before the Cross, in procession upon a Sunday . . ." Sir Thomas More.* 100gns.
1827	178	*View in the South Aisle of the Cathedral of Cologne,* 25gns.
1827	180	*View in the North Aisle of the Cathedral of Cologne,* 25gns.
1827	247	*The West Front of the Cathedral Church of Strasbourg,* 40gns.
1827	271	*Part of the Quadrangle, with the front of the Knights' Hall of the Castle of Heidelberg,* 25gns.
1827	279	*View in the Cathedral Church of Cambray,* 6gns., Mrs. Olive.
1827	307	*View in the Cathedral Church of Amiens,* 10gns., G. Morant Esq., 95 Wimpole St., Cavendish Square.
1827	312	*View in the Church of St. Gery, at Cambray,* 10gns.
1827	314	*East End of the Cathedral Church of Worms,* 6gns., Mr. C. Barclay.
1827	320	*The Sepulchral Chapel of Rubens in the Church of St. James, at Antwerp,* 10gns.
1827	322	*West End of the Cathedral Church of Worms,* 6gns., Mrs. C. Barclay.
1827	328	*View in the South Wing of the Transept of the Cathedral Church of Strasbourg,* 10gns., J. Wyatville Esq.
1827	342	*The Penance of Jane Shore.*
1828	108	*The West Front of the Cathedral of Rheims; being one of the Examples of the ecclesiastical Architecture of France, just published,* 15gns., John Moxon, Lincoln's Inn Fields.
1828	119	*The West Front of the Cathedral of Amiens - for the Examples of the Ecclesiastical Architecture of France,* 15gns., Jeffry Wyatville Esq.

1828	153	*View in Henry VII's Chapel; One of the Examples of the Ecclesiastical Architecture of England; now publishing by Mr. Jennings*, Sold.
1828	165	*The Transept and Part of the Choir of the Cathedral of Ely - for the Examples of the Ecclesiastical Architecture of England*, Sold.
1828	334	*View at the West End of the Cathedral of Ely*, 8gns.
1829	159	*View in St. George's Chapel, Windsor*, 15gns., Parrott Esq.
1829	168	*Interior of the Cathedral Church of Rheims*, 15gns., Parrott Esq.
1829	179	*View in the North Aisle of the Church of St. Ouën at Rouen*, 15gns., Mr. G. Basevi, 17 Saville Row, Wishes to take frame also.
1829	215	*Porches on the South side of the Cathedral of Chartres*, 15gns.
1830	304	*Strasbourg Cathedral*, 15gns.
1831	53	*Hotel de Ville at Louvain.*
1831	63	*Hotel du Bourgtheroulde at Rouen.*
1832	70	*Interior of Henry the Seventh's Chapel in the Abbey Church of Westminster*, 80gns., Frame and glass £7.7.0.
1832	79	*Interior of St. George's Chapel, Windsor. For the Select Examples of the Ecclesiastical Architecture of the Middle Ages in England. Published by Jennings and Chaplin*, 25gns., Lord Rolle, 18 Upper Grosvenor St.
1832	87	*Interior of the Choir of Oxford Cathedral - For the Select Examples of the Ecclesiastical Architecture of the Middle Ages in England. Published by Jennings and Chaplin*, 25gns., Frame and glass included.
1833	81	*Quadrangle of the Archiepiscopal Palace at Liege - being one of a series of Twelve Views on the Continent, now publishing. See Advertisement annexed to this Catalogue*, 5gns., Spencer Smith Esq., 6 Portland Place.
1833	82	*View in the South Wing of Strasbourg Cathedral. See Advertisement as above*, 5gns.
1833	172	*Interior View of the West End of the Metropolitan Church at Mechlin*, 15gns., Mrs. Smith, 6 Portland Place, Instead of No. 81.
1833	242	*Part of Strasburg Cathedral from the Market Place being one of a series of Twelve Views on the Continent, now publishing. See Advertisement annexed to this Catalogue*, 5gns.
1833	275	*The Metropolitan Church of St. Rombaut at Mechlin - being one of a series of Twelve Views on the Continent, now publishing. See Advertisement annexed to this Catalogue*, 5gns., Mr. Moon, Theadneedle St.
1833	314	*Sepulchral Chapel of Rubens in the Church of St. James, Antwerp - being one of a series of Twelve Views on the Continent, now publishing. See Advertisement annexed to this Catalogue*, 5gns.
1833	316	*Altar of the Holy Sacrament in the Church of St. James, at Antwerp - being one of a series of Twelve Views on the Continent, now publishing. See Advertisement annexed to this Catalogue*, 5gns.
1833	347	*Terrace Front of the Castle of Heidelberg - being one of a series of Twelve views on the Continent, now publishing. See Advertisement annexed to this Catalogue*, 5gns., The Right Honble. Lady Rolle, 18 Upper Grosvenor St.
1833	404	*Chapel of the Virgin, in the Church of St. Charles of Borromeo, at Antwerp - being one of a series of Twelve Views on the Continent, now publishing. See Advertisement annexed to this Catalogue*, 5gns.
1833	414	*Ruins of the Knights Hall at Heidelberg - being one of a series of Twelve Views on the Continent now publishing. See Advertisement annexed to this Catalogue.*, 5gns.

WILLIAMS P

1828	154	*Two Children of the Neighbourhood of Attma, preparing for a Festa*, 14gns., Lord C.Townshend, 67 Portland Place.
1828	166	*An Italian Ciociaca Spinning, with her Infant in the Cummella*, 14gns., Mr. Parrott, 13 Millbank Row, Westminster.
1828	349	*Children of the Campagna di Roma, fastening on the Cucia*, 12gns., Sold.
1829	284	*A Roman Beggar Woman, with her Child, in the Costume of Subiacco*, 20gns., Lord Brownlow [deleted].
1829	334	*Peasants, with their Children, in the Neighbourhood of Genzano*, 25gns., Hull Esq.
1830	274	*Peasants of Attina, with their Children*, Sold.
1830	281	*Preparing for the Festa*, Sold.
1830	286	*A Peasant of Ischia, in a Festa dress, Praying to the Madonna*, Sold.
1831	336	*Vintagers returning Home - Scene at Genzano.*
1833	90	*Interior of an Italian Cottage*, 20gns.
1833	306	*An Albanese at her Prayers*, 14gns., Mr. Hixon, Quadrant(?).

WILSON A

| 1823L | 64 | *Baths of Caracalla, from the Palatine Hill - Rome*, Sir Rob. Harry Inglis, Bt. |
| 1823L | 102 | *View of Tivoli*, Sir Rob. Harry Inglis, Bt. |

WILSON J

1820	47	*On the Thames*, £5.5.0, J. Belisario Esq.
1820	61	*A Study*, £5.5.0, Mr. Palmer.
1820	86	*A Lee-shore - Squally Evening.*
1820	109	*A Fresh Breeze.*
1820	119	*A Composition.*

WOODMAN R

| 1820 | 168 | *Portrait of Her Royal Highness the late Princess Charlotte.* |

| 1820 | 181 | *Portrait of his late Majesty George the Third,* £10.10.0, Mr. Dimsdale. |
| 1820 | 189 | *Portrait of a Gentleman.* |

WORRELL A B

| 1819 | 124 | *View of Campveer, from North Beveland,* £15.15.0, Mr. Hodges. |
| 1819 | 134 | *View of Middleburg in Walcheren, from Nieuwland in Walcheren,* £31.10.0, R. Bush Esq. |

WRIGHT F M

| 1827 | 269 | *Captain Wattle and Miss Rowe,* Sold. |

WRIGHT J M

1827	345	*Falstaff and Mrs. Ford, in the Merry Wives of Windsor.*
1831	217	*Una - a Sketch.*
1831	318	*Othello, Iago, Desdemona, and Emilia, "Othello. – 'Farewell, my Desdemona: I will come to thee straight.'" Act III. Scene 3.*
1832	11	*Ophelia - a Sketch,* 4gns.
1832	126	*Jenny Jones before Mrs. Deborah Wilkins, Vide Tom Jones.* 50gns.
1832	136	*Scene from Boccaccio - a Sketch,* 4gns.
1832	345	*Scene in Much Ado about Nothing,* 4gns.
1832	346	*Scene in Twelfth Night,* 4gns.
1832	348	*Scene in Cymbeline,* 4gns.
1832	349	*Scene in the Merchant of Venice,* 4gns.
1832	380	*Scene in the Midsummer Night's Dream,* 4gns.
1833	69	*Scene in Measure for Measure,* 7gns.
1833	141	*Merry Wives of Windsor,* 4gns.
1835	90	*Cinderella,* 40gns.
1836	207	*A Midsummer's Nights Dream,* 50gns.
1837	79	*Village Choristers Rehearsing,* Sold.
1838	237	*The Little Dancing Master, From an Old Spanish Novel.*
1838	330	*The Captive, From an Old Spanish Novel.*
1839	82	*The De'il cam Fiddling through the Town, 'The De'il cam fiddling through the town, And danced awa wi' the exciseman . . ." Burns.* 15gns.
1839	102	*The Vale of Idleness, "Among this gay race I was wandering, and found them ready to answer all my questions, and willing to communicate their mirth . . ." Dr. Johnson's Rambler.* 40gns.
1840	300	*Guardian Angels.*
1841	107	*Scene from Milton's Comus,* 30gns.
1842	58	*Don Quixote fed by the high-born Damsels.*
1842	94	*Scene from the Merchant of Venice.*
1842	209	*Scene from Romeo and Juliet.*
1843	4	*Dorothea, as Princess of Miconicona, begging a boon of Don Quixote,* 25gns.
1843	17	*The Scrutiny in Don Quixote's Library, by the Curate and Barber,* 20gns., S.F. Hartley Esq., Halifax, Prize of 20£ in the Art Union of London.
1843	97	*"The Jolly Beggars" – Burns,* 5gns., Mr. Jones Loyd, 22 New Norfolk St., Parkham.
1843	106	*The Three Blind Minstrels - Norman Tales,* 15gns., James Dorrington Esq., Clarges St., Piccadilly.
1843	180	*Scene from the "Merry Wives of Windsor",* 5gns.
1843	186	*Scene from "As You Like It", Shakespeare,* 5gns.
1843	272	*The Grandfather, from Boccacio's "Decameron",* 8gns.
1843	277	*Juliet and Nurse, "Nurse.– 'Mistress! – what, mistress! – Juliet! . . .'" Romeo and Juliet.* 15gns.
1843	287	*The Glee Club,* 7gns.
1843	294	*"Falstaff. – 'Zounds, I am afraid of this gunpowder Percy, though he be dead: how if he should counterfeit, too, and rise?' . . ." First Part of Henry IV.* 10gns.
1843	330	*Gadshill, 'Then did we two set on you four: and, with a word, out-faced you from your prize . . ." Shakspeare, King Henry IV.* 12gns.
1843	339	*Olivia's Return – Vicar of Wakefield,* 30gns.
1844	239	*The Everlasting Club, "This club was instituted towards the end of the civil war, and continued without interruption, until the time of the great fire, which burnt them out, and dispersed them for several weeks . . ." Vide Spectator, No. 72.* 10gns.
1844	313	*The Row at Mrs. Brulgruddery's,* 15gns.
1845	86	*The Afternoon's Nap,* 30gns., Thos. Boys Esq., 11 Golden Square, Frame and glass £5.12.0.
1845	178	*The Weary Travellers,* 20gns., S. Boyd Esq., Weymouth, Frame and glass £4.10.0, P.AU. 25£.
1845	249	*What you Will,* 15gns., Richd. Ellison Esq., Frame and glass £1.10.0.
1846	97	*Our Saviour caressing little Children, "Suffer little children to come unto me, and forbid them not".* 85gns., Frame and glass £8.8.0.
1846	119	*The Song,* 65gns., William Vokins, Frame and glass £5.12.0.
1846	214	*The Holy Family,* 30gns., Mrs. Bristow, 101 Piccadilly or Broxmore Park, White Parish, Wilts., Frame and glass £2.15.0, P.AU. 25£.
1847	209	*The Virgin and Child,* 15gns.
1847	237	*The Bathing Place,* 15gns., Mr. Vokins, Frame and glass £2.5.0.
1848	222	*Young Thornhill's Introduction to the Wakefield Family,* 15gns., Frame and glass £1.13.0.

1848	247	*The Gentle Shepherd, Vide Allan Ramsay.* 15gns., Frame and glass £2.8.0.
1848	267	*Juliet and the Nurse,* 15gns., W.M. Bigg, 3 Langham Place, Frame and glass £2.8.6.
1848	306	*Haymaking, Vide Vicar of Wakefield.* 15gns., Frame and glass £1.13.0.
1848	332	*Preparing for Sunday,* 25gns., Frame and glass £3.14.6.
1849	45	*Scene from Comus - A Sketch.*
1849	174	*The Mouse, or the Disappointed Epicures.*
1849	219	*Monks Carousing.*
1849	332	*The Cradle Hymn - Dr. Watts.*
1850	265	*Sancho and the Duchess - Don Quixote,* 15gns.
1851	85	*Christian relating his Adventures - Pilgrim's Progress.*
1851	242	*The Pet Kitten.*
1852	152	*Alfred in the Danish Camp,* 20G, Frame and glass £3.5.0.
1853	281	*The Dance.*
1855	211	*Scene from Macbeth,* 15gns.

WRIGHT J W

1831	401	*Girl Reading.*
1832	31	*Isaac of York, Rebecca, and Gurth, "Here the Jew paused again, and looked at the last zecchin, intending doubtless to bestow it upon Gurth . . ." Vide Ivanhoe, Vol. I.* Sold.
1832	235	*Scene in Taming of a Shrew,* 12gns.
1832	297	*Scene in Henry the Fourth,* 4gns.
1832	351	*Scene in Coriolanus,* 4gns.
1832	381	*Scene in Twelfth Night,* Sold, E. Winstanley Esq. Senr., 7 Poultry.
1832	385	*Desdemona and Emilia, Othello. Act IV. Scene 3.* Sold.
1832	409	*The Confidential Communication,* Sold.
1833	193	*Early Piety, "Remember now thy Creator in the days of thy youth". Ecclesiastes, chap. xii. v. i.* Sold.
1833	322	*Free Companions receiving Ransom from the Family of a Calabrian Noble,* Sold.
1833	328	*A Venetian Girl receiving her Nativity from a Jew Astrologer,* 15gns.
1833	334	*Minna and Brenda,* Sold.
1837	83	*The Widow,* 50gns.
1837	163	*Cottager's Family,* 25gns., Revd. Alfred Harford, Locking, near Cross, Somerset, deliver to Mr. Hogarth, 60 Great Portland St.
1837	303	*A Young Lady,* 15gns., Proctor Esq., Fladongs(?) Hotel, Oxford St.
1837	328	*Cottager's Child,* 10gns.
1838	249	*The Gypsey Hat.*
1839	50	*The Opening of the Letter-Bag,* 150gns.
1839	58	*The Lesson Neglected, "Subdued by breathless harmonies Of meditative feeling."* 18gns., Lord T. Egerton, Bridgewater Hse., Cleveland Square.

1839	124	*Una, "One day, nigh wearie of the yrksome way . . ." Fairie Queen, Canto 3, Book I.* 40gns., J. Dorington Esq., 41 Clarges St.
1839	304	*Little Red Riding Hood,* 15gns., Lady Rolle.
1840	75	*The Vow, "Add proof unto mine armour with thy prayers, And with thy blessings steel my lance's point".*
1840	106	*Girl and Child, "The sun is sinking in his glory . . ."*
1840	203	*Study of a Hindoo.*
1840	240	*Portia, "O me! the word chose! - I may neither choose whom I would, nor refuse whom I dislike; so is the will of a living daughter, curb'd by the will of a dead father". Merchant of Venice, Act I. Scene 2.*
1840	279	*Venetian Lady at a Balcony.*
1840	301	*Girl in the Costume of the beginning of the 17th century.*
1840	322	*The Answer.*
1841	237	*The Contrast,* Sold.
1841	319	*Rosalind and Celia, "Celia – 'I pray thee, Rosalind, sweet my coz, be merry.' . . ." As You Like It, Act I. Scene 2.* 70gns.
1841	328	*The Day Dream,* 20gns., ? Laurence Esq., Club Chambers, 15 Regt. St., Art Union.
1844	317	*Antonio,* 15gns.
1846	271	*Anne Bullen, "Lord Chamberlain to Anne Bullen. 'You bear a gentle mind, and heavenly blessings. Follow such creatures.'" – Henry VIII. Act II. Scene 3.* 10gns.

WRIGHT J WM

1842	28	*A Family of Primitive Christians reading the Bible.*
1842	64	*Italian Lady (1500).*
1842	75	*The Orphan.*
1842	295	*Retrospection, "When to the sessions of sweet silent thought, I summon up remembrance of things past".*
1842	309	*Curiosity.*
1842	334	*Expectation.*
1843	163	*The Sisters,* Sold.
1843	173	*The Confession,* 35gns., Charles Prater Junior Esq., 2 Charing Cross, To keep the frame and glass £2.2.0, Prize of 15£ in the Art Union of London.
1843	279	*Asking Consent,* 25gns.
1843	296	*The Love Letter,* 40gns., B.G. Windus Esq., Tottenham.
1843	327	*Lorenzo and Jessica, "Lorenzo. – 'Even such a husband . . .'" Merchant of Venice, Act III., Scene V.* 15gns., John Foster, Newton Willows, Bedale, Yorkshire by B.N. Lumby, 9 Charles St., By. Sq.
1843	341	*Tuning,* 25gns.

1843	344	*Youth and Age*, 25gns.
1844	130	*"What do You Think"?*, 15gns., Lord C. Townshend, Frame and glass £1.8.6.
1844	139	*Rosalind, Celia, and Orlando, "Rosalind (giving him a chain off her neck). 'Gentleman, wear this for me; one out of suits with fortune; that could give more, but that her hand lacks means.'" As You Like It, Act I., Scene 2.* Sold.
1844	229	*Maiden Meditation*, Sold.
1844	243	*The New Lesson*, 8gns., Lord C. Townshend, Frame and glass £1.8.6.
1844	284	*The Reconciliation*, 50gns., Frame and glass £4.10.0.
1845	142	*Instruction, "1. 'Hear, ye children, the instruction of a father, and attend to know understanding' . . ." Proverbs, chap. iv.* 120gns.
1845	290	*Sappho, "Sume fidem et pharetram; fies, manifestus Apollo." – Ovid.* 20gns.
1845	293	*Ill Omens, "As she look'd in the glass which a woman ne'er misses . . ." Moore's Poems.* 15gns., Miss Maria Coles, Old Park, Clapham.
1845	303	*Morning Occupations*, 30gns., Sir John Lowther Bart., Frame and glass £2.5.0.
1845	308	*Love and Hope, "She linger'd there till evening's beam Along the waters lay . . ." Moore's National Airs.* 15gns.
1846	81	*Meditation*, Sold, Mr. Hewett(?).
1846	89	*The Blue Domino*, 20gns., Frame and glass £1.12.0.
1846	229	*Yes, or No*, 40gns., Frame and glass £3.3.0, AU.
1846	235	*"There's nothing half so sweet in life. As love's young dream." – Moore's Irish Melodies.* 25gns., Frame and glass £1.13.0.
1846	272	*Portia, "Por. 'O me, the word choose! I may neither choose whom I would, nor refuse whom I dislike: so is the will of a living daughter curb'd by the will of a dead father.'" – Merchant of Venice, Act I. Scene 2.* 10gns.
1846	273	*Imogen, "Imo. 'Continues well my lord? His health, beseech you?'" Cymbeline, Act I. Scene 7.* 10gns.
1846	274	*Lady Percy, "L. Per. 'In faith, I'll know your business, Harry, that I will.'" King Henry IV. Part I. Act II. Scene 3.* 10gns.
1846	282	*Lady Grey, "K. Edw. 'Twere pity they should lose their father's land.' . . ." Henry VI. Part III. Act III. Scene 2.* 10gns. "
1846	283	*Princess Katharine, of France, "Kath. 'Den it shall also content me.'" – Henry V. Act V. Scene 2.* Sold.
1846	284	*Princess of France, "Pr. 'Amazed, my lord? Why looks your Highness sad?'" Love's Labour Lost, Act V. Scene 2.* 10gns.
1846	285	*Beatrice, "Bea. 'I pray you how many hath he killed and eaten in these wars? But how many hath he killed? for, indeed, I promised to eat all of his killing.'" – Much Ado About Nothing, Act I. Scene 1.* 10gns.
1847	52	*The Despatch, "Here comes a messenger. What news?"* 40gns., Frame and glass £3.0.0.
1847	260	*The Village Glee Club*, 15gns., Mrs. Ellison, Frame and glass £2.5.0.
1847	263	*Celia, "Ros. 'The Duke my father loved his father dearly.' . . ." As You Like It, Act I., Scene 3.* Sold, Frame and glass £1.5.0.
1847	264	*Reading the Scriptures - a Sketch*, 8gns., Ian(?) Angell Esq., 18 Gower Street, Frame and glass £1.0.0.
1847	293	*La Pucelle d'Orleans*, 20gns.

WRIGHT J WM THE LATE

1848	321	*The Pleasing Reverie*, 20gns.

WRIGHT JOHN WILLIAM

1834	17	*The Sisters*, 25gns., Sold.
1834	138	*The Friends, "Abused mortals, did you know Where joy, heartsease, and comforts glow . . ." Sir Henry Wootton.* 20gns.
1834	254	*Anna Boleyn*, 15gns.
1834	286	*Catherine Seyton and Roland Graeme, "Catherine was at the happy age of innocence and buoyancy of spirit, when . . ." The Abbot, Vol. I. chap II.* 40gns., Miss Langston, 32 Upper Brook Street.
1835	48	*Helena and Countess, "Countess – 'Come, come, disclose the state of your affection.' . . ." All's Well that Ends Well, Act I. Scene 3.* 15gns.
1835	107	*Sunday Evening - Cornish Villagers*, 25gns.
1836	44	*Alice Lee and Louis Kerneguy, Vide Woodstock* 50gns.
1836	224	*Lady at a Window, "She through that window looks towards the lake . . ." Wordsworth.* Sold.
1836	286	*Lady with a Letter, "Good verse most good, and bad verse then seems better . . ." Anon.* 15gns., Sir Wm. Middleton.

WRIGHT T M

1824	76	*Scene from the Second Part of King Henry IVth, "Bardolph. – 'Come get you down stairs' . . . Drawing, and driving Pistol out."*

WRIGHT T M

1825	102	*Slender and Anne Page, "Anne - 'I may not go in without your worship, they will not sit till you come' . . ."* 10gns.
1825	35	*Lavinia and her Mother, "When the mournful tale Her mother told . . ."* 10gns., Mrs. Cottam of Whalley, near Lancashire, Frame and glass £8.8.0.
1825	60	*Bruno and Buffalmacco imposing on the credulity of Master Simon the Doctor, Vide Boccacio's Decameron, 8th Day, Novel 9th.* 9gns.

| 1825 | 92 | *Dennis Brulgruddery and his Wife, "Dennis – 'Look up, my sweet Mrs Brulgruddery, while I give you a small morsel of consolation . . .'" John Bull.* 10gns. |

| 1825 | 112 | *Nurse and Peter, "Nurse - 'Peter, take my fan, and go before.'" Romeo and Juliet.* 10gns. |

| 1825 | 123 | *The Beauty who was told to be proud, "A beauty ought, they say, to be a little proud . . ." Froissart.* 10gns., J. Webster Esq. |

| 1825 | 223 | *Launce and his Dog Crab, "Nay, I remember the trick you served me, when I took my leave of Madam Silvia . . ." Vide Two Gentlemen of Verona.* 9gns., Jerden Esq. |

| 1825 | 233 | *Scene from the Seventh Novel of the 8th day of Boccaccio's Decameron - The Scholar who is made to wait a whole Night for his Mistress, during the midst of Winter, in the Snow,* 9gns. |

| 1825 | 281 | *Scene from the Merchant of Venice, Gratiano, Salarino, Lorenzo and Jessica.* 10gns. |

| 1825 | 298 | *Salanio, Salarino, and Shylock, "Shylock – 'If a Jew wrong a Christian, what is his humility? revenge . . .'" Merchant of Venice.* 10gns. |

| 1826 | 90 | *Scene from King Lear, "Lear - 'Life and death! I am ashamed that thou has power to shake my manhood thus. That these hot tears, which break from me per force, should make thee worth them. Blasts and fogs upon thee! The untented woundings of a father's curse pierce every sense about thee". Act I. Scene IV.* 100gns., Lockwood Esq., Lansdown Place. |

| 1827 | 143 | *Bottom and the Fairy Queen,* 9gns., Mr. F. D. Ryder, 39 Grosvenor Square. |

| 1827 | 280 | *A Coquette between Gaiety and Gravity,* Sold. |

| 1827 | 303 | *Scene from the Decameron of Boccaccio, 4th Day, Novel the 9th,* Sold. |

| 1827 | 330 | *Master Simon, the Doctor, and Bruno, imposing on the credulity of Calandrino, Boccaccio's Decameron, 9th Day, Novel 3rd.* Sold. |

| 1828 | 49 | *Falstaff and Page,* 8gns. |

| 1828 | 278 | *The Procession of the Flitch of Bacon, "This singular custom was instituted by Sir Richard de Sommerville, of the manor of Whitchmore, in the county of Stafford, about the time of Edward the Third . . ."* 140gns. |

| 1828 | 354 | *The Burning Shame, a Punishment for a Bad Lawyer, an ancient Custom peculiar to the Isle of Wight, " – by which they drove him, From among them – . . ."* 40gns. |

| 1829 | 97 | *Scene at the Boar's Head, Eastcheap - A Sketch.* |

| 1830 | 77 | *Scene at the Boar's Head Tavern in Eastcheap,* 12gns., Sir Robert Leigh, 33 Soho Square. |

| 1831 | 26 | *Scene in the Play of Pericles - a Sketch.* |

| 1831 | 37 | *Cottage Affliction - A Sketch.* |

| 1831 | 45 | *Henry the Fifth, and the Conspirators.* |

| 1831 | 51 | *Scene in the Play of Measure for Measure.* |

| 1831 | 61 | *A Scene from the Novel of the Antiquary.* |

| 1831 | 224 | *A Scene from the Novel of Waverley.* |

| 1831 | 231 | *A Bandit - Sketch.* |

| 1831 | 288 | *A Scene from Twelfth Night - a Sketch.* |

| 1831 | 349 | *Calandrino the Painter.* |

| 1833 | 194 | *Sir John Falstaff,* 12gns. |

| 1833 | 265 | *Lance and his Dog,* 12gns. |

| 1833 | 276 | *Scene in the Tempest,* 4gns. |

| 1833 | 285 | *Scene in Love's Labour Lost,* 4gns. |

| 1833 | 301 | *Scene in Much Ado about Nothing,* 12gns. |

| 1833 | 346 | *Scene in King Henry IV,* 4gns. |

| 1833 | 402 | *Scene in Much Ado about Nothing,* 8gns. |

| 1833 | 405 | *Death of John of Gaunt,* 4gns. |

| 1833 | 415 | *Scene in the Two Gentlemen of Verona,* 7gns. |

| 1833 | 416 | *Scene from the Induction to Taming a Shrew,* 8gns. |

| 1834 | 331 | *Donna Lauretta relating the Amours of her Youth to Don John and Peter, The Inconstant, an Old Novel.* |

WYON W
| 1814 | 10 | *Medal Die engraving the Head of Ceres.* |

ZEIGLER H
| 1818 | 21 | *Sketch on the Estate of R. P. Knight, Esq. at Bringe Wood, Herefordshire.* |

ZIEGLER H
1817	90	*Sketch at Millbank,* £4.4.0, Lord Ossory(?).
1817	141	*Landscape. Composition.*
1817	160	*Landscape. Composition.*
1817	198	*Landscape. Composition.*
1817	210	*Sketch at Millbank.*
1817	241	*Cottage Children.*
1817	253	*Landscape. Composition.*
1818	110	*Cottage at Laintwerdine, near Ludlow, Shropshire.*
1818	355	*View near Hampstead.*
1820	245	*Walford in Shropshire.*
1820	274	*Sketch at Kinton, Herefordshire.*
1820	278	*View near Kinton, Herefordshire.*
1820	284	*Ethelbert's Tower, Canterbury - A Sketch from Nature.*
1820	306	*The Ferry Boat.*
1820	317	*A Fall of the Monach, South Wales.*
1820	327	*Sketch at Hafod, in South Wales.*
1820	338	*Sketch at Hafod, South Wales.*
1820	355	*View near Wigmore, Shropshire.*

ZIEGLER H B
1819	200	*Scene near the Bridge at Worcester.*
1819	201	*Dark Lane, Kinton, Herefordshire.*
1819	203	*Scene on Col. Johnes's Estate, Hafod.*
1819	221	*Cottage near Laintwerdine, Shropshire.*
1819	238	*Wood near Downton Common, Herefordshire.*
1819	246	*Dark Lane, Kinton, Herefordshire.*
1819	289	*Study from Nature.*